Art in Our Times

W9-BBQ-104

ART IN OUR TIMES

A PICTORIAL HISTORY 1890–1980

Peter Selz
University of California, Berkeley

Harcourt Brace Jovanovich, Inc.
New York San Diego Chicago San Francisco Atlanta Toronto

Harry N. Abrams, Inc.
New York

TO MY DAUGHTERS
TANYA AND GABRIELLE

Editor: Phyllis Freeman
Designer: Ulrich Ruchti

Library of Congress Cataloging in Publication Data

Selz, Peter Howard, 1919–
 Art in our times: a pictorial history 1890–1980.

 Bibliography: pp. 559–565
 Includes index.
 1. Art, Modern—19th century—History—Pictorial
works. 2. Art, Modern—20th century—History—Pic-
torial works. 3. Architecture, Modern—19th century—
History—Pictorial works. 4. Architecture, Modern—
20th century—History—Pictorial works. I. Title.
N6447.S426 709'.04 80-15710
ISBN 0-15-503473-1

Library of Congress Catalog Card Number: 80–15710

Published in 1981 by Harry N. Abrams, Incorporated, New York
All rights reserved. No part of this publication may be reproduced
or transmitted in any form or by any means, electronic or
mechanical, including photocopy, recording, or any information
storage and retrieval system, without permission in writing from
the publisher.

Textbook Edition

Picture reproduction rights reserved by S.P.A.D.E.M. and
A.D.A.G.P., Paris where relevant

Printed and bound in Japan

On the cover: Henri Matisse. *The Sorrows of the King*. 1952.
Gouache on cut and pasted paper, 9' 7¼" x 12' 8". Musée
National d'Art Moderne, Paris. Centre Georges Pompidou

Contents

Preface and Acknowledgments

The history of art is a study of the changing perceptions of the inner and outer environments. In our times there have probably been more diverse attitudes and individual styles than at any other period in the history of art. This book begins with the art of the 1890s. The last decade of the nineteenth century produced revolutionary changes in architecture, painting, and sculpture ranging from the early development of the skyscraper as a new building type to the affirmation of the autonomy of the work of art in painting and sculpture. The new forms and expressions generated in the 1890s shaped many features of the art of the twentieth century. For the vanguard artists at the end of the last century a work of art was no longer a reproduction or definition of the palpable world but a new exploration of visible and invisible reality. If one general statement can be made about the art of our times, it is that one by one the old criteria of what a work of art ought to be have been discarded in favor of a dynamic approach in which everything becomes possible. The purpose of art was stated beautifully by Paul Klee in 1920, when he asserted that "art does not reproduce the visible; rather it *makes* visible," taking us "into the land of greater insight." The quality of a work of art can perhaps best be judged by its potential yield of new experiences. Nobody has said this more cogently than Robert Rauschenberg: "If you do not change your mind about something when you confront a picture you have not seen before, you are either a stubborn fool or the painting is not very good."

It is the distinctive quality of the work, its inherent character, that provides specific meaning and affords aesthetic pleasure. Therefore, instead of adhering to older methods of categorizing modern art as a sequence of movements, I decided to bring the unique aspects of each work into focus by means of visual juxtaposition. In the first chapter, in discussing "Portraits of Women," the contrast of portraits by Boldini, Cassatt, Cézanne, and Toulouse-Lautrec gives immediate insight into their differences in approach, purpose, and form.

To look at art in terms of successive movements or "isms" was a useful didactic method when modern art was first studied seriously. But it is a very unsatisfactory method that has outlived its usefulness. Most major artists cannot be categorized and made to fit into these conceptual pigeonholes. Where does Brancusi belong, or Bonnard, Beckmann, or Bacon? How does one classify Frank Lloyd Wright or Georgia O'Keeffe? Matisse was a Fauve for a very short time in his long career; Duchamp outlived his brief Dada period by more than half a century; and to call Picasso a Cubist is to miss the cataclysmic complexity of his work. Both De Kooning and Rothko have been classified as Abstract Expressionists but De Kooning was rarely abstract and Rothko never expressionist. Categorizations of this sort are simplifications, often meaningless if not misleading. Artists themselves have always felt very uncomfortable when restrictive labels were affixed to their styles. David Smith spoke for many of them when he stated that "names are usually given to groups by people who don't understand them or don't like them."

To label a landscape painted by Georges Braque near L'Estaque in 1908 a "Cubist" painting is correct but does not lead the viewer "into the land of greater insight." A comparative study of contemporaneous treatments of the landscape motif by artists as diverse as Monet, Cézanne, Hodler, Homer, Vlaminck, Mondrian, and Kandinsky as against Braque might indeed lead to greater understanding of artistic problems and particular solutions. It is this methodology which seems most promising. In this book, therefore, painting and sculpture are discussed according to themes, architecture according to building types.

In addition to being a unique object, a work of art belongs to its time, and each age has its own kind of art. It was created under certain circumstances in a particular cultural context, serving a definite purpose. This general time context can be established most conveniently by dividing the art of the last ninety years into decades. For each decade-chapter I have

provided a synoptic table and an introduction to place the artistic development within its general cultural framework. Too often art has been treated as existing in a rarefied, detached realm. The misjudgment of formalist criticism, however, has clearly revealed that art cannot be separated from the thoughts and ideas of its time, from the political and intellectual concerns during the period in which the artists lived and made their art.

This book, with its 1,600 illustrations, provides a comprehensive and inclusive visual record of the art of the twentieth century. It contains not only the most significant monuments but also works of art that are now neglected but were important at the time of their creation. I am including examples of architecture, painting, and sculpture made under fascism, Nazism, and Communism, works which heretofore have been largely disregarded in histories of modern art. Yet, no political historian would or could ignore Mussolini, Hitler, and Stalin in a study of modern European history. Why then do many art historians feel that the art of fascism or Socialist Realism can be overlooked? Perhaps because they imagine there is some invariable "mainstream of art." But art has never been that simple, and work that seems to belong to a side alley at a given time may suddenly turn up in the next generation's mainstream. Nobody, for example, considered the architecture of war of the 1940s very significant aesthetically, yet it may very well have had an impact on the Brutalism of the next decade. In the most recent decades I draw attention to new media such as Happenings, performances, body art, video, and various forms of conceptual art, although many critics would still question their validity as art.

This book is limited largely to painting, sculpture, and architecture with some reference to prints, drawings, posters, and design. Photography, both still and cinematic, could not be included because of the vastness of the body of work produced in these fields. These mediums deserve a comprehensive treatment in their own right.

I want to express my thanks to the friends, colleagues, and students who have helped significantly in completing this book. Above all, I wish to acknowledge Kristine Stiles, whose suggestions were particularly helpful in the final chapters of the book, and Grey Brechin, Brian Horrigan, and Bruce Radde for their knowing advice on the architectural sections. I am greatly obliged to Suzaan Boettger, Mildred Constantine, Andrew Fabricant, Deirdre Lemert, Ned Polsky, Merrill Schleier, Elizabeth Tumasoni, Barbara Williams, and Anne Williamson for their assistance. I profited from the critical judgment of Nan Rosenthal and the encouragement of Moira Roth. Robert Yagura made important suggestions for the design of the book, and Lorna Price was of great help in the original editing.

At Harry N. Abrams, Inc., my greatest gratitude goes to Phyllis Freeman, who for a period of two years worked with sensitivity, much sympathy, and a great deal of endurance on *Art in Our Times*. Appreciation is due to the late Harry Abrams, who helped launch this ambitious project, and to Margaret Kaplan, who nourished it to its completion, as well as to Judith Tortolano, Ellen Grand, Christopher Sweet, and Anne Yarowsky.

Work on this book was done in many libraries. I want to acknowledge especially the Louise Sloss Ackerman Fine Arts Library at the San Francisco Museum of Modern Art and its knowledgeable librarian, Eugenie Candau, who also prepared the bibliography. Once again, I found the libraries of The Museum of Modern Art and The Solomon R. Guggenheim Museum, in New York, of great value.

My gratitude is also due to the many public and private collections and photo archives here and abroad that have granted us permission to reproduce the works of art and provided the necessary photographs and color transparencies.

P. S.
Berkeley, California

One: The 1890s

The 1890s were filled with even more contradictions than are most decades. The century which saw the ascendancy of the bourgeoisie was reaching its conclusion. It had been a century of continuous and incredible progress in which one great scientific and technological invention followed on the heels of the previous one with accelerating speed. Gaslight replaced the kerosene lamp only to be supplanted by the incandescent light bulb which could be turned on by flicking a switch. Mankind looked forward to a new order of ever-expanding production of goods and services with ever-decreasing human toil.

Life in Europe appeared secure. A long period of peace and colonial and industrial expansion had brought with it the promise of full prosperity; "civilized" man could look forward to the uninterrupted continuation of a well-established social order. Queen Victoria's Diamond Jubilee in 1897 symbolized that apparent stability. In Central Europe the long reign of the Emperor Franz Josef—paternalistic, remote, exceedingly oppressive—seemed to ensure the continuity of the prevailing social system. Even a relative upstart like Emperor Wilhelm II of Germany, it was thought, could eventually be absorbed into the fabric of this linear cultural evolution. The entrenched order was buttressed diplomatically and militarily by the Triple Entente (Britain, France, and Russia) and the Triple Alliance (Germany, Austria-Hungary, and Italy).

With the assurance of incomprehension, Darwin's theory of evolution was misapplied from the field of biology to cultural history. Most citizens shared a supreme confidence that the whole world would eventually attain the civilized standards of European culture, which appeared absolutely superior, morally and spiritually, to any previous or contemporary civilization. This attitude rationalized European domination of most of the earth's surface and was highly profitable to the British aristocracy, France's *haute bourgeoisie,* and the Junker class and rising industrialists of imperial Germany, not to omit the Roman clergy. Relatively few individuals were aware of Nietzsche's pronouncement of God's demise, as Christianity continued to be implanted among the heathens of Africa and Asia.

Belief in progress and a bigger and better future within a capitalist society was perhaps most pronounced in the United States—the only major nation except Japan to remain relatively independent of European domination. The Battle of Wounded Knee in 1890 continued the genocide of the native American population, and the Spanish-American War, with the subsequent annexation of the Philippines and the brief occupation of Cuba, set the United States on its own imperialist course, which proved to be primarily economic rather than territorial.

But the 1890s were also a period of profound trouble. France was shattered by deep internal dissensions which surfaced in the antagonisms over the Dreyfus Affair. This scandal had broad political repercussions, as did the disastrous Boer War (1899–1902), in which Great Britain was embroiled. The conserva-

tive ruling class persisted in its view that capitalism was the best system to ensure social and economic well-being. But many intellectuals disagreed. In England members of the Fabian Society, aware of the terrible social, political, and economic injustices which were an inevitable result of the Industrial Revolution, worked for the emancipation of women and children and for greater sexual freedom. They believed in the orderly, rational transformation of institutions and looked forward to a non-Marxist socialist society in which a good life would be possible for all.

Others believed that more radical means were needed to end the oppression and exploitation for which they held the prosperous and complacent ruling class responsible. Presidents of France and the United States, the prime minister of Spain, the king of Italy, and the empress of Austria were assassinated between 1894 and 1901 by anarchists, who, as Pierre Proudhon had taught, believed that "property is theft." They formed a loosely organized movement to eliminate property, law, and government, thereby hoping to bring about the destruction of the bourgeois world. Peter Kropotkin, a Russian prince who became a revolutionary writer and leader, inspired terrorists throughout Europe and beyond with his calls for the "propaganda of the deed." Bombs were exploded with the goal of establishing a more equitable and, above all, free society.

Most of the artists of the period identified with the Establishment, enhancing and glorifying it with their own conservative works, but others refused to accept bourgeois values which dominated their lives and frustrated their careers. It was especially the scientifically oriented Neo-Impressionists, such as Camille Pissarro, Maximilien Luce, and Paul Signac in France, who adhered openly—at least in theory—to the anarchist movement. The old world may have given the appearance of perfect order, but many artists could not share its optimistic and mechanistic view of life. During the same years in which brilliant scientists began to break down the concepts and theories of classical physics, chemistry, and psychology, artists too were engaged in the "transvaluation of values." Friedrich Nietzsche was aware of the danger of modern ideas. He did not share the liberals' faith that rational knowledge and human intellect alone could solve all human problems. He no longer shared the Neoclassicists' belief in measure and calm as the paradigm of Greek art; he understood also the struggle and Dionysian frenzy, especially of the early tragedies. Nietzsche's writings opened a new access to the irrational, and his belief in primordial sources deeply influenced intellectuals and artists in the 1890s.

Having little sympathy for the optimism and utilitarianism which dominated the era, many artists turned to religion, mysticism, and a new transcendentalism, or escaped from the bourgeois life in metropolitan centers to find new strength among the people living in primitive or peasant cultures. Others, in contrast, sought personal salvation by cultivating exquisite sensations and raising the artifice of urban life to an art in itself.

	Political Events	The Humanities and Sciences	Architecture, Painting, Sculpture
1890	Battle of Wounded Knee Sherman Anti-Trust Act becomes law in the U.S.	William James, *Principles of Psychology* James Frazer, *The Golden Bough* Henrik Ibsen, *Hedda Gabler*	Brussels: Significant international exhibitions of art by Les XX (1884–1893)
1891	Triple Alliance linking Germany, Italy, and Austria renewed Franco-Russian entente established	Oscar Wilde, *The Picture of Dorian Gray* Frank Wedekind, *Spring's Awakening* Gustav Mahler, *Symphony No. 2* James Whistler, *The Gentle Art of Making Enemies* Thomas Edison patents a motion-picture camera and projection device Sergei Rachmaninoff, *Piano Concerto No. 1*	Tahiti: Paul Gauguin arrives Brussels and Paris: Posthumous retrospective exhibitions of Vincent van Gogh
1892	Labor unrest in the U.S.: injunctions and troops used to break strikes of unionized steel and railway workers (–1895)	Henrik Ibsen, *The Master Builder* Rudolf Diesel patents an internal-combustion engine Maurice Maeterlinck, *Pelléas and Mélisande* Henry Ford finishes his first motorcar	Paris: Joséphin Péladan organizes the first Rose + Croix exhibition Paris: Auguste Renoir and Camille Pissarro have successful exhibitions at Durand-Ruel's Munich: Secession founded
1893	Grover Cleveland becomes U.S. president Financial panic in the U.S.	William Butler Yeats, *The Lake Isle of Innisfree*	Paris: Gustave Caillebotte leaves his collection of Impressionist paintings to the French government Adolf von Hildebrand, *The Problem of Form in the Plastic Arts* Edvard Munch settles in Germany Chicago: World's Columbian Exposition
1894	Trial and conviction of Alfred Dreyfus in France Czar Nicholas II succeeds to the Russian throne Sino-Japanese War establishes Japan as a major power	Claude Debussy, *Prelude to the Afternoon of a Faun* George Bernard Shaw, *Arms and the Man*	Brussels: La Libre Esthétique supersedes Les XX as the focal point of avant-garde art

	Political Events	The Humanities and Sciences	Architecture, Painting, Sculpture
1895	Cubans revolt against Spanish rule	Trial and imprisonment of Oscar Wilde on charges of homosexual practices Wilhelm Roentgen discovers X rays Sigmund Freud, *Studies in Hysteria*; founds psychoanalysis Richard Strauss, *Till Eulenspiegel*	Paris: Samuel Bing opens his Salon de l'Art Nouveau Paris: Paul Cézanne's first one-man show at Ambroise Vollard's gallery Paris: The Lumière brothers give the first public motion-picture showing
1896	William Jennings Bryan's "Cross of Gold" speech Klondike gold rush	Anton Bruckner, *Symphony No. 9* Anton Chekhov, *The Sea Gull* Richard Strauss, *Also Sprach Zarathustra* Alfred Jarry, *Ubu Roi* Johannes Brahms, *Four Serious Songs*, Op. 121 Henri Bergson, *Matter and Memory* Giacomo Puccini, *La Bohème*	William Morris publishes the Kelmscott Chaucer with illustrations by Edward Burne-Jones Munich: Vasily Kandinsky arrives to study painting
1897	War between Turkey and Greece Queen Victoria's Sixtieth Anniversary Jubilee	Stefan George, *Das Jahr der Seele* Sidney and Beatrice Webb, *Industrial Democracy* Havelock Ellis, *Studies in the Psychology of Sex* (–1928) Stéphane Mallarmé, *Un Coup de Dés*	Brussels: World Exhibition London: The Tate Gallery opens Vienna: Secession founded, headed by Gustav Klimt New York: Alfred Stieglitz founds the review *Camera Work* Ferdinand Hodler formulates the theory of parallelism Paul Gauguin, *Noa Noa*
1898	Empress Elizabeth of Austria assassinated by anarchists Spanish-American War Annexation of the Philippines, Puerto Rico, and Hawaii by U.S. Fashoda crisis, pitting Britain against France in Egypt and Ethiopia, resolved	Pierre and Marie Curie discover radium and polonium Paris Métro opens Oscar Wilde, *The Ballad of Reading Gaol* Arthur Rimbaud, *Collected Works*	Paul Signac, *From Eugène Delacroix to Neo-Impressionism*
1899	Boer War begins in South Africa		Berlin: Secession founded

Commercial Buildings in the United States

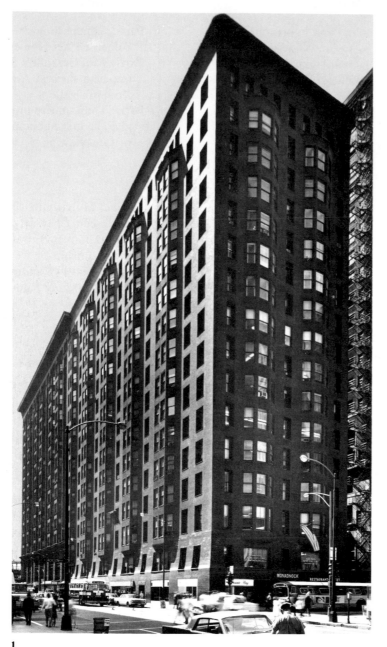

1

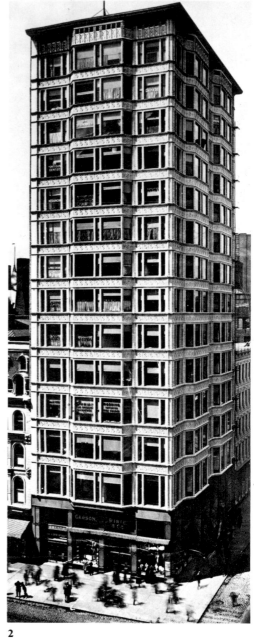

2

In the New World a new kind of architecture emerged. Little bound by tradition, it gave palpable form to the optimism of a rapidly growing economy. It was in faraway Chicago that the new architecture took shape. The great Chicago fire of 1871 had destroyed the city almost completely, and it became profitable to use advanced building methods based on modern engineering techniques rather than on historical precedent to construct new commercial build-ings in the city center. The Monad-nock Building and the Reliance Building, both created by the part-nership of Daniel H. Burnham and John Wellborn Root, represent the passing of old construction meth-ods and the start of a new tech-nology.

The Monadnock, designed by Root in 1889 and completed in 1891, with wall surfaces wholly without ornament, asks to be accepted on its own aesthetic terms of austere geom-etry and pure functionalism. It was the last Chicago building with load-bearing walls—that is, walls that support themselves rather than being carried on a metal frame. It is thus the logical and ultimate end of the long tradition of masonry construc-tion for major urban buildings.

The Reliance takes the next logical step—use of a steel frame. The four-teen-story office building is drama-tically prescient of the aesthetic of dematerialized "curtain" walls, the

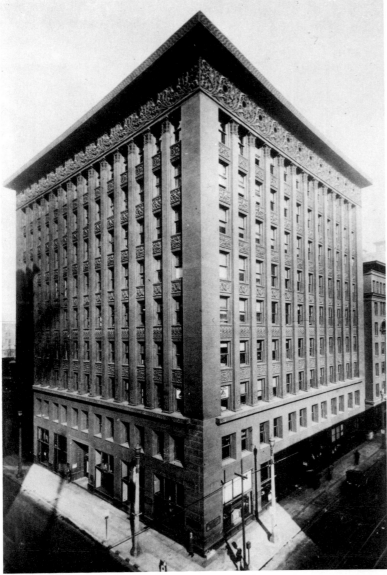

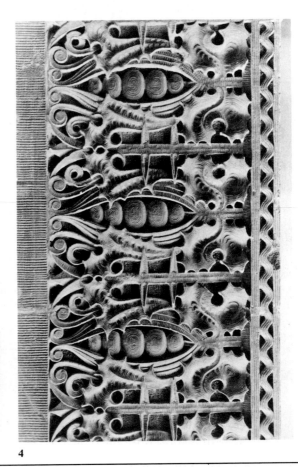

3 4

standard formula for high-rise buildings in the post-World War Two era. The exterior of the Reliance is nothing more than a thin skin of glass and terra-cotta that frankly reveals the basic structure within.

The Wainwright Building in St. Louis was Louis Sullivan's first and in many ways definitive essay in what was to become the archetypal American building, the skyscraper. Though its ten stories are now dwarfed by surrounding struc-

tures, it was originally a towering presence in downtown St. Louis. Spandrels and windows are pulled back from the front plane of the building so that the rhythmically repetitive piers rise in a swift, uninterrupted thrust. The broad expanse of its cornice dramatically defines and halts the vertical rhythm.

1 Burnham and Root. Monadnock Building, Chicago. 1889–91 **2** Burnham and Root. Reliance Building, Chicago. 1890–95 **3–4** Louis Sullivan. Wainwright Building, St. Louis. 1890–91 **4** South entrance (detail)

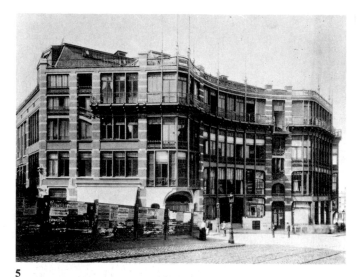

5

7

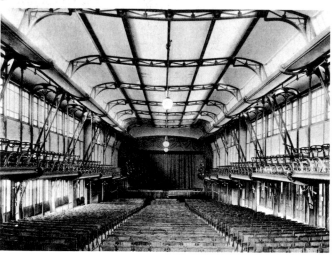

6

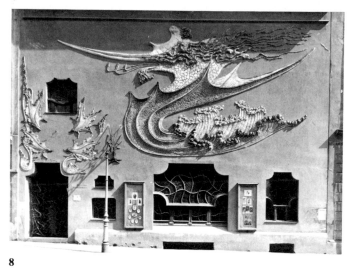

8

In Europe the most innovative buildings were done in the Art Nouveau style, a style which was determined to break with the long series of historic revivals throughout the nineteenth century. It was largely based on decorative linear patterns and placed great emphasis on exquisite craftsmanship. It spread throughout the European continent and also reached the Americas, after its first flowering in Belgium. Some four years after completing the Tassel House (see plate 14), Victor Horta designed the Maison du Peuple in Brussels, which was commissioned by the Belgian Workers' Party. This avant-garde structure has justifiably been called the most important Art Nouveau building. On an awkward site on a circular plaza, Horta pulled the exposed metal frame of the facade into a series of gently undulating curves. He achieved what few other Art Nouveau architects, with their overriding concern for surface decoration, were able to do—the creation of space-shaping urban architecture.

The basically rectangular space of its auditorium is activated and changed by the graceful open metalwork of curving beams and balustrades. The walls, composed of glass and thin metal panels, were held in place by attenuated metal frames. The effect, even in photographs, is stunning—a dazzling volume of light, reconciling strength with delicacy. (Unfortunately this building, like so many other architectural masterpieces of the time, has been torn down for the sake of "progress.")

In Germany in 1898 Bernhard Sehring was able to combine the glass curtain wall supported by a metal skeleton with Art Nouveau (in Germany the movement is termed Jugendstil) ornament in the Tietz Department Store in Berlin. This large shop is typical of the commo-

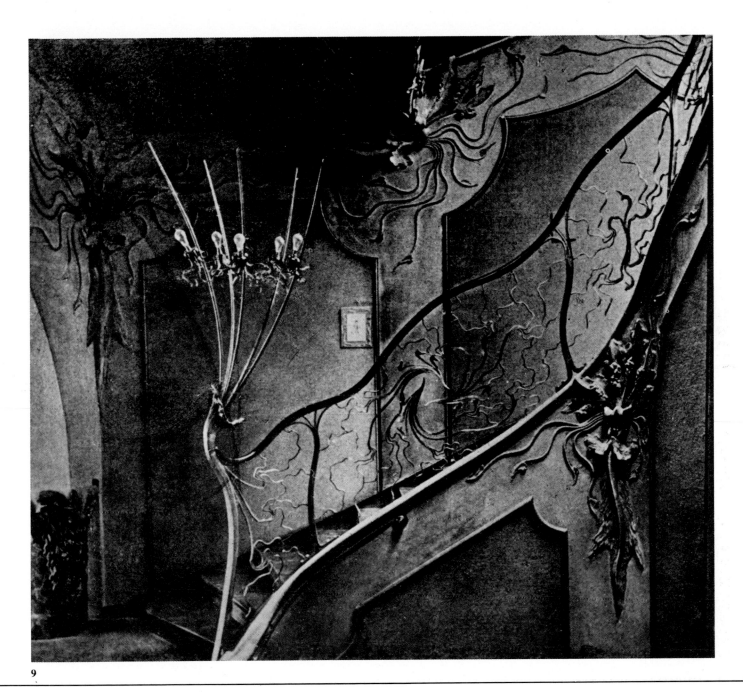

9

dious kind of merchandising establishment that made its appearance in urban centers at the end of the century.

August Endell's Atelier Elvira, a photography studio in Munich, was destroyed during World War Two. It was one of the first, and certainly one of the most vivid, examples of Jugendstil architecture in Germany. A bright green stucco facade is virtually engulfed by an immense abstract purple relief. The whiplash forms of this flamboyant gesture shift from waves, to clouds, to some kind of fire-breathing dragon. The studio provided an almost perverse, unex-pected shock on an otherwise staid street. The interior is no less disquieting. The comparison of the stairwell with that of Horta's Tassel House is obvious. Both employ a snaking decoration for ironwork balustrades and wall surfaces, but the self-conscious suavity of the French and Belgian Art Nouveau is absent here, and in its place Endell substitutes something disturbing and violent, a preview by twenty years of the work of the German Expressionist architects and set designers.

5–6 Victor Horta. Maison du Peuple, Brussels. 1897–99 7 Bernhard Sehring. Tietz Department Store, Berlin. 1898–1900 8–9 August Endell. Atelier Elvira, Munich. 1897

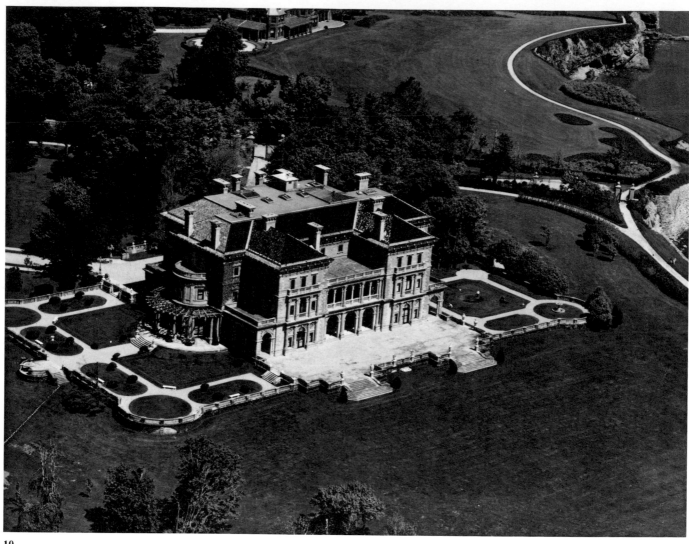

10

Historicism prevailed in American architecture during the second half of the nineteenth century, but at the end of the century archaeological correctness took the place of eclecticism and license. Richard Morris Hunt, who was called the father of Beaux-Arts architecture, developed a style that was considered "more French than the French." He was able to design Gothic, Renaissance, or Imperial Roman buildings, and he received important commissions from the members of the newly rich American aristocracy, such as the Astors and the Vanderbilts, who welcomed French fashions and ideas. At Newport, Rhode Island, the summer playground of the very wealthy, Hunt designed The Breakers for the Cornelius Vanderbilts—a mansion of ostentatious magnificence modeled carefully after a sixteenth-century merchant's palace in the city of Genoa. The Breakers, however, is in the country, facing the ocean, and is three centuries behind the time. When it was built, with its loggia of mosaic, its grand double staircase, its frescoes and imported marble, its seventy rooms (with thirty-three for the servants), it was greatly acclaimed and Hunt was widely admired. At a time when traditions of the European past had enormous appeal to the Americans of the Gilded Age—precisely because such traditions were lacking in the new country—the demand was not for original ideas, but rather for the felicitous manipulation of well-proved forms, and Richard Morris Hunt was certainly a master at reproducing Renaissance splendor.

The young Frank Lloyd Wright, working for Louis Sullivan's firm, Adler and Sullivan, designed the Charnley House in Chicago, an outstanding example of urban elegance. Soon after establishing his own office, Wright designed a house for William H. Winslow in the suburb of River Forest, in which he stressed function and materials rather than historical styles. The elevation of the Winslow House is highly formal—a few simple square

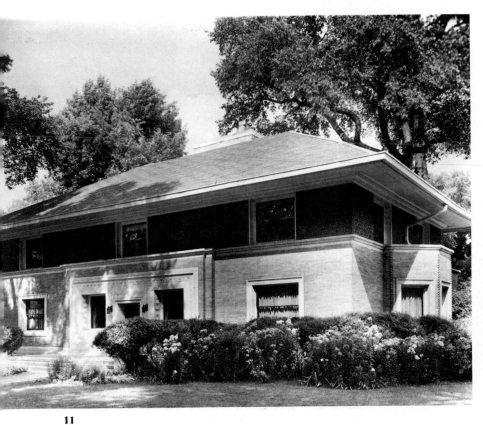

11

12

13

elements, disposed at regular intervals, reflect the straightforward arrangement of the ample living spaces within. The vivid orange-yellow of the Roman brick is contrasted to the white marble entry and the deep brown terra-cotta facing under the eaves. As in most of Wright's later houses, the roof is the dominating element—a broad, simple shape reaching far out over the body of the house and hovering above it protectively. The horizontal disposition, the emphasis on low expanse, relate it organically to the flat landscape of the American Middle West.

Intelligent social planning of housing and community began in England in the last half of the nineteenth century, culminating in Ebenezer Howard's "Garden Cities." Inventive and influential domestic architects, such as Charles F. Annesley Voysey, sustained and nourished this important development. His first major work was the Forster House in the London suburb of Bedford Park, and it was a startling design of roughcast white stucco, with large expanses of unbroken wall and small, willfully disposed openings. The asymmetries and the white, boxlike appearance anticipate by some thirty years the work of such modern masters as Le Corbusier. In his own time Voysey was considered a chief English exponent of Art Nouveau.

10 Richard Morris Hunt. The Breakers, Newport, R.I. 1892–95 11 Frank Lloyd Wright. Winslow House, River Forest, Ill. 1893 12 Frank Lloyd Wright. Charnley House, Chicago. 1892 13 Charles F. Annesley Voysey. Forster House, Bedford Park, London. 1891

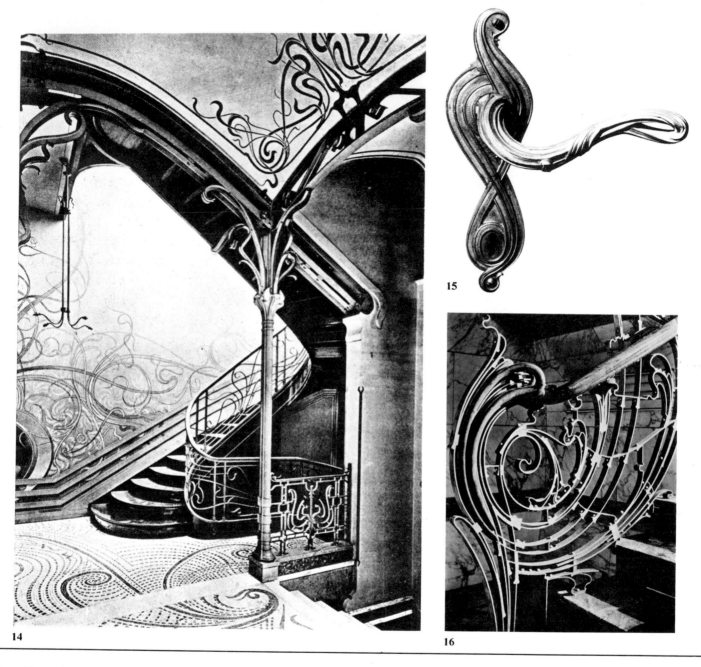

14

15

16

With Victor Horta's Tassel House in Brussels, Art Nouveau suddenly matured beyond a style of applied decoration and became an art of building. The staircase in this urban dwelling is a real environmental work, a perfection of the late-nineteenth-century ideal of the *Gesamtkunstwerk*, the inseparable union of the arts. The centerpiece of this fluctuating composition is an iron column which flowers at the top into elegantly curving brackets. The balustrade snaps into a tight curve, its decorative grille echoing the stylized vines painted on the walls and ceilings and the whiplash curves embedded in the floor mosaic. The door handle from Horta's Solvay House is indicative of the care he took to achieve his total aesthetic aims.

Horta's dedication to expressive freedom is a principle for the shaping of space. The plan allows a large area for the stairwell, and for rooms of varying shapes and sizes, flowing rather freely into one another. Space, structure, and decor unite into the experience of lyrical dance.

In Paris, Hector Guimard established himself as the first interpreter of the new style with the completion

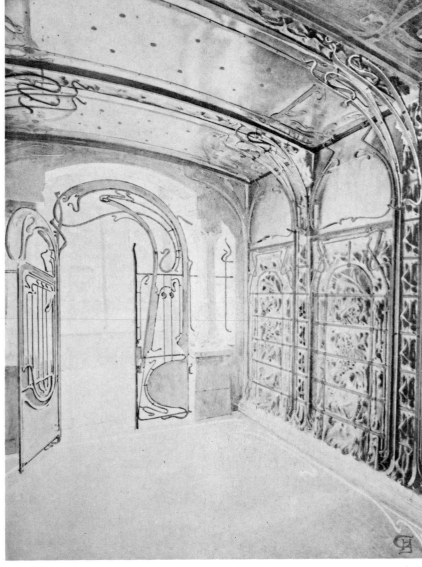

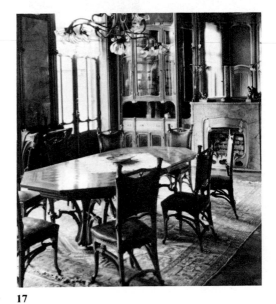

17

18

of his Castel Béranger, a luxury apartment complex in the heart of the city. Like most French architects in the later nineteenth century, Guimard was decisively influenced by Viollet-le-Duc's proselytizing on behalf of the decorative and structural possibilities of exposed metal construction. In the entry to the Castel Béranger, Guimard stretched the decorative quality of metal to its limit, drawing it out in a vibrant, joyful calligraphy. Here also Guimard invigorates another architectural material, ceramic tile, in the panels which line the walls of the entry. The shifting, plastic forms in the tiles are devoid of clear naturalistic reference, and instead become pure exuberant energy.

14 Victor Horta. Tassel House, Brussels. 1892–93 15–17 Victor Horta. Solvay House, Brussels. 1895–1900 15 Door handle 16 Banister 17 Dining room 18 Hector Guimard. Design for the Castel Béranger, Paris. 1894–98

Train Stations

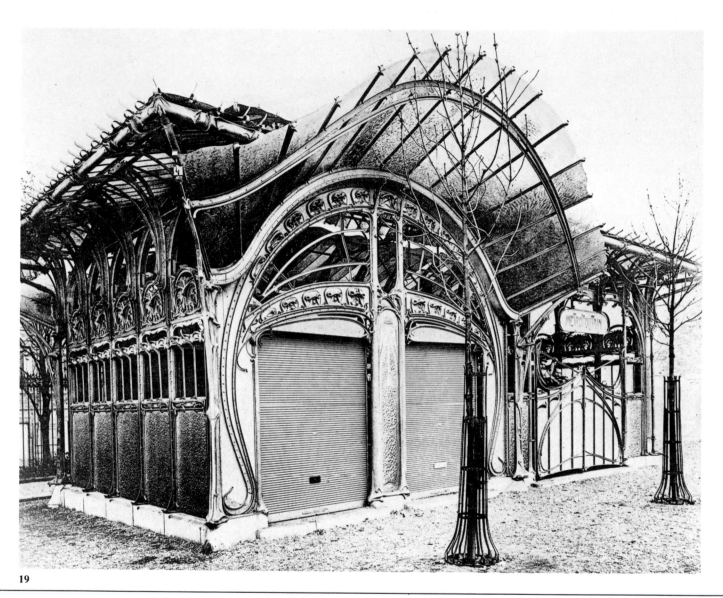

19

One of the most striking manifestations of rapid urbanization in the 1890s was the construction of complex intraurban transportation systems. Boston, Budapest, London, Vienna, Paris, and New York all had started to build subways before 1900.

In 1896, the Compagnie de Chemin de Fer Métropolitain sponsored a competition for the design of the stations for the new Paris subway, the "Métro." The competition was won by an academic architect, but the commission ultimately went to Hector Guimard, who had recently completed the Castel Béranger but had not even entered the competition. The president of the company liked the spirited new Art Nouveau style and considered it a more fitting image for the dramatically modern Métro. Glass-and-iron pavilions, seeming to grow in the urban environment like crustaceans on the ocean floor, brought the new style to the public consciousness on street corners all over the city. Though Guimard's designs date from about 1900, the stations were still being installed in 1913. The most elaborate of the three types of stations included waiting rooms, a triple-tiered roof, and the characteristic glazed "butterfly" awning. The structure is entirely of metal, stretched to incredible plastic limits. Remarkably, these apparently unique, highly original pieces of civic sculpture were actually designed as modular sys-

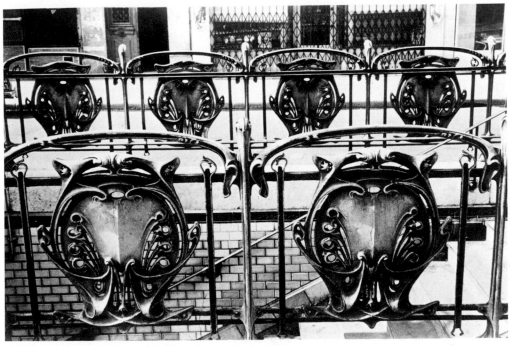

20

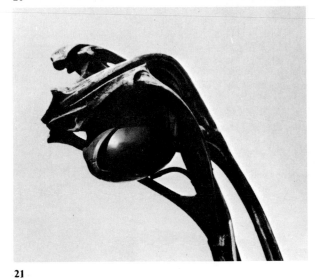

21

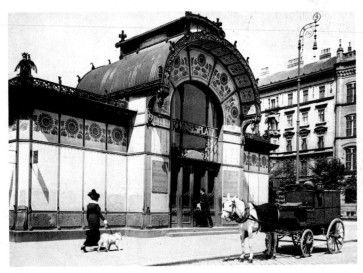

22

tems intended for mass production. Guimard thus took a significant step toward solving the dilemma of modern design—resolution of the conflict between aesthetic values and industrial necessity.

In Vienna the Stadtbahn (subway), which eventually became fifty miles long, was initiated in 1894. The architect chosen to design the freestanding stations was Otto Wagner. In his Karlsplatz station his philosophy that architectural creation must spring from contemporary life is made abundantly clear. Built in the modern idiom of a curved metal frame with prefabricated marble-and-stucco panels, this crisply detailed station is an elegant marriage of utility and delight. Compared to Guimard's contemporaneous stations in Paris, Wagner's design is tighter, more restrained, exhibiting a kind of controlled vivacity entirely appropriate for 1890s Vienna.

19–21 Hector Guimard. Métro, Paris. 1900 19 Place de l'Etoile station 20 Balustrade (detail) 21 Light fixture (detail) 22 Otto Wagner. Subway, Karlsplatz station, Vienna. 1894–97

Exhibition Buildings

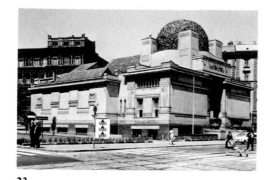

23

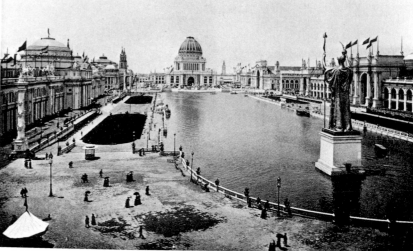

25

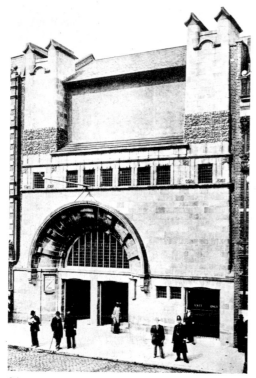

24

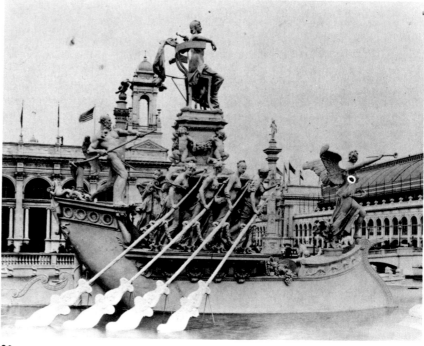

26

Wagner's student Joseph Maria Olbrich was a highly gifted and original architect and a leader of the successful revival of the arts and crafts in Vienna. When the avant-garde Vienna Secession artists decided to build their own exhibition space, the commission went to Olbrich. He designed a solemn, almost ritualistic building of clear, solid geometric masses, surmounted by a spherical pierced-metalwork dome. The bold motto of the Secession, "To the Era Its Art, to Art Its Freedom," emblazoned on the imposing portal adds to the experience that this is a cult temple of the New.

Charles H. Townsend's Whitechapel Art Gallery, on the other hand, contrasts the symmetry of its small twin towers against the off-center placement of its huge arched doorway. Romanesque elements combine with rather eccentric design and scale to make a still startling show in the working-class district of London's East End.

More impressive than individual exhibition buildings were the universal and international expositions, or world's fairs. Ostensibly celebrations of man's lofty achievements in art, architecture, and technology, the world's fairs also gave physical

expression to some of the less felicitous aspects of human character—virulent nationalism, crass commercialism, rampant imperialism. In Chicago the Columbian Exposition of 1893 brought together a vast constellation of painters, architects, and sculptors to create the "White City." In reaction to Chicago's functional architecture, the fair represented the resounding triumph of Beaux-Arts academic building and planning and was called the American Renaissance. Louis Sullivan prophesied with amazing accuracy that "the damage wrought to the country by the Chicago World's Fair will last half a

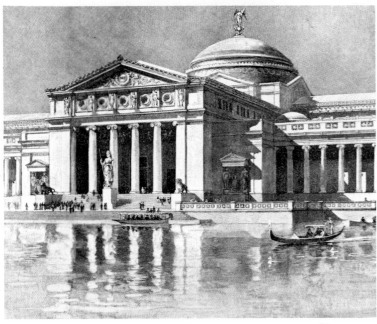

27

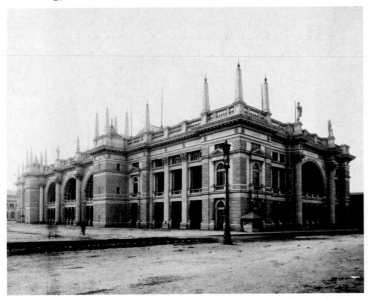

28

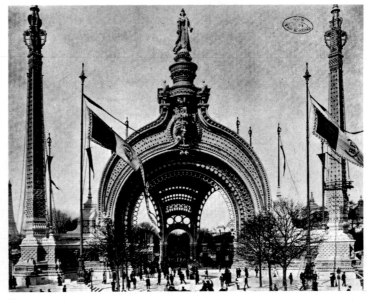

29

century," and in fact, Atwood's Fine Arts Building has lasted to the present.

By 1900 Paris had been host to no less than four major international expositions, the most recent in 1889 when the Eiffel Tower rose to dominate the city's skyline. None of these fairs, however, matched the gaudy splendor of the Universal Exposition of 1900, whose buildings constituted the "Dream City."

Though stately academicism was represented at the 1900 fair by the grandiose Grand Palais (which is still standing), it was here outtrumped by an exotic, rococo version of Art Nou-

veau. The monumental entry to the fair was an immense, rather oriental-looking dome, seven hundred seventy square yards in area. Designed by René Binet, this phantasmagoria in iron was surmounted by a statue of Peace, embodied (unlike the usual classical formula) by a Parisian lady in evening dress. To the fair's fifty million visitors this flamboyant extravagance must have appeared like the grand apogee of *la belle époque*.

23 Joseph Maria Olbrich. Secession Building, Vienna. 1898–99 24 Charles H. Townsend. Whitechapel Art Gallery, London. 1897–99 25–28 Columbian Exposition, Chicago. 1893 25 General view 26 Frederick MacMonnies. *Barge of State* (Grand Fountain, central group) 27 Charles B. Atwood. Fine Arts Building 28 Terminal Railroad Station 29 Universal Exposition, Paris. 1900. René Binet. Entrance Gate to the Place de la Concorde

Portraits of Women

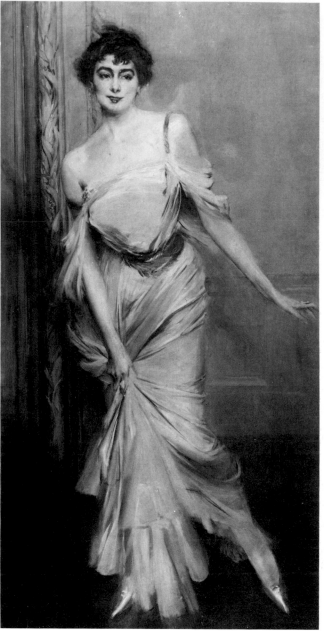

30

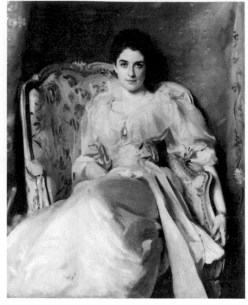

31

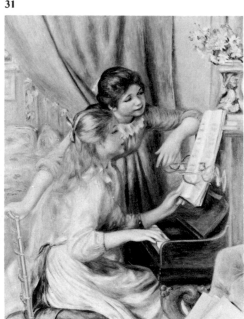

32

Despite the invention of photography in the mid-nineteenth century, the importance and prestige of having one's portrait painted in oil remained unchallenged. The upper classes commissioned their portraits from fashionable artists such as Giovanni Boldini, who had left his native Ferrara to settle in Paris. Largely untouched by the artistic revolutions of his time, he became a fashionable society painter and did dashing portraits such as *Madame Charles Max*.

The cosmopolitan American John Singer Sargent, also born in Italy, now living in London, painted portraits of greater dignity, which seemed more appropriate to the tastes of the British aristocracy. The portrait of *Lady Agnew* combines realism and Impressionism with consummate skill. Pictures of this kind won him the highest praise: Sargent was seen as heir to the grand manner of portraiture, the able successor to Anthony van Dyck and Sir Joshua Reynolds.

Even paintings by Impressionists (who only recently had been the avant-garde), such as Auguste Renoir's sensuously brushed *Two Girls at the Piano* or Mary Cassatt's intimate and tender *The Bath*, glorify the secure world of an established bourgeois society. Cassatt, born in Pennsylvania, joined the Impressionists at Edgar Degas's invitation in 1877. She was able to combine their heightened color and sense of light with a feeling for the weight of the figures.

Paul Cézanne, like Renoir, had participated in the first Impressionist exhibition in 1874 but now moved in a different direction. *Madame Cézanne in the Conservatory* is monumental and clear in its composition.

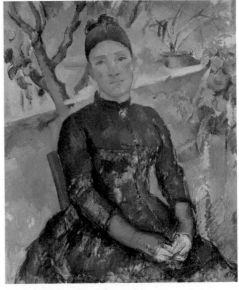

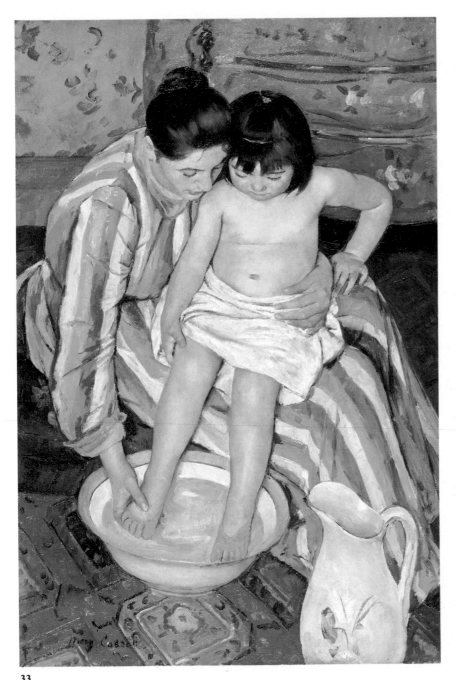

33

34

35

The figure seems solid, yet she is light, almost transparent. Her expression seems neutral and distant, yet also reflective, even melancholy. The complexity of Cézanne's vision and his ability to resolve apparent conflicts between solidity and transparency, between pure form and personal anxiety, between visual sensation of color and light and a definite sense of harmonious structure give profundity to his statement.

And then, how totally different Henri de Toulouse-Lautrec's *Loïe Fuller in the Dance of Veils*! Where Cézanne's portrait is stable, Lau-

trec's is totally ephemeral. The famous dancer, her long, iridescent veils swinging while multicolored lights play on their serpentine movements, appears to be a phantom of the dance rather than an actual performer. The sinuous, convoluted curves of her dance create a great undulating arabesque that is part of the Art Nouveau movement, which influenced most aspects of art, architecture, and design.

30 Giovanni Boldini. *Portrait of Madame Charles Max.* 1896. Oil on canvas, 80 ³/₄ × 39 ³/₈″ **31** John Singer Sargent. *Lady Agnew of Lochnaw.* c. 1892–93. Oil on canvas, 49 ¹/₂ × 39 ¹/₂″ **32** Auguste Renoir. *Two Girls at the Piano.* 1893. Oil on canvas, 27 ¹/₄ × 23 ¹/₄″ **33** Mary Cassatt. *The Bath.* c. 1891. Oil on canvas, 39 ¹/₂ × 26″ **34** Paul Cézanne. *Madame Cézanne in the Conservatory.* 1890. Oil on canvas, 36 ¹/₂ × 28 ¹/₂″ **35** Henri de Toulouse-Lautrec. *Loïe Fuller in the Dance of Veils.* 1893. Oil on canvas, 24 × 17 ³/₈″

Portraits of Men

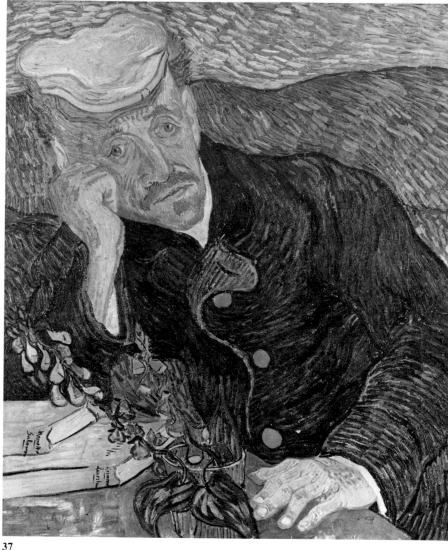

37

36

The Neo-Impressionists, or Pointillists, under the leadership of Georges Seurat, hoped to achieve a scientific way of painting, based on the most advanced physiological theories and experiments on optical perception. Consequently, the French painter and art theorist Paul Signac, in his portrait of the spokesman and critic of the Neo-Impressionist movement Félix Fénéon, approached the effect of linear directions and relationships of contrasting color in a scientific and exact way. And Fénéon stands in profile against a background of geometric design that recalls Japanese textiles.

In contrast to Signac's scientific attitude, Vincent van Gogh was greatly concerned with the psychology of his sitters, as is evident in the penetrating portrait of his friend and physician Dr. Paul Gachet. Using short undulating lines and a heightened palette of intense blues and reds, Van Gogh revealed his passionate involvement with the sitter and his gaze.

Ernst Josephson is regarded by the Swedes as their greatest painter. One of his greatest works is the portrait of his uncle, Ludvig Josephson, a Stockholm theater director, in the guise of a rabbi. His dark, resonant chiaroscuro colors recall the late paintings of Titian and Rembrandt, but they also anticipate much of Expressionist painting. Josephson frames the sitter's face and eyes with chalky white wisps of hair to focus the viewer's attention, and evokes his uncle's elusive spirit through transparent motifs, smoky atmosphere, and patches of brilliant red.

The Swedish playwright August Strindberg was a close friend of the Norwegian painter Edvard Munch and shared with him a highly charged ambivalence toward women. In his probing, nervous lines Munch lays bare Strindberg's anguished mind, creating in the process one of his numerous graphic masterpieces—which were an important impetus in the revival of printmaking.

While Van Gogh, Josephson, and Munch were concerned with psy-

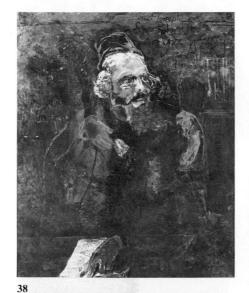

38

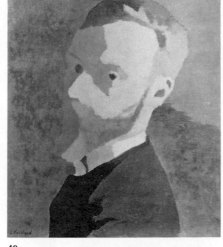

40

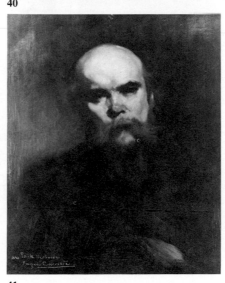

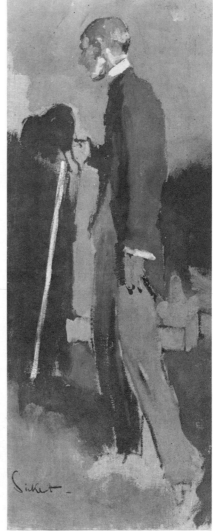

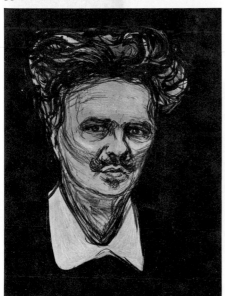

39

41

42

chological insight in their portraits, Edouard Vuillard in his bold *Self-Portrait* of 1892 explored the pictorial effect of juxtaposed hues applied in large, almost abstract areas of color. "I know of few works," the writer André Gide observed about Vuillard's paintings, "where one is brought more directly into communion with the painter."

Vuillard, a member of the group known as the Nabis—young painters who were influenced by oriental motifs, mystical notions, and the work of Paul Gauguin (see plates 53, 59, and 63)—was also close to the Symbolists, who as a matter of principle preserved a psychological distance from their subjects so that corporeality might not interfere with spiritual vision. Eugène Carrière painted the Symbolist poet Paul Verlaine in a monochrome brownish, misty atmosphere. The oily paint, contradictory lighting, and haziness veil the figure in mystery. It was Verlaine who wrote: "For what we still desire is the nuance/ Not the color, nothing but the nuance/ And all the rest is literature."

The English painter Walter Sickert depicted the archetypal Symbolist aesthete Aubrey Beardsley turning away in lost profile. Complete with mandatory cane and top hat, Beardsley is caught in an informal, unguarded moment, as if by a candid camera.

36 Paul Signac. *Against the Enamel of a Background Rhythmic with Beats and Angles, Tones and Colors, Portrait of Félix Fénéon*. 1890. Oil on canvas, 29 × 36 1/$_2$" 37 Vincent van Gogh. *Dr. Gachet*. 1890. Oil on canvas, 26 × 22 3/$_8$" 38 Ernst Josephson. *Portrait of Ludvig Josephson*. 1893. Oil on canvas, 54 × 43" 39 Edvard Munch. *August Strindberg*. 1896. Lithograph, 24 × 18 1/$_8$" 40 Edouard Vuillard. *Self-Portrait*. 1892. Oil on board, 14 × 11" 41 Eugène Carrière. *Portrait of Verlaine*. 1890. Oil on canvas, 24 × 20 1/$_8$" 42 Walter R. Sickert. *Aubrey Beardsley*. 1894. Tempera on canvas, 30 × 12 1/$_4$"

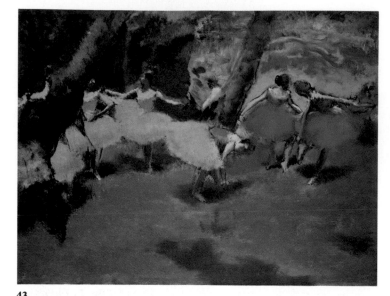

43

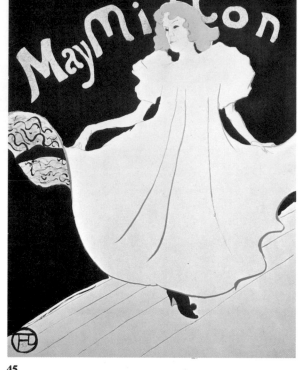

45

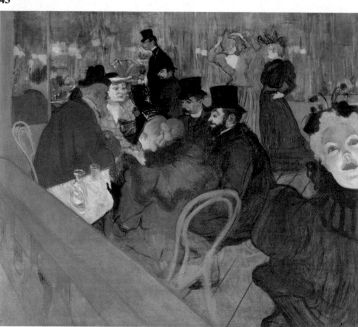

44

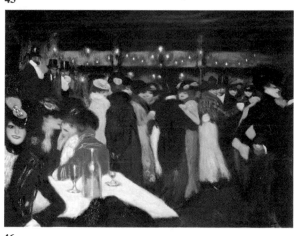

46

Artists in the 1890s were fascinated by the new night life. It served as an escape from humdrum bourgeois existence, and the artist, as Edgar Degas knew so well, is himself poseur and performer. "Say art and you are saying artifice," he declared, "art is dishonest and cruel." And Degas painted the disciplined movement of horses and dancers with a sharp eye and a brilliant sense of composition. The idea of moving his easel outside into the open air, as his friends the Impressionists were doing, seemed ludicrous to him. But his impromptu stage scenes, painted from unex-

pected angles, such as *Before the Performance*, share with the Impressionists an interest in the fleeting and changeable aspects of life and the world.

Toulouse-Lautrec carried Degas's oblique vision further, using Japanese perspective and eerie colors to convey his emotional response in *At the Moulin Rouge*. Lautrec was not only a superb artist; his work forms one of the major passages from the art of the nineteenth to that of the twentieth century. This is particularly noticeable in his use of flat planes of color, as in the portrait of

the cabaret dancer May Milton on a poster—a medium whose revitalization may be largely credited to Lautrec. He became an important source for other artists, among them Pablo Picasso, as is evident in the Spaniard's *Le Moulin de la Galette*, although the nineteen-year-old painter's canvas has not yet achieved the stylistic mastery of the older artist.

When Georges Seurat looked at the cabaret, he produced a painting which was based on his optical studies and on scientific theories of color and light. *Le Chahut*, one of his last pictures, typically consists of

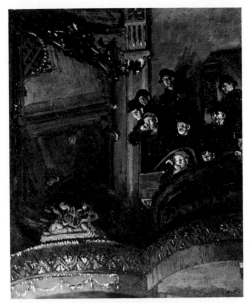

48

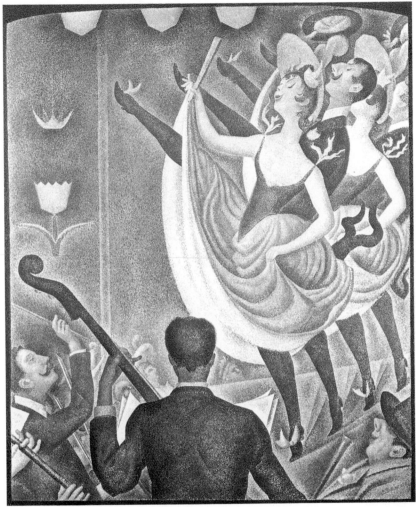

47

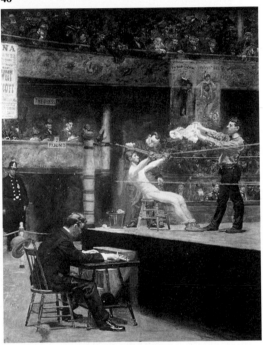

49

small dots of paint, arranged like tesserae in a mosaic. All elements of the design are organized into a clear, solid structure in the great European tradition. Yet the ornamental surface, the rhythmic repetition of flat shapes, and the avoidance of perspective or illusionary depth clearly place this painting within the avant-garde of its time.

In England, Walter Sickert reflects his admiration for Degas's motifs and use of artificial light in the vigorously painted *The Old Bedford*. But Thomas Eakins, working in Philadelphia, is far removed from the new stylistic concerns prevalent among the European vanguard. He chooses the prize fight rather than the theater or café-concert. In *Between the Rounds* America's most incisive painter of the nineteenth century adheres to the pre-Impressionist naturalist tradition and, like a fine reporter, focuses on the reality of fighter and ring, recorder and policeman, audience and posters, organizing the seemingly spontaneous event with a precise eye and executing it with superb draftsmanship.

43 Edgar Degas. *Before the Performance.* 1896–98. Oil on canvas, 18 ³/₄ × 24 ³/₄″ **44** Henri de Toulouse-Lautrec. *At the Moulin Rouge.* 1892. Oil on canvas, 43 ³/₈ × 55 ¹/₄″ **45** Henri de Toulouse-Lautrec. *May Milton.* 1895. Color-lithographed poster, 31 ¹/₈ × 25 ¹/₄″ **46** Pablo Picasso. *Le Moulin de la Galette.* 1900. Oil on canvas, 35 ¹/₂ × 46″ **47** Georges Seurat. *Le Chahut.* 1889–90. Oil on canvas, 66 ¹/₂ × 54 ³/₄″ **48** Walter R. Sickert. *The Old Bedford.* 1897. Oil on canvas, 30 × 23 ³/₄″ **49** Thomas Eakins. *Between the Rounds.* 1899. Oil on canvas, 50 ¹/₄ × 40″

Life and Death I

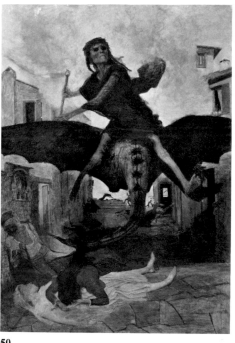

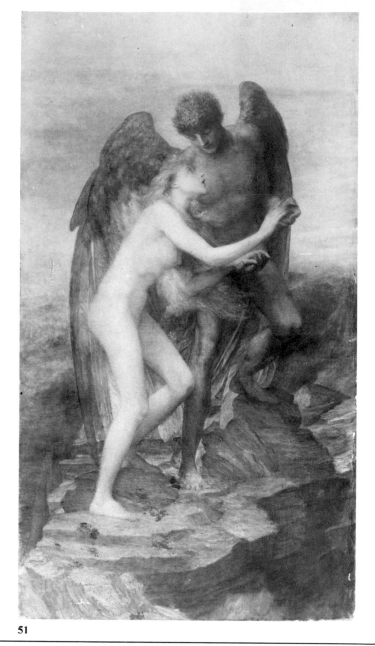

50

51

The 1890s, perhaps more than any other period, were immersed in the problem of Being, of Life and Death. Arnold Böcklin, a German-Swiss painter who spent most of his creative life in Italy, had nothing but disdain for the materialism of his time. Romantically searching for a past that never existed, he painted literary and anecdotal allegories, many of which depended on classical mythology. These paintings earned him great acclaim at the end of the century.

Typical of his late work is *The Plague*, a painting of death and annihilation.

In England, George Frederic Watts continued the academic tradition in rather sentimental allegories such as *Love and Life* and was celebrated both at home and in Paris. Sentimental pathos descends to bathos in the painting by Sir Luke Fildes of a bearded physician seated in vigil at the bedside of a sick child. Reproductions of this painting used to hang in every schoolroom.

At the same time, however, Paul Gauguin dealt very differently with the meaning of life in his masterpiece *Where Do We Come From? What Are We? Where Do We Go?* The trouble with Böcklin's winged dragon swooping down the street is that it is basically an illustration. Gauguin, on the other hand, would have agreed fully with Arthur Rimbaud, who said that "inventions of the unknown require new forms." And Gauguin, like his Symbolist

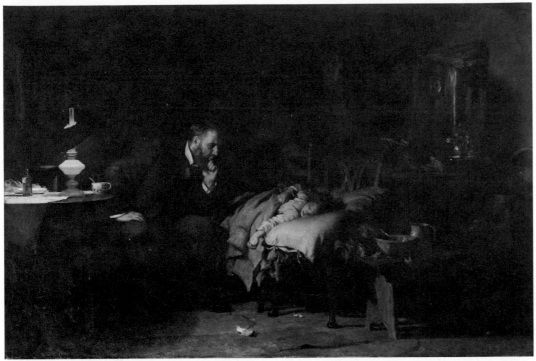

52

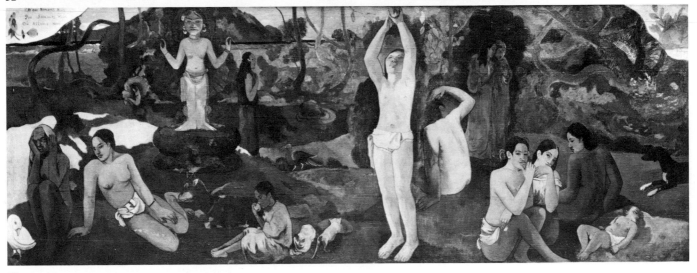

53

contemporaries in art, literature, and music, was very much aware of the need for new forms which, unlike academic, realist, or Impressionist painting, would penetrate to the "mysterious center of thought." To create a new art, the artist had to turn inward. "Life and death, the importance and the existence of the external world, all depend solely on the internal movements of the soul," Richard Wagner had written in 1861.

Gauguin's painting is a metaphor

dealing with the passage from life to death. It is set in the landscape of Tahiti, where he sought a life in intimate union with natural forms. The narrative is full of ambiguity, but the form is precise in its saturated colors and clearly defined flat shapes. These shapes are set in a space which denies the linear perspective used in landscapes since the Renaissance. In other words, new forms are used to evoke a new state of mind.

50 Arnold Böcklin. *The Plague*. 1898. Varnished tempera on pine, 58 $^3/_4$ × 41″
51 George Frederic Watts. *Love and Life*. 1893. Oil on canvas, 87 $^1/_2$ × 48″
52 Sir Luke Fildes. *The Doctor*. 1891. Oil on canvas, 65 $^1/_2$ × 95 $^1/_4$″ **53** Paul Gauguin. *Where Do We Come From? What Are We? Where Do We Go?* 1897. Oil on canvas, 55 $^1/_2$ × 148 $^1/_4$″

Life and Death II

54

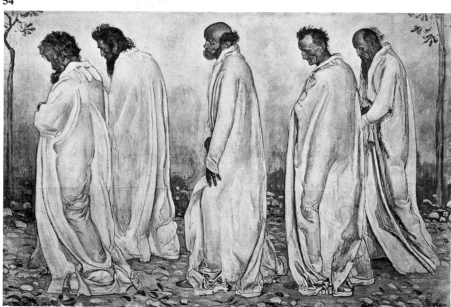

55

Mikhail Lermontov's *The Demon*, a tale of a creature neither mortal nor human, provided his fellow Russian Mikhail Vrubel with an opportunity for curious insights into love and death. In addition to portraying the Demon itself (see plate 85), Vrubel also depicted the tragic heroine, Tamara, lying dead, in oriental majesty.

In the large symbolic canvas *Eurythmy*, Ferdinand Hodler sets five old men in flowing white robes in a very shallow stagelike space. The artist wrote in his notebook that they "represent . . . humanity, marching toward death." They move in a slow, fluid rhythm which conveys the essential meaning of the picture. During the last decade of the century, art increasingly turned toward the non-discursive nature of music and dance, and Hodler's composition of a clearly articulated meter with its accent on unison is clearly related to the origin of modern dance: human experiences and emotions are communicated rhythmically.

In Edvard Munch's work the melancholy aspects of the new vision that Gauguin expressed are brought indoors. In *Chamber of Death* the careful positioning of figures, isolated and distanced from one another, creates a visual equivalent to Munch's grief, endlessly recalled in graphic works and paintings. Munch also dealt with the cycle of life. During the most critical period of his long career he was close to the French Symbolists in Paris and decided no longer to "paint interiors with men reading and women knitting. There must be living beings who breathe and feel and suffer and

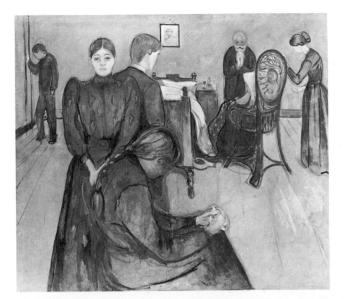

56

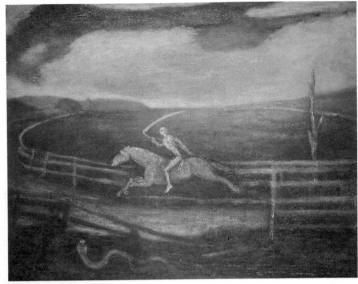

58

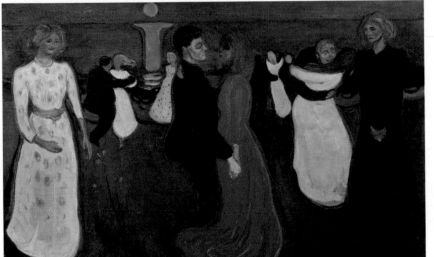

57

love—I shall paint a number of pictures of this kind. People will understand the sacredness of it and will take off their hats as though they were in church." *The Dance of Life* is part of this large frieze of living and dying. Here he treats the problem of life's progression from youth to old age in a manner which has a direct effect on the viewer's nervous system. Munch's paintings are evocative, powerful, and disturbing. The women, at different stages of life, are painted with psychic insight and reveal an anxiety which was very much a part

of the era of the 1890s. But the artist expresses this turbulence with raw intensity instead of veiled mystery.

A similar sense of death as man's destiny is also felt in the work of the great American Romantic painter Albert Pinkham Ryder, who began his *Race Track* probably in 1890 but did not complete it until 1910. This dark, haunting painting is also titled *Death on a Pale Horse*, and indeed Ryder transmuted the subject into the involuntary remembrance of a nightmare.

54 Mikhail Vrubel. *Tamara in Her Coffin.* 1890. Watercolor, 9 $^1/_2$ × 13 $^5/_8$″ (Fragment of a destroyed composition) 55 Ferdinand Hodler. *Eurythmy.* 1895. Oil on canvas, 65 $^3/_4$ × 96 $^1/_2$″ 56 Edvard Munch. *Chamber of Death.* c. 1892. Oil on canvas, 59 × 66″ 57 Edvard Munch. *The Dance of Life.* 1899–1900. Oil on canvas, 49 $^1/_2$ × 75″ 58 Albert Pinkham Ryder. *The Race Track* (*Death on a Pale Horse*). 1890–1910. Oil on canvas, 28 $^1/_4$ × 35 $^1/_4$″

Dream and Sleep

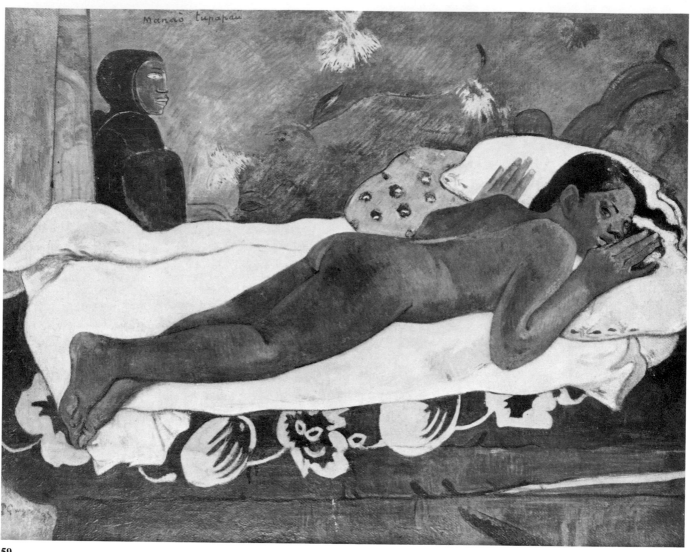

59

Sleep and dreams became prevalent subjects at the end of the century. In Vienna, Sigmund Freud wrote his *Interpretation of Dreams*. In Tahiti, Gauguin painted *Spirit of the Dead Watching*, in which a young Polynesian woman is awakened by her fear of death, personified by Tupapaü, who is seated by her bed. Gauguin used, as he wrote, "a minimum of literary means, unlike the way it was done in the past," and writes of the lines and colors he employed to achieve "musical harmonies" for the expression of "the soul of the living woman united with the spirit of the dead." Hodler, painting large symbolic canvases in Geneva, also rejected narrative painting in his early masterpiece, *Night*. In this large, beautifully articulated horizontal composition of six figures he creates a fusion of eros, sleep, and death with an image of death squatting on the depiction of the artist himself.

Both Gauguin and Hodler are concerned with rhythmic pattern. Henri Rousseau, the French customs official and self-taught artist, creates a sense of mystery in *The Sleeping Gypsy*. Isolated objects are mysteriously juxtaposed: the dark woman in

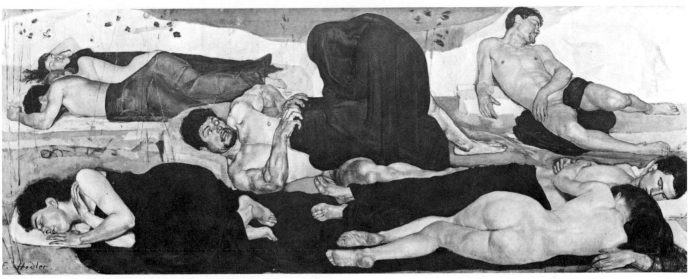

60

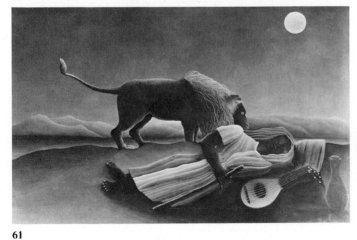

61

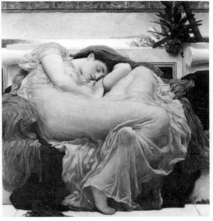

62

her brightly colored gown, the tame lion with his staring eye and extended tail, the mandolin and pitcher—all float in an arid desert by a river. There are no footprints in the sand and a round moon hangs in the sky over the all-pervading stillness. As in some dreams, everything is seen with preternatural precision. Rousseau's bold experiments into the world of the unknown were understood only by a handful of his artist friends.

The general public of the day much preferred *Flaming June*, by Frederic Leighton, with its hothouse eroticism and mastery of traditional forms, as revealed in the figure's drapery. Leighton, who was named president of the British Royal Academy in 1878, was elevated to the peerage in 1896, becoming the only English artist ever created a baron.

59 Paul Gauguin. *Spirit of the Dead Watching*. 1892. Oil on canvas, 28 $^3/_4$ × 36 $^1/_4$" **60** Ferdinand Hodler. *Night*. 1890. Oil on canvas, 45 $^5/_8$ × 117 $^3/_4$" **61** Henri Rousseau. *The Sleeping Gypsy*. 1897. Oil on canvas, 51 × 79" **62** Frederic Leighton. *Flaming June*. 1895. Oil on canvas, 47 $^1/_2$ × 47 $^1/_2$"

Erotic Imagery

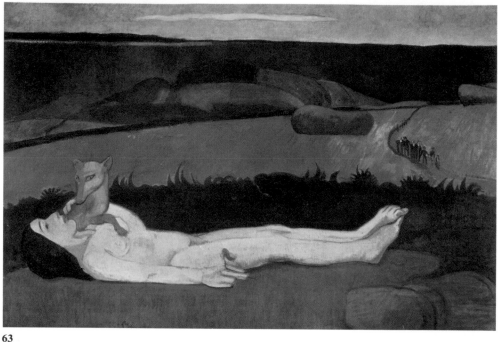

63

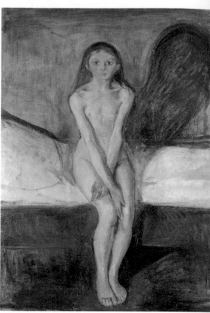

64

65

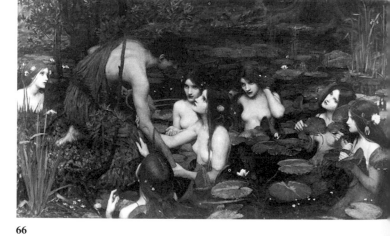

66

Narcissism and the wandering soul seeking its twin were seminal Symbolist concepts. Indeed, meditation, silence, and sometimes cruelty led to the elementary discovery of one's subconscious. Gauguin's *The Loss of Virginity* is the pictorial representation of this psychological state. So absorbed in self that contact with the physical world is lost, a ghostlike young girl lies helplessly, as if on a pyre, in a freshly harvested field. In her hand is the proverbial, but dying, flower of virginity. Her deflowerer, the brown fox, is seated on her shoulder. Set off by color, scale, and line, a procession of harvesters mourns in the background.

Puberty by Edvard Munch is also

a study of modern psychic life. Painting during the *fin-de-siècle* period of disillusion and controversial sexual freedom, Munch depicts the emergence and overwhelming effect of burgeoning sexuality on a young girl. Her bewilderment and fear are apparent in her mournful expression and awkward pose. An ambiguous dark shadowlike shape looms at her side, adding to the atmosphere of threat.

Fernand Khnopff, in Belgium, studies narcissism in *The Caresses of the Sphinx*. A panther with a woman's head embraces the half-naked body of a sensitive young man. She is muse, sexual priestess, and animal, endowed with all the enigma of

the Sphinx. In his admiration for the English Pre-Raphaelites, Khnopff valued works such as John William Waterhouse's *Hylas and the Nymphs*. Here the idyllic setting, the precise, cold draftsmanship, and classical myth speak to the romantic glory of a past that never was. The marked resemblance of the naked nymphs to each other is the idealization of an erotic stereotype. The equation of woman with evil and lust, as in Franz von Stuck's *Sin*, is another prevalent theme in the Age of Decadence. This pictorial allegory by the important teacher and leader of the progressive Munich Secession is accomplished by using a dark brownish palette, enveloping the woman's

67

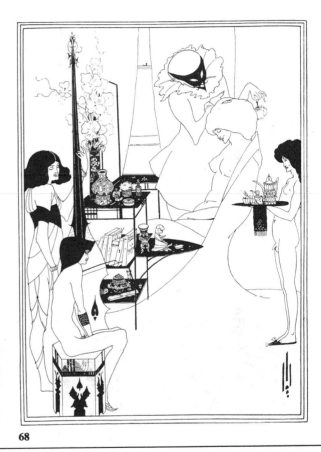

68

face in shadow, and surrounding her with the coils of a snake.

Whereas Stuck presents his woman in a rather immobile classical image, Aubrey Beardsley's drawing is based on nervous energy. He deals with many aspects of sexuality in a drawing such as *The Toilette of Salomé I,* intended for his masterful set of illustrations to Oscar Wilde's play *Salomé* but suppressed at the time. A harlequin dresses the princess's hair, and a young hermaphrodite serves tea. Preoccupied with eroticism, Beardsley unmasked the repressed aspects of late Victorian culture, not exposing its corruption as much as entering more fully into the intellectual indulgence of the *fin de siècle.* And, as his contemporary Arthur Symons recognized, Beardsley transfigured "sin" by the abstract beauty of his line—a biting line which has an independent life and creates a continuously fascinating pattern of crisp blacks and whites, of positive and negative space. Beardsley intellectualized and formalized evil by the stunning facility of his drawings and made the degradation of an overripe, decadent society seem aesthetically attractive. Among the authors whose works appear on the seductress's flimsy Japanese bookshelf is the Marquis de Sade.

63 Paul Gauguin. *The Loss of Virginity.* 1890–91. Oil on canvas, 35 × 51 ¼″
64 Edvard Munch. *Puberty.* 1894. Oil on canvas, 59 ⅝ × 43 ¼″ **65** Fernand Khnopff. *The Caresses of the Sphinx.* 1896. Oil on canvas, 19 ⅞ × 59″
66 John William Waterhouse. *Hylas and the Nymphs.* 1896. Oil on canvas, 38 ⅝ × 64 ¼″ **67** Franz von Stuck. *Sin (Die Suende).* 1895. Oil on canvas, 37 ⅜ × 23 ⅝″ **68** Aubrey Beardsley. *The Toilette of Salomé I.* 1893. Ink drawing, 8 ¹³⁄₁₆ × 6 ⁵⁄₁₆″

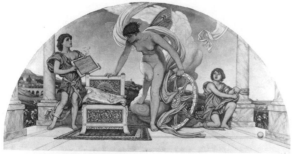

69

70

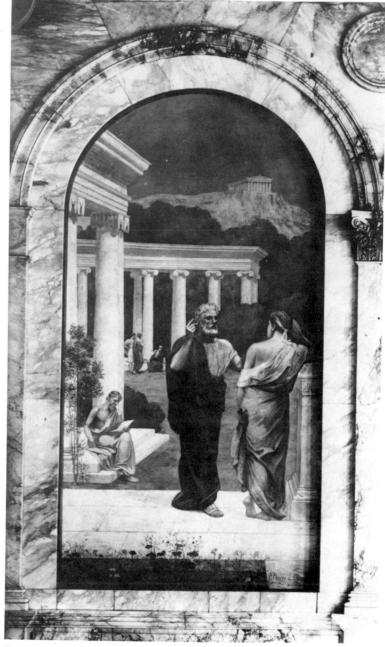

71

While progressive artists like Beardsley looked to the exotic art of Japan for inspiration, many painters, sculptors, and architects still searched for their ideal in classical antiquity. The English critic John Ruskin invented the term "galvanized Elgin" (referring to the Elgin marbles taken from the Parthenon), which is certainly applicable to Elihu Vedder's mural *Goddess Fortune Stay with Us* (see also plate 83) and to Lawrence Alma-Tadema's rendition of *The Baths of Caracalla*. (This kind of painting was later replaced by Cecil B. De Mille's elaborate movie productions.) A much greater serenity is achieved in the muted and clearly structured murals of Pierre Puvis de Chavannes, who, although an honored member of the French Academy, was esteemed by avant-garde artists. They admired his feeling for simplified line and rhythmic composition and his gift for understatement, which is evident even in large murals such as *Philosophy*, commissioned by the Boston Public Library. The American John La Farge, who also did murals in the same building, was often directly inspired by the French master, but as his lunette-shaped *Athens* demonstrates, he did not have Puvis's feeling for a total unity of the picture surface.

Gustave Moreau, also a member of the French Academy and Puvis's Symbolist contemporary, dreamed of a pagan, luxurious, exotic world. The mysterious *Orpheus at the Tomb of Eurydice* evokes classical sentiment by means of jewellike colors; Orpheus, the archetype of the artist, is seen in a contemplative position, agonizing, completely alone in a somber landscape. Like many of Moreau's heroes, Orpheus has an

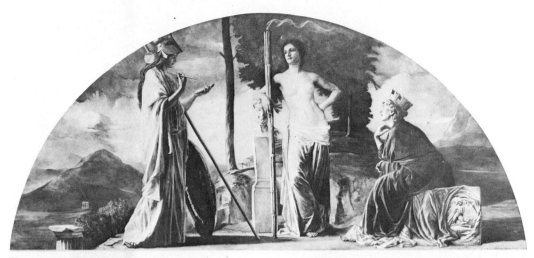

72

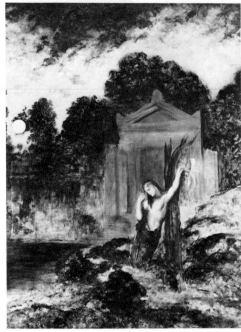

73

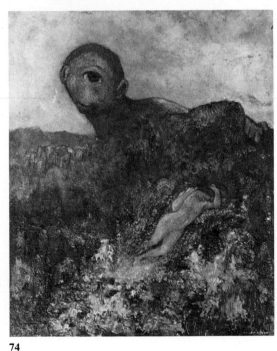

74

androgynous appearance. Indeed, interest in the androgyne and hermaphrodite is an important aspect of the vision and fantasies of the Decade of the Decadents. Moreau consciously used pictorial values for the evocation of thought and was thus very close to Symbolist attitudes. He was a respected member of the Ecole des Beaux-Arts but, unlike many of his colleagues, he was an inspiring teacher and counted Georges Rouault and Henri Matisse among his students.

Another great visionary of the period was Odilon Redon, who created hermetic metaphors of reverie and dream when he painted the surreal image of the mighty *Cyclops* of ancient mythology in iridescent, glowing colors. His unique fantasies were to become a great inspiration to the Surrealist movement (see page 240). His statement that the "logic of the visible is at the service of the invisible" can be seen as a summation of Symbolist thought and art. Simultaneously, it is one of the essential features of the art of the next century.

69 Elihu Vedder. *Goddess Fortune Stay with Us*. Mural, 30 ³/₄ × 58 ³/₄″
70 Lawrence Alma-Tadema. *The Baths of Caracalla*. 1899. Oil on canvas, 60 × 37 ¹/₂″ **71** Pierre Puvis de Chavannes. *Philosophy*. 1894–96. Fresco, 171 × 86″
72 John La Farge. *Athens*. 1898. Oil on canvas, 108 × 240″ **73** Gustave Moreau. *Orpheus at the Tomb of Eurydice*. 1891–97. Oil on canvas, 68 ¹/₈ × 50 ³/₈″
74 Odilon Redon. *Cyclops*. 1898. Oil on wood, 25 ¹/₄ × 20″

Religious Painting I

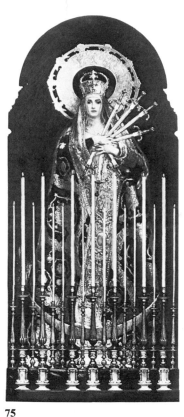

75

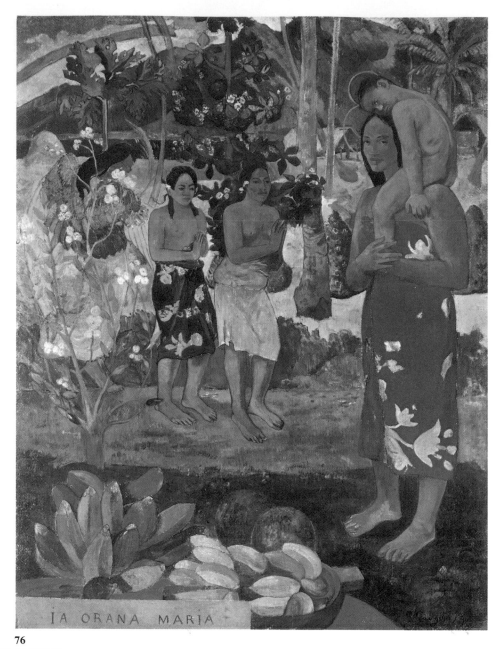

76

John Singer Sargent, brilliant as a portrait painter (see plate 31), was commissioned to execute a cycle of religious murals as part of the program of decorations for the Boston Public Library. Sargent painted his contributions on canvas in London and shipped them to Boston for installation. *Mater Dolorosa* is a majestic apparition, rising on a crescent moon behind a barrier of candles, holding an array of swords before her breast. It is a somber and hieratic image, influenced by his study of Byzantine mosaics.

In contrast, the image of the Virgin in Paul Gauguin's *Ia Orana Maria* (*We Greet Thee Mary*) is a serene Tahitian who carries the infant Jesus while two beautiful half-nude Tahitian girls greet her with folded hands. This is a painting of perfect bliss and devotion, of an earthly paradise which Gauguin found only among the innocent natives of remote South Sea Islands. Here one of the most sophisticated Europeans painted a total idealization of the primitive world.

A Symbolist idealization of a different kind is Johan Thorn Prikker's *The Bride*—silent, muted, quietly evocative. The bride herself is only implied by the long shape of a veillike garment patterned with decorative, flowing floral motifs. To her right can be distinguished an organic shape of the crucified Christ. The two figures are joined by a rotating linear arabesque.

Munch's *Madonna* is, shockingly, naked, but the exalted mood of the face and the stylized rendering of the hair and flesh give this work an undeniably spiritual aspect. Yet one cannot forget that Munch introduced a carnal red for the Madonna's halo. The paintings by Gauguin, Thorn Prikker, and Munch have in common that they are personal and thoroughly unorthodox religious works, and

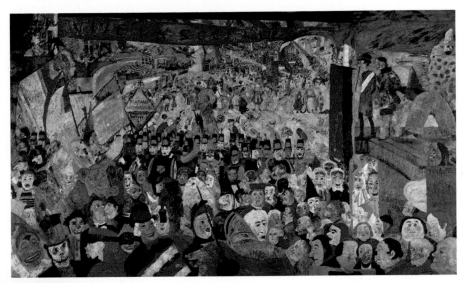

77 79

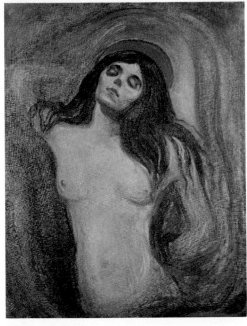

78

that they are part of the religious revival which took place at the end of the century.

James Ensor's totally unorthodox *The Entry of Christ into Brussels in 1889* was painted in 1888. The Savior is surrounded by a raucous, stupid, indifferent crowd. The eccentric Belgian painter combined fantasy and sarcasm in this enormous canvas, in which he sought to indict modern urban society. Using a brilliant palette of complementary colors, he created a modern Flemish kermis, a street demonstration with socialist slogans, people wearing morbid masks almost indistinguish-

able from their real faces, surging masses of merrymakers celebrating a socialist Palm Sunday—all under intense sunlight. If the color and brushwork are totally modern, the compression and the sheer horror place Ensor also in the Flemish tradition of Hieronymus Bosch. But instead of Bosch's hideous medieval tortures, Ensor's anonymous masked crowds suffer from modern man's sense of alienation from any kind of community.

75 John Singer Sargent. *Mater Dolorosa.* 1890–1916. Mural 76 Paul Gauguin. *Ia Orana Maria* (*We Greet Thee Mary*). 1891. Oil on canvas, 44 $^3/_4$ × 34 $^1/_2''$ 77 Johan Thorn Prikker. *The Bride.* 1892–93. Oil on canvas, 57 $^1/_2$ × 34 $^5/_8''$ 78 Edvard Munch. *Madonna.* 1893–94. Oil on canvas, 35 $^1/_2$ × 27'' 79 James Ensor. *The Entry of Christ into Brussels in 1889.* 1888. Oil on canvas, 101 × 149''

80

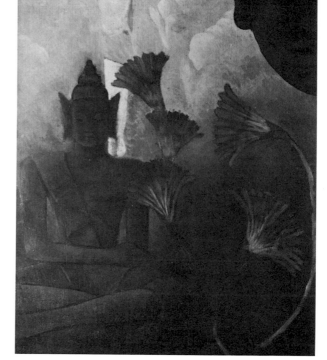

81

In 1897 the German painter and sculptor Max Klinger, in many ways a disciple of Arnold Böcklin's (plate 50), painted his symbolic allegory *Christ on Olympus*. The very idea of the subject matter, the combination of Christ and the Olympian Zeus, a fusion of mythology, philosophy, and religion, is part of a desire to consolidate all religions into a synthetic unity.

A more modest and more esoteric painting is *Christ and Buddha* by the French Symbolist Paul Ranson. This was the period of Joséphin Péladan's Rose + Croix and of Madame Blavatsky's Theosophical movement—religious philosophies based largely on mystic intuition and extrasensory revelations. It was also now that the highly gifted Maurice Denis, originally a follower of Gauguin's dur-

ing the latter's Breton period, sought to give simple artistic expression to his devout Neo-Catholicism in *Annunciation*.

A move toward a new orthodoxy also seems to be the basis for the clear, idealized *Lazarus Rising from the Tomb* by Elihu Vedder, an American who lived in Rome most of his life. In his later years Vedder, like many other artists of his genera-

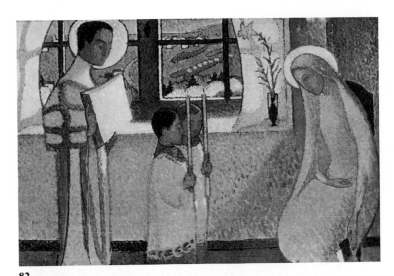

82

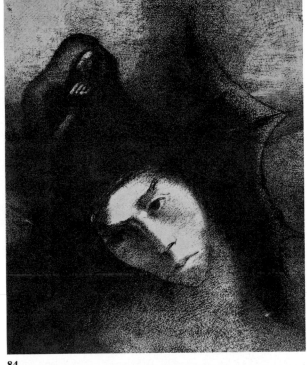

84

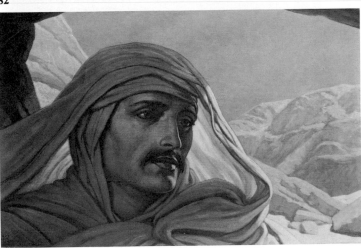

83

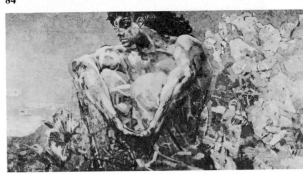

85

tion, became absorbed in Theosophy and also in Buddhism.

The theme of demonology remained popular throughout the waning years of the nineteenth century. Odilon Redon, who dealt with Greek legend in *Cyclops* (plate 74), illustrated Gustave Flaubert's *The Temptation of Saint Anthony* with an ambiguous devil that seemed to spring from Anthony's own mind.

A different attitude toward demonology is communicated by the Russian Symbolist Mikhail Vrubel, as seen in *Seated Demon*—a portrayal of a fallen archangel—with its rich Byzantine color and design. Although Vrubel is still little known in the Western world, he was one of the artists responsible for the great renaissance in Russian painting in the early twentieth century.

80 Max Klinger. *Christ on Olympus.* 1897. Oil on canvas and marble, 11′ 8 $^3/_4$″ × 23′ 8 $^1/_4$″ **81** Paul Ranson. *Christ and Buddha.* c. 1890. Oil on canvas, 26 $^1/_4$ × 20 $^1/_4$″ **82** Maurice Denis. *Annunciation.* 1891. Oil on canvas, 10 $^5/_8$ × 16 $^1/_8$″ **83** Elihu Vedder. *Lazarus Rising from the Tomb.* 1899. Oil on canvas, 20 × 31 $^1/_2$″ **84** Odilon Redon. From *The Temptation of Saint Anthony.* Plate 18. 1896. Lithograph, 12 $^1/_4$ × 9 $^7/_8$″ **85** Mikhail Vrubel. *Seated Demon.* 1890. Oil on canvas, 44 $^7/_8$ × 83 $^1/_8$″

Landscape

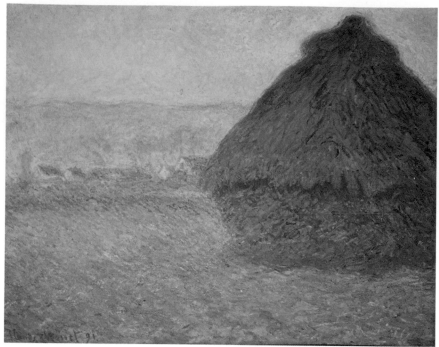

86

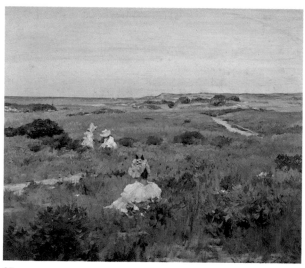

87

88

After the victories of the Impressionists in the 1870s and 1880s, landscape painting in the last decade of the century had innumerable options. Claude Monet continued his sensitive explorations of the nuances of reflected light, such as haystacks dissolving into an evanescent atmosphere in the fading light of the evening sun. In *Landscape: Shinnecock, Long Island* the American William Merritt Chase (plates 208 and 219) created a lively pattern of greens, browns, and blues, defined in a variety of vigorous brushstrokes.

Instead of subtly merging objects into a diffused, all-pervading atmosphere, Paul Signac built a patterned framework of curvilinear shapes, making an overall decorative pattern. In *Place des Lices, Saint-Tropez*, his evocation of the sun-drenched south of France consists of small flecks of color which activate the surface into an abstracted vibrant pattern.

Van Gogh created a different kind of rhythm by the vigor of his brush, projecting his intense passion for nature and for color and paint. The yellows and blues in his last painting, *Crows over the Wheat Field*, are hues at their most saturated brilliance, expressing a tempestuous and foreboding mood. Facing the landscape with unrestrained creative energies, Van Gogh opened a passage to the free expression of man's inner world.

If Van Gogh's landscapes express turmoil and anxiety, Cézanne's *Lake of Annecy* is controlled and restrained. Here the stroke is placed

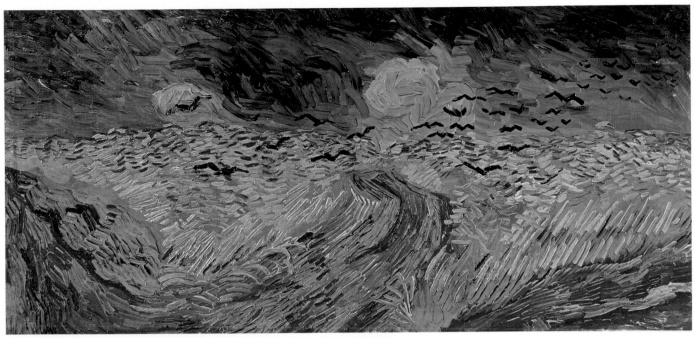

89

90

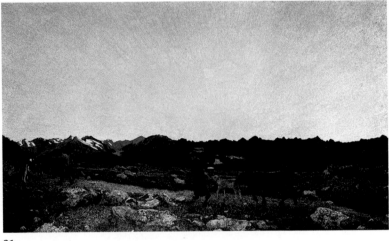

91

with rational deliberation. A restricted palette consisting largely of blues and greens is used to build up a tectonic structure as well as to evoke a somber mood. The branch of the tree in the immediate foreground is interwoven with the mountains in the distance, creating spatial tension between surface and depth.

The Italian-Swiss Giovanni Segantini painted a very different Alpine landscape. Acquainted with the Neo-Impressionist application of bright color dots, he used the technique for *Being*, a symbolic painting that is part of a larger horizontal triptych of nature, also conceived as a "Panorama of Life and Death." Painted in the last years of the century, this canvas combines the new formal innovations with a picturesque romantic and moralizing attitude that recalls the work of the earlier English Pre-Raphaelites. Segantini's evocative style belongs to the Symbolist spirit, however, reflecting a searching for new metaphysical meanings of life.

86 Claude Monet. *Haystack at Sunset near Giverny*. 1891. Oil on canvas, $29 \frac{1}{2} \times 37''$ **87** William Merritt Chase. *Landscape: Shinnecock, Long Island*. c. 1895. Oil on panel, $14 \frac{1}{4} \times 16''$ **88** Paul Signac. *Place des Lices, Saint-Tropez*. 1893. Oil on canvas, $23 \frac{3}{4} \times 32 \frac{1}{8}''$ **89** Vincent van Gogh. *Crows over the Wheat Field*. 1890. Oil on canvas, $19 \frac{7}{8} \times 39 \frac{1}{2}''$ **90** Paul Cézanne. *Lake of Annecy (Lac d'Annecy)*. 1896. Oil on canvas, $25 \frac{1}{2} \times 32''$ **91** Giovanni Segantini. *Being*. 1898–99. Oil on canvas, $92 \frac{1}{8} \times 157 \frac{1}{2}''$

Still Life

93

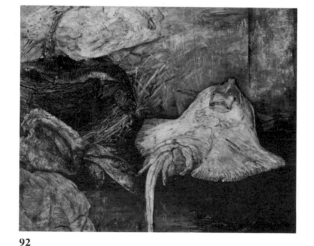

92

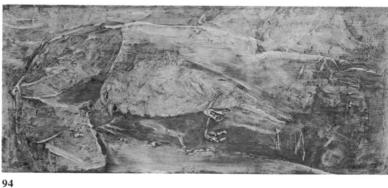

94

There is nothing "still" or removed in Ensor's still life *The Ray*, with its anthropomorphic qualities. A native of Ostend, a seaport and resort annually flooded with summer tourists, Ensor despised the bourgeoisie. Thus the apparently innocent subject matter of fish, straw, shell, and basket becomes a biting commentary: the luridly painted, slimy, and helpless ray has a defiant snarl on its human face.

Cézanne, using a light palette similarly derived from the Impressionists, has a totally different attitude toward the still life. His *The Basket of Apples* is about the con-

creteness of pictorial design, the relationships of colors in space, the organization of painting. The "horizontal" table and the "vertical" bottle veer the perpendicular and the precise toward the diagonal because each object impinges on the other and influences its shape and character. We are aware of hidden energies of form. Basket, plate, and fruit have assumed a dynamic elliptical shape. The implied space is no longer seen from a single, static viewpoint, but from many different and seemingly contradictory ones—to convert the dynamic and ever-changing organic world into vibrant pictorial form, to

"realize his sensations," as the master put it. But Cézanne was not solely concerned with formal problems. The green apples in the basket are not only complementary in color to the red ones, they are also not as ripe, thus implying the biological process of organic growth within a severely structured painting.

Albert Pinkham Ryder's *The Dead Bird* transcends its small format to confront profound questions of nature and existence. As in *The Race Track* (plate 58), Ryder sees the world about him in metaphysical terms.

The Belgian painter Henry van de

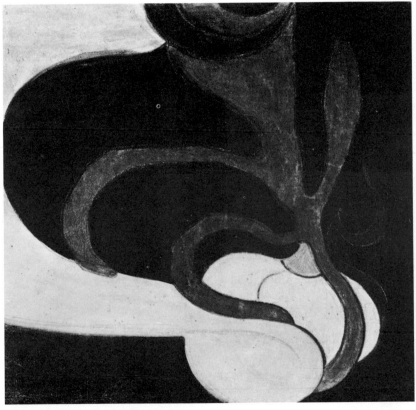

95

96

Velde seems to have arrived at almost total abstraction as early as 1890 in his pastel titled *Ornament of Fruit*. Whereas his fellow Belgian Ensor endowed a fish with human traits, Van de Velde barely suggests a gourd or bulb; even the colors—blue, yellow, and green—no longer serve a descriptive function. The relationship of elliptical planes and sinuous, rootlike shapes creates a decorative picture suggesting organic forms. Abstract patterns shift in an ambiguous space.

At the same time the American painter John Frederick Peto is involved in the utmost realism and pic-torial illusion. Selecting common daily objects, such as letters, a pen, a notebook, and string, he paints them in actual size and naturalistic color on his *Old Time Letter Rack*. The objects in the painting look absolutely real, tangible, palpable; the eye is fooled. Furthermore, Peto deals with objects of human emotion —letters. They are torn, used and abused by the old letter rack. Held captive by this contraption, these inanimate objects pulse with emotional life and cry out for attention.

92 James Ensor. *The Ray*. 1892. Oil on canvas, 31 $^1/_2$ × 39 $^1/_4''$ **93** Paul Cézanne. *The Basket of Apples*. 1890–94. Oil on canvas, 25 $^3/_4$ × 32'' **94** Albert Pinkham Ryder. *The Dead Bird*. 1890–1900. Oil on wood, 4 $^1/_4$ × 9 $^7/_8''$ **95** Henry van de Velde. *Ornament of Fruit*. 1890. Pastel, 18 $^3/_4$ × 20'' **96** John F. Peto. *Old Time Letter Rack*. 1894. Oil on canvas, 30 × 25 $^1/_8''$

Interiors

97

98

The secret life of inanimate objects was seen by painters not only in still lifes, but also in whole interiors. Pierre Bonnard's *Interior* is a complex hide-and-seek picture-within-a-picture. The doorway dividing the three receding spaces frames the central zone. The mundane ritual of setting the table is mysteriously displayed—separated from the viewer, cut off from itself, and apparently studied by a vacant chair. Even nature—the flowers in a vase in the foreground, the trees beyond the window—is domesticated and forms part of the continuum of the intimate domestic scene.

Edouard Vuillard, who, like his lifelong friend Bonnard, was dubbed an Intimist, gives a similar quality of life to setting and figures through a uniform, dappled brushwork in *The Suitor*. He renounced here the flat patterning of the slightly earlier *Self-Portrait* (plate 40) for the sake of a continuous interior in which the figures are part of their surroundings. Indeed, it takes time to identify the figures within the all-pervading pattern. This painting, like many other works by Vuillard of the 1890s, has an air of secrecy about it. Here we actually witness an encounter between Vuillard's close friend the painter Ker-Xavier Roussel, peeking furtively around a screen, and Vuillard's sister, who was to become Roussel's wife. It takes place in a rather claustrophobic space which is actually quite unsubstantial, consisting primarily of intricate lambent color harmonies. Both Bonnard and Vuillard were masters at suggesting the soul of human habitation.

Moonlight was more congenial to Edvard Munch's temperament than daylight, and he used shadows and reflections extensively. However, here the feeble aura cast by the two lamps scarcely illuminates Munch's interior, and the inscrutable top-hatted figure blends almost indistinguishably into the curtain and bench behind him. But unlike Vuillard, Munch achieves pervasiveness with translucent, essentially unpatterned surfaces.

99

100

101

Vuillard and Bonnard were members of the Nabis (see page 27), and although Henri Matisse was not part of their group, he also achieves a sense of intimacy in his early masterpiece *The Dinner Table*, done for exhibition at the suggestion of his teacher, Gustave Moreau (see page 39). In this large painting he uses an Impressionist brushstroke of shimmering colors that reflects the light and creates a luxurious chromatic surface pattern. Space is condensed, the table is flipped up and occupies most of the iridescent picture.

Much more conservative are the interiors of the gifted and popular German painter Wilhelm Leibl, who belonged to an older generation.

Having been influenced by Gustave Courbet and the Barbizon painters, Leibl painted peasants with a romantic realism ultimately derived from the Dutch masters. In his famous painting *The Spinner* he handles details like the carafe on the table or the wrinkles on the women's faces with great precision and extraordinary virtuosity. He also separates the two women, leaving them absorbed in their miniature world of endless spinning. The runny grays and rich browns help create a feeling of peaceful concentration.

97 Pierre Bonnard. *Interior*. c. 1898. Oil on canvas, 20 $^1/_2$ × 13 $^3/_4$" 98 Edouard Vuillard. *The Suitor*. 1893. Oil on millboard panel, 12 $^1/_2$ × 14 $^3/_8$" 99 Edvard Munch. *Moonlight*. 1895. Drypoint and aquatint, 55 $^1/_4$ × 53 $^1/_8$" 100 Henri Matisse. *The Dinner Table (La Desserte)*. 1897. Oil on canvas, 39 $^1/_4$ × 51 $^1/_2$" 101 Wilhelm Leibl. *The Spinner*. 1892. Oil on canvas, 25 $^5/_8$ × 29 $^1/_8$"

Wall Hangings

103

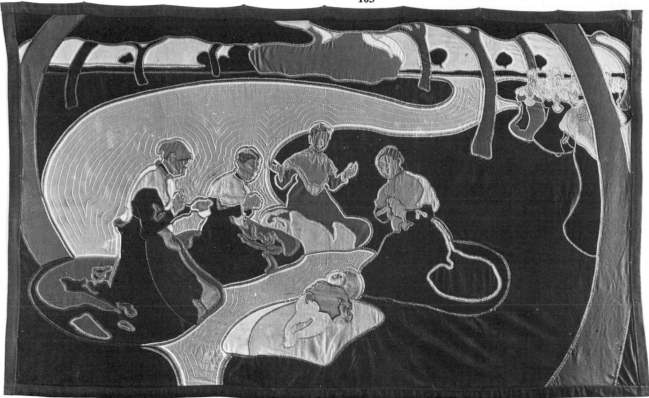

102

Oscar Wilde declared that "art is at once surface and symbol," a notation that defines much of the sensibility evident in paintings of such different artists as Bonnard and Vuillard, Toulouse-Lautrec and Thorn Prikker, Beardsley and Munch. It also characterizes a good deal of the architecture, sculpture, and decorative arts of the period. Called Art Nouveau or Jugendstil, but also known by many other designations, this international style of applied Symbolism derived its sense of honest craftsmanship and its goal of in-

tegrating all the arts from the earlier English Arts and Crafts movement. But, unlike the designers of the previous decade, many of the Art Nouveau artists accepted the machine as a useful tool. Instead of longing for a new medievalism, they rejected all the various forms of eclecticism of the nineteenth century while making use of certain elements of the past, such as the grace and asymmetry of rococo decoration, the intricate interlace of Celtic design, the flamelike tracery of late Gothic, the two-dimensional planar aspects of the Japanese color

woodcut and the evocative quality of its line. Above all, they were inspired by the growth and flow of nature, which they often saw with the aesthetic vision of the Decadents and Symbolists.

Henry van de Velde abandoned painting as too elitist an occupation and became the chief theorist of the Art Nouveau movement. He also worked as an architect (see plates 496 and 497), educator, and craftsman, and designed wall hangings and embroidery, such as *Angels' Watch*. Still essentially a picture, it recounts its

104

105

religious story by means of flat planes of unbroken color and undulating, dynamically curved lines. Van de Velde's statement that "a line is a force . . . which derives its energy from the person who drew it" is an important concept and in total contradistinction to the traditional use of line to imitate nature.

The Swiss sculptor and designer Hermann Obrist reduces a winding cyclamen to an energetic abstract line of springy curves in his wall hanging *The Whiplash*, which had a great influence on younger artists in Munich, where it was produced. Otto Eckmann adhered more closely to nature in his decorative weaving *Five Swans*, in which the serpentine streams and elegantly gliding birds are phrased more literally.

In Vienna, Koloman Moser designed a decorative fabric in which the floral motif is conceived and executed in a curvilinear flat pattern. It creates a decorative component in a unified environment, an element that is part of a total design.

102 Henry van de Velde. *Angels' Watch*. 1893. Wool application on rough linen, 55 $^1/_8$ × 91 $^3/_4$" **103** Hermann Obrist. *The Whiplash*. 1895. Silk embroidery on wool, 47 $^1/_4$ × 73 $^5/_8$" **104** Otto Eckmann. *Five Swans*. 1896–97. Wool on warp of fishing net, 93 $^7/_8$ × 29 $^1/_2$" **105** Koloman Moser. *Decorative Fabric*. 1899. Woven silk and wool

Monuments

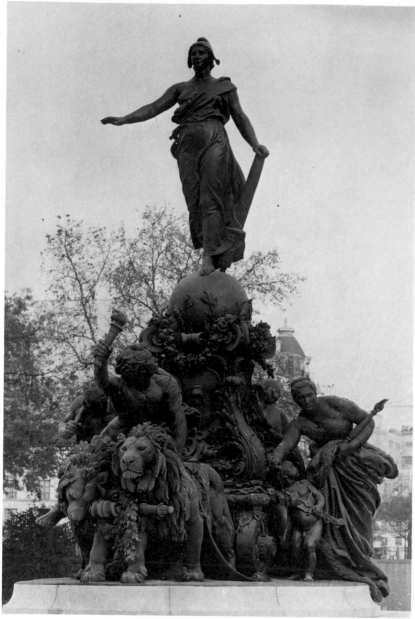

106

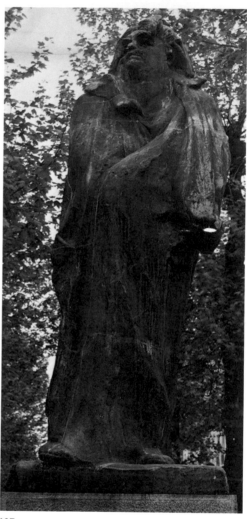

107

It took considerable time for sculpture to attain the phenomenal advances of painting. According to the established and deeply ingrained academic ideal, the purpose of sculpture, and especially of public monuments, was to elevate and educate the masses. Even an artist like Aimé-Jules Dalou, whose left-wing political activities forced him into extended exile from France, could think only of traditional allegories when, upon his return to Paris from London, he was commissioned to create *The Triumph of the Republic*. In this large bronze monument the allegory of the Republic, a young victorious woman, stands in a triumphal chariot pulled by two lions and surrounded by Justice, Liberty, and Peace. Liberal thought was still clothed in the pomp of reactionary form.

It is no surprise, then, that public and critics alike were infuriated when Auguste Rodin first exhibited his audacious *Monument to Balzac* and that the society which had commissioned the work refused to accept it. The great French novelist had been dead for forty years when Rodin began his portrait. The statue is the embodiment of the writer's spirit, perhaps of genius in a more universal sense. A potent, erect figure in loose dressing gown, with tilted stance and exaggerated features, it is no longer the traditional depiction of the hero but a symbol of the physical and creative life force, of the "soul in action" as conceived and executed by the great artist.

In Germany, Adolf von Hildebrand designed the *Wittelsbach Fountain*, commissioned by the city of Munich. Its harmonious composition of sculpture and water, balanced in symmetrical order, continues the old Neoclassic tradition at its best into the 1890s. His art theory, published in 1893 as *The Problem of Form in the Plastic Arts*, was highly influential for a whole generation of artists. In it he took issue with scientific or sensuous naturalism and postulated

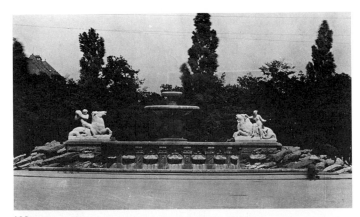

108

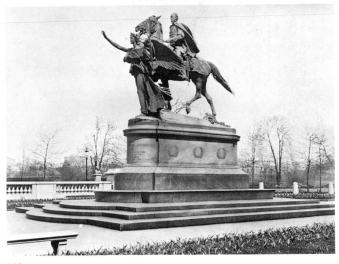

110

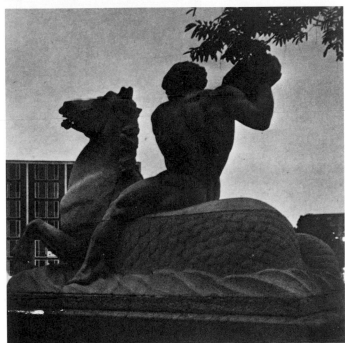

109

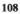

111

the task of the artist to be the rendition of visual sensations of three-dimensional form, or, as his disciple Bernard Berenson said thereafter, to "give tactile values to retinal impressions." Although his own work remained strictly traditional, Hildebrand's demand that art express solid clarity and pure visual order is very much in keeping with the general stylistic trend which would become one of the essential aspects of advanced art.

A similar attitude toward severe form is evident in the prophetic *Adams Memorial* in Washington's Rock Creek Cemetery, by Augustus Saint-Gaudens, the leading American sculptor of his generation. Saint-Gaudens's friend Henry Adams had commissioned the sculptor to design a grave monument for his wife, who had committed suicide in 1885. Seated against a simple stele is a bronze figure, arm uplifted and head shrouded. It is a poignant image with an air of mystery and silent calm. Yet Saint-Gaudens was not above turning out standard Beaux-Arts works such as the equestrian statue of the Civil War hero William Tecumseh Sherman guided by the Greek goddess of victory.

106 Aimé-Jules Dalou. *The Triumph of the Republic*. 1899. Bronze, height 36′
107 Auguste Rodin. *Monument to Balzac*. 1898. Bronze, height 113 ³/₄″
108–109 Adolf von Hildebrand. *Wittelsbach Fountain*. 1895. Stone 109 Detail
110 Augustus Saint-Gaudens. *Adams Memorial*. 1891. Bronze, height 70″
111 Augustus Saint-Gaudens. *General William Tecumseh Sherman*. 1897–1903. Bronze

Female Portraits and Figures

113

112

114

The liberation of sculpture from academic confinement was substantially aided by architects who extended their sensibilities to every detail of their buildings and created door handles, balustrades, and light fixtures which have sculptural qualities in their own right. In such an aesthetic ambience Aristide Maillol began his career. After making decorative paintings and tapestries, he turned to sculpture similar in character. His small *Kneeling Washer-woman* is a delightful ornamental figure in which the open space between the arms is as important as the solid mass surrounding it. In 1890, while in Brittany, Gauguin made his woodcarving *Be in Love*

and *You Will Be Happy*, which he considered "the best and strangest thing I have ever done in sculpture." Gauguin described the meaning of this symbolic work, writing, "Gauguin (like a monster) taking the hand of a woman who resists says to her: 'Be in love and you will be happy.' A fox represents the Indian symbol of perversity, and in the interstices some small figures. The wood will be colored." The mysterious symbolism of this relief clearly relates to the later painting *Where Do We Come From?* . . . (see plate 53), but it is more autobiographical and at the same time more cryptic.

Like Gauguin, Edgar Degas frequently turned to sculpture during

his career as a painter. In his search to give form to mass in motion, Degas decided to model the human body in clay or wax in order to understand movement more completely. The small bronze *Woman Arranging Her Hair* represents a simple instant of arrested motion, much like a photograph, yet it is totally sculptural in its feeling for volume and energetic modeling.

In his bust of the French cabaret star Yvette Guilbert—also portrayed by Toulouse-Lautrec—the Italian Medardo Rosso introduced Impressionist concerns with fleeting light and the dissolution of form into the realm of sculpture. What he sought was not the literal depiction of her

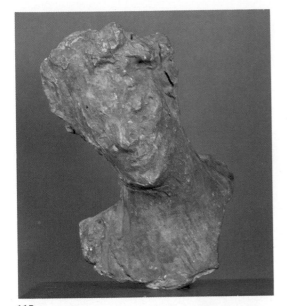

115

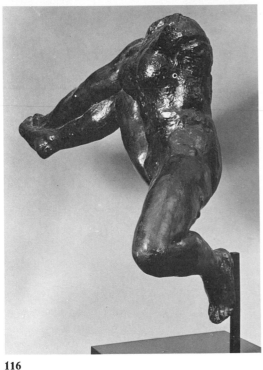

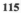

116

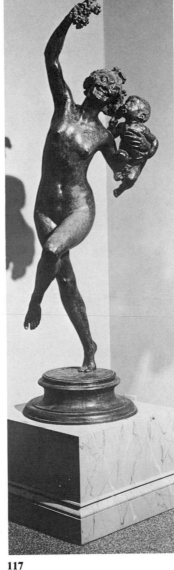

117

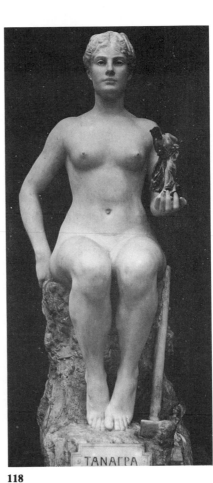

118

features but the distillation, as if remembered, of her visual and emotional essence.

Similarly, Rodin's *Iris, Messenger of the Gods* defies the weight of the human body and the gravity of bronze as it flouts the proprieties of human mores. The vigorously modeled figure of a woman with her legs wide apart surges with sensuous movement. It was Rodin who redirected the course of modern sculpture with his vast output, his understanding of tradition and innovation, his great craftsmanship in direct modeling, and, above all, his genius as an artist.

The nude female form appears in a much more traditional mode in the work of the American Frederick MacMonnies. His *Bacchante and Infant Faun* harks back to seventeenth-century Baroque sculpture. MacMonnies, in his youth a student of Saint-Gaudens, won major official commissions, such as his sculpture group for the Columbian Exposition (plate 26). Although some of the American public were scandalized by the nudity of his figures, MacMonnies continued to be a favorite of the dispensers of government patronage.

Even more typical of nineteenth-century academic sculpture is Jean-Léon Gérôme's marble statue of a nude sitting in a stiff, rigid pose. Named *Tanagra* after the lively Hellenistic terra-cotta figurines, it was carved by an artist who had enjoyed great fame and popularity since the 1850s for his academic history and genre painting and in his old age became noted also for his sculpture.

112 Aristide Maillol. *Kneeling Washerwoman*. c. 1893. Bronze, 8″ at base **113** Paul Gauguin. *Be in Love and You Will Be Happy* (*Soyez Amoureuses, Vous Serez Heureuses*). c. 1890. Painted wood relief, 38 $^1/_8$ × 28 $^3/_4$″ **114** Edgar Degas. *Woman Arranging Her Hair*. 1882–95. Bronze, height 18″ **115** Medardo Rosso. *Yvette Guilbert*. 1894. Terra-cotta (?), height 16 $^1/_4$″ **116** Auguste Rodin. *Iris, Messenger of the Gods*. 1890–91. Bronze, height 33″ **117** Frederick MacMonnies. *Bacchante and Infant Faun*. 1893. Bronze, height 83″ **118** Jean-Léon Gérôme. *Tanagra*. 1890. Tinted marble, with a gold card inscribed in gold, height 59 $^1/_2$″

Male Portraits and Figures

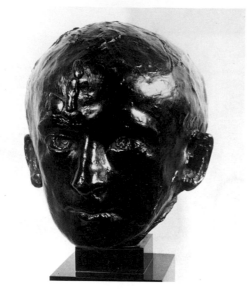

119

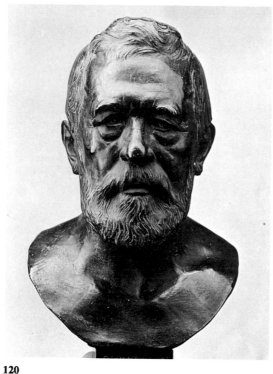

120

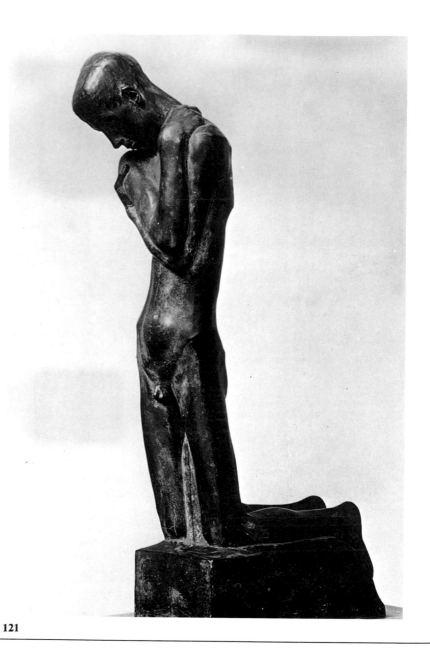

121

It is revealing to compare two portrait heads by contemporaneous sculptors: Rodin's *Head of Baudelaire*, done, like the full-length Balzac, many years after the writer's death, and Adolf von Hildebrand's *Portrait of Arnold Böcklin*. While a capable sculptor like Hildebrand knew how to deal with the bone and skin of the human head, Rodin has internalized his portrait bust yet, simultaneously, its surface has become almost liquid and we are aware of the material—bronze. It is an idealized interpretation of the poet who had been a profound in-

spiration for the sculptor, and this personal projection of the artist's emotion as well as his involvement in the nature of his material makes us see Rodin as an artist who belongs to the twentieth century.

George Minne, a Belgian sculptor who was very close to Art Nouveau designers and Symbolist poets, created his *Kneeling Youth* at the same time. Attenuated, austere, almost rigidly angular, it transforms the figure of an adolescent boy into a linear and evocative sculptural ornament. It is actually one of five

identical naked young boys, kneeling at the edge of a pool, that were cast for a fountain in the entrance hall of Van de Velde's Folkwang Museum in Hagen, Germany. Minne's fountain was an integral part of a unified decorative environment.

The Impressionist sculptor Medardo Rosso created small, ephemeral works in wax. Often he sculpted contemporary characters, like an elegant man in top hat at the horse races—by no means a traditional subject for a sculptor. Rosso's *The Bookmaker* may have helped Rodin

122

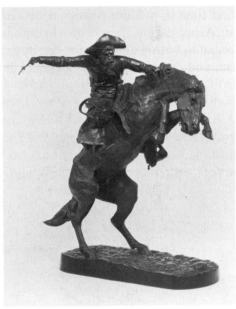

123

decide on the final stance of his Balzac; unlike Rodin, however, Rosso was almost totally neglected in his time. But a generation later the Italian Futurists recognized his great contribution to modern sculpture—his ability to relate sculpture to its environment and the surrounding atmosphere by the judicious use of the effects of light.

While sculptors like Minne and Rosso worked in a subtle and sophisticated manner at the end of the century, the American Frederic Remington went to the rough Western frontier as a cowpuncher and decided to record life in the vanishing West, including the Indian wars of 1890–91. Remington, largely self-taught and totally outside the mainstream of art, was greatly influenced by photography. His proficient, lifelike magazine illustrations, paintings, and sculptures, such as his spirited *The Bronco Buster*, have never lost their popular appeal.

119 Auguste Rodin. *Head of Baudelaire*. 1898. Bronze, height 9″ **120** Adolf von Hildebrand. *Portrait of Arnold Böcklin*. 1897. Bronze, height 17 3/4″ **121** George Minne. *Kneeling Youth*. 1898. Original plaster, height 31 3/8″ **122** Medardo Rosso. *The Bookmaker*. 1894. Wax over plaster, height 17 1/2″ **123** Frederic Remington. *The Bronco Buster*. 1895. Bronze, height 23″

Two: The 1900s

The International and Universal Exposition of 1900 in Paris can be seen as a great celebration of the bourgeoisie in a world at peace. The balance sheet of a glorious century of progress, it was the most extravagant display of the old order. The world of yesterday could also be witnessed in its full regalia in the European opera houses. In these exemplars of ostentation, the flamboyant scenery and costumes and the music were not permitted to interfere with the glory of the audience, which attended in order to be seen. The lights were never dimmed so that singers and orchestra would not interrupt the true presentation.

Industrialization in Europe continued to expand, with increasing colonization in Africa and Asia providing new markets as domestic markets became glutted. Except for the Boxer Rebellion in China, which was quickly crushed by combined European forces, and the Russo-Japanese War, which for the first time in modern history ended in the victory of an Asian nation, peace was maintained. This peace began to be threatened, however, by growing nationalism and demands for independence in areas ranging from Ireland to Bulgaria and from Norway to Albania. Thus the status quo of the British Empire, the Austro-Hungarian dual monarchy, and the Romanov and Ottoman empires was shaken. The United States, meanwhile, was able to continue its "dollar diplomacy" and succeeded in connecting the Atlantic and Pacific oceans by building a great canal in Panama, a new nation which had just separated itself from Colombia for this very purpose. America still seemed the land of golden opportunity, and during the first decade of the century eight million people immigrated to its shores, most succeeding in improving their lot despite the poor working conditions.

In most countries, it was a decade in which people still looked forward to a world in which industry and commerce, science and medicine, plus the application of social justice, could bring about a better life for all. The Fabian socialists in England continued to typify the progressive attitude in their faith that under proper guidance, reason and decency would ultimately triumph.

During the decade before World War One an unparalleled galaxy of geniuses came of age: Max Planck, Albert Einstein, Marie Curie, Sigmund Freud and Carl Gustav Jung, Henri Bergson and Benedetto Croce, Max Weber and Emile Durkheim, André Gide, Marcel Proust, Gertrude Stein, George Bernard Shaw, Thomas Mann, and Rainer Maria Rilke, Igor Stravinsky and Arnold Schoenberg, Gabriele d'Annunzio and Filippo Marinetti, Isadora Duncan and Sergei Diaghilev, Antoni Gaudí and Frank Lloyd Wright, Constantin Brancusi, Henri Matisse, Pablo Picasso, and Georges Braque, Oskar Kokoschka and Egon Schiele, Emil Nolde and Ernst

Ludwig Kirchner. It was a decade which changed minds and hearts, revolutionizing mankind's view of the world. In 1913 the French writer Charles Péguy, who typically for the age combined republican socialism, militant patriotism, and a new adherence to Catholicism, would say that "the world has changed less since Jesus Christ than it has in the last thirty years."

In 1900 Planck formulated the quantum theory, postulating the discontinuous exchange of energy. In 1905 Einstein's special theory of relativity proposed the continuum of space and time. The classical concepts of matter and energy, the optimistic and mechanistic view that man could eventually comprehend an ordered universe designed by the Divine Architect were shattered scientifically as Nietzsche had earlier demolished them philosophically. A new and relativistic concept of the universe began to be established, which Niels Bohr was later to characterize as a world in which "we are both spectators and actors in a great drama of existence." Mechanistic and positivistic views broke down in all areas. Using the language of rational logic, Bergson proclaimed the *élan vital* the all-pervading vital impulse and explored intuitive creation as well as religious mysticism. Freud, employing a positivistic as well as a medical vocabulary, searched the unconscious to uncover man's basic drives, while Jung, his leading disciple and eventual antagonist, began his investigation of myth, religion, the realm of the irrational, and the nature of primordial images. As the old certainties dissolved, the void they left was filled by concern with relativity, ambiguity, and mutability in every aspect of intellectual and artistic endeavor. Simultaneously the old rules of morality continued to be fractured. Although even the right to vote was still denied to women, feminists began attacking the widely held belief in the manifest superiority of men.

In the political sphere, the power of the aristocracy waned while that of a new and a more democratic middle class burgeoned. In their novels Thomas Mann and John Galsworthy described the breakdown of the old patrician order. Painters in Paris and Dresden discovered the great aesthetic value of the art of primitive cultures, thus beginning the erosion of the arrogant belief that European culture was vastly superior to that of all other peoples.

Gradually the realization spread that structures established by man were by no means definite, perfect—or even perfectable. A new sense of reality—subjective and relative reality—appeared in all areas. A new sense of structure, based on inner conviction and the recognition of a new vision of the world, began to emerge.

Political Events	The Humanities and Sciences	Architecture, Painting, Sculpture
1900 Boxer Rebellion in China King Victor Emmanuel III succeeds to the Italian throne after the assassination of his father by an anarchist	Max Planck formulates the quantum theory Count Zeppelin builds the dirigible Henri Bergson, *Laughter* Sigmund Freud, *The Interpretation of Dreams* Theodore Dreiser, *Sister Carrie* Gustav Mahler, *Symphony No. 4* Frank Baum, *The Wonderful Wizard of Oz*	Paris: International and Universal Exposition Crete: Arthur Evans excavates and discovers Minoan culture London: Wallace Collection opens Paris: Large exhibitions of Odilon Redon and Georges Seurat
1901 Death of Queen Victoria; Edward VII succeeds to the English throne Assassination of U.S. President William McKinley; Theodore Roosevelt succeeds him	Guglielmo Marconi transmits signals by wireless telegraph from England to Newfoundland First Nobel prizes awarded Ivan Pavlov studies conditioned reflexes Thomas Mann, *Buddenbrooks* Anton Chekhov, *The Three Sisters*	Frank Lloyd Wright, *The Art and Craft of the Machine* Paris: Major Vincent van Gogh retrospective exhibition Paris: First Pablo Picasso exhibition Henry van de Velde named to head the Weimar Academy of Arts and Crafts, forerunner of the Bauhaus
1902 U.S. assumes control of the Panama Canal British victory ends the Boer War in South Africa	Henry James, *The Wings of the Dove* Maxim Gorky, *The Lower Depths* William James, *The Varieties of Religious Experience*	New York: Alfred Stieglitz founds Photo-Secession
1903 Panama declares independence from Colombia London: Bolshevik Party founded, led by Vladimir Ilyich Lenin	U.S.: First full-length (eleven minutes) commercial motion picture, *The Great Train Robbery*, released Henry James, *The Ambassadors* Kitty Hawk, North Carolina: Orville and Wilbur Wright successfully fly the first self-propelled aircraft G. E. Moore, *Principia Ethica* George Bernard Shaw, *Man and Superman*	Paris: Paul Gauguin retrospective at the first Salon d'Automne Vienna: Retrospective exhibition of Gustav Klimt
1904 Outbreak of the Russo-Japanese War Entente Cordiale established between France and England	Sigmund Freud, *The Psychopathology of Everyday Life* Romain Rolland, *Jean-Christophe* (–1912) Anton Chekhov, *The Cherry Orchard* Max Weber, *The Protestant Ethic and the Spirit of Capitalism*	St. Louis, Missouri: World Exhibition Paris: Major exhibition of Paul Cézanne, Salon d'Automne Paris: Georges Rouault exhibition

Political Events	The Humanities and Sciences	Architecture, Painting, Sculpture
1905 Russo-Japanese War ends with the defeat of the Russians First wave of socialist revolution in Russia; first workers' society meets in St. Petersburg	Albert Einstein formulates the special theory of relativity Rainer Maria Rilke, *Poems from the Book of Hours* Christian Morgenstern, *Gallows Songs* Claude Debussy, *La Mer* Richard Strauss, *Salome* Oscar Wilde, *De Profundis* George Santayana, *The Life of Reason* George Bernard Shaw, *Major Barbara*	New York: Alfred Stieglitz's gallery opens at 291 Fifth Avenue Paris: Louis Vauxcelles applies the term *"les fauves"* to a group of French artists led by Henri Matisse Dresden: Bridge group formed Paris: Major Vincent van Gogh and Georges Seurat exhibitions at the Salon des Indépendants
1906 Algeciras conference on Morocco averts war among the European powers	Upton Sinclair, *The Jungle*	Pablo Picasso meets Henri Matisse Paris: Large Matisse exhibition Prague: Large František Kupka exhibition San Francisco earthquake is followed by extensive rebuilding
1907 Financial crisis in the United States, Japan, and Germany Anglo-Russian entente established	Henri Bergson, *Creative Evolution* William James, *Pragmatism* Rainer Maria Rilke, *New Poems* Maxim Gorky, *Mother* First *Ziegfeld Follies*	Moscow: Blue Rose exhibition Wilhelm Worringer, *Abstraction and Empathy* Formation of the Deutsche Werkbund Paris: Major Paul Cézanne retrospective exhibition
1908 Young Turk revolution foreshadows the end of the Ottoman Empire Union of South Africa founded	Henry Ford mass produces the Model T motorcar Ezra Pound, *A Lume Spento* Anatole France, *Penguin Island* Karl Liebknecht, *Militarism and Antimilitarism* Gustav Mahler, *Das Lied von der Erde* Richard Strauss, *Elektra*	Henri Matisse, *Notes of a Painter* New York: Formation of the Eight
1909 Vladimir Ilyich Lenin, *Materialism and Empirico-Criticism* William Howard Taft becomes U.S. president	Gertrude Stein, *Three Lives* Louis Blériot crosses the English Channel by monoplane Admiral Robert E. Peary reaches the North Pole Gustav Mahler, *Symphony No. 9* Sergei Diaghilev presents the first Ballets Russes, Paris Anton von Webern, *Five Movements for String Quartet* Charles Pathé produces the first newsreel Paul Ehrlich successfully treats syphilis with Salvarsan	Filippo Tommaso Marinetti, *Founding and Manifesto of Futurism* Munich: Neue Künstlervereinigung formed by Vasily Kandinsky, Alexei Jawlensky, and others

Department Stores and Banks

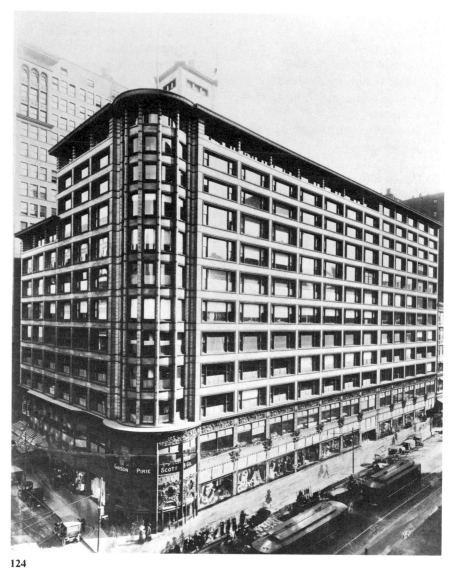

124

125

126

Louis Sullivan's career as an architect of major commercial buildings largely ended with his masterpiece, the Carson Pirie Scott Department Store in Chicago. Unlike his earlier Wainwright Building (plates 3 and 4), Sullivan's emphasis was on the horizontal in this vast store; he recessed wide plate-glass windows between continuous ribbons of white terracotta which cover, yet express, the attenuated steel frame construction as a light surface grid. The top-floor wall is pulled back, allowing the vertical steel supports to emerge from the building's skin as free-standing columns which support the cornice-like roof slab. Austere and functional as the building appears from a distance, it is masterfully related to the street and to the human scale by Sullivan's luxuriant foliate ornament, which covers the first two floors and defines the base of the building.

Like Sullivan's Chicago store, Frantz Jourdain's main branch of the Samaritaine Department Store chain in Paris frankly displays the metal grid of its framework, allowing large expanses of plate glass for display and lighting. Unlike Sullivan, however, Jourdain did not contain his exuberant Art Nouveau decoration; lush metallic tendrils shoot from the structural steel and all flat surfaces are covered with a flowery

127

128

polychrome mosaic. In Sullivan's store the structure has become supreme; in Jourdain's decoration dominates.

In his Vienna Postal Savings Bank of 1904–6 Otto Wagner rejected the Art Nouveau tendencies displayed in his Stadtbahn stations of the previous decade (plate 22) and designed a building in which structure and materials were themselves the sole ornament. The central hall, with its bowed nave and side aisles roofed with a translucent membrane of glass supported by thin aluminum columns, has a spidery, weightless elegance. Flooded with light, it is the commercial culmination of the possibilities suggested by Joseph Paxton's Crystal Palace of 1851 and points to later architectural developments.

124–126 Louis Sullivan. Carson Pirie Scott Department Store, Chicago. 1899–1904 **125** Main entrance **126** Main entrance (detail) **127** Frantz Jourdain. Samaritaine Department Store, Paris. 1905 **128** Otto Wagner. Postal Savings Bank, Vienna. 1904–6

129

In 1897 Hendrik Petrus Berlage won the competition for the new Amsterdam Stock Exchange, built from 1898 to 1903. Though pared to a minimum of ornament and superbly articulated, his brick-and-stone exterior suggests the architecture of the Dutch Middle Ages. Like major railway stations of the nineteenth century, however, the exterior conceals a vast hall, vaulted with iron and glazed. Segmentally arched galleries, cut into thick masonry walls like those in forts and prisons, surround the hall and contrast with the airy vault overhead. Berlage's Expressionistic regionalism exercised considerable influence on the next generation of Dutch architects.

Auguste Perret's garage on the rue de Ponthieu in Paris is a radical exposition in the new building material of reinforced concrete. Though built at the same time as Jourdain's Samaritaine, it goes far beyond that building with a facade made almost entirely of glass set in a severe and minimal framework of exposed concrete members. Eschewing virtually all applied ornament, it makes only the most abstract references to the past, suggesting almost subliminally the geometric clarity of a classical

130

131

132

133

134

facade framing a stylized rose window.

In 1907 Joseph Maria Olbrich, who had been a student of Wagner's, built the Wedding Tower next to the exhibition hall at the artists' colony in Darmstadt. The brick tower, like Berlage's Stock Exchange, recalls local medieval buildings while the five-fingered crest (a stylized hand symbolizing the marriage of the group's patron) suggests Olbrich's debt to Viennese Art Nouveau. Unlike Olbrich's exhibition hall for the Secession (plate 23), however, the tower's shaft has been stripped of heavy molding, reducing it to a space of cubic simplicity. It is most notable for the narrow, asymmetrical bands of windows which turn the corner, a device widely used later in the International Style.

129–131 Hendrik Petrus Berlage. Stock Exchange, Amsterdam. 1898–1903
132–133 Auguste Perret. Garage. Rue de Ponthieu, Paris. 1905–6 132 Front view 133 Rear view 134 Joseph Maria Olbrich. Wedding Tower, Darmstadt. 1907

Industrial Buildings

135

136

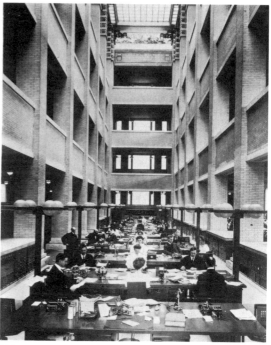

137

The functions of the great urban railroad termini were growing ever more complex. Yet their architecture suggested a costume ball; Roman baths, turreted castles, Baroque palaces, and Spanish missions concealed vaulted train sheds and vast switch-yards.

Eliel Saarinen's competition-winning design for the Central Station in Helsinki offered a fresh approach to the old problem of raising the industrial idiom to monumental scale and dignity. Only the heroic arch of the main entrance of the terminal, echoing the barrel-vaulted hall within, suggests a Roman basilica. Otherwise, the building is strikingly ahis-

torical, a superbly balanced composition of rhythmic verticals united by a long gambrel roof.

The great American individualist Frank Lloyd Wright scorned the European architectural tradition and sought inspiration in such unlikely sources as the grain silos of the American Midwest. Wright, previously a domestic architect, established a new standard of monumentality in his Larkin Building with its spare symmetry, unadorned wall surfaces, and blocky massing. He avoided the usual compartmentalization of offices by having them face onto a delightful five-story atrium. With his characteristic autocratic thoroughness,

Wright designed the novel metal office furniture and light fixtures as well, giving the Larkin Building a rare cohesiveness that marked it as one of the masterpieces of modern design and made its destruction in 1950 the more tragic.

Peter Behrens sought architectonic forms appropriate to the new technology of a rapidly industrializing Germany. With the AEG (German General Electric) Turbine Factory in Berlin, he created an image worthy of the great machines manufactured within. Sloping corner pylons of brick incised with horizontal striations support a massive gambrel roof running the length of the building,

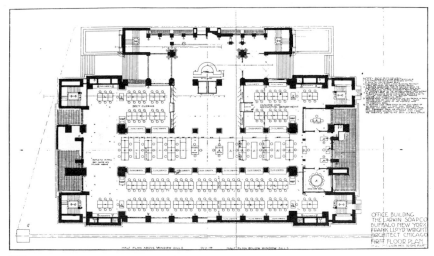

138

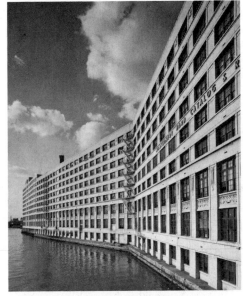

140

139

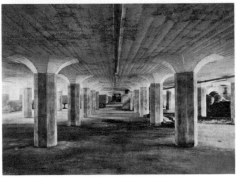

141

while enormous walls of glass admit light at regular intervals. At once elegant, urbane, and functional, Behrens's factory is a modern industrial cathedral.

Concentration of capital and services in large cities demanded structures of unprecedented size. The pioneering use of reinforced concrete on a staggering scale is represented in the Montgomery Ward Warehouse, designed by Richard E. Schmidt, Hugh M. G. Garden, and Edgar D. Martin. The structure resembles the great mills and warehouses of the nineteenth century in its lack of architectural frills and its functional design of a repetitive grid enclosing myriads of windows.

The Swiss engineer Robert Maillart spent the first decade of the century experimenting with the potential of reinforced concrete. In 1908 he designed a warehouse in Zurich whose roof was a simple concrete slab supported by a minimum of widely spaced octagonal columns. These took the weight of the roof on flaring capitals of prestressed concrete which contained a spreading network of steel rods. The resulting "mushroom-slab" construction produced a nearly unobstructed space, which was also uncommonly elegant.

135 Eliel Saarinen. Design for the Central Station, Helsinki. 1904–14 **136–138** Frank Lloyd Wright. Larkin Building, Buffalo. 1904 **138** Plan of the first floor **139** Peter Behrens. AEG Turbine Factory, Berlin. 1908–9 **140** Schmidt, Garden, and Martin. Montgomery Ward Warehouse, Chicago. 1906–8 **141** Robert Maillart. Warehouse, Zurich. 1908

School Buildings

142

The use of industrial materials to create multistoried, light-filled interiors was pioneered in Paris department stores and in Henri Labrouste's Paris libraries in the latter half of the nineteenth century. Labrouste's Reading Room for the Bibliothèque Nationale inspired the fine Beaux-Arts architect John Galen Howard to create a remarkable vestibule for the Hearst Mining Building at the University of California at Berkeley. The heavy segmental arches were meant to suggest mines which open onto an ethereal space of light,

undisguised structural steel. The thinnest columns elegantly support the pendentives, which carry three glazed domes.

Progressive educators at the turn of the century advocated close contact with nature and a homelike atmosphere as the best climate for the moral, physical, and intellectual development of young children. "Open-air schoolhouses" first appeared in intellectual communities and were rapidly adopted, to a greater or lesser degree, by public school systems. Frank Lloyd Wright's Hillside Home

School of 1902 demonstrates the young architect's superb command of materials and scale. Two end pavilions are tied together by a lower passageway and covered with low, hipped roofs, creating a domestic rather than an institutional ambience. With its base of rough masonry capped with horizontal bands of stone, its uprights of natural wood suggesting tree trunks, and a multitude of casement windows, the building is intimately related to its natural setting.

In 1907–8, Charles Rennie Mack-

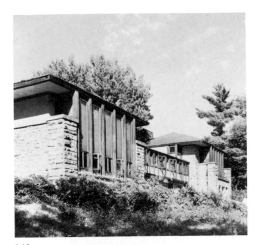

143

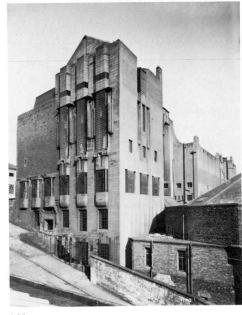

144

145

intosh added a north wing to his earlier School of Art in Glasgow. The verticality of the addition, emphasizing the steep gradient of the site, is achieved by three narrow bay windows extending almost the height of the building and giving it the attenuated grace of Mackintosh's Art Nouveau designs, translated here into a severe and abstract architectonic form. The vertical linearity is further stressed in the library's interior, where an elaborate exposed wooden framework, hanging lamps, and tall, thin furniture all serve to articulate the space. Rectilinear Art Nouveau marked the end of the movement in Europe. It carried the style to its most sophisticated refinement—most notably in Glasgow and Vienna, two cities on the periphery.

142 John Galen Howard. Hearst Mining Building, University of California, Berkeley. 1902 143 Frank Lloyd Wright. Hillside Home School, Spring Green, Wis. 1902 144–145 Charles Rennie Mackintosh. Glasgow School of Art, Library Wing. 1907–8

Churches

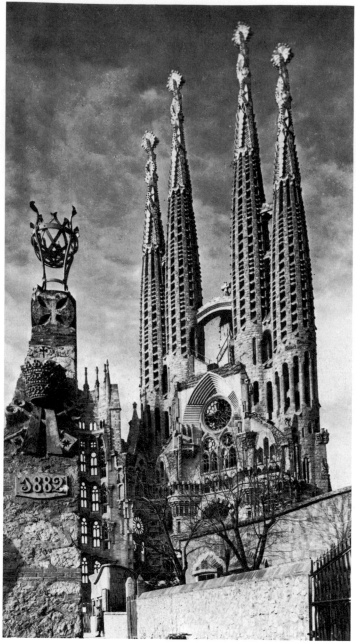

146

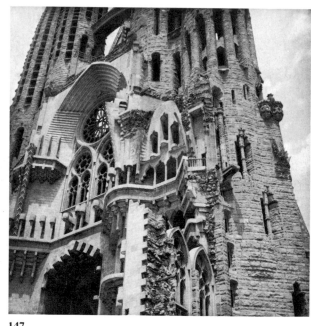

147

Far also from the Continental centers of Art Nouveau but developing a highly personal style, Antoni Gaudí devoted much of his life to the construction of the Church of the Sagrada Familia in Barcelona. Though little more than the end of one transept was built before his death in 1926, Gaudí's church is one of the most extraordinary ecclesiastical monuments of our century, an organic and ever-evolving creation of stone and mosaic. The facade swarms with a wealth of natural and abstract detail, sprouting four astonishing towers resembling asparagus stalks which flower, at their summits, with brilliant polychrome finials. Unlike the numerous Neo-Gothic cathedrals built at the same time, academically correct but entirely lacking the conviction of their prototypes, Gaudí's building remarkably maintained the animating spirit of the earlier churches. This unique architectural creation, even now under continuing construction and totally out of the mainstream of modern machine-inspired architecture, has been an important resource for more recent architectural and sculptural thinking.

Far more influential in the early part of the century, however, was Frank Lloyd Wright's Unity Temple in Oak Park, Illinois. For this small building Wright rejected the usual Gothic references and designed an entirely new ecclesiastical form—squat, symmetrical, and blocky, like the Larkin Building of two years earlier. The exterior shows a daring

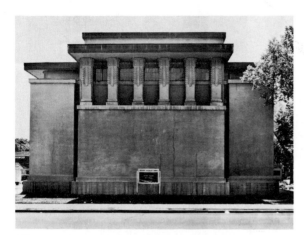

148

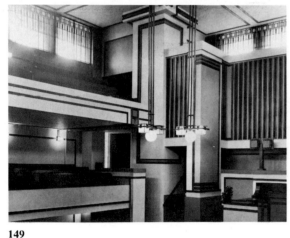

149

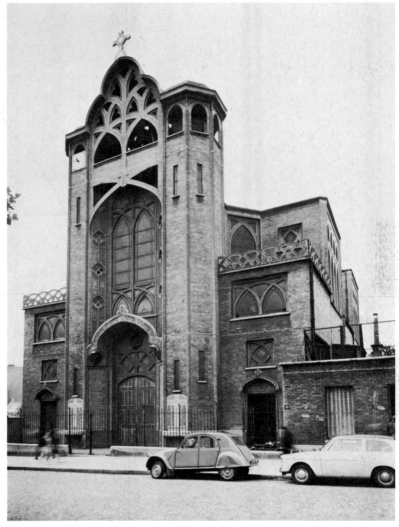

150

use of exposed concrete aggregate, the ornament being an integral part of the structure and the heavy roof slabs and wall bases and caps masterfully tying the composition together. Inside, linear and geometric ornament is used to articulate the open space, brightly lit from high clerestory windows. Throughout, the appropriately named Unity Temple is a superb exercise in the cohesive manipulation of geometric forms and volumes.

In Paris, Anatole de Baudot's Church of Saint-Jean-de-Montmartre represents a pioneering effort in the new medium of reinforced concrete. The vaguely Gothic tracery is actually composed of concrete ribs, drawn to a metallic thinness and so novel for its time that officials obstructed building progress for several years until its structural strength could be proved.

146–147 Antoni Gaudí. Church of the Sagrada Familia, Barcelona. 1889–1926
147 Detail 148–149 Frank Lloyd Wright. Unity Temple, Oak Park, Ill. 1906
150 Anatole de Baudot. Church of Saint-Jean-de-Montmartre, Paris. 1897–1904

Apartment Buildings

151

153

152

154

Baudot's experiment in church building was paralleled and bettered in 1902–3 by Auguste Perret's Paris apartment house at 25 bis rue Franklin, which was also built of reinforced concrete. Unlike Baudot's vaguely Gothic creation, Perret's apartment is a straightforward framework of rectilinear members (albeit still sheathed in stylish Art Nouveau ceramic tiles). An interplay of surface planes, receding and advancing around a central court and stepped back for two additional stories on the roof, creates a subtle and complex architectonic sculpture. The new material, like a metal frame, made possible large expanses of glass windows, of great importance on narrow city lots.

If Perret was part of the dominant course of the modern movement, Gaudí pursued his personal idiom in his Barcelona apartment houses. In the Casa Batlló he used ovoid windows, wavy mullions, and bony columns. The upper walls were embellished with glittering colored glass insets and a reptilian roof of glazed tile arched to meet a tower with a garlic bulb. Even more eccentric is the Casa Milá apartment complex, known in Barcelona as "the quarry," since its restless, molded facade is constructed of roughly cut stone. Metal balconies resembling seaweed cling to a building which recalls the waves surging onto the Catalonian coast. The swirling chimney pots on the roof can also be seen as early examples of abstract organic sculpture. The building is organized around two kidney-shaped courtyards, and its floor plan, almost wholly rejecting right angles, is cellular in appearance. Gaudí, of all

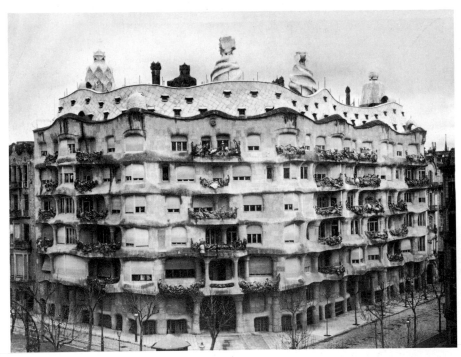

155

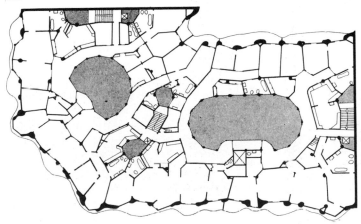

156

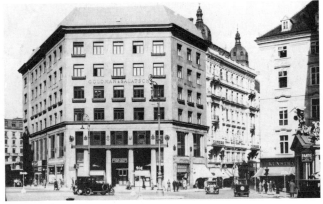

157

modern architects, came closest to creating a living architecture in the most literal sense of the word.

In Vienna, the increasingly spare aesthetics of Wagner were carried further by his pupil Adolf Loos, who combined his teacher's superb sense of geometric form with his own puritan aesthetics, confirmed by a visit to America in the 1890s. His highly influential essay "Ornament Is Crime," published in 1908, attacked Art Nouveau and Secession style ornament and its calculated emotional impact. Though Loos's

rich interiors sometimes belie his rebellious dogma, the apartment house at 5 Michaelerplatz in Vienna offers a stark demonstration of his belief. While relying on sparse classical detailing to articulate the first two floors, he left the top four stories almost wholly unadorned, with the windows crisply cut into the flat wall and set at perfectly regular intervals. Loos's purity of design stands in complete contrast to Gaudí's contemporaneous organic form.

151 Auguste Perret. Apartment House, 25 bis rue Franklin, Paris. 1902–3 152–154 Antoni Gaudí. Casa Batlló, Barcelona. 1907 152 Front facade 153 Rear facade 154 Roof (detail) 155–156 Antoni Gaudí. Casa Milá, Barcelona. 1905–10 156 Floor plan 157 Adolf Loos. Apartment House, 5 Michaelerplatz, Vienna. 1910

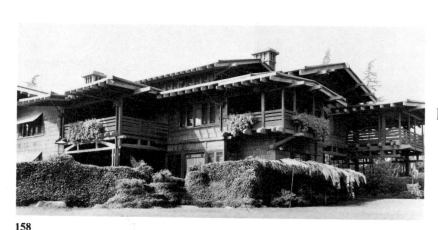

158

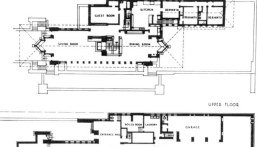

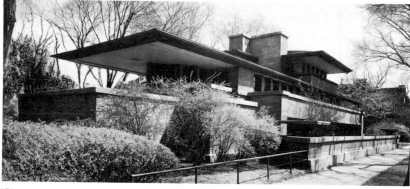

159

160

161

In America and Britain, where the tradition of the detached house is far stronger than on the Continent, domestic architecture developed particularly strongly at the turn of the century. In southern California, William Morris's ideals of craftsmanlike honesty of materials and construction fused with the American stick and shingle styles and the discovery of Japanese architecture in the remarkable wooden "bungalows" of Charles and Henry Greene. The Gamble House in Pasadena demonstrates their highly personal style in the free use of balconies, stickwork trellises and brackets, and overhanging eaves. Impressive as this remarkable response to

a mild Mediterranean climate is, Greene and Greene's houses were luxury items, cabinetwork expanded to architecture, a style doomed by the inflation caused by World War One.

Of far greater significance is Frank Lloyd Wright's Robie House in Chicago, the classic example of his early Prairie House style. Emphatically horizontal, Wright's house also projects into space via dramatically cantilevered roofs which shelter the house symbolically and relate it to the flat horizons of the Midwest. The house is further tied to the earth by the squat vertical of the chimney, which Wright likened to a taproot and from which all

the horizontal planes project. Wright, like Gaudí, sought an "organic" architecture, though he employed a far stricter, more abstract geometry than did his Catalonian contemporary. His development of the open plan in his Prairie Houses was to exercise enormous influence on future generations of American and European architects. In the Robie House, Wright finally achieved a distinctly American style of domestic architecture with no precedents in the Old World.

Adolf Loos carried his purist aesthetics to an extreme in the Steiner House in Vienna, completed in 1910. The garden facade consists of a severe, symmetrical massing of cubic

162

164

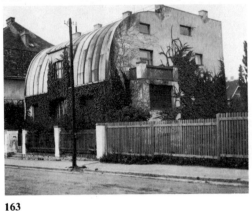

163

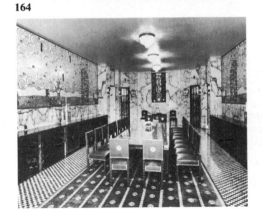

165

166

forms wholly stripped of ornament. In its flat roof and wide and unbroken windows it is prophetic of the International Style. The sense of articulated structure finds unconscious parallels in the analytic paintings of Picasso and Braque, dating from the same time.

Loos's Viennese contemporary Josef Hoffmann built a large residence in Brussels which is also distinguished by geometric form. But the Palais Stoclet achieved the artistic totality and unified harmony of design which was the goal of Art Nouveau and anathema to Loos. Crafted of sumptuous marbles, woods, and metals, it is a genuinely modern palace. On the exterior, large marble

surfaces are framed by rich moldings of gilded bronze, creating a decorative flatness which makes it one of the masterpieces of Art Nouveau's second, rectilinear phase. Hoffmann integrated the work of Gustav Klimt in an elaborate mosaic mural in the dining room, as well as his own furniture, into a total design of restrained but voluptuous beauty. Yet the Palais Stoclet, in style and purpose, belonged to the previous decade, delighting in sensuous luxury rather than creating a new sense of structure as did the houses of Loos and Wright.

158 Greene and Greene. Gamble House, Pasadena, Calif. 1908–9 159–161 Frank Lloyd Wright. Robie House, Chicago. 1909 160 Ground plan 161 Dining room 162–163 Adolf Loos. Steiner House, Vienna. 1910 163 Rear view 164–166 Josef Hoffmann. Palais Stoclet, Brussels 164 Front view 165 Dining room 166 Rear view

Male Figures

167

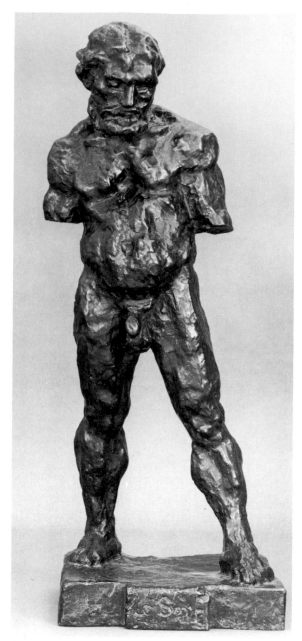

168

In 1905 Auguste Rodin enlarged his much earlier nude figure of *The Walking Man* to more than life-size and had it cast in bronze. Eliminating head and arms, the master has left us an eloquent, potent image of man striding with mighty step across the earth. Seeing the human body as a "temple that marches," Rodin, although he always sought for classical perfection, reduced the human figure to a purposeful frag-ment and elevated it to an almost abstract form, freed from convention.

Rodin's impact was so dominating that when confronted with his work, younger sculptors could only continue in his direction or revolt against it. Henri Matisse, who often found it necessary to turn to modeling in order to gain a fuller grasp of three-dimensional form and volume, created *The Serf,* a torso certainly indebted to Rodin's work. Again, facial and gestural rhetoric are relinquished in favor of a vigorous sculptural stance enhanced by the agitation of the corrugated surface. But in contrast to Rodin's striding figure, Matisse chose a fixed, a more static and permanent pose. Although he worked on this piece for some three years, he was able to sustain the sensation of intuitive directness.

Emile-Antoine Bourdelle, one of

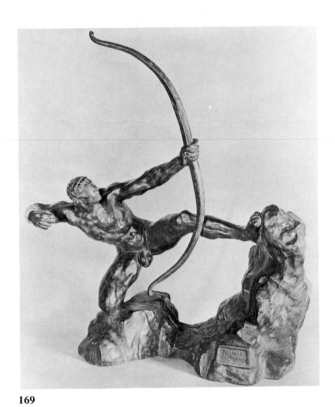

169

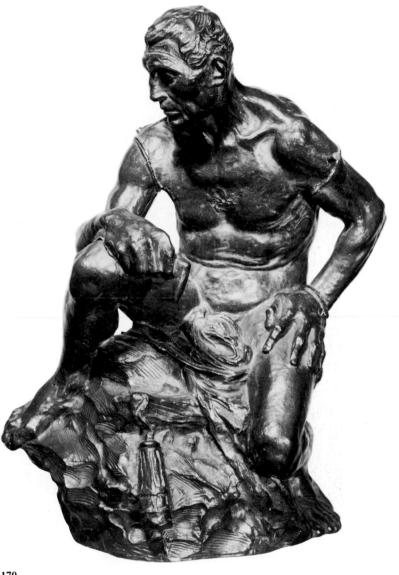

170

Rodin's chief assistants in the nineties, endeavored to attain a monumental style by means of careful organization of masses and volumes, positive and negative space. In his famous *Hercules the Archer* the vigor of the theme is controlled by severe structural organization.

An even greater clarity of form is achieved by the Belgian Constantin Meunier in his *Large Miner*. Meunier, like his contemporary Van Gogh, lived for some time in the poverty-stricken Borinage of Belgium and was deeply concerned with the realities of life of the urban and rural proletariat. His simple and heroic sculptures of laborers, lending a sense of idealized dignity to the working class, created an idiom for the subject which was to become an important model for Socialist Realist sculpture in a later era.

167 Auguste Rodin. *The Walking Man.* 1905. Bronze, height 83 $^3/_4''$ **168** Henri Matisse. *The Serf*. 1900–3. Bronze, height 36″ **169** Emile-Antoine Bourdelle. *Hercules the Archer*. 1909. Bronze, height 14 $^3/_4''$ **170** Constantin Meunier. *The Large Miner.* 1900. Bronze, height 21 $^1/_4''$

The Female Figure: The Nude

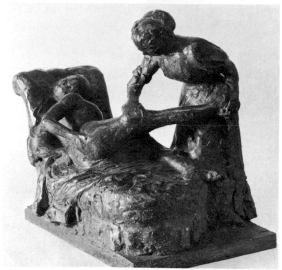

171

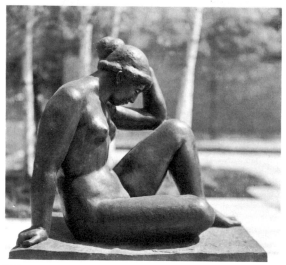

172

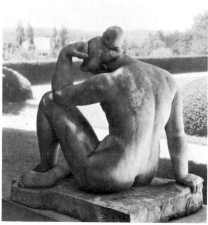

173

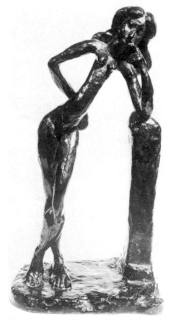

174

Edgar Degas considered his clay sculptures private studies and they were cast only posthumously. In these works the artist allowed himself a great freedom of construction and experimentation in order to focus on gestural movement. He concentrated boldly on the reality of the moment and the immediate event. In *The Masseuse* he chose a most unexpected theme and emphasized the vivid and transitory interaction of two female bodies.

Whereas both Degas and Rodin had been involved in the rendition of movement, Aristide Maillol, belonging to the next generation, established silence, repose, and a new purity of form. Concerned solely with the beauty of the human form and its ideal proportion, he achieved grandeur and stability in his masterpiece, *The Mediterranean,* a modern sculpture of classical restraint and perfect balance.

At the end of the decade Matisse, in *La Serpentine,* reconstructed human anatomy into a body that seems to consist primarily of line. Retaining a rather conventional pose of a nude figure leaning on a pole (the photograph of the model indicates how conventional Matisse's source was), the artist has incorporated this pole into a continuous linear arrangement. He has broken up mass and stretched the elongated figure around the open volume of spaces. In this work, which is contemporaneous with *The Dance* (see plate 229), flesh and bone give way to mass converted into linear rhythms of energy.

Constantin Brancusi's *The Prayer,* in great contrast to Matisse's sculp-

176

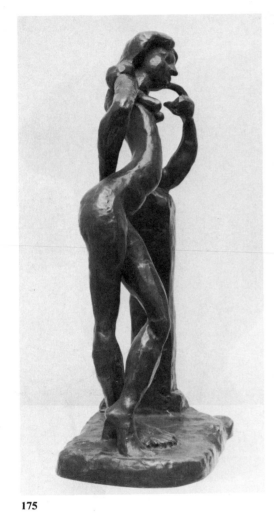

175

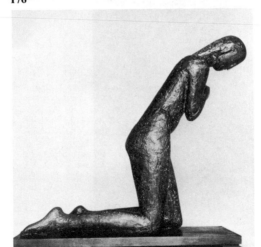

177

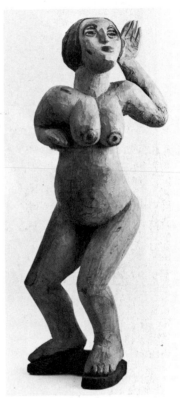

178

ture, is contained, almost ascetic. Creating a work to mark the grave of a Romanian friend, Brancusi modeled a figure of serene gravity. This elongated kneeling woman marks the beginning of Brancusi's lifelong search for idealization, simplification, and abstraction—his search for the essence of sculptural form, which he was to pierce to its core.

While Brancusi worked toward an art which would be unencumbered and lead toward a primal archaic form beyond unnecessary complexities, Ernst Ludwig Kirchner in his

Standing Nude of the same time was much more directly influenced by "primitive" art. This highly expressive polychromed wood carving repeats some of the geometric stylizations of Cameroon figures with their pronounced swells of breast and buttock. Kirchner, who saw these works in the ethnographical museum in Dresden, was one of the first artists to realize their great aesthetic force and regarded them, as he explained, as parallel to his own endeavors.

171 Edgar Degas. *The Masseuse*. 1896–1911. Bronze, height 16 $^{1}/_{4}$″
172–173 Aristide Maillol. *The Mediterranean* (*Méditerranée*). 1902–5. Bronze, height 41″ **174–175** Henri Matisse. *La Serpentine*. 1909. Bronze, height 22 $^{1}/_{4}$″ **176** Photograph of the model for *La Serpentine* **177** Constantin Brancusi. *The Prayer*. 1907. Bronze, height 43 $^{7}/_{8}$″ **178** Ernst Ludwig Kirchner. *Standing Nude* (*Dancing Woman*). 1908–12. Yellow painted wood, height 35 $^{1}/_{2}$″

The Female Figure: Loïe Fuller

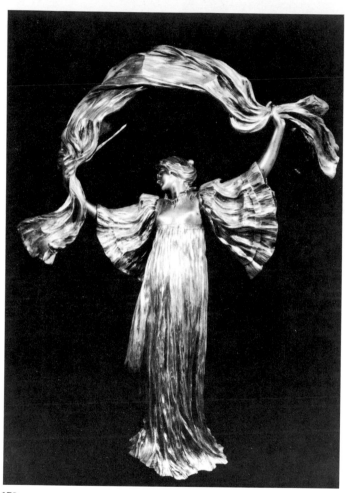

179

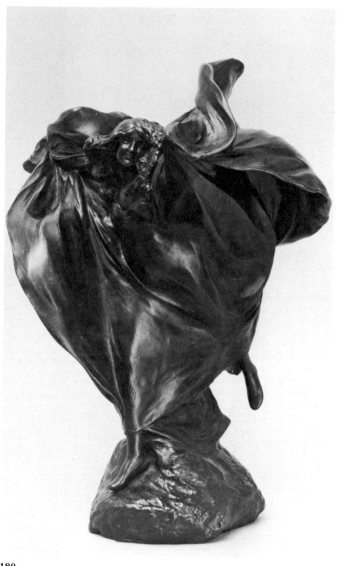

180

The female figure who typified the love for the arabesque and sinuous movement during the early part of the decade was the American dancer Loïe Fuller. She probably owed her phenomenal success on the Continent during the nineties and continuing into the new century to the fact that in her performances the dance no longer seemed a physical act but the actualization of free-flowing design. La Fuller would appear in long iridescent veils and swing them into billowing forms, while multicolored light played on her serpentine movements; at the proper moment perfume would be sprayed into the audience. Her dance, greatly admired by Mallarmé and other Symbolists, was a true *Gesamtkunstwerk*, an experience affecting all the senses at one time.

Fuller was an embodiment of the new taste for the dance, as well as for the evanescent and ephemeral.

Nobody expressed the essence of her movement better than Toulouse-Lautrec in the painting he did of her in 1893 (plate 35). This was followed after the turn of the century by the works of minor French sculptors such as Agathon Léonard, who

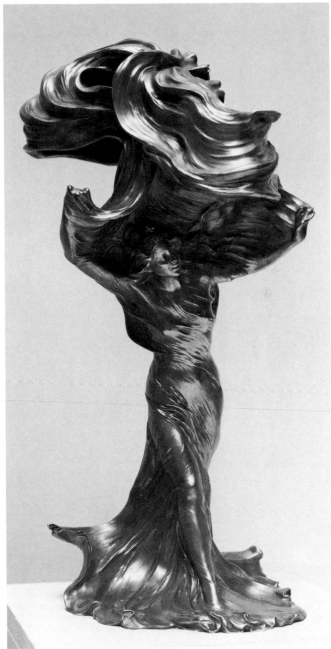

181

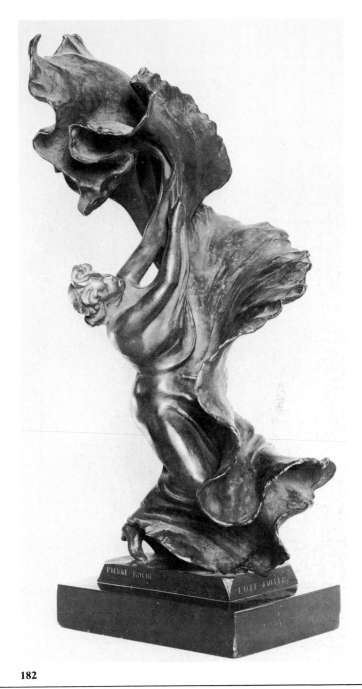

182

portrays the dancer in an elegant pose, swinging her scarf above her head.

In Théodore L.-A. Rivière's small bronze we see only the dancer's head and feet, while her body is engulfed in the billowing gown. Raoul-François Larche's statuette of gilt bronze is actually fitted with a socket for a small electric light bulb, well concealed in the undulating scarf, which casts a mysterious sheen on the figure.

In Pierre Roche's bronze the skirt has become an almost totally abstract Art Nouveau ornament enveloping the wraithlike dancer. It was Pierre Roche who also designed a special theater for Fuller in Paris about 1900, a small building in which the entrance wall resembled the veils of the dancer.

179 Agathon Léonard. *Loïe Fuller*. c. 1900. Bronze, height 23 $^1/_2''$
180 Théodore L.-A. Rivière. *Loïe Fuller*. c. 1900. Bronze, height 11'' 181 Raoul-François Larche. *Loïe Fuller, the Dancer*. c. 1900. Bronze, height 18 $^1/_8''$ 182 Pierre Roche. *Loïe Fuller Dancing*. c. 1904. Bronze, height 21 $^1/_2''$

Composers

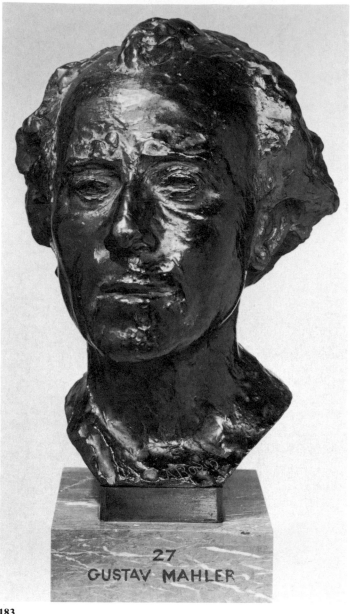

183

GUSTAV MAHLER

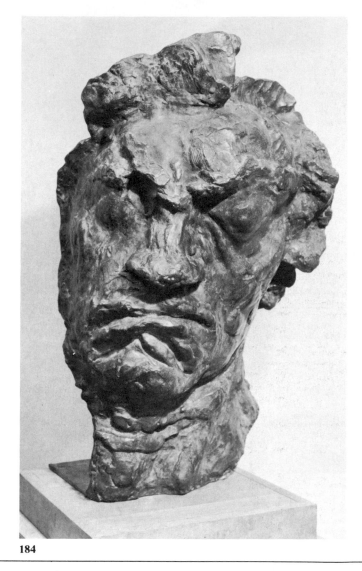

184

Music as well as the dance captivated the minds of artists and public alike. Early in the nineteenth century Arthur Schopenhauer saw in music the highest form of art, the expression of the will itself, and Symbolist artists at the end of the century strove toward the condition of music, a nonnarrative art which could affect the senses directly. Composers became perhaps the most admired creators among all artists, and when Rodin made his bust of Gustav Mahler he did not actually model it from the Austrian composer but created a generalized head of genius with a quality of timelessness and a synthesis of composure and concentration.

His follower Emile-Antoine Bourdelle, in his *Beethoven,* created a wildly dramatic and romantic mask of the suffering genius whose over-expressive quality borders on caricature.

Max Klinger built a most extravagant monument to Beethoven, which was given the place of honor in 1902 in Vienna's Secession Building. Gustav Klimt provided sumptuous decorations on the walls with a large frieze based on Schiller's *Ode to Joy.* Klinger, who had painted the mural *Christ on Olympus* (plate 80), now converted the composer into the image of the Olympian Zeus, seated on an elaborate throne, bent

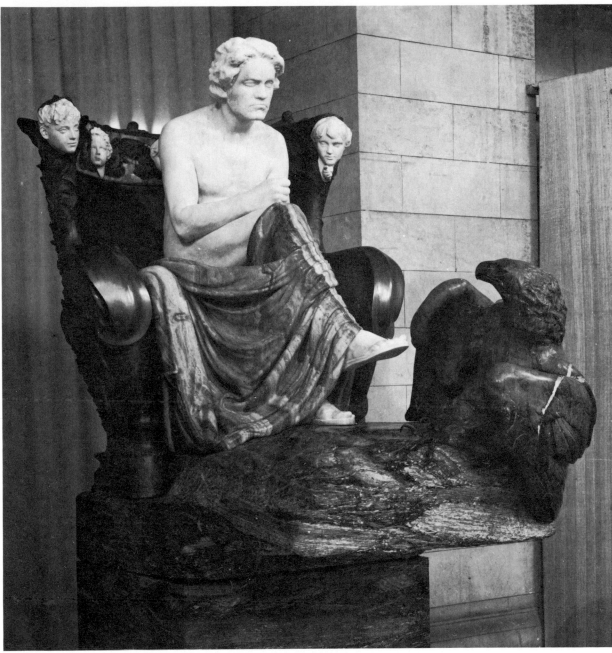

185

forward, deeply engaged in creative thought. The German fantasist carved Beethoven's head realistically after an extant life mask, and having learned that ancient sculpture was largely polychrome, Klinger used a great variety of materials: Pentelic marble for the flesh of the figure, alabaster for the drape (which resembles a tablecloth), gilded bronze and polished gold with insets of ivory, jade, and opal for the throne. The whole configuration is placed on a cloud of dark marble and confronted by a large rearing eagle. We may question the taste of this grandiose and flamboyant monument, but at the time a critic called it a "great carved symphony by a modern genius."

183 Auguste Rodin. *Gustav Mahler*. 1909. Bronze, height 13 ³/₈″ **184** Emile-Antoine Bourdelle. *Beethoven*. 1901. Bronze, height including base 27″ **185** Max Klinger. *Beethoven Monument*. 1899–1902. Marble, alabaster, bronze, gold, ivory, amber, mosaic, and gems, height 122″

Heads: Women and Men

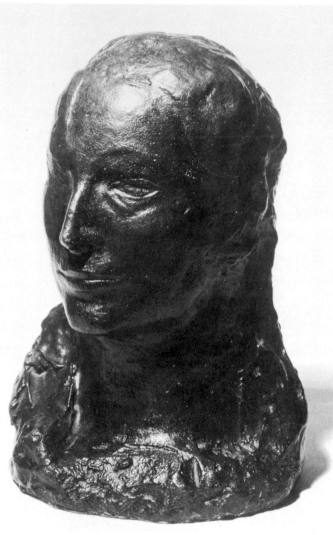

186

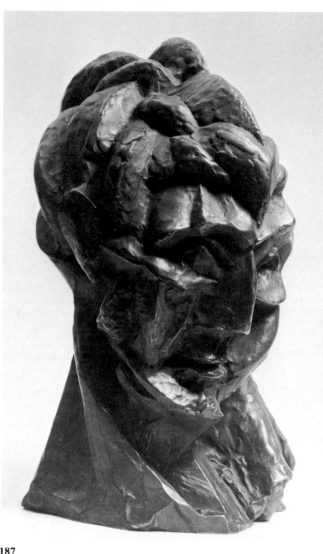

187

Picasso's serene *Head of Fernande* is contemporary with his *Family of Saltimbanques* (plate 245) and just one year earlier than the *Portrait of Gertrude Stein* (plate 214), which it resembles in its simplified structure. The bronze bust, however, is more generalized. Again, it is clear that he was informed by the Iberian sculpture of Spain and perhaps even more by the carvings of Gauguin. The density of volume and fullness of form shows his great concern with plastic considerations.

In 1909 Picasso once again modeled the head of his lover Fernande Olivier in *Woman's Head*. But now,

instead of the unbroken surface, he cuts into the planes, breaks them down, and reassembles them much as in the Cubist paintings of the same time. By applying the methodology of his new painting style, Picasso experiments here with the literal transcription to the third dimension of the multiplicity of views he had achieved in painting. Starting with the mass of head and always respecting its core, he assaults the surface and cuts it into geometric components, into sharp ridges and what he called a "scaffolding of planes." The impact of light on the many facets causes perceptible

shifts in the head as the viewer moves around the sculpture, suggesting the potential of movement.

Elie Nadelman was born in Warsaw and after studies in Munich arrived in Paris in 1903. Rejecting the influence of Rodin, Nadelman worked in a Neoclassical vein, creating a series of idealized marble heads of women. With these somewhat abstract heads Nadelman paid homage to Greek sculpture rather than attempting to imitate it, as many early-nineteenth-century sculptors had done. Nadelman, like the Greeks, believed in an absolute canon or norm of beauty, which he hoped to achieve by

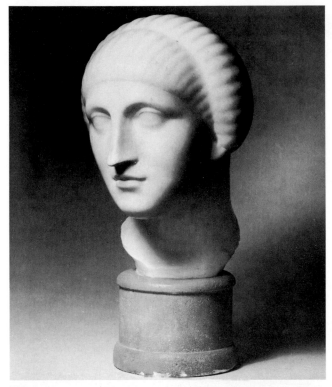

188

189

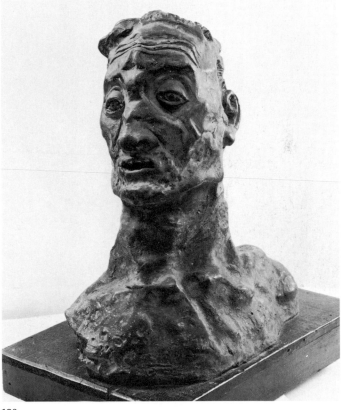

190

a harmonious relationship of curves and countercurves.

Constantin Brancusi, who arrived in Paris from Romania at the same time, also sought perfect form. His *Sleeping Muse* breaks with tradition in the elimination of the neck. But more important is the great simplification in Brancusi's floating head, his search for essential form, which he finds in the ovoid. This shape relates to growth and gestation, and it is also a form of harmony and tranquillity.

There is nothing restful in Oskar Kokoschka's *Self-Portrait as a Warrior,* the only known sculpture by the

Austrian painter. This work was modeled in clay and painted when the young artist was involved in psychological portraits, such as the *Portrait of Adolf Loos* (see plate 207), and Loos became, in fact, the original owner of the clay self-portrait. As in these poignant paintings, Kokoschka here penetrated beyond the conventional decorum of portraiture and revealed himself with a stunning, terror-stricken expression. This was the young Kokoschka, fighting the smug Vienna art establishment with his radical visions of art and the theater, looking very much older than his twenty-two years.

186 Pablo Picasso. *Head of Fernande.* 1905. Bronze, height 14 $^{1}/_{4}''$ **187** Pablo Picasso. *Woman's Head.* 1909. Bronze, height 16 $^{1}/_{4}''$ **188** Elie Nadelman. *Classical Head.* c. 1909–11. Marble, height 12 $^{3}/_{8}''$ **189** Constantin Brancusi. *Sleeping Muse.* 1910. Marble, length 11 $^{1}/_{2}''$ **190** Oskar Kokoschka. *Self-Portrait as a Warrior.* 1908. Painted modeling clay, height 16 $^{1}/_{2}''$

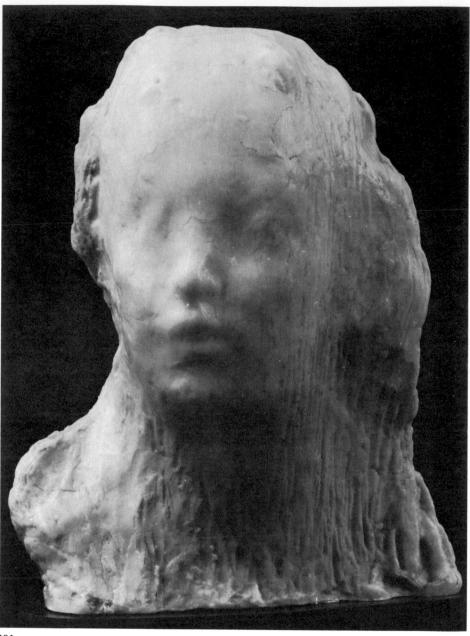

191

Ludwig Hevesi in Vienna was one of the few critics who understood Kokoschka's importance, and he was also the first critic to realize that Medardo Rosso was a major artist when the Milanese sculptor showed at the Vienna Secession in 1903. Rosso's *Ecce Puer (Behold the Boy)* is indeed a daring and astonishing work. Cast in wax-covered plaster, this delicate head of a child, based on the fugitive impression of the young boy, transmits a vivid sense of life and its ephemeral character. Yet in spite of its amorphous quality, *Ecce Puer* also has a feeling of stability.

Ecce Puer was exhibited at the Salon d'Automne in Paris soon after its completion and may have inspired Brancusi. His *Torment II*, compact in form and intense in feeling, gives expression to the sense of suffering in childhood without resorting to contractions in the features or any other melodramatic devices. Another child's head done the same year has a pensiveness that also sets it

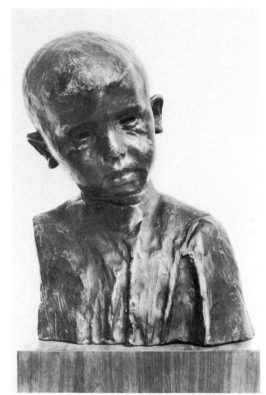

193

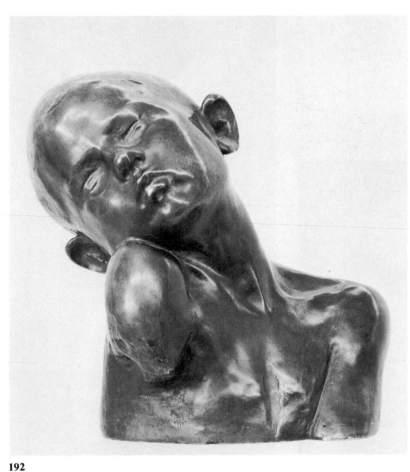

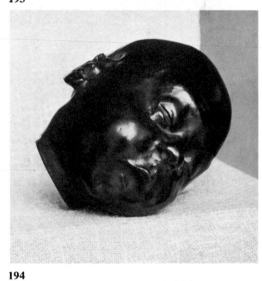

192

194

apart from conventional representations of children.

Jacob Epstein, born in New York, soon established residence in England and became familiar with European sculpture. Compared to Rosso's bust of a child, Epstein's small bronze *Head of a Baby* seems still to be traditional, but his decision to exhibit the work without a base was a very radical move in 1907 and indicates an early rejection of the traditional Salon display piece and a new sense of freedom as art is taken off its pedestal.

191 Medardo Rosso. *Ecce Puer* (*Behold the Boy*). 1906–7. Wax over plaster, height 17 $^1/_4''$ **192** Constantin Brancusi. *Torment II*. 1907. Bronze, height 11 $^1/_2''$ **193** Constantin Brancusi. *Head of a Child.* 1907. Bronze, height 13 $^3/_4''$ **194** Jacob Epstein. *Head of a Baby.* 1907. Bronze, height 5''

Lovers

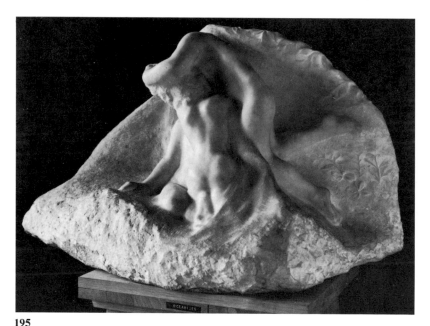

195

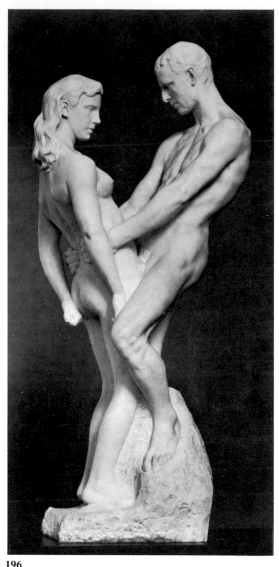

196

Rodin had dealt with human love in many versions in his massive bronze *Gates of Hell*, exploring both its tragic and its exuberant aspects. He continued to approach this theme freshly. In *Océanides* sensuous passion is expressed by the undulating, sinuous curves of Art Nouveau.

The Norwegian sculptor Gustav Vigeland belonged to the next generation. Although little known outside his native country, he was the man who received the largest official sculpture commission of the period— perhaps of the century—when he was asked to carve an enormous quantity of sculptures for Oslo's Frogner Sculpture Park, dealing largely with the erotic aspects of human life. Typical of his work is the life-size marble *Young Man and Woman,* a very literal rendition of a physical encounter between two idealized Nordic individuals.

Maillol's relief *Desire,* on the contrary, has the sense of measured rhythm of classical Greek sculpture. The confined interlocking of limbs and bodies filling the square, the arrested action, and the tectonic order recall the metopes of Olympia. There is no imitation here, but classical sculpture is recast by a fine modern sensibility.

It was Brancusi who, in *The Kiss,* broke with naturalism and tradition, pointing to the future. He revived the technique of carving directly into the stone block, a process which is more rigorous than modeling in clay and likely to yield less naturalistic results. With this work he challenged the celebrated Rodin, who had modeled his famous *The Kiss* for bronze casting some thirty years earlier.

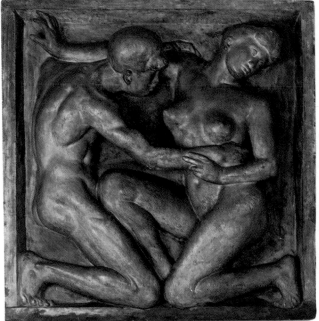

197

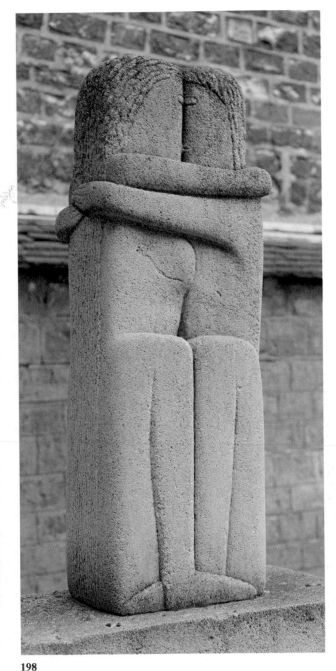

198

In Brancusi's sculpture the two elemental figures are in a compact embrace. The sexual differences between male and female are understated, but the two figures are engaged in an act of sexual intimacy which is both passionate and tender. Yet because of its rigor of concept and strength of form, the work is totally discreet. In many respects it recalls carvings from pagan and primitive societies. This sculpture in the Montparnasse Cemetery in Paris marks the grave of a young Russian medical student who had committed suicide over an unhappy love affair with a Romanian friend of Brancusi's. It was the second of a long series of works on the theme of the kiss, which occupied the sculptor for most of his life. The first version was done in 1907–8, only three years after his arrival in Paris, and the last one was carved in the early 1940s. All the other versions are much shorter and squatter than this full-size work of 1909.

195 Auguste Rodin. *Océanides*. 1905. Marble, height 22″ **196** Gustav Vigeland. *Young Man and Woman*. 1906. Marble, height 75 ¼″ **197** Aristide Maillol. *Desire*. 1906–8. Tinted plaster relief, 46 ⅞ × 45″ **198** Constantin Brancusi. *The Kiss*. 1909. Stone, height 35 ¼″

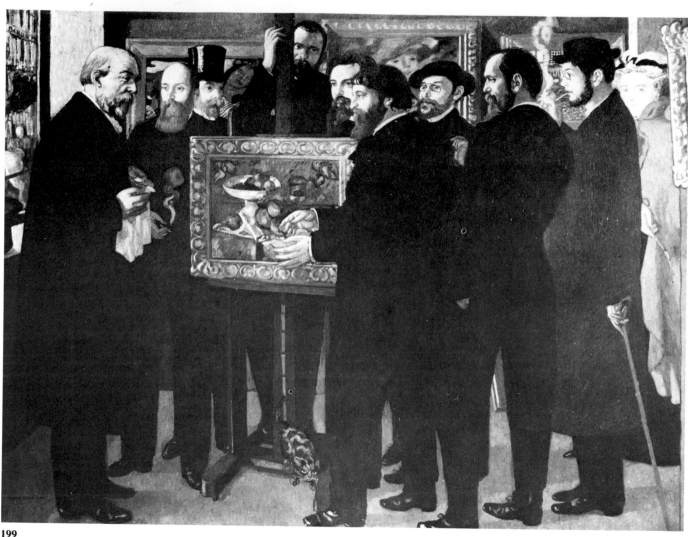

199

A number of young artists at the turn of the century began to express their admiration for Cézanne, who was leading a retiring life in Aix-en-Provence in the south of France. His work began to appear in Paris and Brussels, in Vienna, Munich, and Berlin, and was bought in Moscow. In 1900 Maurice Denis painted a large canvas, *Homage to Cézanne,* which showed several artists, including Redon, Bonnard, Vuillard, as well as Denis himself, assembled around a large Cézanne still life that had once belonged to Gauguin, who went to Tahiti in 1895; the painting was then bought by André Gide, who realized Cézanne's pivotal importance.

During the decade other painters made fascinating portraits of men of promise. Vuillard painted a fine picture of the Swiss painter, printmaker, and fellow Nabi Félix Vallotton. Done in muted colors on cardboard, it is a tender, intimate, modest, and informal portrait, relating the man closely to his home.

The brash simplification of André Derain's portrait of Maurice de Vlaminck, with whom he shared a studio, is at the opposite pole from Vuillard's approach. Derain displays the exuberant color and brushwork of the group that came to be called the Fauves (see page 96).

The tall man directly behind the easel in Denis's *Homage* is Ambroise Vollard, the dealer of the Paris avant-garde, who exhibited the work of Cézanne, Gauguin, and also Picasso. Picasso's *Ambroise Vollard,* painted at the end of the decade, is a completely different kind of picture. The placement of the sitter facing the

200

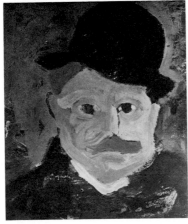

201

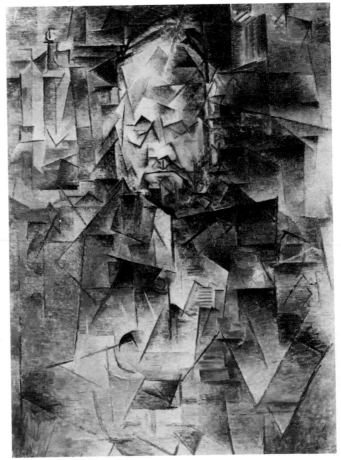

202

viewer frontally is quite formal and traditional, but the treatment of form is radically different in this Cubist painting. The viewer is totally aware that he is looking at a painting—not at a man. Forms have been broken up and fragmented and then rearranged in a fashion that at first seems arbitrary. Angles and rectangles are patterned across the surface of the picture, a surface which consists of intersecting planes and facets in a vibrating interlocking of energies. There is also a dynamic interaction between figure and background.

Nevertheless, the longer the viewer spends with the painting, the more he realizes its surprising likeness to the sitter. Although all the parts seem to be in a state of flux and transition, and expected spatial relationships are rejected in favor of discontinuous interaction, a new analytical and palpable structure is established which has its parallels in contemporaneous scientific and philosophical thought.

199 Maurice Denis. *Homage to Cézanne.* 1900. Oil on canvas, 70 7/8 × 94 1/2″
200 Edouard Vuillard. *Portrait of Félix Vallotton in His Studio.* 1900. Tempera on cardboard mounted on panel, 25 5/8 × 19 5/8″ **201** André Derain. *Portrait of Vlaminck.* 1905. Oil on canvas, 16 1/8 × 13″ **202** Pablo Picasso. *Ambroise Vollard.* 1909–10. Oil on canvas, 36 1/4 × 25 5/8″

203

204

The revolutionary quality of Picasso's portrait is apparent again when contrasted to Max Liebermann's *Dr. Wilhelm von Bode.* Liebermann, who belonged to an earlier generation, was for many decades Germany's most admired and respected painter; Bode was the noted art historian who was largely responsible for creating the magnificent collections of the Berlin museums. It was Liebermann who led the protest against the official closing of an exhibition of works by Edvard Munch in Berlin in 1892. Fifteen years later Munch's work was a great deal less controversial and turbulent, and the industrial-

ist Walther Rathenau commissioned the Norwegian to paint his portrait. The strong vertical composition retains much of the expressive power of Munch's earlier work; in the portrait Munch conveys the sense of strength and power of Rathenau, who was to become one of the leading statesmen of the Weimar Republic before he was assassinated by extreme right-wing nationalists in 1922.

Munch's psychological insight into his subjects greatly influenced the next generation of artists in Germany and Austria. When Paula Modersohn-Becker painted the likeness of

her friend Rainer Maria Rilke, she too was less interested in creating a likeness than in expressing an emotional equivalent in paint. Severely simplified to almost geometric, totemic proportions, this leading modern poet appears as a demon in stiff collar, an image of concentrated intensity.

Lovis Corinth, a prolific German painter of portraits and religious subjects, was often given to overblown heroics. In *Eduard, Count Keyserling,* however, Corinth lays bare the ravaged and life-scarred psyche of an aristocratic novelist of his day—and anticipates several charac-

205

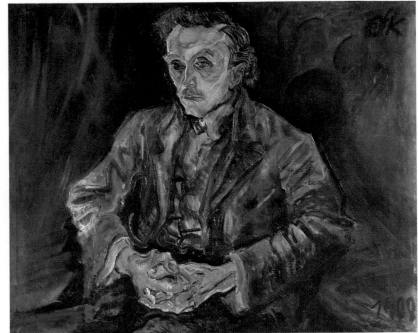

207

206

208

teristics of Kokoschka's portraits of some of Vienna's leading intellectuals. Kokoschka found eloquent expression for the turmoil and turbulence which culminated in the great outburst of creative energies that made Vienna a major center of European culture during the prewar years. In *Portrait of Adolf Loos* Kokoschka focuses on the sitter's tragic, thoughtful face and clasped hands. This portrait of the modern architect, one of the painter's early friends and patrons, shows a man of intense mental energy at momentary rest. It is a potent visual message in which the artist projects his vision of the sitter into the psychic consciousness of the viewer.

The influence of the American William Merritt Chase (see plates 87 and 219) made itself felt through his extensive teaching career, spanning several decades. His students included Charles Sheeler and Georgia O'Keeffe, and among his friends were James Whistler and John Singer Sargent. The latter's portrait of Chase, done when the subject was fifty-three, presents a man unquestionably in command of his profession and his destiny.

203 Max Liebermann. *Dr. Wilhelm von Bode*. 1904. Oil on canvas, 41 ³/₄ × 35″ **204** Edvard Munch. *Portrait of Walther Rathenau*. 1907. Oil on canvas, 86 ⁷/₈ × 43 ¹/₄″ **205** Paula Modersohn-Becker. *Portrait of Rainer Maria Rilke*. 1906. Oil on canvas, 13 ³/₈ × 10 ¹/₄″ **206** Lovis Corinth. *Portrait of Eduard, Count Keyserling*. 1900. Oil on canvas, 39 ¹/₈ × 29 ³/₄″ **207** Oskar Kokoschka. *Portrait of Adolf Loos*. 1909. Oil on canvas, 29 ¹/₈ × 35 ⁷/₈″ **208** John Singer Sargent. *William Merritt Chase*. 1902. Oil on canvas, 62 ¹/₂ × 41 ³/₈″

Self-Portraits

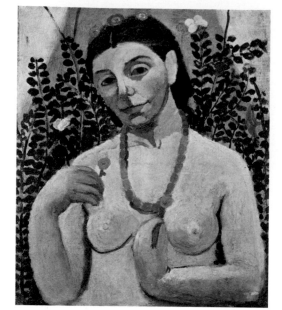

209

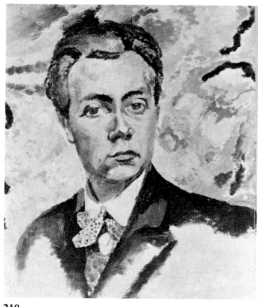

210

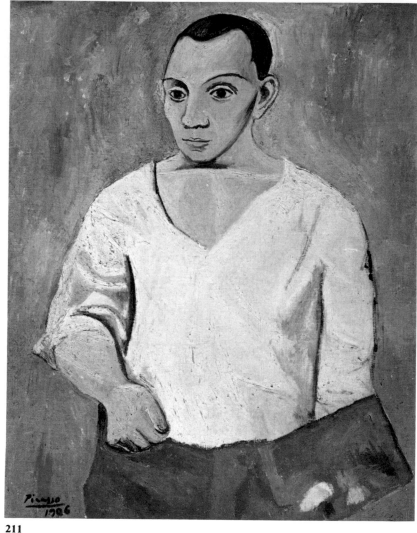

211

Shortly before her death at thirty-one in 1907, Paula Modersohn-Becker painted a series of self-portraits such as the one now in the Kunstmuseum in Basel. Although she lived in the artists' colony at Worpswede near Bremen, she made visits to Paris and understood the messages of Cézanne and Gauguin, Van Gogh and Munch. Here she depicts herself half-nude, with sorrowing eyes, standing before a leafy screen which denies depth and brings the figure into the frontal plane. A quiet portrait of measured dignity, this painting combines intimacy with iconic power.

The precocious French painter Robert Delaunay did this *Self-Portrait* at the age of twenty-one. Its startling colors—the face is modeled in greens, yellows, reds, and blues—reveal the influence of the Fauves (see page 96), who had burst on the Paris art scene a year before. Delaunay soon formulated his own color theories, but he retained the vigorous palette of Fauvism.

Picasso's *Self-Portrait* of the same year has a massive, lapidary stance. He presents himself with a relatively small, sharply outlined head, a massive body, and a muscular short right arm which would be incapable of reaching the palette he holds in his other hand.

Matisse, eleven years older than Picasso and fairly well established in Paris at the time, painted his own likeness with complete self-assurance. Unlike Modersohn-Becker or Picasso, Matisse presents only his head and directs his clear gaze

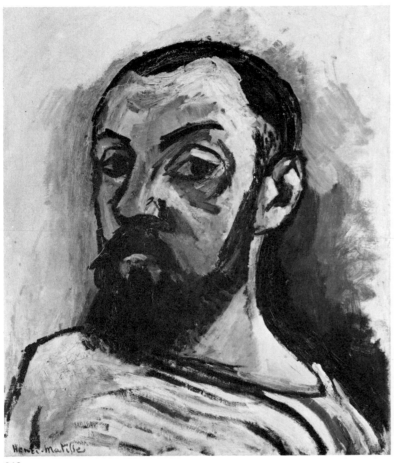

212

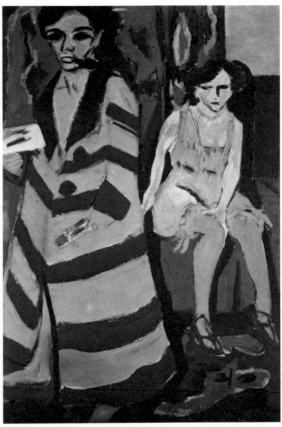

213

straight at the viewer. It is a painting in which line and color exist in a balanced equilibrium between cerebral and sensory experience. Matisse declared that "only one who is able to order his emotions systematically is an artist."

None of this balance and visual clarity exists in Ernst Ludwig Kirchner's *Self-Portrait with Model.* Here the artist stands self-consciously off center, dressed in a brightly striped robe, while his much smaller, sexually provocative model is placed on a chair behind him. We are confronted by a restless artist who has found a highly personal style for the expression of his fantasies and anxieties. Instead of the harmony we experience in Matisse, the German painter presents us with agitation and existential tension which point to a future art in which a sense of dread becomes increasingly apparent.

209 Paula Modersohn-Becker. *Self-Portrait.* 1906. Oil on canvas, 24 × 19 ¹¹/₁₆″ **210** Robert Delaunay. *Self-Portrait.* 1906. Oil on cardboard, 21 ¹/₄ × 18 ¹/₈″ **211** Pablo Picasso. *Self-Portrait.* 1906. Oil on canvas, 35 ⁵/₈ × 28″ **212** Henri Matisse. *Self-Portrait.* 1906. Oil on canvas, 21 ⁵/₈ × 18 ¹/₈″ **213** Ernst Ludwig Kirchner. *Self-Portrait with Model.* 1907. Oil on canvas, 59 ¹/₄ × 39 ³/₈″

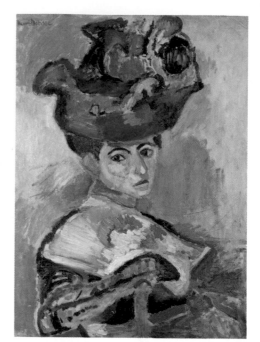

215

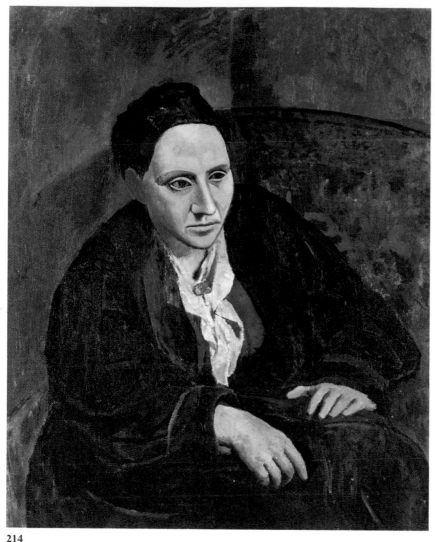

214

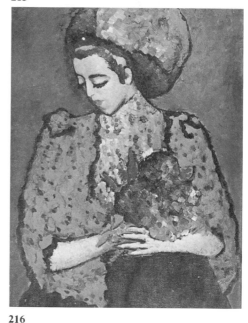

216

After some eighty or ninety sittings, Picasso completed his *Portrait of Gertrude Stein* from memory. This massive painting of the distinguished American writer, art patron, and hostess was done in the winter of 1906, only a few years before the radical Cubist portrait of Vollard (plate 202). As in the later portrait, Picasso uses a limited, muted palette, but here it is the colors of the earth. The figure seems chiseled out of rock and has an austere, eternal quality—yet the masklike face is animated by the irregularity of her distinctly asymmetrical eyes.

What a contrast is Matisse's

Woman with the Hat with its unrestrained colors! In fact, the heightened complementaries, largely liberated from descriptive purposes, made a critic of 1905 refer to Matisse and his painter friends as "*les fauves,*" that is, the wild beasts. The name of the first art "movement" of the twentieth century, Fauvism, is as misleading as are most such categories. Instead of acting like wild beasts, Matisse, Derain, Vlaminck, and the rest were artists who painted pictures of luscious and luxurious decoration, whose composition is the result of thought as well as intuition. In this lavishly painted portrait of his wife

Matisse worked with great varieties of textures, but the brushwork in the face is less agitated, less abstract and flattened than in the rest of the painting; her expression is rather cheerless in contrast to the brilliant explosion of flashing colors. The painting was bought by Gertrude's brother Leo Stein from the Salon where it caused so much furor, and hung for many years close to Picasso's very solid portrait of Gertrude.

Matisse's influence rapidly made itself felt throughout Europe. The Russian painter Alexei Jawlensky, who had lived in Munich since 1896, went to Paris in 1905 to exhibit in the

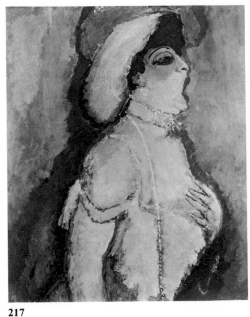

217 218

same Salon d'Automne with the Fauves. In *Young Woman with Peonies* the girl with her bouquet of flowers is painted in erotic and sensuous colors of adjacent reds and pinks and outlined in heavy dark contours, silhouetted strikingly against a turquoise background.

Kees van Dongen, who retained his sensuous Fauve palette and outlook until his death in 1968 at the age of ninety-one, helped to support himself at the turn of the century by doing satirical sketches for newspapers. In this painting of Modjesko these aspects combine in a witty accolade.

Gustav Klimt, leader of the Vienna Secession, flattens out his ladies completely in pictures like *Portrait of Adele Bloch-Bauer*. Only the head of the figure, or rather the insular face, is treated in any kind of realistic manner, while the remainder is an abstract, decorated body, a rigid part of an ornate environment. The sitter seems almost imprisoned in her elaborate surroundings, helplessly captive in the luxuriant futility of an overripe civilization in decline.

214 Pablo Picasso. *Portrait of Gertrude Stein*. 1906. Oil on canvas, 39 $^{1}/_{4}$ × 32″
215 Henri Matisse. *Woman with the Hat*. 1905. Oil on canvas, 31 $^{3}/_{4}$ × 23 $^{1}/_{2}$″
216 Alexei Jawlensky. *Young Woman with Peonies*. 1909. Oil on cardboard, 39 $^{3}/_{4}$ × 29 $^{1}/_{2}$″ **217** Kees van Dongen. *Modjesko, Soprano Singer*. 1908. Oil on canvas, 39 $^{3}/_{8}$ × 32″ **218** Gustav Klimt. *Portrait of Adele Bloch-Bauer*. 1907. Oil on canvas, 55 $^{1}/_{8}$ × 55 $^{1}/_{8}$″

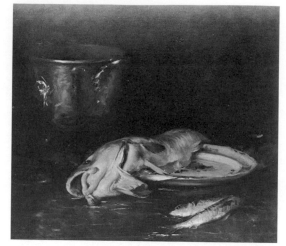

219

221

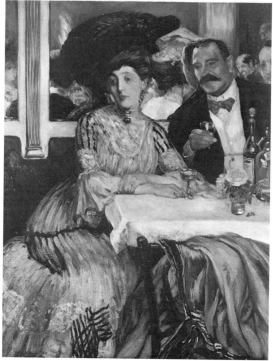

220

222

People dining, as well as edibles and still-life compositions, remained popular themes during the decade. In America the "old master" William Merritt Chase, who was born in 1849, continued to work in the tradition of Dutch still-life painting as channeled through the Munich academy. In such carefully arranged picturesque ensembles as *An English Cod,* he concerned himself with the accurate rendering of textures and the effect of light. The much younger William Glackens brought a refreshing observation of the social theme to works such as *Chez Mouquin.* Like many of his friends in the Eight, he had worked as a magazine illustrator before turning to easel painting, and

he was able to make good use of the lessons he had learned from studying the works of the artists he most admired: Hals, Renoir, and Manet.

The interior still life with an anecdotal tinge was the forte of John Sloan, who like Glackens was a member of the Eight and an illustrator. Sloan displayed a special affinity for the "loner" in a city, a major concern of Edward Hopper later in the century. In *Three a.m.,* Sloan recorded in his diary, he depicted a view seen from "the back window of a Twenty-third Street studio . . . a poor, back, gaslit room."

Edouard Vuillard, who in the 1890s had developed an Intimist style suited to subtle familial inter-

play (see plate 98), utilized the enclosed room to suggest both isolation and grand drama as well. By absorbing the child into the patterns of the bedcoverings and rug, and setting the chair towering over her, Vuillard establishes a scale of values on which the child is outranked by the furnishings of a bourgeois house.

The British portraitist Sir William Orpen seems to have composed his *A Bloomsbury Family* with meticulousness and deliberation. The family of the painter Sir William Nicholson, around their dining table, is precisely arranged in a picture which exudes a sense of well-being and good breeding, of clarity and order.

The early Matisse *Still Life with*

223

225

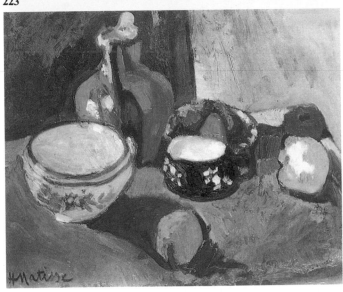

224

226

Dishes and Fruit, once owned by the Moscow collector Sergei Shchukin, reveals the decisive influences of Gauguin and Cézanne, the former in the color range and off shades—mauves and hot pinks—and pools of color. The tipped-up dishes, seen both from the side and from above, speak of Cézanne, as does the sculptural pear in the foreground, casting its shadow at an inexplicable right angle.

Georges Braque's *Violin and Pitcher* carries the new Cézannesque vision hinted at in the Matisse into what seems a totally different world. At this point Braque had joined Picasso, and together, sublimating their individuality, the two artists brought about a new style of painting—

Cubism. In this still life Braque denies three-dimensional space and fragments violin, jug, and wall into prismatic planes, much as Picasso did in his *Ambroise Vollard*. In their exploration of the relationships of shapes and space both artists reduced their palettes to muted tones of gray, brown, and white, creating a nonimitative art which permits the viewer new insights into the nature of reality, a reality which had been reconstructed by the artist's volition. And then a new sense of stability appears in Picasso's *Bread and Fruit Bowl on a Table*, a painting in which the objects are again clearly defined. They are large, palpable, and stable in a still life which actually resembles the

grand still-life paintings of seventeenth-century Spain. At the end of the decade, after the dismemberment of the object, a new order and sense of permanence had been established.

219 William Merritt Chase. *An English Cod*. 1904. Oil on canvas, 36 $^1/_4$ × 40 $^1/_4''$
220 William Glackens. *Chez Mouquin*. 1905. Oil on canvas, 48 $^3/_{16}$ × 36 $^1/_4''$
221 John Sloan. *Three a.m.* 1909. Oil on canvas, 32 × 26'' **222** Edouard Vuillard. *Child in a Room*. c. 1900. Oil on cardboard, 16 × 32'' **223** Sir William Orpen. *A Bloomsbury Family*. 1907. Oil on canvas, 35 × 36 $^1/_2''$ **224** Henri Matisse. *Still Life with Dishes and Fruit*. 1901. Oil on canvas, 20 $^1/_8$ × 24 $^1/_4''$
225 Georges Braque. *Violin and Pitcher*. 1910. Oil on canvas, 46 $^1/_8$ × 28 $^3/_4''$
226 Pablo Picasso. *Bread and Fruit Bowl on a Table*. 1909. Oil on canvas, 64 $^1/_2$ × 52 $^1/_8''$

Nudes: Three Masterpieces

227

Although the traditional hierarchies of subject had long been discarded, painting during the first decade of the new century largely continued to adhere to long-established themes.

When Cézanne painted the last and most monumental of his long series of female bathers, he placed the figures in a space created for them—a close architectural edifice which is solid in its geometric construction and simultaneously luminous and transparent in its use of atmospheric color and refracted light. The pyramidal space is formed and defined by the structure of nudes and trees. Any erotic emotion toward the female nude has been suppressed, and the stiff, awkward bodies serve not only to build the tectonic composition but also to support the vibrant reflection of color surface which *is* the painting. Cézanne created a new construct of form and color based on his visual perceptions as well as his mental concept of nature.

Picasso, who completed his radical *Les Demoiselles d'Avignon* in 1907, was certainly greatly indebted to the master of Aix. The figures in Picasso's large canvas of women in a brothel, however, are assertive rather than passive. Their sharp, angular bodies seem carved out, lacerated; they do not exist in a lyrical natural environment but in an imaginary, congested, airless indoor space. There is no longer any recession, but rather a shallow stage which interacts even more directly with the figures. The lessons of Iberian and Ivory Coast sculpture are incorporated for the first time in a major European painting. A feeling of exuberant energy is evoked by the splintered and riotous distortions of the bodies. Cézanne's Apollonian attitude has

228

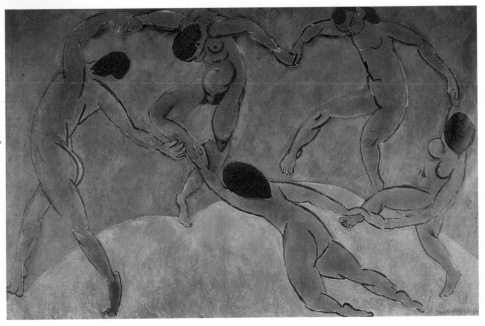

229

been replaced by Picasso's dissonant Dionysian involvement.

In both Picasso's *Demoiselles* and Matisse's *The Dance*, line, space, and, above all, color lead an autonomous existence, independent of the traditional demands of representation. *The Dance*, one of two great murals originally commissioned by Sergei Shchukin for his mansion in Moscow, is limited to the vermilion color of the bodies, the saturated green of the imaginary hill, and the blue of the sky or background—all these are in full intensity. The dancers create a vigorous arabesque

of polyphonic movement. "We are moving toward serenity by simplification of ideas and means," Matisse said at the time. "Our only object is wholeness. We must learn, perhaps relearn, to express ourselves by means of line." In these three masterpieces, Cézanne created a painting of stable and permanent structure, Picasso a work which destroyed previous values in a radical composition that became a turning point in modern painting, while Matisse extolled the freedom and energy of the human body.

227 Paul Cézanne. *The Large Bathers.* 1898–1905. Oil on canvas, 82 × 99″
228 Pablo Picasso. *Les Demoiselles d'Avignon.* 1906–7. Oil on canvas, 96 × 92″ **229** Henri Matisse. *The Dance.* 1909. Oil on canvas, 101 5/8 × 153 1/2″

Nudes: Innovation and Tradition

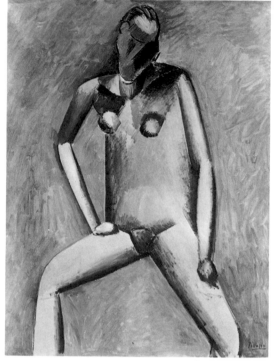

230

231

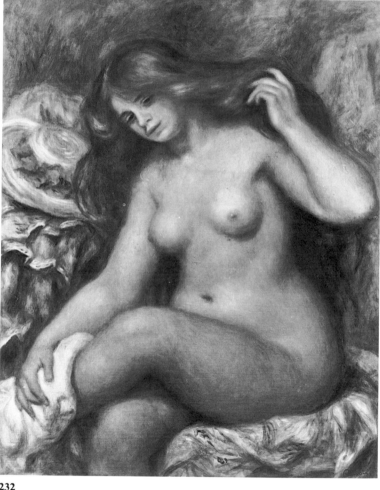

232

Picasso's *Seated Female Nude,* painted only one year after the *Demoiselles,* is an image of much greater restraint. He concentrates here on certain formal problems suggested in the earlier pivotal canvas and restores a Cézannesque sense of order and calm, which he needs for the analysis of cylindrical forms and volumes. The figures in Fernand Léger's *Nudes in the Forest* also have a cylindrical appearance, and Léger acknowledged his debt to Cézanne for teaching him "to love forms and volumes" and to realize that "draw-

ing has to be rigid and in no way sentimental." In this ambitious painting the three robotlike figures are part of a landscape in which everything is reduced to basic geometric shapes. Colors are limited to shades of gray and green; a dynamic movement in a compressed space is created by churning mechanical forms as the landscape and its people become part of a technological world.

During the same decade Renoir, who lived until 1919, continued to paint sensuous nudes of serene beauty in the privacy of their bou-

doirs. In his later work, however, he moved away from his earlier, more naturalistic manner by broadening his brushstroke, by altering his color field to almost a single hue, and by giving the figure herself a much greater amplitude.

While the nude is a subject that seems to occur in almost all cultures and has often been considered the supreme subject of aesthetic expression, there were few paintings of nudes in puritan America. William Glackens's *Nude with Apples,* which translates Renoir's style into a rather

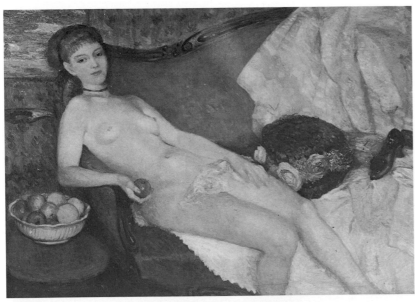

233

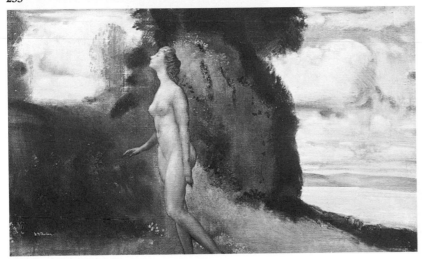

234

235

wooden and stilted academic work, must have seemed quite daring in 1910, especially since the lady is holding an inviting red apple in her hand.

Although Arthur B. Davies was one of the Eight, exhibiting with Glackens and the other members of the Ashcan School, his work is much more related to European Symbolism than theirs. There is a great deal of nostalgia in his work, and the nude in his *Dream* recalls figures from the Early Renaissance in Florence, but the painting is ren-

dered in vaporous colors, giving it an air of the ephemeral.

Probably the most widely reproduced painting of the female nude in the decade was Paul Chabas's *September Morn*. Chabas painted a coy naked lady bathing in a lake during the morning's soft light. His sweetly erotic academic realism gained wide popular admiration on two continents as well as the highest official honors of the French Republic.

230 Pablo Picasso. *Seated Female Nude.* 1908. Oil on canvas, 45 $^3/_4$ × 35″
231 Fernand Léger. *Nudes in the Forest.* 1909–10. Oil on canvas, 47 $^1/_4$ × 66 $^7/_8$″
232 Auguste Renoir. *La Toilette.* 1902. Oil on canvas, 36 $^1/_4$ × 28 $^3/_4$″ **233** William Glackens. *Nude with Apples.* 1910. Oil on canvas, 40 × 57″ **234** Arthur B. Davies. *Dream.* 1909. Oil on canvas, 18 × 30″
235 Paul Chabas. *September Morn.* 1905. Oil on canvas, 61 $^1/_2$ × 85 $^1/_4$″

Nudes: Expressive Form

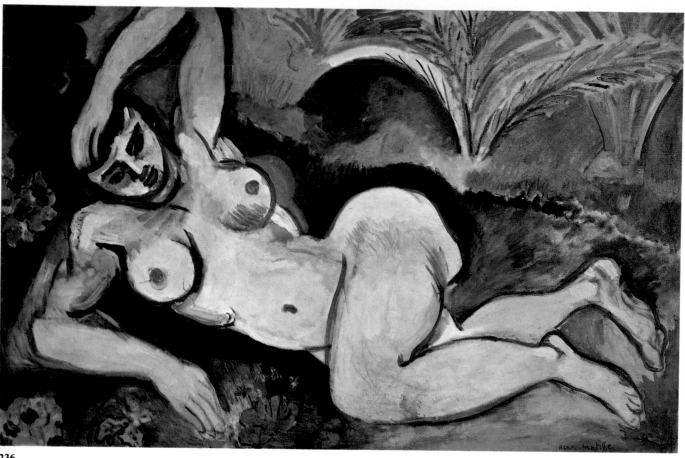

236

Like his contemporary the philosopher Henri Bergson, Matisse saw art as intuitive expression taking tangible form. Two years before *The Dance*, he painted *The Blue Nude*, a woman whose body is sensuously contorted and whose exaggerated physical features reveal the artist's intense feeling about the subject as well as his sense of pictorial order. The sensations of the recumbent female figure on the couch are expressed with great intensity and are at the same time subordinated to the spirit of the picture.

When Georges Rouault, Matisse's erstwhile fellow student in Gustave Moreau's atelier, painted a nude on the same theme of the reclining *Odalisque*, he was not concerned merely with the forms of the female body or even with the demands of the pictorial composition. He depicted a prostitute in this classical pose as a poignant accusation against a moribund society. Painted with an almost frantic brushstroke, the figure is outlined in heavy black against the background of the brothel. Léon Bloy, the novelist, wrote that "all that remains of the body is the silhouette line; a caress is practically inconceivable in these grimy pigments, redolent of the grave."

German artists revealed a similar and at times even more violent attitude against bourgeois society, academic conventions, and naturalism of all kinds. They searched

237

238

239

for affirmation in various forms of primitive art, hoping to regain the emotional impact and primordial power of the iconic object. Kirchner, the leader of the early Expressionist Bridge group in Dresden (later Berlin), painted *Girl under a Japanese Umbrella* in strident color with vigorous spontaneity. It is a frankly sexual and provocative expression of his own feelings of masculine virility.

Emil Nolde in his *Dance around the Golden Calf* has converted a religious subject into a sensual and frenzied scene of four half-naked yellow and purple dancers who worship a forbidden idol. The orgiastic feeling is achieved by the free and lavish use of contrasting color and the whirling movement of the wildly applied brushstrokes.

236 Henri Matisse. *The Blue Nude (Souvenir of Biskra)*. 1907. Oil on canvas, 36 $^1/_4$ × 55 $^1/_8$" **237** Georges Rouault. *Odalisque*. 1907. Watercolor and pastel, 24 $^3/_4$ × 38 $^3/_8$" **238** Ernst Ludwig Kirchner. *Girl under a Japanese Umbrella*. 1909. Oil on canvas, 36 $^1/_2$ × 31 $^5/_8$" **239** Emil Nolde. *Dance around the Golden Calf*. 1910. Oil on canvas, 34 $^5/_8$ × 41 $^3/_8$"

The Theater and the Circus

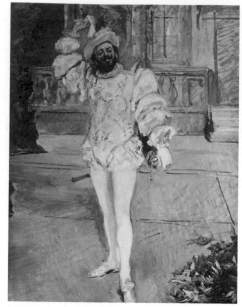

240

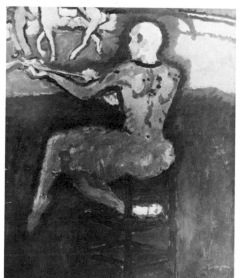

241

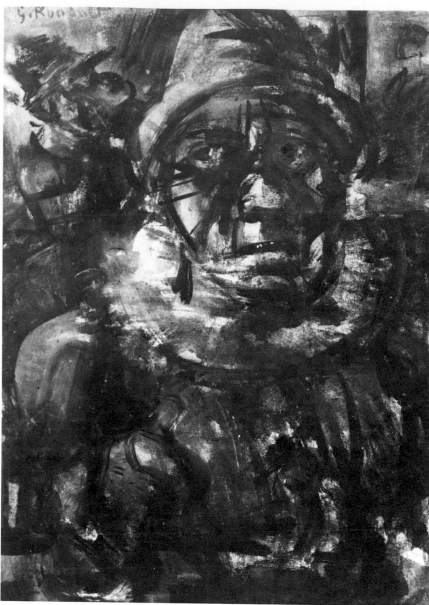

242

Actors, clowns, and acrobats, symbolizing life on the periphery of bourgeois existence, have always engaged the attention of painters. In 1902 the German Impressionist Max Slevogt made a spirited portrait of a Portuguese singer, *D'Andrade as Don Juan.* This picture, painted in lively rich colors with the dash and bravura of a fine craftsman, is a delightful and positive statement about life on the stage.

Not so Van Dongen's *The Clown,* one of a series of sketches of women performers at the Moulin de la Galette whom the contemporary critic Louis Vauxcelles described as "chlorotic clowns in flesh-colored tights."

Van Dongen's vision is heightened and deepened in Georges Rouault's renderings of clowns and other entertainers. Like his *Odalisque,* they are a passionate indictment of a society which brings human beings, as

he once remarked, to a state of "laughter that chokes itself." Rouault, a moralist and religious artist who strove to create an "art for man's sake," painted the clown without his social mask—a poignant picture of agony, communicating what the philosopher Jacques Maritain called "an immortal wound."

Picasso's *Family of Saltimbanques* was painted shortly after the Rouault. This large canvas is probably

243

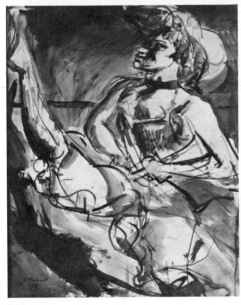

244

245

the first true masterpiece by the Spaniard, who was then twenty-four years old. Based on a large number of paintings and drawings, it was the ultimate version on the theme of circus performers and acrobats, pictures which to a large extent can be seen as metaphors of the artist's own position in society. The acrobats here do not perform. They merely stand there, without contact, silent, isolated, mute. They hardly touch or glance at each other as they exist in an empty reddish-brown desert. This canvas is completely different in style, in form, and in its elegiac feeling from the violence and stylistic innovation of his next monumental work, *Les Demoiselles d'Avignon* (plate 228).

240 Max Slevogt. *D'Andrade as Don Juan (The Champagne Song)*. 1902. Oil on canvas, 84 ⁵/₈ × 63″ **241** Kees van Dongen. *The Clown*. 1906. Oil on panel, 29 ¹/₈ × 23 ⁵/₈″ **242** Georges Rouault. *Head of a Tragic Clown*. 1904. Watercolor, pastel, and gouache, 10 × 8 ¹/₂″ **243** Georges Rouault. *Punch*. 1906. Oil and watercolor, 17 ³/₈ × 13″ **244** Georges Rouault. *Bal Tabarin (Dancing the Chahut)*. 1905. Watercolor and pastel, 27 ⁵/₈ × 21 ¹/₄″ **245** Pablo Picasso. *Family of Saltimbanques*. 1905. Oil on canvas, 83 ³/₄ × 90 ³/₈″

Lovers

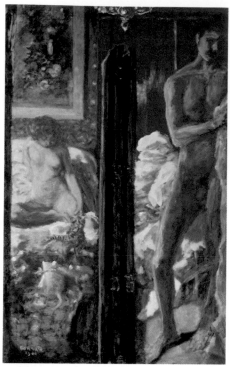

246

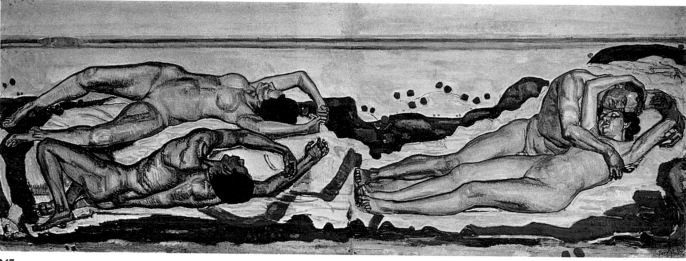

247

A sense of great seriousness prevails in Bonnard's *Man and Woman*, a painting in which two lovers, whose embrace and momentary fulfillment is past, seem to reflect the isolation in the modern world. The center of the painting is occupied by the vertical partition of a screen, emphasizing their separateness. They seem poised in reflection on their fleeting moments together before resuming their normal solitary activities, and their emotional isolation creates an unexpected contrast to the sensuously luxuriant painting surface and its rich and sonorous color.

In his horizontal mural painting *Love*, Ferdinand Hodler's sleeping couples stretch parallel across the picture plane in various poses of sleep. Set in an imaginary landscape with symbolic overtones, the lovers are in awkward repose and clumsy embrace, intertwined with slashes of red paint vibrating next to a fluid complementary green. The theme of love is painted in a strange imbalance between passion and dream. Unity is possible only in a state of exhaustion or sleep.

Picasso's *La Vie* carries on the vagueness and mystery which were typical of Symbolism at the end of the nineteenth century, with its concern for the tragic aspects of life, love, and death. The lovers embrace in

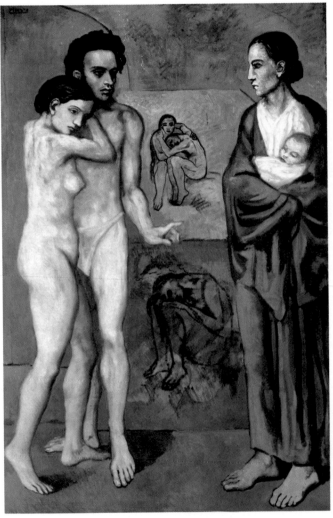

248

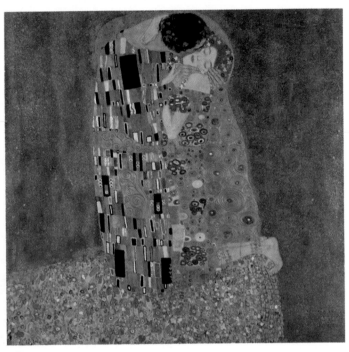

249

solitude while a painting of a desolate couple appears in the background and a canvas of a solitary crouching figure is seen in the lower half of the painting. A woman with a child stands sternly on the right, almost threatening the man who points to her with a gesture of questioning. Veiled in an all-pervading blue, this painting of love evokes a feeling of ambivalence and melancholy.

Only in Gustav Klimt's *The Kiss*

do we seem to experience lovers in complete union. Set against the sumptuous decoration of Art Nouveau, the lovers form a continuous pattern of rapture. But here the abstract patterns of gown and background dominate the suggestion of physical union. Again we find the lovers of the first decade of the twentieth century a complex reflection of a time of alienation.

246 Pierre Bonnard. *Man and Woman (L'Homme et la Femme)*. 1906. Oil on canvas, 45 $^1/_4$ × 28 $^3/_8$" **247** Ferdinand Hodler. *Love*. c. 1905. Oil on canvas, 55 $^3/_4$ × 152" **248** Pablo Picasso. *La Vie*. 1903. Oil on canvas, 77 $^3/_8$ × 50 $^7/_8$" **249** Gustav Klimt. *The Kiss*. 1907–8. Oil on canvas, 70 $^7/_8$ × 70 $^7/_8$"

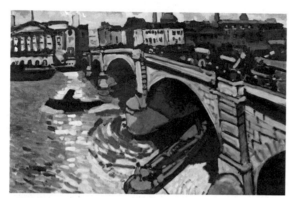

250

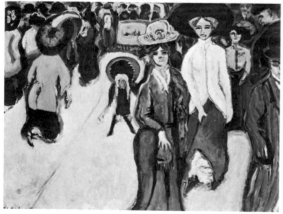

251

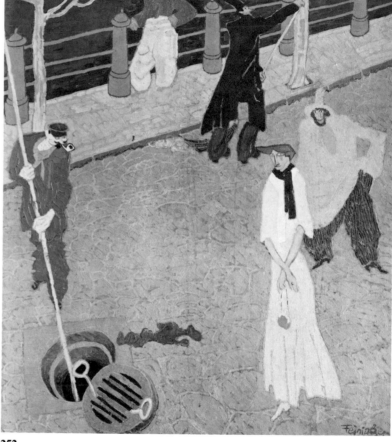

252

Color is the dominant element in André Derain's *London Bridge,* as it was in the contemporaneous work of his fellow Fauve Matisse. The gray of London is transformed into a riverscape of brilliant color contrasts at their brightest hues. "Colors became charges of dynamite," Derain wrote later, and indeed pigments were applied with exuberance and vigor as the energy of the painter was transmitted to the painting. Whereas the Frenchman's painting is one of pure exhilaration, Kirchner in Ger-

many uses similarly unadulterated but more strident colors in *Street, Dresden* for a painting full of anxiety and constriction. The people are in close physical contact but at great psychological distance. The street itself is tilted up, and large figures with masklike faces move threateningly out of the picture plane toward the observer.

The American Lyonel Feininger, also working in Germany, deals with the story of a murder in the curious painting *The Manhole.* Five carica-

turelike, elongated figures are choreographed as in a dance on a mauve pavement and seem to be acting out some secret ritual focused on the open manhole.

A similar tragic sense of mystery prevails in Giacomo Balla's *Bankrupt.* The gates of the business establishment have been sealed, and children have marked the silent doors with their graffiti.

In the United States urban life seemed more pleasant. Maurice Prendergast, who was also a member

253

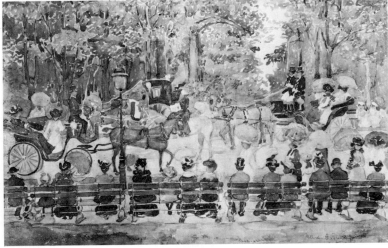

254

255

of the Eight, paints a charming view of the good life of leisure in New York's *Central Park*. Influenced by Cézanne and Seurat, Prendergast created oils and watercolors with a rich mosaiclike pattern and a keen sense of the picture surface. John Sloan seems less affected by the European avant-garde. And his themes, too, are very different. Instead of well-dressed ladies and gentlemen seated on park benches and viewing the parade of horse-drawn carriages, Sloan's spectators in *Hairdresser's Window* are a motley crowd of lower-class strollers looking up into the window to watch the redheaded girl get a haircut. Sloan painted a vivid genre scene, giving us a view of life in the tenements. He is sure to add painted signs, advertisements, and placards, reminding us of Balla's graffiti. Sloan, the American realist, felt that he had to tell the whole story.

250 André Derain. *London Bridge*. 1906. Oil on canvas, 26 × 39″ 251 Ernst Ludwig Kirchner. *Street, Dresden*. 1908 (date on painting 1907). Oil on canvas, 59 1/4 × 78 7/8″ 252 Lyonel Feininger. *The Manhole*. 1908. Oil on canvas, 31 3/4 × 23 3/4″ 253 Giacomo Balla. *Bankrupt*. 1902. Oil on canvas, 46 1/2 × 63 1/4″ 254 Maurice Prendergast. *Central Park*. 1901. Watercolor, 14 1/8 × 21 3/4″ 255 John Sloan. *Hairdresser's Window*. 1907. Oil on canvas, 31 7/8 × 26″

Landscape I

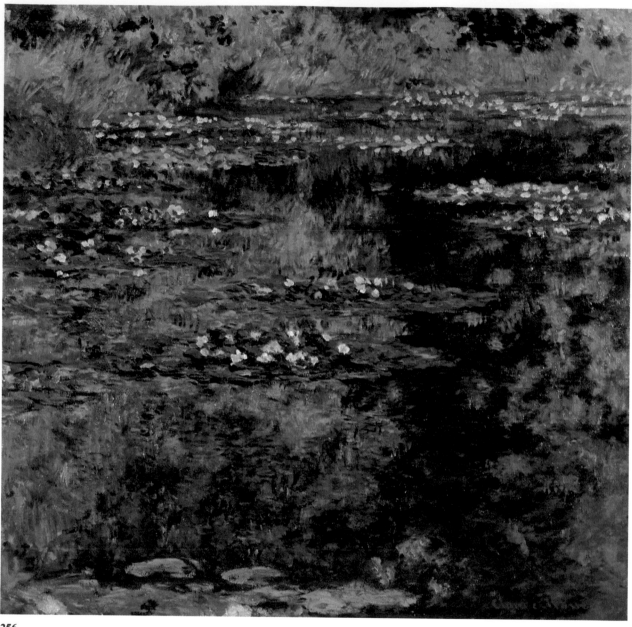

256

When the first Impressionist exhibition was held in the photographer Nadar's studio in 1874, Monet and Cézanne were among the original participants. In the next thirty years their work had taken completely diverse directions, but now, in the 1900s, their landscapes are still based on the sensation of nature. Monet contemplated the water garden next to his house at Giverny over many decades and painted the blossoms and pads of the floating waterlilies. He pictured fragments of an ephemeral landscape with no horizon, without limitation of any kind.

If the floating *Water Garden at Giverny* was the prime landscape motif of Monet during his mature years, Cézanne chose the solid rock of Mont Sainte-Victoire, close to his home in Aix. The solidity of the structure, at the opposite extreme of Monet's fluidity of substance, had been evident in his earlier *Lake of Annecy* (see plate 90). This substance, which was basic to his construction of bathers in a landscape, now achieved a turbulence and dynamism, an intensity of color—mostly blues, greens, and yellows—and rhythmic hatchmarks which gave a vitality to

the landscape like the energy underlying the universe itself.

Ferdinand Hodler, slightly younger than Monet and Cézanne, rejected the random vision of Impressionism early in his career in favor of a more severe symmetrical structure. He achieved what is doubtless the greatest representation of the Alpine landscape—*Eiger, Mönch, and Jungfrau in Moonlight*. The mood of the painting is set by the blueness of the composition, and a great celestial drama unfolds in light and in the revelation of floating luminous shapes. Here Hodler achieved a

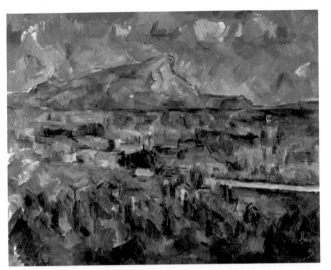

257

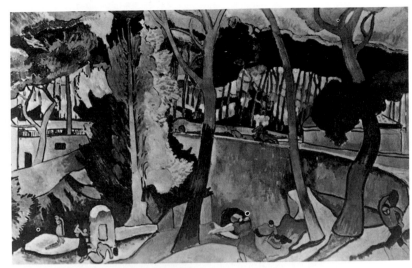

259

258

260

rhythmic structure and cosmic feeling which made some contemporary critics note important parallels between him and Cézanne.

The Mediterranean village of L'Estaque had drawn Cézanne years earlier, and now Derain depicted it in Fauve colors with an oriental simplification of forms and complexity of pattern.

The work of one of America's finest landscape painters, Winslow Homer, born in 1836 and thus a contemporary of the Impressionists, revealed little of that new European style. His careful observations of nature, however, and his understanding of outdoor color and light created an art that can be seen as an independent parallel to that of the Impressionists. In some of his late work, painted in his voluntary isolation on the rocky coast of Maine, he bestowed his own empathic understanding, often of man battling the elements. He gave pictorial form to the merging with nature's dynamic forces in a picture like *Kissing the Moon,* with its boldly balanced tensions among men, boat, waves, and sky.

256 Claude Monet. *Water Garden at Giverny (Pond with Waterlilies).* 1904. Oil on canvas, 35 $^1/_2$ × 36 $^1/_4$" **257** Paul Cézanne. *Mont Sainte-Victoire.* 1904–6. Oil on canvas, 25 $^5/_8$ × 31 $^7/_8$" **258** Ferdinand Hodler. *Eiger, Mönch, and Jungfrau in Moonlight.* 1908. Oil on canvas, 28 $^1/_8$ × 26 $^1/_8$" **259** André Derain. *L'Estaque.* 1906. Oil on canvas, 50 $^3/_8$ × 76 $^3/_4$" **260** Winslow Homer. *Kissing the Moon.* 1904. Oil on canvas, 30 × 40"

261

262

263

Maurice de Vlaminck, a painter who loved the substance of paint almost instinctively, reached Fauvism under the impact of Van Gogh. He worked with great spontaneity in a painting like *Landscape with Red Trees,* dominated by swirls and blocks of primary color.

Never as vehement or aggressive as Vlaminck, Braque nevertheless had worked in a Fauvist manner when a very young painter, but then he felt that such "internal fire cannot be sustained for long." His innate sense of form and structure manifested itself in paintings like *Houses at L'Estaque.* Instead of intuitive outpouring, color here serves in the creation of a coherent spatial structure which denies illusionist space. Greatly indebted to Cézanne, Braque organized houses and trees into faceted planes and stereometric volumes. It was pictures with this sense of geometry that caused the critic Louis Vauxcelles to speak of "cubical oddities" in 1909, thereby giving rise to the term "Cubism."

Two masters who were to become the leading abstractionists in the following decade painted landscapes of a very different mode in 1909. Piet Mondrian, having just abandoned more romantic Dutch landscapes and symbolic flower pieces, now adopts a Pointillist technique (see page 26) and paints *Dune III* in light, delicate color, simplifying forms and transforming the appearance of nature into an interwoven, allover surface texture which, however, transmits the organic vitality that he divined in the mysterious forms of nature's tranquillity.

264

The Russian Vasily Kandinsky was, like his Dutch contemporary, imbued with a romantic mysticism as well as the teachings of Eastern and Theosophist philosophy. His *Picture with an Archer* is a work of almost unbounded energy. Dynamic shapes are formed by dissonant colors which derive from the artist's fantasies and recollections. The horseman (surely a self-image of the artist) gallops wildly across the countryside, in which a huge cylindrical form suggesting the neck and head of a horse rears up and sets

the theme. Unlike Mondrian or Braque, who deduced their structure from nature, Kandinsky, now leader of the most advanced group of German artists in Munich, projected his own vision, experience, and emotions into the landscape—much as Kokoschka or Kirchner had in their portraits, or Nolde in his religious motifs. Kandinsky often spoke of the painter using his "inner eye" to follow the dictates of his "inner necessity."

261 Maurice de Vlaminck. *Landscape with Red Trees*. 1906. Oil on canvas, 25 $^{1}/_{2}$ × 32″ **262** Georges Braque. *Houses at L'Estaque*. 1908. Oil on canvas, 28 $^{3}/_{4}$ × 23 $^{5}/_{8}$″ **263** Piet Mondrian. *Dune III*. 1909. Oil on cardboard, 11 $^{5}/_{8}$ × 15 $^{3}/_{8}$″ **264** Vasily Kandinsky. *Picture with an Archer*. 1909. Oil on canvas, 69 × 57″

Three: The 1910s

It is impossible to understand the art of the war decade without understanding the nature of the cataclysm itself. The years 1910 to 1920 were years of war, turmoil, and revolution that permanently changed the face of Europe and the world. In a vivid report of the funeral cortege of King Edward VII, in May 1910, Barbara Tuchman describes the great procession in which nine kings rode magnificently into the morning from Buckingham Palace to Westminster Hall to the clangor of bells tolling from Big Ben, "but on history's clock it was sunset, and the sun of the old world was setting in a dying blaze of splendor never to be seen again."

When war would occur was merely a matter of timing; that war would come was inevitable. Treaties, alliances, intrigues, competition for new colonies, vast armies and navies, detailed plans for mobilization and military strategy by the major powers—all exerted inexorable pressures on the fragile tissue of what remained of world order. The Great War was preceded by smaller ones: Italy fought Turkey in 1911, the Balkan Wars occurred in 1912 and 1913. The Turkish Empire crumbled, and Austria-Hungary was in constant danger from internal separatist ambitions.

On June 28, 1914, the Archduke Franz Ferdinand, heir apparent to the Austrian throne, was assassinated by Serbian nationalists in the Bosnian town of Sarajevo. Austria delivered an ultimatum to Serbia to cooperate in tracking down the guilty and to cease its anti-Austrian activities. The reply from Belgrade, which had received assurances of support from Russia, was rejected by Austria. Emperor Franz Josef declared war on Serbia July 28. Within a week Russia, Germany, France, Belgium, England, and Turkey were embroiled in a war that most kings, prime ministers, diplomats, and generals thought would be over "before the leaves fall." While some leaders and a few intellectuals were apprehensive, and even Emperor Wilhelm felt anxiety about the mechanism he had helped set in motion, the masses in general were enthusiastic about going into battle for the honor of their countries against foreign aggression. Demon-

strations supporting the war took place in the streets of Berlin and London. Socialists everywhere in Europe, although urged by some of their leaders to respond to the declaration of war with a revolutionary strike, failed to do so because of the pressure of war psychology; instead they rallied to the support of their respective nations, especially after Jean Jaurès, a humanitarian and enlightened leader of the Second International, was shot by a young French superpatriot the day before France and Germany mobilized. Emperor Wilhelm II could proudly announce: "Henceforth I know no parties, I know only Germans." Comparable statements echoed throughout Europe.

Nobody knew what proportions the war would assume after Germany, until then a guarantor of Belgian neutrality, invaded that country to gain relatively easy access to Paris. There was public outrage throughout Europe over the violation of Belgium's neutrality. Concerned about the possibility of German domination of the Continent, England joined its ally, France, August 4. During the first weeks of the war the German armies made very rapid progress toward Paris and also managed to destroy a large part of Russia's military forces in East Prussia. But by autumn of 1914 the war had reached a stalemate at the Marne River. During 1915 all the powers—including Italy, which had decided to join the war on the side of the Allies—threw vast numbers of additional troops into the trenches. The struggle seemed endless and millions of Europeans died in battle. By the spring of 1917, partly provoked by Germany's unrestricted submarine warfare, the United States declared war on Germany, and mobilized its enormous resources of men and matériel. Although some American intellectuals and pacifists considered war itself, rather than imperial Germany, to be the great enemy of mankind, the United States' entry into the war was generally supported eagerly and enthusiastically by the people.

During that same year the German Reichstag had demanded an end to the hostilities, but this made little impact on Wilhelm and his generals. In March

1917 Czar Nicholas II was overthrown, and a "bourgeois" provisional government was established in Petrograd. In November 1917 the Communist Party, led by Lenin, in turn overthrew the provisional government and established the "dictatorship of the proletariat" which Karl Marx had forecast for the most developed industrialized countries. The new Soviet government, represented by Leon Trotsky, signed a truce with Germany, and soon after a peace treaty dictated by the Germans. But in view of constantly increasing casualties and clear indications that Germans were no longer willing to be killed, the Berlin government had to admit defeat in the summer of 1918; an armistice was signed in November.

President Woodrow Wilson had offered his Fourteen Points for armistice, including establishment of a League of Nations, in the utopian hope that the war would bring an end once and for all to international anarchy and national hostilities and assure a world system of peaceful coexistence among free, self-determining nations. Lenin, however, saw World War One as the final phase of capitalism and imperialism and the Soviet Revolution as the first step toward world revolution in which universal socialism would prevail. Indeed, for a brief period in 1919 soviet republics ("soviet" in the literal sense of "representative councils") were established in Bavaria and Hungary, but they were soon overthrown by right-wing nationalist forces. By the end of the decade a new society was being created in the Soviet Union, and a number of new nations, carved largely from the old Austro-Hungarian Hapsburg Empire, were created. A League of Nations with relatively little legislative and even less executive power was established. By conservative estimates, ten million soldiers had been killed in the war and another twenty million wounded. When the war ended, when armistices were declared, the old political order was reestablished throughout most of Europe—at least superficially. Yet on a deeper level, confidence in the doctrine of continuous progress had finally been shattered, and the balance of power throughout the world was to undergo fundamental change. In 1918 Oswald Spengler published a book in which he thunderously announced "the decline of the West."

The art of this decade of war and revolution can be seen only in relationship to these epochal events. If the Cubists' fragmentation of form might possibly be described as an analogue to the breakup of the old society and its order, it is certainly clear that Filippo Tommaso Marinetti's Futurist manifestoes, explosive eulogies on nationalism, technology, war, and revolution, were cogent prophecies of things to come. The Expressionists, greatly moved by Nietzsche's aggressive affirmation of life, had created a dynamic art of disharmony which eventually propelled them to complete abstraction from nature. During the years of war they also painted pictures presaging the oncoming catastrophe. At the war's end they joined together in an idealistic belief that painters and architects, writers and composers would bring about a better future of solidarity and human brotherhood under a socialism which would be removed from politics. During the war intellectuals including Albert Einstein, George Bernard Shaw, Bertrand Russell, Albert Schweitzer, Maxim Gorky, and Hermann Hesse had supported Romain Rolland, who issued humanistic pacifist messages from neutral Switzerland; in this period, too, a younger, more defiant, and highly aggressive group (who were to adopt the name Dada), convinced of the utter absurdity and madness of a society which could bring about its own annihilation, ridiculed arts and letters as well as politics. On the other hand, artists in the newly established Union of Soviet Socialist Republics—some of whom called themselves Constructivists—believed that their work and theories had forecast the political revolution. They joined in the new radical developments, reorganizing artistic life in Russia, creating vast projects in factories and streets, and bringing about an uneasy and short-lived rapprochement of the artistic vanguard with the Bolshevik forces—only to be disillusioned by the establishment of a rigid new bureaucracy.

Political Events	The Humanities and Sciences	Architecture, Painting, Sculpture
1910 Death of King Edward VII; George V succeeds to the British throne Japan annexes Korea Outbreak of the Mexican Revolution	Bertrand Russell and Alfred North Whitehead, *Principia Mathematica* Igor Stravinsky, *The Firebird* Richard Strauss, *Der Rosenkavalier* Victor Herbert, *Naughty Marietta*	Moscow: Jack of Diamonds exhibition Umberto Boccioni, Carlo Carrà, Luigi Russolo, Giacomo Balla, Gino Severini, *Technical Manifesto of Futurist Painting* Berlin: Der Sturm gallery and magazine founded
1911 War between Italy and Turkey Revolution in China; overthrow of the Manchus	Igor Stravinsky, *Petrushka* Nils Bohr and Ernest Rutherford, *Theory of Atomic Structure* Arnold Schoenberg, *Harmonielehre* Captain Roald Amundsen reaches the South Pole	Paris: Cubists exhibit in the Salon des Indépendants and Salon d'Automne Munich: First Blue Rider exhibition New York: Pablo Picasso exhibition at Alfred Stieglitz's Photo-Secession Gallery St. Petersburg: World of Art exhibition
1912 First Balkan War	Henry Ford introduces the assembly line in Detroit; beginning of the Second Industrial Revolution *Titanic* sinks after hitting an iceberg Thomas Mann, *Death in Venice* Benedetto Croce, *The Philosophy of the Spirit* (–1920)	Paris: Section d'Or exhibition; Italian Futurist exhibition Albert Gleizes and Jean Metzinger, *Du Cubisme* Munich: Second Blue Rider exhibition Vasily Kandinsky, *Concerning the Spiritual in Art* Cologne: Sonderbund exhibition Umberto Boccioni, *Technical Manifesto of Futurist Sculpture*
1913 Second Balkan War Peace Palace is inaugurated at The Hague Woodrow Wilson becomes U.S. president Ratification of the Sixteenth Amendment to the U.S. Constitution, permitting income tax	George Bernard Shaw, *Pygmalion* Edmund Husserl, *Ideas for a Pure Phenomenology and a Phenomenological Philosophy* Igor Stravinsky, *The Rite of Spring* D. H. Lawrence, *Sons and Lovers* Guillaume Apollinaire, *Alcools* Sigmund Freud, *Totem and Taboo* Marcel Proust, *Swann's Way*	Berlin: Herwarth Walden organizes the First German Autumn Salon New York: Armory Show Moscow: Mikhail Larionov issues the *Rayonist Manifesto* Guillaume Apollinaire, *The Cubist Painters*

	Political Events	The Humanities and Sciences	Architecture, Painting, Sculpture
1914	Panama Canal opens Assassinations of Archduke Franz Ferdinand of Austria and French Socialist Jean Jaurès Outbreak of World War One Battle of the Marne	Stefan George, *The Star of the Covenant* Charlie Chaplin, *Tillie's Punctured Romance*	London: Vorticist group formed Antonio Sant'Elia, *Manifesto of Futurist Architecture* Cologne: German Werkbund Exposition
1915	Italy joins the Allies in the war against the Central Powers German submarine sinks the *Lusitania*	D. W. Griffith, *The Birth of a Nation* Albert Einstein formulates the general theory of relativity	Moscow: Kasimir Malevich proclaims Suprematism San Francisco: Panama-Pacific International Exposition San Diego: World's Fair
1916	Battle of Verdun Death of Emperor Franz Josef of Austria	James Joyce, *A Portrait of the Artist as a Young Man* Carl Sandburg, *Chicago Poems* Sigmund Freud, *Introductory Lectures on Psycho-Analysis* (–1917)	Zurich: Dada is born, named, and displayed at the Cabaret Voltaire
1917	Abdication of Czar Nicholas II; provisional government established in Petrograd; Soviet Revolution led by Vladimir Ilyich Lenin U.S. enters the World War Worldwide influenza epidemic (–1919)	Sergei Diaghilev's Ballets Russes produces *Parade*—plot by Jean Cocteau, music by Erik Satie, choreography by Léonide Massine, set and costumes by Pablo Picasso T. S. Eliot, "The Love Song of J. Alfred Prufrock" William Butler Yeats, *The Wild Swans at Coole* Sergei Prokofiev, *Classical Symphony*	Amsterdam: Review *De Stijl* founded
1918	Armistice ends World War One Abdication of Emperor Wilhelm II; founding of the German Republic	Oswald Spengler, *The Decline of the West*	Paris: Purism is formulated by Le Corbusier and Amédée Ozenfant Berlin: November Group founded
1919	Peace treaty signed at Versailles German Constitution adopted at Weimar Leaders of the German left, Karl Liebknecht, Rosa Luxemburg, and Kurt Eisner, murdered Prohibition of alcoholic consumption in the U.S. (Eighteenth Amendment) ratified	Robert Wiene, *The Cabinet of Dr. Caligari* Ernest Rutherford splits the atom John Reed, *Ten Days That Shook the World* Abel Gance, *J'Accuse*	Weimar: Establishment of the Bauhaus, with Walter Gropius as director

The War I

265

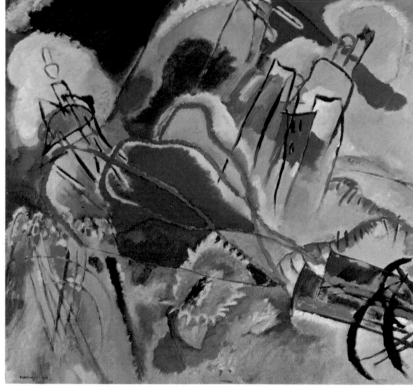

266

Especially in Germany painters in the years immediately preceding the war expressed their presentiments of the coming catastrophe. In Berlin in 1913 Ludwig Meidner painted apocalyptic cityscapes with distorted perspectives, compressed forms, and exploding earth and sky. The heaving streets, the toppling houses, all painted with a vehement brushstroke, evoke terror. These paintings, whose intensity indicated Meidner's admiration for Van Gogh, were strangely prophetic of the shelling and bombardments soon to occur. Many years later, at the end

of another world war, Berlin assumed an appearance not unlike Meidner's cityscapes of doom. During 1913 Franz Marc painted his large canvas *The Fate of the Animals* (plate 287), which, he noted later, was a "premonition of this war, horrible and stirring." Marc's friend, mentor, and collaborator in the Blue Rider (Blaue Reiter) group, Vasily Kandinsky, had moved toward almost complete rejection of representational form by this time, but in his *Improvisation 30 (Cannon), No. 161* a cannon and toppling houses make their appearance in a

painting that, he wrote later, "could probably be explained by the constant war talks going on throughout the year." Whereas Marc uses somber colors symbolically to carry his shattering message, Kandinsky's color exists independent of any narrative or allegorical meaning and flows freely throughout the painting. Marc retains the symbolic use of color when he departs almost entirely from objective painting, as in *Fighting Forms*. The canvas of dynamic red and dark-blue organic forms, engaged in primeval combat, is an abstract painting of war. This is one of

268

267 **269**

the spiritual paintings that Marc himself considered "timeless in the Indian sense, in which the living feelings shine in their purity." It is also one of his last paintings: he was killed near Verdun in 1916.

Among those associated with the Blue Rider group was the American painter Marsden Hartley, who had been sent to Paris in 1912 by Alfred Stieglitz, the great photographer and animator of modern art in America. Hartley discovered that the more intuitive art he found in Germany was closer to his artistic aim than the art he saw in France. Like the Blue Rider painters, he turned toward symbolic semiabstraction of bold and strident color as in his painting of the German military, in which he experimented with the letter and image, as did several fellow painters in this decade (see pages 172–73). *Portrait of a German Officer*, done at the outbreak of the war, incorporated the Iron Cross, flags, letters, numbers, targets, epaulets, military badges, and the German national colors, all locked together against a flat black background—a highly inventive and carefully structured painting.

265 Ludwig Meidner. *Burning City*. 1913. Oil on canvas, 26 $^1/_2$ × 31 $^1/_4$″
266 Vasily Kandinsky. *Improvisation 30 (Cannon), No. 161.* 1913. Oil on canvas, 43 $^1/_4$ × 43 $^1/_4$″ 267 Franz Marc. *Fighting Forms.* 1914. Oil on canvas, 35 $^7/_8$ × 51 $^3/_4$″ 268 Marsden Hartley. *Portrait of a German Officer*. 1914. Oil on canvas, 68 $^1/_4$ × 41 $^3/_8$″ 269 Marsden Hartley. *Military Symbols 3*. c. 1914. Charcoal, 24 $^1/_4$ × 18 $^1/_4$″

The War II

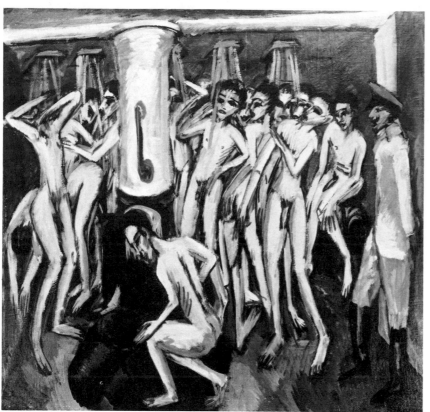

270

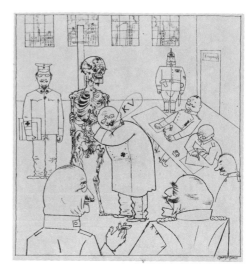

271

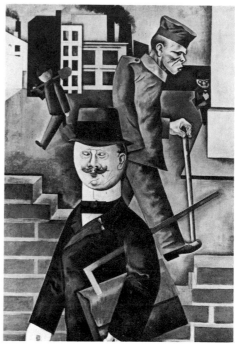

272

The malaise of military service is represented by Ernst Ludwig Kirchner's *Artillerymen*, in which a large number of emaciated naked men are pressed together in a small shower room under the surveillance of one of the officers. The painting expressed the extreme constraint and confinement of life in the barracks. A short time after his enlistment in the army, Kirchner suffered a complete nervous breakdown.

The postwar generation of German artists took a much more active and radical attitude toward the war experience. The most important of them was George Grosz, who, at least

in the early and most successful part of his career, regarded his art as a political weapon. In 1916–17 he made a highly effective series of drawings; one is *Fit for Active Service*, in which he depicted a fat army doctor, surrounded by various representatives of the German military, pronouncing a spectral skeleton as ready to move into the trenches. Here the artist uses a poignant angular line which pierces hypocrisy and corruption. A few years later he depicted the skeleton as a returned veteran, in the charge of a cross-eyed bureaucrat, with cane and briefcase.

Otto Dix presented both the un-

mitigated horror of war as well as its harvest: the cripples who populated the cities of Europe. These paintings by Dix and the related drawings of Grosz remain permanent memorials to the war. In Dix's *Matchseller* a man in his army cap, who has lost his eyesight—as well as his arms and legs—for the Fatherland, sits on the sidewalk, while well-dressed passers-by move quickly up and down the tilted pavement.

A very different political attitude was expressed early in the war by the Futurists, in Italy, who aggressively advocated its glory. Carlo Carrà's brilliant small collage *Patri-*

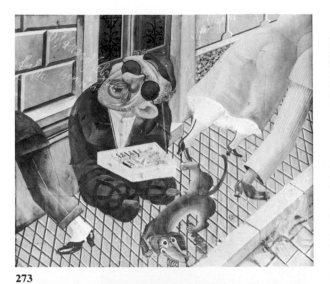

273

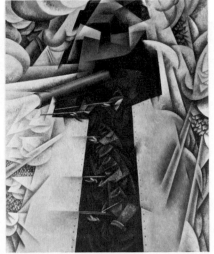

274

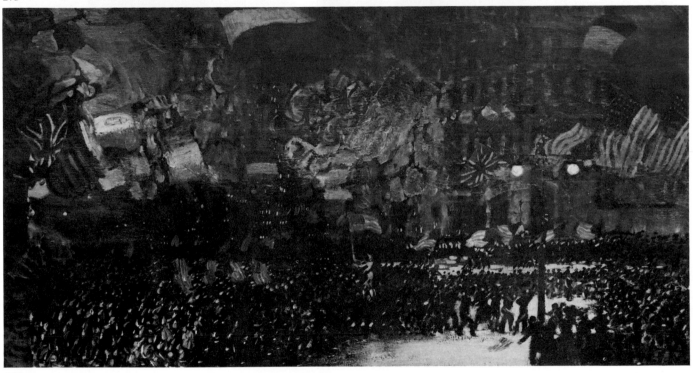

275

otic *Celebration* (see plate 400) is a powerful centrifugal vortex, freely using explosive words to shout out its message. As early as 1914, Carrà combined typography, painting, and collage into a successful unity. The flat pictorial surface is used to scream sounds and noises with a frankly propagandistic purpose in a work which is also entitled "Manifesto for Intervention." Similarly, Gino Severini's *The Armored Train* explodes Cubist form into a polemical painting of strangely stylized motion with a strong, clean palette depicting the war machine in emphatic action.

George Luks's *Armistice Night* is a much more illustrative and conservative painting. Luks, like many of his friends in the Eight, had begun his career as a newspaper artist, and this canvas is a realistic representation of the great armistice celebration in New York. But this bright, colorful, teeming picture also reflects some of the explosive nature of the new European painting that had been introduced to America by Alfred Stieglitz in his 291 Gallery in 1908 and received its most potent publicity with the Armory Show of 1913 in New York—an event that was to alter the form of art in America.

270 Ernst Ludwig Kirchner. *Artillerymen.* 1915. Oil on canvas, 55 $^1/_4$ × 59 $^3/_8$″
271 George Grosz. *Fit for Active Service.* 1916–17. Brush, pen, and ink, 20 × 14 $^3/_8$″
272 George Grosz. *State Functionary for the War Wounded (Gray Day).* 1921. Oil on canvas, 45 $^3/_8$ × 31 $^1/_2$″ 273 Otto Dix. *The Matchseller.* 1920. Oil on canvas, collage, 55 $^3/_4$ × 65 $^3/_8$″ 274 Gino Severini. *The Armored Train.* 1915. Oil on canvas, 46 × 34 $^1/_2$″ 275 George Luks. *Armistice Night.* 1918. Oil on canvas, 37 × 68 $^3/_4$″

Nudes

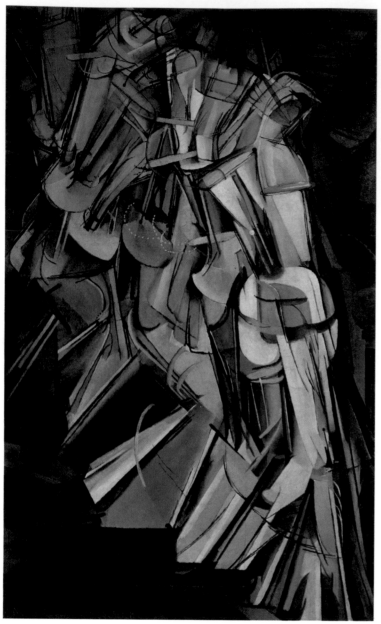

276

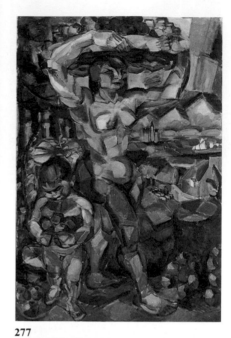

277

278

The painting that met with the most violent antagonism in this crucial exhibition was Marcel Duchamp's *Nude Descending a Staircase*. It became the focal point of the exhibition and was described as "an explosion in a shingle factory," among many other similar gibes by critics in this country who could not comprehend the new art coming from Europe. Duchamp used Cubist vocabulary, brought into dynamic action by a study of E. J. Marey's successive positions of a nude figure in motion superimposed on a single photographic plate. This resulted in a work that appears similar to what the Futurists were doing at precisely the same time in Italy (see page 130). It

was so radical that it had, in fact, been objected to by the more orthodox Cubists in the Paris Salon des Indépendants a year before the Armory Show. Duchamp's human machine is a far cry from the carefully structured nude by Henri Le Fauconnier entitled *Abundance*, painted two years earlier. Whereas the more form-conscious Cubists, Picasso and Braque, restricted their iconography to portraits, still lifes, and other aspects of daily life, Le Fauconnier's painting used some aspects of Cubist syntax for a very personal symbolic representation of a grand theme.

Le Fauconnier's concern with universal themes, as well as with color and light, were of great interest to

his German contemporaries. When Erich Heckel painted his finest nude in *The Glass Day*, he used angular planes of color and light to transform the surface of his painting into crystalline blue transparencies, enhanced by jagged orange and white forms. It is worth noting that his painting dates from the same period as the glass structures by Bruno Taut and Walter Gropius in Cologne (see plates 487 and 488), which were destroyed in World War Two. Otto Mueller's *Three Girls in a Forest* shares Heckel's angularity and a feeling of unity with nature where the nude becomes an integral and melodious part of the surrounding landscape. The German Expressionists rejected the idea

279

281

280

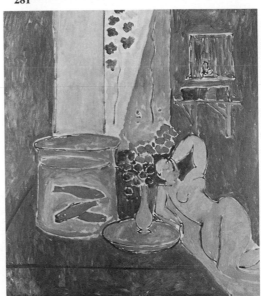

282

of painting the nude model in studio surroundings and, like the contemporaneous German youth movement, were prompted by a desire to achieve a close link, indeed a merging, with nature (see plate 287, Marc's *The Fate of the Animals*).

In contrast, *Girl in Black Stockings*, by the Austrian Egon Schiele, is a highly erotic, seductive being. The routine gesture of putting on the stockings again after lovemaking, the state of partial undress, the bent neck, are very provocative, yet Schiele's incisive line and the strong vertical shape contain his charged image within a severe pictorial form.

At the close of the decade, Picasso, the greatest innovator of the earlier

period, turned to a new classical formulation after a trip to Italy. It is exemplified in a large painting, *Two Seated Women*, in which there is a new emphasis on solid, plastic form that relates to the great European tradition, going back to Attic vase painting, Pompeian wall painting, and Roman sculpture, which creates strong works of deep human drama.

Matisse's *Goldfish and Sculpture* is a study of the nude, still life, and animal, combined harmoniously by the relationship of the sea greens—defining the objects in the center from doorway to the dish on the table—and the surrounding, pervasive blue. The reclining female is actually based on the terra-cotta

sculpture which was the original study for the master's *Blue Nude* (plate 236), but the stretched-out nude in this newly invented context gives the whole painting a sense of quiet contemplation.

276 Marcel Duchamp. *Nude Descending a Staircase, No. 2*. 1912. Oil on canvas, $58 \times 35''$ **277** Henri Le Fauconnier. *Abundance*. 1910. Oil on canvas, $75 \frac{1}{4} \times 48 \frac{1}{2}''$ **278** Erich Heckel. *The Glass Day*. 1913. Oil on canvas, $59 \frac{3}{8} \times 44 \frac{7}{8}''$ **279** Otto Mueller. *Three Girls in a Forest*. c. 1920. Oil and tempera on canvas, $48 \times 52''$ **280** Egon Schiele. *Girl in Black Stockings*. 1911. Gouache and pencil, $21 \frac{1}{2} \times 14 \frac{1}{2}''$ **281** Pablo Picasso. *Two Seated Women*. 1920. Oil on canvas, $76 \frac{3}{4} \times 64 \frac{1}{4}''$ **282** Henri Matisse. *Goldfish and Sculpture*. 1911. Oil on canvas, $46 \times 39 \frac{5}{8}''$

Animals

283

285

284

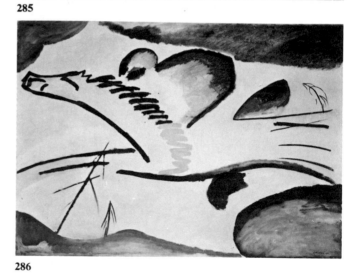

286

Filippo Tommaso Marinetti's *Founding and Manifesto of Futurism*, published on the front page of the Paris newspaper *Le Figaro* in 1909, proclaimed the Futurists' glorification of technology. When Futurists chose to paint animals, they often focused on their dynamic aspects. In Giacomo Balla's *Dynamism of a Dog on a Leash*, both dog and lady seem to have an abundance of fast-running feet. A year later in a much more ambitious work, Balla did a series of studies of the swooping flight of birds, among them *Swifts: Paths of Movement + Dynamic Sequences*. The whorls of the birds are recorded on this canvas as if by an oscilloscope that transcribes the

fluid rhythm of their rapid flight.

In contrast to the observed reality that is the subject of these paintings by Balla, Gino Severini's *Black Cat* is based on a story by Edgar Allan Poe about a drunkard who blinds his cat in one eye but suffers the vengeance of another cat. The drunkard's glass is depicted straightforwardly at the lower right, but the pervasive menace of the cats fills the upper canvas by means of Severini's use of Cubist planes that suggest numerous cats. In fact, although nominally a Futurist, Severini had close ties with the Cubists and with France (see page 130).

Kandinsky, a lover of horses since his youth in Russia, outlined the

body of a horse and rider in *Lyrical*. Only a few dynamic lines and some clear patches of intense color are needed to evoke the feeling of quick, energetic movement as horse and rider take a hurdle and sweep through the landscape. This was painted at a decisive moment in Kandinsky's life. He had just finished his pivotal essay *Concerning the Spiritual in Art* and was going through the painful and exhilarating process of approaching free pictorial expression independent of representation. *Lyrical*, in its hope and joyous optimism, stands in great contrast to the grand cosmic tragedy—*The Fate of the Animals*—painted two years later by the other Blue Rider, Franz Marc. In this large

287

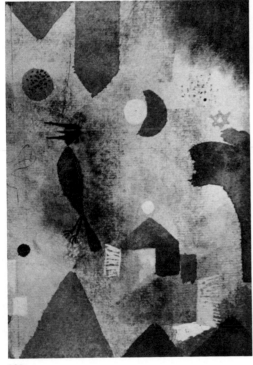

288

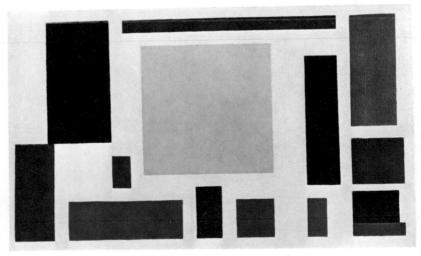

289

canvas Marc searched for a "pantheist empathy with the vibrations and flow of the blood of nature." He felt that by penetrating the soul of the animal this cosmic rhythm could be achieved. Marc had written "And All Being Is Flaming Suffering" on the back of the canvas, and this painting of violence, sacrifice, and death depicts a total and inescapable deluge. Marc completed this major work less than a year before the outbreak of the war that claimed his own life.

Marc's friend Paul Klee painted his *Trilling Nightingale* while he felt the confinement of military service. The bird above the mountain peak, the open door, the magic symbol of

the star made of two triangles, and the emphatic arrowlike form pointing to the nightingale, imply yearnings for liberation.

Unlike Klee, who used his bird as a vehicle for human feeling, Theo van Doesburg, colleague of Mondrian and with him leader of the Dutch De Stijl group, used a rational intellectual approach to his formal analysis. His *Composition (The Cow)* is the final stage in a series that began with a naturalistic sketch of a cow standing in profile, and culminated in this abstract reduction into rectilinear shapes of primary colors set at right angles to each other. Artists as different as Balla, Kandinsky, Marc, and Klee turned

to the theme of the animal in order to participate in the rhythmic flow of nature. Van Doesburg, on the other hand, postulates man's superiority to the irregular world of nature by his transcription into pure rectangular color forms.

283 Giacomo Balla. *Dynamism of a Dog on a Leash*. 1912. Oil on canvas, $35\,^5/_8 \times 43\,^1/_4''$ **284** Giacomo Balla. *Swifts: Paths of Movement + Dynamic Sequences*. 1913. Oil on canvas, $38\,^1/_8 \times 47\,^1/_4''$ **285** Gino Severini. *The Black Cat*. 1911. Oil on canvas, $21\,^1/_4 \times 28\,^1/_2''$ **286** Vasily Kandinsky. *Lyrical*. 1911. Oil on canvas, $37 \times 51\,^1/_4''$ **287** Franz Marc. *The Fate of the Animals*. 1913. Oil on canvas, $76\,^3/_4 \times 103\,^1/_2''$ **288** Paul Klee. *Trilling Nightingale*. 1917. Watercolor, $9 \times 5\,^3/_4''$ **289** Theo van Doesburg. *Composition (The Cow)*. 1916–17. Oil on canvas, $14\,^3/_4 \times 25''$

Portraits: Friends of the Artists

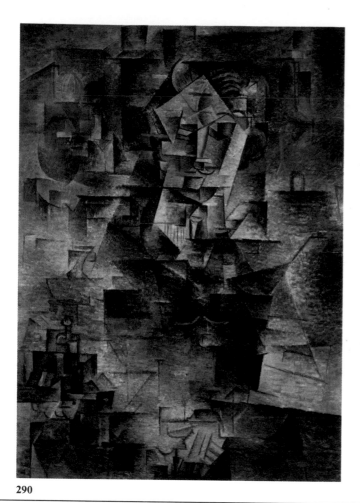

290

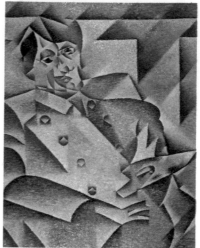

291

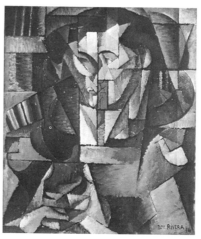

292

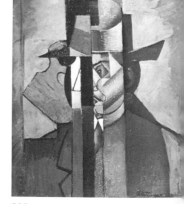

293

Picasso during his Cubist period dominated the revolution in pictorial space. He permanently altered the treatment of the human figure. Since *Les Demoiselles d'Avignon* in 1906–7 (plate 228), he had continued to reduce form to the interaction of planes on the picture surface. In the *Portrait of Daniel-Henry Kahnweiler*, his dealer and champion, he has further flattened volumes, leaving only the plane of the nose, the contour of the eye, the curve of the chin, and the gesture of the clasped hands to express the essence of the individual, who had sat twenty times for Picasso to achieve this portrait.

Picasso's younger Spanish colleague Juan Gris painted a *Portrait*

of Picasso, almost an homage to the master, in which he used many of the strategies introduced by Picasso around 1909. The painting combines aspects of the full face and profile of the sitter. The unique feature of Gris's portrait is his rigorous adherence to a preconceived geometric structure consisting largely of triangles and prisms.

Another foreign painter in Paris in the 1910s was the Mexican Diego Rivera. Long before he launched himself as a national muralist (see plates 625–627) Rivera steeped himself in the European tradition. In Paris he met the Lithuanian sculptor Jacques Lipchitz (plate 718), whom he portrayed in Cubist style,

with the typical simultaneous view of profiles and full face.

In 1912 Jean Metzinger and Albert Gleizes collaborated on the first theoretical explanation of the Cubist movement in their essay *Du Cubisme*, relating it to the concepts of relativity and simultaneity. In his portrait of Gleizes, by creating strong parallel vertical planes with a minimum of faceting, by retaining considerable volume in the face, and by paying relatively little attention to the background, Metzinger creates a painting that lacks both the vital tension of Picasso's portrait and the pure geometric structure of the work by Gris.

The Italian painter Amedeo Modigliani was in direct contact with the

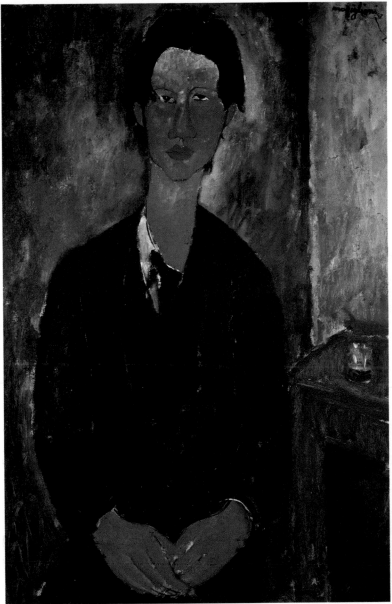

294

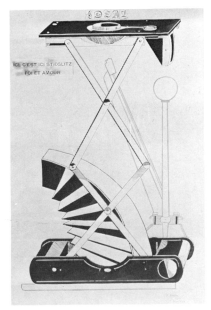

295

296

Cubist painters after his arrival in Paris in 1906, but we find little trace of their work in his personal style, which combined a Cézannesque palette with a Mannerist elongation of the figure, as exemplified in the portrait of his friend the painter Chaim Soutine.

After working with the Cubists for some time, and moving far toward total abstraction, Francis Picabia turned to creating imaginary machines as symbols to comment on men. In 1915 under the aegis of Alfred Stieglitz, Picabia, together with Duchamp and Man Ray, founded an American counterpart to the rebellious Dada group that was just beginning in Zurich. The Dadas' antiart beliefs led them to reject even the most advanced forms of painting and sculpture and to question the very nature of art; concept became more important than form. In *Ici, c'est ici Stieglitz (Here, This Is Stieglitz)* Picabia created an equivalent of the photographer by drawing a crazy broken camera. The sitter's great passion and hope for art is indicated by the word IDEAL (in German script), written over the camera-machine.

Portraiture reached its point of greatest abstraction in Jean Arp's Dada portrait of his Romanian friend Tristan Tzara, Dada leader and poet. Arp, like Tzara, had faith in the elements of chance and arbitrary configurations to make either art or poetry. Arp's painted collage reliefs may not have been entirely created at random but they are the outgrowth of his earlier Dada experiments (see page 167).

290 Pablo Picasso. *Portrait of Daniel-Henry Kahnweiler.* 1910. Oil on canvas, 39 ⁵/₈ × 28 ⁵/₈" **291** Juan Gris. *Portrait of Picasso.* 1912. Oil on canvas, 36 ³/₄ × 29 ¹/₄" **292** Diego Rivera. *Jacques Lipchitz (Portrait of a Young Man).* 1914. Oil on canvas, 25 ⁵/₈ × 21 ⁵/₈" **293** Jean Metzinger. *Portrait of Albert Gleizes.* 1912. Oil on canvas, 25 ¹/₂ × 24 ¹/₄"
294 Amedeo Modigliani. *Portrait of Chaim Soutine.* 1917. Oil on canvas, 36 ¹/₈ × 23 ¹/₂" **295** Francis Picabia. *Ici, c'est ici Stieglitz.* 1915. Pen, and red and black ink, 29 ⁷/₈ × 20" **296** Jean Arp. *Portrait of Tzara.* 1916. Painted wood relief, 18 ⁷/₈ × 18 ¹/₄"

297

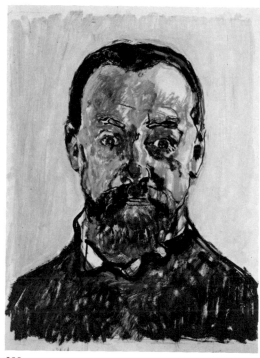

298

The *Manifesto of Futurist Painting*, drawn up in 1910, celebrated simultaneity of vision and the multiple appearances of the object in motion. Futurism was originally a literary movement; when it turned to the visual arts, the new vocabulary of Cubism best served its needs. And among the Futurists, Gino Severini, who had lived in Paris since 1906, was the closest to Cubism. His *Self-Portrait* of 1912 combined Cubist faceting with high ideals of dynamic motion essential to the aims of Futurism. Planes of the face project farther and farther toward the right side of the canvas, emphasizing continuous flux. The sweep of curves and the dynamic tilting of broken facial planes make a more direct appeal to the emotions of the viewer than the more formal geometric analysis in a painting such as Picasso's *Portrait of Daniel-Henry Kahnweiler.*

Similar as Cubist and Futurist portraits appear, the Cubists, pursuing an intellectual experiment, directed their energy to defining the essential features of reality on the two-dimensional picture plane, with relatively little concern about involving the viewer. But it was that involvement that was of primary importance to the Futurist painters and sculptors.

While these formal innovations were going forward, more conservative portraits remained an essential aspect of the art of this decade. The older Ferdinand Hodler, working in Geneva, became increasingly involved with his own countenance toward the end of his life. A final *Self-Portrait* shows a disturbed human being with great insight into his own appearance as well as psyche. Painted with a loose, amazingly vital brush, this self-image has an almost ritual stare and poignant expression of fright and anxiety.

The German Christian Rohlfs, who belonged to the generation born around the mid-nineteenth century,

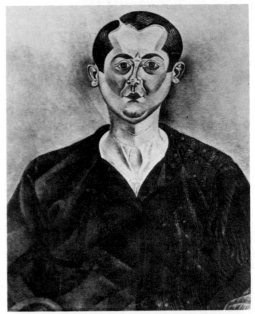

300

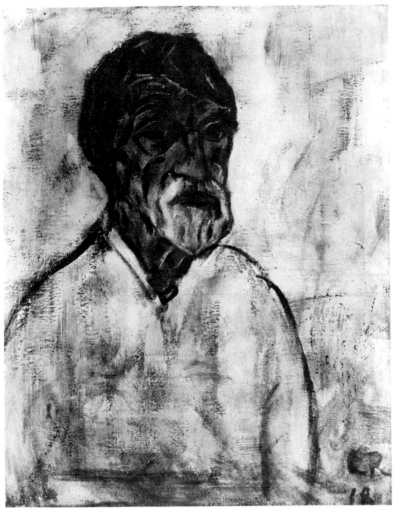

299 301

also came to a free expressive form toward the end of his long life. In 1918, nearly seventy, he painted a beautiful and curious *Self-Portrait* in which he seems more concerned with rendering the insubstantiality of his aging frame than in manifesting its presence. Using color and light in almost transparent fashion, he merged his body with the background, as the Cubists did, but in a completely different manner.

Joan Miró's early *Self-Portrait* flirts with Cubism in treating the planes of the face as discrete forms, but he diverges from the course favored by his fellow Spaniards Picasso and Gris and focuses on volumetric

aspects—in the forehead, the ears, the hollow of the neck. Yet in his mature style Miró became a master of the flat, nonvolumetric canvas with prime interest in the surface.

Thomas Hart Benton, later to become the leader of the American Regionalists, had gone to Paris in 1908. The forthright *Self-Portrait*, painted when he was twenty-three years old, demonstrates that the Missourian was not touched by the modernist aesthetics of Paris, although he toyed briefly with Cubism and Synchromism a few years later, before establishing his own conservative style (see plate 859).

297 Gino Severini. *Self-Portrait*. 1912. Oil on canvas, 21 $^5/_8$ × 18 $^1/_8$″
298 Ferdinand Hodler. *Self-Portrait*. 1917–18. Oil on board, 16 $^7/_8$ × 13″
299 Christian Rohlfs. *Self-Portrait*. 1918. Tempera on canvas, 28 $^2/_5$ × 22 $^2/_5$″
300 Joan Miró. *Self-Portrait*. 1919. Oil on canvas 301 Thomas Hart Benton. *Self-Portrait*. 1912. Oil and tempera on canvas, 31 $^1/_2$ × 22 $^3/_4$″

Portraits: Self-Portraits II

302

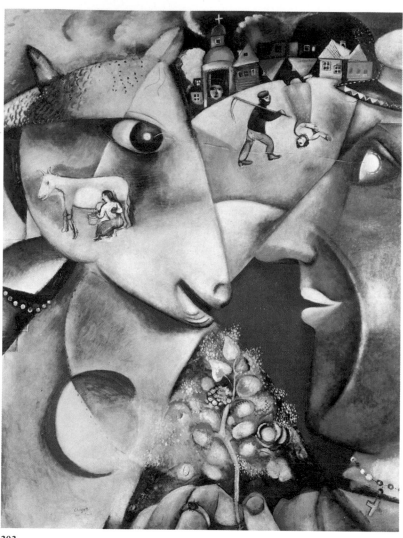

303

Oskar Kokoschka's *Self-Portrait* of 1913, with its large soulful eyes and expressive hands, is far less disturbing than his sculptured *Self-Portrait as a Warrior* of 1908 (plate 190), and far less emotion-laden than the painted portraits done in the preceding decade (see plate 207). In the 1913 *Self-Portrait* Kokoschka works in a freer, more spontaneous manner, in a less linear, more painterly style; at the same time he is more concerned with pictorial composition. A year later, using an even freer brushstroke, he painted a double portrait with Alma Mahler, *The Tempest (The Bride of the Wind)* (plate 351).

The self-portrait by Marc Chagall, *I and the Village*, is very different in kind. Chagall, a provincial Russian Jew, dwelled in a world of fantasy and visions. Obsessed by memory, custom, festival, object, he painted fables. When he arrived in Paris from St. Petersburg in 1910, Chagall became part of the ambience of Apollinaire, Modigliani, Soutine, Delaunay, and the Cubists. In *I and the Village* Chagall used concepts of fragmented, superimposed objects and intense, evocative colors. His combination of memory objects in a space out of context together with elements of expected reality anticipated the compositions of the Surrealists. The image of a woman milking a cow placed on the animal's jaw, the upside-down houses and woman, the mutually blank stares of cow and green man create a metaphysical poetry structured by centrifugal composition, triangles, circles, and resonant color. A few years later, in *Birthday* (plate 354), we see the painter coasting through the air to join and kiss his wife, Bella.

Chagall's Russia was far from Jawlensky's; the latter was born into the Russian nobility and grew up in a world of Russian Orthodox icons and Byzantine art. Among his numerous portraits is this one of him-

304

305

306

self in brilliant hues: the pink of the smock against the thickly impastoed blue of the background, the florid flesh tones of the large head, and the intense blue of the staring eyes. The head seems already to have burst the confines of the canvas and to be confronting the viewer.

Coming from a family whose patriarch died insane from syphilis in 1904, Egon Schiele doubted, feared, and explored his own sexuality in *Self-Portrait, Masturbating*. The repressive propriety of Viennese society that ironically also produced Sigmund Freud is exploded in this rapidly painted watercolor of a trancelike figure, almost shocking in

its rather calligraphic description of self-gratification.

The romantic tragedy of Modigliani's life in Paris is almost as well known as Van Gogh's life history. Both men were extremely productive despite their physical and mental problems, though Van Gogh left a far more substantial body of work. But Modigliani's portraits (see plate 294) create their own world of tranquillity and thoughtful assurance—a world far from the reality Modigliani knew.

302 Oskar Kokoschka. *Self-Portrait*. 1913. Oil on canvas, 32 $^1/_8$ × 19 $^1/_2$″ **303** Marc Chagall. *I and the Village*. 1911. Oil on canvas, 75 $^5/_8$ × 59 $^5/_8$″ **304** Alexei Jawlensky. *Self-Portrait*. 1912. Oil on cardboard, 21 $^1/_4$ × 19 $^5/_8$″ **305** Egon Schiele. *Self-Portrait, Masturbating*. 1911. Pencil and watercolor, 18 $^1/_2$ × 12 $^1/_4$″ **306** Amedeo Modigliani. *Self-Portrait*. 1919. Oil on canvas, 39 $^3/_8$ × 25 $^3/_8$″

307

308

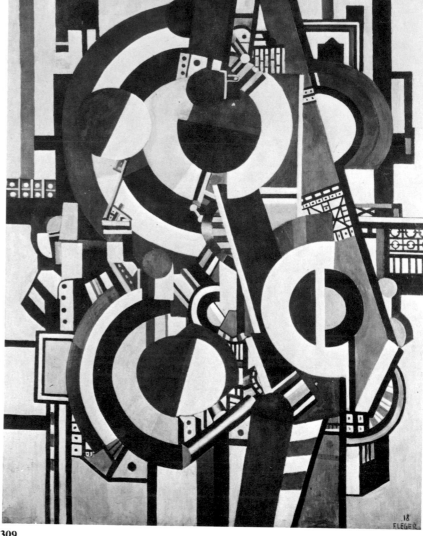

309

The machine became an object of fascination to artists of the war decade. Duchamp's Dada attitude of visualizing the machine as a sexual apparatus was shared by his friend Picabia in a splendid work, *Amorous Procession*, painted while he lived in New York. During this time Picabia —who was in close contact with Alfred Stieglitz, publisher of *291*— began to publish his own lively Dada periodical, which he entitled *391*. *Amorous Procession*, an effective, loose-jointed machine with sexual overtones of male and female devices, was undoubtedly inspired by Duchamp's *Large Glass* (plate 323). Very similar in feeling is *Machine*, by Morton Schamberg. This Philadelphia artist was among the group attracted to the work of the Europeans Duchamp and Picabia, but Schamberg's painting is much more abstract than their work, more concerned with formal values, and in certain aspects rather closely akin to Fernand Léger's *The Disks*, a painting that shows the artist's admiration of purity and of the precision of engineering feats and smooth surfaces. In it he achieves a mechanistic lucidity in oil on canvas.

It was, of course, the Futurists who idolized the machine: Luigi Russolo's *Dynamism of an Automobile* is certainly a highly visionary painting of the energy of speed, at considerable variance with the actual velocity automobiles could attain in 1911. Russian painters were quick to pick up the Futurist message, as is evident in Natalia Goncharova's *Dy-*

310

311

312

namo Machine of 1913. In England a small group of artists also set out to blast the past and gave the name *Blast* to their magazine. Drawing their inspiration from technology, they extolled the machine as the essence of modern life. The American poet Ezra Pound found a name for his radical and rebellious friends—the Vortex—and he became the Vorticists' acute critic and vociferous spokesman. Wyndham Lewis, the painter, writer, and strident propagandist, was the leader of the group,

which, in spite of its great debt to Italian Futurism, claimed that the "Modern World is due almost entirely to Anglo-Saxon genius." Lewis's small *Composition*, done in pencil, ink, and watercolor on paper, has the scale of a monumental work. It affirms the power and promise of the technological age with a dynamic diagonal thrust, whereas Léger's *Disks* displays a balanced sense of clarity and structure.

307 Francis Picabia. *Amorous Procession (Parade Amoureuse)*. 1917. Oil on canvas, 38 × 29″ **308** Morton L. Schamberg. *Machine*. 1916. Oil on canvas, 30 $^1/_8$ × 22 $^3/_4$″ **309** Fernand Léger. *The Disks*. 1918. Oil on canvas, 94 $^1/_2$ × 71″ **310** Luigi Russolo. *Dynamism of an Automobile*. 1913. Oil on canvas, 41 × 55 $^1/_2$″ **311** Natalia Goncharova. *Dynamo Machine*. 1913. Oil on canvas, 41 $^3/_4$ × 34 $^1/_4$″ **312** Wyndham Lewis. *Composition*. 1913. Pencil, ink, and watercolor, 13 $^5/_8$ × 10 $^3/_8$″

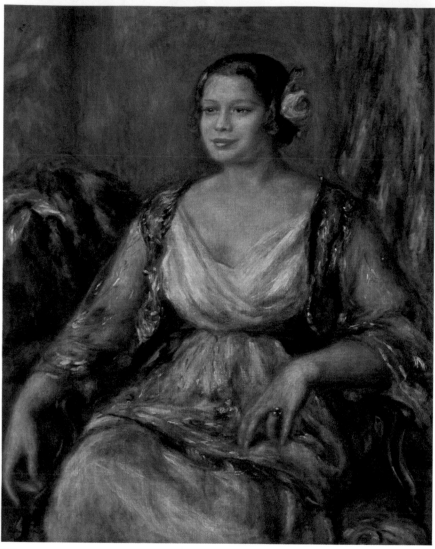

313

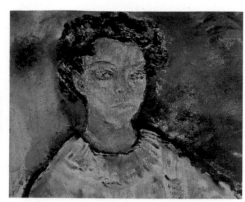

314

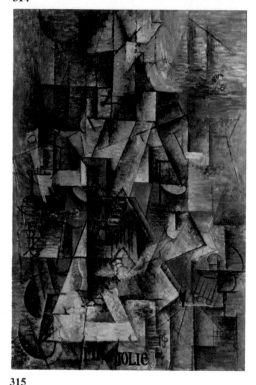

315

The year that World War One started, Auguste Renoir, aged seventy-three, having left Impressionism far behind, painted a portrait in the old European tradition. His *Tilla Durieux* retains his mastery of color and shimmering surface. This remarkable woman, who was then the wife of the Berlin art dealer Paul Cassirer and ended her life as an active leader of the Resistance in Yugoslavia during World War Two, had been portrayed only four years earlier by the young Oskar Kokoschka in one of his most incisive and intensely poignant personal statements.

Three years before Renoir's traditional portrait, Picasso painted "*Ma Jolie*," a portrait belonging to a new classical form (e.g., Cubism) that to a great extent replaced the older tradition of which Renoir was still a part. Basically the structure, the luminosity, the fragmentation of form of "*Ma Jolie*" are similar to Picasso's contemporaneous *Portrait of Daniel-Henry Kahnweiler* (plate 290), and like his friend's portrait, "*Ma Jolie*" takes more time, more energy, to interpret than Renoir's work. The viewer is encouraged to decipher the forms, and he finishes by experiencing a new kind of autonomous ordered structure.

Even less easy to "read" is Picabia's portrait of the *Fille Née sans Mère* (*Girl Born without a Mother*). Although the curvaceous forms of the drawing suggest a female, Picabia was probably not thinking of direct visual associations, since another work with this title done the next year consists chiefly of a large circular gear. Rather, the fertile, creative possibilities of the machine are apparently what Picabia is celebrating here—although it has been suggested that his departure point may have been alchemy, or Genesis (Eve's creation without a mother), or miraculous births in Greek mythology (such as Athena's from Zeus's forehead).

In 1912 Fernand Léger painted the monumental *Woman in Blue*, which works toward a synthesis of the figure and its surroundings. Like

316

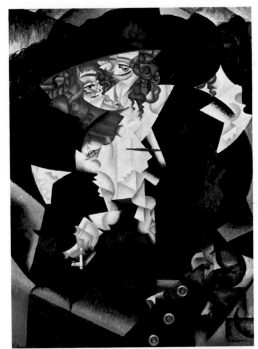

318

317

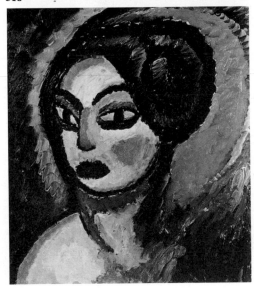

319

"*Ma Jolie*," Léger's woman is centered geometrically on a vertical axis. Whereas Picasso used transparent forms against a defined backdrop, Léger opens up the space entirely so that the viewer's eyes penetrate the fragments of the body. Because of the fluidity of space and objects in the composition, the spectator becomes aware of the passage of time through the form. Picasso worked primarily with chiaroscuro; Léger reintroduced a world of bright and luminous color.

Severini's *Portrait of Madame M. S.*, also painted in 1912, uses the vocabulary of Cubism, as did his *Self-Portrait* (plate 297). Superficially he conveys movement by means of

constantly shifting lines and planes. It is precisely this dynamic structure that saves this portrait, with its big eyes, ringlets of hair emerging from the large floppy hat, and little lap dog, from becoming merely an expression of sentimentality.

Jawlensky's portrait of the opera heroine *Princess Turandot*, done soon after his *Self-Portrait*, discloses another side of his personality. Instead of the scowling directness of his own portrait, he depicts here an unapproachable, flawless female, with mysterious, heavily rimmed eyes reminiscent of those in Byzantine mosaics and the bold, willful lips of a royal personage. This is a work of luxuriant fantasy.

313 Auguste Renoir. *Tilla Durieux*. 1914. Oil on canvas, 36 $^1/_4$ × 29″ **314** Oskar Kokoschka. *Tilla Durieux*. 1910. Oil on canvas, 22 × 25″ **315** Pablo Picasso. *"Ma Jolie" (Woman with a Zither or Guitar)*. 1911–12. Oil on canvas, 39 $^3/_8$ × 25 $^3/_4$″ **316** Francis Picabia. *Fille Née sans Mère (Girl Born without a Mother)*. c. 1915. Pen and ink, 10 $^3/_8$ × 8 $^1/_2$″ **317** Fernand Léger. *Woman in Blue*. 1912. Oil on canvas, 76 $^3/_8$ × 51″ **318** Gino Severini. *Portrait of Madame M. S.* 1912. Oil on canvas, 36 $^3/_8$ × 25 $^3/_4$″ **319** Alexei Jawlensky. *Princess Turandot*. 1912. Oil on canvas, 23 $^3/_8$ × 20 $^3/_8$″

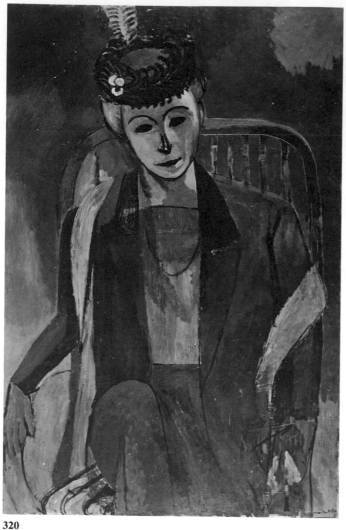

320

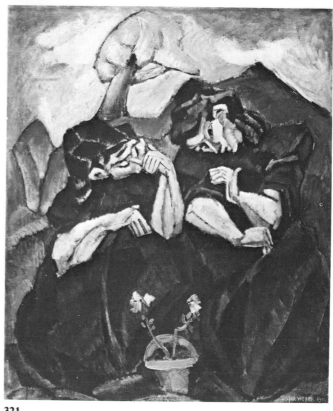

321

Henri Matisse combines an innate sense of structure and color in his beautiful *Portrait of Madame Matisse*. After returning from his second visit to Morocco, he made this portrait of his wife, seated serenely in a green garden chair. It was painted with extraordinary care—the result of more than a hundred sittings. Although her face is a gray mask, the features are exceedingly warm and understanding. In 1908 Matisse wrote that "what interests me most is neither still life nor landscape, but the human figure. It is through that, that I best succeed in expressing the almost religious feeling I have toward life." Here he succeeded in identifying with the model and in creating a portrait of exquisite harmony and balance, achieved through his intuitive sense of painting.

The dominant dark blues and greens of this picture also occur two years earlier in Max Weber's *The Geranium*. This Russian-born American painter went to Paris in 1905, became a friend of Henri Rousseau, enrolled in Matisse's short-lived private art school, and also became familiar with the aims and techniques of the Cubists. Weber, a member of the Stieglitz circle, was one of the prime figures to introduce the new formal discoveries of Paris to New York. In this painting of two

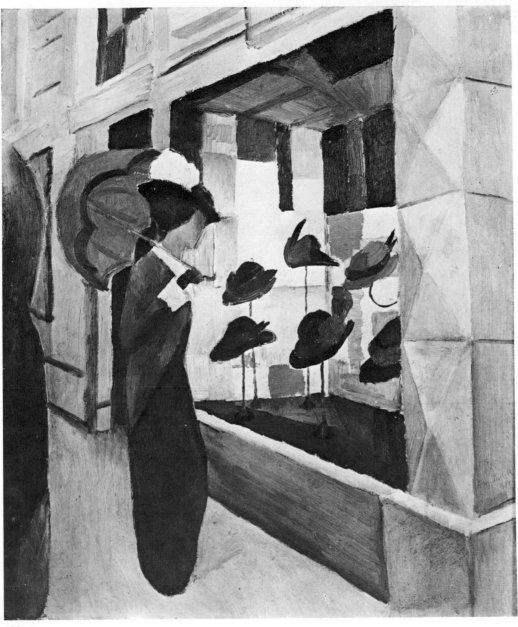

322

women a sense of color harmonies derived from his study with Matisse is combined with a Cubist breakup of forms and a pictorial coherence relating to Cézanne. Despite its eclectic nature, however, *The Geranium* has a highly personal, wistful aura of solitude and tragedy.

The German August Macke, in contrast, painted a series of pictures of pure coloristic joy. Macke, a member of the Blue Rider group, was fascinated by his friend Robert Delaunay's experiments with pure color relationships. Often his subjects—such as the typical *Woman Looking in a Shop Window*—were related to Impressionism, and frequently he partially dissolved his forms into bright color patches. He achieved numerous paintings of lyrical enchantment before being killed in the war in September of 1914.

320 Henri Matisse. *Portrait of Madame Matisse*. 1913. Oil on canvas, 57 $^5/_8$ × 38 $^9/_{16}$″ **321** Max Weber. *The Geranium*. 1911. Oil on canvas, 39 $^7/_8$ × 32 $^1/_4$″ **322** August Macke. *Woman Looking in a Shop Window*. 1912. Oil on canvas, 41 $^7/_8$ × 32 $^1/_2$″

Women III: Duchamp

323

324

When Marcel Duchamp painted *The Passage from Virgin to Bride* in Munich in the summer of 1912, he moved even further away from the formal considerations of his Cubist friends than he had in *Nude Descending a Staircase*, painted earlier that year. In *The Passage* he rejected the stroboscopic effect of the passage through space and time and was concerned with the psychological changes of a humanoid mechanical being energized by sexual passion. The passage from the virgin to the bride is simultaneously morphological and mechanical; it is a visceral love machine, and the conversion takes place in a labyrinthine chemical—or rather alchemical—laboratory.

Soon thereafter Duchamp resolved that painting had reached an impasse. He decided that the intellectual aspect, the artist's concept, was of greater import than what a painter might make with hand and brush in an attempt to appeal to the viewer's eye rather than to his mind. Duchamp had exhibited his readymades (see plates 459 and 471), and then embarked on a most original and significant painting of a woman—if it can be said to represent a woman. *The Bride Stripped Bare by Her Bachelors, Even* is a huge composition (almost ten feet high) in oil paint, lead foil, quicksilver, and dust, on glass. It was largely worked out in written notes and studies, begun in

Munich in 1912. He started painting on the glass in New York in 1915 and had completed most of the work by 1918, when it was sold; he continued working on it until 1923, when he felt that it needed no further work. When it was first exhibited, in Brooklyn in 1926, it was shattered into its present symmetrical arcs. Ten years later it was pieced together by the artist and installed in the library of Katherine S. Dreier, founder of the Société Anonyme.

The Large Glass, as it is usually referred to, is an enigmatic and mysterious work; Duchamp compiled elaborate notes that are of some help in deciphering its esoteric meaning. The upper half of the glass is "the

325

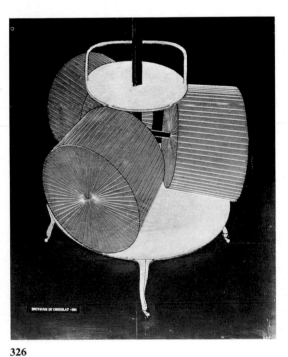

326

Bride's Domain," and the stripped but inviolate rosy pink lady ("a sex cylinder") hangs on the upper left in her "last state . . . before orgasm which may bring about her fall."

To her right is a very complex mechanism of a "triple cipher," surrounded by the Milky Way. While her realm is essentially organic, the Bachelor Apparatus in the lower half is primarily mechanical. The "fat and lubricious" Bachelors themselves are on the left as Nine Malic Molds (or Eros's Matrix); there are nine Capillary Tubes, a Chocolate Grinder, and a Chariot or Glider, as well as various symbols alluding to male sexuality and frustration. The transparent disks on the

right are three Oculist Witnesses, relating to voyeurism and the visual puns of the artists. Most of these individual images are based on earlier paintings and studies for this major work—in which the Bride hangs inviolate in her sphere, while the Bachelors must grind their chocolate in the world below.

Years later, in his *Green Box* of 1934, a literary adjunct of explanatory notes on *The Large Glass,* this master of irony and wit, perhaps the century's most innovative artist, called the glass "A Hilarious Painting." He also realized that he had created a myth in *The Large Glass,* saying, "In general, the picture is an apparition of an appearance."

323 Marcel Duchamp. *The Large Glass (The Bride Stripped Bare by Her Bachelors, Even).* 1915–23. Oil, lead foil, and quicksilver on plate glass, 109 $^1/_4$ × 69 $^1/_4$." 324 *The Large Glass* in Katherine S. Dreier's library, c. 1937 325 Marcel Duchamp. *The Passage from Virgin to Bride.* 1912. Oil on canvas, 23 $^3/_8$ × 21 $^1/_4$." 326 Marcel Duchamp. *Chocolate Grinder, No. 2.* 1914. Oil, thread, and pencil on canvas, 25 $^9/_{16}$ × 21 $^1/_4$."

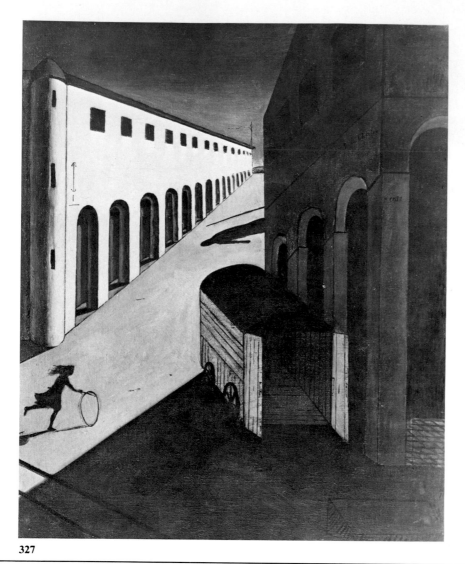

327

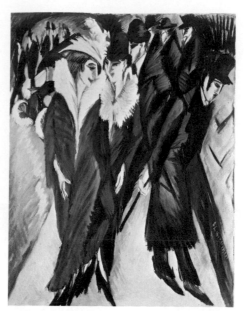

328

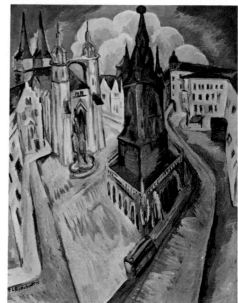

329

Giorgio de Chirico took a totally different approach toward apparition and appearance. In *The Melancholy and Mystery of a Street* he depicted an inexplicable fantasy of Renaissance architecture, menacing buildings receding dramatically into the distance, silent spaces invaded by dark and haunting shadows in an unidentifiable city square. We are never certain about the source of shadow and substance in this painting; at first it seems realistic enough, but ultimately it becomes an image of perplexity.

Ernst Ludwig Kirchner, like de Chirico, was greatly impressed by Nietzsche, and both painters were absorbed with the irrational in human nature, but their expressions of this aspect of the psyche took entirely different forms. In Kirchner's 1913 painting of the city, *Street, Berlin*, thin, angular figures are crowded into a space where they convey a sense of total alienation, an inability to establish any kind of reciprocal relationship. Five years earlier, Kirchner had painted another picture of a street, in Dresden (see plate 251), in which his clashing colors and distorted perspective produce a highly disturbing composition that relates this painting closely to Edvard Munch. But in the 1913 work, as in the 1915 *Market Place with Red*

330

Tower, the curvilinear forms of his earlier painting have given way to elongated, pointed forms with hatched strokes that express Kirchner's undefined fears, his antagonism to technology and urban life.

For Fernand Léger the city, like the machine, was a place for celebration. In *The City* each part becomes a geometric architectural unit whose interplay of complementary and contrasting lines is beautiful in itself and gains further meaning from an overriding formal relationship. To Léger the city was a jubilant unity of motion, color, space, and volume. He used Cubist vocabulary for a grand theme to relate modern man to modern technology in a new structured order.

327 Giorgio de Chirico. *The Melancholy and Mystery of a Street*. 1914. Oil on canvas, 34 $^1/_4$ × 28 $^1/_8$" **328** Ernst Ludwig Kirchner. *Street, Berlin*. 1913. Oil on canvas, 47 $^1/_2$ × 35 $^7/_8$" **329** Ernst Ludwig Kirchner. *Market Place with Red Tower*. 1915. Oil on canvas, 47 $^1/_2$ × 35 $^7/_8$" **330** Fernand Léger. *The City*. 1919. Oil on canvas, 91 × 117 $^1/_2$"

331

333

332

334

Although the Futurists virtually made a cult of technology, Umberto Boccioni turned to gigantic lunging horses rather than machines to indicate the energy of the life of the city. In *The City Rises* he attempted, as he wrote, a "great synthesis of labor, light, and movement." The unification of action with environment, the relentless activity of the city, the aggressive movement that suppresses individuality are achieved by a painting using deliberately nonrealistic devices: the light and space do not duplicate actual conditions, and forms are built of dots of color applied in a technique known as Divisionism or Pointillism (see page 26).

The city could also serve as a theatrical backdrop, as New York City did for a patriotic parade in Childe Hassam's lively canvas. *Allies Day, May 1917* is related closely in style and subject to Luks's *Armistice Night* (plate 275). Although Hassam's techniques were largely derived from the nineteenth-century Impressionists, there is an understanding of modernist distortion in his skewing of perspective to focus on the flags dwarfing the people on the street below.

Most other American painters of the city—which usually meant New York—were still working in a conventional vein, as John Sloan did in his painting of elevated trains, *Six o'Clock*. An exception was Joseph

Stella, a painter born in Italy but brought up in the United States, who painted a startling Futurist canvas, *Battle of Light, Coney Island*, in 1913. With its exploding color shapes, radiant primaries juxtaposed against their complementaries, it is a painting whose energy literally dazzles the eyes. It is more linear than Boccioni's paintings, and its pattern is also more explicit. Stella captures movement in a kaleidoscope of shifting color, and seems to freeze it for a brief moment.

Lyonel Feininger uses Cubist analysis of form for his paintings of medieval cities. A yearning for the past is rendered with the most modern sensibility; churches like the

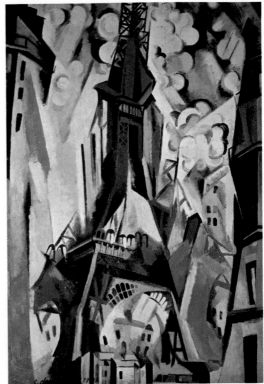

336

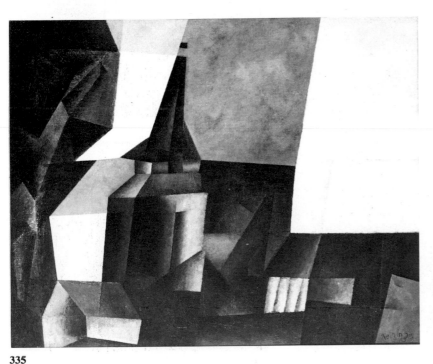

335

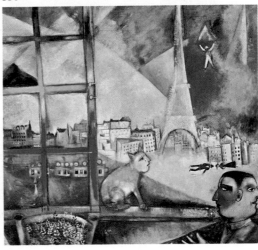

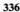

337

one in *Zirchow V* are faceted into semitransparent geometric planes. "My Cubism," he wrote, "is visionary, not physical."

A counterpart is Robert Delaunay's *Eiffel Tower*. The Eiffel Tower, a controversial but most eloquent symbol of technological aspiration, was only twenty years old at the time, but for Delaunay it became "the barometer of my art." Delaunay's tower, which is orange (the color it was painted originally), is penetrated by rays of light, and it interacts dynamically with the surrounding buildings.

Eiffel Tower is a celebration of modern art and modern life. It is also a determined visual analysis of

successive movement, which gives vivid energy to the painting. How different the Eiffel Tower appears in Marc Chagall's *Paris through the Window*! The lyrical dream of Chagall's personal vision challenges the concern with dynamic form that moved the Futurists and Delaunay. Yet clearly Chagall had absorbed many lessons from avant-garde art, including Delaunay's research into the optical reinforcement of contrasting colors when placed next to each other; but in Chagall's world it all becomes a mystical rainbow—a symbolic picture with floating figures, a humanoid cat, the double visage of a man, an upside-down train, and a flowering chair.

331 Umberto Boccioni. *The City Rises.* 1910. Oil on canvas, 72 $^1/_2$ × 118 $^1/_2''$ **332** Childe Hassam. *Allies Day, May 1917.* May 17, 1917. Oil on canvas, 36 $^3/_4$ × 30 $^1/_4''$ **333** John Sloan. *Six o'Clock.* c. 1912. Oil on canvas, 26 × 32" **334** Joseph Stella. *Battle of Light, Coney Island.* 1913. Oil on canvas, 75 $^3/_4$ × 84" **335** Lyonel Feininger. *Zirchow V.* 1916. Oil on canvas, 31 $^7/_8$ × 39 $^5/_8''$ **336** Robert Delaunay. *Eiffel Tower.* 1910–11. Oil on canvas, 77 × 50 $^3/_4''$ **337** Marc Chagall. *Paris through the Window.* 1909–11. Oil on canvas, 52 $^3/_8$ × 54 $^3/_4''$

The City III: Brooklyn Bridge

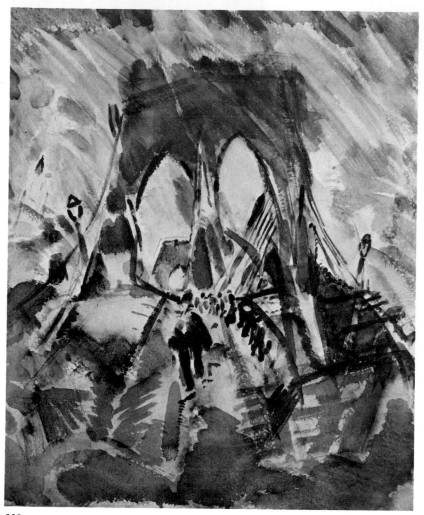

338

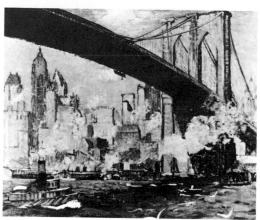

339

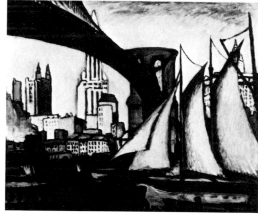

340

National traditions still prevailed in the early part of this century: de Chirico found his artistic sources in the Italian art of the past (and we think of such an artist as Piero della Francesca as a prime source of inspiration), Kirchner—as he stated—had great admiration for Lucas Cranach and the German tradition, and Léger's sense of lucid form and rational geometry had its precedents in the great French tradition of Nicolas Poussin and Jacques-Louis David.

Americans did not feel that they had such traditions to fall back on.

John Marin, the most famous of the artists clustered around Alfred Stieglitz, had gone to Paris early in the century and absorbed many of the major directions of French art from Impressionism to Cubism. In 1910, like several other painters of the time, he turned his attention to the subject of the Brooklyn Bridge. This great suspension span, designed by John Roebling in 1868 and completed in 1883, was a technical feat that evoked feelings similar to those inspired by the Eiffel Tower. But whereas more conservatively inclined artists—noted in their time—such as Leon

Kroll and Samuel Halpert remained faithful to its visual appearance and painted the bridge with ferry boats under it against the backdrop of the Manhattan skyline, John Marin visualized it as a powerful energetic phenomenon in an Expressionist picture. When it was exhibited in his first one-man show at 291, he wrote: "I see great forces at work; great movement; the large buildings and the small buildings. . . ."

The energy of the city, the traffic that is part of its environment, and the complex pattern of the bridge itself were painted by Joseph Stella

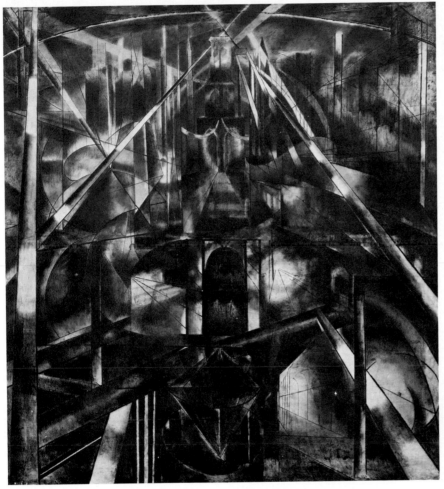

341

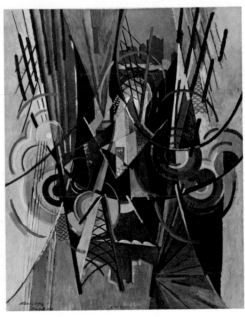

342

in an affirmative ode to the bridge as machine. His *Brooklyn Bridge* consists of shifting planes, luminescent perspective, and vibrating rhythm, resulting in a subjective painting that fuses light, color, and line into an agitated totality. It may well have been among the sources that inspired the poet Hart Crane in 1930 to write his resounding, visionary poem, *The Bridge.*

The French artist Albert Gleizes painted the bridge during a visit to New York in 1917, and his somewhat didactic painting corresponds to his purpose of situating the organism of the city in a social and humanitarian

context. The visual reality of his *On Brooklyn Bridge* is a delicate balance of flattened planes, suggesting depth through the device of overlapping shapes and the ribbon of continuity provided by his linear structure. The disklike shapes attest to his admiration for Delaunay's work, which he extolled in 1913, stating that he "defined the goal of Cubism." By this time Gleizes had also adopted Delaunay's brilliant Orphist color schemes.

338 John Marin. *Brooklyn Bridge.* 1910. Watercolor, 18 $^1/_2$ × 15 $^1/_2$″ **339** Leon Kroll. *The Bridge.* 1911. Oil on canvas, 40 × 50″ **340** Samuel Halpert. *Brooklyn Bridge.* 1913. Oil on canvas, 34 × 42″ **341** Joseph Stella. *Brooklyn Bridge.* 1917–18. Oil on canvas, 84 × 76″ **342** Albert Gleizes. *On Brooklyn Bridge.* 1917. Oil on canvas, 63 $^3/_4$ × 51″

Dancers I

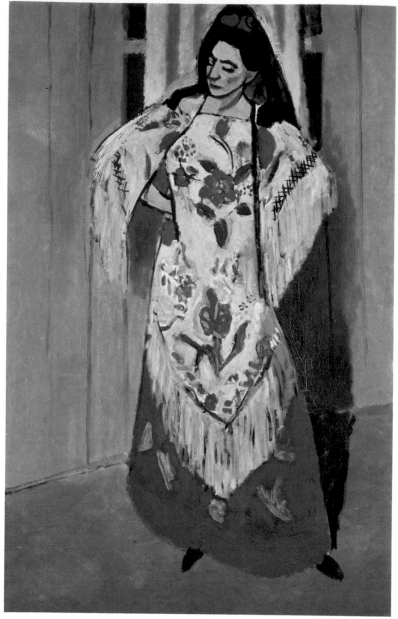

343

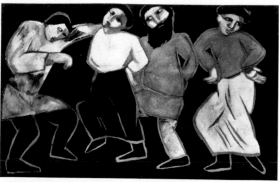

344

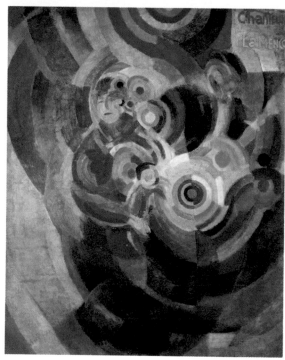

345

Movement was a significant theme for painters of this decade—movement not only in the city and its activities but also in the ballet and other dance. Henri Matisse had completed his great mural *The Dance* in 1909 (see plate 229), and in 1911 he did a much more intimate painting of a dancer, *The Manila Shawl*. Madame Matisse posed for this picture of a somewhat stilted figure placed slightly off center in a narrow vertical space of a purple floor and blue wall. The woman is painted without modeling and has a rather flat appearance. The work was painted after Matisse made a trip to Moscow, where he studied Russian icons, and after his first journey to Morocco—hence the use of extremely opulent colors. Matisse had written in 1908: "When I have found the relationship of all the tones, the result must be a living harmony of tones, a harmony not unlike that of a musical composition."

In 1909 Sergei Diaghilev, who had originally brought the beauty of Russian icons to the Western art world's attention, opened his Ballets Russes in Paris. Eventually this company was to attract some of the finest artists of its time to do sets and costumes. Like Diaghilev, Natalia Goncharova was greatly interested in Russian icon paintings, their brilliant color range and ornamental quality. *Dancing Peasants* reflects these concerns, as well as her interest in the Russian peasantry and their "primitive vitality," which became a crucial matter for Russian artists and intellectuals at this time; it also shows the artist's familiarity with the avant-garde sense of design in paintings from Paris, of which many superb examples had been bought by Moscow collectors. Within a short time she was able to move toward greater abstraction, as in the Cubo-Futurist *Dynamo Machine* (plate 311).

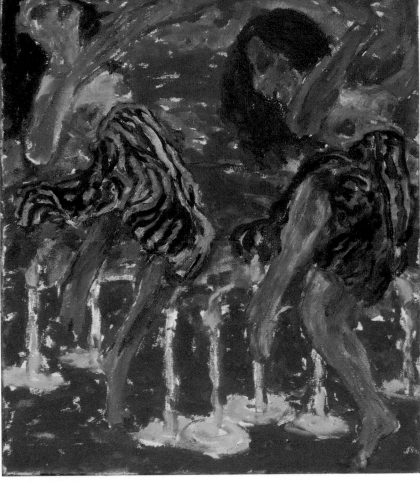

346

347

Sonia Delaunay, who had left Russia for Paris in 1905, shared with Goncharova an interest in costume design, abstraction, and indigenous customs. Dance and musical performances, with their rich combination of rhythms and patterns in movement, frequently served as the subject of her brilliantly colored compositions (see plate 392). It is not surprising that *Flamenco Singers* was her favorite work, and remained in her possession at her death in 1979.

Still a third Russian-born artist, Max Weber, turned to the dance for inspiration. In the blazing stage lights, which became one with the volutes of the set itself, the dancers twirl and lap, with parallel forms marking their trajectory.

Emil Nolde's mythic belief in the primeval powers of primitive people and their rituals was the source of his paintings of masks and dancers, such as *Dance around the Golden Calf* of 1910 (plate 239) and *Candle Dancers*, done two years later, in which the tall, flickering candles repeat the rhythm of the writhing dancing women, and in which the brushstroke that applied the vibrating Chinese reds, sulfur yellows, and purples seems to perform with the wild abandon of the dance being depicted.

343 Henri Matisse. *The Manila Shawl.* 1911. Oil on canvas, 44 $^1/_8$ × 27 $^1/_2$″
344 Natalia Goncharova. *Dancing Peasants.* 1910. Oil on canvas, 36 × 56 $^3/_4$″
345 Sonia Delaunay. *Flamenco Singers, No. 145.* 1913. Oil and encaustic on canvas, 68 $^1/_2$ × 56 $^3/_4$″ **346** Max Weber. *Russian Ballet.* 1916. Oil on canvas, 30 × 36″ **347** Emil Nolde. *Candle Dancers.* 1912. Oil on canvas, 39 $^3/_8$ × 33 $^1/_4$″

Dancers II

348

Severini's *Dynamic Hieroglyphic of the Bal Tabarin* is a much more abstract vision of the rhythm of the dance. This large and ambitious painting includes words and sequins in a Futurist version of the *café dansant*. Although Severini used the word "hieroglyphic" in his title, he portrays a sophisticated urban dance rather than a primitive ritual. In this kaleidoscopic whirl of staccato forms

and colors, Severini's formal vocabulary is completely different from that in Nolde's painting of the same year, yet the two works are comparable, since both involve the viewer directly in the tempo and feeling of the dance.

Another painting dating from 1912 is Picabia's *Dances at the Spring*, done earlier than his mechanical inventions (see plates 295 and 307),

while he was still very much under the influence of his Cubist friends. Here he deals with Cubist concerns of space, fragmented forms, light, and motion, successfully employing a palette of closely related rather than discordant colors in a painting that brought him to the verge of total abstraction.

The American Man Ray, who was associated with Picabia (and Du-

349

350

champ) in the New York Dada group, painted a canvas in 1916 that appears to be totally abstract and in which space has become entirely two-dimensional. At first we are aware only of the flat color areas of orange, green, red, blue, yellow, and brown in *The Rope Dancer Accompanies Herself with Her Shadows* until a tiny stylized ballet dancer appears on top of the angular color fields,

which are, in fact, her "shadows." The dancer's own crystalline self is shown with her skirt, legs, and lassolike gray rope in many successive positions in this painting, which was Man Ray's homage to Duchamp and his Nudes. The serpentine curves of the lariat in contrast with the hard-edged "shadows" give this work an animated rhythm of syncopation.

348 Gino Severini. *Dynamic Hieroglyphic of the Bal Tabarin*. 1912. Oil on canvas with sequins, 63 $^5/_8$ × 61 $^1/_2$" **349** Francis Picabia. *Dances at the Spring*. 1912. Oil on canvas, 47 $^1/_2$ × 47 $^1/_2$" **350** Man Ray. *The Rope Dancer Accompanies Herself with Her Shadows*. 1916. Oil on canvas, 52 × 73 $^3/_8$"

Lovers

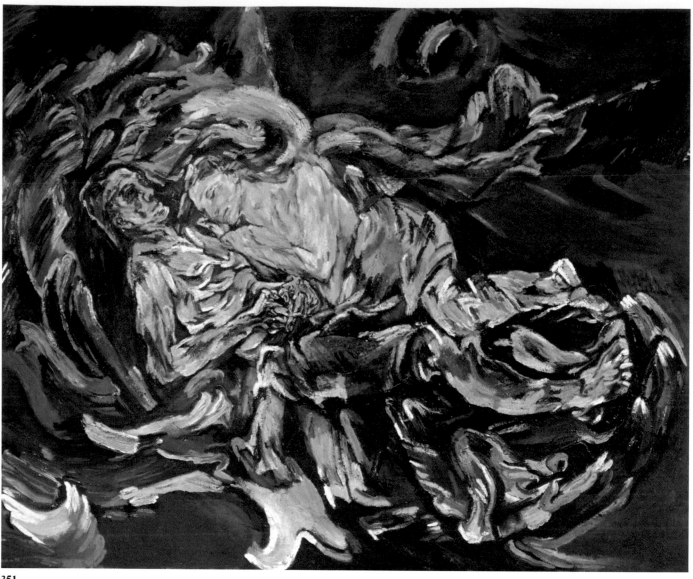

351

Oskar Kokoschka's *The Tempest (The Bride of the Wind)* whirls ribbons of paint in a stormy rhythm conveying the emotions of the couple resting after the tempest of their passion. Layers of long circular brushstrokes swirl around the pair as if to reinforce the unity formed by their coupling. The rough brush, the predominantly blue color highlighted with white, and the rotating, dynamic movement recall the Baroque style much admired by Kokoschka. But this representation is entirely modern. Kokoschka's agitated hand disturbs the surface as a marker. It serves as a reminder of his own tempestuous relationship at the time, his wildly intense love affair

with Alma Mahler, widow of the composer.

Enfolding themselves in *The Embrace*, Egon Schiele's lovers share the paradoxical condition of peaceful unity and pulsing fever in Kokoschka's *The Tempest*. Similarly composed, Schiele's couple, compressed within the confines of their white-sheeted world, cling to each other in anguished eroticism. Clutching and open, the woman nevertheless remains apart, pressed away from her lover by the thrust of her knee. Schiele's angular linearism assumes the role that Kokoschka's thick swirling brush played. Kokoschka's autobiographical statement about his love affair and Schiele's tense lovers

who are naked rather than nude attest to the breakdown of Victorian morality that occurred in Freud's Vienna as it did in the rest of Europe.

Otto Mueller's *Lovers*, painted the year after the war ended, has a modernity of feeling and appearance, heightened by the cramped verticality of the picture's format. The sharply angled forms of the man, echoed by the railing behind him, highlight the sinuous curves of the woman. But like Schiele's and Kokoschka's lovers, their romance is far from idyllic.

At the core of the eruption of the old order was the modern agreement that the world existed not as a "whole" but rather as a series of

352

354

353

355

unique contextual fragments and experiences. Marc Chagall's *Birthday* was begun the year he married Bella, his Russian sweetheart. *Birthday* captures the delirium roused by her simple kiss, a love that endured until her death in 1944. With perspective distorted, objects hanging from their surfaces, the world outside the physical confines of these two lips no longer commands or needs its logical order. Chagall's brilliant color, learned in his Paris experience with the avant-garde from 1910 to 1914, increases the mood of mental and physical abandon. This world whose order has no rules, where gravity complies with the spirit of man, was declared by the poet Guillaume

Apollinaire to be "*sur-réel*" ("super-real").

Very remote from the physical and psychological ecstasy expressed by Chagall, but similar in its rejection of natural appearances, is Giorgio de Chirico's *Hector and Andromache*. The heroic legendary figures of the Trojan War are without organic identity, expressing the two kinds of loneliness described by de Chirico—physical or "plastic" and psychic or "metaphysical" loneliness, both conditions of the modern experience. Juxtaposing a vaguely comfortable perspective space with these figures, recognizable in form but unknown in content, de Chirico shatters our tenuous objective security and fore-

shadows the world of the Surrealists. There every object will reveal its double character, thus announcing the final dissolution of all natural boundaries.

351 Oskar Kokoschka. *The Tempest (The Bride of the Wind)*. 1914. Oil on canvas, 71 $^1/_4$ × 86 $^5/_8$'' 352 Egon Schiele. *The Embrace (Lovers)*. 1917. Oil on canvas, 27 $^5/_8$ × 49 $^3/_8$'' 353 Otto Mueller. *Pair of Lovers*. 1919. Tempera on burlap, 41 $^3/_4$ × 31 $^1/_2$'' 354 Marc Chagall. *Birthday (L'Anniversaire)*. 1915. Oil on cardboard, 31 $^3/_4$ × 39 $^1/_4$'' 355 Giorgio de Chirico. *Hector and Andromache*. 1917. Oil on canvas, 35 $^1/_2$ × 23 $^5/_8$''

356

357

Biblical themes, which are very often treated as pious clichés in the twentieth century, were also infused with personal vision by a number of artists. In Emil Nolde's religious painting there is an urgency similar to that in his paintings of dancers. He felt a deep, personal, nearly visionary concern with religion; he regarded himself as almost a mystic evangelist. One of his strongest canvases in a cycle dealing with the New Testament is *The Entombment,* in which he treats the ultimate trage-

dy of the death of Jesus by using two large shapes, Mary and Saint Joseph of Arimathea, who seem to hold Christ's body like a coffin, containing or trying to contain him. The artist has reduced his palette to blues and yellow; the faces have become masks of grief. It is a painting that strongly recalls Late Gothic German altarpieces.

Similarly Max Beckmann sought inspiration in the art of the Northern tradition—particularly in the work of Grünewald. Renouncing a suc-

cessful career as a traditional painter, he shifted to a highly personal vision after his return from military service in World War One. His *Christ and the Woman Taken in Adultery,* painted in strange pale colors, enacts the Biblical drama on a narrow, compressed stage in which all the "actors" seem detached and alienated. Their incomprehension of the meaning of the scene strikes us as an enigmatic metaphor of the life of the time.

In France, Georges Rouault was

358

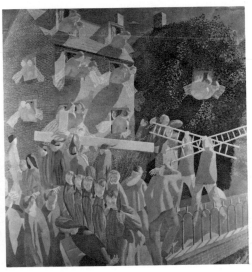

359

also haunted by the somber and tragic aspects of existence. He, too, belongs to those artists who early in the century yearned for the order and morality of the Middle Ages. His hieratic *Crucifixion*, painted in glowing colors and outlined with heavy black lines, recalls the great stained-glass windows that evoke awe and reverence.

The English painter Stanley Spencer was a visionary and eccentric artist in the tradition of William Blake, but he incorporated events from daily modern life in his religious painting. *Christ Carrying the Cross* shows the burdened figure of Jesus followed by workmen with their ladders, while stylized winged figures emerge from the windows of their London houses on a peaceful sunny morning. Spencer's mystical, imaginative paintings are parables, literally teaching a religious lesson.

356 Emil Nolde. *The Entombment*. 1915. Oil on canvas, 33 $^3/_4$ × 43″ **357** Max Beckmann. *Christ and the Woman Taken in Adultery*. 1917. Oil on canvas, 58 $^3/_4$ × 49 $^7/_8$″ **358** Georges Rouault. *Crucifixion*. c. 1918. Oil and gouache on paper, 41 $^1/_4$ × 29 $^5/_8$″ **359** Stanley Spencer. *Christ Carrying the Cross*. 1920. Oil on canvas, 60 $^1/_4$ × 56 $^1/_4$″

Interiors

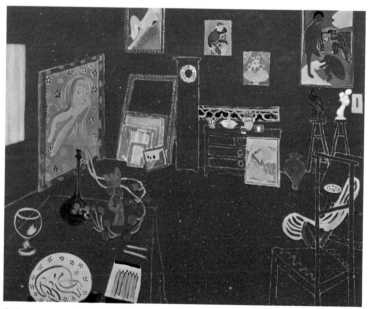

360

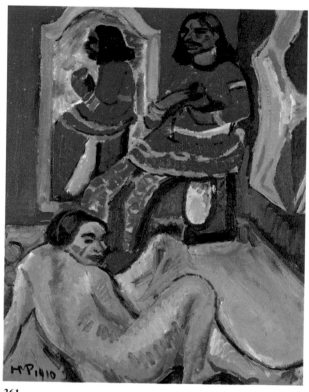

361

To an even greater extent than in *Goldfish and Sculpture* (plate 282) it is color that dominates Matisse's *Red Studio*. In this radical painting color—a carnelian red—defines the picture plane before it defines the studio space. In fact, the space of the studio is bent for the artist's pictorial necessity; this is why the upper corner between the left-hand wall and the far wall has been eliminated. In this sea of red only the light yellow lines, indicating the edges of the transparent object, create any kind of spatial illusion. The table, chair, sculpture stands, chest of drawers are merely ghosts; the only things that have a palpable reality are the pictures and statues by Matisse, his box of crayons, the vase with vine, and the clockface. Only the objects resulting from creativity, growth, and time have a real existence.

The Fauves, above all Matisse himself, had a strong impact on the Bridge painters, who formed a group in Dresden and later Berlin. One of them, Max Pechstein, in *Indian and Woman* also uses the identical intense red for figure and ground, Indian and wall. The arrangement of the space, the treatment of the angle, the emphasis on surface pattern are also reminiscent of Matisse, as is the sensuous nude woman in the frontal plane. The Indian's reflection in the mirror pulls the back wall toward the frontal plane, and the color of the nude is echoed in the mirror's frame. This spatial tension embodies the relationship between the two figures.

Max Weber's *Chinese Restaurant* is certainly one of the finest American Cubist paintings. This interior is filled with a cacophony of exotic color, light, texture, movement, and imagined clashing sounds and smells in a Chinese restaurant. Weber has utilized Cubist fragmentation to explore the bits and pieces that make up our sensual experience of reality. He has united them through a kind of painted montage to form a pattern of unique but separate experiences.

In Russia, Kasimir Malevich, working along parallel lines, also found that Cubism provided a model

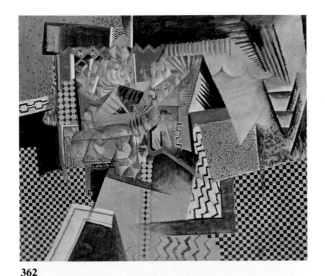

362

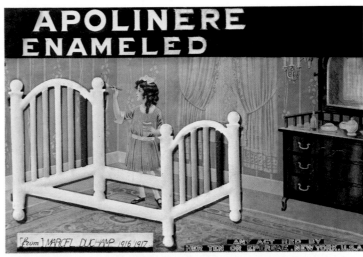

364

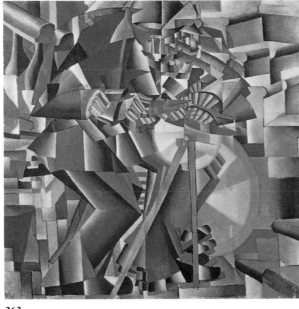

363

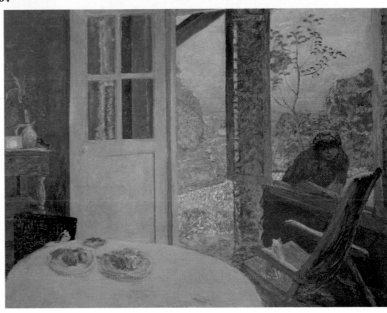

365

for achieving coherence out of the world's separate sensory and contextual experiences. His *Scissors Grinder* is a picture of clattering metal that is earsplitting, and eyesplitting. The several positions of the grinder's hands reproduce the vibration of his wheel; the stairway of cornices moves and shudders, and the disks spin into separate sections. Malevich shows a man dominated by his machine—but it is a machine he himself probably has fashioned.

It was this kind of painting of successive states of movement, not totally different from his own *Nude Descending a Staircase* of 1912, that Marcel Duchamp repudiated in his "corrected readymades," such as

Apolinère Enameled. Duchamp used an advertisement for Sapolin enamel paint, but he erased the *S* of Sapolin and added the letters *ÈRE* to refer obliquely to the poet. *ED* was added below to make a pun of "enamel": Apollinaire ("Apolinère") is being "enameled" by a child who cannot spell his name as she is too young to know of him. Duchamp makes sure to leave the additions in a slightly different color, so that the astute viewer can begin to puzzle it out.

Pierre Bonnard's *Dining Room in the Country* is a painting that causes a sensation of unadulterated joy. It is also a very complex, carefully structured composition in which we look down at the cool table with its

still life and out at the luscious landscape. The distant sunlit garden is related to the table in the foreground by its richly painted surface laid over a framework of verticals, diagonals, and curves.

360 Henri Matisse. *Red Studio*. 1911. Oil on canvas, 71 $^1/_4$ × 86 $^1/_4$″ **361** Max Pechstein. *Indian and Woman*. 1910. Oil on canvas, 32 $^1/_4$ × 26 $^1/_4$″ **362** Max Weber. *Chinese Restaurant*. 1915. Oil on canvas, 40 × 48″ **363** Kasimir Malevich. *Scissors Grinder*. 1912. Oil on canvas, 31 $^1/_2$ × 31 $^1/_2$″ **364** Marcel Duchamp. *Readymade, Girl with Bedstead* (*Apolinère Enameled*). 1916–17. Painted tin advertisement for Sapolin enamel, altered and added to by the artist, 9 $^1/_4$ × 13 $^1/_4$″ **365** Pierre Bonnard. *Dining Room in the Country*. 1913. Oil on canvas, 63 × 80″

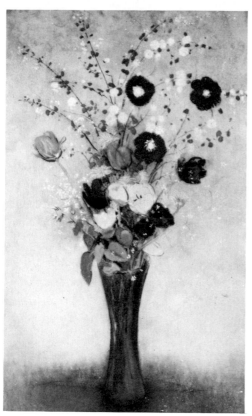

366

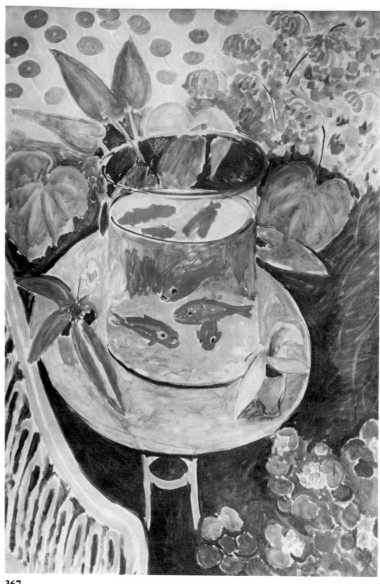

367

Well into this second decade of the twentieth century Odilon Redon, who was born in 1840, a full twenty-seven years before Bonnard, continued to make oils that resembled pastel paintings. His *Vase of Flowers,* recalling the Symbolist world of opiate dreams, is an anachronism in the world of 1916. The esoteric, beautifully evocative delicacies explored at the turn of the century had dissolved in a dramatic confrontation with reality on the part of some artists, or had led others to the creation of an art abstracted from reality. Matisse's *Goldfish* takes objects in an ordinary setting—goldfish in a glass jar on a table, a floor, plants, wallpaper—and transforms them in-

to an almost autonomous decorative pattern. In this painting bought by his great Russian patron, Sergei Shchukin, Matisse made his subject simple, precisely because it is relatively unimportant; what matters is the direct sensation produced by the painting. "A work of art," Matisse wrote, "must carry its complete significance and impose itself on the beholder even before he can identify the subject matter."

Georges Braque, associated earlier with Matisse as one of the Fauves, now deals with reality in a different manner. In his *Still Life with Harp and Violin* he boldly examines the discrepancies between our vision and cognition. Breaking down

form, reassembling the multitude of possible views, and simultaneously presenting them on the flat two-dimensional picture plane, Braque was seeking to unify our segmented senses. By retaining traditional subject matter, still life or figure in space, the Cubists could focus attention instead on their analysis of objects in space. By limiting his palette to monochromes, Braque was better able to explore the patterns of shadow and light that segregate and break up volume. In *Still Life with Harp and Violin* the fragmented objects merge with a faceted space, ultimately dissolving the boundaries between the two.

Juan Gris, who had studied science

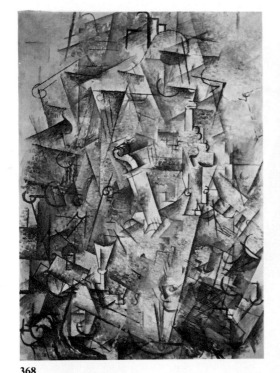

368

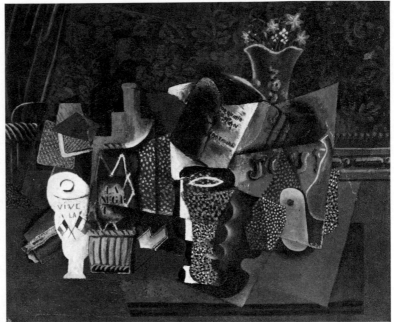

370

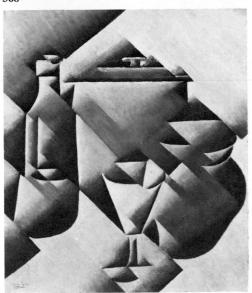

369

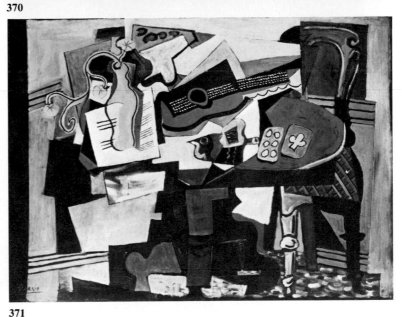

371

and engineering in his youth in Spain, made a pure geometric analysis of the objects in his *Still Life*. Section, plan, and elevation are examined and combined, but Gris's probing is by no means cold. His friend Gertrude Stein knew this early on when she said: "Juan Gris always made still lifes but to him still life was not a seduction it was a religion."

A few years later, however, Gris, as well as Picasso and Braque, did feel the painter's desire to work with color, with pattern, and with texture. In *Vive la France* Picasso uses all these elements for a painting which has almost a *trompe l'oeil* effect: we are not quite sure what is real and

what is painted. Picasso painted, pasted, and combined bits of letters and words from his daily experience to create a lively dialogue among objects, words, painted imitation, and pasted reality. Picasso's new fascination with texture and pattern—the Neo-Impressionist structure of dots, the Matisse-like wallpaper—helped liberate the artist from the strict discipline of "analytic Cubism" toward a freer form, often referred to as "synthetic Cubism." By 1918 his *Still Life* displays a distinct decorativeness that gently mocks the earlier Cubism.

366 Odilon Redon. *Vase of Flowers*. 1916. Pastel, 36 $^1/_8$ × 23 $^7/_8$" **367** Henri Matisse. *Goldfish*. 1911. Oil on canvas, 57 $^7/_8$ × 38 $^5/_8$" **368** Georges Braque. *Still Life with Harp and Violin*. 1912. Oil on canvas, 45 $^5/_8$ × 31 $^7/_8$" **369** Juan Gris. *Still Life*. 1911. Oil on canvas, 23 $^1/_2$ × 19 $^3/_4$" **370** Pablo Picasso. *Vive la France*. 1914. Oil on canvas, 21 $^1/_4$ × 25 $^5/_8$" **371** Pablo Picasso. *Still Life*. 1918. Oil on canvas, 38 $^1/_4$ × 51 $^1/_4$"

Early Abstraction: The Leaders I

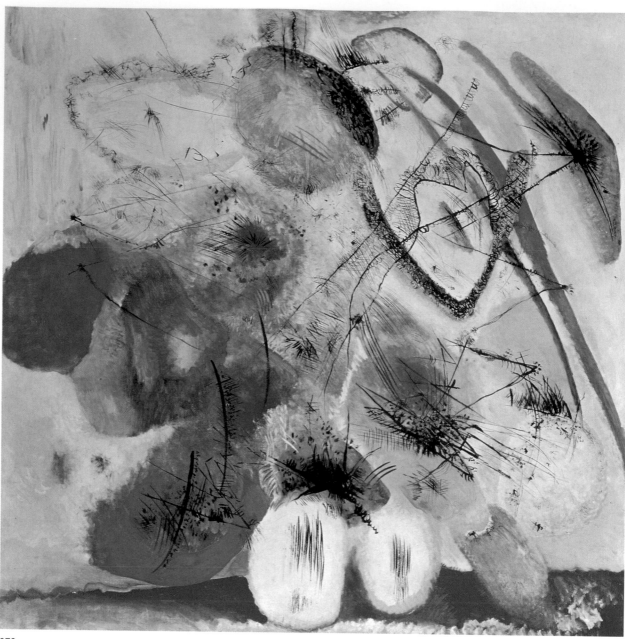

372

Ever since the invention of photography fulfilled the desire for true verisimilitude, artists have tended to discard traditional adherence to outer reality. In the early years of the decade a number of artists in various centers arrived almost simultaneously at complete abstraction. As the leading theorist of pure composition and one of the great early masters of abstract art, Vasily Kandinsky was perhaps the most important. By 1913, when he painted *Black Lines*, he had already mastered this audacious new way of painting, and here freely drawn lines help define the swirl of floating flowerlike color spots. Color, line, shape, space, light—all the pictorial elements no longer have recourse to the known world, as the artist communicates his spiritual feelings directly. Kandinsky wrote: "The harmony of color and form is solely based upon the principle of the proper contact with the human soul."

Robert Delaunay arrived at complete abstraction after having worked in a Neo-Impressionist and a Cubist vein. Abandoning themes of the

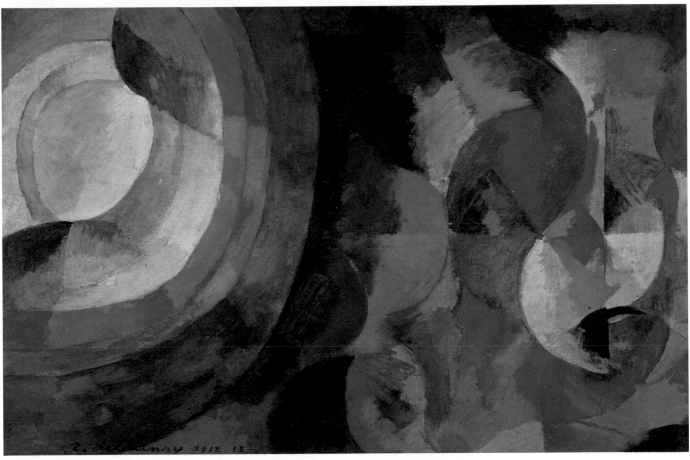

373

visible world, he became a master of pure color relationship, reintroducing color into painting after Braque and Picasso had renounced it in their formal explorations. Like Kandinsky, Delaunay realized the deep emotional significance of color and its rhythms. His *Circular Forms: Sun and Moon* of 1912–13 is a work of pure color orchestration. He felt that "color alone is form and subject" and that through colors, their contrasts and harmonies, he could reach directly to "the heartbeat of man himself" in his paintings, called "pure" or "Orphist" by the poet-critic Guillaume Apollinaire.

372 Vasily Kandinsky. *Black Lines*. 1913. Oil on canvas, 51 × 51 1/4″ **373** Robert Delaunay. *Circular Forms: Sun and Moon*. 1912–13. Oil on canvas, 25 1/4 × 39 3/8″

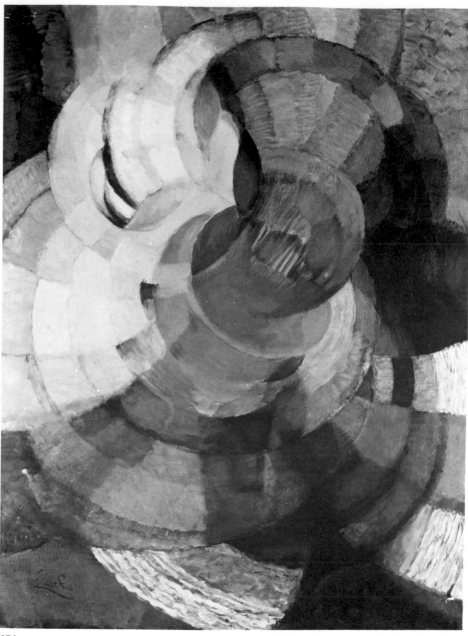

374

František Kupka, a painter who had moved from Prague to Paris by way of Vienna in 1894, arrived at similar abstract color disks; his *Disks of Newton, Study for Fugue in Two Colors* also dated from around 1912. It is a vibrating picture of circular color rhythms, which, like Delaunay's painting, is based on the color theories of Chevreuil and Seurat (see above, pages 26ff.).

Piet Mondrian had gone to Paris from his native Holland in 1911. Although he was very much attracted by Cubist paintings, particularly the work of Picasso and Léger, he soon decided that the Cubists had not sufficiently separated art from nature. His analysis of a pier in the ocean reduces visual reality to vertical and horizontal lines of different lengths. Despite his great concern with problems of form, Mondrian, like Kandinsky, was involved in the world of the spirit, in Theosophy and Eastern symbolism. The crosses are not only a simplification of the Cubist grid, they have also been seen as Christian symbols and universal signs: the masculine and the vitalistic aspects finding expression in the vertical, while the feminine and tranquil principle is expressed in the horizontal direction.

In Russia, where many painters had moved toward total abstraction

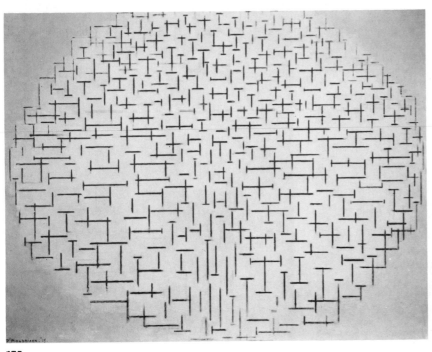

375

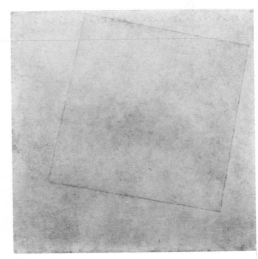

376

in the early years of the decade, it was Kasimir Malevich who departed from his earlier Cubo-Futurism (plate 363) and carried this trend to its limit in 1915 by exhibiting a number of paintings of pure geometric forms—black circles, squares, and crosses. Continuing in his search for pure painting, he arrived at his "Suprematist compositions" in which he liberated art "from the useless weight of the object" and

made paintings which signified solely "the supremacy of pure feeling and perception." His *White on White* is the first monochrome abstraction. Only delicate differentiations of texture distinguish a tilted white square from its white ground. Malevich felt that completely nonobjective works —that is, works representing no specific object—such as this penetrated to the essence of creation.

374 František Kupka. *Disks of Newton, Study for Fugue in Two Colors.* 1911–12. Oil on canvas, 39 3/8 × 29″ **375** Piet Mondrian. *Composition No. 10, Pier and Ocean.* 1915. Oil on canvas, 33 1/2 × 49 9/16″ **376** Kasimir Malevich. *Suprematist Composition: White on White.* c. 1918. Oil on canvas, 31 1/4 × 31 1/4″

Early Abstraction: Landscape and Figures

379

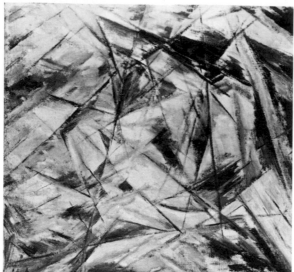

377

380

378

As early as 1912—i.e., before Malevich—Mikhail Larionov and Natalia Goncharova proclaimed the founding of Rayonism. A painting such as *Blue Rayonism* retains only the slightest indication of a landscape. It consists almost entirely of colored lines or rays that cross diagonally over a field of muted colors. According to Larionov's *Rayonist Manifesto*, issued in 1913, Rayonism is a Russian synthesis of Cubism, Futurism, and Orphism. More important, he announced in the same declaration that "painting is self-sufficient, it has its own form, color, and timbre."

In Germany, Kandinsky was not 164 alone in reaching abstraction early

in the decade. Working and teaching in Stuttgart, Adolf Hoelzel left realist painting to immerse himself in the study of color theory and created the boldly constructed *Abstraction II*. In Munich, in close contact with Kandinsky and Marc, Paul Klee started to form one of the most personal styles of the century. After coming to know the advanced artists of his time and, most significantly, immediately after a trip to Tunisia, he painted high-colored, incisive watercolors, such as *Opened Mountain*. The painting represents the beginning of Klee's lifelong investigation of the meaning of natural form, which finds expression in art which is "the likeness of creation,"

involving the concept of a totally new invention parallel to nature.

Marsden Hartley (see page 121), the American painter close to the Blue Rider group, worked for a brief time around 1913 with vividly painted forms having only a minimal relationship to landscape, as in *Abstraction—Blue, Yellow, and Green*.

Still earlier, in 1910, Arthur G. Dove exhibited six small landscapes that were so far removed from illustration and representation that he called them "abstractions." In 1914 Dove did a series (one of which is *Nature Symbolized, No. 2*) in muted variations of earthy and green tones with a velvety pastel texture. The stylized curvilinear organic shapes

381

382

383

384

evoke a dynamic sense of growth and lyrical veneration of nature reminiscent of Symbolist painting.

Another American of extraordinary talent and originality, Georgia O'Keeffe was, like Arthur Dove, part of the circle of American painters supported by Alfred Stieglitz, whom she married in 1924. Her early work, seen in the watercolor *Light Coming on the Plains*, is an abstraction related to an image in nature and rendered as a large free-form color area—a symbol of the light and dark forces in the universe. This purely personal expression, which seems to owe nothing to the avant-garde painting of Europe, has a unique visionary quality that foreshadows

American color painting of the post-World War Two era.

The Swiss painter Augusto Giacometti reached abstract forms of vividly decorative patterns as early as 1910, as in *May Morning*. Although derived from floral designs, Giacometti's first abstractions presage the allover painting of the 1950s.

In England the Vorticist David Bomberg was only in his early twenties when he painted *The Mud Bath*, a dynamic painting of semigeometric machinelike shapes in irregular formation, vaguely suggesting a relationship between human and mechanical action.

377 Mikhail Larionov. *Blue Rayonism.* 1912. Oil on canvas, 25 $^1/_2$ × 27 $^1/_2$″
378 Adolf Hoelzel. *Abstraction II.* 1913–14. Oil on canvas, 20 $^1/_2$ × 26 $^3/_8$″ **379** Paul Klee. *Opened Mountain.* 1914. Watercolor, 9 × 7 $^1/_4$″ **380** Marsden Hartley. *Abstraction—Blue, Yellow, and Green.* 1913. Oil on canvas, 24 $^3/_8$ × 18 $^3/_4$″
381 Arthur G. Dove. *Nature Symbolized, No. 2.* 1914. Pastel, 18 × 21 $^5/_8$″
382 Georgia O'Keeffe. *Light Coming on the Plains.* 1917. Watercolor, 12 × 9″
383 Augusto Giacometti. *May Morning.* 1910. Oil on canvas, 18 $^1/_2$ × 28 $^1/_8$″
384 David Bomberg. *The Mud Bath.* 1914. Oil on canvas, 60 × 88 $^1/_4$″

Early Abstraction: Geometric Form

385

From the very beginning, abstract art has taken two directions. Romantic abstraction, ultimately expressed by Kandinsky's work, is organic, flowing, and Expressionistic. The other side of abstraction, structured, geometric, and classical, developed in the canvases of Mondrian and Malevich.

Malevich's early *Suprematist Composition: Red Square and Black Square* proclaimed his search for an absolute beyond the images found in nature, although he explained, "real forms were approached in most cases as the grounds for formless painterly masses." A visual mathematics, the black square off center and hovering above a smaller, tilted red square attests to his theoretical, analytical mind. Forms were to represent the absolutes of the world, the realities of space, motion, and time that we cannot see but that we experience and know. Malevich explored conceptual relationships and gave them colored geometric equivalents.

Based on Malevich's example, many other artists in Russia established their own styles. Outstanding among them was a woman, Lyubov Popova. Rather than following Malevich's severe geometricism, Popova fused Cubist fragmentation of form with Futurist repetition of shapes intended to express speed and motion. Her *Architectonic Painting,* executed in strong color and flat angular shapes, is powerfully aggressive—perhaps reflecting the fact that it was painted in the year of the Revolution.

The next year Aleksandr Rodchenko painted his *Black on Black,* consisting of a black circle and black lozenges on a black ground; it was the logical extension of Malevich's *White on White* (see plate 376). These paintings represent the zenith of Russian abstraction; in fact, this Rodchenko painting was exhibited in the last group show of the Russian avant-garde in the Soviet Union, in 1920.

When Kupka exhibited his abstractions as early as 1912 in the Sa-

386

388

387

389

lon d'Automne in Paris, he showed both curvilinear and rectilinear abstractions. *Vertical Planes* is one of the latter, a disciplined study of clear, geometric shapes pointing toward the hard-edge style that became popular decades later. However, the foundation for Kupka's abstraction was his adherence to the spiritualists' belief in the perceptual properties of colored shapes, and their correspondences in sound and in tactile sensations; in fact, the vertical bars of his painting seem to ring like chimes on a wall. As with Kandinsky, it was his mystical beliefs that led Kupka to visualize in abstract shapes at such an early date.

Jean Arp's *Arrangement according to the Laws of Chance* is one of his few really geometric works. Exasperated with some of his drawings, he ripped them up and let them flutter to the floor. In accordance with Dada's investigation of the laws of chance, Arp allowed the accidental configuration to become the basis for his composition. Working in collaboration with Sophie Taeuber, his wife, Arp explored the possibilities of composing with geometric and organic shapes in the hope of suppressing individual style and creating in its place an optical composition with no traces of authorship.

385 Kasimir Malevich. *Suprematist Composition: Red Square and Black Square*. 1915. Oil on canvas, 28 × 17 1/2" 386 Lyubov Sergeievna Popova. *Architectonic Painting*. 1917. Oil on canvas, 13 1/2 × 38 5/8" 387 Aleksandr Rodchenko. *Black on Black*. 1918 (destroyed) 388 František Kupka. *Vertical Planes*. 1912–13. Oil on canvas, 79 3/8 × 46 3/4" 389 Jean Arp. *Arrangement according to the Laws of Chance*. 1916–17. Collage, torn and pasted papers, 19 1/8 × 13 5/8"

Early Abstraction: Stress on Color

390

391

393

392

Much brighter in color and derived from the theme of the dance is Picabia's *Edtaonisl.* This painting indicates a new direction for the talents of this artist, who in 1913 was among the leading abstractionists in Paris.

At this time the towering figures of French abstraction, however, were Robert Delaunay and his wife, Sonia. Robert had been moving toward abstraction through experiments with Cubism and color theories (see pages 160–61). In one of his interim innovations, an adaptation of the Neo-Impressionist technique

of Pointillism (see page 26), he broke his subjects into colored rectangles that simulated the optical effects of light on the retina and on adjacent objects in the picture itself. This was one of the early precursors of the Op Art of the midcentury. At about the same time as Robert, Sonia arrived at her designs of shimmering color, or paintings that appear to be made of colored light, such as *Le Bal Bullier.* Like Severini's *Dynamic Hieroglyphic of the Bal Tabarin* (see plate 348), painted a year earlier, this is an abstraction of a dance hall, but Sonia Delaunay creates a composition in

which the colors themselves are engaged in vibrating movement.

In 1914 Severini also turned to depicting pure color and light, but he used the Divisionist technique to paint a picture which is much more dynamic than Delaunay's, indeed explosive. Its title, *Spherical Expansion of Light (Centrifugal)*, is a very apt description of the energetic forces in the work. In 1913 Severini had exclaimed that "Objects no longer exist. One must forget the exterior reality and the knowledge we have of it in order to create new dimensions which our sensibilities will or-

394 395 396

ganize into a system. . . ." But the "system" of this abstract painting already begins to show signs of decoration rather than the powerful cosmic, universal forces the artist had hoped to transcribe.

A short time after the Delaunays', Kupka's, and Picabia's first paintings of pure color relationships—as early as 1913—Stanton Macdonald-Wright and Morgan Russell, young American painters living in Paris who called themselves Synchromists (meaning "with color"), exhibited their work. They were soon joined by Patrick Henry Bruce and others in

their investigation of the physical properties and the emotional effects of light and color relationships. They preferred the bright quality of primary colors, but they also knew that complementary colors intensify each other when used in large adjacent areas, and proceeding from this premise, they developed their own abstract style of color painting.

390 Francis Picabia. *Edtaonisl.* 1913. Oil on canvas, 118 $^3/_4$ × 118 $^1/_4$″ 391 Robert Delaunay. *Window on the City, No. 3.* 1911–12. Oil on canvas, 44 $^3/_4$ × 51 $^1/_2$″ 392 Sonia Delaunay. *Le Bal Bullier.* 1913. Oil on canvas, 38 $^1/_8$ × 133 $^1/_2$″ 393 Gino Severini. *Spherical Expansion of Light (Centrifugal).* 1914. Oil on canvas, 24 $^3/_8$ × 19 $^5/_8$″ 394 Stanton Macdonald-Wright. *Conception Synchromy.* 1914. Oil on canvas, 36 $^1/_4$ × 30 $^1/_4$″ 395 Morgan Russell. *Synchromy in Orange: To Form.* 1913–14. Oil on canvas, 135 × 123″ 396 Patrick Henry Bruce. *Composition II.* 1916–17. Oil on canvas, 38 $^1/_4$ × 51″

Early Abstraction: Collage

397

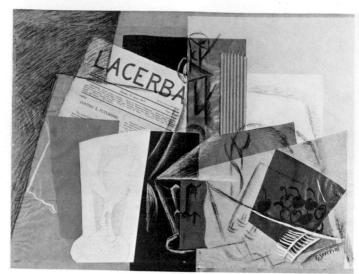

399

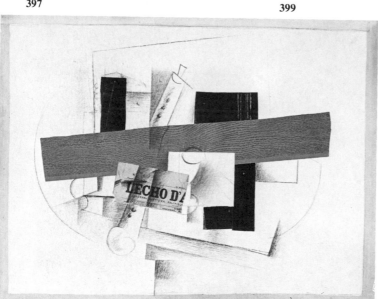

398

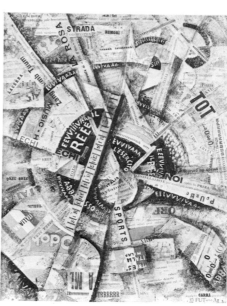

400

Arp's collage (see plate 389) was clearly derived from Cubism. It was the Cubists who began pasting objects onto the canvas, originating the collage technique. After their experiments in the penetrating analysis of objects in Cubist paintings, they decided to include actual things from the world around them and incorporate them in their canvases. Although there are precedents for pasted pictures, especially in folk art and children's art, the idea of collage as a major art form originated in 1912 with Picasso and Braque.

In his famous *Still Life with Chair*

Caning Picasso pasted a piece of oilcloth to simulate chair caning, and instead of a frame, he wrapped a length of rope around the oval picture, in which he also painted the letters *JOU*. Obviously he was concerned with the philosophical questions about the relationship of illusion and reality. By bringing in objects from the outside, Picasso combined reality and abstraction into a new relationship. Braque worked along almost identical lines at the same time, making the first *papiers collés* (pasted papers), in which —as in *The Clarinet*—he juggles

our perceptions of fact and illusion.

Almost at once this kind of reinterpretation of reality by means of actual objects was picked up by Severini in his *Still Life with Cherries*. More didactic in his purpose, he pasted the front page of the Futurist journal *Lacerba* with an article by Giovanni Papini into his collage, while his comrade Carlo Carrà made a thoroughly propagandistic work in *Patriotic Celebration*, referred to earlier (pages 122–23). A third Futurist, Umberto Boccioni, then a soldier, combined patriotism with the collaging of print for *Cavalry Charge*,

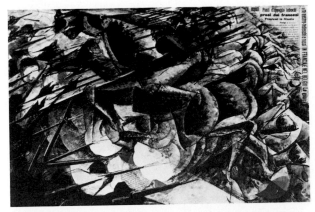

401

403

402

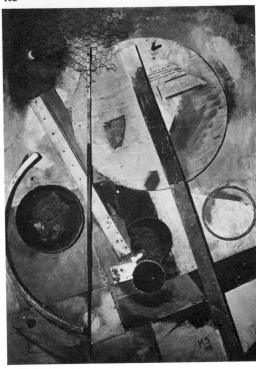

404

his only work to deal with the war. The clippings report advances against the Germans, but Boccioni did not survive the war. In the middle of 1916, he was thrown from his horse and subsequently died of his injuries.

Very rapidly the collage found echoes in Russia, and Ivan Puni, a follower of Malevich, moved this new medium into the realm of total abstraction in his bold and much more three-dimensional *Suprematist Construction*, made of wood, iron, and cardboard.

Suddenly everything was allowed. The little-known American artist

John Covert used string on composition board in 1919 in his surprising, highly personal, and dynamic abstraction, *Brass Band*. In the same year, in Germany, Kurt Schwitters evolved his own kind of collage, which he called "Merz." He combined the formal innovations of Cubism and Futurism with the spirit of Dada, collecting all kinds of trash and rubbish, then pasting and nailing it together with a great sensitivity to formal structure that was actually quite different from the iconoclasm of the Dada movement, of which he was a peripheral member.

397 Pablo Picasso. *Still Life with Chair Caning*. 1911–12. Oil and pasted oilcloth simulating chair caning, 10 $^5/_8$ × 13 $^3/_4$″ oval **398** Georges Braque. *The Clarinet*. 1913. Pasted paper, charcoal, and oil on canvas, 37 $^1/_2$ × 47 $^3/_8$″ **399** Gino Severini. *Still Life with Cherries*. 1913. Collage, pencil, and crayon, 19 $^1/_2$ × 26 $^1/_2$″ **400** Carlo Carrà. *Patriotic Celebration (Free Word Painting)*. 1914. Collage, 15 $^1/_8$ × 11 $^3/_4$″ **401** Umberto Boccioni. *The Cavalry Charge*. 1914. Pasted paper, 13 × 19 $^5/_8$″ **402** Ivan Puni. *Suprematist Construction*. 1915. Painted wood, metal, and cardboard, mounted on panel, 27 $^1/_2$ × 18 $^7/_8$″ **403** John Covert. *Brass Band*. 1919. Oil and string on composition board, 26 × 24″ **404** Kurt Schwitters. *The Worker Picture (Das Arbeiterbild)*. 1919. Collage, wood, and pasted papers, 49 $^1/_4$ × 35 $^7/_8$″

Early Abstraction: Letter and Image

406

405

407

With the invention of collage, it became permissible to introduce all kinds of elements, including letters and words, into the heretofore sacrosanct canvas. The presence of the word or the fragmented letter or number multiplied the possibilities for shape and meaning within the confines of the painted image. Braque's *Glass, Bottle, and Newspaper* and Picasso's *Bottle, Glass, Violin* reflect this commingling of typographic and drawn imagery. Sometimes letters are utilized only as abstract shapes, and at other times—as in Picasso's use of "Journal"—the word directs our attention away from the painted reality to the world beyond the canvas. Suddenly street life becomes part of the *nature morte*.

Braque plays with our notions of what is real and what is illusory in the pasted and painted papers, wood grain, and cutout letters. The painted guitar fuses with the pasted letter. Sounds from the realm of spoken words enter the painting as we are no longer compelled only to see, but are now allowed to utter, the letters and words before us.

In Russia, Malevich used this new idiom in *An Englishman in Moscow.* Letters and images combine to conjure up an iconographic tale of the objects and words describing the Englishman's identity. The painting is oddly prophetic of the Surrealist combination of unrelated objects and remembered impressions. But the Russian painter, instead of further exploring the direction of the interrelationship of language and image, turned toward completely nonobjective work. Ivan Puni used letters in a most iconoclastic painting, *Baths.* As if he were a sign painter directing bathers to a public convenience, he painted red block letters on a white rectangle, shifting just off center on a red ground. The letters seem to focus attention upon an idea dissociated from any painterly preoccupations, thereby suggesting that the meaning of the painting is directed both into and beyond its own content.

Vladimir Tatlin's collage combines

408

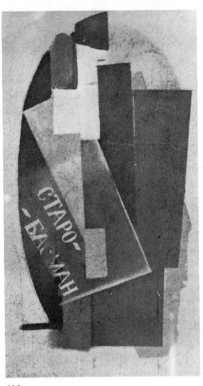

409

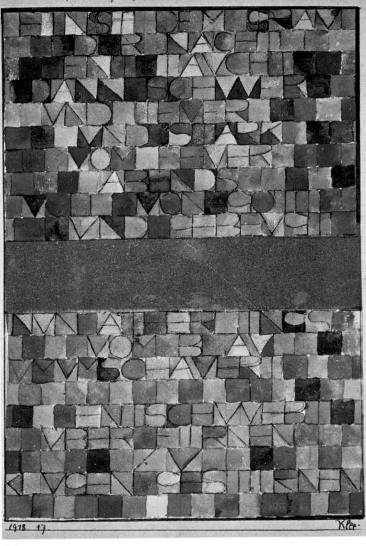

410

found letters, which translate and transliterate as "Old Basmannaya," with paint and gilt to make a hybrid that is part sculpture and part two-dimensional painting. By deliberately violating the flatness of the surface of his work, Tatlin reinforces the extra dimension also introduced by the letters.

Paul Klee in his constant search for new meanings also combined words and images in order to expand a purely visual message to include a linguistic message. His *Once Emerged from the Gray of Night . . .* is a modern corollary of medieval manuscripts. Klee uses isolated capital letters, each in its own color square, making reading very difficult and consequently stressing the ornamental content, as did Celtic manuscript illuminators. But the inscription at the top, handwritten in Klee's script, directs the viewer to a partial poem. Perhaps it is in the lines from the poem that Klee's painting may best be understood. The flow from letter to geometric shape blended by color seems to be a visual equivalent to that melding of "gray night, light of fire, evening blue ether and snow-fields and stars." It is through the introduction of words into the body of the canvas that this kind of visualization of the poetic can take place.

405 Georges Braque. *Glass, Bottle, and Newspaper.* 1913. Pasted paper and charcoal on paper, 24 $^5/_8$ × 11 $^1/_4$'' 406 Pablo Picasso. *Bottle, Glass, Violin.* 1912. Charcoal with pasted papers, 18 $^1/_2$ × 24 $^5/_8$'' 407 Kasimir Malevich. *An Englishman in Moscow.* 1913–14. Oil on canvas, 34 $^5/_8$ × 22 $^1/_2$'' 408 Ivan Puni. *Baths.* 1915. Oil on canvas, 28 $^3/_4$ × 35 $^1/_4$'' 409 Vladimir Tatlin. *Board No. I: Old Basmannaya.* 1916–17. Tempera and gilt on board, 41 $^3/_8$ × 22 $^1/_2$'' 410 Paul Klee. *Once Emerged from the Gray of Night . . .* 1917–18. Watercolor on paper on cardboard, 8 $^7/_8$ × 6 $^1/_4$''

Early Abstraction: Music

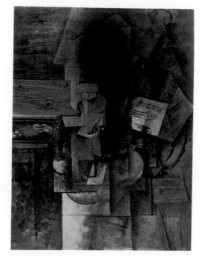

411

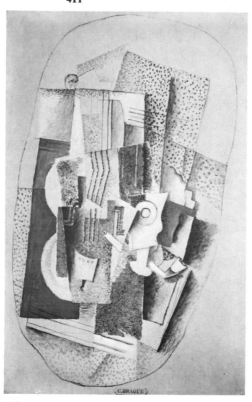

412

413

Music and musical instruments were a frequent subject for many avant-garde artists during this decade—especially because they began to see in abstraction an equivalent to pure musical composition. Picasso's *The Violin (Jolie Eva)* of 1912 with its neutral tones of ochers, grays, and browns incorporates painted letters and imitates wood textures. The instrument, like all objects, was a source of intellectual curiosity to Picasso, a thing to be shattered, faceted, and reconstructed as an autonomous painting. Braque, too, analyzed the musical instrument in many of his still-life paintings, no-

tably *Music*, a work of classical simplicity painted two years later. Here the strings of the instrument form a structure of overlapping planes, modified by the typical undulating contour of a violin or guitar. Angled planes, muted tones, rough sandy textures create a highly sophisticated and satisfying painting. Malevich's *Musical Instruments* is a much less resolved composition than Braque's interpretation of the same theme.

Braque, Picasso, and Malevich were more interested at this moment in the intellectual problem of rendering a three-dimensional object on a two-dimensional plane than in music

and its cluster of associations, but Kandinsky's belief in a period of spiritual rebirth brought him to a metaphysical and synesthetic attitude in which he saw all the arts striving for a common transcendence. In his book *Concerning the Spiritual in Art,* he cites Schumann, Wagner, Debussy, Mussorgsky, Scriabin, and Schoenberg as contributing to the "road of inner necessity." He wrote: "Color is the keyboard. The eye is the hammer, while the soul is a piano of many strings," and he exemplified his synesthetic view in painting a totally abstract canvas significantly called *Fugue*.

415

414

416

Klee, like Kandinsky, considered music the most comprehensive art, and he too explored analogies between the two expressions. In a watercolor entitled *In Bach's Style* solid, almost geometric, fundamental shapes making up the structure of the painting allow the counterpoint of more spontaneous lines, forms, and various signs to float freely. Son of a musician and a violinist himself, Klee brought about an integration of painting and music, the plastic and the temporal arts.

Among these abstractionists Kupka's painterly equivalent of music is perhaps the most lyrical. In *Solo of a Brown Line* the line's dance is like notes of a flute, isolated in space, frozen in time, distinct, clear. Kupka's color disks provide a setting within which the line performs. "I am still groping in the dark," he wrote in 1913, "but I believe I can find something between sight and hearing and I can produce a figure in colors as Bach has done in music."

411 Pablo Picasso. *The Violin (Jolie Eva)*. 1912. Oil on canvas, 24 × 32 ³/₈″ **412** Georges Braque. *Music*. 1914. Oil, sand, and charcoal on canvas, 36 ¹/₈ × 23 ¹/₂″ **413** Kasimir Malevich. *Musical Instruments*. 1912–14. Oil on canvas, 32 ⁷/₈ × 27 ³/₈″ **414** Vasily Kandinsky. *Fugue*. 1914. Oil on canvas, 51 ¹/₈ × 51 ¹/₈″ **415** Paul Klee. *In Bach's Style*. 1919. Watercolor and gouache, 6 ³/₄ × 11 ¹/₄″ **416** František Kupka. *Solo of a Brown Line*. 1912–13. Oil on canvas, 27 ¹/₂ × 45 ¹/₄″

Dancers

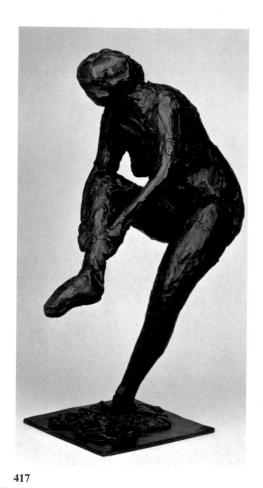

417

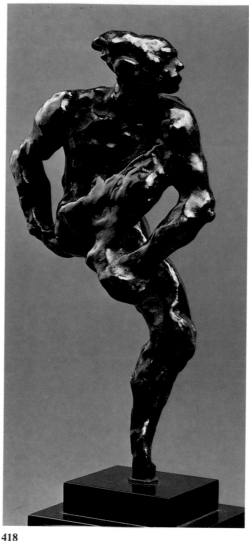

418

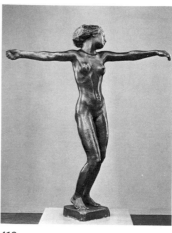

419

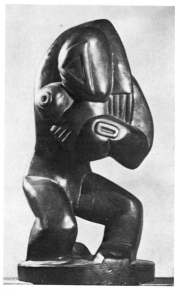

420

Both Rodin and Degas, now in their seventies, continued to explore the human figure. Until their deaths in 1917, both masters, who had studied movement all their lives, shaped images of dancers in clay, treating the figure unconventionally in free motion rather than in heroic stances. Degas recorded the habituated, automatic movement of his models in rough surfaces, as in *Dancer Putting on Her Stocking,* as he had done earlier in *The Masseuse* (see plate 171) and *Woman Arranging Her Hair* (see plate 114). His sculptures of dancers, like those of horses, display his great understanding of bodily movement through their firmly balanced pos-

tures. These fragile, roughly executed works were primarily studies for painting, and Degas did not allow them to be cast during his lifetime. Whereas Degas's concern was primarily with the instant, Rodin's was more universal. The latter's dancers are also more sensual in their modeling. Rodin's vital interest in the nature and effect of physical movement is beautifully expressed in his *Nijinsky,* a tour de force of bronze casting and a splendid interpretation of the disciplined physical energy that made Nijinsky the most famous dancer of his time. Here Rodin succeeded in rendering the essence of physical movement in bronze.

Around the same time the young German sculptor Georg Kolbe made a bronze of a female *Dancer* standing with arms outstretched. This passive figure of harmonious, almost classical repose is probably Kolbe's masterpiece.

It is a shock to see the crouching, powerful *Red Stone Dancer,* by Henri Gaudier-Brzeska, among these cool, classic figures. Although today, largely due to an understanding of the strength and beauties of primitive art, our sensibilities respond positively to a powerful figure like this, we can appreciate how offensive this work was to gallery goers in England in 1914.

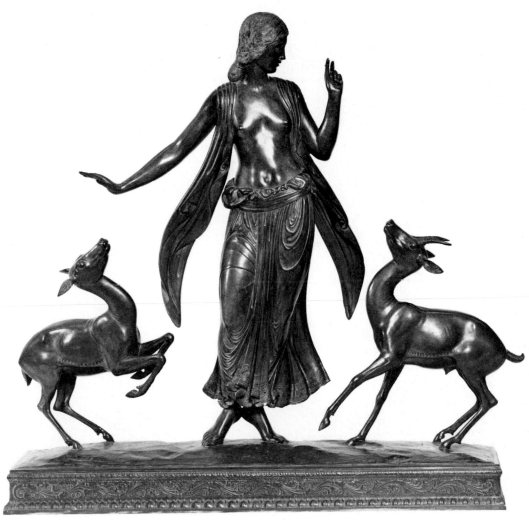

421

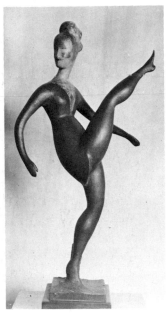

422

Although Gaudier had a champion in the American expatriate Ezra Pound, who along with the sculptor was a member of the British Vorticist group (see page 135), art lovers on both sides of the Atlantic much preferred the static and stylized classicism in the work of Paul Manship. An American who considered himself the perpetuator of tradition (and was so seen by others), Manship managed to reduce all form and action to a frozen decorative pattern as in his famous *Dancer and Gazelles.* He enjoyed great popularity in America for almost half a century and became president of the National Sculpture Society, an extremely conservative organization of sculptors which at one time seemed to have a monopoly on sculpture commissions in the United States.

In 1914 Elie Nadelman came to the United States, where he began to endow his work with sophisticated wit exemplified in his carved and painted *Dancer.* Nadelman stylized movement but did so with a fine sense of grace, which was well described by André Gide: "He has discovered that each curve of the human body is accompanied by a reciprocal curve opposite and corresponding to it."

417 Edgar Degas. *Dancer Putting on Her Stocking.* 1896–1911. Bronze, height 17″
418 Auguste Rodin. *Nijinsky.* 1912. Bronze, height 7 $^1/_2$″ 419 Georg Kolbe. *Dancer.* 1911–12. Bronze, height 60 $^5/_8$″
420 Henri Gaudier-Brzeska. *Red Stone Dancer.* 1914. Waxed stone, height 33 $^1/_2$″
421 Paul Manship. *Dancer and Gazelles.* 1916. Bronze, height 32 $^1/_4$″
422 Elie Nadelman. *Dancer.* c. 1918. Painted wood, height 28 $^1/_2$″

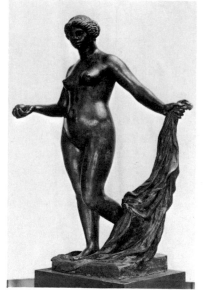

423

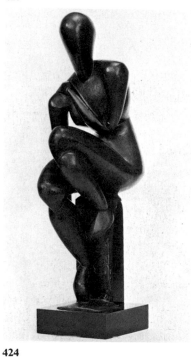

424

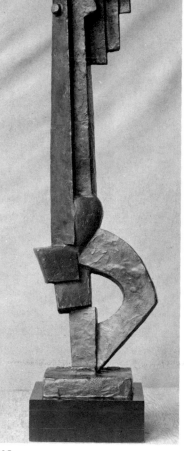

425

426

Renoir, like many other painters of his and the following generation, also worked in sculpture. But it was only during his old age, when he was badly crippled, that he designed works in three dimensions and permitted a trained craftsman to translate the highly sculptural aspects of his late painting into bronze. *Venus Victorious* is a nude woman in a classical pose. The contours of the body are gently rising forms, conceived as mass and concentrated into an integrated unit of latent energy.

The year before Marcel Duchamp's *Nude Descending a Staircase*, his brother Raymond Duchamp-Villon created his own version of a female nude, *Seated Woman*. He was close to the Cubist artists in Paris at the time and became, in fact, one of the most original and finest sculptors of the group. He reduced his nude to a series of related volumes: ovoid head, tubular arms and thighs, triangular kneecaps, tubular calves and feet. Here all the forms press inward toward an internal core, around which, in turn, they revolve.

Jacques Lipchitz adhered much more closely to Cubist principles in his fine *Bather*, where he translates the flat, sharply articulated planes of Synthetic Cubist painting into bronze. Although the figure bears little relationship to nature, we still recognize it as a woman by the indi-

cation of a head, a long torso, a bent knee. Lipchitz in a work like this creates a feeling for sculptural space, not by traditional treatment of mass and volume, but by overlapping planes and the play of light and dark.

Max Weber, an artist who had thoroughly absorbed the lessons of the avant-garde in Paris, where he lived and worked from 1905 to 1908 (see plates 321 and 362), turned his attention to sculpture after his return to New York. *Spiral Rhythm* transforms a woman's torso into generalized rounded and faceted forms, indeed, into upward-striving continuous, dynamic spiral rhythms. This very innovative work remained, however, an isolated achievement in

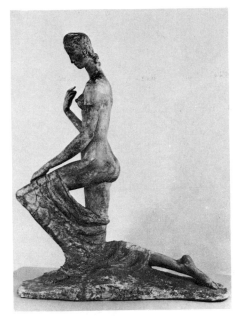

427

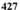

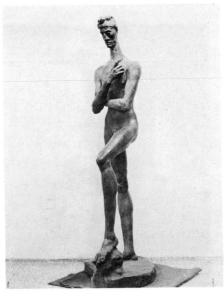

428

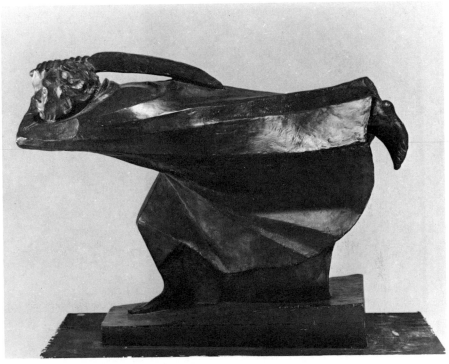

429

American sculpture of the time, and like many other progressive American artists, Weber turned to a more naturalistic and conservative mode after World War One.

Whereas Weber in his experiments in sculpture was primarily involved in a solution to post-Cubist problems of form, Wilhelm Lehmbruck's elongated, withdrawn *Kneeling Woman* and the *Standing Youth*, with bowed head, folded arms, and forefinger pointing over his shoulder to the oppressive void, suggest that the artist is concerned as much with psychological implications as with the analysis of form. Traditional concerns for sculptural mass, solidity, and density give way to sculpture characterized

by contour and linearity; it is apparent that in his treatment of form Lehmbruck incorporated the aesthetic of Symbolism and Art Nouveau— introduced to him through the work of the Belgian sculptor George Minne (see plate 121). It is this reduction of the sense of materiality which contributes to Lehmbruck's success in summoning spiritual feeling, much like the early Gothic stonecarvers, and closely related his work to the movement of Expressionism in his native Germany.

Another German sculptor involved in Expressionism and its interest in the art of the Middle Ages was Ernst Barlach. *The Avenger* is a dense, highly compact form in which

the violent gesture becomes ritualistic, recalling the wooden figures in medieval German churches. Even the treatment of hair and facial features recalls the sharp contours usually associated with wood carvings rather than with modeling.

423 Auguste Renoir. *Venus Victorious.* 1915. Bronze, height 71″ 424 Raymond Duchamp-Villon. *Seated Woman.* 1911. Bronze, height 25 ³/₄″ 425 Jacques Lipchitz. *Bather.* 1915. Bronze, height 38 ¹/₂″ 426 Max Weber. *Spiral Rhythm.* 1915 (enlarged and cast 1958–59). Bronze, height 24″ 427 Wilhelm Lehmbruck. *Kneeling Woman.* 1911. Cast stone, height 69 ¹/₂″ 428 Wilhelm Lehmbruck. *Standing Youth.* 1913. Cast stone, height 92″ 429 Ernst Barlach. *The Avenger.* 1914. Bronze, height 17 ¹/₄″

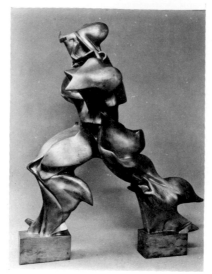

431

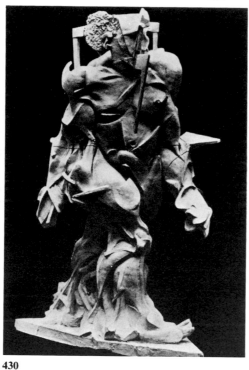

430

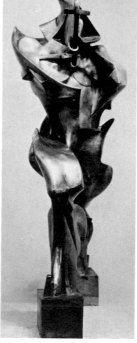

432

433

Umberto Boccioni announced "the absolute and complete abolition of definite line and closed sculpture" in his *Manifesto of Futurist Sculpture* and continued: "We break open the figure and enclose it in Environment." This manifesto was written in 1912, the year he created *Synthesis of Human Dynamism*, a plaster sketch for *Unique Forms of Continuity in Space*. This final version of 1913 observes and expresses motion very differently from Rodin's powerful *Walking Man* (plate 167). Boccioni created a striding figure who churns so dynamically that he needs two bases. This is a work that may well be the masterpiece of the Futurist movement.

Late in 1913 Marinetti traveled to London to deliver lectures to a group of revolutionary artists who a few months later appropriated the idea of Vortex from their champion, Ezra Pound, and called themselves Vorticists (see page 135). Although they shared the Futurists' disgust with conservative academicism, the Vorticists did not worship the machine. Rather, as is apparent in Jacob Epstein's *Rock Drill*, they considered it a technological weapon that could effectively blast sentimentality, but also unwittingly destroy humanity.

This sculpture shows a mechano-morph about to activate the machine. Its ghostlike color, stomach cavity housing an unborn child, and lowered head symbolize fear at the potential for death inherent in the rock drill's shattering motion. (When the sculpture was first exhibited, it was set on an actual pneumatic drill —seen in this installation photograph from 1915.)

Still another way of expressing powerful movement is demonstrated by Alexander Archipenko, who was born in Kiev and came to Paris in 1909, where he was immediately drawn into the avant-garde and par-

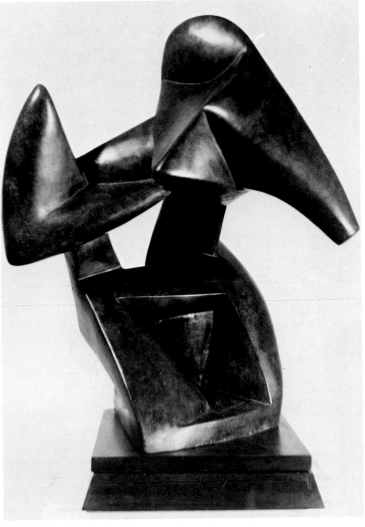

434

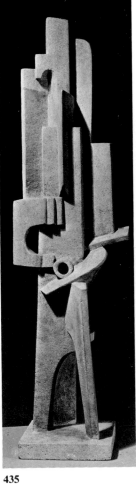

435

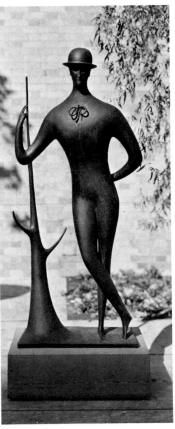

436

ticipated in the chief Cubist exhibitions. In *The Boxers* he reduces forms, as he said, to "their fundamentally geometric structure," but he also allows for dynamic action and the penetration by the external environment through the spaces between the volumetric shapes.

Lipchitz's *Man with a Guitar* (1915), like his *Bather* (plate 425) of the same year, is much more static than Archipenko's work and remains true to his formal concerns with interpenetrating Cubist planes. Vertical linear planes dominate an elegant geometric figure with few curves. Lipchitz's sculptures of this period have a tectonic presence resulting from their strict regularity and high degree of abstract simplification.

Nadelman, whose style was much more sensuous and witty, simplified the human form in a very different manner. His *Man in the Open Air* has some of the slick qualities of a seal. He is naked except for his bowler hat and neat bow tie. Like a Greek hero or god, he leans on a tree, but this stylized trunk, which is supposed to give him support, appears to go right through his arm. Nadelman has presented us with a delightful satire, both on art and on fashionable behavior.

430 Umberto Boccioni. *Synthesis of Human Dynamism*. 1912. Plaster (destroyed) **431–432** Umberto Boccioni. *Unique Forms of Continuity in Space*. 1913 (cast 1931). Bronze, height 43 $^7/_8$" **432** Side view **433** Jacob Epstein. *Rock Drill*. 1913–15. Plaster and readymade drill (dismantled 1915), height (top portion) 27 $^3/_4$" **434** Alexander Archipenko. *The Boxers*. 1914. Bronze, height 23 $^1/_2$" **435** Jacques Lipchitz. *Man with a Guitar*. 1915. Limestone, height 38 $^1/_4$" **436** Elie Nadelman. *Man in the Open Air*. c. 1915. Bronze, height 54 $^1/_2$"

Heads

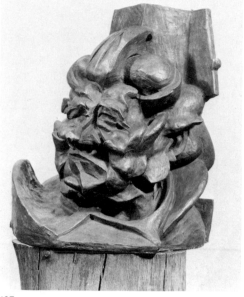

437

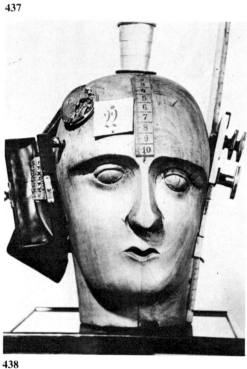

438

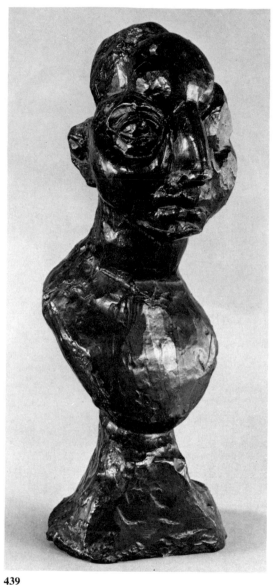

439

A year before he created his *Unique Forms of Continuity in Space,* Boccioni did a portrait of his mother —significantly called *Antigraceful*— which was surely inspired by Picasso's *Woman's Head* of 1909 (see plate 187). *Antigraceful* is composed of intersecting curves, freely moving planes, and dynamically vital surfaces in a most expressive face which appears to smile as well as frown as the viewer moves around its volume.

The Spirit of Our Time, by the Berlin Dadaist Raoul Hausmann, is a sculpture that is related to collage and photomontage. Hausmann's head—a mannequin bedecked with the tools of the haberdasher's trade—

is a satire on bourgeois narcissistic concern for shallow appearance. Numbers, a screw, and a measuring tape further comment, in outrageous Dada fashion, on the pervasive anonymity and the puppetlike role played by man during World War One.

Matisse began to produce a series of portrait heads of Jeanne Vaderin in 1910. During a period of three years he made increasingly abstract alterations. In the last of the series, *Head of Jeannette V*, working from a plaster cast of the third state of the portrait, Matisse eliminated the hair, filled in the left eye, and accented the planes of the face. This fifth portrait

stands in a fascinating contrasting relationship to Cubist sculpture of the same period.

Brancusi also began with a fairly close naturalistic likeness in his long series of portraits of Mademoiselle Pogany. The marble version of 1912 is a condensed solid form, allowing only the large eyes ("the gateways to the soul"), the fine nose, and folded hands to interrupt its universalized egglike form and spiraling composition. The extremely high polish of the marble surface moves this portrait from material reality toward a mystical concept of form which resists penetration.

Like his friend Brancusi, Amedeo

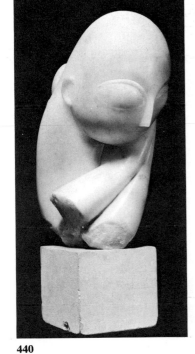

440

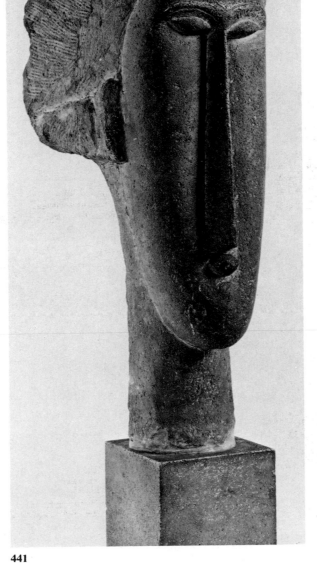

441

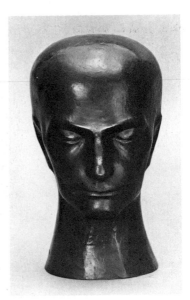

442

Modigliani sought to let primordial shapes assume their natural authority in his work. The elongated oval *Head of a Woman* recalls archaic Greek *kouroi* as well as Baule African masks, which appealed to him because of their emphasis on linearity and elongation. His volumes are sensuous, as is his surface of hewn limestone. Both Brancusi and Modigliani reduced their objects to essential characteristic shapes, but whereas Brancusi's form takes on a sense of universal harmony, Modigliani's rare works in sculpture remain solid, earthbound stone carvings.

Duchamp-Villon's work seems to combine the universal harmony of

Brancusi with Modigliani's sense of solidity. His *Head of Baudelaire* is an idealized memento mori of the great nineteenth-century writer. Fundamentally different from Rodin's earlier version (see plate 119) with its vigorous surface, Duchamp-Villon's *Baudelaire* embodies the author's interest in the power of the imagination. The writer's eyes are closed in introspection so that stimuli from the external world cannot interfere with his exploration of the internal realm. The chiseled brow, smooth forehead, and exaggerated cranium reinforce the stress on the power of the intellect.

437 Umberto Boccioni. *The Mother (Antigraceful)*. 1912. Bronze, height 24″ **438** Raoul Hausmann. *The Spirit of Our Time*. 1919. Wood, metal, leather, and cardboard, height 12 ³/₄″ **439** Henri Matisse. *Head of Jeannette V*. 1910–13. Bronze, height 23″ **440** Constantin Brancusi. *Mademoiselle Pogany*. 1912. White marble, height 17 ¹/₂″ **441** Amedeo Modigliani. *Head of a Woman*. c. 1910. Limestone, height 25 ³/₄″ **442** Raymond Duchamp-Villon. *Head of Baudelaire*. 1911. Bronze, height 15 ¹/₂″

Relief I

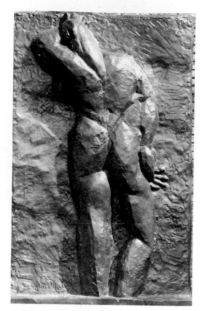

444

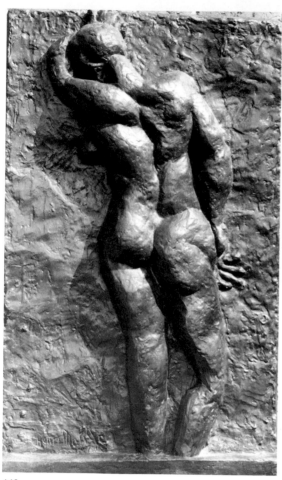

443

445

446

Relief sculpture in this century—unlike in past eras—is generally detached from architectural settings and programs and made by the artist as his own free invention. Between 1909 and 1930 Matisse made a group of five studies of the female back—done originally in clay and eventually cast in bronze. In *Back I* a nude woman seen from the back is represented with strength and sensitivity. Her stance is somewhat off balance, which gives the work additional animation. Four years later, in *Back II*, he reworked the subject into a more balanced composition,

while *Back III*, done in 1916–17, is even more simplified in its forms; its solid structure derives largely from the braid of the model's hair, which, serving simultaneously as a spine, gives symmetry to the relief. Years later, in 1930, Matisse was to make the final version of the series, *Back IV*, a more static, more geometric sculpture in which the woman, now a pretext for studying volume, becomes a synthesis of the organic and the architectural.

Matisse said that he "took up sculpture because what interested me in painting was a clarification of my

ideas. . . . When I found it in sculpture, it helped me in painting." Although Matisse considered his work in sculpture essentially as studies for his prime vocation of painting, there is no question that if this greatest colorist of the century had never put brush to canvas, his work would still have a significant place in the annals of modern art.

A much more conventional relief, made in marble, is Gaston Lachaise's *Nude on Steps* (1918). Lachaise was born in Paris and received traditional training at the Ecole des Beaux-Arts. When he came to the United States

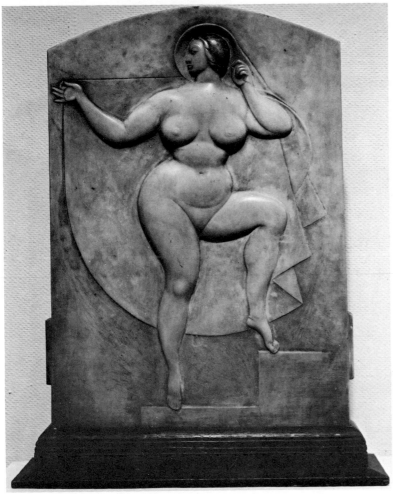

447

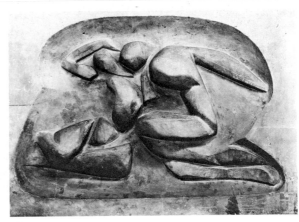

448

in 1906, he found employment as an assistant to the academic sculptor Paul Manship (see plate 421). His own work, however, began to take on a very distinct character during this decade, and his *Nude on Steps* is a figure of a voluptuous body, surmounted by a stylized head, which is surrounded by an immobile cloak that acts as a halo for this modern fertility goddess. Lachaise's large languid nudes have a strange weightless, floating quality that he developed into a major *oeuvre* during the next decade.

In all his mature sculpture Du-champ-Villon sought to strip his work down to the smallest number of elements essential to convey the image he wanted to present. Although never departing from an observed subject, he tried to suppress individual traits in his models and his artistry —without sacrificing expressive power. The forceful feeling between his lovers, challenging his probable model, Rodin's *Eternal Springtime,* arises as much from this paring down of anatomical details as from the resultant play between concave and convex forms, the equivalent of negative and positive areas in painting.

443–446 Henri Matisse. Bronze reliefs
443 *Back I.* 1909. Height 75″ 444 *Back II.*
1913. Height 72 ³/₄″ 445 *Back III.*
1916–17. Height 74″ 446 *Back IV.* 1930.
Height 74 ¹/₂″ 447 Gaston Lachaise. *Nude on Steps.* 1918. Polychromed marble, height 29 ³/₈″ 448 Raymond Duchamp-Villon.
The Lovers. 1913. Plaster, height 27 ¹/₂″

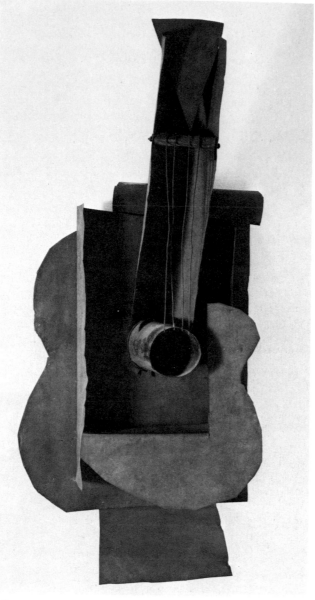

449

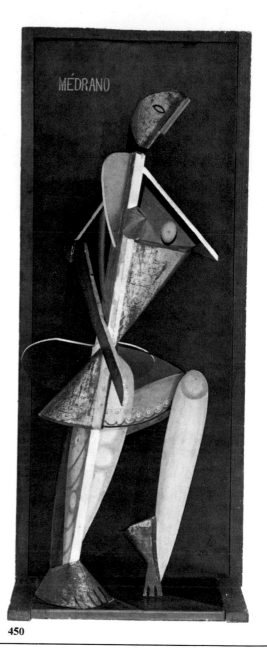

450

Like Matisse, Picasso also turned to sculpture at many times during his very long career. Many of his paintings, in fact, have a distinct sculptural quality, and Cubism itself deals largely with problems of volume. While introducing objects from the real world into his collages, as in *Still Life with Chair Caning* (see plate 397), he pioneered a new way to create sculpture. Until then sculpture was made either by carving an image from a block of wood or stone or by modeling with clay, which was then cast into plaster and eventually into bronze. Picasso's *Guitar* of 1914 was a construction, assembled from sheet metal and then brightly painted. The idea of constructing sculpture was one of this century's great artistic innovations and opened up many new possibilities for sculptors. Picasso himself playfully reorganized natural elements to create an artistic concept of an unusable musical instrument.

A short while after Picasso's assemblages, Archipenko developed reliefs which he called "sculpto-paintings," such as *Médrano II*. In this Cubist construction, concerned with concave and convex elements, he experimented with materials from everyday life, such as tin, glass, wood, and oilcloth. Soon after Constructivists and Dadaists were to use industrial materials and ordinary objects for different purposes.

Vladimir Tatlin's *Relief* of 1917 goes a great step further: here is a work of sculpture which has totally renounced any ostensible relation to visible reality. Whereas in painting many artists simultaneously moved toward abstraction, there is little doubt that in sculpture it was the Russian Constructivist Tatlin who was responsible for the first totally abstract work in that medium. His first abstract "painting-reliefs" made of heterogeneous materials date from 1913–14. Certainly he based some of his concepts and techniques on Picasso's innovations, which he saw on a trip to Paris in 1913, and he also carried out Boccioni's pronouncement that every kind of material is

451

453

452

454

usable for the sculpture of the new age.

Other new and exciting investigations were going on in Russia. Naum Gabo's *Head of a Woman* is a corner relief in which the planes of the woman's head project out into space. Using thin sheets of metal and celluloid in this work, Gabo renounced sculptural mass and volume in favor of translucency and light and, above all, open space. In order to achieve this goal, the solidity of sculptural mass had to be penetrated and the void admitted into the total form.

It was not only Constructivists such as Tatlin and Gabo who brought industrial materials and processes into sculpture. In Zurich, Jean Arp,

one of the originators of the Dada movement, cut the parts of his relief *Forest* by machine to avoid traces of a hand. Clearly there are associations of the tree, the moon, and the forest in this relief of decorative biomorphic shapes.

Max Ernst also participated in the Dada movement before becoming one of the founders and leaders of Surrealism (see page 240). In his relief *Fruit of Long Experience,* he nailed wood and metal together and painted it, primarily for narrative reasons, for this work is autobiographical, humorous, laden with covert sexual overtones. Ernst was at that time, as he said later on, concerned with things "visible within

me" and set out to "record a faithful and mixed image of my hallucinations" to "reveal my most secret desires."

449 Pablo Picasso. *Guitar*. 1914. Painted sheet metal, height 37 $^7/_8$″ **450** Alexander Archipenko. *Médrano II*. 1914. Painted tin, glass, wood, and oilcloth, height 49 $^1/_2$″ **451** Vladimir Tatlin. *Relief*. 1917. Zinc and wood **452** Naum Gabo. *Head of a Woman*. c. 1917–20, after a work of 1916. Construction in celluloid and metal, height 24 $^1/_2$″ **453** Jean Arp. *Forest*. 1916. Painted wood, height 12 $^7/_8$″ **454** Max Ernst. *Fruit of Long Experience*. 1919. Painted wood and metal, height 15″

Still-Life Sculptures

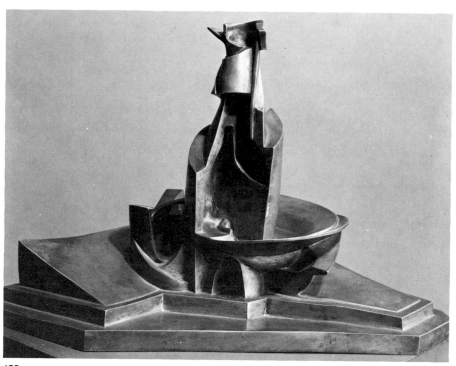

455

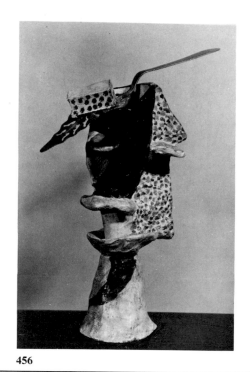

456

While nudes and reliefs are among the most traditional subjects and forms in the history of sculpture, the decade under discussion brought sculpture a new subject matter which until then had been the preserve of painters: the still life. The Futurist sculptor Boccioni made his *Development of a Bottle in Space,* in which an ordinary bottle—instead of a man or woman—was the focal point of a major composition. In other words, as in Picasso's *Guitar* (plate 449), an everyday object devoid of spiritual or heroic associations is elevated to a position of significance. The main cylindrical bottle consists of smaller bottle shapes which are fitted into the larger one, and as they are all at slightly different angles, they create the illusion of spiraling and continuous motion. This highly polished bronze also creates highlights and shadows, which form their own rhythms, at times in conflict with the apparent movement of the bottle, resulting in a dynamic relationship between object and environment.

Picasso's most famous still-life composition, in contrast, does not create this sense of movement. In his witty *Glass of Absinthe,* also of 1914, he placed an actual silver strainer among the varicolored dots, continuing his philosophical investigation of the relationship between illusion and reality and his formal concern with the problems of fusing solidity and transparency. In another *Still Life* of the same year he included a piece of upholstery fringe to make the same point.

A few years later Henri Laurens, who had been introduced to Cubism by Braque, made much more literal still-life compositions such as *Dish with Grapes*, in wood and sheet metal. He painted it in solid colors chiefly to counteract the effect of light on his assemblage.

When Marcel Duchamp purchased a urinal from Mott Works to exhibit at the Society of Independents show in New York in 1917, he turned it on its back and signed it "R. Mutt" and gave this still-life sculpture the title

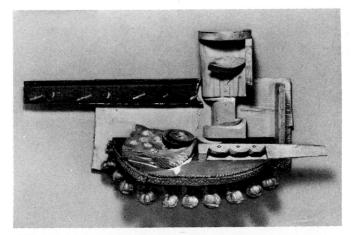

457

459

458

460

Fountain. This is one of the artist's early "readymades" (see also page 192), a category which has revolutionized the concept of art in this century as greatly as any of the other innovations. In 1917 an article published anonymously by the artist stated: "Whether Mr. Mutt with his own hands made the fountain or not has no importance. He CHOSE it. He took an ordinary article of life, placed it so that its useful significance disappeared under the new title and point of view—created a new thought for that object. As for plumbing, that is absurd. The only works of art America has given are her plumbing and her bridges."

Gerrit Rietveld, a member of the Dutch De Stijl movement, created a novel appearance for a similar kind of commonplace object. His *Armchair* of 1917 is meant to be sat in, but function—denied totally in Duchamp's urinal—is here only incidental to aesthetic appearance. The *Armchair*, composed of thin jutting planes painted in primary colors, could be viewed as a three-dimensional counterpart to a painting by Mondrian, the aesthetic leader of De Stijl. It attempts to purify and simplify its user's environment so that the essential relationship between growth (vertical) and stability (horizontal) might be better experienced.

455 Umberto Boccioni. *Development of a Bottle in Space.* 1912 (cast 1931). Silvered bronze, height 15″ **456** Pablo Picasso. *Glass of Absinthe.* 1914. Painted bronze with silver sugar strainer, height 8 $1/2$″ **457** Pablo Picasso. *Still Life.* 1914. Painted wood with upholstery fringe, width 18 $7/8$″ **458** Henri Laurens. *Dish with Grapes.* 1916–18. Polychromed wood and sheet metal, height 31 $1/2$″ **459** Marcel Duchamp. *Fountain.* Original 1917; reproduction 1964. Readymade urinal turned upside down, height 24″ **460** Gerrit Rietveld. *Armchair.* 1917. Painted wood, height 34 $1/2$″

The Animal Transformed

461

462

Sculptors continued to be interested in the animal as a subject but transformed it significantly in their work. A few years before Duchamp deported himself with such audacity by putting a urinal in an art exhibition, his older brother Raymond Duchamp-Villon created a series of bronze sculptures of a horse. The 1914 *Horse* sums up many of the Cubist and Futurist concerns in art in an eminently successful work. As dynamic as Boccioni's sculpture, this masterpiece is a synthesis of organic and machinelike forms. "The sole purpose of art," Duchamp-Villon wrote, "is neither description nor imitation, but the creation of unknown beings from elements which are always present but not apparent." And he actually created a new and totally unpredictable organism which has become a symbol for a new era, filled with energy and optimism.

Brancusi's *Penguins II* is one of his lifelong studies of birds. Though it lacks the soaring brilliance of his elongated metal birds, *Penguins* is a marble sculpture of whimsical charm. His *Maiastra* is a supernatural, miraculous, and beneficial animal, the Bird with the Golden Feathers in Romanian folklore. Brancusi made at least seven versions of this subject between 1910 and 1915, all in highly polished marble or bronze. The brilliant finish on the bronze in *Maiastra* embraces light within the sculptural form and simultaneously reflects the environment (including the viewer) while absorbing it into its being. The serene line and form of the bird, together with this all-important finish, create a symbol for human longing and worship of the sun. Its form, combining phallic and egglike shapes into a unity, creates the kind of universal form and meaning which Brancusi brought to the sculpture of this century.

In 1912, while Brancusi was working on another of the *Penguin* series, Jacob Epstein, the expatriate American sculptor, visited his studio in Paris. On his return to England, where he had settled, Epstein began a series of studies of doves copulat-

464

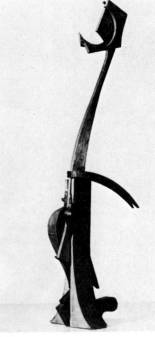

466

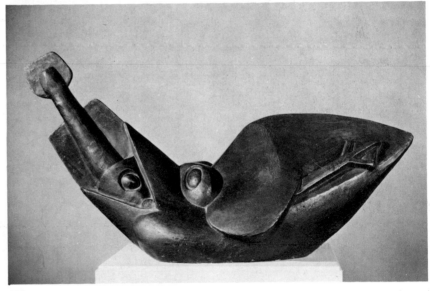

463

465

ing, and at the end of the year he showed *Third Marble Doves* at an exhibition in London. Outrage greeted the work, on both moral and aesthetic grounds. But it was strongly defended by another American in England, who like Epstein was associated with a group that was soon to be called the Vorticists (see page 135): the émigré poet Ezra Pound. Pound was also to be the earliest biographer of another Vorticist, Henri Gaudier-Brzeska. His *Bird Swallowing a Fish*, originally cast in gunmetal, depicts a bird with razor-sharp outline and mouth that firmly clamps a fish which has a tail that resembles an airplane. The bird, executed with clear edges and re-

flecting a hard light, is frozen in mid-swallow, illustrating the Vorticist precept that man/animal inhabits the calm center of a rotating holocaust or whirlpool. His image is "not an idea. It is a radiant node or cluster . . . a Vortex, from which, and through which, ideas are constantly rushing," said Ezra Pound.

In a much lighter vein is the *Bird* assembled from wooden slats by the young Max Ernst in Cologne. Extending his Dadaist relief collages (see plate 454) into free-standing sculpture, Ernst hammered pieces of wood together to end up with a ludicrous image of a bird, standing in surprised astonishment.

461 Raymond Duchamp-Villon. *Horse.* 1914. Bronze, height 18 $^1/_4''$ **462** Constantin Brancusi. *Penguins II.* 1914. Marble, height 21 $^1/_4''$ **463** Constantin Brancusi. *Maiastra.* 1912. Polished bronze, height 24'' **464** Jacob Epstein. *Third Marble Doves.* c. 1913. Length 29'' **465** Henri Gaudier-Brzeska. *Bird Swallowing a Fish.* c. 1913–14. Bronze, height 12 $^1/_2''$ **466** Max Ernst. *Bird.* 1916–20. Wood, height 40 $^1/_8''$

The Invasion of Space

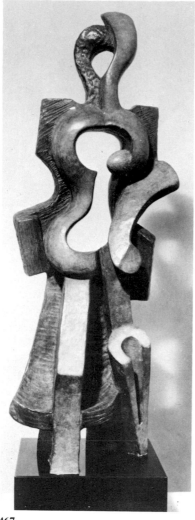

467

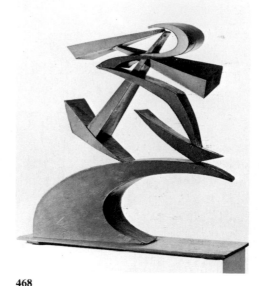

468

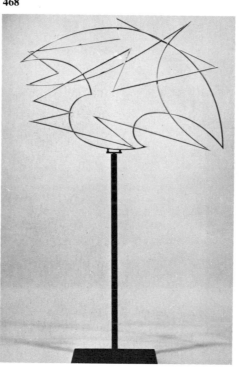

469

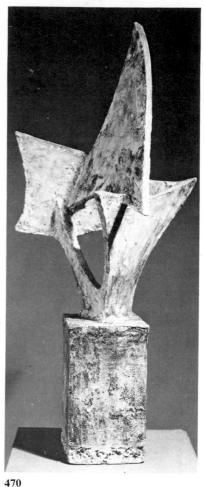

470

One of the essential breakthroughs in the sculpture of this decade was the notion that a work of sculpture could and should be opened up to the space surrounding it and become an integral part of what physicists called the space-time continuum. In 1912 Archipenko perforated a basically Cubist form in *Walking Woman*. Here for the first time a large part of the human figure consists of vacant space, a cavity. In fact, the solid bronze is used to encircle the space which was left open.

Boccioni, who proclaimed that the new (Futurist) sculpture should be opened up to the environment, related bronze forms to their surroundings in a highly dynamic fash-

ion of continuity of form fused with space. Giacomo Balla, one of the first artists in the twentieth century to create total environments, spread out his sculpture entirely in one of his rare three-dimensional compositions, *Fist of Boccioni—Lines of Force*. This work is a symbol of the aggressive action which Boccioni himself had pronounced in his manifestoes, his life, and his work.

Commonplace materials—in this case polychromed plastic—are used in *Air—Light—Shadow*, by Max Weber. This sculpture, based on Cubism, incorporates a series of related triangular forms which open to include the surrounding environment, though not so dynamically as in Balla's work.

But nothing could really be more open than a bicycle wheel. Viewed as an aesthetic rather than as a utilitarian object, it is a void defined by a round rim and articulated by a series of lines (spokes) connecting the center to the rim. These formal considerations may not have been in Duchamp's mind when, in 1913, he took a bicycle wheel, mounted it on a stool, and rotated it on its axle. In 1915 he exhibited *Bicycle Wheel* as his first readymade. It is also the first kinetic sculpture of the century.

In 1915, in his *Counter Relief,* the Russian Constructivist Vladimir Tatlin rejected wall brackets as well as a pedestal or any other device which would separate the work from its

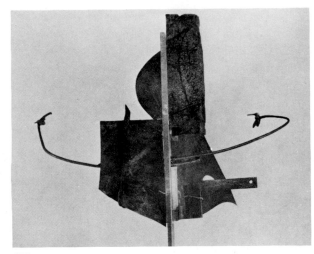

472

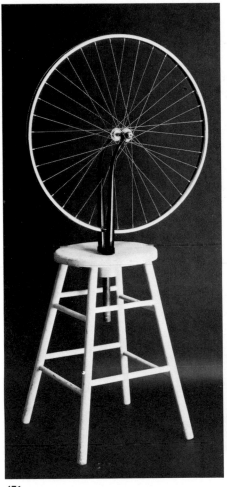

471

473

474

real surroundings. Tatlin's counter (or corner) reliefs were part of the actual space of the room, and the sculpture helps us become aware of the reality of the surrounding environment (see plate 409). A totally "abstract" work creates a new sense of reality. Unfortunately none of Tatlin's epoch-making constructions has been preserved. A follower of Tatlin's, Kasimir Meduniezky, created one of the few important works still intact from this period of great experiments in Russia. Meduniezky's *Construction No. 557* is an entirely open sculpture whose only association to the visible world is its sculptor's concern with the tensile strength of the contemporary materials.

Naum Gabo's *Project for a Radio Station* intermingles sculpture and architecture into a Constructive totality. Based on crossed diagonals and sharp zigzag lines, the tower rises on feet that recall the Eiffel Tower and terminates on top in cone shapes, which are visual indicators of its function of amplification. It seems improbable that Gabo ever expected this radio station to be built, but its experimental quality, its effort to find a synthesis between science and aesthetics reflect the optimism in the Soviet Union in the early years after the Revolution. It was designed just before Gabo and his brother Antoine Pevsner published their *Realistic Manifesto* in Mos-

cow. It concluded: "The past we are leaving behind as carrion. The future we leave to the fortune-tellers. We take the present day."

467 Alexander Archipenko. *Walking Woman*. 1912. Bronze, height 26 $^3/_8$″ 468 Giacomo Balla. *Fist of Boccioni—Lines of Force*. 1915. Cardboard, wood, and paint, height 33″ 469 Giacomo Balla. *Line of Speed and Vortex*. 1913–14, reconstructed 1968. Chromed brass on painted metal base, height 78″ 470 Max Weber. *Air—Light—Shadow*. 1915. Polychromed plaster, height 28 $^7/_8$″ 471 Marcel Duchamp. *Bicycle Wheel*. Original 1913 (lost); third version 1951. Assemblage: metal and painted wood, height 50 $^1/_2$″ 472 Vladimir Tatlin. *Counter Relief*. 1915. Wood and metal construction 473 Kasimir Meduniezky. *Construction No. 557*. 1919. Tin, brass, and iron, height 10 $^7/_8$″ 474 Naum Gabo. *Project for a Radio Station*. 1919–20. Pen and ink

Train Stations

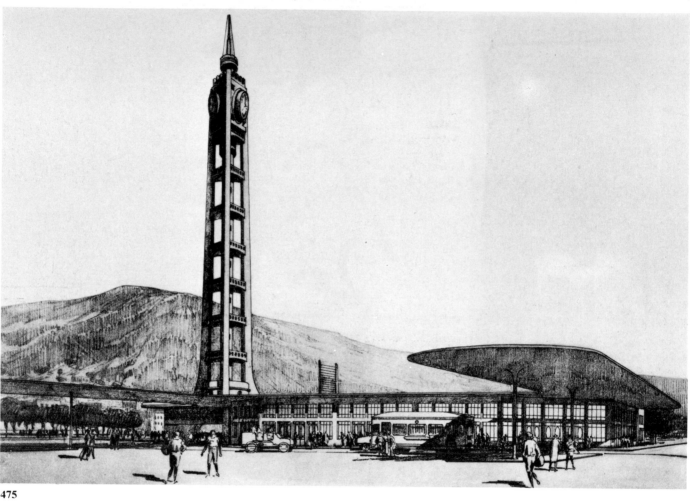

475

The railroad was still the major means of transportation in the second decade of the century, and the railway station, as the gateway to the city, remained one of the most important urban monuments. While in England, Ebenezer Howard championed the Garden City movement as a romantic flight from blighted urban cores, Tony Garnier in France affirmed his faith in the technological city, separating the functions of work, transportation, leisure, and residence by green belts. His railway station is a straightforward statement of function utilizing reinforced concrete and glass, while rejecting academic historicism and Art Nouveau. Garnier eventually became the city architect of his native Lyons and there realized several projects similar to those in this comprehensive Cité Industrielle design.

The World War terminated the life of the Italian architect Antonio Sant'Elia before he had a chance to find out if his much more radical ideas could be turned into reality. Sant'Elia, who was closely associated with the Italian Futurists and believed in "universal dynamism," in the vitality, the noise, the mobility of the modern industrialized metropolis (as opposed to the bucolic Garden City), designed multistoried circulation systems segregating pedestrian, automotive, train, and air traffic. Unlike Garnier's design, Sant'Elia's plan for a combined train station and airport for the Città Nuova (New City) revels in the multilayered movement of machinery, reducing humanity to insignificance and rejecting nature altogether.

The stations which were actually built did not carry through the brilliance of vision and formal modernity of Garnier or more especially of Sant'Elia. Grand Central Terminal in New York, despite its conservative appearance based on academic views of Roman models, actually anticipated many of Sant'Elia's concepts in its layout. With vehicular and pedestrian traffic separated by means of great ramps which appear to penetrate its base on the exterior

476

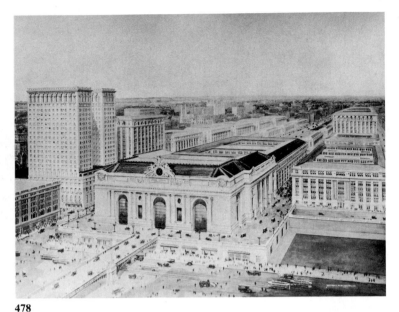

478

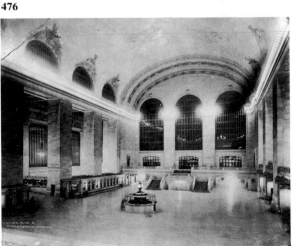

477

479

and by ramps and stairways conveying passengers to train platforms inside, the New York landmark proudly straddles Park Avenue. The terminal was designed by Charles A. Reed, Allen H. Stem, Whitney Warren, and Charles D. Wetmore in 1903, but not completed until 1913. It provided a vast vaulted interior space which had a lofty elegance in its original uncluttered state and permitted a large-scale circulation of people efficiently.

In Germany the most important railway station built at the time was the terminal in Stuttgart by Paul Bonatz and F. E. Scholer. Designed in 1911, it was not completed until 1927 due to interruption by the war.

The architects used the rusticated masonry of Florentine Renaissance palaces and the massiveness of Egyptian architecture as models. There was, indeed, a revival of interest in Egyptian architecture at the time: the German architect Walter Gropius (see page 196) compared the American grain silo (the ideal of modern functional building) with Egyptian structures, and Charles Demuth called his painting of a Pennsylvania grain elevator *My Egypt*. The Stuttgart station became an important model primarily because of its break with symmetry and its functional grouping of masses and openings.

475 Tony Garnier. Design for a Railway Station for the Cité Industrielle. c. 1917 476 Antonio Sant'Elia. Design for an Airplane and Railroad Terminal for the Città Nuova. 1914 477–478 Reed and Stem, Warren and Wetmore. Grand Central Terminal, New York. 1903–13 477 Photograph 1914 478 Preliminary design 479 Paul Bonatz and F. E. Scholer. Railway Station, Stuttgart. 1911–14, 1919–27.

Designs, Projects, and Studies

480

481

482

Because of the war, building in Europe came to an almost complete halt in the 1910s, but audacious utopian projects of personal and often mysterious inspiration resulted from the stored-up pressure of ideas unable to be realized.

Bruno Taut published a book of drawings called *Alpine Architektur* in 1919, proposing to fashion whole mountain ranges in the Alps into crystalline buildings, symbols of hope and contemplative beauty. His fantasies can be considered as gigantic science fiction sets but they can also be seen as brilliant precursors of earthworks and canyon-spanning curtains in the Rocky Mountains which, more than a half-century

later, do not match the grandiosity of Bruno Taut's imagination.

Hans Poelzig's visionary design for a house of friendship in Istanbul would have totally dominated the ancient city. Had it been realized, Poelzig's vast and fantastic concept of a large terraced building with hanging gardens, standing on the top of a ridge overlooking both the Bosporus and the Sea of Marmara, would have crowned the city, but would also have been at odds with the urban fabric of domes and minarets. Similarly, his design for a festival hall in Salzburg would have introduced an immense colonnade topped by an exotic zigguratlike circular structure with turreted out-

posts—distinctly out of keeping with the flavor of the existing buildings.

Perhaps the most significant visionary of the period was Erich Mendelsohn. Impressed by the strong expression of Jugendstil designers like Henry van de Velde, as well as by natural objects themselves, Mendelsohn attempted to create dynamic reinforced-concrete analogues of organic energy. His sketch for a labor hall suggests glacially carved cliffs and banked waves, as well as anticipating the tailfins of a 1957 Cadillac.

When Walter Gropius asked Lyonel Feininger to design the cover for the first *Bauhaus Manifesto* in 1919, Feininger made a woodcut of a *Cathedral of Socialism* whose three star-

483

484

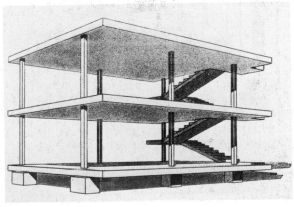

485

486

crowned towers signified the three arts of architecture, painting, and sculpture. Though never intended to be built, Feininger's cathedral is indeed the emblem of a new concept for an art school which, at least in its early stages, sought to integrate the arts and crafts, put an end to the alienation of industrial workers from their products, and involve all people and classes in a new community effort of comprehensive environmental design.

No less visionary were some of Antonio Sant'Elia's designs for the Città Nuova, constructed from a few simple geometric forms amplified to monumental scale. Sant'Elia dreamed of apartment houses, office build-

ings, and transportation networks of a scale, complexity, and order that could be realized only by totalitarian regimes and immense corporations.

Far less imposing in size but of much greater consequence are the designs of the Swiss architect Le Corbusier (Charles-Edouard Jeanneret) for the "Dom-ino" system, an immediate response to a desperate housing shortage caused by the wartime drain of materials and labor. Designed to be totally standardized and prefabricated, the Dom-ino houses consisted simply of concrete slabs doubling as roof and floor supported by a few steel columns and linked by a staircase. Of greatest significance for all modern housing

was the unprecedented degree of freedom provided by the elimination of interior walls in the initial construction; the Dom-ino was the ultimate in open planning.

480 Bruno Taut. *Snow Glacier Glass.* Drawing in *Alpine Architektur,* 1919 481 Hans Poelzig. Design for a House of Friendship, Istanbul. 1916 482 Hans Poelzig. Design for a Festival Hall, Salzburg. 1919 483 Erich Mendelsohn. Design for an Imaginary Labor Hall. 1914 484 Lyonel Feininger. *Cathedral of Socialism.* Woodcut. Cover of the *Bauhaus Manifesto.* 1919 485 Antonio Sant'Elia. Design for a Power Station for the Città Nuova. 1914 486 Le Corbusier. Design for the Dom-ino System of Construction. 1914

Glass in Architecture

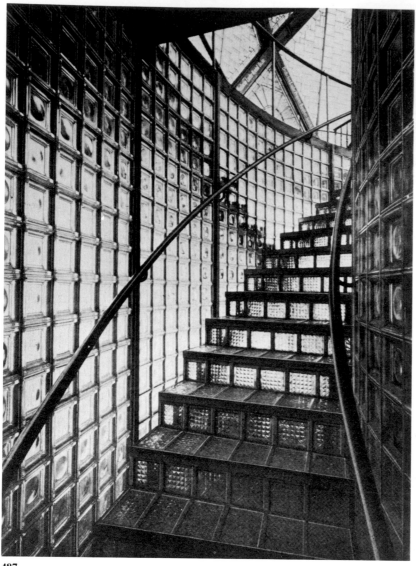

487

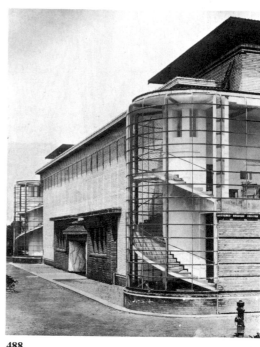

488

Along with reinforced concrete, glass was considered to offer the most exciting possibilities as a new structural material, permitting creation of buildings of crystalline purity and dazzling spatial innovations. Two outstanding examples of the new use of glass were seen at the exhibition in Cologne in 1914 sponsored by the German Werkbund, an association of artists and architects dedicated to improving standards of industrial design. Bruno Taut's prismatic glass pavilion at Cologne was a structural manifesto of his belief that glass heightens and activates human perceptions. The glass floors,

walls, and ceilings were translucent, and visitors said that the building looked like a giant kaleidoscope, especially at night, when it was illuminated and probably resembled the light shows of fifty years later.

Walter Gropius and Adolf Meyer's office building on the same exhibition grounds employed glass to enclose the stairwells. Whereas Taut's walls were translucent, Gropius and Meyer used wholly transparent glass to display a staircase elegantly cantilevered from a core column. Its curved curtain wall, insubstantial as it is, recalls in shape the American grain silos admired by Gropius and

contrasts with the blocky massing and heavy slab roofs of the main building, clearly inspired by the early designs of Frank Lloyd Wright.

Glass, it is true, had been used for large buildings ever since Joseph Paxton's Crystal Palace housed the first international exposition, in London in 1851, but its wholesale use was usually restricted to impermanent exposition structures or utilitarian train sheds. The direction pointed by the Chicago steel-frame skyscrapers at the turn of the century culminated in Willis Polk's Hallidie Building in San Francisco, where the entire facade becomes a

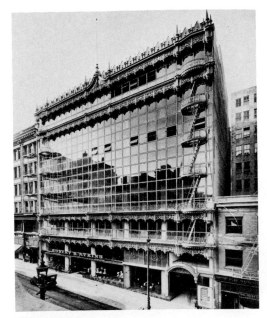

489

490

491

smooth shimmering membrane, supported from within by reinforced concrete floors. The Hallidie Building marks the first use of a curtain wall in a large commercial structure, though it was little known outside of San Francisco and of little influence even there. Indeed, as if unsure of his own daring, Polk capped his revolutionary creation with an ornate cast-iron filigree whose Gothic tracery echoes the conservative street lamps below, designed by Polk at the same time.

Glass also inspired Ludwig Mies van der Rohe's never realized project for an office building on Berlin's Friedrichstrasse in 1919. The building, set on an awkward triangular site, was conceived as three separate towers, free-standing, with faceted walls. The towers are linked by a central service core. Their glass curtain walls supported by cantilevered interior floors compose a heroic urban sculpture, showing the Expressionist influence on the early Mies, but also suggesting Russian Constructivist sculpture in plastic, steel, and glass. The project follows Polk's Hallidie Building by only a year but makes no concession to historic forms and extrapolates the glass wall, enlarging it to gigantic dimensions.

487–488 Werkbund Exposition, Cologne. 1914 487 Bruno Taut. Glass Pavilion, staircase 488 Walter Gropius and Adolf Meyer. Office Building, glass-walled staircase with cantilevered steps 489–490 Willis Polk. Hallidie Building, San Francisco. 1918 490 Detail 491 Ludwig Mies van der Rohe. Design for an Office Building on the Friedrichstrasse, Berlin. 1919

Theaters, Exhibition Buildings, and Observatories

492

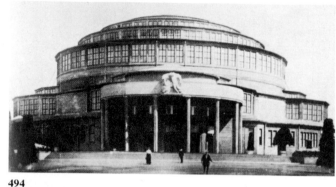

494

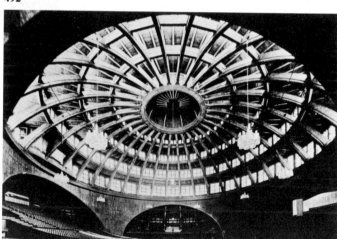

493

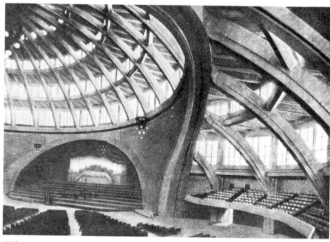

495

When Hans Poelzig converted a circus hall in the center of Berlin into the Grosses Schauspielhaus, which became Max Reinhardt's Theater of the Five Thousand, he created one of the architectural landmarks of German Expressionism. The vast amphitheater with its domed ceiling, dripping with concrete stalactites, resembles an immense vaulted cavern or a grand Baroque caprice.

Poelzig clearly owed a debt to Max Berg's prewar Centenary Hall in Breslau (now Wroclaw), a giant monument built to commemorate the centennial of the War of Liberation against Napoleon. A ribbed dome, far greater than any then in existence, is supported by massive canted concrete arches which, like the piers of a Gothic cathedral, are carried onto the exterior by flying buttresses. But Berg made no aesthetic concessions to the past, nor, like Poelzig, did he hide his structure for dramatic effect. Berg's theater is a pure, unadorned structure whose simple geometry is its own decoration. Backlit by windows, the massive ribs of the vault become a concrete spiderweb. In the Centenary Hall, Berg achieved the modern ideal of abolishing the distinction between architect and engineer.

For the Werkbund Exposition of 1914 in Cologne, the Belgian architect Henry van de Velde also designed a concrete theater with undulating, curvilinear walls and roof, creating a dynamic effect in spite of the building's strict symmetry. Whereas Berg was primarily concerned with mass and volume, Van de Velde's emphasis was primarily linear, the heritage of his earlier involvement with Art Nouveau.

An exhibition structure deriving from a very dissimilar vision is Bernard Maybeck's Palace of Fine Arts, built for the Panama-Pacific International Exposition in San Francisco. While Maybeck remained proud of his academic training at the Ecole des Beaux-Arts in Paris, he always interpreted its conservative teachings with a freedom and idiosyncrasy matched by few of its other gradu-

496

499

497

498

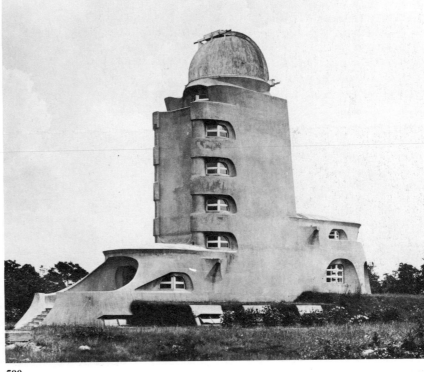

500

ates. When on short notice he was called upon to design an art gallery for the San Francisco fair, he concocted a great monument of romantic classicism, a rainbow-hued instant ruin inspired by the drawings of Giovanni Battista Piranesi. A colossal rotunda embraced by a semicircular colonnade, the structure overgrown with trees and vines and reflected in a swan-haunted lake, the palace was an opium dream come true. The theatrical piece, originally built of plaster, so captured the local imagination that it was rebuilt in 1965, fifty years after the other exposition structures had been demolished.

During the war Erich Mendelsohn had sketched many fantastic projects.

On his return from military service he was given the opportunity to adapt one of them to reality when the Astrophysical Institute in Potsdam commissioned him to build an observatory and laboratory for Albert Einstein. The Einstein Tower is at once Mendelsohn's expression of architecture as spiritual intuition and the masterpiece of German Expressionist architecture. Conceived as an architectural symbol of Einstein's Theory of Relativity (which had already found expression in Cubist and Futurist art), the tower surges upward, deliberately rejecting static structure in order to express the physicist's theory of the dynamic correlation of energy and matter.

492 Hans Poelzig. Grosses Schauspielhaus, Berlin. 1919 **493–495** Max Berg. Centenary Hall, Breslau (Wroclaw). 1910–13 **496–497** Werkbund Exposition, Cologne. 1914. Henry van de Velde. Theater **496** Rear view **497** Front view **498** Panama-Pacific International Exposition, San Francisco. Bernard Maybeck. Palace of Fine Arts. 1914–15; rebuilt 1965 **499** Erich Mendelsohn. Design for the Einstein Tower, Potsdam. 1919 **500** Erich Mendelsohn. Einstein Tower, Potsdam. 1919–21

Industrial Buildings

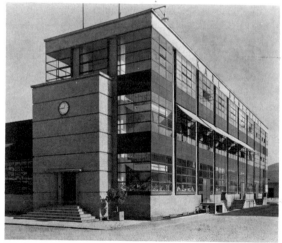

501

502

It is not surprising that some of the greatest advances in modern architecture were made in industrial buildings, traditionally the field of engineers. Such utilitarian structures were regarded by young designers as archetypes of modern life determined by the machine, purely and simply functional and freed of historic associations.

The Fagus Factory for the production of shoe lasts, which was designed in 1911 by Walter Gropius and Adolf Meyer, is a landmark of the modern movement. Its rhythmic facade is composed almost entirely of glass barely interrupted by a skeleton of

brick piers which are recessed to emphasize the dominance of the new wall material. Further, the glass wall boldly turns the corner without the aid of an exterior support. Glazed opaque panels of the same dimensions as the individual panes of glass articulate the three stories within and create a subtle horizontal continuity across the facade that echoes the brick base and roof band. In the Fagus Factory, Gropius and Meyer created a glass box which was the prototype for innumerable industrial and commercial structures to follow.

In the prewar years the form of the tower obsessed German architects,

who likened it to the Holy Grail. Hans Poelzig built an extraordinary water tower for a chemical factory near Poznań. Structure is clearly articulated by an exposed iron framework filled in with brick and windows, suggestive of medieval half-timbering but actually inspired by Peter Behrens's work for the AEG (see plate 139). Poelzig's tower possesses a monumental symmetry and simplicity, while its changing diameters, suggesting the expansion and contraction of a flexible diaphragm, give it a surprising dynamism.

Peter Behrens's water tower for the Frankfurt Gas Works, built

503

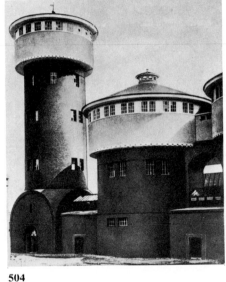

504

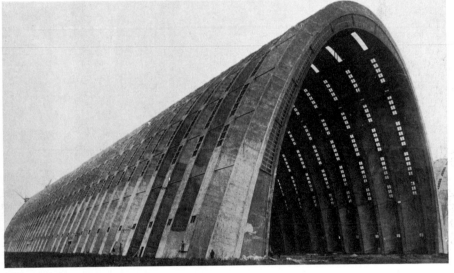

505

around the same time, offers an interesting contrast to Poelzig's tower. Whereas the latter, with its squat proportions and exposed metallic framework, appears to be a lightweight, almost inflated structure, Behrens's brick tower, composed of a minimum of simple, geometric shapes, appears to be hewn from solid rock. The pristine geometric economy of Behrens's tower makes Poelzig's look fussy by comparison, yet both suggest the image of the chalice, blown up to heroic dimensions.

Understandably, some of the most daring structures of the period were built in the new material of reinforced concrete and not by architects at all but by engineers. In France, Eugène Freyssinet's enormous airship hangars at Orly fulfilled a wholly new function and pioneered parabolic arch construction on a grand scale. The corrugated rib vaulting, punctuated by narrow vertical bands of windows, abolished the distinction between wall and ceiling and pointed the way to thin shell constructions of reinforced concrete, shells which are lightweight yet enormously strong.

501 Walter Gropius and Adolf Meyer. Fagus Factory, Alfeld. 1911 502 Hans Poelzig. Water Tower, Poznań. 1911 503–504 Peter Behrens. Water Tower for the Frankfurt Gas Works. 1912 504 Detail 505 Eugène Freyssinet. Airplane Hangar, Orly. 1916

Churches

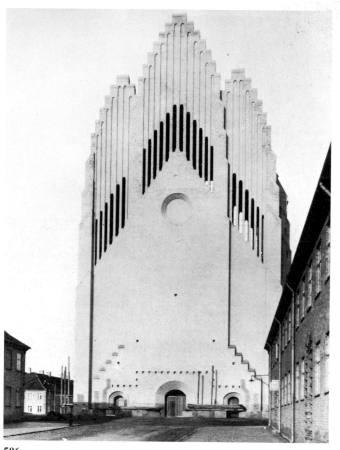

506

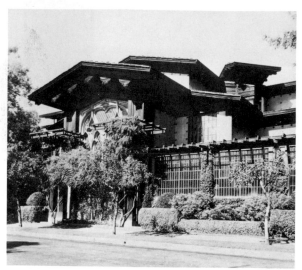

507

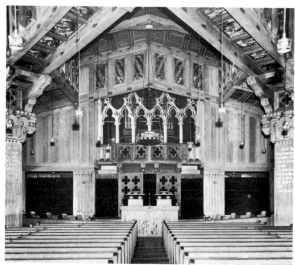

508

Few important churches were built during the war decade, but one which represents an interesting hybrid of modern austerity and regional tradition is P. V. Jensen Klint's Grundtvig Church in Copenhagen, designed in 1913 but not completed until 1926. In its emphatic verticality, tripartite division, tympana, and central rose window, it clearly refers to Gothic cathedral prototypes, while its stepped gable motif and brick construction are peculiarly Baltic in inspiration. The raked and attenuated fluting terminating the facade suggests an immense pipe organ, but the exaggerated verticality and plain surfaces convey something of the nightmarish aspects of Expressionist stage and movie sets of the period.

Much bolder in every respect is Bernard Maybeck's First Church of Christ, Scientist, in Berkeley, California, a masterpiece of cohesive eclecticism, combining Romanesque, Gothic, Japanese, Scandinavian, Byzantine, and industrial elements in a structure of extraordinary richness and complexity. Vegetation is intimately wedded to the building by means of planter boxes and wooden outriggers protruding from asbestos-shingled walls capped by broad-eaved, heavy-beamed roofs. From within, vines sway in silhouette against translucent walls of pink glass. The interior displays an almost barbaric splendor of rich color applied to virtually every surface. Massive wooden trusses, inset with golden Gothic tracery and containing ventilation shafts, support a roof which hovers mysteriously above a continuous band of light pouring through walls of glass set in industrial steel sash. The happily wedded contradictions which abound in this church were Maybeck's most successful attempt to portray "the life that is behind the visible" in built forms.

No less extraordinary is the chapel which Antoni Gaudí planned for the Colonia Güell, a textile workers' housing project near Barcelona. Though Gaudí began planning this ambitious undertaking in 1898, only the crypt was completed (it was ded-

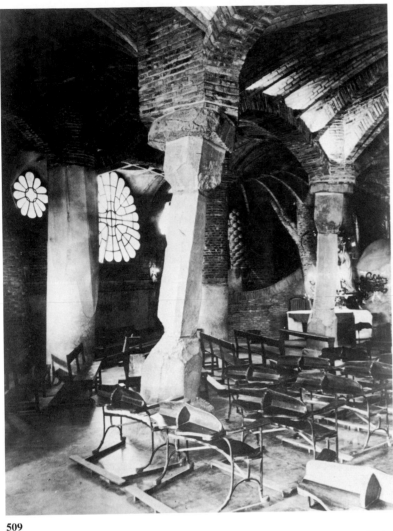

509

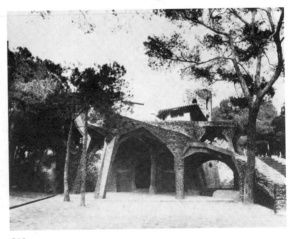

510

icated in 1915). Gaudí used the chapel as a laboratory for elaborate structural and geometric speculations which were made possible solely by wealthy and indulgent patrons and a crew of outstanding craftsmen. Models were constructed of suspended strings—representing the arches of the structure—from which were hung weights proportional to the stresses exerted by loading. The distorted curves thus produced showed the inclinations necessary for arches and piers to carry a thrust at any particular point. Gaudí made sketches from inverted photographs of these elaborate models which show a completed church supported by parabolic arches in the vegetal Gothic style

which he was to employ in his great Sagrada Familia church (see plates 146 and 147). Further models were constructed of suspended and weighted sheets to show the stonemasons a vaulting system far too elaborate to be conveyed in plans. An idea of the extent to which Gaudí was willing to carry his speculations can be had from the crypt. This primeval, cavelike, yet spidery structure, with its attenuated furniture, is one of Gaudí's most ingenious designs, embodying almost as many contradictions as Maybeck's church in Berkeley.

506 P. V. Jensen Klint. Grundtvig Church, Copenhagen. 1913–26 507–508 Bernard Maybeck. First Church of Christ, Scientist, Berkeley, Calif. 1910–12 509–510 Antoni Gaudí. Colonia Güell, Barcelona. Chapel. 1898–1915. 509 Crypt 510 Porch

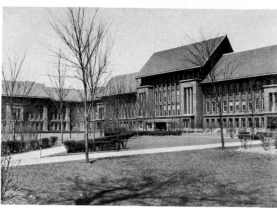

512

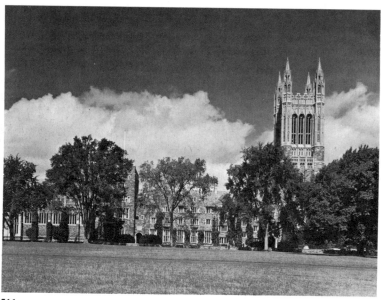

511

513

The war decade saw few innovations in collegiate architecture after Ralph Adams Cram and Frank W. Ferguson's Graduate College at Princeton, New Jersey, set a national fashion for Neo-Gothic academic buildings placed around grassy quadrangles. The popularity of so-called Collegiate Gothic, redolent of Oxford and Cambridge, as well as Neo-Georgian, extended from New Canaan to Seattle and even penetrated California, where, amid palm trees and hibiscus, it appeared at its most ludicrous.

In contrast with such revivalisms is the Carl Schurz High School in Chicago by Dwight H. Perkins.

While the bold, blocky massing and geometric articulation of vertical and horizontal elements clearly reflect the ahistorical Prairie Style of Frank Lloyd Wright, the steeply pitched roofs suggest more traditional domestic architecture.

Irving Gill's Bishop's School in La Jolla, California, demonstrates that a strictly regional style could be effectively used as a springboard for the development of wholly new and prophetic forms. Gill, a native of Chicago, had worked in the office of Adler and Sullivan before moving to California early in the century and had undoubtedly absorbed some of

the functionalist rationale which pervaded that firm. In San Diego, he created a style of geometric simplicity and abstraction inspired by the adobe buildings of the Spanish Colonial period, then enjoying a revival. The square windows and repetitive arches cut sharply into flat concrete walls and the low profile of the Bishop's School clearly suggest the arcaded courtyards of the California missions, while the flat roofs, concrete-slab construction, and functional austerity are a remarkable foreshadowing of the International Style of the following decades and parallel the revolutionary formal

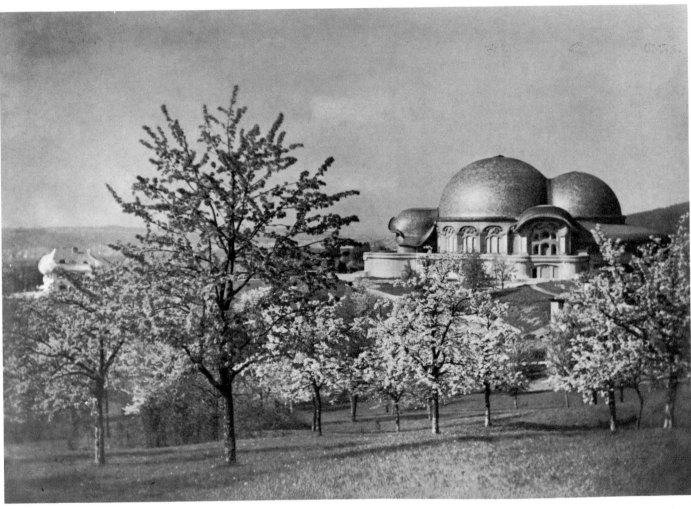

514

abstraction of Adolf Loos in Europe. Isolated on the Pacific Coast, Gill's remarkable early buildings received little notice and were overwhelmed by a vogue for Spanish Baroque caused by the world's fair in his own San Diego in 1915. The Bishop's School remained an unfulfilled promise, and Gill himself died in obscurity in 1936.

Although intended primarily as a school, meeting hall, and theater, Rudolf Steiner's first Goetheanum in Switzerland was, in reality, a temple to Anthroposophy, of which Steiner was himself founder and high priest. This movement, together with The-

osophy, from which it sprang, embraced all religions and claimed to be the spiritual pathway to higher states of consciousness. Although Steiner had no architectural training, he designed this exotic two-domed meeting hall, as well as most of the other buildings in a village on a hilltop in Dornach near Basel. After the wooden Goetheanum burned in 1923, the concrete Goetheanum II carried Steiner's fantastic fusion of Art Nouveau and Expressionist forms into the next decade.

511 Ralph Adams Cram and Frank W. Ferguson. Graduate College, Princeton, N.J. 1913 512 Dwight H. Perkins. Carl Schurz High School, Chicago. 1908–10 513 Irving Gill. Bishop's School, La Jolla, Calif. 1909–16 514 Rudolf Steiner. Goetheanum. Dornach, Switz. 1913 (demolished)

Public Buildings

515

516

While German architects such as Poelzig and Taut dreamed of great towers as Holy Grails and urban crowns, Americans actually built towers of unprecedented height, due more to economic than polemic considerations. The skyscraper, born in Chicago, quite logically flourished on the constricted island of Manhattan, where real estate values, inflated by ever-increasing density of function and population, demanded vertical stacking. The sheer magnitude of the massed towers rising at the tip of Manhattan created a totally new cityscape and a skyline which was the wonder of the world. New York embodied the wealth,

energy, vulgarity, and dynamism of America in a few square miles. Here at last, in the New World, was rising the city of which the Futurists dreamed.

Ironically, however, instead of the clear articulation of function characteristic of the new architecture in Chicago at the turn of the century, New York's towers were clothed in traditional forms. In his Woolworth Building, Cass Gilbert chose a Gothic vocabulary to invoke historical precedents for his soaring 792-foot skyscraper. The stepped-back tower bristling with Gothic tracery and finials was a highly functional structure decked out in an architectural

masquerade. For some twenty years it remained the world's tallest building and served as Manhattan's crown.

Adherence to historic forms of a different manner is evident in Ragnar Östberg's Town Hall of Stockholm, as superbly sited on the water's edge as the British Parliament in London. Its simplified and stylized medieval elements and brick construction were an expression of the romantic nationalism popular in Scandinavia and Holland in the first decades of the century and are in perfect harmony with the cityscape of Sweden's capital.

Like Antoni Gaudí's other work,

518

519

517

520

his Entrance Pavilions to the Güell Park in Barcelona stand entirely outside the mainstreams of contemporary architecture as the individual caprice of Catalonia's great visionary architect. The writhing organic forms, built of stone and brick encrusted in parts with a garish polychrome mosaic of broken ceramic, glass, and other scrap, resemble submarine molluscs crowned with toadstool chimney pots. Bizarre as they are, they provide a fitting introduction to the fantastic park which Gaudí laid out as the basis for an English Garden City overlooking the Mediterranean.

Frank Lloyd Wright's most impor-tant structure of the decade, Midway Gardens, in Chicago, was an elaborate building for outdoor entertainment, dining, and concerts. Extremely complex in its interrelation of terraces on various levels, it was tied together by its strong geometric massing of forms and its highly original abstract sculptural ornamentation. In Midway Gardens, Wright's ideal of interweaving indoor and outdoor space was fully realized for the first time in a large public structure. Chicago, however, was not prepared to support this luxurious resort, and it gave way to a parking lot within a decade of its construction.

515 Cass Gilbert. Woolworth Building, New York. 1910–13 516 Ragnar Östberg. Town Hall, Stockholm. 1909–23 517–518 Antoni Gaudí. Güell Park, Barcelona. 1900–14 517 Entrance Pavilions 518 Rooftops 519–520 Frank Lloyd Wright. Midway Gardens, Chicago. 1914 (demolished)

Four: The 1920s

The violence of World War One left much of postwar Europe in a chaotic situation. "The War to End Wars" produced only a temporary halt to bloodshed. "The War to Make the World Safe for Democracy" created little true democracy. In Russia the battles continued into the twenties as White Russians and Polish forces, supported by the Allies, fought the Bolshevik regime. By the early part of the decade, however, the Communist Party was in complete control. At the end of the decade, Josef Stalin concentrated all political, social, economic, and spiritual power in his own hands, liquidating all possible opposition and carrying through industrialization and collectivization at tremendous cost to human life and liberty. In Germany, which was to become the key to Europe in many ways, the attempts by Communists and Spartacists to seize power and institute a revolutionary government failed and most of the old imperialist patterns were reestablished. The spirit that had chosen Goethe's city of Weimar as the site in which to create a fine, humanistic doctrine of constitutional government was not able to prevail. The Weimar Republic, unable to come to grips with the immediate problems, seemed doomed almost from the first. The Versailles Treaty, although not harsh enough to suppress a resurgent Germany permanently, was thoroughly humiliating to German morale and eventually roused many elements of the population to revenge. The Social Democrats, who assumed control, answered the threats from the left by the brutal murders of its leaders, Rosa Luxemburg, Karl Liebknecht, and Kurt Eisner, in 1919. Turmoil continued. By 1923 the runaway inflation had ruined the middle class and had a far more wide-reaching effect than the abortive revolution. The German judicial system sentenced men of the left to death sentences or long imprisonments, while rightists were hardly troubled at all and even Hitler served less than a year in a minimum-security prison after his putsch of 1923.

In other European countries, as in Germany, the left was split profoundly by the Communists' insistence on total revolution while Socialists and Social Democrats urged compromise with the old order. This made it possible for Benito Mussolini of Italy to talk revolution and to establish the first fascist dictatorship in Europe, in 1922. This was followed by the development of right-wing autocracies in southern and eastern Europe, including Poland under Pilsudski, Hungary under Horthy, and Portugal under Salazar.

In the victorious countries of France and England, there were no such extreme solutions, but the drive for a return to law and order was widespread. With the Marxist parties riddled by internal dissension in France, the ultraconservative Bloc National was elected in 1919. It enforced a restrictive situation at home and brought about the military occupation of the Ruhr Valley in 1923 in order to collect German reparations by direct seizure of coal and industrial output. In Great Britain, troubled by unrest and revolt from Ireland to India, the conservative Tory government ruled for most of the twenties.

The political situation in the United States was also one of fear and suppression. Warren Harding, a banal, corrupt back-country politician from Marion, Ohio, and a man of the most modest intellectual endowments, was elected on a "Back to Normalcy" platform in 19⁀⁀. The possibility of this country's entering the League of Nations vanished as a new isolationism seemed the answer to the general disillusionment. Anti-Red hysteria swept the country and Attorney General A. Mitchell Palmer organized bloody countrywide raids against striking workers, aliens, and indeed anyone suspected of left-wing tendencies. In the South and the Midwest, a revived Ku Klux Klan, terrifying and lynching Negroes, reached a membership of four to five million by 1923. As in Weimar Germany, civil liberties seemed to be reserved for those citizens loyal to the regime. Prohibition, enacted in 1919 by constitutional amendment to establish "clean living," encouraged organized crime and the spread of gangsterism. Few racketeers were ever brought to trial, and Al Capone, the czar of bootleg liquor, was seen as a popular hero rather than a murderous criminal. When Calvin Coolidge came to power upon Harding's death in 1923, he expressed the generally accepted notion that the "business of America is business." The 1920s saw the beginning of advertising and public relations on an unprecedented scale. What has since been labeled the "consumer society" began to flourish in America during that decade.

By the mid-twenties, however, the tenor of life underwent considerable changes. The wide dispersion of the automobile and the radio brought a still largely rural America into contact with the urban centers. The film industry in Hollywood exported American entertainment throughout the world: while Rudolph Valentino, Douglas Fairbanks, and Mary Pickford played out the people's fantasies, masters of comedy—Charlie Chaplin, Buster Keaton, and Harold Lloyd—made cogent comments on the ludicrous absurdity of life. People heard Louis Armstrong, Duke Ellington, and many other brilliant jazz composers and performers, who brought a new form of music based on the beat of African syncopation into the limelight in an era that was aptly called the Jazz Age by its literary spokesman, F. Scott Fitzgerald.

In Berlin, which in the face of impending doom became the world's entertainment capital, an even freer morality and life of libertinism and dissipation prevailed. Berlin, however, was not only the city of the cabaret, the café, the bordello, the street; it also became a major intellectual center, where great music and theater were written and performed and where important art and literature were produced. Many of the intellectual heroes, from the poet Stefan George and his cultist worshipers to the antirationalist and mystic philosopher Martin Heidegger, had little but disdain for the democratic republic, which was to their minds the height of vulgarity. The beliefs set forth by Walter Gropius and his colleagues at the Bauhaus (i.e., that a technological society could be controlled only by a full comprehension of technology and modernity) found little appeal in a basically romantic society that was engaged in a love affair with death. Some of the decade's leading writers in English, F. Scott Fitzgerald and D. H. Lawrence among them, were also preoccupied with the relationship of sex and death. Leading intellectuals of the period, including Oswald Spengler, T. S. Eliot, George Santayana, and José Ortega y Gasset, were intellectuals of the right, warning of the dangers of populism, egalitarianism, and the vulgarization of the cultivated mind, while the decade's most original philosopher, Ludwig Wittgenstein, established a philosophy of mathematical and scientific orientation, far removed from the problems of mundane life.

This was also the decade in which psychoanalytic theory attained general interest. Sigmund Freud himself broadened his investigations to include society and culture as a whole rather than focusing merely on the individual and his family. Carl Jung proposed a collective unconscious, advancing the possibilities of mystical transcendence, while Wilhelm Reich saw the total social establishment as the principal repressive agent and proposed a complete sociopolitical reform, based on sexual liberation and a new consciousness. Surrealism, the most important movement in painting—and a significant tendency in literature—had its basis in psychoanalytic insight into the human psyche.

Although the twenties was the decade in which two of the great novels of the twentieth century— *Ulysses* by James Joyce and *The Magic Mountain* by Thomas Mann—were published, it was not a time of intellectual or artistic creativity comparable with the preceding decades, which had set the standards for the new aesthetic values of the century. In Russia the great alliance of artistic and political revolution came to an abrupt end as a reactionary Socialist Realism became the only admissible doctrine. In Western Europe the "modern movement" became socially acceptable, even fashionable. Many of the avant-garde artists and intellectuals were— for a brief time, at least—deprived of the privilege of isolation. Some—Marie Laurencin, Kees van Dongen, Alexander Archipenko—became fashionable and chic. Others—most of the erstwhile Fauves in France, the Expressionists in Germany, the Futurists and Metaphysical painters in Italy—could not sustain their earlier innovative strength. In many aspects of art, inventive creativity was replaced by a new sense of order, utility, popular acceptability, and a conservatism which mirrored the political climate. Nevertheless, individuals such as Le Corbusier, Ludwig Mies van der Rohe, Walter Gropius, and Erich Mendelsohn in architecture, Constantin Brancusi in sculpture, and Piet Mondrian, Paul Klee, Joan Miró, Max Ernst, and Max Beckmann in painting were to make significant, indeed, revolutionary contributions during the twenties.

Political Events	The Humanities and Sciences	Architecture, Painting, Sculpture
1920 Geneva: First Assembly of the League of Nations Ireland partitioned Ratification of the Nineteenth Amendment to the U.S. Constitution providing women's suffrage	Eugene O'Neill, *The Emperor Jones* Sinclair Lewis, *Main Street* Salzburg festival of music and drama	Katherine Dreier, Marcel Duchamp, and Man Ray form the Société Anonyme Berlin: First International Dada Fair Moscow: Naum Gabo and Antoine Pevsner write the *Realist Manifesto* Piet Mondrian, *Neoplasticism*
1921 Arrest of Nicola Sacco and Bartolomeo Vanzetti in Boston on murder charge New Economic Policy adopted in U.S.S.R., partially rolling back government control over farms and private enterprises	D. H. Lawrence, *Women in Love* Luigi Pirandello, *Six Characters in Search of an Author* Alban Berg, *Wozzeck* (first performance, 1925) Ludwig Wittgenstein, *Tractatus Logico-philosophicus* Karel Čapek, *R.U.R.* (*Rossum's Universal Robots*)	Vasily Kandinsky returns to Germany from Russia Man Ray invents Rayograph László Moholy-Nagy invents Photogram *New York Dada*, edited by Marcel Duchamp and Man Ray André Breton interviews Sigmund Freud
1922 Benito Mussolini's March on Rome; fascist dictatorship established in Italy Treaty of Rapallo between Germany and the Soviet Union	James Joyce, *Ulysses* T. S. Eliot, *The Waste Land* Robert Flaherty, *Nanook of the North*	Mexico City: Manifesto issued by Technical Workers, Painters, and Sculptors Weimar: Constructivists hold a congress Chicago Tribune Tower architectural competition
1923 France and Belgium occupy the Ruhr Valley Runaway inflation in Germany Munich: Unsuccessful putsch by Adolf Hitler	Rainer Maria Rilke, *Duino Elegies*	
1924 Death of Vladimir Ilyich Lenin	Thomas Mann, *The Magic Mountain* George Gershwin, *Rhapsody in Blue* Charlie Chaplin, *The Gold Rush* Leon Trotsky, *Literature and Revolution*	André Breton, *Surrealist Manifesto* Galka Scheyer forms the Blue Four Paris: Review *La Révolution Surréaliste* founded

	Political Events	The Humanities and Sciences	Architecture, Painting, Sculpture
1925	John Thomas Scopes "monkey trial" in Tennessee Adolf Hitler, *Mein Kampf* (–1927)	Franz Kafka, *The Trial* F. Scott Fitzgerald, *The Great Gatsby* Dmitri Shostakovich, *First Symphony* Theodore Dreiser, *An American Tragedy*	New York: Alfred Stieglitz opens the Intimate Gallery Mannheim: Gustav Hartlaub organizes "The New Objectivity" exhibition Paris: First Surrealist group exhibition, Galerie Pierre Paris: Exposition des Arts Décoratifs
1926	General strike paralyzes Great Britain	Franz Kafka, *The Castle* Ernest Hemingway, *The Sun Also Rises* Book-of-the-Month Club founded	Man Ray, *Revolving Doors, 1916–1917*
1927	Josef Stalin assumes supreme power in the U.S.S.R.; Leon Trotsky is expelled from the Communist Party Nicola Sacco and Bartolomeo Vanzetti executed	First public showing of a talking picture Charles A. Lindbergh makes the first solo flight across the Atlantic Greta Garbo and John Gilbert, *Flesh and the Devil* Werner Heisenberg formulates the uncertainty principle Martin Heidegger, *Being and Time*	Stuttgart: Construction begins on the Weissenhof Siedlung Kasimir Malevich, *The Nonobjective World*
1928	Signing of the Kellogg-Briand Peace Pact condemning war as an instrument of national policy First Five-Year Plan launched in the U.S.S.R. Chiang Kai-shek becomes president of the Chinese Nationalist government	Bertolt Brecht and Kurt Weill, *The Threepenny Opera* Walt Disney produces his first Mickey Mouse cartoon Alexander Fleming uses *Penicillium* as an antibacterial agent	André Breton, *Surrealism and Painting* Congrès Internationaux d'Architecture Moderne (CIAM) founded
1929	Herbert Hoover becomes U.S. president Leon Trotsky expelled from the Soviet Union New York: Stock market crash	Ernest Hemingway, *A Farewell to Arms* Erich Maria Remarque, *All Quiet on the Western Front* José Ortega y Gasset, *The Revolt of the Masses* Marx Brothers, *The Coconuts*	New York: Museum of Modern Art opens with Alfred H. Barr, Jr., as director André Breton, *Second Surrealist Manifesto* Barcelona: International Exposition

Architectural Monuments

522

521

523

After the end of the Great War, governments—both victors and vanquished—commissioned ambitious commemorative monuments. In the Soviet Union the new revolutionary government resolved to erect a monument to the Third International—the wing of the Socialist movement founded in Moscow in 1919 to rally the Communists of the world behind the victorious Russian Communist state and to inspire revolution worldwide.

In his design for this monument Vladimir Tatlin (pages 186–87 and 192–93) broke with past styles and formal values, believing that contemporary material and technology would convey the revolutionary mes-

sage. His monument was to be made of metal in the form of a dynamic revolving spiral thirteen hundred feet high, which was to enclose large, glass-walled chambers. On the bottom, a cubiform conference room would turn on its axis once a year. Above this, a pyramidal enclosure, housing executive offices, was to complete one revolution each month, while a cylinder surmounting the pyramid was to rotate once a day and was to serve as a center of administration and propaganda.

This advanced structure, combining new concepts of industrialized art, propaganda, and hope, was to function as a didactic and political monument. It represented the climax

of Constructivist aesthetics, abolishing distinctions between sculpture and architecture. The Soviet authorities, however, were not convinced of its merits or of the feasibility of building it and so Tatlin's tower was never constructed.

When the Soviet government finally commissioned a major national monument, the Lenin Mausoleum in Moscow's Red Square, Academician A. V. Shchusev built a simplified, geometric rendition of the classical temple in black, gray, and red granite. This stolid architectural pile expressed the spirit of the new bureaucracy as cogently as Tatlin's tower stood for the earlier, revolutionary aspirations.

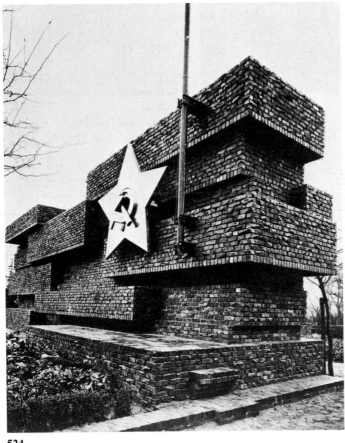

524

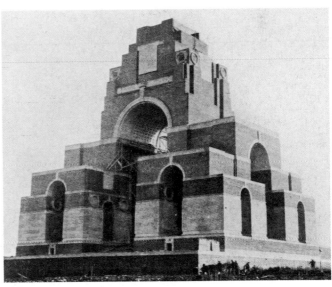

525

In Germany Walter Gropius, who had recently founded the Bauhaus in Weimar, created the dynamic Monument to the March Heroes in that city, commemorating the German workers killed in the right-wing Kapp putsch of 1920. More sculpture than architecture, the structure consists of a series of aggressively slanting concrete slabs whose forms suggest an affinity with the German Expressionists. Even an architect as little concerned with political issues as Ludwig Mies van der Rohe executed a monument to Karl Liebknecht and Rosa Luxemburg. This structure of rectangular, cantilevered blocks in almost symmetrical arrangement constituted a powerful and disturbing memorial to the two martyrs of the Weimar Republic. Like Gropius's monument in Weimar, it was demolished by the Nazis.

Monuments to the dead and missing World War One soldiers were designed to reassure the bereaved that the casualties had not been in vain and that their names would be hallowed, albeit en masse. The Memorial to the Missing of the Somme, at Thiepval in France, was designed by the great Edwardian classicist Edwin L. Lutyens. It is an immense triumphal arch around which are carved the names of 73,357 soldiers, and it represents a colossal sepulcher for the fallen. Though clearly relying on Roman prototypes, Lutyens pared his multiple arch to a minimum of classical detail. Here he anticipated both the stripped-down classicism and the Art Deco form popular in the thirties.

521 Vladimir Tatlin. Model for a Monument to the Third International, Moscow. 1919–20 **522** A. V. Shchusev. Lenin Mausoleum, Moscow. 1924–30 **523** Walter Gropius. Monument to the March Heroes, Weimar. 1921 (demolished) **524** Ludwig Mies van der Rohe. Monument to Karl Liebknecht and Rosa Luxemburg, Berlin. 1926 (demolished) **525** Edwin L. Lutyens. Memorial to the Missing of the Somme, Thiepval. 1924–25

215

The Chicago Tribune Tower Competition

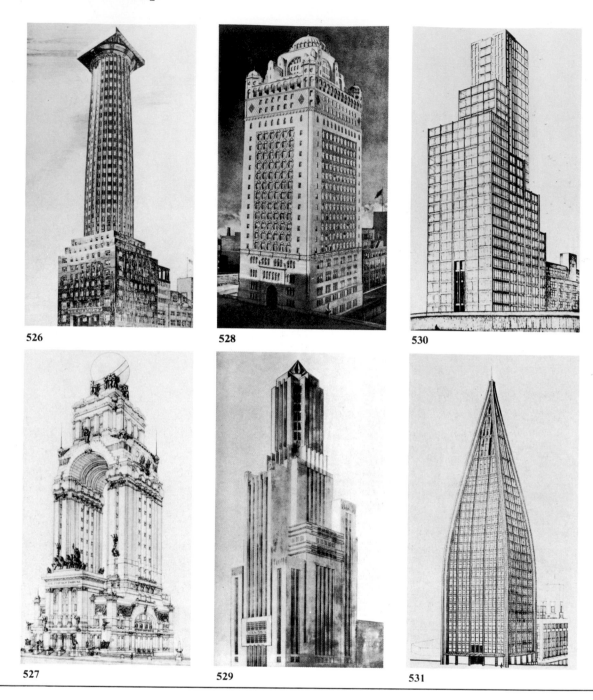

526

528

530

527

529

531

A monument of a more practical nature was the proposed high-rise building to house the offices of Robert McCormick's *Chicago Tribune*. The announcement in 1922 of a lucrative international competition for a skyscraper in Chicago elicited two hundred sixty entries from twenty-three countries. The fully illustrated publication of all entries had an enormous influence on skyscraper design during the next two decades and is an invaluable guide to the aesthetics of a period of critical transition. The designs ran the gamut from solid masses without articulation to Adolf Loos's facetious phallic Doric shaft and included every kind of historicizing and modern hokum. Towers took the form of ziggurats, pyramids, Roman triumphal arches (Dioguardi), attenuated medieval castles, shafts surmounted by cathedrals or Byzantine domes (Stokes) and frosted with Maya, Venetian, and Moorish motifs. Debased decorative modernistic designs (Batteux) competed with numerous proposals based on Gothic prototypes and inspired by Cass Gilbert's famous Woolworth Building in New York City (see plate 515).

The most avant-garde entries, picking up the dropped thread of early Chicago skyscraper design as well as pointing to future developments in tower design, were submitted by the German architects Max Taut, his brother Bruno, and Walter

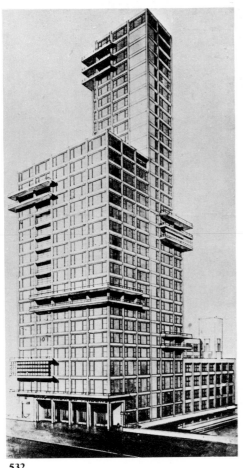

532

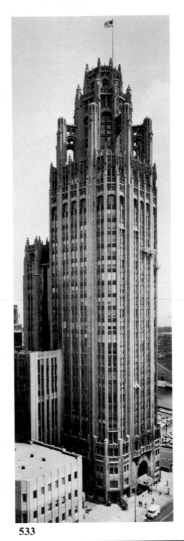

533

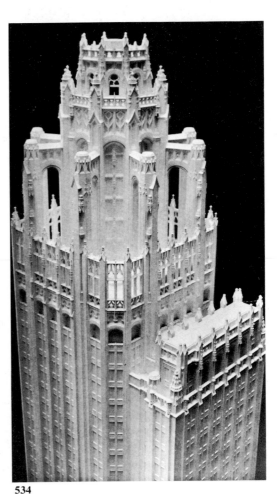

534

Gropius in association with Adolf Meyer. The Gropius-Meyer design, highly rational in concept and flagrantly antihistorical in style, was an articulate steel structure with a glass curtain wall composed of the large tripartite "Chicago windows" favored earlier by Louis Sullivan. The design was far too unconventional to receive serious consideration at the time and was quickly passed over in favor of the winning scheme by John Mead Howells and Raymond M. Hood. The soaring verticality of the Tribune Tower's Neo-Gothic form, crowned with immense flying buttresses and spiky finials creating a romantic silhouette against the sky, was clearly preferred by the jury and was, in fact, far more in keeping with the ultraconservative editorial policy of the journal, which called itself "The World's Greatest Newspaper."

526–532 Designs for the Chicago Tribune Tower Competition. 1922 526 Adolf Loos 527 Saverio Dioguardi 528 I. N. Phelps Stokes 529 J. Batteux 530 Max Taut 531 Bruno Taut, Walter Gunther, and Kurz Schutz 532 Walter Gropius and Adolf Meyer 533–534 John Mead Howells and Raymond M. Hood. Chicago Tribune Tower. 1922–25 534 Model (detail). 1922

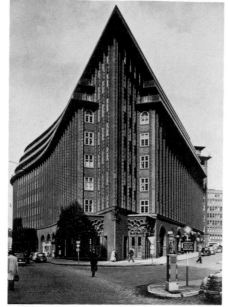

535

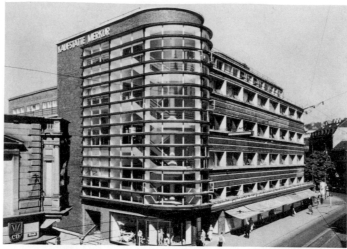

537

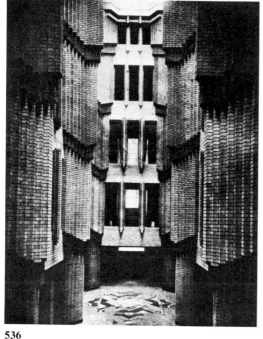

536

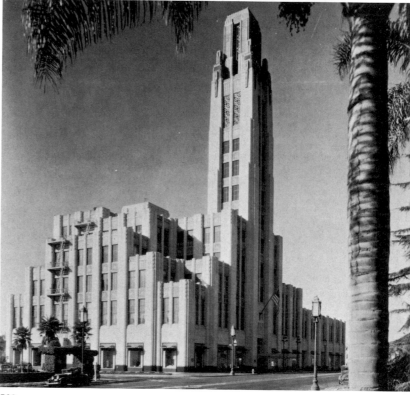

538

While American architects were erecting Gothic and Roman skyscrapers, Fritz Höger utilized the forms of the past in a more creative way. His Chile House was an Expressionist rendition of the German Middle Ages without directly quoting previous styles. On an awkward, triangular site, Höger created a massive brick building shaped on one side in a sinuous double curve and with heavy, overhanging slab eaves. The walls of the building come to a sharp point, like the looming prow of a ship; Höger's structure was eminently suitable for shipping offices in a maritime city.

Peter Behrens had begun his career as an Art Nouveau painter and designer before turning to large-scale industrial design. Before World War One, Le Corbusier, Walter Gropius, and Mies van der Rohe all worked in Behrens's Berlin office and were influenced by his functional design principles. In the twenties, returning to an Expressionistic style in both form and space, he designed the entrance hall to the I. G. Farben Dyeworks in Höchst—a heavy, restless, constrained space whose multistoried walls are hung with angular curtains of brick.

Erich Mendelsohn, who had the largest architectural office in Berlin, continued to pioneer in modern building design. He built a series of department stores for the Schocken chain in Germany, such as the immaculate building in Stuttgart. An asymmetrical composition, consisting largely of uninterrupted courses of glass that set up a rhythmic movement of considerable velocity, it relates, especially in its fenestration, to Louis Sullivan's Carson Pirie Scott department store in Chicago of a generation earlier (see plates 124–126). Mendelsohn counterbalanced the rhythm of the planar walls with the transparent semicircular stair tower, creating a dynamic relationship of masses and volumes.

In Los Angeles, John and Donald

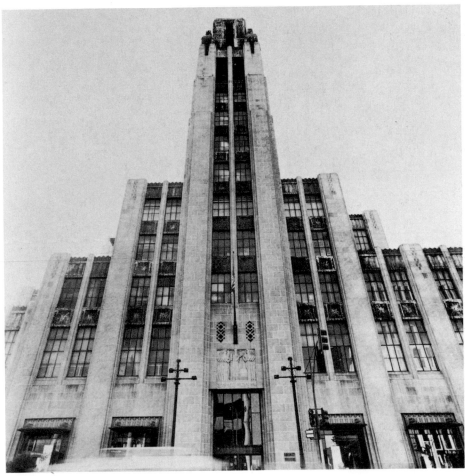

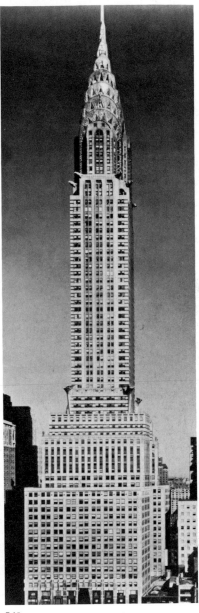

539

540

Parkinson designed the graceful Bullocks Wilshire department store, a classic statement of the Art Deco style. This was a modernist vernacular idiom of the twenties, based on Art Nouveau, with Expressionist, Cubist, Futurist, and Wrightian features fused in an appealingly chic stylization. This elegant memento of Hollywood's most opulent years contains splendid details in bronze and inlaid wood and murals in paint and mosaic. The architects manifested a fine sense of light and space and an understanding of architectural rhythms so that the tower seems to sprout organically from the building itself.

Perhaps the greatest monument of the Art Deco style, as well as a significant engineering feat, was the Chrysler Building by William Van Alen, probably the most ambitious skyscraper to follow the Chicago Tribune Tower. Still one of New York City's premier monuments, this opulent building rises more than a thousand feet to a flashing spire of ascending arcs made of stainless steel that surround jewel-like triangular windows. This sunburst crest, as well as the streamlined stainless-steel gargoyles, are ingeniously modeled after automobile hood ornaments.

535 Fritz Höger. Chile House, Hamburg. 1922–23 **536** Peter Behrens. I. G. Farben Dyeworks, Höchst, Germany. 1920–24. Entrance hall **537** Erich Mendelsohn. Schocken Department Store, Stuttgart. 1926 **538–539** John Parkinson and Donald Parkinson. Bullocks Wilshire, Los Angeles. 1929 **539** Front facade **540** William Van Alen. Chrysler Building, New York. 1926–30

Public Buildings

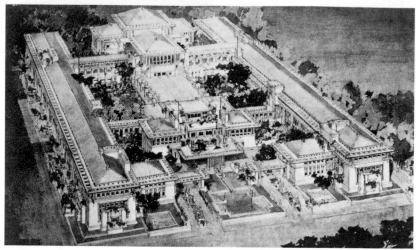

541

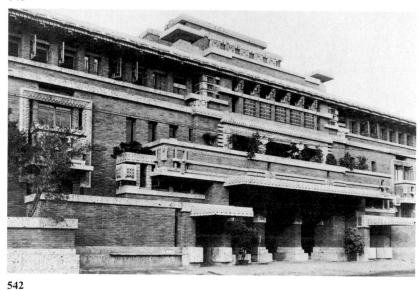

542

543

Frank Lloyd Wright's Imperial Hotel in Tokyo, on which he worked from 1915 to 1922, was designed in a personal idiom completely different from that of his colleagues in Europe, America, or Japan. It is the masterpiece of the protean Wright's "baroque" phase and contained a great variety of spatial surprises. The most remarkable was its use of concrete slabs with each section ingeniously balanced on carefully engineered posts to resist seismic stress. Thus, despite the dire warnings of American critics during its construction, it was one of the few buildings to withstand the great earthquake of 1923, which leveled Tokyo. A building of personal fantasy, the Imperial Hotel was perhaps more influenced by Maya temples than by the indigenous architecture of Japan, which Wright had incorporated into his earlier domestic designs. The relationship, however, between the many outdoor gardens and reflecting pools and the elegant interiors, decorated with abstractly carved blocks of green lava, was based on Japanese concepts of spatial planning, which the architect had long admired. Hounded by the American press because of his unconventional personal life, Wright executed this largest of his early commissions, significantly, outside the United States. Unfortunately, this grand complex has been demolished to make way for a more efficient hostelry.

Willem Marinus Dudok's town hall in Hilversum, Holland, has an open quality not usually associated with buildings of this kind—a feature derived probably from the work of Wright, who was admired in Holland and published extensively in the Dutch magazine *Wendingen*. The Wrightian influence is further suggested by the blocky, horizontal massings and the flat slab eaves. Set

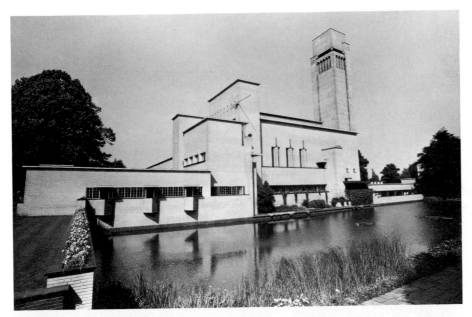

544

545

in gardens and reflected in pools, the town hall at Hilversum relates also to the modern tradition of architecture in Holland initiated by H. P. Berlage (see plates 129–131). It is a building of interlocking geometric blocks, superb craftsmanship, and elegant idiosyncrasies.

Constructivist architects in Russia were concerned with the rational expression of structure. Konstantin Melnikov, a man of great imaginative power, added new formulations to the modern movement in architecture. The workers' club became an important type of public building in the U.S.S.R. in the 1920s, and being

a multipurpose theme without tradition, it lent itself to new formal ideas. Melnikov worked with powerful projections of reinforced concrete in the upper stories of the Rusakov Club for Transport Workers, in Moscow. These austere overhangs split the rectangular volumes of the building in a most unexpected way. Too unconventional for the new academicism which shadowed the growing Soviet bureaucracy, Melnikov came under considerable criticism in his own country, and many of his subsequent projects were never realized.

541–543 Frank Lloyd Wright. Imperial Hotel, Tokyo. 1915–22 (demolished) **541** Design **542** Front facade **543** Gardens **544** Willem Marinus Dudok. Town Hall, Hilversum, Holland. 1928–31 **545** Konstantin Melnikov. Rusakov Club for Transport Workers, Moscow. 1927–29

Exhibition Pavilions

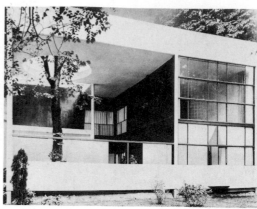

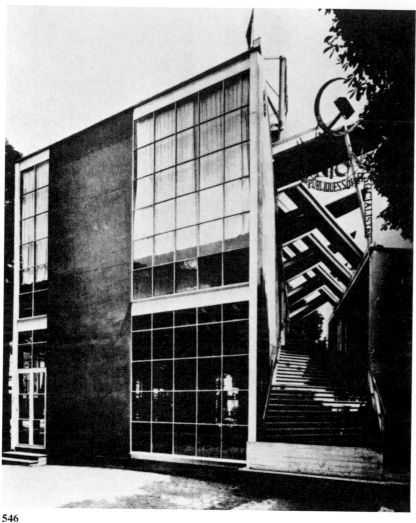

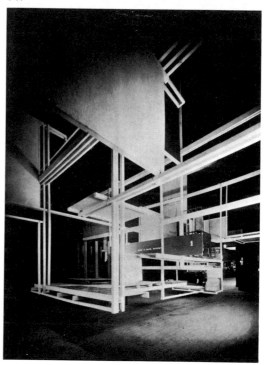

Exhibition buildings served in the exploration of new ideas in the 1920s as they had previously. The International Exhibition of Modern Decorative and Industrial Arts in Paris in 1925, although dominated by old-fashioned, somewhat monumental edifices, provided an opportunity to display the new architecture from many different European countries. Here Melnikov interjected an open, diagonal staircase into the glazed facade of his Soviet Pavilion. Above the staircase were the letters for the U.S.S.R. and the hammer and sickle painted in red; these letters and emblems gave the building the impact of a political poster. The dynamism of the new Soviet republic was symbolized by the building as a whole, composed asymmetrically of triangles in an irregular ground plan.

Le Corbusier's L'Esprit Nouveau Pavilion (meaning "the new spirit," the name of Le Corbusier's own architecture journal) was undoubtedly the most innovative and the most influential building of the exhibition. Le Corbusier, who had been apprenticed to two of the great pioneers of the modern movement before the war—Auguste Perret and Peter Behrens—began to believe that the machine, and the pure geometry of form it produced, could be used to create beautiful, humanistic buildings. A painter as well, he helped to initiate the post-Cubist movement of Purism and subsequently developed an architecture based on pure forms of "masses brought together in light," an architecture that is profoundly Mediterranean. His pavilion was a very simple concrete cube within a cube and stressed the free interpenetration of solids and voids. Even a tree became part of the building, with its own circular opening in the roof, its irregular, organic form playing off against the crisp, rectilinear lines of the building.

In the same exhibition Frederick Kiesler's utopian design for the Austrian Pavilion, a City in Space, was a visionary concept of a machine-created and -dominated city, an idea that seemed as glamorous in

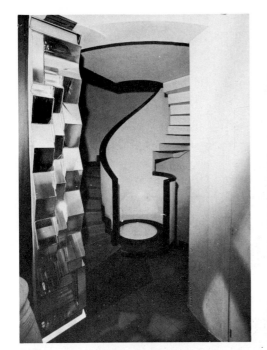

549

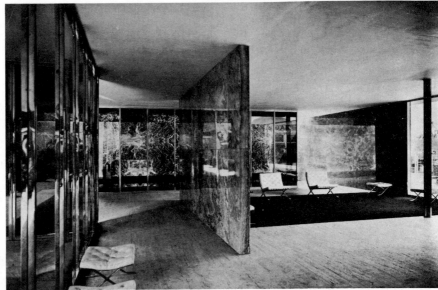

551

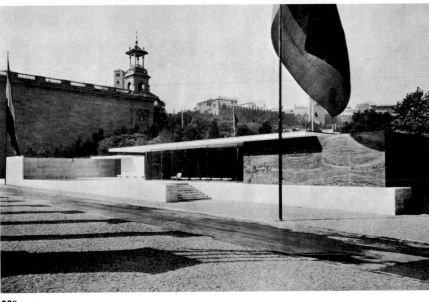

550

the twenties as it had to the Futurists in the previous decade.

Whereas Melnikov, Le Corbusier, and Kiesler sought new basic ideas in the machine and modern technology, the fashionable French designer Robert Mallet-Stevens turned to machine forms for decorative possibilities and created the modish and modernistic Martel House. The building was named for its interior designers, Joël and Jan Martel. Their designs, as well as Mallet-Stevens's, became a model for the new, rapidly spreading style of Art Deco.

A few years later Mies van der Rohe designed the German Pavilion for the International Exposition in Barcelona, using a severe modern

discipline. By this time the German architect had achieved considerable renown as one of the great masters of architectural design. The pavilion's precious materials, horizontal sweep, and above all, its flowing, open space and supremely rational order have caused it to be regarded as one of the truly seminal buildings of the century. The elegantly minimal "Barcelona chairs" Mies designed for the interior were intended to appear machine-made but were, in fact, painstakingly handcrafted. They have become staple items in executive suites. The structure itself was razed long ago and exists now only in photographs.

546–549 Exhibition of Decorative Arts, Paris. 1925 **546** Konstantin Melnikov. Soviet Pavilion **547** Le Corbusier. L'Esprit Nouveau Pavilion **548** Frederick Kiesler. Austrian Pavilion, Model for a City in Space **549** Robert Mallet-Stevens. Martel House, Foyer **550–551** International Exposition, Barcelona. 1928–29. Ludwig Mies van der Rohe. German Pavilion

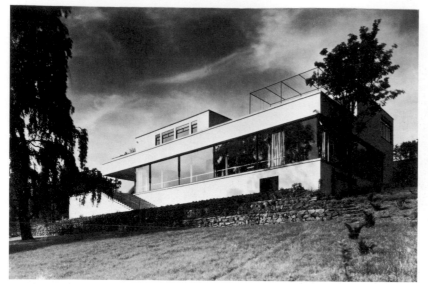

552

554

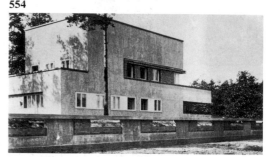

555

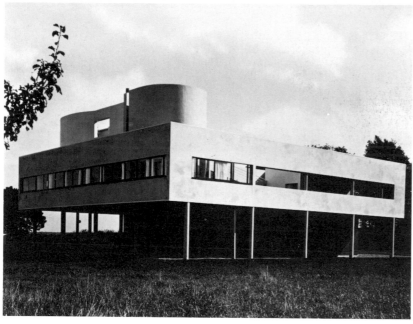

553

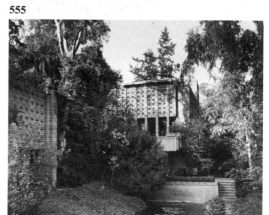

556

Mies van der Rohe and Le Corbusier were also the central figures in designs for private houses of the twenties. When Mies was asked to build a house for Mrs. Tugendhat in Brno, Czechoslovakia, he continued his development of the free, unencumbered flow of space, and the glass exterior permits the landscape colors to penetrate the interior. The materials were the most exquisite available, and after the success of his Barcelona pavilion and its furnishings, Mies again designed elegant furniture so that the house became a total work of art.

At the same time Le Corbusier worked on his early masterpiece, the Villa Savoye. Like the Tugendhat House, it is built of smooth stucco and glass, but it is supported on slender columns (*pilotis*) that lift it from the ground and open it to air and sky. Its geometric structure, white against the blue Mediterranean sky, suggests the austere abstraction of Greek temples overlooking the countryside of which it is clearly not a part. Ironically, the buildings that embodied the pristine qualities sought by the great architects of the twenties have become premature ruins in our time.

Earlier Erich Mendelsohn's Villa Sternfeld, in Berlin, was laid out asymmetrically, in a successfully balanced dynamic composition. Its emphasis on horizontality recalls Wright's earlier Prairie Houses. After his return from Japan, Wright himself moved on to new formulas. Insisting on the identity of "democratic" and "organic" architecture, Wright made his houses an integral part of the natural surroundings, far more than did his European contemporaries. This represented a major American contribution to the modern movement. Wright substituted molded, precast concrete blocks for "natural materials" in a series of houses in Southern California. The blocky mass and geometric ornament utilize Maya design elements, though this was steadfastly denied by Wright. His outstanding Millard House in Pasadena, entered from the

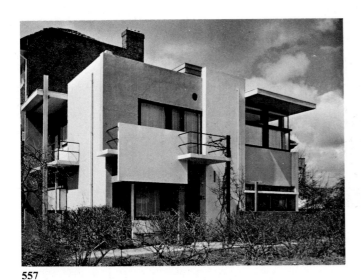

557

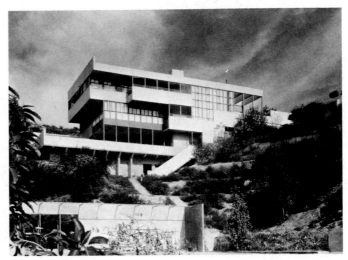

559

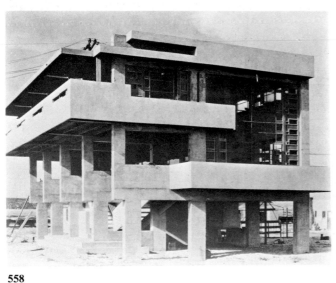

558

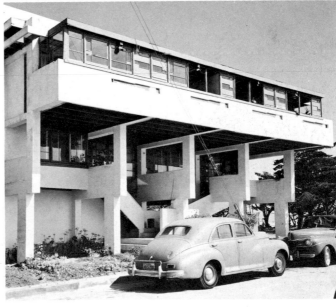

560

rear, encapsulates unexpected spaces on interlocking levels. Set at the bottom of a canyon, the house emerges from lush gardens, reflected as overgrown jungles in surrounding pools.

Gerrit Rietveld was a member of the Dutch De Stijl—a group of artists, architects, and designers dominated by Mondrian. His Schroeder House, in Utrecht, is pictorial and painterly in concept. Flat slabs, painted in primary colors to define space, are organized irregularly but harmoniously, resembling a painting by Mondrian.

Rudolph Schindler, a Viennese-born architect who had been strongly influenced by Otto Wagner (see plates 22 and 128) before working in

Wright's Chicago office, created a daring structure in the Lovell Beach House in California—the first example of the International Style in the United States.

Richard Neutra, also born in Vienna, had known Adolf Loos (see plates 157 and 162–163) when he was very young and had worked with Mendelsohn in Berlin and with Wright in Taliesin. He incorporated these influences in another major commission for Dr. Lovell. Situated on a dramatic Pacific Ocean hillside, the structure is a brilliant synthesis of Wright's organic conception and Le Corbusier's floating steel skeleton and stucco planes. Southern California's benign climate permitted

physical openness, and its spirit of toleration (and lack of a continuous tradition) encouraged innovations.

552 Ludwig Mies van der Rohe. Tugendhat House, Brno, Czechoslovakia. 1930
553–554 Le Corbusier. Villa Savoye, Poissy, France. 1929–30 554 Floor plans
555 Erich Mendelsohn. Villa Sternfeld, Berlin. 1923–24 556 Frank Lloyd Wright. Millard House, Pasadena, Calif. 1923
557 Gerrit T. Rietveld. Schroeder House, Utrecht. 1923–24 558 Rudolph Schindler. Lovell Beach House, Newport Beach, Calif. 1926 559–560 Richard Neutra. Lovell House, Los Angeles. 1929–32
560 Back view

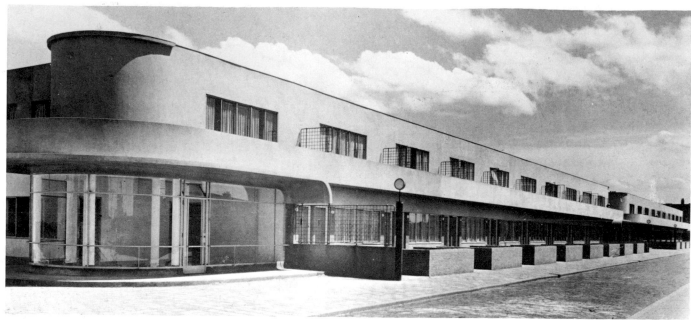

561

562

Although an understanding of the development of modern architecture would be inconceivable without a knowledge of the individual house and the exhibition pavilion, it must also be noted that much of the energy and thought of the postwar decades went into the construction of multiple-dwelling units. Because of the almost complete cessation of building during the war, the destruction of much existing housing during the hostilities, and the unparalleled inflation in building costs after the war, the housing shortage throughout Europe was critical during the twenties. Many were left homeless, and despite or because of massive political unrest, all govern-ments were faced with the immediate need to provide cheap mass housing.

Because of its neutrality during the war and a progressive and humane policy of public building, Holland was in a better position than most of its neighbors to lead the way in mass housing. Among the finest of its projects was J. J. P. Oud's small housing project at the Hook of Holland. Here he departed somewhat from the doctrinaire formal aesthetics of De Stijl and its almost exclusive use of cubic form. Without discarding his refined sense of form and structure, Oud also showed a much greater concern for social needs, which was very much in keep-ing with Mondrian's theories. The two low terraces, with ground-floor shops at their elegantly curved ends, the balconies and tiny private gardens, had an enormous impact on building elsewhere in Europe.

In Germany, also, large-scale progressive planning programs were begun. Many of the municipalities of the Weimar Republic appointed avant-garde architects to propose new solutions for public housing. The example of the English Garden Cities was immensely influential on planners seeking a solution to the congestion and squalor of large industrial cities. In Frankfurt, Ernst May was in charge of the construction of approximately fifteen thousand dwellings over a period of six

563

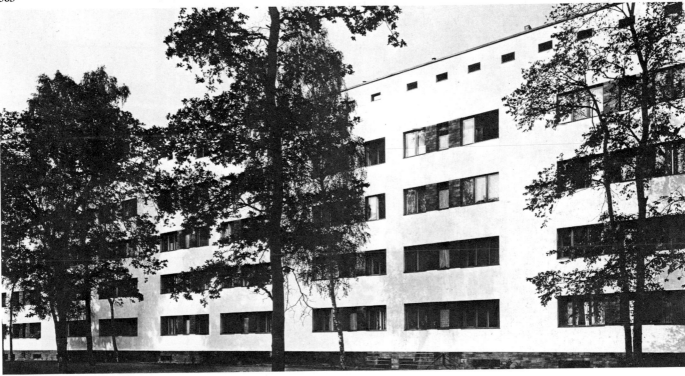

564

years. In general, he and his colleagues favored compact row housing, arranged in irregular patterns, using flat roofs and simple, bare surfaces and set in pleasant garden environments on the outskirts of the city. Frequently restaurants, schools, churches, and shops were included, making these projects almost self-contained satellite cities (though most workers still had to commute).

Hans Scharoun designed one of the best of these Siedlungen (housing projects) for the Breslau Home and Work Exhibition of 1928, gracefully playing long curved and planar walls against one another. Scharoun's elegant terraces would have probably been totally uneconomical to re-produce on a large scale. Gropius's Siemensstadt Housing in Berlin provided a culmination of the public housing project of the decade and also can be seen as the prototype for the tall slab apartment that could be efficiently extended ad infinitum—and was, in residential developments throughout Europe. Few, however, could match Gropius's extraordinary refinement, as expressed in these rhythmically windowed apartments set into existing greenery. Shortly after they were erected, the Nazis put an end to this "un-German," "Bolshevik" architecture in the Fatherland. Gropius's influence was carried on elsewhere.

561 J. J. P. Oud. Workers' Housing Units, Hook of Holland. 1924–27 **562** Ernst May. Höhenblick Housing, Frankfurt. c. 1925 **563** Home and Work Exhibition, Breslau. 1928. Hans Scharoun. Housing. **564** Walter Gropius. Siemensstadt Housing, Berlin. 1929–30

Weissenhof Siedlung

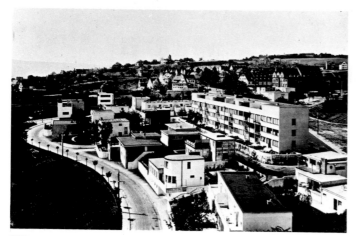

565

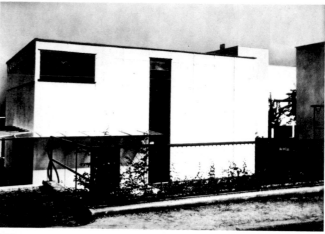

567

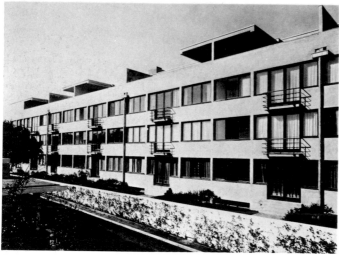

566

568

In 1927, in order to popularize the finest aspects of the new multiple dwellings, the German Werkbund (see page 198) asked its vice president, Ludwig Mies van der Rohe, to direct the building of a small model district at the Weissenhof, a suburb of Stuttgart. To participate in the Weissenhof Siedlung, Mies invited Europe's foremost practitioners of what was soon to be called the International Style; Oud from Holland, Le Corbusier from France, and Mies, Behrens, Scharoun, Gropius, and Max Taut from Germany were among those who submitted designs. Participants were given complete

freedom with the sole stipulation that their buildings should have flat roofs for a degree of cohesiveness. Twenty-one permanent structures, from individual homes to apartment buildings, were constructed in what was to be one of the most influential exhibitions of the century, ranking with the Werkbund's seminal exhibition at Cologne in 1914.

Standardization was attempted so that the exhibited dwellings might serve as models for large-scale, economical reproduction, consistent with the Werkbund's intent to utilize the machine for humane ends. The postwar housing shortage had made

such standardization not only aesthetically desirable but socially imperative. Mies's own block of flats, for example, used standardized wall sections and windows applied to a steel frame on a modular grid, suggesting that such a building could be prefabricated in a factory. Mies's superb sense of scale and proportion created a humane building of the highest aesthetic order, employing vertical stair windows and drain spouts to punctuate the continuous flow of horizontal window bands across a model apartment grouping.

Walter Gropius, in his detached houses, sought to create dwellings

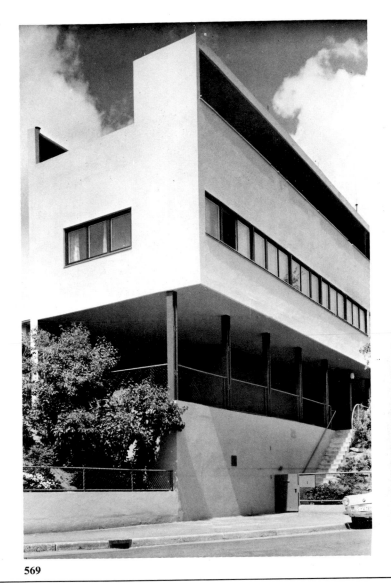

569

570

that could be prefabricated and even furnished cheaply and well. His structures employed asbestos cement sheets on a modular steel framework and were finished with highly functional interiors designed in Gropius's Bauhaus (see pages 232–233). Gropius's houses sought a kind of industrial anonymity rejected by Hans Scharoun, whose own house had a highly individual verve that made it impossible to reproduce cheaply.

Probably the most significant contribution to the exhibition was made by Le Corbusier, whose reinforced-concrete houses were raised from the ground on steel posts, or *pilotis*, and

incorporated roof gardens, ribbon windows extending from one structural column to another, and a remarkable openness in plan and facade that gave them an unprecedented flexibility. Although, like Scharoun's houses, Le Corbusier's structures were individual and impossible to prefabricate, they were far ahead of their time. The Weissenhof project might be seen as a trial run for the architect's masterpiece, the Villa Savoye (see plates 553–554), begun two years later, and they indicate the growing clarity of Le Corbusier's new philosophy of architecture.

565–570 Weissenhof Siedlung, Stuttgart. 1927 565 Ludwig Mies van der Rohe et al. Total complex 566 Ludwig Mies van der Rohe. Apartment house 567 Walter Gropius. House 568 Hans Scharoun. House 569–570 Le Corbusier and Pierre Jeanneret. House

Restaurants

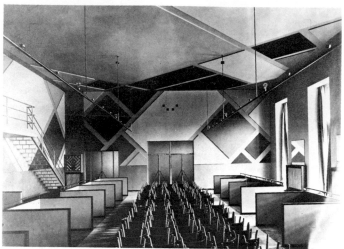
572

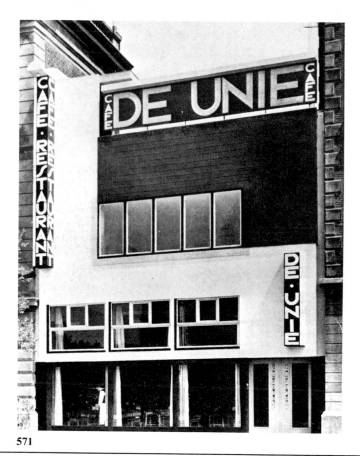
571

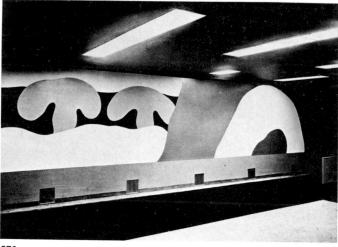
573

The twenties witnessed a phenomenal increase in the number and size of restaurants as eating out became ever more popular with the middle class. The reasons for the boom are complex; they include the growing emancipation of women from traditional roles, a sharp decline in domestic servant labor, increased mobility and affluence, and the mechanization of the food industry, which lowered the cost of the average meal. Dining out represented a glamorous urban existence formerly available only to a few, and architects obliged by creating environments for mass culture. Needless to say, social

critics, particularly in America, saw the restaurant as an insidious threat to the family and ruefully predicted impending moral decay.

In his design for the Café de Unie in Rotterdam, J. J. P. Oud again displayed his affinities with the Dutch De Stijl group by composing a facade of square and rectangular windows and areas painted in bright primary colors. The building itself became not only a work of art but also an eye-catching advertisement incorporating large lettering, an early use of the supergraphics that became popular in the 1970s. The café building was destroyed by bombing in 1940.

Theo van Doesburg, the foremost spokesman for De Stijl, devised a somewhat more dynamic decorative scheme when he redesigned the Café l'Aubette in Strasbourg, together with Jean Arp and Sophie Taeuber-Arp. Here the collaborators achieved De Stijl's ideal of combining painting and architecture with the use of large rectangles of primary colors that cut across the walls and ceiling of the room. Colliding with the regular horizontals and verticals of doors, windows, floor, and ceiling, and playing against the long receding lines of suspended lighting fixtures, they help create a restless atmo-

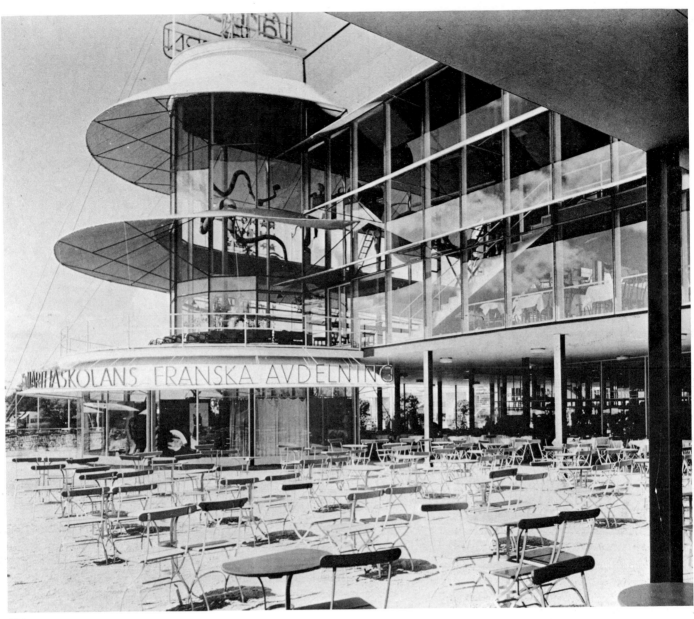

574

sphere of motion entirely appropriate for the large restaurant and dance hall. Jean Arp decorated several rooms with murals in a freer and much more organic mode. Both Van Doesburg and Arp were working with flat shapes of pure color, but whereas the Dutch artist favored geometric forms, Arp's biomorphic forms provided a fascinating contrast and a very different environment.

In Sweden the architect E. G. Asplund shifted from Neoclassicism to a full recognition of the new possibilities offered by steel and glass in the building he designed for the Stockholm Exposition. His Paradise

Restaurant was an elegant, airy essay, employing a curtain wall entirely composed of plate glass raised on the thin steel *pilotis* favored by Le Corbusier. Brightly colored sun blinds stretched across the almost nonexistent walls and around the glass silo protruding from the building. This delightfully transparent structure, wherein everything was visible, abolished distinctions between exterior and interior and provided a superb setting for long hours of dining and conversation during the interminable Swedish summer evenings.

571 J. J. P. Oud. Café de Unie, Rotterdam. 1924–25 (destroyed) 572–573 Café l'Aubette, Strasbourg (destroyed) 572 Theo van Doesburg. Interior. 1926–28 573 Jean Arp. Mural: *Rising Navel and Two Heads*. 1927–28. Oil on plaster 574 Exposition, Stockholm. E. G. Asplund. Paradise Restaurant. 1930

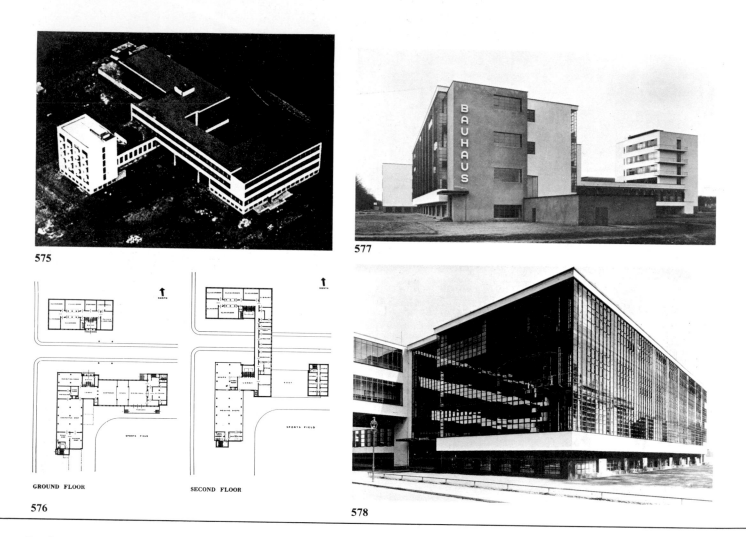

575

577

GROUND FLOOR SECOND FLOOR

576

578

By far the most notable example of innovative school architecture of the twenties was the complex designed to house the Bauhaus, in Dessau, Germany. This is not surprising because the Bauhaus constituted not only a school but a philosophy. The initial aim of the Bauhaus, to reunite the arts and crafts as recommended earlier by William Morris in England, was soon enlarged to accommodate and transform an increasingly technological civilization. This new synthesis gave birth to what we now know as industrial design. The adherents of the Bauhaus philosophy, first formulated by Walter Gropius, hoped to remedy both the alienation of the artist from the public and the alienation of the worker from his product. Toward this end Bauhaus designers strove to achieve a complete human environment. Their concerns, consequently, embraced everything from painting to photography, from stage design to typography, from the design of a spoon to the planning of a new city. However, the increasing complexity of the technology Gropius hoped to master has resulted more often in specialization than in the integration that the Bauhaus encouraged.

In 1925, when the Bauhaus moved from Weimar to Dessau because of local political opposition, Gropius began designing new buildings for the school which were to serve as daily lessons in his philosophy of functional design. Using a pinwheel plan, whose three arms consisted of a workshop, a dormitory, and a design school connected by suspended bridges containing offices, Gropius created a complex of exemplary clarity and cohesion. The function of each unit dictated the completely nontraditional form of the building. Mushroom posts were used in the workshop building to support reinforced-concrete slab floors, allowing the entire block to be sheathed in a three-story curtain wall of glass. Elsewhere, superbly proportioned

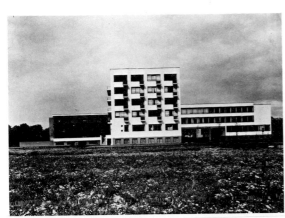

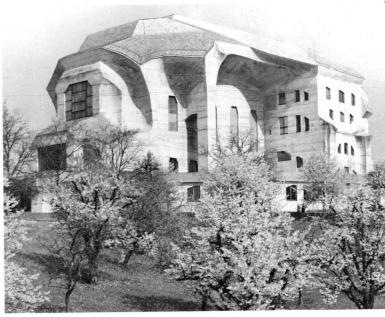

579

580

581

reinforced-concrete walls and long ribbon windows created an exposition of what would soon become known as the International Style.

Gropius and his team of designers provided interiors of an austere and functional economy; there is no formal facade, but rather an intricate and organic interplay of concrete buildings, flat roofs, and glass curtain walls. The whole structure, set in open fields, has a feeling of lightness and openness in keeping with both the new architectural spirit and the philosophy of the Bauhaus itself. Unfortunately, in the hands of lesser designers and in large-scale developments that excluded nature, such as

the new industrial suburbs, the humane Bauhaus criteria all too often became a formula for unrelieved monotony.

Compared to this revolutionary school building, Rudolf Steiner's contemporaneous school, the Goetheanum II, in Dornach, seems like an organic relic from the past. Its oddly shaped windows seemingly gouged out of its substance and the curved shadows of its eaves playing over its molded and faceted concrete walls in sinuous patterns, it both recalls the earliest Expressionist designs of Erich Mendelsohn and seems a prophecy of Le Corbusier's final sculptural work.

575–580 Bauhaus, Dessau. Walter Gropius and the Bauhaus Workshop. 1925–26
575 General view 576 Floor plans
577 Bauhaus buildings 578 Workshop Wing 579 Dormitory and Studio Wing
580 Bedroom of a student 581 Rudolf Steiner. Goetheanum II. Dornach, Switz. 1925–28

Projects: Visionary Designs

582

583

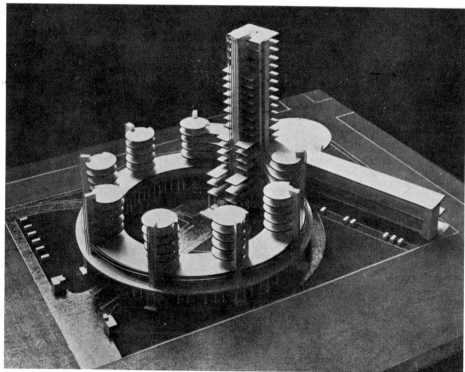

584

Visionary architecture continued to abound in the twenties, and nowhere with greater vigor than in the revolutionary society of the Soviet Union. The most significant project, of course, was Tatlin's colossal tower (plate 521). Soon thereafter, Kasimir Malevich translated the abstract, rectilinear shapes of his paintings into the third dimension of architecture. His model for a Suprematist structure of the future organized simple, intersecting cubes on a long axis, creating a unified, dynamic system that recalls Wright's Prairie Houses. Although his designs were geometric, Malevich, like Wright, felt them to be the organic outcomes of functional necessity.

Malevich's disciple El Lissitzky, in association with the Dutch architect Mart Stam, designed cloud props (or Wolkenbügel). These were plateau skyscrapers in which the functional space was to be horizontal, cantilevered from stiltlike shafts containing service functions. Lissitzky wanted these structures to be built at busy intersections throughout the Soviet capital, permitting the ground to be reserved for traffic, pedestrians, and parks. A. Silchenko's project for a building for the People's Commissariat for Heavy Industry likewise used advanced cantilevered construction for tall, circular steel-and-glass buildings arranged around an elevated circle.

Such designs would have been economically feasible, given the centralized authority of the Soviet state. Unfortunately, none of them was realized due to Lenin's disapproval of vanguard tendencies in art, and because of the even more conservative doctrines that followed his death.

Similarly, the project for the Rosenberg House by Theo van Doesburg and Cornelis van Eesteren exhibited at De Stijl's exhibition in 1923 in Paris was never built. However, its Dom-ino-like (see page 197) arrangement of solid rectangular masses around a central core and its cantilevered terraces would have made it the culminating effort of De Stijl architecture, rivaling Le Cor-

585

586

587

busier's Villa Savoye dating from the end of the decade.

New ideas for building projects made possible by innovative technology and materials were indeed prolific during this period, and designs like Charles Morgan's skyscraper bridge, consisting of a bridge topped by a superhighway and supported on office building piers twenty-five stories high, were by no means isolated or unreasonable. It is interesting that Morgan's design was fashioned on the style of Roman aqueducts.

Certainly the most radical proposal of the period was Buckminster Fuller's Dymaxion House. Fuller—inventor, cosmologist, technologist,

engineer, mathematician, and scientist—was convinced that the developing modern architecture he saw around him was only a novel kind of formalism, still based on antiquated building methods and assumptions. He proposed, therefore, a building that could be mass produced anywhere in the world, could be delivered by air, and could nurture and sustain the growing world population by doing more with less. Not really a building so much as an efficient, factory-produced appliance, the Dymaxion House was the first link in Fuller's chain of revolutionary ideas based on what he called "anticipatory design science."

582 Kasimir Malevich. Suprematist Architectural Model. c. 1926–27 583 El Lissitzky and Mart Stam. Cloud Props (Wolkenbügel). 1925 584 A. Silchenko. Design for the People's Commissariat for Heavy Industry. c. 1925 585 Theo van Doesburg and Cornelis van Eesteren. Model for the Léonce Rosenberg House. 1923 586 Charles Morgan. Design for a Skyscraper Bridge, Chicago. 1928 587 Buckminster Fuller. Model for a Dymaxion House. 1929

Projects: High Rise

588

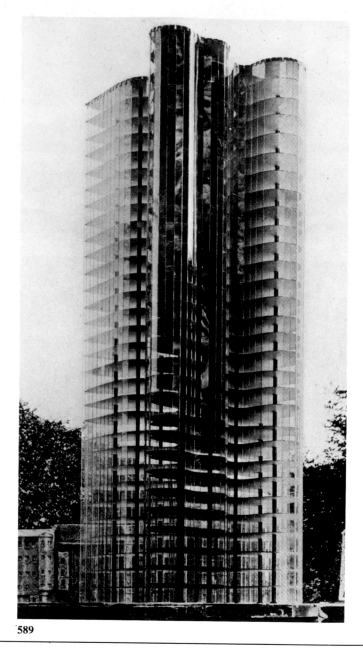

589

Though rejecting the congestion of the city in favor of planned, horizontal dispersal allowing for a common contact with nature, Frank Lloyd Wright did design a number of urban skyscrapers, which were never realized. Opposed to the industrial aesthetic of the glass-walled, steel-framed tower, Wright favored the "organic" use of reinforced concrete, with slab floors cantilevered from piers like branches from a tree trunk. His isometric drawing of a proposed skyscraper for the National Life Insurance Company in Chicago demonstrates Wright's fondness for varied and ornamental surface textures. The project consisted of immense inter-

secting slabs, permitting generous open-ended light wells and ventilation. Wall surfaces of repetitively patterned concrete blocks contrasted with curtain walls of glass set in copper frames, while Wright's ubiquitous vines cascaded from airy roof gardens.

A few years earlier Mies van der Rohe constructed a model of a glass skyscraper and had it photographed from a pedestrian vantage point with model houses and a background of real trees made to scale, creating an accurate impression of the curtain-wall skyscrapers that began to rise in the 1950s. In fact, some fifty years later, a high-rise glass luxury apartment tower very similar in design to

this was built by a former student of Mies van der Rohe on the shores of Lake Michigan in Chicago. In 1922 Mies himself outlined a new theory of technological aesthetics: "Skyscrapers reveal their bold structural concept only during construction when the impression of the gigantic steel structure is overwhelming. The construction of the outer walls, however, destroys this impression of constructive thought. . . . New structural principles appear most clearly when glass is used for the exterior walls which no longer bear the weight of the building." Similarly enamored of machine aesthetics, Le Corbusier envisioned the obsolete Paris, with its choked streets and

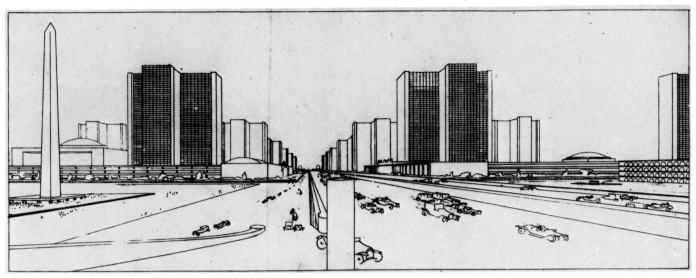

590

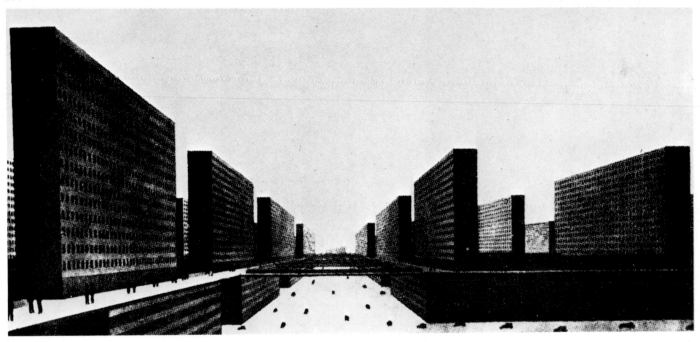

591

crowded living conditions, leveled and transformed into an ideal white city of the future to which he subsequently gave the name Ville Radieuse (Radiant City). Le Corbusier's city consisted of immense slab buildings placed at regular intervals in an immense park and connected by high-speed freeways. A similar design was proposed in Germany by Ludwig Hilberseimer in 1925. Pedestrian and motor traffic were to be on separate levels, ensuring greater safety.

Although never realized in the heart of Paris, the Ville Radieuse became the model for innumerable new cities and for large-scale urban redevelopment after World War Two. While the monotony of these schemes, as well as the drastic social dislocations and the destruction of the historic urban fabric they entail, has generally since been acknowledged, it should be remembered that the Ville Radieuse was both a reaction to dehumanizing and unhygienic conditions and a glamorous image of a future wherein man would be liberated by the machine. Ironically, such order, regularity, and cohesiveness as Le Corbusier and Hilberseimer proposed in their utopian drawings could have been achieved only by a totalitarian state. Further, their image of the city is a static one, for any subsequent major change would have destroyed its remarkable symmetry.

588 Frank Lloyd Wright. Design for the National Life Insurance Company, Chicago. 1924 **589** Ludwig Mies van der Rohe. Model for a Glass Skyscraper, Berlin. 1922 **590** Le Corbusier. Design for the Ville Radieuse. 1922 **591** Ludwig Hilberseimer. Design for a Skyscraper City. 1925

Dada Collage

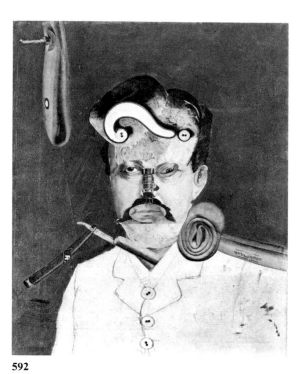

592

593

594

595

Dada had its origins in Zurich (see page 129) and in New York and spread rapidly throughout Europe during the immediate post–World War One period. Equally opposed to the pathos of Expressionism, the patriotic stance of Futurism, and the sense of structure in Cubism, it benefited from all these movements but did not produce a new, coherent artistic style. Dada was characterized by cynicism, nihilism, and sarcasm, and it cast established values—aesthetic as well as moral—into doubt.

In Berlin, embroiled in political, social, and economic upheaval, Dada tried to be politically engaged. Originally, it was in sympathy with the Communist Party, which was a contradiction to its affirmation of anarchy—but Dada approved only of contradictory attitudes. George Grosz, called the "Propagandada," was angry at what he considered the betrayal of the revolution by the bourgeoisie. At times this anger was stated with the incisive, biting clarity of a political pamphlet; at other times, as in *Remember Uncle August, the Unhappy Inventor*, done just prior to this decade, he used cutout magazine advertisements, rubber products, as well as buttons to make an ambiguous statement that is both grotesque and nihilistic.

Johannes Baader, a mysterious mock hero called the "Oberdada," had a taste for scandal and the totally absurd. His work combined heterogeneous materials such as photographic images, lettering, and handwritten descriptions—as in the innovative *The Author in His Home*.

A year after Raoul Hausmann made his satirical sculpture *The Spirit of Our Time* (plate 438), he made an extraordinary collage, *Tatlin at Home,* which comments on the great Russian Constructivist with a blend of admiration and sarcasm.

In all these collages, photographs were part of the composition, and Berlin Dadaists developed a new art form—the photomontage. Eventually, Grosz and John Heartfield, as well as Hausmann and Hannah Höch, all claimed to be its inven-

596

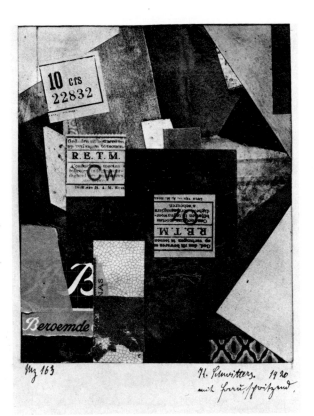

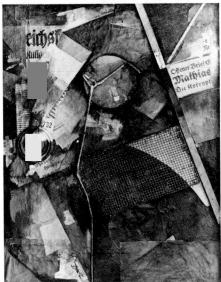

597

598

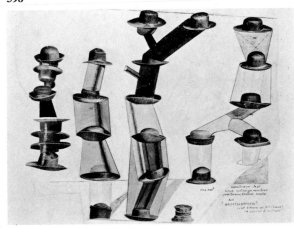

599

tors. This unique additive process, which at first combined photographs with painting and drawing, soon relied entirely on cut and pasted photographs. And Heartfield and Hausmann wound up quoting from each other. Heartfield used a photograph of Hausmann openmouthed for the cover of the magazine *Der Dada* in 1920, while Hausmann used the same photograph for the centerpiece of a collage of his own three years later. Kurt Schwitters, the Dada king of Hanover, continued his Merz collage, as in *Merzbild 25A* and *Merz 163*, explaining later that he felt that leftover objects found in garbage bins and in dumps—

impregnated with people's lives— were as worthy for making a painting as were paints produced in factories. This attitude, which was primarily responsible for his large and impressive *Merzbau* (plates 711–712), had important repercussions on several generations of artists.

In Cologne, Max Ernst was the Dada chief. When he turned to collage, as in *The Hat Makes the Man,* he was much more concerned with its "image value" than with its formal composition. Here he provides a humorous commentary on the bourgeois belief that "clothes make the man" by presenting a series of colorful empty display cylinders united by different hats,

and words, including titles like the one for this collage, were a very important part of the hybrid image.

592 George Grosz. *Remember Uncle August, the Unhappy Inventor.* 1919. Oil on canvas and assemblage, 19 $^{1}/_{4}$ × 15 $^{1}/_{2}$"
593 Johannes Baader. *The Author in His Home.* 1918–19. Collage, pasted photographs on book page, 8 $^{1}/_{2}$ × 5 $^{3}/_{4}$" **594** Raoul Hausmann. *Tatlin at Home.* 1920. Collage and watercolor, 18 $^{1}/_{8}$ × 12 $^{3}/_{4}$" **595** John Heartfield. Cover for *Der Dada* (Berlin), no. 3. 1920 **596** Raoul Hausmann. *ABCD.* 1923–24. Photomontage, 15 $^{3}/_{8}$ × 10 $^{9}/_{16}$" **597** Kurt Schwitters. *Merzbild 25A: Das Sternenbild (The Star Picture).* 1920. Collage, 41 × 31 $^{1}/_{8}$" **598** Kurt Schwitters. *Merz 163, with Woman, Sweating.* 1920. Collage mounted on paper mat, 11 $^{7}/_{8}$ × 8 $^{3}/_{4}$" **599** Max Ernst. *The Hat Makes the Man.* 1920. Collage, pencil, ink, and watercolor, 14 × 18"

Surrealist Automatism

600

601

Metaphors and subconscious associations were concepts that linked Dada with Surrealism, along with the artistic techniques of collage and montage. The Surrealist artist prompts the release of the unconscious to allow the unexpected and the marvelous to come to the surface. Relying greatly on the techniques of Freud—who exerted a major influence on the programmatic leader of the group, André Breton—the Surrealist artist welcomes the element of chance and cultivates the possibilities of automatic responses to unconscious feelings. Max Ernst was the artist who formed a great bridge between Dada and Surrealism and who in many ways remained the prototype of the Surrealist artist (much as Monet was the "essential" Impressionist). In 1922 Ernst moved from Cologne and joined Breton in Paris, and soon the new Surrealist movement, consisting principally of poets and writers, but including a number of painters, was launched.

Ernst extended the principles of random drawing toward the automatic by developing his "frottage" method, i.e., drawing or shading over the texture of another object, thus allowing its surface to be reproduced on paper or canvas. In this manner Ernst was able to include any conceivable texture (natural or man-made) and its hidden multiple images. In *To 100,000 Doves* a grill-like surface has been explored within which Ernst perceived and fixed a multitude of doves. This automatic association freed the artist to explore the richness of textures such as sand, bark, chicken wire, and the like, and to become aware of imaginative subconscious associations.

In his *Ink Drawing* Picasso, who was never an official adherent of Surrealism, reversed the process somewhat. He placed a number of ink spots at random and then connected them with lines, as in a child's puzzle. Afterward the design was reproduced by an artisan as a wood engraving.

603

602

604

Figure, by André Masson, a leading member of the Surrealist group, suggests multiple images. By drawing at random with paint and glue, then pouring sand over the glue, Masson arrived at a structure of a man with fishlike configurations, random eyes, and flowing swirls of water. Beginning with no image in mind and working impulsively, he permitted an image to emerge and ended up with an ordered composition.

By 1925 the Catalan painter Joan Miró had reached an abstract kind of imagery which departed significantly from his earlier, more realistic and narrative painting (see plate 652) into a world of free poetic imagination. In *The Birth of the World* he applied his paint freely onto the canvas, allowing it to run across the surface. He then placed the calligraphic signs at random but with an intuitive sense of composition, arriving at primordial symbols. The whole painting rejected the Cubist grid as much as traditional perspective, and created a totally open kind of picture. Although he welcomed accident, it is difficult to assume that Miró's composition is entirely automatic. Much as Arp did in his earlier *Automatic Drawing* and *Arrangement according to the Laws of Chance* (plate 389), so Miró was able to rely on his innate sense of selective balance of form and color. In fact, Miró and Arp met in 1924. Also, Miró's studio on the rue Blomet was next to Masson's and the two artists explored the phenomena of automatic responses together. Their studios served as salons for many Surrealist poets, authors, and artists.

600 Max Ernst. *To 100,000 Doves*. 1925. Oil on canvas, 32 × 39 $^1/_2$" **601** Pablo Picasso. *Ink Drawing*. 1926. Subsequently reproduced by wood engraving in Balzac's *Le Chef-d'oeuvre inconnu* (Vollard, Paris, 1931) **602** André Masson. *Figure*. 1926–27. Oil and sand on canvas, 18 $^1/_8$ × 10 $^1/_2$" **603** Joan Miró. *The Birth of the World*. 1925. Oil on canvas, 98 $^3/_4$ × 78 $^3/_4$" **604** Jean Arp. *Automatic Drawing*. 1916. Ink, 16 $^3/_4$ × 21 $^1/_4$"

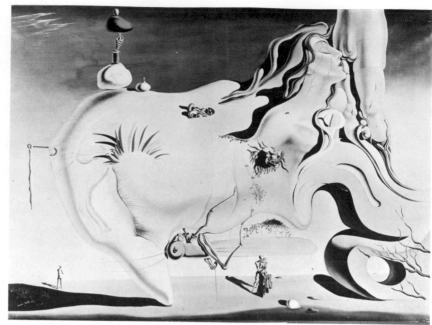

606

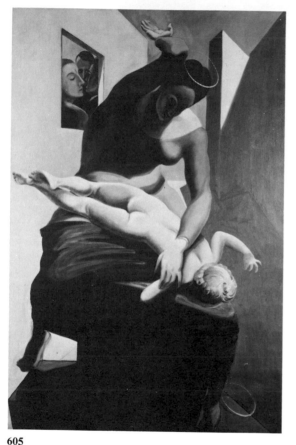

605

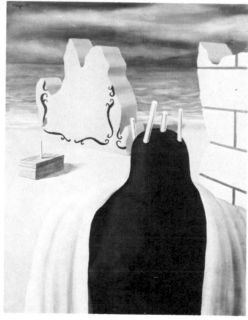

607

Max Ernst shared his Dada and Surrealist confrères' fascination with sexual and erotic imagery. His *The Blessed Virgin Chastises the Infant Jesus before Three Witnesses, A. B., P. E., and the Artist* is a startling and very irreverent picture. Showing both his humor and knowledge of past art, Ernst takes Parmigianino's famous image of the elegant *Madonna with the Long Neck* (1534–40) and transforms this fragile, adoring Virgin into a hefty bourgeois woman who punishes her traditionally virtuous and holy child while Surrealists André Breton, Paul Eluard, and the artist himself witness this sadistic scene. Executed with mysterious spatial layout, this painting shows the Surrealists' distaste of traditional religion and of bourgeois life style, their joining of physically and temporally distant realities, and their emphasis on images arising from vision turned inward (note the witness with closed eyes).

Salvador Dali, in *The Great Masturbator,* depicted fetishes and sexual fantasies in a complicated, yet overt, iconography which shocked, disgusted, confused, and fascinated his observers. Demonstrating extreme technical virtuosity, Dali created the head of a dreaming man (his nose is on the ground) and the provocative sexual images passing through his mind.

Like other Surrealists, the Belgian painter René Magritte often masked his erotica with disguises of personal significance, but sometimes his images elaborated on more accessible sources. *The Vestal's Agony* refers to the Roman cult of the goddess of the hearth. The virgins who attended the sacred fire at her altar were to be walled up in a tomb if they broke their vow of chastity. Magritte's pitiable figure stands before two embodiments of her punishment: the walls and the coffin.

Picasso, too, painted images whose chief characteristic is one of Surreal imagination. The figures often have sharp projections for teeth, causing them to resemble frightening dream images. Even the breasts of the

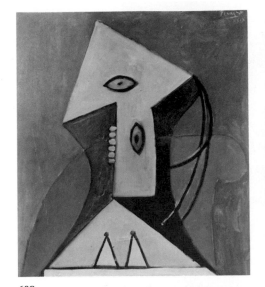

608

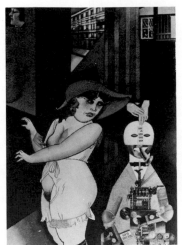

610

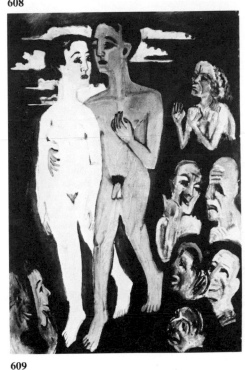

609

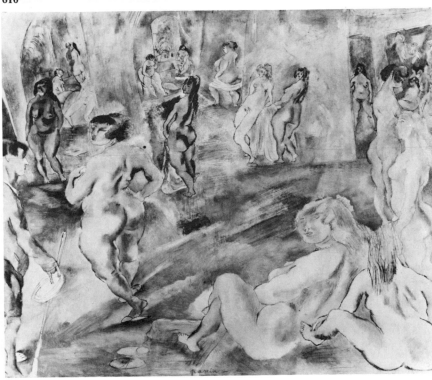

611

Woman in a Red Armchair are spiky and repellent.

Ernst Ludwig Kirchner's *Two against the World* comes from a very different tradition. Here rigid male and female forms are united against a jeering, hostile crowd. Kirchner's obsession with sexuality manifests itself now in a manner much more decorative and predesigned than in his previous, more vehement, more spontaneous, more Expressionist work (plates 238 and 251).

In *Daum Marries* . . . George Grosz continues his assault on the decadent middle class, but becomes more pointed now in his accusations against bourgeois life style. The groom is made up of meaningless technolog-ical contrivances—many of them alluding to the black market—and is pasted down onto the cardboard. He is mechanized, amputated, and totally impotent. Daum, the exposed bride, is full-bodied and overwhelming. Their unequal, frightened, obscene encounter takes place in a barren urban environment. Other individuals appear mysteriously at window openings. As in Kirchner's painting and Ernst's *Blessed Virgin*, the event is witnessed by spectators.

Jules Pascin, born in Bulgaria, worked in Vienna, Munich, Berlin, Paris, and New York, where he exerted a considerable influence on American painters who admired his fine draftsmanship and delicate color as well as his bold choice of subject matter. *The Prodigal Son* depicts a large room in a brothel in which a multitude of women display themselves in provocative nakedness.

605 Max Ernst. *The Blessed Virgin Chastises the Infant Jesus before Three Witnesses, A. B., P. E., and the Artist.* 1926. Oil on canvas, 76 $^3/_4$ × 51 $^1/_4$″
606 Salvador Dali. *The Great Masturbator.* 1929. Oil on canvas, 42 $^1/_2$ × 59 $^1/_8$″
607 René Magritte. *The Vestal's Agony.* 1926. Oil on canvas, 37 $^3/_8$ × 28 $^3/_4$″
608 Pablo Picasso. *Woman in a Red Armchair.* 1929. Oil on canvas, 25 $^1/_2$ × 21 $^1/_4$″ **609** Ernst Ludwig Kirchner. *Two against the World.* 1924–28. Oil on canvas, 60 $^1/_4$ × 40 $^1/_4$″ **610** George Grosz. *Daum Marries.* . . . 1920. Watercolor and collage, 6 $^5/_8$ × 4 $^3/_4$″
611 Jules Pascin. *The Prodigal Son.* 1928. Oil on board, 15 × 18″

The Omnipotence of the Dream

612

613

614

With the popularization of Freud's study of dreams and the predominance of Surrealist exploration among avant-garde artists in the twenties, dreamlike images become an important source for painting. Ernst's forest pictures are night scenes of dark and dangerous primeval growth. In *The Great Forest* the moon is a luminous ring standing out sharply in the sky: light against darkness, clarity against the heavily textured labyrinth.

In *A Large Picture Which Is a Landscape* Yves Tanguy depicted an unidentifiable landscape in deep perspective, a device adapted from de Chirico. The objects, on a sandy floor of desert dunes, have never been encountered by the viewer, yet they could conceivably exist: some sort of seaweed, a quadruped, anthropomorphic shapes, etc. The ephemeral quality of the artist's application of paint, the undulating shadows, the strange hairlike projections seem to belong to a dream state in which thoughts shift so rapidly that the image is held only for a moment and then transformed.

Salvador Dali had been an avid reader of Freud and Krafft-Ebing, and his *Illumined Pleasures* not only are dream images, recalling the fetishes of his mind, but also have a hallucinatory, delirious quality similar to that of the art of psychotics. The obsessive images reflect the dis-

ruption and disassociation of the modern mind, but many of the images are derivative, as is his technique of using thin glazes in the Renaissance tradition, which may be why he was more easily accepted by the public than were the other Surrealists.

In René Magritte's dream image of *The Lovers* the two veiled figures stand in a trancelike state of complete alienation. A new reality, often experienced only in the dream, now becomes part of the waking world. Perhaps the painting is a reference to Magritte's memory of his mother's death: she had drowned with her gown wrapped around her head.

Paul Klee's *Dance, Monster, to*

244

615

617

616

618

My Soft Song is a delightful work of fantasy. Klee's world is one in which miracles occur, or can be brought about by small children. A little girl is singing her "soft song" next to a transparent skeletal piano, making a benign large-nosed airborne monster do her bidding. Although Klee's work was exhibited in the first Surrealist exhibition, in 1925, he never participated in the movement. He was less concerned with autonomous expression of the unconscious, but he used all internal sources—as he used the art of children—for his more deliberate artistic purpose.

At the end of the decade Picasso did a series of bathers, strange configurations resembling the human body, yet having little in common with it except random breasts, arms, a leg, a head. *Seated Bather* is a truly disquieting image of dislocation. Like a praying mantis, this specter of a woman is ready to devour whatever comes her way.

In the same year as Klee did his *Dance, Monster,* Maxfield Parrish painted *Daybreak,* a dreamy landscape with two youthful figures— actually his daughter and a friend. With its back lighting and sun-dappled blue mountains, this kitsch painting won Parrish speedy acclaim, and within two years reproductions of it had brought him $75,000 in royalties.

612 Max Ernst. *The Great Forest.* 1927. Oil on canvas, 45 $^4/_5$ × 58 $^3/_5$″ **613** Yves Tanguy. *A Large Picture Which Is a Landscape.* 1927. Oil on canvas, 46 × 35 $^3/_5$″ **614** Salvador Dali. *Illumined Pleasures.* 1929. Oil and collage on composition board, 9 $^3/_8$ × 13 $^3/_4$″ **615** René Magritte. *The Lovers.* 1928. Oil on canvas, 21 $^3/_8$ × 28 $^7/_8$″ **616** Paul Klee. *Dance, Monster, to My Soft Song.* 1922. Plaster, watercolor, and ink on gauze, gouache on a paper mount, 17 $^3/_4$ × 12 $^7/_8$″ **617** Pablo Picasso. *Seated Bather.* 1930. Oil on canvas, 64 $^1/_4$ × 51″ **618** Maxfield Parrish. *Daybreak.* 1922. Oil on panel, 26 $^1/_2$ × 45 $^1/_2$″

Women

619

620

621

Although Picasso was greatly admired by Breton and the Surrealists, and lent much support to their activities, he remained much more attached than they to visual reality as well as traditional themes. In sharp distinction to his radical breakthrough in the prewar years, his *A Woman in White* expresses a search for order and clarity. It goes back to the Mediterranean tradition and is certainly indebted to the art of classical antiquity, as well as to the paintings and drawings of Ingres.

Also within the classical tradition is the motif of Georges Braque's *Nude Woman with a Basket of Fruit.* Braque did not abandon his early innovations but concentrated on refining and enriching them, investigating the range of relationships between volume and color. His paintings of the twenties reveal a magnificent sense of touch and mastery of varied sensuous textures.

Matisse, too, retained the traditional subject of the woman posed in the studio. In *Decorative Figure on an Ornamental Background* the nude seems to be more stark than decorative, while wallpaper, carpet, Moorish mirror, and plant are profuse in ornamental richness, a quality achieved primarily by the painter's use of almost equal color tones.

A decorative impulse also informs Léger's *Woman with a Cat.* A dazzling number of circular forms (one even with a domino pattern) reiterate the rounds of the woman's breasts and thighs; the cat, too, is enlisted, and the open book contributes another variation on the circle. This is the painting of a true virtuoso.

Pierre Bonnard, who seemingly pursued his personal vision without being significantly influenced by the postwar tendencies, was primarily a colorist, as is evident in *The Bath.* Observing his scene from the top, he has posed his model in a large bathtub, elongated the lower torso, tilted the tub itself, and painted transparent nuances of luminous intensity using color with

622

624

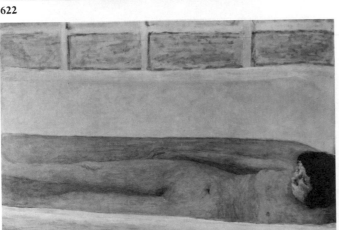

623

625

total arbitrariness. Bonnard demonstrates here his great subtlety and extreme aesthetic refinement.

The English painter Sir Matthew Smith also remains faithful to the opulence of resonant color. *Model Waking,* which is related to Fauve painting, has a spontaneous quality that years later motivated Francis Bacon to write: "I think that painting today is pure intuition and luck and taking advantage of what happens when you splash the bits down, and in this game of chance Matthew Smith seems to have the gods on his side"—a statement that, incidentally, tells us even more about Bacon than it does about Smith.

Spontaneity was hardly what Diego Rivera had in mind in any of his politically and socially oriented mural paintings—great public art projects commissioned in hopes of bringing about what he referred to as a "transition from a decrepit to a new order." Mexican mural painters advocated a nonelitist art, valuable to the largely illiterate masses in their revolutionary struggle. One of Rivera's many murals was created in the chapel of the National Agricultural School in Chapingo between 1923 and 1927. Here *The Fertilized Earth* dominates the end wall. As his model he used Lupe Marín, his first wife. Below this symbol of fertility are allegorical images depicting mineral wealth and electrical and wind energy in a powerful didactic painting indebted more to Florentine Renaissance frescoes and Gauguin than to pre-Columbian Mexican art.

619 Pablo Picasso. *A Woman in White.* 1923. Oil on canvas, 39 × 31 ¹/₂″
620 Georges Braque. *Nude Woman with a Basket of Fruit.* 1926. Oil on canvas, 63 ³/₄ × 29 ¹/₄″ **621** Henri Matisse. *Decorative Figure on an Ornamental Background.* 1925. Oil on canvas, 51 ¹/₈ × 38 ¹/₂″ **622** Fernand Léger. *Woman with a Cat.* 1921. Oil on canvas, 36 ¹/₄ × 25 ⁵/₈″ **623** Pierre Bonnard. *The Bath.* 1925. Oil on canvas, 33 ⁷/₈ × 47 ¹/₂″ **624** Matthew Smith. *Model Waking.* c. 1924. Oil on canvas, 25 ¹/₂ × 31 ¹/₈″ **625** Diego Rivera. *The Fertilized Earth.* 1926–27. Fresco

Social Protest

626

627

628

Rivera had begun his career as a landscape painter and then did highly accomplished Cubist canvases in Paris (plate 292) before returning to Mexico in 1921 to participate in the mural movement. Before he had begun to work in Chapingo, he had received a commission to paint a large cycle of murals for the Ministry of Education in Mexico City. The murals deal with the life of the Mexican peasant and worker, with Mexican history, and with contemporary issues. In *The Bourgeois Family* he symbolized the Mexican proletariat by a powerful pair of soldier-peasants standing above an odious-looking family whose members are sitting down to dine on gold

pieces. *The Night of the Rich* shows the drunkenness and other depravity that money can buy.

At the same time José Clemente Orozco, undoubtedly the strongest artist of the Mexican Renaissance, painted frescoes at the National Preparatory School in Mexico City—the first of many significant mural cycles. Orozco's work, often tragic in its message and monumental in form, is exemplified by *Revolutionary Trinity*. The soldier in the center, grasping a rifle with his enormous hand, has his face covered and his eyes blinded by his red banner. The worker on his right shows the stumps of his mutilated arms, and the peasant covers his face in a gesture of anguish.

While an art of social protest was supported by the revolutionary government of Mexico during a brief time in the 1920s, the politically involved artists in Germany were in dissent against the repressive order. Käthe Kollwitz, an artist whose work shows the most intimate empathy with the tragedy of war, with suffering, starvation, and death, had lost a son in the trenches, and her vigorous lithograph *No More War* is a work of monumental power.

The very aggressiveness of Kollwitz's drawing is in great contrast to the total pessimism conveyed in Karl Völker's *Girl of the People*. Völker's young woman is no longer part of a dramatic environmental

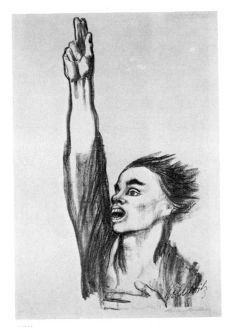

629

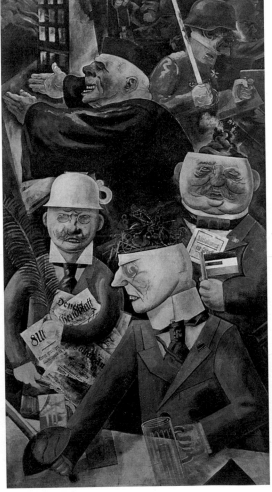

631

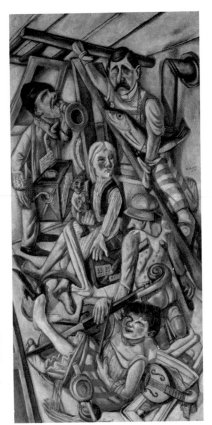

632

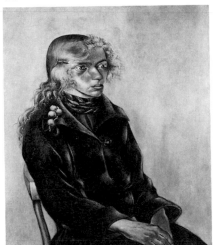

630

context, as she would have been in an Expressionist painting (see Pechstein, plate 361), but is seen from a clear and definite distance like an actor in the Brechtian theater. Sitting in total isolation, she is the embodiment of disillusion.

George Grosz painted more sarcastic indictments of society. In *Pillars of Society* we are confronted with the veteran student with his dueling scar and beer glass, emptyheaded but dreaming of the glories of the artillery, and wearing a swastika pin on his tie; the bureaucrat, grasping bourgeois newspapers, and crowned by a chamber pot; the fatheaded, hollow socialist, whose open head seems filled with garbage;

the repulsive priest, opening his blessing arms in a gesture of complete hypocrisy; and the old-time soldier marching off to war.

Max Beckmann also felt the need to comment on the horror of life in the postwar period. Whereas Grosz dealt with Germany's social and political evil in a direct fashion, Beckmann explored his own personal fears and anxieties and therefore created work of universal scope. In *The Dream,* a crammed composition, even the perpetrators of the silent murder are the victims of their own actions. Here he has painted a blind beggar blowing a trumpet; a lame and blind prisoner standing on a ladder and holding a fish; a drunk-

en maid with a cello between her legs; a crippled clown; and in the center of the vertical composition, an innocent country girl holding her suitcase and a puppet. It is a painting of chaos and turmoil; Beckmann originally entitled it "Madhouse."

626 Diego Rivera. *The Bourgeois Family (Wall Street Banquet).* 1923–28. Fresco **627** Diego Rivera. *The Night of the Rich.* 1923–28. Fresco **628** José Clemente Orozco. *Revolutionary Trinity.* 1923–24. Fresco **629** Käthe Kollwitz. *No More War.* 1924. Lithograph, 39 × 26″ **630** Karl Völker. *Girl of the People.* 1925. Oil on pasteboard, 34 $^7/_8$ × 29 $^1/_8$″ **631** George Grosz. *Pillars of Society.* 1926. Oil on canvas, 78 $^3/_4$ × 42 $^1/_2$″ **632** Max Beckmann. *The Dream.* 1921. Oil on canvas, 71 $^3/_4$ × 35 $^7/_8$″

Portraits

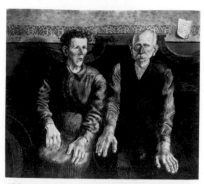

635

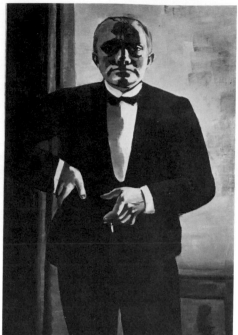

633

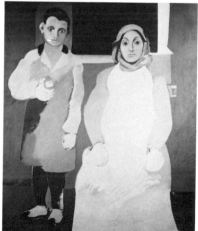

636

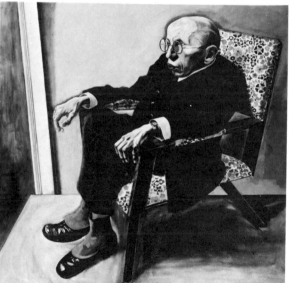

634

637

Six years later, recognized as one of the leading artists of his time, Beckmann reveals great self-confidence in his life-size *Self-Portrait in a Tuxedo*. Whereas diagonals were essential in his earlier paintings of trouble and violence, a severe structure of horizontal and vertical planes makes up this rigidly frontal, highly formal portrait. Beckmann, who painted his self-image probably more often than any other major artist since Rembrandt, depicts the artist as man of the world.

In 1925 a number of German artists whose works were characterized by bitter and often dry realism exhibited together in a famous show in Mannheim called "The New Objectivity," in which Beckmann, Grosz, and Dix were included. Grosz's *Portrait of Max Hermann-Neisse* displays meticulous and ruthless attention to the details of the thin, hunchbacked body and large bald head of the poet and critic. Similarly, Otto Dix's *My Parents* portrays his mother and railway-worker father with an acerbic clarity of form that consciously harks back to German Renaissance painting. Certainly there is compassion in these portraits, but the twenties transformed the agitation of earlier Expressionist work into more sober social criticism.

In *Into the World There Came a Soul Called Ida* Chicago's foremost painter, Ivan Le Lorraine Albright, portrays decaying flesh. The space is ambiguous, and a strange light coming from various directions fragments the figure, who holds a mirror to her grotesque face—a sarcastic twist on the traditional image of vanity. Albright pays obsessive attention to detail, to materials, and to gritty textures, and a feeling of putrescence is skillfully evoked.

Arshile Gorky's *The Artist and His Mother* was painted from an old photograph that showed the pair before they immigrated to America from Armenia. He generalized and simplified his forms and flattened the figures. This portrait has a hieratic, solemn quality and a great sense of

638

639

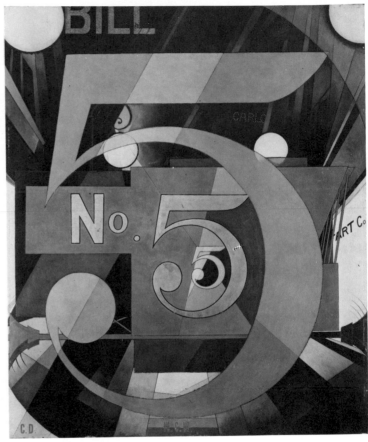

640

abstract formal values, which clearly relate it to the classical tradition of Ingres, Degas, Cézanne, and Picasso. Gorky was one of the principal artists to bring European modernism into American painting, leading toward the great achievements of the New York School.

Arthur Dove, who belonged to an earlier generation, did a *Portrait of Alfred Stieglitz* in 1925 (ten years after Picabia; plate 295) employing objects to symbolize his friend's character, interests, and bushy hair. He created an assemblage of a camera lens—probably standing for Stieglitz's head or perhaps his eyes—and a photographic plate on which is placed a clock spring and

steel wool. Other members of the Stieglitz group were also involved in creating symbolic portraits at this time. Charles Sheeler, a photographer as well as a painter, hid himself in a reflection against the glass, as he would conceal himself behind the lens of his camera. Only the machine that transmits his voice is depicted in sharp, realistic detail.

One of the finest symbolic portraits is Charles Demuth's *I Saw the Figure 5 in Gold*. Based on a poem by his friend William Carlos Williams, it is more a homage than a portrait in the traditional sense. The number 5, lettering, including allusions to Williams's name and initials and a city street, are all put together

in a hard-edged cinematic composition relating to the poem.

633 Max Beckmann. *Self-Portrait in a Tuxedo.* 1927. Oil on canvas, 54 $\frac{1}{2}$ × 37 $\frac{3}{4}$″ **634** George Grosz. *Portrait of Max Hermann-Neisse.* 1925. Oil on canvas, 40 × 40″ **635** Otto Dix. *My Parents.* 1924. Oil on canvas, 45 $\frac{7}{8}$ × 51 $\frac{1}{4}$″ **636** Ivan Le Lorraine Albright. *Into the World There Came a Soul Called Ida.* 1929–30. Oil on canvas, 56 $\frac{1}{8}$ × 47″ **637** Arshile Gorky. *The Artist and His Mother.* 1926–29. Oil on canvas, 60 × 50″ **638** Arthur G. Dove. *Portrait of Alfred Stieglitz.* 1925. Assemblage: camera lens, photographic plate, clock and watch springs, and steel wool, on cardboard, 15 $\frac{7}{8}$ × 12 $\frac{1}{8}$″ **639** Charles Sheeler. *Self-Portrait.* 1923. Watercolor, conté crayon, and pencil, 19 $\frac{3}{4}$ × 25 $\frac{3}{4}$″ **640** Charles Demuth. *I Saw the Figure 5 in Gold.* 1928. Oil on composition board, 36 × 29 $\frac{3}{4}$″

641

643

642

644

A successful relationship between painter and poet is by no means an isolated phenomenon in the art of the twenties. The most successful fusion of painting and the theater arts was Sergei Diaghilev's Ballets Russes. Diaghilev brought the Russian ballet to Paris in 1909 and subsequently attracted many of the major Paris artists to work with choreographers, composers, and writers. For example, the ballet *Parade,* performed in 1917, was based on the theatrical ideas of Jean Cocteau, with music by Erik Satie, highly innovative costumes and decor by Picasso, and choreography by Léonide Massine.

The Nabis and the Symbolists (see page 27) had been involved with the theater since the 1890s, especially with Aurélien-Marie Lugné-Poe's Théâtre de l'Oeuvre. Out of this background come Pierre Bonnard's airy, springlike designs for his friend Claude Debussy's *Jeux*, performed by the Ballets Suédois in Paris. The backdrop, done in blues and greens and oranges with just a bare indication of light, dancing figures, seems to be a perfect foil for Debussy's music. Soon thereafter Fernand Léger did the stage designs for *La Création du Monde*, with music by Darius Milhaud and a libretto by Blaise Cendrars. Employing African figures to capture the primordial dark and terrifying aspects of the mystery of creation, Léger attempted

to duplicate the "lyrical state of astonishment" felt when the world first burst into existence. But true to his own visual sense, he created a man-made world with mechanomorphic beings.

Oskar Schlemmer's famous *Triadic Ballet* was first performed in 1922. He completed it while teaching at the Bauhaus, and Paul Hindemith wrote the music for it. Being a choreographer as well as a painter and sculptor, Schlemmer created a tension between the human quality of physical movement and the restraint of his Constructivist costumes. To a great extent the costumes are designed to determine and delimit the dance. In a prescribed space, the

645

647

646

648

dancer, costume, light, and music interact.

His older colleague at the Bauhaus Vasily Kandinsky had experimented with abstract stage composition earlier. In 1928 he designed sets for Modest Moussorgsky's *Pictures at an Exhibition*. His settings were "made out of forms that appeared to my mind's eye while listening to the music." The result is a felicitous mixture of abstract geometric shapes with Russian cupolas and suns and moons in deep, sonorous colors.

László Moholy-Nagy had already left the Bauhaus when he designed the sets for *Tales of Hoffmann*. These intellectual, formal, stark, and uncompromisingly modern designs

would, at first, seem to be at odds with both Hoffmann's romantic stories and Offenbach's rather sentimental music. But the delicacy of Moholy-Nagy's pure forms, their lightness and transparency proved to be very much in keeping with the spiritual feeling of the opera. Another highly successful collaboration between painters and choreographers was achieved in the sets and decor for *Roméo et Juliette* designed by Joan Miró and Max Ernst for the Ballets Russes. In the backdrop Ernst used the frottage technique to create an almost cosmic effect of sea and sky. Aleksandra Ekster's designs for Shakespeare's play on this theme, presented by Aleksandr

Tairov at the Kamerny Theater in Moscow in 1921, are highly stylized, but their governing principle is the awareness of the change in surfaces produced by light and movement.

641 Pierre Bonnard. *Design for a Set for "Jeux."* 1920 **642** Fernand Léger. *La Création du Monde.* 1923. Watercolor, 15 1/2 × 23 7/8" **643** Oskar Schlemmer. *Study for "Triadic Ballet."* 1922. Gouache, ink, and collage of photographs, 22 5/8 × 14 5/8" **644** Vasily Kandinsky. *Pictures at an Exhibition.* 1928. Watercolor, 8 3/8 × 10 3/4" **645** László Moholy-Nagy. *Stage Drawing for "Tales of Hoffmann."* 1929. Drawing, 6 3/4 × 8 7/16" **646** Max Ernst. *Roméo et Juliette.* 1926. Oil and charcoal on paper, 12 3/4 × 15 3/4" **647–648** Aleksandra Ekster. Costume designs for *Romeo and Juliet.* 1921. Gouache and lead white on cardboard

Landscape I

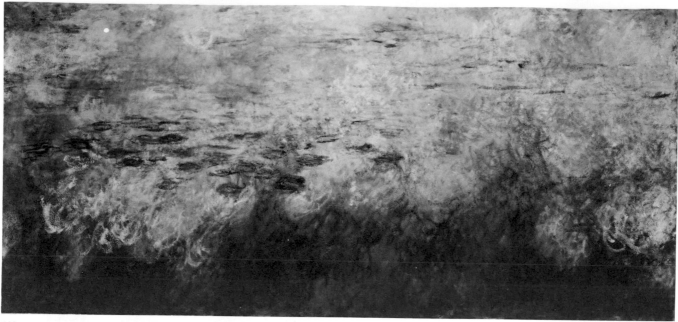

649

650

651

Ernst's backdrop for *Roméo et Juliette,* also called *The Sea,* is of course also an example of the continuing interest of artists in landscape motifs. Claude Monet, in his eighties, continued and deepened his exploration of the water garden near his house in Giverny. He seems to have submerged his whole being into the contemplation of the *Water Lilies* floating on its surface. They merge with the shimmering reflections of sky and trees in gigantic canvases which have no compositional center, and no longer have a beginning or an end. Knowing that the effects of nature are fugitive and that the world is in constant flux, Monet brought a sense of peace

which he must have found in himself—peace which comes from a deep understanding of the timeless world in continuous flow.

At the same time in France we find Chaim Soutine creating the most violent Expressionist landscapes. Born in a poor Jewish community in Lithuania in 1893, Soutine found his way to Paris in 1913 and to Céret, in the French Pyrenees, in 1919. There he did a series of highly tortuous and convoluted landscapes such as *View of Céret.* The hills, trees, and houses are distorted into quivering, violent forms, painted at a high emotional pitch. Using thick pigment and a loaded brush, Soutine created a dense, vibrant sur-

face that activates the total canvas from edge to edge. Totally different in their character and emotional content, Monet's and Soutine's canvases both share an all-over vitality of the picture surface.

The German painter Lovis Corinth was only slightly younger than Monet. After years of heavy academic studio painting, he became one of the finest Impressionists in Germany. Certainly influenced by the work of his younger colleagues who expressed themselves in a more dynamic style, Corinth in his old age arrived at landscapes which have a brushstroke of great energy and a sweep of color and expressive distortion of form. This placed the old

652

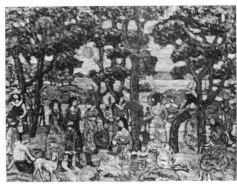

653

man in the mainstream of the art of Germany of his time, although he was working in solitude, high up in the Bavarian Alps, painting canvases such as *Tree at Walchensee.*

One of the finest landscapes of the decade was painted by the youthful Catalan Joan Miró. His *Farm* actually summarizes his early efforts, prior to his involvement with Surrealism. He repeats many motifs throughout the relatively small canvas and makes use of bright colors with crystalline clarity. Although it is carefully composed, the picture has a delightful freshness and spontaneity. It combines high sophistication with an almost primitive encounter; it fuses realism and fan-

tasy. Ernest Hemingway, who bought the picture soon after it was painted, wrote in 1934 that "No one could look at it and not know it had been painted by a great painter. . . . It has in it all that you feel about Spain when you are there and all that you feel when you are away and cannot go there. . . . No one else has been able to paint these two very opposing things. . . ."

Maurice Prendergast's *Landscape with Figures* distills something of this blend of nostalgia and immediacy. Prendergast, little influenced by new styles or techniques, retained his personal version of Pointillism (see plate 254) all his life, after younger colleagues had turned instead to

Cubist techniques. But in Prendergast's hands it activates the surface with light, air, and happy voices.

649 Claude Monet. *Water Lilies* (center panel). c. 1920. Oil on canvas; triptych, each section 78 × 168″ **650** Chaim Soutine. *View of Céret.* c. 1921. Oil on canvas, 29 1/8 × 29 1/2″ **651** Lovis Corinth. *Tree at Walchensee.* 1924. Oil on canvas, 28 3/8 × 36 3/8″ **652** Joan Miró. *The Farm.* 1921–22. Oil on canvas, 52 × 58″ **653** Maurice Prendergast. *Landscape with Figures.* 1921. Oil on canvas, 32 5/8 × 42 5/8″

Landscape II

655

654

656

John Marin, who spent many of his summers in Maine, made some of the freshest and most exuberant watercolors depicting the Northeastern coast. The fluid watercolor medium was perfect for Marin, whose eyes were constantly aware of surface movements and who believed that "the painter should follow the paint." These watercolors, such as *Maine Islands,* are dynamic and calligraphic in style; they capture the atmospheric effects, the air, the light. They have a sense of place.

In 1929 Georgia O'Keeffe visited New Mexico, became overwhelmed with the mysterious desert country, its dry light, strong color, and pure atmosphere, and eventually moved there to live. During her initial visit she painted *Black Cross, New Mexico*, in which an enormous black cross stands out against the sharp-focused, rounded hills in the evening sun, a symbol of the spirit of the Penitentes in this land heavy with the history of Spanish Catholicism.

A very different aspect of the American landscape appears in the work of Charles Demuth, yet both artists worked with a precise structure and isolation of motifs. Whereas O'Keeffe's painting dealt with nature, history, and myth, Demuth painted the industrial landscape. European architects admired American grain silos, and Demuth too saw in these structures pure geometric

forms, comparable perhaps to the pyramids. With irony and awe and possibly an admixture of romantic sentiment, he entitled a painting of a large grain elevator in his native Lancaster, Pennsylvania—*My Egypt*.

Impressions gathered on a trip to Egypt, where all the fields lead to the Nile, were also at the source of Paul Klee's *Highway and Byways*. But it is by no means a replication of what he saw. Here the "experience [is] recollected in [the] tranquillity" of his studio. "Art does not reproduce the visible; rather it *makes* visible," he wrote in his *Creative Credo*. Klee used parallel bands of color, a veritable color scale, separated by vertical lines to arrive at a rhythmic form,

657

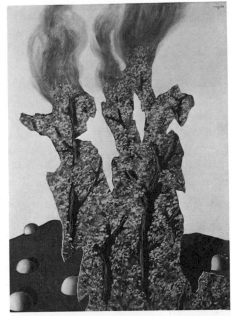

659

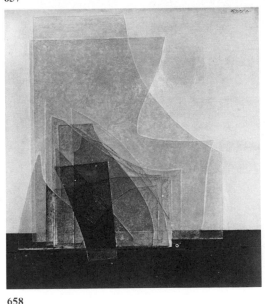

658

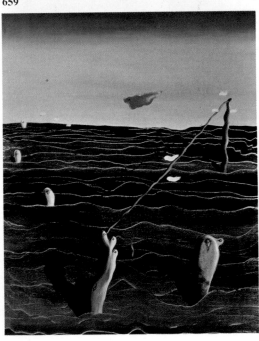

660

moving upward and inward, to indicate that among the many possible paths into the unknown there is still one which goes straight and without diversion toward the goal.

The American-born Lyonel Feininger, who was the first painter appointed to teach at the Bauhaus, reveals a most astute feeling for the precision of formal fantasy in his luminous abstraction *Broken Glass*. In many of his sophisticated paintings of churches, shore, and sea, Feininger discerned the fragility and transparency of both man-made and natural forms, reaching at times into the metaphysical, as in this painting of overlapping sheets of glass.

At first glance, Magritte's *Coun-tryside III* has the look of a collage: varied surfaces, strange, oddly shaped elements juxtaposed in a single form. But since the picture was painted in oil on canvas, the collage effect becomes the intent, not the means, of the artist. In fact, Magritte is collaging two perceptions of landscape—the leafy, tree-filled vertical landscape and the menacing barren landscape below, with stony protrusions. Both landscapes cast shadows, but the flame consuming the trees casts none. There is a hint of war and helmets and graves in this enigmatic work, painted shortly before Europe itself burst into flames.

Tanguy's *Landscape with Red Cloud* also has metaphysical implica-tions. Its terrain is in a universe unknown to terrestrial geologists. Is it a moonscape? Is it a view of Mars? And what atmosphere generates a gleaming cloud like this, suggestive of an angry amoeba—or a pair of inviting lips?

654 John Marin. *Maine Islands*. 1922. Watercolor, 16 ³/₄ × 20″ **655** Georgia O'Keeffe. *Black Cross, New Mexico*. 1929. Oil on canvas, 39 × 30″ **656** Charles Demuth. *My Egypt*. 1927. Oil on composition board, 35 ³/₄ × 30″ **657** Paul Klee. *Highway and Byways*. 1929. Oil on canvas, 33 × 26 ⁵/₈″ **658** Lyonel Feininger. *Broken Glass*. 1927. Oil on canvas, 28 ¹/₂ × 27 ³/₄″ **659** René Magritte. *Countryside III*. 1927. Oil on canvas, 28 ⁷/₈ × 21 ¹/₄″ **660** Yves Tanguy. *Landscape with Red Cloud*. 1928. Oil, 36 ¹/₄ × 28 ³/₄″

The City

661

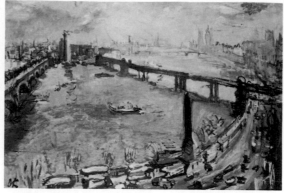

663

662

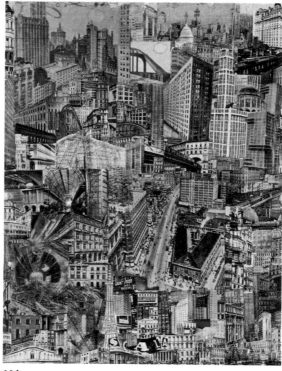

664

Modern artists painting the city did not necessarily see it as a large metropolis. Feininger continued to paint pictures of small medieval towns and their churches in central Germany, and he rendered the church of Gelmeroda with the mystic precision evident in *Broken Glass*. In *Gelmeroda VIII* a number of generalized figures stand in silent contemplation in front of the Gothic church, which has been totally transformed into a transparent metaphysical structure of rays of light. Making use of the discoveries of the Cubists, and building his painting from severely linear geometric planes, Feininger in this visionary painting gives tangible form to his

mysterious and romantic fantasies.

Stuart Davis's *Place Pasdeloup* is also a nostalgic view of the past. This canvas of the little Paris square is far removed from Davis's stark painting of the isolated *Odol* bottle, done four years earlier (plate 675). *Place Pasdeloup* is a charming, almost frilly painting in which the artist flattened out the view of the small square into a stage set, keeping the viewer waiting for the actors or singers to make their appearance.

In contrast, Oskar Kokoschka's *London, Large Thames View I* is a grand panoramic vista. By this time the Austrian painter had largely discarded his earlier, hauntingly tragic view of life and looked outward

to the world around him. He did a series of paintings of the European cities with great verve and virtuosity. From a high elevation Kokoschka paints the river with three bridges radiating from a focal point near the upper left-hand corner of the horizontal composition. The bright colors and energetic brushstrokes create a vibrant life in a painting that gives a new visual form to London, the city which had served as a great motif for Turner and Whistler, Monet and Pissarro, as Venice had for Canaletto and Guardi.

Coming out of the Dada movement, the Dutch artist Paul Citroen makes a wild photomontage of the city in which he gives a truly cine-

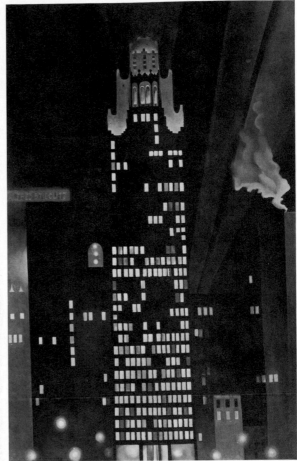

666

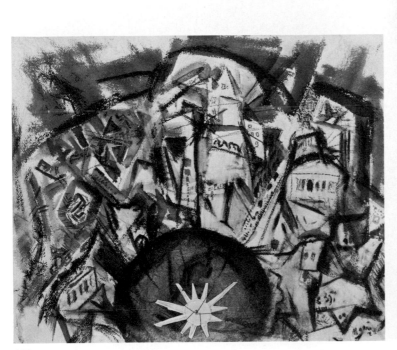

665

667

matic, almost dizzying view of the American-European *Metropolis.* In his watercolor *Lower Manhattan* John Marin employed a treatment and mood different from that in his *Maine Islands.* In *Lower Manhattan* he has created a dynamic explosion of lines and kaleidoscopic movement resembling the works of the Futurists a decade earlier. Using as his vantage point the top of Cass Gilbert's Woolworth Building (see plate 515), he looked down at the vitality and energy of the city. The picture is an assemblage of watercolor, charcoal, and paper which is cut out and attached with thread. Lines of force radiate from the cutout sunburst in the nucleus of the painting.

In contrast, Georgia O'Keeffe's *Radiator Building—Night, New York* looks up at the skyscraper, which is seen as a gigantic monolith glowing in the night, topped by an ornate and fantastic Art Deco spire. The name of her husband, Alfred Stieglitz, in its red rectangle on the left, adds to the personal, almost Surreal quality of the painting. At the same time this painting is so clearly structured in its abstract pattern that it also seems related to *City,* Josef Albers's abstract composition of colored glass created at the Bauhaus in 1928. Albers reduces the city to the play of shadow and shape; only the rectangular forms of glass are used to re-create the undulating pattern.

661 Lyonel Feininger. *Gelmeroda VIII.* 1921. Oil on canvas, 39 $^1/_4$ × 31 $^1/_4$″
662 Stuart Davis. *Place Pasdeloup.* 1928. Oil on canvas, 36 $^1/_4$ × 28 $^3/_4$″
663 Oskar Kokoschka. *London, Large Thames View I.* 1926. Oil on canvas, 35 $^3/_8$ × 51 $^1/_4$″ **664** Paul Citroen. *Metropolis.* 1923. Collage, 30 × 23″
665 John Marin. *Lower Manhattan.* 1922. Watercolor and charcoal with paper cutout attached with thread, 21 $^5/_8$ × 26 $^7/_8$″
666 Georgia O'Keeffe. *Radiator Building— Night, New York.* 1927. Oil on canvas, 48 × 30″ **667** Josef Albers. *City.* 1928. Colored glass, 11 × 21 $^5/_8$″

Figures in Interiors

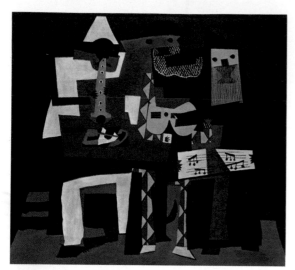

668

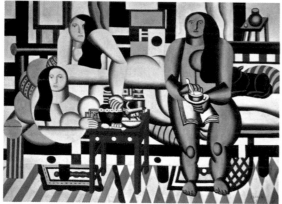

669

670

Most of the landscapes and city-scapes painted in the twenties seem to be without human beings. It is in the man-made environment of the interior that the relationship of man to his ambience becomes more apparent.

Picasso, even before painting *A Woman in White* (plate 619), had turned to Neoclassic compositions. At the beginning of this period the master worked in a heavier, more ponderous mode. His *Two Seated Women* (plate 281) are gigantic figures that convey the timeless and tragic feelings of the human condition. This belongs to the Mediterranean classic heritage. The work's strong sense of structure, however,

is also indebted to Picasso's austere exploration of form in his Cubist paintings. In fact, he painted Cubist pictures at the same time. This is not a matter of divided loyalties, but part of his consistent effort to solve formal problems. In 1921 he painted *Three Musicians*, one of his Cubist masterpieces. The life-size masquers confront the viewer like judges on a bench in this painting, which epitomizes Picasso's previous accomplishment. Instead of the deep modeling of *Two Seated Women*, the figures are two-dimensional and are undoubtedly based on his earlier experiments with cutout and collage. Instead of the almost monochrome dark-brown tones of *Two Seated*

Women, Three Musicians is painted in bright, festive colors. The figures of Amazons of antiquity are replaced by characters from the Italian commedia dell'arte: Pierrot on the left, Harlequin in the center, and a domino on the right. There is also a small dog hiding under the table that adds to the wittiness of this picture.

Léger's *Three Women (Le Grand Déjeuner)* was painted during the same year and is almost identical in dimensions. Again three figures—here women instead of men—are seated, facing the viewer. Depersonalized machine volumes, these women also are a tribute to the promise and meaning of modern technology. The light, brilliant colors, juxtaposed

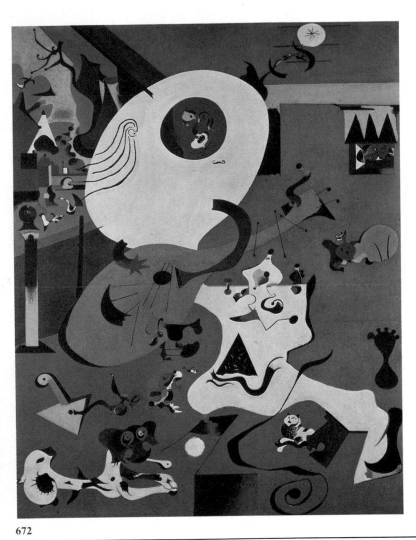

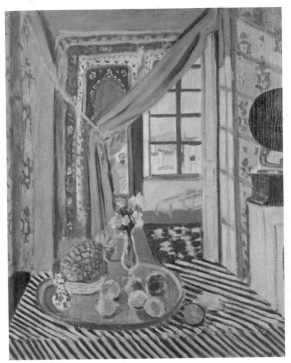

671

672

to the sharp contours of black and white, and the geometric patterning throughout the canvas contribute to a disciplined and rigid harmony between figures and surroundings.

The vertically disposed figures in Oskar Schlemmer's *Römisches* are —like caryatids on ancient temples— part of the architecture, but here it is the architecture of the canvas. The space inhabited by these four figures is as real and alive as the figures themselves.

In contrast, Matisse's *Interior at Nice* is a warm and inviting room of infinite depth. The viewer enters the painting through a still life of fruit and flowers and moves back into an opulent interior, painted in

soft hues. Behind a yellow curtain the artist's self-portrait is reflected in a small mirror. An even greater sense of depth is achieved by the view to a window in a distant room. The complexity of space in this remarkable painting is comparable to that in some of the great pictures in the European tradition, such as Vermeer's *Girl Reading a Letter* or Velásquez's *Las Meninas*.

In *Dutch Interior I* Miró recalls the work of the Dutch "Little Masters" that he had seen on a visit to Amsterdam and of which he had brought postcards back. The details in Miró's work, the animals, the musical instruments, and the open window—unlike those in the Dutch

picture—are transposed into a playful composition of gaiety and wit, and the painting is done in brilliant, unmodulated colors of almost unprecedented vitality.

668 Pablo Picasso. *Three Musicians.* 1921. Oil on canvas, 79 × 87 ³/₄″ **669** Fernand Léger. *Three Women (Le Grand Déjeuner).* 1921. Oil on canvas, 72 ¹/₄ × 99″. **670** Oskar Schlemmer. *Römisches.* 1925. Oil on canvas, 38 ³/₈ × 24 ³/₈″ **671** Henri Matisse. *Interior at Nice.* 1924. Oil on canvas, 39 ³/₈ × 31 ⁷/₈″ **672** Joan Miró. *Dutch Interior I.* 1928. Oil on canvas, 36 ¹/₈ × 28 ³/₄″

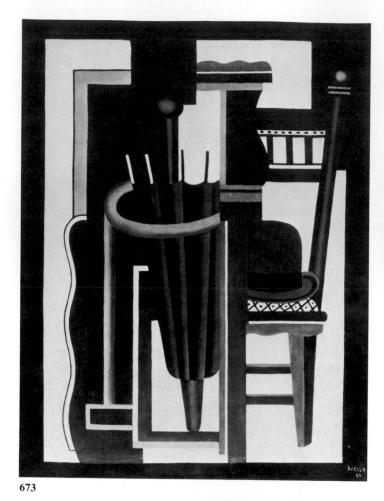

673

675

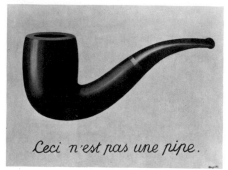

676

Ceci n'est pas une pipe.

674

677

The traditional motif of still life had been one of the chief subjects of Cubist painting, and Léger's *Umbrella and Bowler* has the rigorous organization and flat, almost geometric pattern of earlier Cubist work. Color again is limited, here chiefly to browns and blacks. Léger eliminates most curved shapes, concentrating on right angles and ordinary static objects such as a mass-produced hat, an umbrella, and a chair. With them he achieves an austere monumentality.

Léger's forthright representation of common, ordinary objects (forecasting some of the elements of Pop Art forty years later) was shared by two Americans: Gerald Murphy and Stuart Davis. Murphy, trained

as an architect, retained the quality of the architectural draftsman. While his composition owed much of its form to the Cubist overlapping and flattened grid, his imagery is that of commercial America: a matchbox, a safety razor, and a fountain pen—all in a flat geometric composition painted with simple posterlike colors.

Stuart Davis also turned to commercially produced objects and incorporated their lettering, as in the painting of the mouthwash *Odol*. The bottle is flattened, enlarged, and placed against a simple pattern of squares, creating a balance between plausibility and illusion.

René Magritte's pipe is also a product that can be obtained in any

store and is painted with the same meticulous realism that we saw in Murphy and Davis. This painting is enigmatically entitled *The Wind and the Song*. The caption "This is not a pipe" is written under the depiction of a smoker's pipe; it is a painting, not a pipe. Magritte challenges the identity of the object as object and deals with the duality of meaning, with the difference between word and image.

Le Corbusier's *Still Life* also partakes of the blending of industrial objects with Cubist vision. But along with Murphy, he also demonstrates the synesthetic spirit of the twenties, when architects were painters and painters were architects.

678

680

679

681

Giorgio Morandi, who was a member of the school of Metaphysical painters in Italy, evokes a sense of quiet meditation in his serene paintings. He was imbued with the Italian tradition from Piero della Francesca to de Chirico and had a deep understanding of the still-life paintings by Chardin and Cézanne. Working in his native Bologna, he painted still lifes, of precisely arranged bottles, over a period of more than thirty years. The early *Still Life (The Blue Vase)* combines an architectonic clarity and a purity of form with a silent lyricism of feeling.

Dali's versatility is evident again in his *Basket of Bread*. While painting his Surrealist sequences, he was also able to execute a work in the austere tradition of the seventeenth-century Spanish still-life painters.

Emil Nolde's watercolors do not have the powerful urgency of his great religious testimonials such as *The Entombment* (plate 356), but they share his vibrant sense of color. In his watercolors, such as *Red Poppies,* he would moisten highly absorbent Japanese paper before applying the paint and then permit the colors to flow into each other, controlling their movement with a tuft of cotton.

Charles Demuth's mastery of watercolor is reserved for figures in action and the fragile movements of flowers. *Poppies* is an exceptionally sensitive, complex example of his mastery of the medium and of the evanescent subdivision of still life that flower painting constitutes.

673 Fernand Léger. *Umbrella and Bowler.* 1926. Oil on canvas, 50 $^1/_4$ × 38 $^3/_4$″ **674** Gerald Murphy. *Razor.* 1922. Oil on canvas, 32 × 36″ **675** Stuart Davis. *Odol.* 1924. Oil on canvas, 24 × 18″ **676** René Magritte. *The Wind and the Song.* 1928–29. Oil on canvas, 23 $^7/_8$ × 32″ **677** Le Corbusier. *Still Life.* 1920. Oil on canvas, 31 $^7/_8$ × 39 $^1/_4$″ **678** Giorgio Morandi. *Still Life (The Blue Vase).* 1920. Oil on canvas, 19 $^1/_2$ × 20 $^1/_2$″ **679** Salvador Dali. *Basket of Bread.* 1926. Oil on wood panel, 12 $^1/_2$ × 12 $^1/_2$″ **680** Emil Nolde. *Red Poppies.* c. 1920. Watercolor, 13 × 18″ **681** Charles Demuth. *Poppies.* 1926. Watercolor, 28 $^1/_2$ × 21 $^1/_2$″

Animals

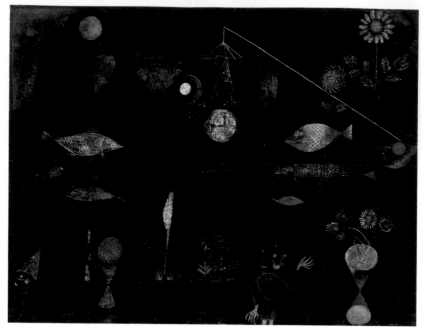

682

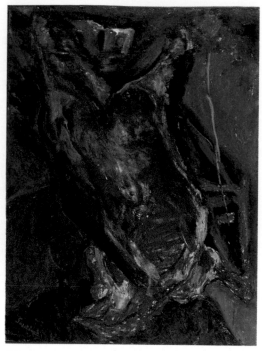

684

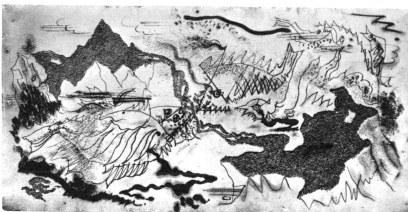

683

685

Animals continued to be an important theme of human fantasy in the twenties. In Paul Klee's *Fish Magic*, fish glide fluidly on a black ground. Their back-and-forth positioning makes them look as though they could all abruptly flip around, as fish are wont to do, and reverse their paths. Klee achieves this by placing all the fish on the same horizontal line, three on each side of the picture, and having some in each group face right, while the others face left. Colorful flowers, branches of trees, and a gesticulating two-headed little man inhabit this magic universe, as does a clock that is suspended in a cagelike structure. Gravity and time seem not to exist.

In contrast to Klee's lyrical world, André Masson's *Battle of Fishes* is a violent scene of massacre. Probably informed by Masson's experiences during World War One, this painting is replete with violence—rough sand on the surface, jagged mounds, and fanged fish. Although the indefiniteness of some shapes does provoke associations of flowing, they are fraught with terror.

Like Rembrandt before him, Chaim Soutine painted a *Carcass of Beef*—a hanging, gutted, bloody carcass curing before a celestial blue background. Applied with heavy, Expressionistic brushwork, these colors, usually associated with religious figures, carry such a violent emo-

tional impact that the artist did not even stop to "correct" the dripping pigment.

Though Pablo Picasso is depicting a potentially terrifying subject in *Running Minotaur*, he focuses instead on the metamorphic character of this mythical beast—the half-bull, half-human offspring of the wife of Minos, king of Crete. The act of running, the transparency of the outlined figure, and the lack of defined torso accentuate this being's state of transformation. The horror of the Minotaur myth dear to the Surrealists—where the creature devours his human tribute—can perhaps be seen in the creature's open mouth, but without teeth this gesture

686

687

688

becomes one of fear or pain, foreshadowing the *Guernica* imagery (plate 877).

Depersonalization in the modern world was often signaled by faceless people or mannequins, as in Taeuber-Arp's *Dada Head* (plate 725) and Hausmann's *The Spirit of Our Time* (plate 438). Another Dadaist, Max Ernst, painted a headless woman and a bull's head that is also a woman's breasts and an elephant's trunk attached to an enormous two-footed boilerlike beast—all poised in a desolate landscape. The painting resists rational analysis, but it exudes dread.

In *Dog Barking at the Moon* Joan Miró invites us to an adventure of whimsy. The open surface, uncluttered by distracting details, allows the mind's eye to travel freely. We are given access to the mysterious world by the multicolored ladder which cannot be climbed, just as the little dog cannot reach the tantalizing moon which seems to hang from the frame.

Arthur Dove's *Monkey Fur* was assembled on a houseboat in Long Island Sound. Composed of rusted metal, hide, fur, cloth, and tinfoil on metal, it demands the viewer's involvement and rewards one with a stream of associations that offer insight into the complexity of deeper reality. Although Dove had no contact with the Surrealists, they would have liked the disparity of objects in his assemblages. After all, they admired the Count de Lautréamont for writing about the "chance encounter of a sewing machine and an umbrella on a dissection table."

682 Paul Klee. *Fish Magic*. 1925. Oil on canvas and watercolor, 30 $^1/_4$ × 38 $^5/_8$″ **683** André Masson. *Battle of Fishes*. 1926. Sand, gesso, oil, pencil, and charcoal on canvas, 14 $^1/_4$ × 28 $^3/_4$″ **684** Chaim Soutine. *Carcass of Beef*. c. 1925. Oil on canvas, 55 $^1/_4$ × 42 $^3/_8$″ **685** Pablo Picasso. *Running Minotaur*. 1928. Oil on canvas, 63 $^3/_4$ × 51 $^1/_4$″ **686** Max Ernst. *The Elephant Celebes*. 1921. Oil on canvas, 58 $^1/_8$ × 43 $^1/_4$″ **687** Joan Miró. *Dog Barking at the Moon*. 1926. Oil on canvas, 28 $^3/_4$ × 36 $^1/_4$″ **688** Arthur G. Dove. *Monkey Fur*. 1926. Corroded metal, monkey fur, tinfoil, and cloth on metal, 17 × 12″

The Machine

689

690

691

The attitude of artists toward the machine and technology was highly ambiguous and certainly diverse. Klee's *Twittering Machine* is much too fragile and unbalanced to function, and although it appears to imitate the sound of birds, pointed little objects foil their beaks, preventing them from twittering. This is an ironic commentary, which mocks our faith in machines and our sentimental attitude toward songbirds.

Max Ernst's *The Teetering Woman* is placed in a fantastic vibrating machine, with a mechanical coil reaching up to hide, almost to penetrate, her eyes. The mannequin, the enigmatic space, the cool colors indicate the impact of de Chirico (see plates

327 and 355) on this early Surrealist painting, as on *The Elephant Celebes*.

Give to Heavy Industry, painted in 1927 by the Soviet painter Yury Pimenov, still retains much of modernist geometric form and symbolic color from the recent Russian Constructivist past. It is a serious panegyric to labor, to the strength of fire, of steel, and of the men who work it. In theme it leads toward propagandist Socialist Realism (see plates 739, 869, and 871).

The steamship, with its clean, functional lines, became an exemplar to modernist architects and a motif for painters, just as the great sailboats had been for earlier painters. Charles Demuth in *Paquebot, Paris* achieves

a remarkable grandeur and monumentality by simple means: the two red-and-black smokestacks are placed to adjoin each other, thereby reinforcing the verticality of the composition, which is emphasized further by the tubular white ventilators.

Charles Sheeler's *Upper Deck* seems to be a totally realistic rendition of all the machinery found on a ship's deck. But like his photographs, this sharp-focus painting is very carefully planned and composed. Shapes and volumes are severely delineated.

The American Futurist Joseph Stella, who had apotheosized the Brooklyn Bridge (plate 341), continued his romance with the capital

266

695

692

693

694

696

of technology in a series entitled *New York Interpreted.*

A much more objective view was taken by Victor Servranckx. Servranckx was the first Belgian painter to work in a purely abstract style, reflecting his knowledge of the painting of Mondrian and his friends in Holland. In 1926 he traveled across the Atlantic after having been invited by Marcel Duchamp to exhibit his work in the United States. In his semi-realistic *The Port* the moon and the great industrial fixtures are all flattened out into clear-cut, hard-edged geometric patterns—again an exaltation of the promise of technology.

Servranckx was very close to the aesthetic of the Bauhaus and a long-time friend of László Moholy-Nagy, who, as an exponent of Constructivism, believed that the technological society had the potential of liberating mankind. "It is the machine that woke up the proletariat," Moholy-Nagy wrote in 1922. "This is our century: technology, machine, Socialism. Make your peace with it; shoulder its task." Instead of painting workers at a foundry, he tried to eliminate all sensation and emotion from art, in both subject and execution, including the artist's own hand and sense of *peinture.* In 1922, therefore, he dictated a number of paintings to the foreman of a sign factory by telephone, making use of a standard color chart and graph paper, as in *Telephone Picture EM 2.* A new cool art, based on a different kind of information and communication, was suggested, as well as the possibility that the artist could control technology by his strategy.

689 Paul Klee. *Twittering Machine.* 1922. Watercolor, pen, and ink, 16 1/$_4$ × 12″ **690** Max Ernst. *The Teetering Woman.* 1923. Oil on canvas, 51 3/$_8$ × 38 3/$_8$″ **691** Yury Pimenov. *Give to Heavy Industry.* 1927. Oil on canvas, 102 3/$_8$ × 83 1/$_2$″ **692** Charles Demuth. *Paquebot, Paris.* 1921–22. Oil on canvas, 24 1/$_2$ × 19 7/$_{16}$″ **693** Charles Sheeler. *Upper Deck.* 1929. Oil on canvas, 29 1/$_8$ × 22 1/$_8$″ **694** Joseph Stella. *The Port.* 1920–22. From the series *New York Interpreted.* Oil on canvas, 88 1/$_2$ × 54″ **695** Victor Servranckx. *The Port.* 1926. Oil on canvas, 36 1/$_4$ × 27 5/$_8$″ **696** László Moholy-Nagy. *Telephone Picture EM 2.* 1922. Porcelain enamel on steel, 9 1/$_2$ × 6″ 267

Geometric Abstraction

697

698

699

700

In many ways modernist art can be seen as a continuous series of reductions. It was through carefully considered reductions as well as metaphysical studies that Piet Mondrian reached the perfection of his work about 1920. His geometric abstractions were intended to express pure reality and pave the way for a better world and a life of balance and equilibrium as exemplified in his work. *Composition* consists of rectangles of primary colors and white and black perpendicular lines on a white ground, all in "equilibrated relationships." Mondrian came from Holland, a country which is almost totally flat, in which all the fields and canals are laid out at angles. It is a country,

moreover, whose population had embraced a puritanical form of Calvinism. Mondrian's highly disciplined work of pure geometric precision does achieve the state of perfect and unalterable equilibrium for which he strove.

Kandinsky's work also became much more geometric and controlled in the twenties, in contrast to his free-flowing, exuberant expression in the previous decade. He concentrated on such shapes as triangles, squares, rectangles, and especially circles, and wrote a manual of formal composition called *Point and Line to Plane* while teaching at the Bauhaus. *Circles in a Circle* is done on a square canvas cut diagonally by two color

ribbons, while circles flow freely within the rigorous confines of a large black ring. The circle, Kandinsky believed, had infinite varieties. It could be assertive and filled with all possible tensions, both stable and flexible, concentric and eccentric. "The circle which I have been using to such a large extent in my recent work," he wrote at the time, "can often be described as a Romantic circle. And the coming Romanticism is a piece of ice in which a flame burns." Neither Kandinsky's nor Mondrian's paintings of this period can be understood in purely formal terms but require an understanding of their philosophical origins.

Another seeker in metaphysical

701

realms was Patrick Henry Bruce, descendant of the American hero whose name he bore. A student of Matisse, from whom he learned much about color, Bruce was led by his restless temperament into explorations of ambiguities of volume and mass defined and defied by color, as in this still life of objects on a table.

László Moholy-Nagy was largely unconcerned with philosophical problems, and in 1923, when he joined Kandinsky at the Bauhaus, he introduced a radical attitude toward the education of the artist and designer. His own paintings, such as *A IX-1923*, indicate his interest in space, light, and move-ment. Sharp straight lines and light overlapping transparent planes in distorted perspective float freely in space, creating a rhythm of mathematical clarity and aesthetic economy.

Klee began making pictures of rectangles in 1919, but his geometric paintings somehow always remain within the realm of the organic. Pictures like *Ancient Sound* have been referred to as "magic squares." Klee, who was also a musician and liked to play the music of Bach above all on his violin, took colors to stand as equivalents for musical notes. We can interpret this abstract painting—and Klee's titles serve as welcome cues—in musical terms and see a movement from the dark and gloomy greens and blacks on the edges to the bright yellows and pinks at the center.

697 Piet Mondrian. *Composition*. 1925. Oil on canvas, 15 $^7/_8$ × 12 $^5/_8$″
698 Vasily Kandinsky. *Circles in a Circle*. 1923. Oil on canvas, 38 $^3/_4$ × 37 $^5/_8$″
699 Patrick Henry Bruce. *Forms #12*. 1927. Oil on canvas, 35 × 45 $^3/_4$″
700 László Moholy-Nagy. *A IX-1923*. 1923. Oil on canvas, 51 × 39 $^1/_2$″ 701 Paul Klee. *Ancient Sound*. 1925. Oil on cardboard, 15 × 15″

Machine Form

702

703

Man Ray was a protean artist: painter, photographer, writer, poet, designer, filmmaker, inventor of new art forms, and creator of Surreal objects. Man Ray, certainly America's most important Dadaist, followed Duchamp back to Paris from New York and settled there in 1921. Duchamp had suggested irreverently that a Rembrandt painting be used as an ironing board. Soon thereafter, Man Ray produced his *Gift*. He took a simple, ordinary flatiron and stuck a row of fourteen tacks onto its smooth bottom—a senseless work of art, but also one loaded with hostility.

Morton L. Schamberg, who was also a friend and disciple of Duchamp during the latter's first New York period, had glorified the machine in an early painting called *Machine*, done in 1916 (see plate 308). Two years later, just before he died in his thirties during the influenza epidemic of 1917–19, this highly gifted artist made a very different kind of statement about the machine. He produced a construction of a plumbing trap set into a miter box and entitled it *God*. In the Dada spirit of the time, this work no longer has any set of formal principles, and it does not seem to express

any particular kind of emotional feelings.

Oskar Schlemmer, as we have seen, had a much more positive attitude toward the machine and analyzed the human figure in precise and rational terms. To Schlemmer man was "an organic as well as a mechanical creation." His highly polished *Abstract Figure* consists of a complex interrelationship of geometric forms—triangles, circles, cylinders, etc.—and alternating concave and convex volumes and their resulting shadows. This stable figure is based also on perpendicular relationships between the vertical, ex-

704

705

tending from the helmet to the powerful torso, and the horizontal of shoulder and arm. Schlemmer was perhaps the most pivotal figure of the Bauhaus. At different times he was master of the mural workshop; the stone, wood, and metal workshops; and the stage workshop. Much as his colleagues hoped to find ultimate design solutions for many aspects of the human environment, Schlemmer attempted to define symbolically the Platonic essence of the human form, to create a valid icon for the technological age.

Rudolf Belling, another pioneer of abstract sculpture in Germany, was

similarly fascinated by machine aesthetics and created a brilliantly expressive bronze head in 1923. *Sculpture*, a work of extraordinary industrial precision in all its parts, consists of solid and hollow forms, which comment both positively and negatively on the mechanical transformation of modern man.

702 Man Ray. *Gift*. Original 1921; reproduction 1963. Flatiron with nails, height 6 $^1/_2$″ **703** Morton L. Schamberg. *God*. c. 1918. Miter box and plumbing trap, height 10 $^1/_2$″ **704** Oskar Schlemmer. *Abstract Figure, Sculpture in the Round*. 1921–29; cast 1962. Nickeled bronze, height 41″ **705** Rudolf Belling. *Sculpture*. 1923. Bronze, partly silvered, height 18 $^7/_8$″

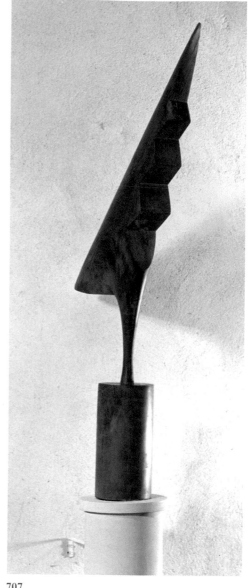

706 707

Much like certain mechanical objects, Brancusi's *Bird in Space* is polished to a mirrorlike smoothness. The high polish, although applied painstakingly by the artist, actually denies any handcrafted quality to this sculpture. In fact, this work was the object of lengthy litigation with U.S. customs officials, who, perceiving similarities to airplane propellers, claimed that it was a manufactured object rather than art. In some ways *Bird in Space* can be seen as a crystallization of Gabo's *Kinetic Sculpture: Standing Wave* (see plate 732), which Brancusi did not know; but we are dealing with a similar consciousness that relates sculpture to the modern world. *Bird in Space* is

actually an outgrowth of the earlier *Maiastra* (plate 463), and Brancusi made a good many versions of it in polished marble as well as bronze, constantly simplifying its form. The work, halfway between representational and abstract sculpture, has a single upward thrust seemingly free of gravity. "All my life," Brancusi said, "I have been working to capture the essence of flight." In his search for universal and timeless meanings, Brancusi was also aware that "what is real is not the external form, but the essence of things. Starting from this truth, it is impossible for anyone to express anything essentially real by imitating its external surface."

At the same time he transformed

another animal into a highly expressive compact structure. *The Cock* was carved from the trunk and branch of a tree. Somehow this serrated form evokes both the image and sound of a crowing cock, with the voice going all the way up its body, which really becomes a reverberating throat. Brancusi identified with *The Cock*, and again he made many versions of this piece, some of them eight feet high.

Inspired by Brancusi's direct carving technique, Barbara Hepworth, who had traveled to Paris and studied in Italy for two years, carved her *Doves* in Parian marble. "The excitement of discovering the nature of carving," she felt, "carried its own

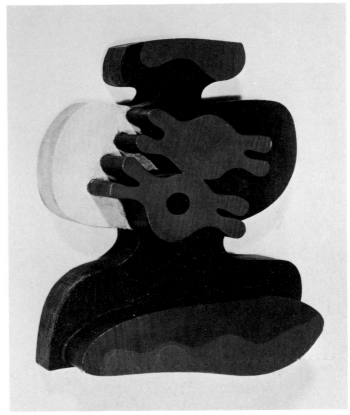

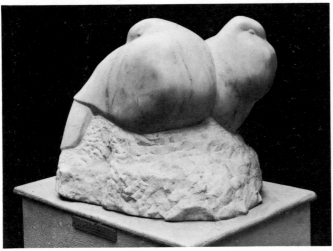

708

709

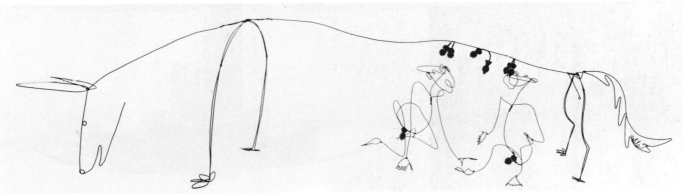

710

emotional logic." The artist had also studied the sculpture of the Vorticists Jacob Epstein and Henri Gaudier-Brzeska (plates 433 and 465). Like their work, *Doves* has simple volumes and a polished surface. Hepworth, however, is more interested in the sensitive rhythm of carving, apparent when light reveals rippling bulges.

Jean Arp continued his series of painted abstract wood reliefs. One, which he called *Birds in an Aquarium*, has brightly colored biomorphic forms: witty shapes which seem to be twittering and flying while attached to their organic support.

Even more amusing is Alexander Calder's wire sculpture *Romulus and Remus*, which dates from 1928, the same time as his famous wire *Circus*. Here we see the very long mother wolf, happily suckling the founders of the Eternal City. Everything is made of bent wire except her teats, which, like the penises of the boys, are made of wooden doorstops. Calder, who was to become the most famous of American sculptors, had gone to live in Paris in 1926. He was undoubtedly aware that avant-garde sculptors had "opened up its mass," and it is his inventiveness, his wit, and his economy of means that are a constant source of delight.

706 Constantin Brancusi. *Bird in Space.* 1925. Polished bronze, height 49 ³/₄″ **707** Constantin Brancusi. *The Cock*. 1924. Walnut, height 47 ⁵/₈″, including cylindrical base 11 ¹/₂″ high **708** Barbara Hepworth. *Doves*. 1927. Parian marble, length 19″ **709** Jean Arp. *Birds in an Aquarium*. c. 1920. Painted wood relief, height 9 ⁷/₈″ **710** Alexander Calder. *Romulus and Remus*. 1928. Wire, height 31″

Structure in Space

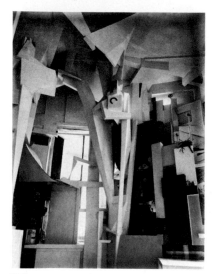

711

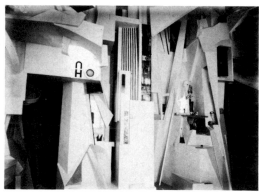

712

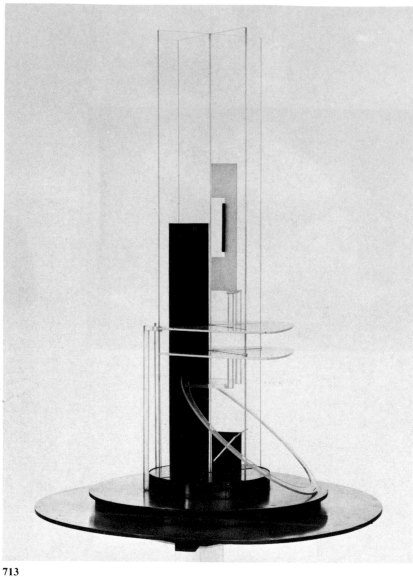

713

Kurt Schwitters's *Merzbau* was an exercise in sheer fantasy of a different kind. Belonging to the realm between architecture and sculpture, it was a huge three-dimensional assemblage of wood, cardboard, scraps of metal, old furniture, and anything else Schwitters had at hand. It extended through several floors and rooms of his house in Hanover, and its many caves can be seen as secret places to express, and simultaneously conceal, aspects of his personal life. Although the original *Merzbau* (which was destroyed in World War Two) was the magnum opus of Germany's leading Dadaist, its bold and imagi-

native structure and formal sense are also related to the Constructivists' emphasis on contemporary materials, their denial of mass and weight in sculpture, and their emphasis upon the interaction of form and space.

A leading Russian Constructivist, Naum Gabo, after leaving Russia for Germany, simplified his earlier sculptural experiments and constructed his *Column* of plastic, wood, and metal. *Column* is actually more technical in feeling than his *Project for a Radio Station* (plate 474). It is outstanding for its lucidity, its purity of form, and its clearly enunciated contrast of

vertical and horizontal, opaque and translucent elements. Most important, in *Column* Gabo has been able to abandon weight for depth in space, achieved by the transparency of his materials.

László Moholy-Nagy was among the first artists to follow Constructivist principles in his *Nickel Construction* of 1921, in which a metal spring is welded to a metal column. The spring is a "thing" we find in our everyday surroundings, and its spiral form denotes infinity. The Constructivists' proposition that contemporary sculpture be redirected from a concern with the relationship

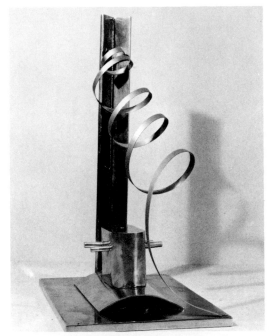

714

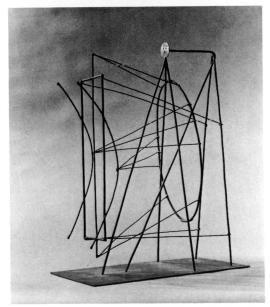

715

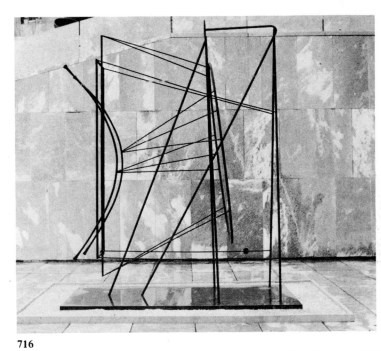

716

of masses to a concern with interaction of open volumes had a great impact on the sculpture of the future and, through Moholy-Nagy, a direct impact on the work at the Bauhaus, where he taught.

In the late twenties Picasso returned to sculpture, designing a monument to mark the grave of his friend the poet and critic Guillaume Apollinaire. Regrettably, the work was never installed, and Picasso's wire construction remained a twenty-inch maquette until much later, when it was enlarged to its intended size. In this work the master seems to be drawing in space with wire. Like Gabo's *Column*, this sculpture consists of circular and rectangular forms. However, this spare, transparent wire construction is clearly the image of a person. The triangle and oval forms inside the latticework seem to be a body, while the other triangles, jutting forward and criss-crossing each other, are the figure's arms. There is also a flat symbol of a head to complete the transparent stick figure. Intuitively, Picasso has given a human interpretation to abstract sculpture in space.

711–712 Kurt Schwitters. *Merzbau* (Hanover). 1924–37 (destroyed 1943) **713** Naum Gabo. *Column.* 1923. Plastic, wood, and metal, height 41 $\frac{1}{2}$" **714** László Moholy-Nagy. *Nickel Construction.* 1921. Nickel-plated iron, welded, height 14 $\frac{1}{8}$" **715–716** Pablo Picasso. *Monument.* 1928–29 **715** Original model **716** Enlarged reproduction 1972. Cor-ten steel, height 155 $\frac{5}{8}$"

The Human Figure

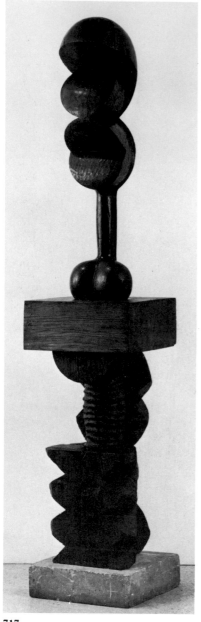

717

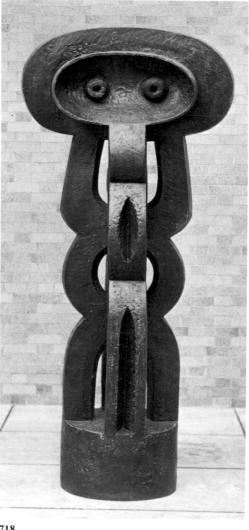

718

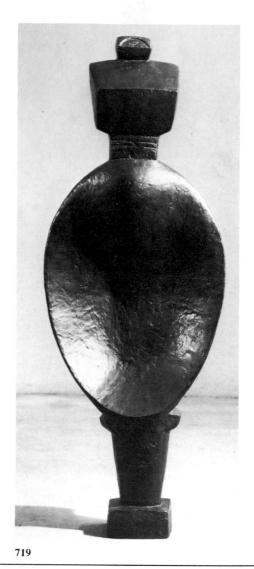

719

The wooden base was of such importance to Brancusi that he made little distinction between base and figure in *Adam and Eve*. Adam, the lower member of this duplex sculpture, is in fact a compressed, gnarled wooden pedestal, almost crushed beneath the burden of the elegant Eve. Four years after the Adam, Brancusi carved this androgynous figure, whom he described as "fertility, a bud opening, a flower germinating," and decided to set it on top of its mate. Brancusi's attitude toward the relationship of the sexes had changed significantly since he carved the ideal male-female affinity in *The Kiss* (plate 198). Stylistically, this work is greatly indebted to African

sculpture. Brancusi maintained that only the Africans and the Romanians understood the meaning of carving a figure and were able to retain the life of the wood.

Jacques Lipchitz, a similarly archetypal figure, moved away from Cubist principles and started experimenting with many different forms. Between 1926 and 1930 he worked on the large *Figure*. Informed by the art of primitive cultures, Lipchitz arrived here at a totemic figure, which, somehow, relates to the mythical foundations of human history. It is lucidly composed with an equilibrium between open and closed forms, yet has an appearance of magic. It is an ancestral idol,

made when there was little understanding of monumental sculpture.

Also related to ethnic art was Alberto Giacometti's first major sculptural work, *Spoon Woman*. The piece is probably indebted to the Dan ladles from Liberia, which expressed life and fertility. Giacometti's satisfying solid frontal figure with a great concavity, symbolizing a pregnant belly and a large spoon, established the twenty-five-year-old artist as one of the major sculptural forces of his time.

Adhering to the more traditional form of the female body, Gaston Lachaise also deals with woman as goddess of fecundity in his *Standing Woman*. Lachaise was concerned

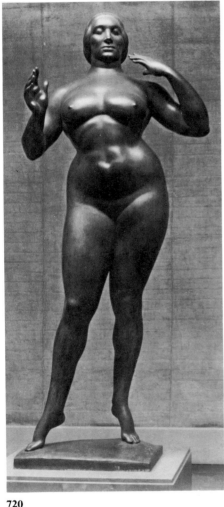

720

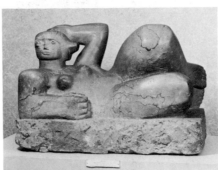

721

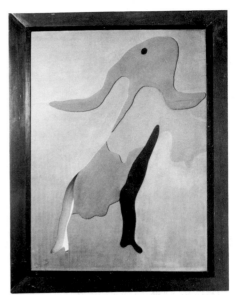

723

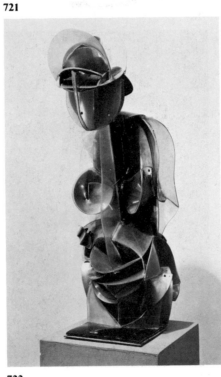

722

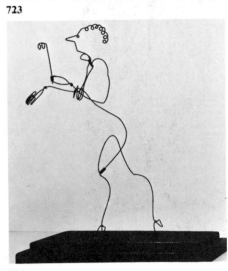

724

with women as erotic, sexual, somewhat mysterious beings. We agree with the painter Marsden Hartley, who wrote: "He saw the entire universe in the form of a woman."

In England, Henry Moore, like Barbara Hepworth, was devoted to "truth to the material" in a work like *Reclining Figure*. The key influence on Moore's work at the time was Mexican sculptures such as the Toltec figures from Chichén-Itzá. *Reclining Figure* is only thirty-three inches long, but it has the impact of a much larger piece. This sense of monumentality arises from the massive square arms and legs that are attached to the roughhewn base slab, and from the planar surfaces with

large areas of undisturbed shadow.

In complete contrast is the construction of transparent plastic and thin sheets of copper, called *Torso*, by Antoine Pevsner. Pevsner, older brother of Naum Gabo, had also been one of the originators of Constructivism and had moved from Russia to Paris in 1923. The very reason for his use of transparent materials was to destroy opacity, the "inertia of mass," which he would have criticized in the carving of the English sculptors.

With the use of thoroughly traditional materials Jean Arp also avoids in *Dancer* the massiveness Pevsner sought to overcome. Arp endows his whimsical figure with the liveli-

ness of a sprightly ghost. A similar wit inspires Calder's caricature of a lorgnetted *Hostess*. Yet another of his purposes is to experiment with open and closed forms; here he cages air with wire.

717 Constantin Brancusi. *Adam and Eve.* 1916–21. Oak and chestnut, height 94 ¹/₄″ 718 Jacques Lipchitz. *Figure.* 1926–30; cast 1937. Bronze, height 85 ¹/₄″ 719 Alberto Giacometti. *Spoon Woman.* 1926. Bronze, height 57 ¹/₈″ 720 Gaston Lachaise. *Standing Woman.* 1912–27. Bronze, height 70″ 721 Henry Moore. *Reclining Figure.* 1929. Brown Hornton stone, length 33″ 722 Antoine Pevsner. *Torso.* 1924–26. Construction in plastic and copper, height 29 ¹/₂″ 723 Jean Arp. *Dancer.* 1928. Painted wood relief, height 57 ¹/₂″ (destroyed) 724 Alexander Calder. *The Hostess.* 1928. Wire construction, height 11 ¹/₂″

277

The Human Head

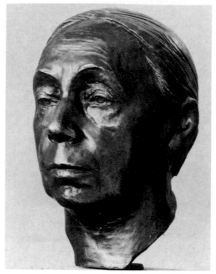

726

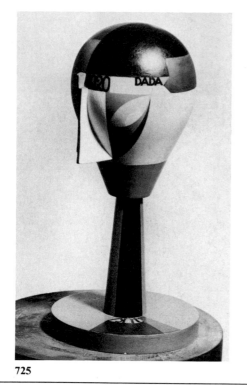

725

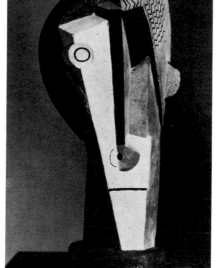

727

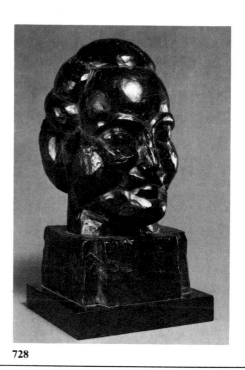

728

Dada Head, by Taeuber-Arp, is concerned little with technical advance; it is content to comment, in generally Cubist terms, on the facelessness of postwar humanity.

In contrast, Käthe Kollwitz, known primarily for her masterful prints and drawings, which passionately recorded the misery and struggles of the poor, modeled her deeply human *Self-Portrait*. In this sculpture, which occupied her for many years, her empathy with the common people and her deep understanding are transferred to her own self-image. Kollwitz was one of the few modern artists who succeeded in infusing traditional form with relevant modern meaning.

Henri Laurens continued to experiment with the language of Cubism, with faceted planes and passages that pull background and foreground elements closer together. His *Head* of 1920 is one of a series on the same subject begun a few years earlier. Although made of painted plaster, *Head* seems to contract actual volume and affects the viewer like a painting because of its single viewpoint and stylized, incised zigzag lines representing the hair.

Henri Matisse, like Laurens, also worked in series, both in sculpture (see *Jeannette*, plate 439, and *Backs*, plates 443–446) and in painting, especially landscapes at Nice. In these he recorded the proc-

ess of abstraction, a transformation into the simplified formal elements and meaning which naturalistic elements undergo when the artist scrutinizes them to extract essential characteristics. In Nice, where he had moved after the war, he did a portrait series of his model Henriette Darricarrère. The final work, *Grosse Tête (Henriette)*, is the largest and least naturalistic of the series. The hair is stylized into regular bulges that frame the head. Puffed cheeks and rounded forehead are a counterpoint to the angled mouth and chin. The eyebrows have been raised and rendered symmetrically over the closed eyes. These characteristics result in a distant, static, iconic work.

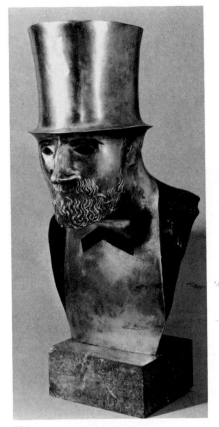

729

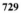

730

731

Many of Elie Nadelman's sculptures of the 1920s are witty comments on the social scene. His *Man in a Top Hat* is characterized by its sharp contours, which are highlighted further by the painted details the artist added to the shiny bronze cast.

Isamu Noguchi, the Japanese-American sculptor, did a portrait of his friend Buckminster Fuller in 1929, the same year that Fuller designed the Dymaxion House (plate 587). Noguchi had just returned from working for Brancusi in Paris, and the older sculptor's influence is evident in the ultramodern high finish of the chromeplated bronze.

Brancusi's *The Newborn* of 1925 goes back to 1915 and picks up the theme of a child's head, then called *The First Cry*. In a constant search for reduction, he has discarded the pronounced hole of the mouth of the crying baby and now indicates the primal scream only by a subtle shift of planes and a small bulge. Brancusi slowly moved in this series toward a perfect oval, which he called *The Beginning of the World*, a work that represents the egg of creation and symbolizes the process of the universe. But in *The Newborn* Brancusi has been able to deal with a universal concept with a subtle sense of wit. The high polish on the piece, which, like all Brancusi's bronzes, reflects its environment as well as the viewer, also involves his sculpture in a dialogue with light. This 1925 version remained in Brancusi's studio and is now in the Centre Pompidou in Paris, where the whole studio has been reconstructed.

725 Sophie Taeuber-Arp. *Dada Head.* 1920. Painted wood, height 13 3/8"
726 Käthe Kollwitz. *Self-Portrait.* 1926–36. Bronze, height 15 1/4" 727 Henri Laurens. *Head.* 1920. Plaster, height 17" 728 Henri Matisse. *Grosse Tête (Henriette).* c. 1927. Bronze, height 15 3/4" 729 Elie Nadelman. *Man in a Top Hat.* c. 1927. Painted bronze, height 26" 730 Isamu Noguchi. *Buckminster Fuller.* 1929. Chrome-plated bronze, height 12" 731 Constantin Brancusi. *The Newborn.* 1925. Polished bronze, length 9 3/4"

Kinetic Sculpture

732

733

734

The Constructivists' awareness of the space-time continuum led artists into the creation of kinetic sculpture, i.e., sculpture that moves in time as well as exists in space. Gabo and his brother Antoine Pevsner had written in their famous *Realist Manifesto:* "We affirm in these arts a new element, the kinetic rhythms, as the basic forms of our perception of real time." His *Kinetic Sculpture: Standing Wave* is a construction of extreme simplicity. Gabo, who had studied mathematics and physics at the University of Munich when he was a young man, now attached an electric motor to a strip of steel. This work, however, creates harmonic wave patterns that could almost be seen as illustrations of the simultaneous theories of wave mechanics proposed by advanced physicists. Working also in Moscow, Aleksandr Rodchenko realized his *Hanging Construction* at the same time. This complex interweave of open, circular wooden shapes, which he hung from the ceiling, is actually a "mobile," created a dozen years before Duchamp coined this term for sculpture by Alexander Calder.

Duchamp himself continued to be fascinated by objects in motion, as in the mechanically operated *Revolving Glass*, also made in 1920. As in Gabo's *Kinetic Sculpture*, we are dealing with "virtual volumes" when the work is operated. From a distance of one yard, the lines painted on the five rotating glass plates create an optical illusion of a continuous concentric circle. The rotary motion, moreover, distracts the viewer into an almost hypnotic kind of self-absorption.

Man Ray, who had assisted Duchamp in his *Revolving Glass,* was, a few years later, to affix a cutout

735

736

737

photograph of an eye on the pendulum of a metronome, an instrument that measures real time. Man Ray nonchalantly entitled this work *Object to Be Destroyed*, and when it was indeed broken, he made a replica of it in 1964, calling it, in a typical Dada gesture, *Indestructible Object*.

Certainly the most advanced work along optical-mechanical lines was Moholy-Nagy's *Light-Space Modulator*, a machine on which he worked for a period of eight years, from 1922 to 1930. It is an intricate apparatus, consisting of a series of perforated metal disks and a glass spiral placed

on a circular base. It is motorized and equipped with more than one hundred varicolored light bulbs. The *Modulator*, which still works, combines light, space, and motion, and deals with time. It was produced to create shadows or reflect light in its environment and was also scored by the artist for the purpose of documenting the flow of light in space in a film which he called *Light Display, Black and White and Gray*.

732 Naum Gabo. *Kinetic Sculpture: Standing Wave*. 1920. Metal, height 24 $^1/_4$" **733** Aleksandr Rodchenko. *Hanging Construction*. 1920. Wood **734** Marcel Duchamp. *Revolving Glass*. 1920. Three strips of painted glass on metal frame, height 47 $^1/_2$" **735** Man Ray. *Indestructible Object (or, Object to Be Destroyed)*. Original 1923; destroyed 1957; reproduction 1964. Assemblage, height 11 $^1/_2$" **736–737** László Moholy-Nagy. *Light-Space Modulator*. 1922–30. Metal and plastic, height 59 $^1/_2$"

Five: The 1930s

During the 1930s Europe retreated toward authoritarianism, toward suppression of the individual and of freedom of expression. By the end of the decade dictatorial governments were firmly established in Italy, Germany, Spain, Portugal, and throughout most of Eastern Europe. The Soviet Union was completely collectivized and forcibly industrialized under Josef Stalin, who, after Trotsky's expulsion from the Communist Party in 1927, instituted vast purges that eliminated all political opposition and brought the execution or incarceration of millions of citizens. Simultaneously, rigid standards of Socialist Realism were established not merely prohibiting free artistic and intellectual expression, but also forcing artists and writers to praise and glorify the state. Ignoring Marx's clearly stated disdain for an art of idealization or glorification, Vladimir Kemenov, director of Moscow's Tretyakov Gallery during the Stalin regime, spoke of an "art created for the people, inspired by the thoughts, feelings, and achievements of the people, and which in turn enriches the people with its lofty ideas and noble images."

In Italy, Mussolini, who had founded the first fascist dictatorship and the "corporate state" as early as 1922, cemented his policies against labor and established a restrictive system in which the secret police suppressed all opposition and free intellectual expression. His government served as a model for other countries when the worldwide Depression, unemployment, and fear of revolution set the stage for similar right-wing dictatorships.

In Germany the Weimar Republic, weak from the beginning, suffered from pressures from both the right and the left. Hitler and his National Socialist German Workers' Party were able to bring about a coalition of wealthy industrialists, old agrarian interests (Junkers), and the military. After years of political unrest and eroding faith in the "disorderly" parliamentary system and democratic procedures, Hitler was appointed chancellor of Germany by President Paul von Hindenburg, the aged general and authority figure of the Fatherland. Adolf Hitler proceeded to establish an ironclad dictatorship based on fear, concentration camps, and racist policies that led eventually to the deaths of millions. His preparations for war, however,

eliminated unemployment, and he was able to rule a constantly expanding German Reich with the support of the upper and middle classes and of a good deal of disillusioned labor and with the relative tolerance of both the Catholic and Protestant hierarchies. The few remaining Western democracies appeased the Nazis because of their fears of Communism and the Soviet Union.

Spain, a backward, underdeveloped, agrarian, church-ridden country, had become a republic in 1931, but having almost no experience in democratic policies, it quickly fell prey to General Francisco Franco and his military forces, who attacked the Republican government with the aid of Italy and Germany. This in turn made Spain the testing ground for World War Two weapons and tactics.

Fascist and semifascist authoritarian governments were also established throughout most of the old territories that had previously made up the Austro-Hungarian Empire.

Japan, the only Asian country that had remained fully independent during the period of European imperialism, now embarked on imperialist expansion of its own. Under a totalitarian government controlled largely by its army and navy, and resembling European fascist dictatorships in many respects, the empire of Japan directed its aggressive policies primarily against China, which had been weakened under the corrupt Kuomintang government.

In Europe, only Great Britain, France, Switzerland, Belgium, the Netherlands, and the Scandinavian countries maintained governments where individual rights continued to be respected. But France was ripped asunder by social conflict and bloody battles between radical forces of left and right. Léon Blum's Popular Front government, with its policies of modest social, economic, and political reform, was short-lived, and the Third Republic in France was deeply divided and not ready to enter the war when it broke out in 1939. Great Britain, despite enormous unemployment and economic strife, somehow managed to retain its worldwide empire and maintain greater political stability, at least at home.

The United States had not suffered the vast loss of human life and material resources to which

Europe was subjected during World War One. In fact, that war had stimulated industrial production in this country. The 1920s had been a period of unequaled prosperity, but if the boom was great, so was the bust. After the stock market crash of 1929, the United States entered a period of economic depression. By the mid-1930s a third of the labor force was unemployed and the gross national product fell to half its 1929 level. Although many intellectuals, including artists, were radicalized by the Depression, no large organized movements of the left or right materialized, and faith in the American system of capitalism was maintained. At the depth of the Depression, President Franklin Delano Roosevelt, in fact, infused new confidence when, soon after his election, Prohibition was repealed, the banks rescued, the antiquated gold standard abolished, and some overdue social reforms instituted. Farmers were protected from the threat of having their land foreclosed, collective bargaining became national policy, and temporary jobs were found for millions of the unemployed. Nevertheless, almost ten million people were still out of work at the end of the decade, and real economic recovery was only the result of the preparation for a new world war.

With the purpose of providing work for the unemployed, the government instituted the Works Progress Administration (WPA), which was extended into the arts as the Federal Art Project (FAP). The FAP, together with an existing Treasury Department art program, reached sizable proportions at its peak. Well over ten thousand artists were employed in the New Deal art projects at one time or another. More than four thousand murals were created, and innumerable other works of art were produced, including easel paintings, sculptures, and graphic arts—not to mention photographs and crafts, produced under separate sections. In the years between its founding in 1935 and its demise in 1943, the FAP alone established nearly a hundred community art centers in all parts of the country with the purpose of integrating art into the daily lives of the people, reaching areas where no original art had ever been seen before. The FAP meant not only support, subsistence, and the possibility for artists to devote full time to their work, it was also the first time that American artists were officially recognized as professionals. As members of the Project, artists were no longer alone but were members of a community.

During the 1930s many of America's leading writers, such as Sherwood Anderson, Malcolm Cowley, Theodore Dreiser, James T. Farrell, Waldo Frank, Clifford Odets, John Dos Passos, and Elmer Rice, were committed to radicalism and writing about the "common man." These writers and the artists who shared their left-wing persuasion were profoundly and permanently disillusioned when Stalin signed a nonaggression pact with Hitler in 1939, opening the way for Germany to embark on World War Two. But other important writers—Ernest Hemingway, Eugene O'Neill, William Faulkner, and Thomas Wolfe—were less concerned with political issues and more involved with personal experience and formal values. In the visual arts the so-called Regionalists were inclined toward a nationalist and isolationist point of view. In fact, much of the painting, sculpture, and architecture of the 1930s seems to be characterized by authoritarian attitudes, entrenched antimodernism, and a return to the old conventions which prevailed not only in Russia, Italy, and Germany but also in France and the United States. It was a political event, the fascist bombing of Guernica, that inspired Picasso to paint the greatest masterpiece of the decade, possibly of the century. In general, however, the political climate of the decade was not conducive to new experiments. If the first two decades of the century stand out as periods of unparalleled innovation and artistic creativity, and if the 1920s can be seen as a period of ripening and expansion of these new forms of modernism, the 1930s, by and large, saw the retrenchment of art in the face of authoritarian systems which engulfed the world. Instead of free expression and new exploration, much of the art of the time was recruited to serve the purposes of propaganda. To overlook the art and architecture produced in the Soviet Union, in Nazi Germany, or in fascist Italy would be similar to studying the history of Europe during this period without reference to Stalin, Hitler, or Mussolini.

	Political Events	The Humanities and Sciences	Architecture, Painting, Sculpture
1930		John Dos Passos, *The 42nd Parallel* Bertolt Brecht and Kurt Weill, *The Rise and Fall of the City of Mahagonny* Hart Crane, *The Bridge* Marlene Dietrich, Emil Jannings, *The Blue Angel*	New York: Alfred Stieglitz opens An American Place gallery Paris: Review *Le Surréalisme au Service de la Révolution* founded, succeeding *La Révolution Surréaliste* Luis Buñuel and Salvador Dali, *L'Age d'Or* Paris: Cercle et Carré group and magazine founded
1931	Japan invades Manchuria Spain becomes a republic	Ernest O. Lawrence invents the cyclotron Edgard Varèse, *Ionisation* Edmund Wilson, *Axel's Castle*	Lodz: a.r. (artistes révolutionnaires, a Polish avant-garde artists' group) deposits an important collection of international nonobjective art at the City Museum New York: Whitney Museum of American Art opens with Juliana Force as director Paris: Abstraction-Création group founded
1932	Lausanne Conference ends reparation payments by Germany	André Breton, *Les Vases Communicants* Aldous Huxley, *Brave New World* James T. Farrell, *Young Lonigan*	Hartford, Conn.: First important exhibition of Surrealist art in the U.S., at the Wadsworth Atheneum
1933	Franklin D. Roosevelt becomes U.S. president; the New Deal launched Adolf Hitler appointed chancellor of Germany by President Paul von Hindenburg Prohibition of alcohol in the U.S. repealed (Twenty-first Amendment)	André Malraux, *Man's Fate* Gertrude Stein, *The Autobiography of Alice B. Toklas* Erskine Caldwell, *Tobacco Road* Thomas Mann, *Joseph and His Brothers* (–1943)	Chicago: Century of Progress World's Fair Bauhaus closed in Germany New York: Hans Hofmann opens his school Paris: Review *Minotaure* founded by Albert Skira and E. Tériade
1934	Soviet Union enters the League of Nations Serge Kirov assassinated in Leningrad in the beginning of Josef Stalin's purges Seventh Congress of the Communist International; founding of the Popular Fronts	Paul Hindemith, *Mathis der Maler* Socialist Realism proclaimed as the sole doctrine of artists and writers in the Soviet Union F. Scott Fitzgerald, *Tender Is the Night* Claudette Colbert and Clark Gable, *It Happened One Night*	

Political Events	The Humanities and Sciences	Architecture, Painting, Sculpture
1935 Italy invades Ethiopia Social Security Act becomes law	Thomas Wolfe, *Of Time and the River* George Gershwin, *Porgy and Bess* Radar used to detect aircraft	Works Progress Administration established; Holger Cahill named national director of Federal Art Project
1936 General Francisco Franco, supported by Germany and Italy, starts Civil War in Spain Germany reoccupies the Rhineland Hitler-Mussolini pact (Rome-Berlin Axis) Léon Blum forms a Popular Front government in France Ethiopia annexed by Italy	William Faulkner, *Absalom! Absalom!* John Maynard Keynes, *A General Theory of Employment, Interest, and Money* Federico García Lorca, *La Casa de Bernarda Alba;* Lorca assassinated by Franco agents Margaret Mitchell, *Gone with the Wind* T. S. Eliot, *Four Quartets* (–1943)	New York: American Abstract Artists founded New York: "Fantastic Art, Dada, Surrealism" exhibition, The Museum of Modern Art London: International Surrealist Exhibition
1937 Japan invades China Bombardment and destruction of Guernica, Spain, by German planes	Paul Muni, *The Life of Emile Zola* Jean Renoir, *The Grand Illusion* Dmitri Shostakovich, *Fifth Symphony*	Pablo Picasso paints *Guernica* for the Spanish Pavilion at the Paris Universal Exposition Munich: Hitler opens the House of German Art; "Degenerate Art" exhibition opens
1938 Munich Conference, attended by Germany, Italy, the United Kingdom, and France, provides for the dismemberment of Czechoslovakia	Jean-Paul Sartre, *Nausea* André Breton and Leon Trotsky, *Toward an Independent Revolutionary Art* (signed by Diego Rivera to shield Trotsky) Ernest Hemingway, *The Fifth Column*	E. L. T. Mesens founds the *London Bulletin*
1939 Final victory of General Francisco Franco in Spain Hitler-Stalin Pact Germany invades Poland Britain and France declare war on Germany Defeat of Poland U.S.S.R. invades Finland	James Joyce, *Finnegans Wake* Sigmund Freud, *Moses and Monotheism* John Steinbeck, *The Grapes of Wrath* Bertolt Brecht, *Mother Courage* Béla Bartók, *Divertimento for Strings* C. G. Jung, *The Integration of the Personality*	New York: Solomon R. Guggenheim Foundation Museum of Non-Objective Painting opens with Hilla Rebay as director Chicago: Ludwig Mies van der Rohe is commissioned to design the campus of the Illinois Institute of Technology

Propaganda and Social Protest

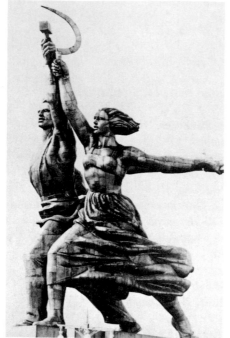

739

740

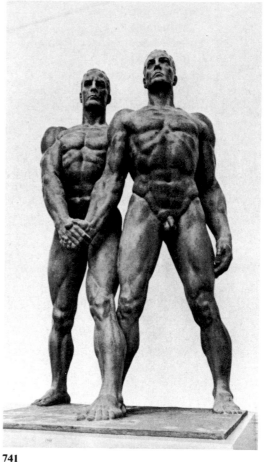

741

738

Academic art for the sake of propaganda, whether worship of the current authoritarian state or glorification of the past and present, was very prevalent throughout the 1930s. It reached a point of unequaled banality in the redoubtable monument *The Empire* by Ferruccio Vecchi, in which a naked Duce, a raised sword in his right hand, the *fasces*, symbol of fascism, in his left, stands with ferocious gusto on his own head!

Worker and Collective Farm Woman was not only seen atop the Soviet Pavilion at the Paris World's Fair of 1937 but was also exhibited in different sizes throughout the Soviet Union. An industrial worker and a peasant woman are striding forward, energetically bearing hammer and sickle, in a dynamic sculpture whose symbolism is unmistakable. This work is at a far remove from Rodin's passion for a suffering humanity, yet Vera Mukhina, who was responsible for it, had studied in Paris with Emile-Antoine Bourdelle (plate 169), who, in turn, had been a disciple of Rodin's.

Minna Harkavy's *American Miner's Family* expresses a totally different view of work. Her mute, hieratic figures are immobilized by poverty and hardship. The children barely reveal any personas—or even bodies—of their own.

It seems incredible that these Americans inhabit the same world at the same time as Josef Thorak's oversize pruriently naked, muscular males. The Nazi government in Germany commissioned sculptors to fashion heroes who could inspire patriotically minded women toward the propagation of the Aryan race and who were perhaps also highly provocative to homosexual storm troopers. *Comradeship* was shown at the opening exhibition of the Haus der Deutschen Kunst (plate 845), and Hitler himself declared that the works shown contributed "to the honor and prestige of the entire German nation."

A gigantic figure of *Atlas* in highly polished bronze, holding the world

742

743

744

745

in the form of the cycle of the zodiac in his arms, rises in front of New York's Rockefeller Center. The developers of this large, well-planned site of high-rise commercial buildings (plate 815) commissioned the decorative architectural sculptor Lee Lawrie to design this statue, which, on its pedestal, stands forty-five feet high. This muscular, heroic figure was installed facing Fifth Avenue during the depth of the Depression. It can be seen as a symbol of the durable strength and imperial power of American capitalism.

While heroic sculptures of this mode were being produced everywhere, the American David Smith made a series of fifteen small *Medals*

for Dishonor, such as *Propaganda for War* and *War Exempt Sons of the Rich*. These plaques are skillful intaglio reliefs filled with various visual metaphors, many of which are topical. The *Medals for Dishonor*, Smith recalled, "were on a plane which I considered to be . . . classical . . . and Humanitarian in content and opposed to Fascist war ideology."

Isamu Noguchi briefly entered the field of social protest with his *Death (Lynched Figure)*. A grimly contorted figure in the form of a Crucifixion swings from an actual rope within a vertical metal framework—a searing indictment of human hatred and violent practice. There is little doubt

that Noguchi's ominous enclosure is indebted to Giacometti's open cages, just as Smith admired Surrealist fantasies and made use of them in his work.

738 Ferruccio Vecchi. *The Empire*. 1939–40
739 Vera Mukhina. *Worker and Collective Farm Woman*. 1937. Stainless steel, height c. 80′ 740 Minna R. Harkavy. *American Miner's Family*. 1931. Bronze, height 27″
741 Josef Thorak. *Comradeship*. 1937
742 Lee Lawrie. *Atlas*. 1937. Bronze, height 45′ 743 David Smith. *Medal for Dishonor: Propaganda for War*. 1939–40. Bronze, diameter 9 $^1/_2$″ 744 David Smith. *Medal for Dishonor: War Exempt Sons of the Rich*. 1939–40. Bronze, height 10″
745 Isamu Noguchi. *Death (Lynched Figure)*. 1934. Monel metal, height 36″

287

Erotic Imagery

746

747

748

749

Alberto Giacometti's *Suspended Ball*, a work esteemed by the Surrealists, is laden with symbolic images and sexual suggestions. A structural environment or cage encloses two forms: a crescent-shaped wedge on a table that nestles a sphere or ball, suspended from a string. The string is just slightly too short for the two objects to touch, but the coupling, which is imagined when the ball is made to swing from the string, evokes a deep level of sexual response in the observer while simultaneously suggesting occult, solar, and lunar imagery.

In Méret Oppenheim's *Object* a fur-covered spoon is placed on a fur-covered saucer next to a fur-lined teacup. Oppenheim, one of several women included in and lauded by the Surrealist group, produced quite a sensation with this metaphoric work, whose provocative implications are largely due to the tactile and oral associations implicit in it.

Fantastic imagery, related to the sexual-Surreal vision, is most completely expressed in Hans Bellmer's *Poupée*. Bellmer created sadistically erotic, fragmented dolls of great ingenuity which he displayed as sculpture. Related, no doubt, to the mannequins which were popular with earlier Surrealists, Bellmer's contorted, decapitated composition, which could be assembled in a variety of ways, recalls the Surreal fascination with the fetish object and erotic imagination.

In relation to the work of Bellmer and Oppenheim, the *Torso* by Gaston Lachaise must be considered a forthright, artistic appreciation of the female form. Lachaise kneads the sensuous curves and bulges and the soft volumes of woman into smooth configurations of clay. The result, cast in bronze, is an erotic cult image that recalls the ancient mother-goddesses whose ample breasts and round bellies were awesome objects to be worshiped and defended.

William Zorach, a distinguished American sculptor, had been a radical advocate of modernism in his

751

750

752

younger years but became quite conservative by the 1930s. Dealing very directly with the theme of physical human love, Zorach somehow solidified his kiss into a rigid embrace. The woman, balanced upon the man's knee and held in place by his gigantic hand, swoons to the kiss of her somewhat preoccupied, well-coifed lover. The sculpture, while contemporaneous with the work of Lachaise and Giacometti, certainly reminds us of a time past, and in fact takes us back to Gustav Vigeland's Nordic lovers of 1906 (plate 196).

Lucio Fontana did a series of small sculptures in terra-cotta, colored plaster, and tinted cement.

Lovers of the Pilots recalls the Etruscan terra-cotta sarcophagi on which lovers rested in a reclining position and relates also to the Impressionist treatment of materials by Medardo Rosso (plate 191). But Fontana's works are surprisingly advanced for their time and anticipate the "informal" handling of material that marks the end of the forties in Europe and America. He uses subtle bands of color to separate the figures and stresses tactile qualities by allowing the marks made by his hands to remain visible on the lively surface.

746 Alberto Giacometti. *Suspended Ball.* 1930–31. Wood and metal, height 23 ⁵/₈″ **747** Méret Oppenheim. *Object.* 1936. Fur-covered cup, saucer, and spoon, height 2 ⁷/₈″ **748–749** Hans Bellmer. *La Poupée.* 1936. Painted bronze, height 16 ⁷/₈″ **749** Back view. **750** Gaston Lachaise. *Torso.* 1930. Bronze, 11 ¹/₂″ **751** William Zorach. *The Embrace.* 1933. Bronze, height 66″ **752** Lucio Fontana. *Lovers of the Pilots.* 1931. Colored plaster

The Object of Fantasy

753

754

755

756

Closely related to the works of Giacometti, Bellmer, and Oppenheim were other Surrealist objects of fantasy and poetic assemblages of the period. Giacometti himself, who was a member of the Surrealist group in the early 1930s, created *Caught Hand*, in which the arm of a mannequin is held almost voluntarily in a mechanical contraption which, when turned, would cause great pain. It suggests the futility of choice and comments on man's negative, disastrous relationship to the machine. Victor Brauner combines two disparate objects in the best Surrealist tradition in *Wolf-Table*, consisting of a table and parts of a stuffed wolf.

While the real meaning of this assemblage is probably best understood metaphorically, the macabre and frightening image of the wolf, fangs bared in view of his own tail, relates to the horror and the mystique of magic fetish objects.

Kurt Seligmann's *Ultrafurniture* combines four mannequin legs that double as chair legs. The image of this "ultrafurniture," while humorous, has clear sexual overtones: the seat of the chair was covered in velvet, an extra inducement to sit where the thighs of the dummy would be expected to meet the torso.

Marcel Jean's nightmare fantasy portrait *Specter of the Gardenia*

is a classic head, made of plaster and covered with a dark fabric. At first, the eyes, represented by circular zipper pulls, appear to be open; however, the zippers of which they are a part clearly seal off any vision. The image suggests the permanent vacant stares of people populating Hell in Jean-Paul Sartre's *No Exit*, written about eight years later.

Yves Tanguy, like Kurt Seligmann, made very few three-dimensional objects. His *From the Other Side of the Bridge* was done in 1936, based on drawings he had made five years earlier for André Breton's journal *Le Surréalisme au Service de la Révolution*. It is a handsome

757

758

759

object of stuffed pink linen whose fingers disappear into the holes of a pegboard; it was meant to be suggestive of whatever the observer's imagination could conjure up.

Surely one of the most fascinating Surrealist assemblages is Joan Miró's poetic *Object*. A doll's leg is suspended in a hollowed-out wooden block that presses on a hat decorated with (what else?) a red fish. On top of it a stuffed parrot is perched on a wooden stand from which a ball is suspended. Free association has indeed taken objective form.

In America, Joseph Cornell was closest to the Surrealists and was indeed accepted by Breton as an artist who "completely reverses the conventional usage to which objects are put." In addition, Cornell's carefully carpentered boxes are filled with enigma and nostalgia. His little environments are projections of the unconscious, both separate from and part of the everyday world. The compartmentalized *Soap Bubble Set* contains an egg nestling in a glass, a clay pipe laid out in front of a map of the moon, a doll's head set on a pedestal, and four cylinders which appear in the upper register. The interpretation of the box is up to the viewer: Cornell, the magician-poet-sculptor, does not reveal the meaning of the metaphorical elements.

753 Alberto Giacometti. *Caught Hand.* 1932. Wood and metal, length 23″
754 Victor Brauner. *Wolf-Table.* 1937. Wood with parts of stuffed animal, length 22 $^7/_8$″ 755 Kurt Seligmann. *Ultrafurniture.* 1938 756 Marcel Jean. *Specter of the Gardenia.* 1936. Plaster covered with black cloth, zippers, and movie film, height 10 $^1/_2$″ 757 Yves Tanguy. *From the Other Side of the Bridge.* 1936. Painted wood and stuffed cloth, height 5 $^3/_4$″ 758 Joan Miró. *Object.* 1936. Assemblage, height 31 $^7/_8$″ 759 Joseph Cornell. *Soap Bubble Set.* 1936. Construction: glass case containing map, goblet, egg, pipe, head, and four boxes, height 15 $^3/_4$″

760

761

762

Whereas Cornell's box is an environment of fantasy objects, Giacometti's *Palace at 4 a.m.* is a construction suggestive of a stage set. Giacometti, who completely realized the work in his mind before he commenced the structure, created a palace of matchsticks. It is a construction that is open and transparent rather than a solid traditional work of sculpture. On the left of the palace is the statue of a woman—the artist's early recollection of his mother—standing against a thrice-repeated curtain. On the right is a spinal column or backbone in its own cage with a skeletal bird hovering over it. The object in the center in front of a board, below the scaffolding of a tower, is

unrecognizable, but Giacometti said that he identified it with himself. The whole composition is a mysterious arrangement of isolated organic and geometric forms in a linear environment, deriving from memory and dream.

An environment of a very different kind is Salvador Dali's *Rainy Taxi*, which the artist placed at the entrance to the International Exhibition of Surrealism in Paris in 1938. The ivory-covered old taxicab contained two mannequins—a chauffeur with a shark's head and a hysterical blonde, seated among snails and vegetables—all this in dripping water provided by a system of water pipes.

This grand exposition, the last of the original Surrealist shows, was designed by Marcel Duchamp, who had conjured up the most extravagant installation of objects. At the same time, Duchamp worked very quietly for a period of five years, from 1935 to 1940, on creating his own intimate environment, the *Box in a Valise*, which was published in 1941. This was Duchamp's "portable museum" of seventy-one superb reproductions of his most important works. Some of them were printed on transparent celluloid, others on fine paper, and there are some miniature models. All these replications were fitted most carefully into a leather valise. Although it resembles

763

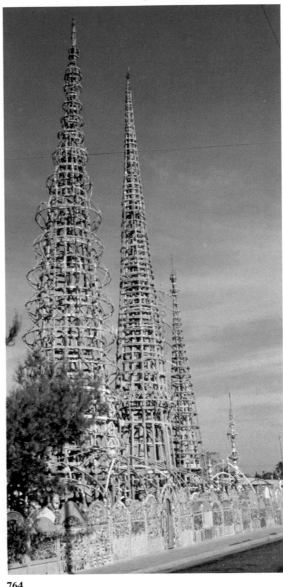

764

a traveling salesman's display case, it is an artist's environment, a container, conceptually referencing his life's production.

During this time, but extending over a period of thirty-three years, from about 1921 to 1954, an Italian immigrant tile setter named Simon Rodia built a large environment that is both sculpture and architecture, in Watts, a poor section in Los Angeles. Completely isolated from the world of art, Rodia with his own hands erected high, sturdy towers of cement on frames of steel. The highest of the group rises almost a hundred feet. These towers, constructed without the normal building techniques of posts and beams, welds, rivets, or bolts, are basically sculptural assemblages on a huge scale. They are lacy, transparent, and linear in form—veritable labyrinths of fantasy. They are covered with shells, broken dishes, bits of glass, pieces of ceramic tile, and fragments of mirrors. These pieces of detritus were selected to create color harmonies and contrasts; the resultant surfaces are magical mosaics of color and pattern, reminiscent of certain works by Antoni Gaudí (plates 509–510 and 517–518), which Rodia certainly did not know. Totally outside the mainstream of sculpture or architecture, the *Rodia Towers* stand as a phenomenon of human creativity.

760 Alberto Giacometti. *The Palace at 4 a.m.* 1932–33. Construction: wood, glass, wire, and string, height 25″
761 Salvador Dali. *Rainy Taxi.* 1936–38. Assemblage: taxi, two mannequins, snails, vegetables, water, and other materials
762 Marcel Duchamp. *Box in a Valise.* 1935–41. Leather valise containing miniature replicas, photographs, and color reproductions of works by Duchamp, height 16″ 763–764 Simon Rodia. *Simon Rodia Towers in Watts.* 1921–54. Cement with various objects, height 98′
764 Front view

The Female Form

765

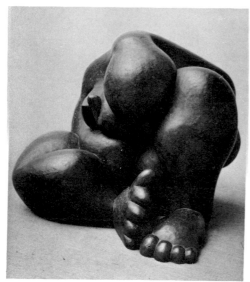

766

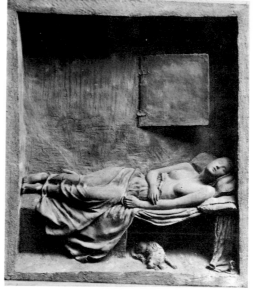

767

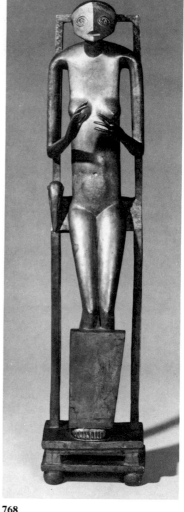

768

Aristide Maillol had established his classical style at the turn of the century (see plates 172–173) and made very little change in either his form or the range of his subject matter, which was limited largely to the perfect female body. Like Maillol, Henri Laurens also created tributes to the female nude. His *Crouching Figure*, a massive form consisting exclusively of rounded shapes and curves, is a far remove from his geometric Cubist *Head* of 1920.

Italy's most important sculptor between the wars, Arturo Martini, hoped to revitalize the great past—ancient or medieval. *The Dream* reflects his understanding of Italian tomb sculpture tradition, going back

to Etruscan sarcophagi, which were intense representations of the dead reclining on their beds. Martini tells a story filled with mystery about the sleeping woman, the opened window, and the dog—all in their shadow box.

Alberto Giacometti's *Invisible Object*, inspired partly by Egyptian statuary, is the figure of a woman holding an invisible, phantom object. A phantom object, according to the Surrealists, is an entity whose presence is felt but whose existence is missed because it does not exist. At one time the artist also called this pivotal sculpture *Hands Holding the Void*; it gives an indication of the artist's need to conquer the void, his compulsion to make art in order to

gain a hold on reality. He wrote the author: "Reality has never been a pretext to make art objects, but art a necessary means to render to myself a better account of what I see."

In the hands of Jacques Lipchitz the female form became a subject for spatial and technical experimentation. He called *Elle* one of his "transparents," in which he conceived "of sculpture as space, as air or spirit rather than as solid mass." Dematerializing the central torso, Lipchitz opened his figure up to express her resonances and presences, enveloping and reaching out simultaneously.

In these pieces Lipchitz found the technical problems almost insurmountable. Pursuing parallel paths

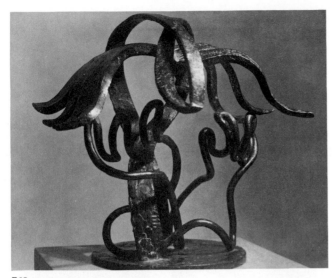

769

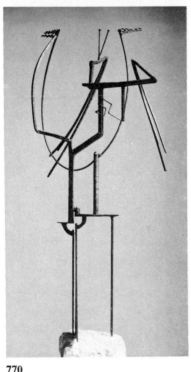

770

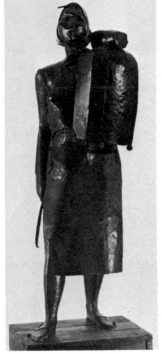

771

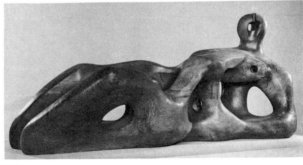

772

was Julio González, who had started out as a painter but was also a highly skilled foundryman and welder. These techniques, unlike carving a block of stone or wood, or modeling in clay, enabled him to project into space and to construct a work with almost unlimited freedom. *Woman Combing Her Hair* consists of a series of tubular, linear elements that define an oval head and give faint indications of eyes and hair. What this elegant work is really about, however, was clearly stated by the artist: the "marriage of material and space." In answer to the fascist horrors of the civil war in his native Spain, González created a much more figurative and accessible work

by welding pieces of sheet metal into a sculpture, *The Montserrat*, named for the holy mountain of Catalonia. The Spanish peasant woman carrying a scythe and the child whose kite has become a metal shield create an image of strength and defiance; this is one of the rare examples of meaningful heroism in modern sculpture.

Henry Moore's major theme—recurring over half a century—was the recumbent female figure. *Reclining Figure* is much lighter than the massive carving of ten years earlier (plate 721). The holes that the sculptor dug into the wood relate the work to the surrounding space. In addition, there is a sense of mystery, not unlike the experience of

exploring caves or cliffs. The figure is animated with great potential energy, which seems to flow through the grain of the wood. As Moore explained, it was not beauty (in the classical sense) but vitality and intensity which were the aim of his art.

765 Aristide Maillol. *Nymph*. 1936–38. Bronze, height 60 ¹/₂″ 766 Henri Laurens. *Crouching Figure*. 1936. Stone, height 36 ¹/₂″ 767 Arturo Martini. *The Dream*. 1931 768 Alberto Giacometti. *Invisible Object (Hands Holding the Void)*. 1934–35. Bronze, height 61″ 769 Jacques Lipchitz. *Elle*. 1931. Bronze, height c. 10 ¹/₄″ 770 Julio González. *Woman Combing Her Hair*. 1931–33. Iron, height 59″ 771 Julio González. *The Montserrat*. 1936–37. Wrought and welded iron, height 65″ 772 Henry Moore. *Reclining Figure*. 1939. Elm wood, length 79″

Abstract Sculpture: Anthropomorphic Form

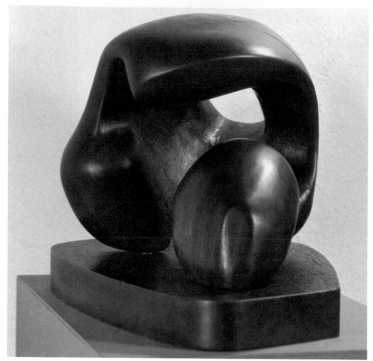

773

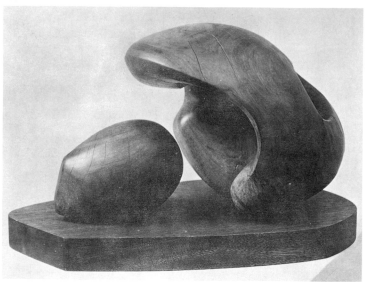

774

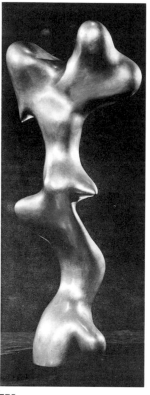

775

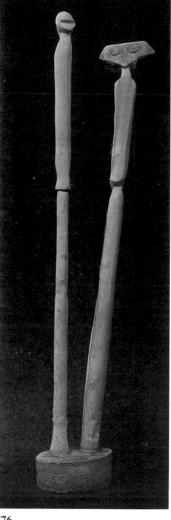

776

Moore's work always remained close to living organisms, even in a relatively abstract work like the carving *Two Forms*, arrived at by an intuitive analysis of human form. The concavity in one form and the convexity in the other create a dialogue. The two elements fit together, though they are apart. They may allude to the relationship of mother and child or possibly also to a potential male-female relationship.

By 1930 Jean Arp, after his earlier experiments with Dada collages and reliefs, turned to three-dimensional sculpture. He referred to his anthropomorphic forms such as *Growth* as "concretions," "curdling solidifications of growth." His sculptures

became dense and solid. Whereas Moore's biomorphic carvings have a bony skeletal character, Arp's bronzes seem to put more emphasis on the epidermis, and look like organic forms that could metamorphose and continue in their growth. "Art should lose itself in nature, should even be mistaken for nature," Arp wrote, continuing: "only one must not try to achieve this by imitating but by the very opposite of naturalistic imitation."

Max Ernst, a close friend of Arp's, once wrote that Arp "has enabled us to understand again the language that the universe itself speaks." His own sculpture *Les Asperges de la Lune (Lunar Asparagus)* is actually

more a continuing tribute to the Surreal sense of humor than to an organic identity. The asparagus stalks seem to smirk at the observer, they demand his recognition as objects with an intrinsic life, but they are organic objects of a very different nature from what one would be likely to encounter on this planet.

The early work of Otto Freundlich, painter, graphic artist, teacher, and sculptor, was related to the work and concepts of Cubism. By the thirties, however, he had become associated with the Abstraction-Création group in Paris, of which Arp was a cofounder. In his *Composition* of 1933, the planes and volumes of Cubism still exist in

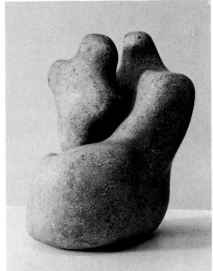

778

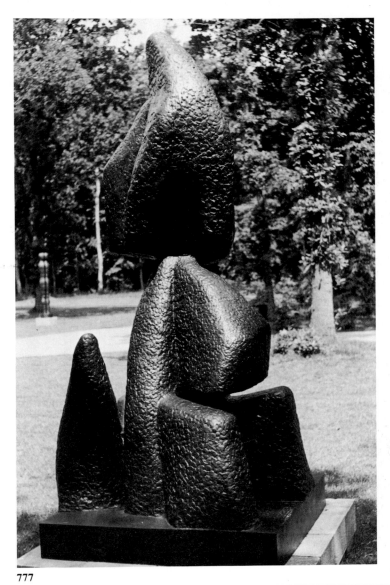

777

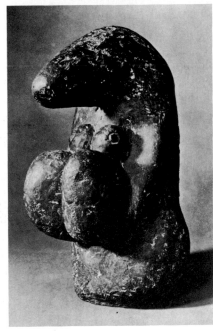

779

three-dimensional space, but this work, with its virile textured forms poised in daring equilibrium, has the appearance of a great but undefined, craggy mystical being.

Barbara Hepworth's *Mother and Child* of 1934 was one of the artist's last works to be defined by human form and rhythm. But by this time she had achieved a truly universal, timeless quality in her representations of human images. A small, compact, slightly irregular form nestles inside the larger enveloping form in this work created in the year when triplets were born to Hepworth and her husband, the artist Ben Nicholson (plates 903 and 988).

Picasso made his bronze *Bust of*

a Woman only a few years after his *Monument* (plates 715–716). Transparent linear construction has been discarded for heavy, massive, totally solid form. In his new, large sculpture studio in the south of France, Picasso made an astonishing series of sculptures in the early 1930s, mostly dealing with heads, busts, and whole bodies of women. *Bust of a Woman* recalls prehistoric fertility idols from the paleolithic period, such as the famous Venus of Willendorf. The humanoid shape, with its conical, canine head and its large, bulging breasts, is still undefined. Its articulation is that of massive sculptural form rather than of a woman's body.

773–774 Henry Moore. *Two Forms*. 1934. Pynkado wood, height 11″ 774 Side view 775 Jean Arp. *Growth*. 1938. Bronze, height 31 ¹/₂″ 776 Max Ernst. *Les Asperges de la Lune (Lunar Asparagus)*. 1935. Plaster, height 65 ¹/₄″ 777 Otto Freundlich. *Composition*. 1933. Bronze, height 90 ¹/₂″ 778 Barbara Hepworth. *Mother and Child*. 1934. Pink ancaster stone, height 12″ 779 Pablo Picasso. *Bust of a Woman*. 1932. Bronze, height 25 ¹/₈″

Abstract Sculpture: Organic and Geometric Form

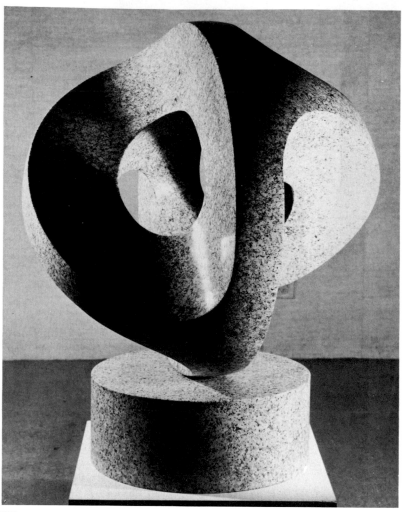

780

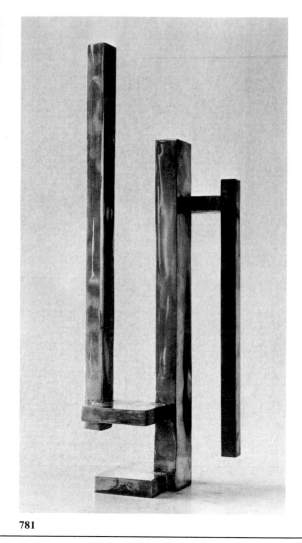

781

The Swiss artist Max Bill, who had studied at the Bauhaus, became a lifelong advocate of a synthesis of the arts, working as architect, painter, sculptor, designer, teacher, and theorist. Believing in the "mathematical way of thinking," he nevertheless welcomes the notion of inspiration, and many of his works can be seen as models that attempt to eradicate the barrier between scientific knowledge and artistic intuition. *Construction* exemplifies the tangible form of the innate beauty of scientific concepts with a very personal sense of material and scale.

Georges Vantongerloo, born in Belgium but greatly influenced by the Dutch De Stijl group, also worked

as a painter, sculptor, and architect and also believed in the mathematical basis of art. He titled a significant sculpture *Construction $y = 2x^3 - 13, 5x^2 + 21x$*. This small, carefully structured geometric piece is meant to work as a model for architecture or town planning because it polarizes the unshaped space surrounding it. In its minimalism—it consists of three slender, vertical bars joined by horizontal platforms—as well as in its suppression of the "hand" of the artist, it is a forerunner of a tendency that almost dominated modernist sculpture in the 1960s.

While a sense of movement is implied in the pure abstractions of Bill and Vantongerloo, it was the

American Alexander Calder who truly brought motion and time into the sculptural idiom. A few years after his playful circus and animal constructions such as *Romulus and Remus* (plate 710), he began working on sculptures in which organic shapes are suspended from metal rods on wires or strings in a delicate state of balance. Trained as an engineer, Calder calculated these kinetic structures by measuring relative length and weight. An early venture was the *Crank-Driven Mobile*, but he quickly progressed to the 1934 *Mobile*, in which the slightest stirring in the air moves the sculpture, causing it to change its configuration. Marcel Duchamp coined the word

782

784

783

785

"mobile" to describe Calder's new kind of sculpture, in which time is as important as form and space.

While Calder was a member of the French Abstraction-Création group, which also counted other sculptors—Pevsner, Freundlich, Arp, Hepworth, Bill, and Vantongerloo—among its adherents, the American sculptor Ibram Lassaw was one of the founders of its U.S. equivalent, the American Abstract Artists. After seeing the work of González in French art periodicals, Lassaw began welding, creating open-space constructions of sheet metal such as *Sculpture in Steel*. Miró-like organic forms are suspended in a rectangular space frame. The total composition, reminiscent

of Giacometti's *Palace at 4 a.m.*, had a very considerable influence on the development of modernist sculpture in America.

The work of the American John Storrs, who lived and worked in Paris for much of his life, had relatively little impact on contemporary sculpture. His *Composition around Two Voids* is certainly indebted to Cubist form, but by using highly burnished stainless steel, Storrs achieved very appealing decorative and dynamic effects in both his abstract and his figurative subjects. He was given commissions for Chicago's Century of Progress Exhibition (see plate 788), and became a leading exponent of the Art Deco style.

780 Max Bill. *Construction*. 1937 (executed 1962). Granite, height 39″ **781** Georges Vantongerloo. *Construction* $y = 2x^3 - 13, 5x^2 + 21x$. 1935. Nickel silver, height 15 $^1/_8$″ **782** Alexander Calder. *Crank-Driven Mobile*. 1931–32. Wood, wire, and sheet metal, height 23″ **783** Alexander Calder. *Mobile*. c. 1934. Sheet metal, metal rods, and cord, height 9″ **784** Ibram Lassaw. *Sculpture in Steel*. 1938. Steel, height 18 $^1/_2$″ **785** John Storrs. *Composition around Two Voids*. 1932. Stainless steel, height 20″

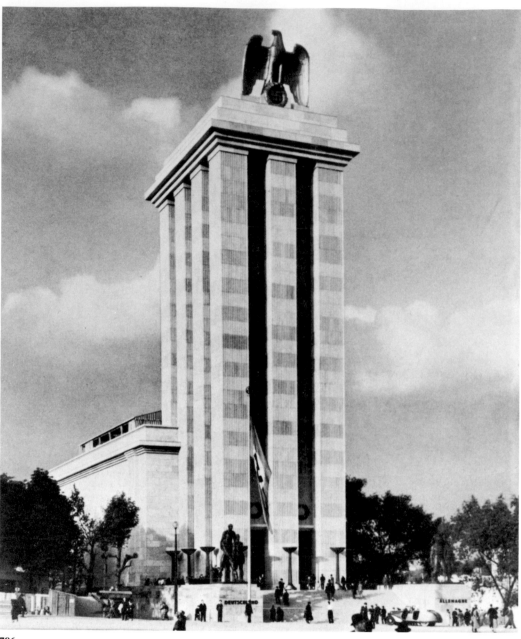

786

Three distinct styles characterize the architecture of this decade. Exploration of the possibilities of rational architecture continued in what has been called the International Style, with important "second generation" figures such as Alvar Aalto, Marcel Breuer, Pier Luigi Nervi, Oscar Niemeyer, and Eduardo Torroja making their debuts. Concurrent with, and often opposed to, the avant-garde functionalism favored by the intelligentsia was the highly popular and sometimes exquisite Art Deco style, which proliferated throughout Europe and America. Third, a dehydrated but highly impressive and grandiose Neoclassic revival was favored by officialdom not only in the totalitarian nations but almost universally.

Exhibition buildings, especially those built for world's fairs, have long been the bellwethers and exemplars of the architecture of a given period since they dramatize architecture for the general public and, being temporary, invite experimentation. Just as the most brilliant advances in architectural thought and design of the 1920s were exemplified by the exhibition pavilions of Le Corbusier in Paris and Mies van der Rohe in Barcelona, the architectural trends of the 1930s were well illustrated by the exposition buildings of the decade.

The Paris Universal Exposition of 1937 was dominated by the German and Soviet pavilions facing each other on the banks of the Seine, both representing the new academicism favored for official buildings. Hitler himself claimed to be an expert on architecture, which, he felt, was the highest form of art, serving immediate propagandistic functions and immortalizing his ideas in stone. Architecture was considered a political weapon by the Führer and his chief architects, Paul Ludwig Troost and Albert Speer. Hitler entrusted Speer with the most ambitious and expansive building scheme in modern times, a program which was to transform the total environment of the "Thousand-Year Reich." It

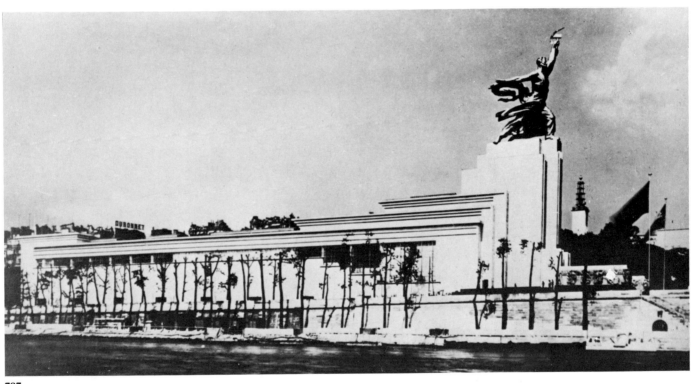

787

786–787 Universal Exposition, Paris. 1937
786 Albert Speer. German Pavilion
787 B. M. Iofan. Soviet Pavilion

was Speer who designed the German Pavilion for the Paris exposition, a building dominated by a tall, massive, square tower composed of heavy stone pillars. The German eagle, clutching a wreathed swastika, crowned this imposing structure, which was to symbolize "security, pride, self-consciousness, clarity, and discipline."

The somewhat more dynamic Soviet Pavilion, directly opposite, seemed to charge aggressively against Germany's solid tower. A large steel sculpture surmounting the pavilion's spire, Vera Mukhina's *Worker and Collective Farm Woman* (plate 739), seemed to advance against the Nazi eagle. In opposition to what Russian officials called the "eclecticism and formalism" of the early Revolutionary period, this Soviet structure, designed by B. M. Iofan, announced a new architecture "expressing the deepest thoughts, stirrings, and ideals of the working class." Basically, the German and Soviet buildings had in common a complete rejection of twentieth-century architecture and of the visionary promise of the postwar period in both countries. Both buildings served primarily a propagandistic function by means of a dry, simplified, but eloquent Neoclassic vocabulary. Symbolically opposed, they struck visitors to the exposition with their formal similarity.

Exhibition Buildings: Chicago, New York, San Francisco

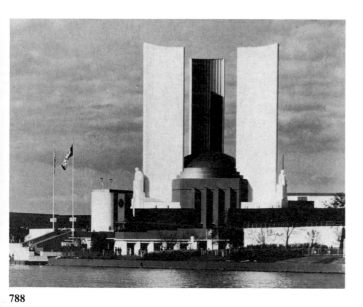

788

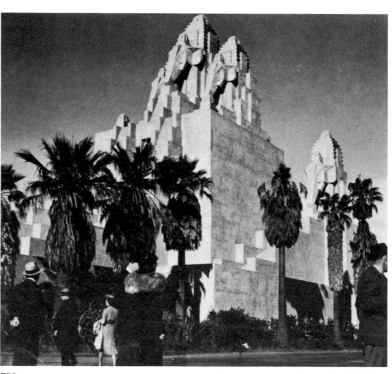

789

In 1933, forty years after the World's Columbian Exposition, Chicago opened another huge fair, called the Century of Progress. As the name implied, the fair was future oriented and eschewed the historical trappings of the Paris Universal Exposition of a few years later. Typical of the misunderstood "modernism" was the U.S. Federal Building designed by the classicists Edward H. Bennett and Arthur M. Brown, Jr., a large Art Deco structure of three window-less towers set at angles to each other around a central dome. The shafts, smooth and brightly painted, were spectacularly illuminated at night by powerful searchlights, their towering images doubled in a large reflecting pool. Officials saw the towers as "the symbol of the architecture of the future." Frank Lloyd Wright, as usual, dissented, describing the fair as "gesture and gaudy—sometimes bawdy—self-indulgence."

Major world's fairs with widely differing emphases were held on opposite sides of the United States in 1939. A fantasy city was built on a four-hundred-acre artificial island in San Francisco Bay to celebrate the completion of the two great bridges across the harbor and, ironically, the peaceful community of the Pacific basin nations. The dominating styles were therefore historic, principally Maya, Inca, Aztec, Malayan, and Cambodian smoothed to a suave Art Deco "modernity." All these elements were combined in Ernest Weihe's massive Elephant Towers, which served as gateways to the inner courts of the fair, while the highly stylized elephants that crowned the pyramids strongly suggested the influence of Cubism. At night, the towers were indirectly lit in shades of apricot, orange, lemon, green, silver, and gold.

At the same time, New York staged an exposition whose theme

791

790 **792**

was the "World of Tomorrow." Germany, preoccupied, did not participate, but the Soviet Union erected a building similar to the one in Paris, a lavish, monumental structure that was voted the most popular pavilion at the fair. Such academicism was, however, the exception; the fair was dominated by the modernistic symbols of the Trylon and Perisphere, designed by Wallace K. Harrison and J. André Fouilhoux. The Trylon, a three-sided obelisk rising six hundred fifteen feet, adjoined a huge sphere whose diameter was nearly a whole city block long. Inside the Perisphere, the visitor

could observe Democracity, a grand vision of a new city of the future with satellite towns laid out meticulously to give the viewer "an exciting picture of a way of life that is technically possible today." The General Motors Futurama, designed by Norman Bel Geddes, offered a similar prospect and drew some of the fair's longest lines, as did the Electric Utility Industry exhibit. Indeed, the urban sprawl and system of superhighways envisioned were soon to become a grim reality.

788 Edward H. Bennett and Arthur Brown, Jr. U.S. Federal Building, Century of Progress Exhibition, Chicago. 1933 789 Ernest Weihe. Golden Gate International Exposition, San Francisco. 1939. Elephant Towers 790–792 World's Fair, New York. 1939 790 Wallace K. Harrison and J. André Fouilhoux. Trylon and Perisphere 791 Norman Bel Geddes. General Motors Building 792 The Avenue of Tomorrow in the Electric Utility Industry Exhibit

Bridges

793

794

The best bridges are simultaneously both architecture and engineering. Unlike other works of architecture, they do not enclose space and are entirely functional in purpose; their form, at best, is an expression of pure structure. It is small wonder that the leading architects of the modern movement used bridges, as well as factories, steamships, and airplanes, as lessons for a new and rational architecture, rather than consulting the forms of the past.

Robert Maillart's extraordinary purity of design, resulting from an intuition that was based on his formidable technical knowledge, was most visible in the many reinforced-concrete bridges he built throughout

Switzerland. He was able to discard accepted standards and patterns in bridge architecture, developing arched structures of spidery grace. In the Schwandbach Bridge he unified the bearing and loading functions of the bridge into an economical, integrated structure of rare visual elegance.

Othmar Hermann Ammann, like Maillart, was born in Switzerland. His George Washington Bridge, crossing the Hudson River between New York and New Jersey, is an immense suspension bridge, supported by four cables of remarkably shallow curvature with no stiffening truss in the center. The large towers were not encased in masonry but

were left exposed, revealing their handsome steel skeletal structure. Although the renowned Cass Gilbert was consulting architect on the bridge, the span is primarily a work of engineering, designed by Ammann.

As a result of public works projects during the Depression, bridges of unprecedented size and technical virtuosity were built in America during the 1930s. These works of engineering art stand in marked contrast to the pompous official architecture of the time. In 1936, five years after the George Washington Bridge was opened to traffic, the San Francisco–Oakland Bay Bridge, whose designer and chief engineer

795

796

was Charles H. Purcell, was put into operation. Hailed as the longest bridge in the world, it crosses the entire width of San Francisco Bay; its western span is a suspension bridge, while the path east of Yerba Buena Island is a cantilevered truss structure. Simultaneously, the Golden Gate Bridge, several miles northwest, at the mouth of the harbor, was constructed. With his experience from the George Washington Bridge, O. H. Ammann served as consulting engineer to Joseph B. Strauss on the span, which many thought could not be built because of the surging tides in the narrow channel. But Strauss, rejecting earlier plans for an ungainly truss structure, built a colossal yet minimal bridge of stunning beauty, wholly worthy of its dramatic site. The two towers, rising seven hundred forty-six feet above the water, were taller than any skyscraper in San Francisco. They were decorated with restrained Art Deco detail while the entire structure was painted bright orange to ensure maximum visibility in heavy fogs. The Golden Gate Bridge, opened in 1937, was the longest single span in the world until 1964, when the Verrazano-Narrows Bridge, also engineered by the venerable Ammann, was opened in New York.

793 Robert Maillart. Schwandbach Bridge, Berne. 1933 794 Othmar H. Ammann. George Washington Bridge, New York. 1927–31 795 Charles H. Purcell. San Francisco-Oakland Bay Bridge. 1933–36 796 Joseph B. Strauss. Golden Gate Bridge, San Francisco. 1930–37

Buildings for Industry

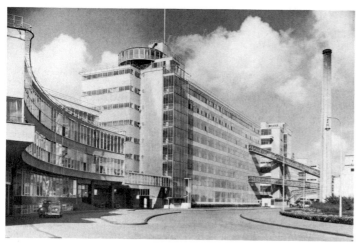

797

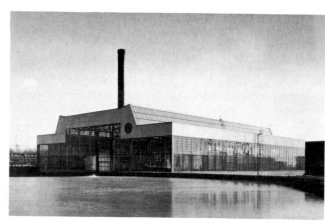

798

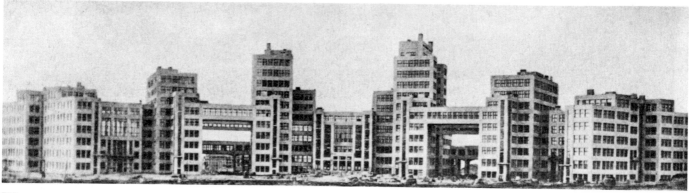

799

Factories, like bridges, were largely immune to the heavy load of symbolism required by official architecture in the thirties. Predicting the style of the 1930s, J. A. Brinkman and L. C. van der Vlugt designed the Van Nelle factory in Rotterdam in the late 1920s. These young Dutch architects, following in the footsteps of the generation of De Stijl, became much more functional in their design, and the Van Nelle factory, with its open and clearly articulated form allowing for future expansion, was—and remains—an excellent example of structural analysis that is not lacking in human considerations.

In the United States, Albert Kahn,

a member of an older generation, continued to build houses and public buildings in the Beaux-Arts style in Detroit. Starting in the early years of the century, he was also commissioned to design industrial buildings. Here he departed completely from the opulent historicism of his domestic structures. In buildings such as the Roll Shop of the Ohio Steel Foundry Company, there is evidence of the purity of design and fine craftsmanship that place Kahn's factories among the landmarks of modern industrial architecture, strongly suggesting the clarity of Peter Behrens's earlier work for the AEG in Germany (plate 139).

In the House of State Industry in Kharkov, by S. S. Serafimov, S. M. Kravets, and M. D. Felger, the spirit of Russian Constructivist principles of style is still visible. Standardized industrial methods are applied to a huge complex building of rectangular, well-fenestrated blocks of varying heights. The complex is functionally composed, with bridges and thoroughfares connecting buildings at various heights for maximum efficiency in circulation.

Frank Lloyd Wright received very few commissions for industrial buildings throughout his long career, but in 1936 to 1939, when he designed the Administration Building for the

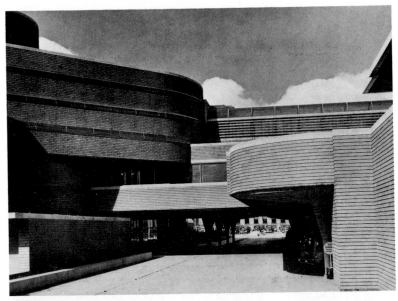

800

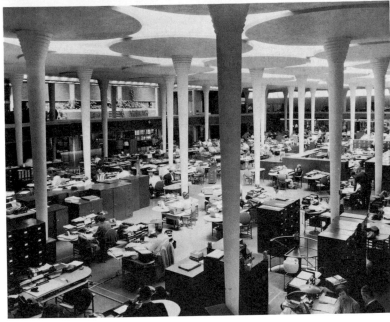

801

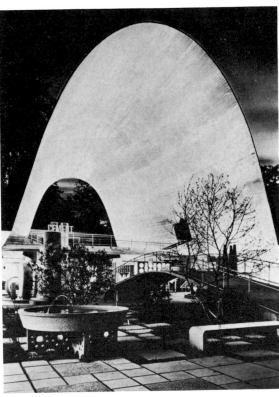

802

Johnson Wax Company in Racine, Wisconsin, he produced a simple structure of generous horizontal expanse and sweeping curves. He discarded the detailed decorative features that characterized his work of the previous decade in this complex building of brick and glass tubing and softly rounded contours. Interior spaces are continuous and open. Most surprising is the main office area, with its forest of slender, tapered columns molded in concrete. These columns, rising from small bronze shoes, expand into large circular disks resembling lily pads. They support a roof of glass tubing that admits light of a very special quality into an airy and humane space containing the secretarial pool.

At about the same time the veteran Swiss architect Robert Maillart, who had pioneered the notion of the "mushroom-slab" (see plate 141), very much like Wright's lily pads, utilized still another departure from the traditional post-and-lintel support. This was the arching curve in tension, which he had used earlier in bridges, as in Schwandbach in 1933. In the Cement Hall at the Swiss Provinces Exhibition in Zurich the potentialities of the material are exploited elegantly, and the delicate footbridge serves as a reminder of the origins of the concept.

797 J. A. Brinkman and L. C. van der Vlugt. Van Nelle Factory, Rotterdam. 1928–30 **798** Albert Kahn. Ohio Steel Foundry Company, Roll Machine Shop, Lima, Ohio. 1939 **799** S. S. Serafimov, S. M. Kravets, and M. D. Felger. House of State Industry, Kharkov. 1931 **800–801** Frank Lloyd Wright. Johnson Wax Company, Administration Building, Racine, Wisc. 1936–39 **802** Robert Maillart. Cement Hall, Zurich. 1939

Domestic Architecture: Two Masters

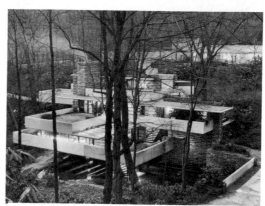

804

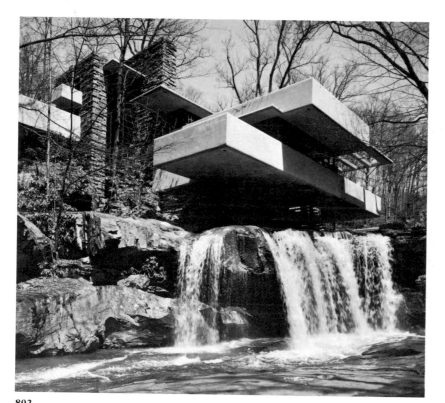

803

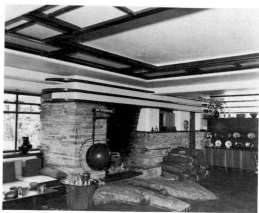

805

Just before the construction of the Johnson Wax complex, Wright designed what is perhaps his finest house, Falling Water, for Edgar J. Kaufmann, at Bear Run, Pennsylvania. This house combines the most advanced engineering methods of cantilevered concrete construction with a romantic appreciation for nature which is entirely Wrightian. A series of concrete slabs with smooth, seamless parapets projects boldly into space from a vertical core of heavy-textured native fieldstone which

serves both as the chimney and as the symbolic taproot of the house, anchoring it to the rock ledge on which it is built. Yet the house is so open that it appears to float in its wooded surroundings, suspended over the small waterfall that gives it its name and pervades it with the sound of running water. Walls entirely composed of glass and an extremely open plan blur any distinction between forest and interior, and indeed, the rock ledge erupts into the living room as part of the

hearth. There is a constant interplay of man-made versus natural forms and materials, each expressed intensely and according to its own character, creating a grand poetic symbol of man's place in the natural world.

Walter Gropius left Nazi Germany for England in 1934. Three years later, upon receiving an invitation to teach at Harvard University, he moved to Massachusetts, where, in partnership with the young Marcel Breuer, he immediately designed his

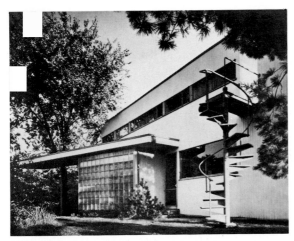

806

807

808

own house in suburban Lincoln. Eschewing the steel frame and stucco finish of his earlier houses and apartments, Gropius adopted the native American wood frame and siding construction; for the related Ford House he used native stone. However, building materials were the only significant concession to Gropius's new country in these houses, which remained strictly within the formalist and disciplined mode of the Bauhaus and the International Style, of which Gropius himself was

one of the founders and chief proponents. While in his own house wide expanses of glass and ground-level terraces invite an interchange with the hillside apple orchard in which the house is set, it remains, essentially, a space-containing box. Rational, austere, and compact, the Gropius house is in stark contrast to Wright's contemporaneous statement in the forest at Bear Run, which, intimately wedded to nature, seems an expression of American transcendentalism.

803–805 Frank Lloyd Wright. Falling Water. Kaufmann House, Bear Run, Pa. 1936–38 **806–807** Walter Gropius (with Marcel Breuer). Gropius House, Lincoln, Mass. 1937 **808** Walter Gropius (with Marcel Breuer). James Ford House, Lincoln, Mass. 1939

Domestic Architecture: The International Style

809

810

811

The structures exhibited at the Weissenhof Siedlung in 1927 had indicated that architects throughout Europe were working along similar lines in their efforts to satisfy the material and emotional needs of contemporary life. In 1928, the leading modern architects of Europe formed CIAM (Congrès Internationaux d'Architecture Moderne), a supranational organization intended to define and extend the developments evident at Weissenhof the previous year. The final statement of that first congress reads like a political manifesto of the day: "The destiny of architecture is to express the spirit of an age. . . . [The attending architects] have come

together to seek to harmonize the elements confronting them in the modern world and to put architecture back in its true sphere, which is economic, sociological, and wholly at the service of humanity." Furthermore, the purpose of CIAM was frankly propagandistic: since the public taste had been "perverted" by traditional, academic infatuation with the forms of the past, "it is vital that architects should exert an influence on public opinion, to make the means and resources of modern architecture known."

To these ends, the congress was spectacularly successful. In the opening years of the thirties, in every country of Europe, houses appeared

that paid homage to Le Corbusier's Villa Savoye (plates 553–554) and Mies van der Rohe's Tugendhat House (plate 552), as well as to the modernist imperatives of CIAM. Rejecting the formulas and forms of the past, they constituted a style in themselves, typified by taut, smooth wall surfaces of white stucco or concrete, flat roofs, horizontal window bands, thin metal balconies, abstract geometric forms, and free-flowing spaces—a style which, because of its sudden and concurrent appearance in so many places, was soon dubbed the International Style. Characteristic examples are Farkas Molnár's villa in Budapest with its Constructivist emphasis on the rounded stair-

812

813

well and its large white unfenestrated wall, the house in the countryside near Helsinki that Alvar Aalto designed for himself, with its bold play of opaque mass against transparent forms, and the reinforced-concrete, L-shaped two-story Villa Hefferlin by the distinguished French architect André Lurçat.

In England, Amyas Douglas Connell and Basil Robert Ward, both trained in New Zealand, in collaboration with Colin Anderson Lucas designed houses in the new style—such as the ingenious house at Grayswood in Surrey, which expands like a fan from a central core. Here again, the glass-encased staircase gives a visual focus to the varied masses. All these architects owed a great debt to Vienna's Adolf Loos (plates 162–163), who in his 1932 duplex house continued to build in the new style in which, he believed, uncorrupted minds were to design undecorated houses.

The new style was employed in public buildings and apartments as well as in private houses, and was propagandized by a number of polemical and moralistic books. Although the final statement of CIAM announced that the new architecture would escape "the sterile influence of the academies," its Olympian pronouncements and the growing stature of the first generation of modernists who organized the new "rational" architecture announced its respectability, and with its formulation of rules to counter those of more traditional schools, it eventually entered its own academic phase.

809 Farkas Molnár. Villa, Budapest. 1932 **810** Alvar Aalto. Aalto House, Helsinki. 1934–36 **811** André Lurçat. Villa Hefferlin, Ville-d'Avray, France. 1931–32 **812** A. D. Connell, B. R. Ward, and C. A. Lucas. House, Grayswood (Haslemere), England. 1932 **813** Adolf Loos. Duplex house, Vienna. 1932

High-Rise Buildings

814

815

Despite the onset of the Depression, the skyscraper boom of the 1920s continued through the early years of the next decade, finding its most imposing expression in Richmond H. Shreve, William F. Lamb, and Arthur Loomis Harmon's colossal Empire State Building of 1931, for forty years the world's tallest building. Its isolated, stepped-back shaft rises to a height of twelve hundred fifty feet, dominating midtown Manhattan. Renouncing Neo-Gothic or any other kind of historicizing ornament (although Art Deco details are seen in the treatment of the walls and spire), the building depends on simple massing and vertical fenestration to convey a soaring dynamism. As

the grandiloquent symbol of the heroic age of skyscrapers as well as the hallmark of Manhattan, it incorporated a mooring mast for dirigibles and provided a fitting perch for King Kong I.

The twelve-acre complex of Rockefeller Center, which remains a classic example of large-scale, cohesive urban design, required three teams of architectural firms, known collectively as The Associated Architects. The total plan includes office buildings, entertainment facilities, large plazas, esplanades, and roof gardens. Two acres remain public space and are adorned by paintings, sculptures, and mosaics, showing considerable concern for pedestrians.

Completed in 1932, George Howe and William Lescaze's Philadelphia Saving Fund Society Building stresses the steel skeleton of the skyscraper. Clarity of asymmetric design —then new for high-rise buildings— distinguishes the three component structures: the bank proper with its curved wall, the office tower, and the attached cross bar, primarily housing utilities. Here, too, no concessions were made to historical or Art Deco ornament. This building was the first U.S. skyscraper in the International Style, and it served as the prototype for innumerable high-rises of the postwar period.

At the same time, Raymond M. Hood, one of the designers of the

816

818

817

819

Chicago Tribune Tower, had become a convert to the International Style. His Daily News Building in New York is a simplified, planar shaft with continuous vertical window strips, equal in width to the masonry supports. Hood's design demonstrates both a growing dissatisfaction with the attempts to hide new materials with period masquerade and a willingness to let the structure speak for itself.

Toward the end of the decade, Lúcio Costa, in association with Oscar Niemeyer, Affonso Eduardo Reidy, Ernani Vasconcellos, and others, designed the Ministry of Education and Public Health in Rio de Janeiro. Le Corbusier was a

consultant, and the resulting building includes many of his ideas: it is built on stilts to allow pedestrian flow through and under the building, it is equipped with projecting, movable sun breaks, which interrupt the glare of the heat and give a vigorous rhythm to the facade. It also has a fine, usable roof garden. In this first major high-rise outside the United States, modern architecture was introduced to Brazil, a country which has since continued to experiment significantly with architectural ideas. The ministry also served as the prototype for the United Nations Secretariat building in New York.

814 Richmond Shreve, William F. Lamb, and Arthur Loomis Harmon. Empire State Building, New York. 1929–31 815 Harvey Wiley Corbett, Wallace K. Harrison, and William MacMurray; Raymond M. Hood and J. André Fouilhoux; L. Andrew Reinhard and Henry Hofmeister (The Associated Architects). Rockefeller Center, New York. 1928–c. 1940 816–817 George Howe and William Lescaze. Philadelphia Saving Fund Society Building, Philadelphia. 1929–32 817 View of corner facade 818 Raymond Hood and John Mead Howells. Daily News Building, New York. 1930 819 Lúcio Costa, Oscar Niemeyer, Affonso Eduardo Reidy, Ernani Vasconcellos, Jorge Machado Moreira, and Carlos Leão. Ministry of Education and Public Health, Rio de Janeiro. 1937–42

820

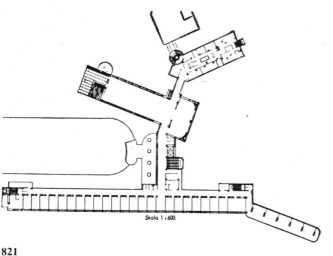

821

822

823

During this decade Alvar Aalto emerged in Finland as a major and unique personality in modern architecture. His work relates to vigorous Scandinavian modern design with its fine craftsmanship and durable simplicity. Aalto's Tuberculosis Sanatorium at Paimio consists of geometric blocks set at oblique angles to each other and opening like a fan to the surrounding countryside. While the building is formally in the International Style, Aalto's rejection of the right-angle grid, which orders the plan of similar buildings of this period, offers a new freedom of layout and suggests a greater sympathy for the environment. All details, from the color of

the walls and ceilings and the impact of light in the rooms to the doorknobs and washbasins, were designed by the architect for the well-being of the patients. At Paimio, Aalto demonstrated the absence of dogma that characterized the rest of his significant career.

In Italy the modern movement of architecture managed to ally itself, briefly, with fascist politics in joint opposition to bourgeois traditions. A fine example of this concordance was Giuseppe Terragni's Casa del Fascio in Como. Designed with great formal discipline and sheathed in fine marble, it suggests some of the work of Mies van der Rohe.

Great Britain, which at the turn of

the century had produced important pioneers of the modern movement, had returned to generally conservative taste, and it was only in the thirties, largely as the result of the temporary immigration of some of the leading architects of Germany—Mendelsohn, Gropius, and Breuer among them—that a new and vigorous architecture began to take its place. In association with Serge Chermayeff (who had been born in Russia but was educated in England), Erich Mendelsohn built the De La Warr Pavilion, a recreation center at an English resort. The pavilion is a long, low building articulated in the center by a projecting, semicircular stair tower enclosed in glass; this

824

826

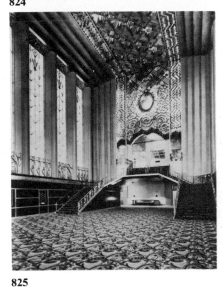

825

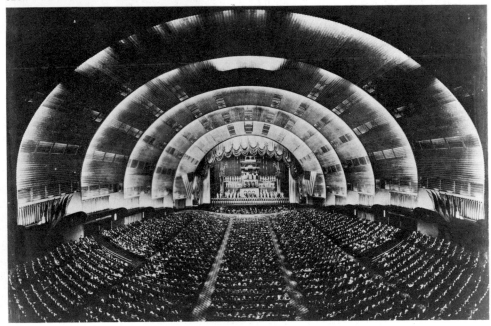

827

divides the glass-sheathed eastern wing from the blank concrete western wing, which houses a multipurpose hall. Buildings such as this signaled the belated acceptance of the International Style for British public buildings.

As the technical proficiency of the cinema grew throughout the twenties, so did the size, ingenuity, and sumptuousness of movie theaters throughout America. Vast movie palaces seating thousands of viewers, and decorated in every historical style, as well as in Art Deco, provided fantasy and escape from the grim reality of the Depression in the following decade. Among the largest was the Oakland Paramount, de-signed by Timothy L. Pflueger, a lush exposition in the Art Deco style employing new industrial materials—frosted glass, neon lights, aluminum, and Bakelite—to create magical effects. Probably the most famous movie palace in the world is Radio City Music Hall, in Rockefeller Center. Theaters such as these allowed everyone to experience something of the glamour and spaciousness of the luxury ocean liners of the period, while an unprecedented array of technological apparatuses converted the entire building into a sensual barrage for the audience.

820–822 Alvar Aalto. Tuberculosis Sanatorium, Paimio, Finland. 1929–33 **821** Plan of ground floor **822** Plan of first floor **823** Giuseppe Terragni. Casa del Fascio, Como, Italy. 1932–36 **824** Erich Mendelsohn and Serge Chermayeff. De La Warr Pavilion, Bexhill, England. 1933–34 **825–826** Timothy L. Pflueger. Paramount Theater, Oakland, Calif. 1931 **827** The Associated Architects. Radio City Music Hall, New York. 1931–32

Official Architecture

828

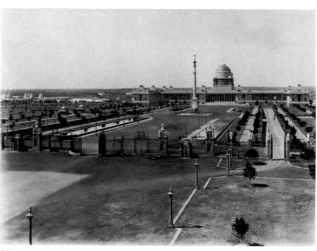

830

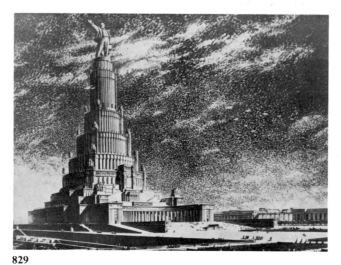

829

831

In 1931 Le Corbusier took part in an international competition to design the Palace of the Soviets in Moscow. His ideas were rejected, however, as more conservative, academic concepts of architecture became state policy. Building was to serve propagandistic purposes and was to be easily understood and appreciated by the people as a whole, leaving no room for the elitist formalism of the International Style. The Palace of the Soviets was to be modeled, according to official sources, after "Hellenic architecture, which is the cradle of civilization and art." It was there that inspiration and guidance could be found for the art of the "Proletarian Renaissance." B.

M. Iofan, together with V. G. Helfreich and V. A. Shchuko, designed a circular structure, resembling the Tower of Babel, more than thirteen hundred feet high and surmounted by a colossal statue of Lenin. The building—fortunately never built—would have dwarfed the Kremlin.

Neoclassicism continued to stamp the work of Sir Edwin Lutyens, who had designed the Somme memorial (plate 525). When he was commissioned to supervise the design for the administrative center of the new capital of India in New Delhi, he made the Viceroy's House the focal point of the geometric complex. He employed the classical orders with considerable freedom, creating a

structure whose size and imposing quality were clearly meant to symbolize imperial majesty. In the Viceroy's House, Lutyens used traditional forms in a symmetric design, but primarily because of his innate sense of proportion and monumental simplicity, the building provides a great contrast to the coldness of many of the era's other official buildings done in a stripped-down Neoclassical Beaux-Arts style.

Cass Gilbert's U.S. Supreme Court Building, for example, is a forbidding marble edifice of official grandeur and conservative taste, with inspiring allegorical figures at either side of a large staircase and grave inscriptions on the pediment above.

832

833

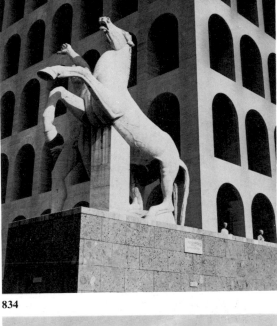

834

835

In Italy the battle of the modernists was lost to an architecture which, it was felt, should be related to the architectural grandeur of ancient Rome and be suited for the new Grande Roma, of which Mussolini considered himself the spiritual father. On the reclaimed Pontine Marshes south of the city, a permanent world exposition, the "Olympic Games of Civilization," was to be erected. Much of this complex was actually built; it is a grandiose and bombastic ensemble that, although dreary in its Neoclassic details, is made impressive by its vast horizontal spaces. The central building of the Esposizione Universale di Roma (EUR) complex, the Palazzo della Civiltà Italiana, is a cubic building with six stories of superimposed arcades. It was meant to be a modern adaptation of the Colosseum, and with its heroic, classicizing marble sculpture it achieves a dramatic impact.

In Germany, Paul Ludwig Troost designed the grandiose Führerbau in Munich, a very large edifice of Danubian limestone in exact axial symmetry to its twin, the Party Administration Building, across the street. Doric porticoes, balconies, and a bronze eagle grasping a swastika were part of the emblematic design of the exterior. The interior, executed in marble and wood paneling, was equipped with tapestries, big paintings, thick carpets, and leather furniture—all the product, according to an official Nazi Party publication of 1942, of "a highly developed artistic culture."

828 Le Corbusier. Design for the Palace of the Soviets, Moscow. 1931 **829** B. M. Iofan, V. G. Helfreich, and V. A. Shchuko. Palace of the Soviets, Moscow (final design). 1932–37 **830–831** Edwin L. Lutyens. Viceroy's House, New Delhi. 1913–31 **832** Cass Gilbert. U.S. Supreme Court Building, Washington, D.C. 1935 **833–834** Attilio La Padula, Giovanni Guerrini, and Mario Romano. Palazzo della Civiltà Italiana, Rome. 1937–41 **834** Closeup of facade **835** Paul Ludwig Troost. Führerbau, Munich. 1935

Arenas

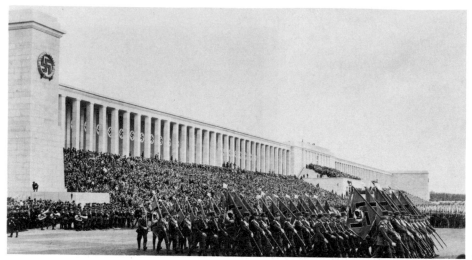

836

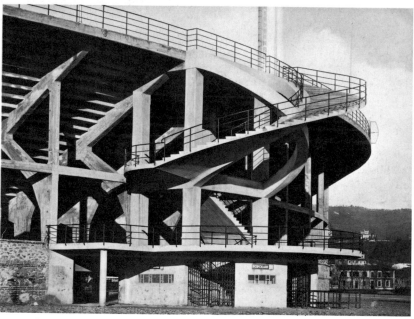

837

The Zeppelin Field in Nuremberg was designed by Albert Speer to accommodate a quarter of a million spectators of—or rather, participants in—the great Nazi Party conventions, which were immortalized in Leni Riefenstahl's overpowering films of Nazi propaganda. Before a vast horizontal columnar structure with large fortresslike pylons at either end, the great spectacles of the Nazi Party were enacted each year—with martial music, speeches, parades, gymnastics, and one hundred fifty searchlights beaming ten miles into the sky, illuminating the clouds.

Sports arenas, like bridges and factories, broke new ground in architectural design and practice during the 1930s. In Florence, Pier Luigi Nervi, affected little by the pompous glories of fascist archi-tectural ambitions, engineered the Municipal Stadium, employing a totally exposed seventy-five-foot cantilevered roof. All the structural elements of reinforced concrete were visible, including a broad spiral staircase projecting boldly into space and supported by a countercurving concrete strut. This simple, elegant building—similar in concept to the work of the Swiss engineer Mail-

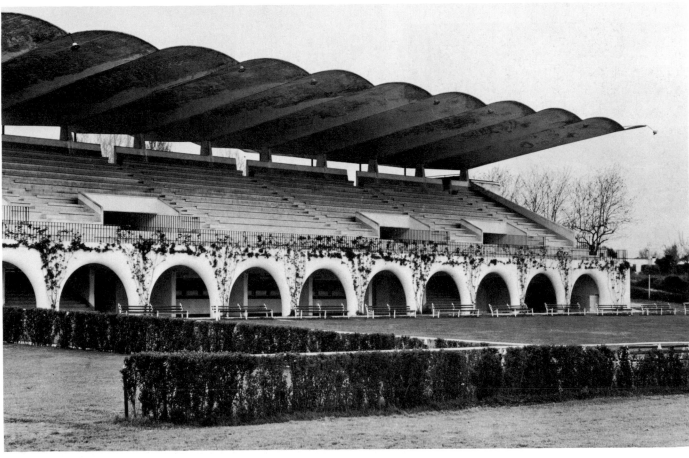

838

lart—was an important pioneering structure, displaying the versatility and strength of modern engineering methods and of reinforced concrete.

A similar synthesis of art and technology, probing the possibilities of cantilever construction, is the Zarzuela Hippodrome in Madrid, by Eduardo Torroja, a master of hyperboloid thin-shell construction. The round arches of the substructure are echoed in the daring vaults of the overhanging roof, made of large, elliptical shells which appear to be suspended in midair. Using mathematical formulations as the basis of his structure, Torroja stated that "every mathematical curve has a nature of its own, the accuracy of law, the expression of an idea, the evidence of virtue."

836 Albert Speer. Zeppelin Field, Nuremberg. 1934 **837** Pier Luigi Nervi. Municipal Stadium, Florence. 1930–32 **838** Eduardo Torroja. Zarzuela Hippodrome, Madrid. 1935

Museums

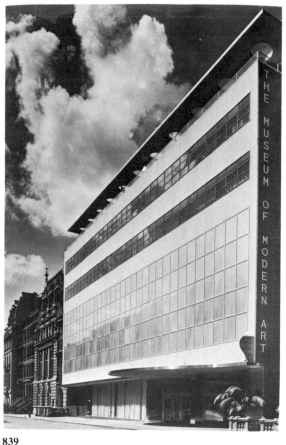

839

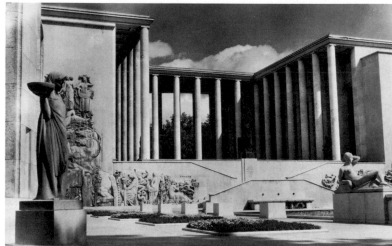

840

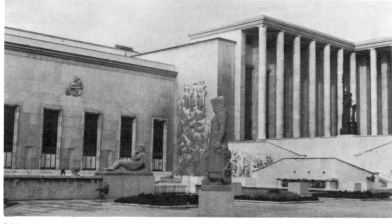

841

The museums that were being built during this decade, unlike the bridges and sports arenas, exemplified little of the refined poetic qualities which can result from fusing engineering and architecture in a manner comparable to Gothic church architecture. With the exception of New York's Museum of Modern Art by Edward Durell Stone and Philip L. Goodwin—a fine and workable building in the Corbusian mode and, in fact, Manhattan's first major building in the International Style—museums were the very essence of reactionary building concepts.

When the French authorities decided to reconstruct the old Trocadéro for the Universal Exposition of 1937 and to build their own museums of modern art, they chose a style "whose sober and dignified character should be worthy of the monumental character of French art." The words and the purpose are very similar from country to country; only the nationality seems to change. The Musées d'Art Moderne, with their dry colonnades and meager ornamentation, were indeed in keeping with the style of the Soviet and Nazi exposition pavilions and caused the Italian architectural historian Bruno Zevi to speak of an international "Trocadéro Style." The difference between the museums of modern art in Paris and New York was indicative of a shift in the im-

petus of modern art itself to the New World. The Trocadéro provided an official mausoleum for its brilliant beginnings in France.

The essentially worldwide character of the new academicism, which was both an attempt to return architecture to the historical models in which most of the architects of the age had been trained and an attempt to find a compromise with the modern movement by stripping off ornament, is reflected in Eliel Saarinen's museum for Cranbrook Academy. The distinguished Finnish architect was associated with Cranbrook almost from his arrival in the United States, in 1923. The museum peristyle, designed at the end of the 1930s,

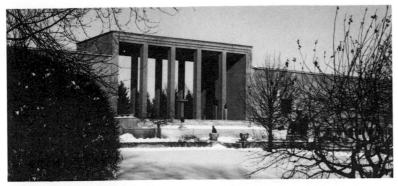

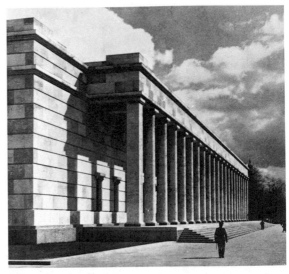

842

845

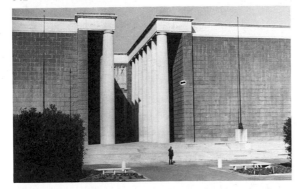

843

844

capped his work for the academy. He resorted to a bare, simplified Neoclassic mode, which has a clear affinity to the generally backward-looking official architecture of the decade.

The Museo della Civiltà Romana, erected for Mussolini's vast EUR scheme, is basically similar in appearance to the Cranbrook museum, except that here the austere masses and the colonnade are strangely crowded, facing each other and leaving only a narrow cleavage for access. The effect is highly oppressive, like that of an Egyptian hypostyle hall.

The conviction that Greek and Roman architecture—no matter how misunderstood—could furnish the repertoire of form and content for the modern period and that an important building must be equipped with columns, pilasters, and pediments prevailed in Washington, D.C., with its long classical tradition. When the United States finally built a National Gallery of Art in the capital, John Russell Pope designed a large edifice of Tennessee marble whose centerpiece was an adaptation of the Pantheon with long, identical wings extending to either side. Though well-proportioned and impressive in size, the building is cold, formal, and austere, a fittingly serious "temple of art." Its counterpart is found in Paul Ludwig Troost's contemporaneous Haus der Deutschen Kunst in Munich, with its heavy stonework and interminable colonnade. Beside all these official treasuries, the Museum of Modern Art in New York, with its thin marquee and its great expanses of glass, appears all the more open and inviting.

839 Edward Durell Stone and Philip L. Goodwin. The Museum of Modern Art, New York. 1939 840–841 J.-C. Dondel, A. Aubert, P. Viard, and M. Dastugue. Musées d'Art Moderne, Paris. 1937 841 Side view 842 Eliel Saarinen. Cranbrook Academy of Art, Bloomfield Hills, Mich., Peristyle. 1940–42 843 Pietro Aschieri, Domenico Bernardini, and Cesare Pascoletto. Museo della Civiltà Romana, Rome. 1938–42 844 John Russell Pope. National Gallery of Art, Washington, D.C. 1936–41 845 Paul Ludwig Troost. Haus der Deutschen Kunst, Munich. 1933–37

Landscape of the Eye

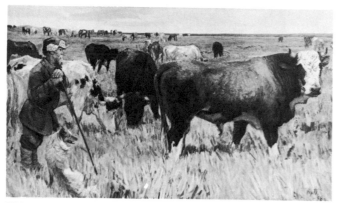

846

848

847

849

Soviet painters, German painters, and many American painters of the 1930s returned to various forms of naturalism and advocacy of an art based on national experience rather than on formal values. Landscape became a major theme. This trend was partly a rebellion against the acceptance of abstraction by the progressive art establishment, but to an even greater extent, it was a response to the political and economic realities of the Depression era.

In the Soviet Union an academic style called Socialist Realism was well established when Arkady A. Plastov painted a totally traditional picture emphasizing the health and sturdiness of Soviet livestock—*Col-*

lective Farm Cattle, done for the Commissariat of the Food Industry.

In Nazi Germany, where Hitler banned every progressive painting from Cézannes and Van Goghs onward from museum walls, Willy Paupie was admired by the new art establishment for his meticulous *Mountain Village in Winter*, in which he evidently misconstrued Pieter Bruegel's landscapes. The international art of the recent past was replaced by an art that would no longer alienate the ordinary German peasant, who wanted to see clear representations of his native hills, village, and fields.

Similarly, in the United States painting saw a return to the native soil, which was glorified by the

American Regionalists. Grant Wood, a leader of that movement, had painted in Paris in the early 1920s but returned to his native Iowa to extoll the stability of the land. His *Fall Plowing* shows the gently rolling hills of the Midwest plowed in perfect order; the haystacks and their shadows line up with military regularity. A wooden plow stands in the foreground as the age-old symbol of man's encounter with the earth. Peyton Boswell, editor of the influential magazine *Art Digest*, described Regionalism as "looking forward to the production of works of art that, avoiding foreign influences, actually express the spirit of the land."

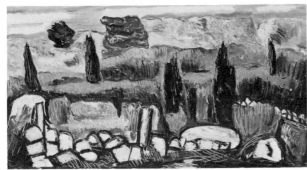

850

851

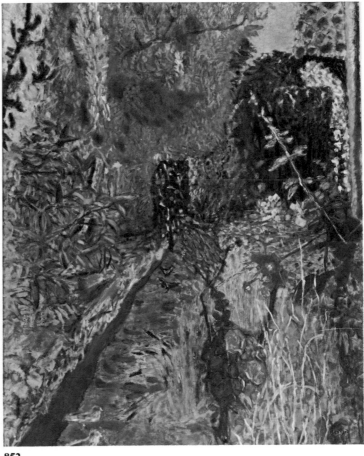

852

Charles Burchfield dealt with the landscape in a much more romantic vein. In *November Evening*, with its dark, threatening clouds, the old clapboard houses left, as he said, from "our tag-end pioneer days" and the farmer plowing the field evoke a mood of foreboding, enhanced by Burchfield's personal involvement in the subject.

Other artists transformed the landscape they saw into paintings of great freshness and beauty. John Marin created oils of verve and spontaneity, such as *Off Cape Split, Maine*. Energy and exhilaration of a different kind are evident in Marsden Hartley's painting of another stretch of Maine coast.

Hartley captured the eternal rocks and hills, while Marin was primarily concerned with finding visual equivalents of the forces of nature, the rhythms of the waves in the sea and the effect of light on color.

Pierre Bonnard was almost seventy when he painted his luxurious *The Garden*—a densely painted interweaving of color patches. It is a jungle, but not a threatening one; rather, the viewer stands in the midst of gently exploding organic growth. This work can be seen as an abstract all-over painting: every inch of the canvas is activated, there is no longer any foreground or background, and the viewer is enveloped in the visual experience of the picture.

846 Arkady A. Plastov. *Collective Farm Cattle*. 1938. Oil on canvas, 70 $^7/_8$ × 91 $^3/_8$" 847 Willy Paupie. *Mountain Village in Winter*. 1937 848 Grant Wood. *Fall Plowing*. 1931. Oil on canvas, 30 × 40" 849 Charles Burchfield. *November Evening*. 1934. Oil on canvas, 32 $^1/_8$ × 52" 850 John Marin. *Off Cape Split, Maine*. 1938. Oil on canvas, 22 $^1/_8$ × 28 $^1/_8$" 851 Marsden Hartley. *Dogtown, the Last of the Stone Wall*. 1936. Oil on academy board, 18 × 24" 852 Pierre Bonnard. *The Garden*. 1937. Oil on canvas, 50 × 39 $^3/_8$"

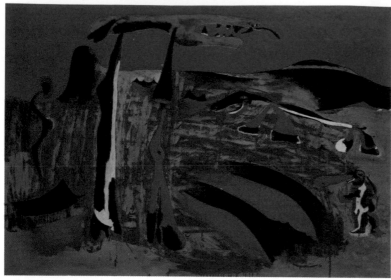

853

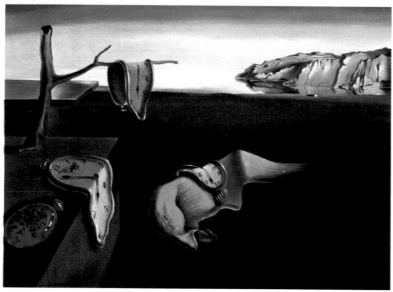

854

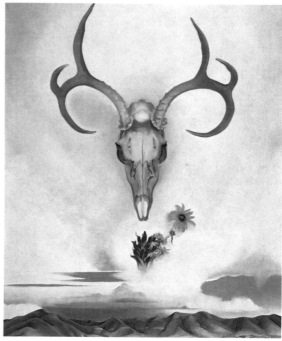

855

The French poet Paul Eluard observed that "the description of the landscape is of little importance," but that "all transformations are possible." When we look at Joan Miró's *Person in the Presence of Nature*, we realize that no one has ever seen bizarre creatures such as the gnome with his balloonlike nose. This painting was done in 1935, when Miró, living quietly in the south of France, was deeply troubled by the terror and brutality beginning to engulf Europe. The playfulness of Miró's canvases is gone. Instead, animals are changed into horrifying monsters with dragons' teeth, occupying a devastated landscape. Dali's meticulously painted *The*

Persistence of Memory is precise and explicit. Like a catchy tune or a fine illustration, this picture is highly memorable—what he called a "hand-painted dream photograph." The limp watches invented by Dali have become part of our visual vocabulary. Time is under attack and melting away. One watch droops over a gray object in the center. Appearing at first to be the corpse of an animal, it is actually a caricature, a self-portrait of the sleeping artist in profile.

Georgia O'Keeffe's *Summer Days* represents an animal skull with elegant antlers hovering in the cloudy sky and flowers floating beneath it over the red hills of the

American desert. It is an exercise of free imagination, counterpoising life and death. Yet it is quite different from the Surrealists' deliberate exploration of the unconscious. O'Keeffe's visionary landscape is both more simple and more direct. It is a collection of things she loved in the desert, and it is painted with balance and lucid precision.

Arthur Dove, who exhibited with O'Keeffe and John Marin in Stieglitz's An American Place gallery during these years, also painted landscapes that often take on a mystic, symbolic meaning. In *Moon* several spherical shapes expand from their nucleus, like ripples from a pebble thrown into water. The dark secret

857

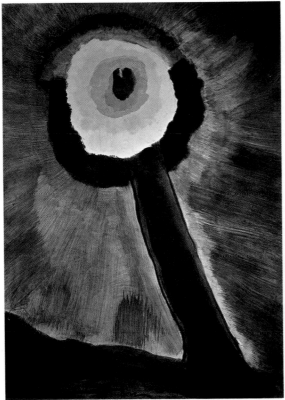

856

858

core of this evocative painting appears like a mandala, which the psychologist Carl Jung interpreted as an archetype of inner and outer order. This basic pattern occurs in a good many of Dove's paintings and lies at the center of his vision of energized order.

Augustus Vincent Tack's *Aspiration* is a landscape of the mind. It is sublime, in the Romantic sense, inspiring awe by its atmosphere of the grandeur of natural forces. Tack limits his palette here largely to various blues for the lower part of the picture, which suggests the earth, and light yellows for the upper part. The organic color segments in the lower regions are turbulent, striving upward toward the luminous celestial expanse. This painting of primeval chaos forming itself into order is similar to the work of the Abstract Expressionists in the next generation.

In 1932 Paul Klee completed one of his most ambitious paintings, *Ad Parnassum*. It epitomizes his Divisionist pictures made up of color dots, but unlike the Neo-Impressionists, who used the dots to achieve optical color mixture (see page 26), Klee introduces them into his work to fill space with light. It is also based on his series of magic squares (see plate 701), and it incorporates the consummate graphic quality of his line. It relates to Mount Parnassus, in Greece, sacred to Apollo and home of the Muses, but it also resembles the Egyptian pyramids, and the arch of the temple below the great triangle recalls the architecture of ancient Rome.

853 Joan Miró. *Person in the Presence of Nature*. 1935. Oil and gouache on board, 29 ³/₄ × 41 ¹/₂″ 854 Salvador Dali. *The Persistence of Memory*. 1931. Oil on canvas, 9 ¹/₂ × 13″ 855 Georgia O'Keeffe. *Summer Days*. 1936. Oil on canvas, 36 × 30″ 856 Arthur G. Dove. *Moon*. 1935. Oil on canvas, 35 × 25″ 857 Augustus Vincent Tack. *Aspiration*. c. 1931. Oil on canvas, 76 ¹/₂ × 135 ¹/₂″ 858 Paul Klee. *Ad Parnassum*. 1932. Oil on canvas, 39 ³/₈ × 41 ³/₄″

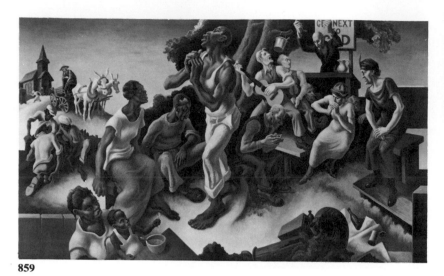

859

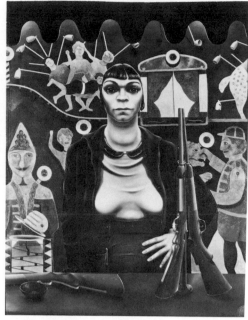

861

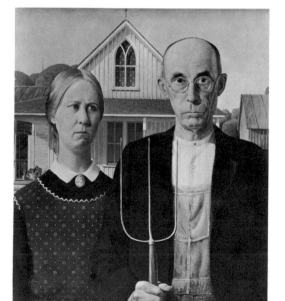

860

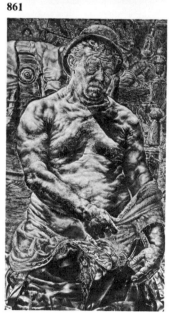

862

After participating in the modern movement in Paris, Thomas Hart Benton returned to Missouri, becoming the central figure of the American Regionalist movement. He advocated a public art for the people and painted a series of murals, one of which was on the theme *The Arts of Life in America*. The section entitled *Arts of the South* shows blacks and whites preaching, praying, dancing, throwing dice and doing farm chores—with rather contrived vigor.

Although the American Regionalists denounced European art, Benton owed a great deal to El Greco's distortion of the human figure, and his colleague Grant Wood was indebted to the detailed realism of Flemish Renaissance painting. *American Gothic*, probably the most popular painting in America in the decade, is an interesting mixture of approval and criticism. The title of the picture derives from the church-like window of the picturesque clapboard carpenter Gothic homestead.

The Dutch painter Pyke Koch also turned to the Northern realist tradition for a clear assault on bourgeois smugness in *The Shooting Gallery*. The linear composition is constructed of right angles, and the picture is executed in sharply focused photographic style. The woman standing behind her stacked guns confronts and challenges the viewer with merciless vulgarity and defiance.

All hope has vanished in Ivan Albright's *And God Created Man in His Own Image*, a sardonic, pessimistic comment on the condition of man in an existential, godless world. With minute care, Albright confronts the viewer with the harsh facts of lumpy skin, tattered clothes, a face reddened by drink and exposed by bare bulbs. This social commentary is one of the cruelest kinds; it forces the viewer to examine the reality of solitary life in its most brutal state.

A powerful attack on the modern social order, on ancient wars and human sacrifice, and on the history of European imperialism was mounted at the Baker Library of

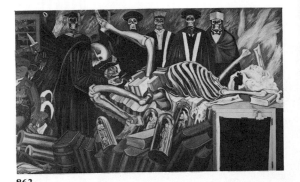
863

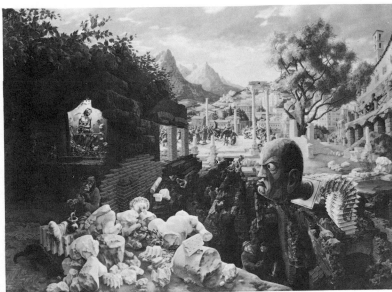
865

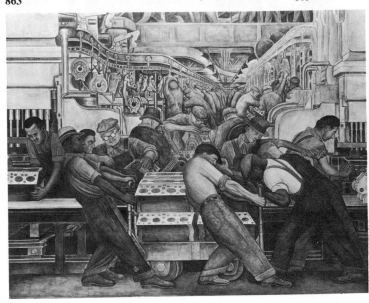
864

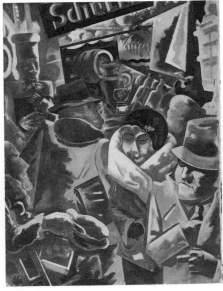
866

Dartmouth College, where José Clemente Orozco was commissioned to create frescoes dealing with American civilization. In *Modern Education* a row of dead gods of academia, with academic caps on their skulls, is seen behind a large yellow skeleton stretched out on books and test tubes. The pompous ritual and hypocrisy of sterile higher education is attacked with great insight and irony.

At the same time, another Mexican, Diego Rivera, was adorning the Detroit Institute of Arts with a mammoth fresco on the subject of *Man and the Machine*. Rivera visited Ford's River Rouge automobile plant and translated his on-the-spot sketches into the rhythmic rendering of workers bent shoulder to shoulder to mass produce for the modern gods of industry.

The American painter Peter Blume responded to the fascist dictatorship in *The Eternal City*, in which a jack-in-the-box with Mussolini's head in jarring green appears on the right, and the Man of Sorrows is on the left. Blume's political symbolism and his meticulous old-master technique earned him a popularity almost equal to that of Salvador Dali.

George Grosz's *Berlin Street* lacks the panoramic scope of Blume's Rome. It concentrates instead on the close crush of people hurrying past a well-stocked bar and restaurant—each, except the omnipresent beggar, shut up in private isolation and smugness.

859 Thomas Hart Benton. *Arts of the South*. 1932. Tempera on canvas, 96 × 156″ 860 Grant Wood. *American Gothic*. 1930. Oil on beaverboard, 29 $^7/_8$ × 24 $^7/_8$″ 861 Pyke Koch. *The Shooting Gallery*. 1931. Oil on canvas, 67 × 51 $^1/_4$″ 862 Ivan Albright. *And God Created Man in His Own Image*. 1930–31. Oil on canvas, 48 × 26″ 863 José Clemente Orozco. *Modern Education: Gods of the Modern World*. 1932–34. Fresco 864 Diego Rivera. *Making of a Motor* (detail of north wall of mural court). 1932–33. Fresco 865 Peter Blume. *The Eternal City*. 1934–37. Oil on composition board, 34 × 47 $^7/_8$″ 866 George Grosz. *Berlin Street*. c. 1931. Oil on canvas, 32 × 23 $^5/_8$″

Art and Society: Protest and Propaganda

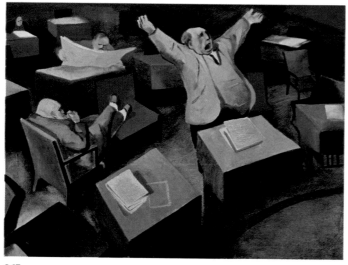

867

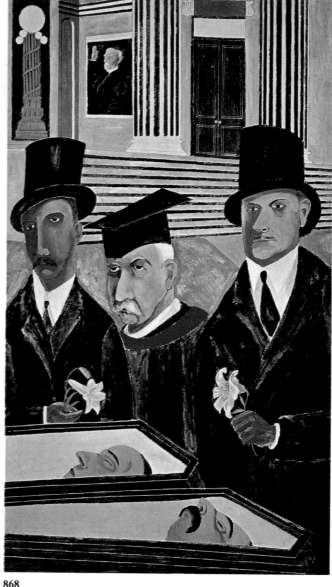

868

Sharply critical of the social order and the political establishment, William Gropper painted *The Senate* to describe the bombast, the boredom, the irresponsibility, and the disaffection of the politicians on Capitol Hill. Gropper had studied with Robert Henri, was a great admirer of Daumier's trenchant political caricatures, and had worked himself as a radical cartoonist before turning to painting in the 1920s. In this, his most famous painting, he was able to strip the institution of the Senate of its sacrosanct trappings and expose its vulnerability. Gropper thereby helped secure himself an important niche in Social Realist painting of the 1930s.

Ben Shahn was born in Lithuania and brought to Brooklyn as a child. He was trained as a commercial lithographer as well as a painter and also became known as a fine documentary photographer. By the 1930s he had achieved the most prominent place among the Social Realists, largely because of his series on *The Passion of Sacco and Vanzetti*, the two Boston anarchists who were arrested during the "red" hunts of the 1920s, convicted on flimsy evidence, and sentenced to execution by a biased judge. Shahn stated: "I was living through another crucifixion. Here was something to paint." He created a powerful and imaginative indictment against injustice by de-

picting the victims not heroically or symbolically, but with an almost naïve, childlike simplicity. We see the two victims in their coffins after their execution. Standing next to them in mock piety are the members of the Lowell Commission, who had sanctioned the controversial trial. The judge is seen in the background. Shahn's flat, clear silhouetting served him well in his endeavor to characterize the individuals as part of a strong, direct pictorial composition.

In Soviet Russia and Nazi Germany at this time, we find only praise, no criticism, of the social and political order. The officially approved artists in the totalitarian

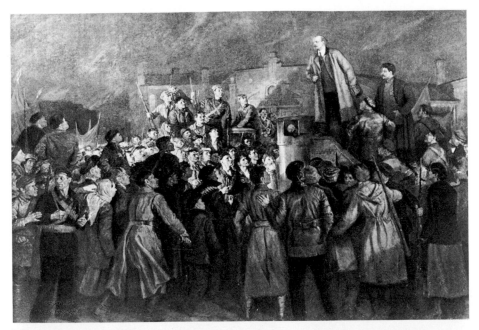

869

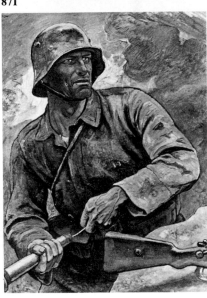

871

870

872

countries worked in a regressive, academic style, which by itself belies any revolutionary pretense. Typical of such painting is Vladimir Serov's *Lenin's Arrival in Petrograd, 1917,* painted in 1937. Lenin, the hero, is giving the word to the workers, peasants, and soldiers surging toward him upon his arrival from exile. He is backed up by Stalin, who, in fact, was not present at this historic occasion. An almost identical composition, painted the same year, had the incredibly pretentious title *In the Beginning Was the Word.* It shows Adolf Hitler, also on the right side of the painting, exhorting his early followers at some mythical cellar meeting. Both leaders are speaking

to groups of people who are meant to represent the masses whom they educate as well as inspire.

The common man, in turn, can aspire to become a people's hero, a glorious soldier in uniform, defending the country. As early as 1929 N. I. Strunnikov portrayed *Partisan A. G. Lunev* in a thoroughly traditional style. A more aggressive pose is assumed by Elk Eber's determined hero in *The Last Hand Grenade,* who stands behind his gun emplacement, ready to detonate the deadly missile.

867 William Gropper. *The Senate.* 1935. Oil on canvas, 25 $^1/_8$ × 33 $^1/_8''$ **868** Ben Shahn. *The Passion of Sacco and Vanzetti.* 1931–32. Tempera on canvas, 84 $^1/_2$ × 48'' **869** Vladimir Serov. *Lenin's Arrival in Petrograd, 1917.* 1937. Oil on canvas, 116 $^1/_2$ × 168 $^1/_2''$ **870** Hermann Otto Hoyer. *In the Beginning Was the Word.* 1937 **871** N. I. Strunnikov. *Partisan A. G. Lunev.* 1929. Oil on canvas, 46 $^7/_8$ × 34 $^5/_8''$ **872** Elk Eber. *The Last Hand Grenade.* 1937

Art and Society: The Civil War in Spain

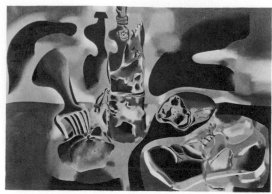

874

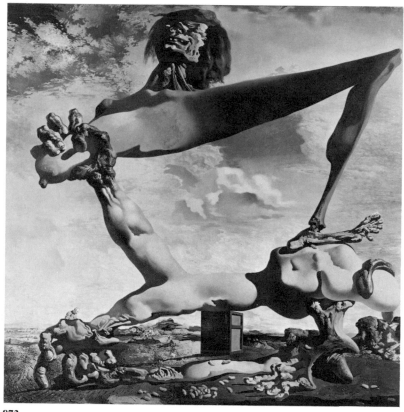

873

875

The first battlefields of World War Two were in Spain. There the German and Italian as well as the Soviet military forces found their first testing grounds. The Spanish Civil War (1936–39) had a profound impact on artists, writers, and others who realized that if democracy was to survive, the forces of fascism in Spain had to be held in check. In 1936 Salvador Dali expressed his concern in *Soft Construction with Boiled Beans: Premonition of Civil War*, combining an obsession with anatomic and sexual symbolism with a fairly obscure political message.

More complex is Joan Miró's *Still Life with Old Shoe*. It is a transfigured still life: the bottle, the bread, the apple and fork, as well as the old shoe, are all transformed by a fantastic use of color and distortion of form. These simple objects have become frantic, threatening, savage images, as the Spanish painter, though living in France, felt that the civilized world was being destroyed.

More direct in its experience of war is *Echo of a Scream*, by Mexico's David Alfaro Siqueiros. In this work the artist, who fought for the Spanish Republic, attacks the horrors of war with potency and imagination. A baby, with a hugely magnified image of his head behind him, cries out amid the metallic rubble of the instruments of war and annihilation.

The brilliant German political satirist John Heartfield, a former leader of the Berlin Dada group, responded to the political events with one of his many piercing and eloquent photomontages, *That Is the "Heil" They Bring*. The caption is a play on the Hitler salute, "Heil," a German word that actually means safety and happiness.

The bombing of the Basque town of Guernica by the German Luftwaffe in April of 1937 led Picasso to create his great mural *Guernica*. The work was commissioned by the Republican government of Spain for its pavilion at the Paris Universal Exposition, where, ironically, it was located in close proximity to the

876

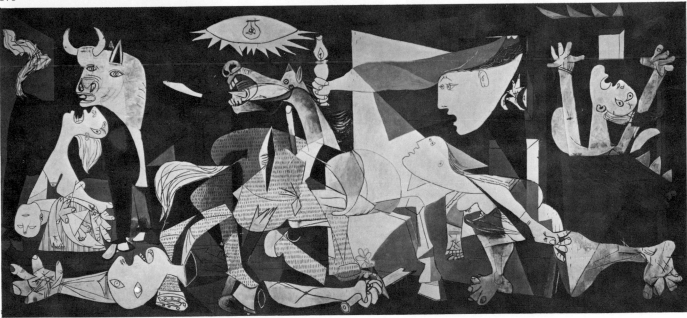

877

German Pavilion (pages 300–1). Still using a basically Cubist idiom, Picasso commemorates the bombing of Guernica in a general and universal manner. The canvas has the format of an epic painting, and the viewer must take time to look from one side to the other of this twenty-five-foot mural. The composition recalls the heroic sculptures that embellish the pediments of Greek temples. Here the apex of the triangle is indicated by a kerosene lamp being thrust forward by the arm of a woman. Perhaps the lamp is a symbol of hope.

Picasso condensed the facts of the bombardment in space and time. The crowds fleeing the bombs are absent. There are only nine figures: four women, a child, a fallen warrior, a bull, a horse, and a bird. It is the women who enact the drama. They scream, run, fall, and carry the light. They symbolize the assault on humanity. At the top of the canvas is the Surreal image of a vigilant eye with its eyeball formed by a naked electric bulb and its lower eyelid resembling jagged light rays. Underneath, the horse, in great agony, is contrasted to the dominant stolid bull. It is unclear whether the bull, which has a long symbolic history in all Mediterranean cultures, represents the Spanish people or Franco and the foreign aggressors.

873 Salvador Dali. *Soft Construction with Boiled Beans: Premonition of Civil War.* 1936. Oil on canvas, 43 $\frac{1}{4}$ × 33 $\frac{1}{8}$″
874 Joan Miró. *Still Life with Old Shoe.* 1937. Oil on canvas, 32 × 46″ **875** David Alfaro Siqueiros. *Echo of a Scream.* 1937. Duco on wood, 48 × 36″ **876** John Heartfield. *That Is the "Heil" They Bring.* 1938. Photomontage, 15 × 10 $\frac{5}{8}$″
877 Pablo Picasso. *Guernica.* 1937. Oil on canvas, 138 × 308″

The City

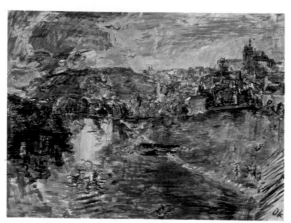

878

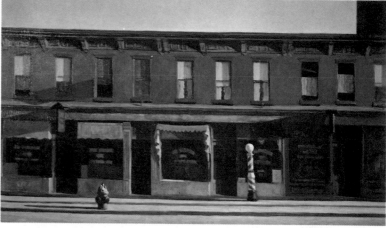

880

879

881

With the threat of the Nazi invasion of Austria, Oskar Kokoschka, against whom the Nazis had a particular vendetta, left Vienna for Prague in 1934. He recorded the Golden City on the banks of the Moldau, illuminating its character and atmosphere by painting its "portrait," as he had done for London some ten years earlier (plate 663).

Prague's great poet, Rainer Maria Rilke (plate 205), was enthusiastic about the extraordinary artistic talent of the fourteen-year-old Balthus Klossowski de Rola when he met him in Switzerland in 1922. Several years later Balthus, as he prefers to be called, had settled in Paris, and there began painting magic and disturbing pictures of the city. While in his teens, he also copied frescoes by Piero della Francesca. The solidity of the great Renaissance painter comes across in Balthus's nine individuals in their alienated encounter in *The Street*. The figures, walking as if hypnotized or marionettes, each in his or her own bizarre reality, create a haunting atmosphere.

Edward Hopper, who was born in New York and was a student of Robert Henri's, achieves a similar feeling of strange anxiety in his *Early Sunday Morning*. The street with its monotonous brick houses is deserted in the clear and crisp early morning light. The composition is carefully constructed: the windows and doors, hydrant, and barber pole give a definite rhythm of verticals to the seemingly endless horizontal expanse. The bleak painting leaves us with a sense of waiting, detachment, loneliness.

Stuart Davis was also a Henri student, and his city scene is also devoid of people. But by the interaction of abstract pattern, variegated textures, bright colors, and innovative spatial composition Davis achieves a human feeling and a lively, exciting urban environment. He presents two views of the city landscape, using the sequence of the cinema or film strips.

Much of Charles Sheeler's work of the 1930s is based on photography, a medium in which he also excelled.

882

884

883

885

Focusing on the inner workings of the city, its factories and freight yards, he represented in *City Interior* what he saw with immaculate exactitude and in a brightly lighted orderliness.

Reginald Marsh paints the crowded city streets and devastating effect of the Great Depression in a generally traditional narrative style. In his typical painting *The Bowery*, men cluster in groups next to the old elevated train. Poor and unemployed, they offer each other simple warmth, but have abandoned hope. The often repeated hotel signs promise only lice-filled rooms crowded with unwashed, smelly bodies.

Philip Evergood's daytime cast differs considerably from Marsh's night group. Several of Evergood's people have a definite function, as indicated by the neomedieval device of showing them with their implements. Even the street urchins are busy, and no one looks down at the scraps of headlines in the gutter celebrating crime, gossip, and war.

Just before creating his early masterpiece *Broadway*, Mark Tobey had studied Oriental calligraphy in a Zen monastery in Japan. The "white writing" that derived from this experience is a nervous, energetic course of the brush which seems to follow its own movement. At the same time, the undulating linear quality of this work illuminates the night life in Times Square, the noise of the street, and the crush of multiple layers of existence. The autonomy of brush and line and the description of the actual scene are part of the unity of art and nature which is a key to Tobey's vision.

878 Oskar Kokoschka. *View of Prague from the River.* 1936. Oil on canvas, 38 × 52″ **879** Balthus. *The Street.* 1933. Oil on canvas, 76 ³/₄ × 94 ¹/₂″ **880** Edward Hopper. *Early Sunday Morning.* 1930. Oil on canvas, 35 × 60″ **881** Stuart Davis. *House and Street.* 1931. Oil on canvas, 26 × 42 ¹/₂″ **882** Charles Sheeler. *City Interior.* 1936. Oil on fiberboard, 22 ¹/₈ × 27″ **883** Reginald Marsh. *The Bowery.* 1930. Tempera on canvas, 48 × 36″ **884** Philip Evergood. *Street Corner.* 1936. Oil on canvas, 30 × 55″ **885** Mark Tobey. *Broadway.* 1936. Tempera on masonite board, 26 × 19 ¹/₂″

Modern Allegories

887

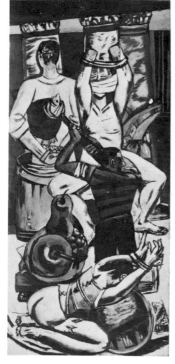

886

While *Guernica* makes reference to a specific historic event, Max Beckmann's *Departure* deals with man's predicament more enigmatically, drawing on ancient Greek, biblical, and Indian mythology. Beckmann chose the traditional form of the triptych—originally reserved for altarpieces. The two side panels refer to the present situation as the artist experienced it in Nazi Germany. Against the dim and crowded life of oppression and brutality, torture and mutilation of the side panels, the center panel is open and filled with hope. The figures have room, they are larger, almost monumental in scale, and in contrast to the dark hues on either side, the colors here

are primaries, painted at high intensity in the full light of a bright morning. Beckmann, in referring to the ancient myth of the Great Flood, deals with the contrast of the catastrophe and redemption. In the center panel he presents us with a new beginning, with the renewal of life toward human freedom. The hooded man, the fisher-king, and the woman with a child are floating in a barge on a luminous blue sea. The woman is an allegory of hope. She wears the Phrygian cap of classical Greece, while the king is ennobled with a medieval crown. He pulls in a full net with his left hand, while his right, lifted in a royal gesture, signals his rejection of the despair of the events in the

side panels. He gazes across the waters into a distant space, a world unknown but free.

Artists working in a "modern" idiom do not paint widely known, easily understood allegories, as artists of the past were apt to do. When Orozco painted his *Prometheus* fresco at Pomona College in California, he chose not to depict the hero of Greek mythology in the traditional manner—bound to a rock with heavy chains as punishment for stealing fire from the gods. Instead, the Mexican artist painted a gigantic figure of the Titan reaching upward and losing his hands in the fires of the heavenly hearth. At his sides are passionate masses of

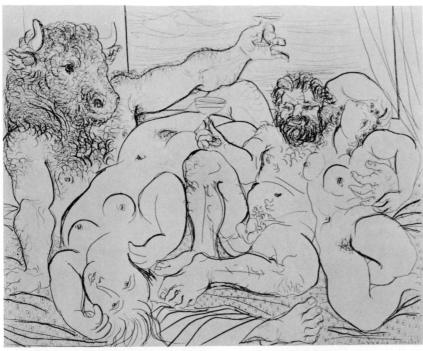

888

889

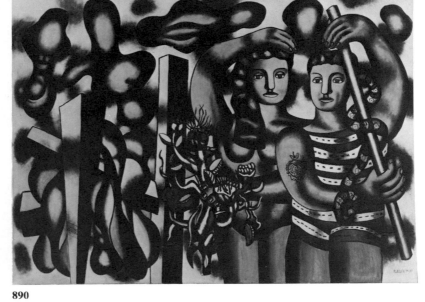

890

humanity, gesturing their acclaim on the left, disparaging him on the right: a metaphor for the blessed and the damned.

Both Picasso and Braque, who had worked almost as one in formulating Cubism, later turned to Greek myths for their themes. Picasso's interest had been reawakened by the 1920s, when he painted in a style often called classical (plate 619), and he continued to explore the myth of the Minotaur (see page 264) for most of his life. Here the Minotaur is serving as artist's model. Braque's foray into a classical myth at this time was stimulated by a commission from the dealer Ambroise Vollard (plate 202), who also published many sumptuous volumes

and portfolios with work by Picasso, Chagall, Bonnard, Matisse, Masson, and others. Braque's *Hercules*, done for a deluxe edition of Hesiod's *Theogony*, was executed in a free linear idiom which had its origin in the artist's study of Greek vase painting.

Fernand Léger was also engaged in mural painting in the 1930s, and it was then that he composed *Adam and Eve*. Léger wanted to create a grand public art in this architecturally ordered composition. Here he chose a biblical theme, but his ponderous figures resemble acrobats. Massive, immobile, and inaccessible, they do not stir our emotions. More than half of the ten-foot-long canvas is taken up by structural objects

and cloud forms. Except for the bright, colorful flowers in the woman's hand, the colors are very subdued ochers and steel blues, with some yellow and black. Human beings and nature have assumed an emblematic character, in a painting in which classic formal clarity is of the essence.

886 Max Beckmann. *Departure.* 1932–33. Oil on canvas, triptych, center panel 84 3/4 × 45 3/8''; side panels 84 3/4 × 39 1/4'' **887** José Clemente Orozco. *Prometheus.* 1930. Fresco. Frary Dining Hall, Pomona College, Claremont, Calif. **888** Pablo Picasso. Vollard Suite, pl. 85 (*Drinking Minotaur and Sculptor with Two Models*). 1933. Combined technique, 11 11/16 × 14 3/8'' **889** Georges Braque. *Hercules.* 1932. Engraved plaster, 10 5/8 × 8 1/4'' **890** Fernand Léger. *Adam and Eve.* 1935–39. Oil on canvas, 89 3/4 × 127 3/4''

Two Kings and an Emperor

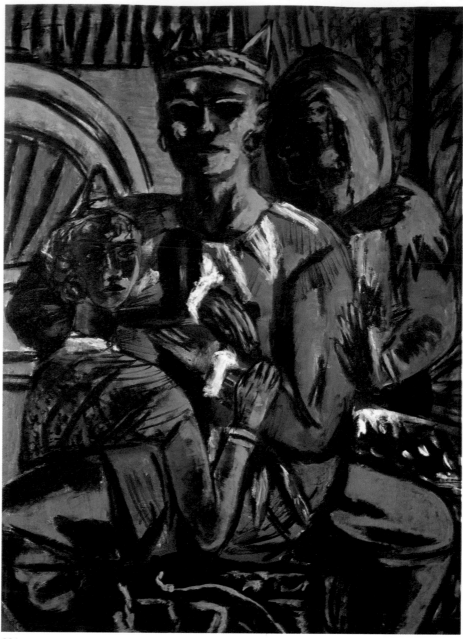

891

If there is such a thing as a mainstream in art, Georges Rouault and Max Beckmann were not part of it, although Rouault exhibited with the Fauves in 1905 and Beckmann has mistakenly been identified with the German Expressionists. They shared, however, a deep concern for the place of man and his alienation in the modern world; they had both painted pictures of Christ as well as prostitutes; they were absorbed in cruelty and myth, and they developed styles that are among the most individualistic of the first half of the century. In the 1930s they both completed images of kings.

Beckmann painted his splendid picture *The King* in 1937. His king bespeaks intractable tenacity. He is a hieratic figure, seen frontally with legs spread out. He stares at the viewer (the world?) from the deep cavities of his eye sockets. Beckmann's king is not alone, but is accompanied by two mysterious women. An intriguing play of hands occurs among the three figures. Like Rouault, Beckmann uses black outlines within this painting of dark, glowing colors. Unlike Rouault, however, Beckmann crowds every inch of the picture space in this foreboding depiction of power and fear, supplication and rejection, silence and mystery. Beckmann's *King* has the artist's own features. It is a veiled self-portrait of the artist,

his first wife standing behind him, his second wife leaning on his knee, and the wheel of fortune behind them.

Rouault's *The Old King* is a thickly painted canvas, glowing with the luminosity of stained glass. The artist had been apprenticed to a stained-glass maker in his youth, and the heavy black outlines of this painting are clearly derived from the leading in stained-glass windows. Rouault's king is a mystic and spiritualized biblical image. The old man, in severe profile, with gold crown and necklace and crimson robe, tenderly holds a flower and sits in resigned contemplation.

Early in World War Two, after

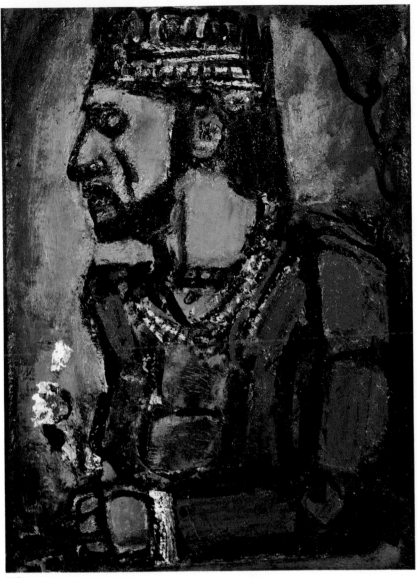

892

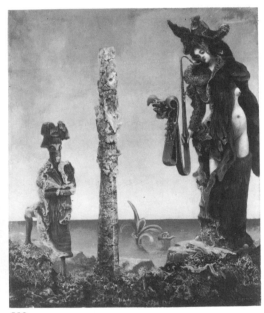

893

being interned by both the French and the Germans, Max Ernst was able to escape from Europe, only to be interned again in New York upon his arrival in the United States. With him he brought his canvas of *Napoleon in the Wilderness*. Before leaving France in 1940, Ernst had laid down the decalcomania ground for it—decalcomania is a Surrealist device of squashing thin wet paint onto the canvas with a pane of glass, thereby producing an uneven spread of pigment and color of varying intensity—but he was able to complete the work only after reaching California in 1941. Ernst used the decalcomania technique because it yielded him totally unexpected tex-

tures and helped him find surprising images: Napoleon, the totem, and the seminude woman with her imaginary musical instrument with a fabulous beast on the bell. As brushwork was added to the decalcomania, a transformation of the medium took place and suggested the metamorphosis of plant-human-bird to the artist. The strange figure of Napoleon with its horse's head and legs, standing in the emperor's typical pose with arms akimbo, was evoked, Ernst tells us, by his thoughts of St. Helena, i.e., exile, and his concern with the dictator. But what about the vegetal phallic column and the erotic siren who dominates the painting?

891 Max Beckmann. *The King.* 1937. Oil on canvas, 53 $\frac{1}{4}$ × 39 $\frac{1}{4}$" **892** Georges Rouault. *The Old King.* 1937. Oil on canvas, 30 $\frac{1}{4}$ × 21 $\frac{1}{4}$" **893** Max Ernst. *Napoleon in the Wilderness.* 1941. Oil on canvas, 18 $\frac{1}{4}$ × 15"

Portraits

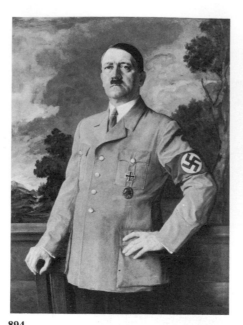

894

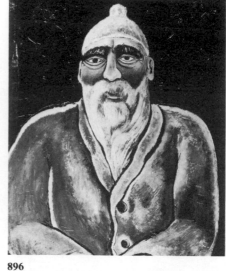

896

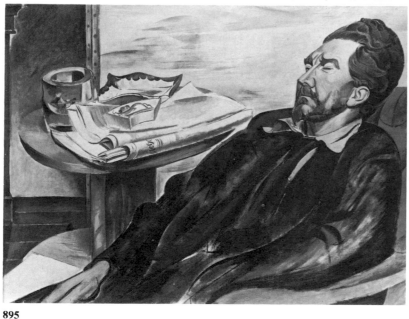

895

897

In his official *Führerbildnis (Portrait of the Führer)*, the Nazi painter Heinrich Knirr made use of the props in Titian's famous portrait of Charles V in Munich's Alte Pinakothek, in which the emperor is seated in front of a balustrade with a grand park and dramatic clouds in the background. In a calculated effort to legitimize the self-appointed leader from the beer halls of Munich, he depicted Adolf Hitler in the traditional European monarchic pose; his painting was one of the most widely reproduced canvases of the Führer.

An admirer of fascism, but also a great poet who strongly influenced the English and American literary avant-garde, was Ezra Pound. Wyndham Lewis, earlier the leader of the short-lived Vorticist movement in England (see page 135), made this highly accomplished portrait of Ezra Pound at a time when, largely because of photography, the art of portraiture was generally on the decline. Showing the energetic poet in a state of relaxation, eyes closed but not asleep, Lewis reveals his sense of plastic form at its best in the finely chiseled semi-Cubist features of the poet's head.

Marsden Hartley's *Portrait of Albert Pinkham Ryder* is a mythological, iconic image of the earlier American painter done more than two decades after his death. Hartley admired Ryder's mastery of the arabesque and the austerity of his moods (see plate 58). Although Hartley had long ago discarded the abstract style of his *Portrait of a German Officer* (plate 268), his painting of Ryder has an even stronger formal quality.

Milton Avery made a small, simple, contemplative portrait of a younger contemporary in 1933, when he painted the likeness of Mark Rothko. It is a tender picture, done in soft colors. Some thirty years later in his eulogy on Avery, Rothko recalled being both subject and "idolatrous audience" to Avery and spoke of his "inner power in which gentleness and silence proved . . . audible and poignant."

899

898 900

Victor Brauner's cool *Self-Portrait*, with its right eye torn out, seemed a perfect Surrealist symbol for the visual artist's psychic fears. It proved prophetic, however, in 1938, when Brauner did lose an eye when interceding in a brawl.

Hard and incisive realism marks Charley Toorop's *Portrait of the Raedecker Family*. Charley Toorop was the daughter of Dutch Symbolist painter Jan Toorop and was under Van Gogh's influence early in her career. But in the period between the wars her sharp-focus realism and sense of structure were clearly under the influence of the investigations of pure form by artists of De Stijl (Mondrian, Van Doesburg, Riet-

veld); her aggressively realistic portraits also point to the tough Photorealism of the 1970s.

Florine Stettheimer, an American who has received little artistic recognition since her death, in 1944, was very much a part of New York artistic and intellectual life in the 1920s and 1930s, but it was as the hostess of her own salon, rather than as an artist, that she was known. She did, however, have an outstanding sense of color and a feeling for fantasy admirably expressed in *Family Portrait, II*, in which the members of her family (named with great care on a kind of patchwork rug made of pieces recalling pennants from a football game) sit and walk

in a stylish stagelike tearoom, with a transparent ghostly version of the Chrysler Building in the background. This picture transforms the exotic decadence of the Symbolists of the 1890s into modern garb.

894 Heinrich Knirr. *Führerbildnis (Portrait of the Führer)*. 1937 **895** Wyndham Lewis. *Ezra Pound*. 1939. Oil on canvas, 30 × 40″ **896** Marsden Hartley. *Portrait of Albert Pinkham Ryder*. 1938–39. Oil on canvas, 28 × 22″ **897** Milton Avery. *Portrait of Mark Rothko*. 1933. Oil on canvas, 22 × 16″ **898** Victor Brauner. *Self-Portrait*. 1931. Oil on wood **899** Charley Toorop. *Portrait of the Raedecker Family*. 1935–38. Oil on canvas, 26 ³/₄ × 31 ¹/₂″ **900** Florine Stettheimer. *Family Portrait, II*. 1933. Oil on canvas, 46 ¹/₄ × 64 ⁵/₈″

Pure Form

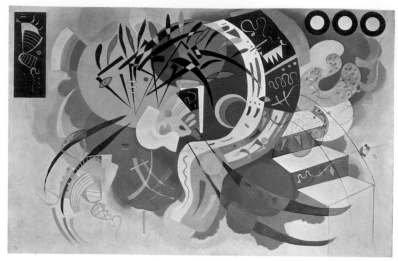

901

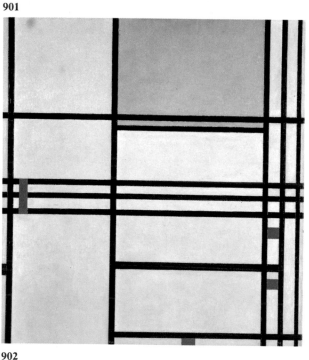

902

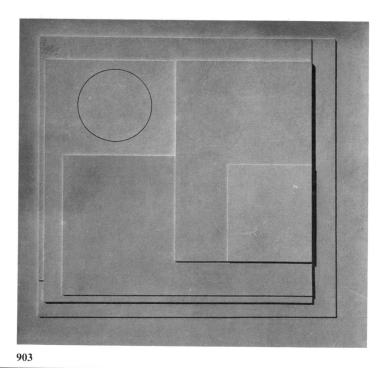

903

Kandinsky left Germany in 1933, when the Nazis closed the Bauhaus, and moved to Paris. There his work underwent its final major change. His painting became degeometricized; it became exuberant and rich and reached new heights of vitality. Intricate Eastern—and Scythian—calligraphic and arabesque elements appeared and expanded of their own volition, with luminous color, and a variety of textures. In *Dominant Curve*, painted when he was seventy, Kandinsky reached an art not easily accessible—a synthesis of his early Expressionist and later geometric phases, of intuition and intellect, of solemnity and play.

In Kandinsky, form, although abstract, is still the carrier of feeling. For Mondrian form stands by itself. The Dutch painter decided early on to eliminate tragedy and all traces of emotion from his canvases in order to create an art of pure relationships of color, line, and plane in asymmetrical balance and dynamic equilibrium. In *Painting No. 9* a large yellow rectangle, small blocks of red, and a network of black lines define a flat surface, and the painting itself is both subject and object.

Ben Nicholson, son of Sir William (page 98), was an early admirer of Mondrian's and turned toward pure abstraction in the 1930s. *White Relief*, consisting of geometric shapes, is a concrete physical object in white monochrome. In concept and execution it is in that subtle area between painting and sculpture. But Nicholson also establishes an architectural relationship between the shallow geometric relief and the space and light surrounding it.

Ben Nicholson and his wife Barbara Hepworth were the British contingent of the Abstraction-Création group, founded in Paris in 1931 on the principles of pure abstract or "concrete" art. Among its members were the Russians Gabo and Pevsner, Max Bill from Switzerland, the Belgian Georges Vantongerloo, and a few Parisians—Michel Seuphor, Auguste Herbin, and Jean Hélion. Hélion's *Composition* uses a kind of synthetic

904

905

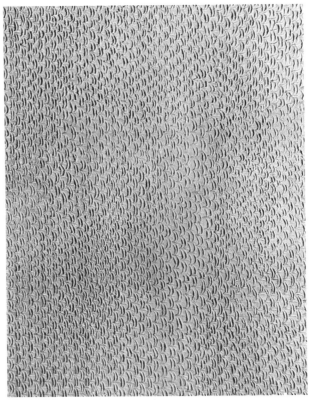

906

illusionism for strongly modeled, machinelike volumetric shapes, disposed rhythmically on their ground.

In America—despite the popularity of Regionalism and Social Realism—abstract art, primarily of the geometric variety, attracted an impressive number of artists. In 1936 many of them organized themselves in the American Abstract Artists. One of the original members, Burgoyne Diller, had been appointed in 1935 to head the Mural Division of the WPA in New York. Diller's work exists within the limitation of De Stijl principles, but he created paintings of faultless proportions and well-reasoned surface tensions, such as *First Theme*. The movement

here is determined by the action of the primary color planes in relation to each other and the dark ground.

Some of the most advanced abstractionists worked in Poland between the two wars. The most noteworthy Polish nonobjective artist of this era was Wladyslaw Strzeminski, who painted canvases of uniform monochromes, such as *Unistic Composition 11*, renouncing even the use of color as well as the illusion of time and space. As in the work of the Minimalists several decades later, all that is to be seen in one of his pictures is what is actually there. The painting is an object, a "thing" reduced to the reality of pure visual presence. It is not anything else.

901 Vasily Kandinsky. *Dominant Curve, No. 631.* 1936. Oil on canvas, 50 $^7/_8$ × 76 $^1/_2$" **902** Piet Mondrian. *Painting No. 9.* 1939–42. Oil on canvas, 31 $^1/_4$ × 29" **903** Ben Nicholson. *White Relief.* 1930. Painted wood, 41 $^1/_2$ × 39 $^3/_8$" **904** Jean Hélion. *Composition.* 1934. Oil on canvas, 56 $^5/_8$ × 78 $^3/_4$" **905** Burgoyne Diller. *First Theme.* 1933–34. Oil on canvas, 30 × 30" **906** Wladyslaw Strzeminski. *Unistic Composition 11.* 1931–32. Oil on canvas, 19 $^5/_8$ × 15"

Nudes

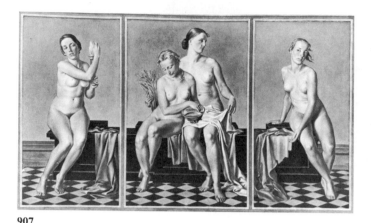

907

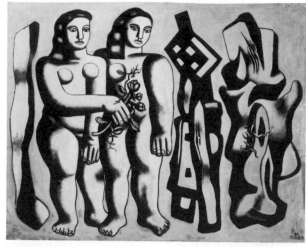

909

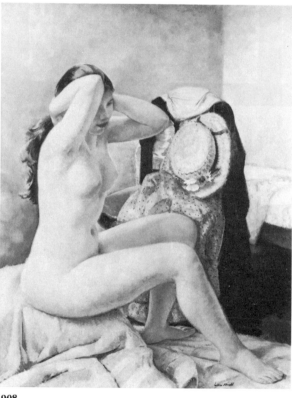

908

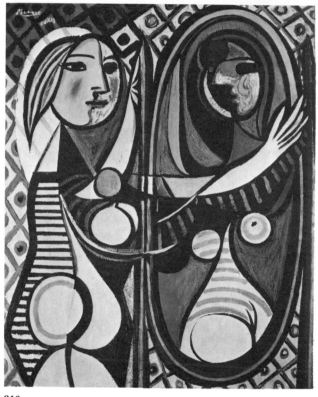

910

No other theme could summarize the great variety of styles of the 1930s better than the most traditional subject, the female nude. On the extreme right was Adolf Ziegler's *The Four Elements*. In this work, which simulates the classical tradition, the artist has created a triptych of the allegories of Fire, Water, Earth, and Air. The sexual character of the four women, obvious but suppressed, earned the appellation of "Master of the Pubic Hair" for Herr Ziegler, who was Hitler's favorite artist. The painting hung over Hitler's desk in the chancellery in Berlin.

Leon Kroll, a popular American painter of the 1930s, worked in a more recent tradition, derived from Renoir. He endowed his *Nude* with a feeling of simple humanity and warmth in a painting typical of much of the figurative work being done in the United States at the time.

For the masters of French painting the nude remained an engrossing subject. Fernand Léger moved far from his mechanistic *Three Women* of 1921 (plate 669) to depict earthy creatures rooted in Mediterranean mythology, one holding a flowering branch as an age-old symbol of fertility, and accompanied by vertical forms that embody both organic and mechanistic existence.

In Pablo Picasso's highly complex *Girl before a Mirror* the image of his lover Marie-Thérèse Walter on the left is seen simultaneously both frontally and in profile. A standing mirror, indicated by a vertical orange and black stripe, separates the girl's youthful and rather bland figure from the more expressive image of an older woman. This second figure is painted in slightly—but significantly—deeper colors. Perhaps she represents the maturing woman, perhaps the girl's inner being. Both images emphasize the sexuality of the girl, who has been described as "simultaneously clothed, nude and X-rayed." The whole work has a sumptuous stained-glass effect.

Henri Matisse's *Pink Nude* is both more restrained and more voluptuous. The colors of this picture are

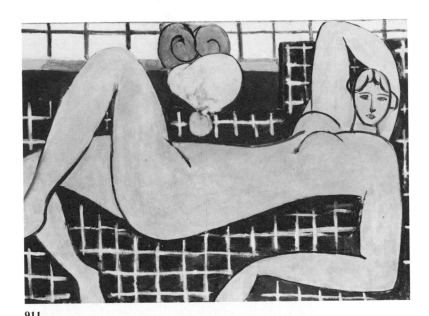

911

912

913

914

915

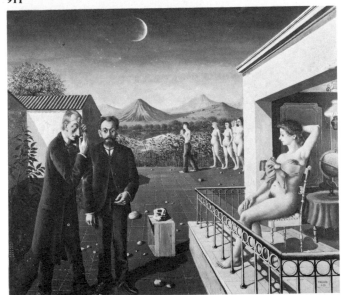

917

916

primarily the pink of the majestically disposed model and the blue of the grid background. Instead of Picasso's psychological tension, the older painter has represented the carefully studied nude in the traditional pose of Venuses and Odalisques—lying in repose with her arm behind her head. But the figure has been flattened out, and we are reminded of what Gustave Moreau told Matisse when Matisse was still his student: "You were born to simplify painting."

Very different images of women were created by the Belgian Surrealists. In *The Eternal Evidence* René Magritte dismembered the female anatomy into five sections, each of which is framed separately.

The spectator is confronted with an unexpected and enigmatic view of a standing nude who has been cut up but bears no trace of violence.

Paul Delvaux painted a dream sequence with great precision in *Phases of the Moon*. Women, generally in an erotic or sexual context, are the center of Delvaux's world. Here a woman, naked except for a pink bow, is seated in a chair while a scientist, oblivious to her charms, is engaged in a myopic investigation, and another man stares vacantly at the spectator. More nude women are walking in the distance. The painting's title, the waxing moon, and the somewhat pregnant-looking nude females suggest a reference to the

monthly cycles of women. The women the two Belgians painted are passive and desirable sex objects living in a voyeur's dream world of erotic observation.

907 Adolf Ziegler. *The Four Elements.* 1937. Oil on canvas, center panel 67 $^3/_8$ × 43 $^1/_4$''; side panels 67 × 33 $^1/_2$'' **908** Leon Kroll. *Nude.* 1933–34. Oil on canvas, 48 × 36'' **909** Fernand Léger. *Two Nudes and Three Objects.* 1936. Oil on canvas, 51 $^1/_4$ × 63 $^3/_4$'' **910** Pablo Picasso. *Girl before a Mirror.* 1932. Oil on canvas, 63 $^3/_4$ × 51 $^1/_4$'' **911** Henri Matisse. *Pink Nude.* 1935. Oil on canvas, 26 × 36 $^1/_2$'' **912–916** René Magritte. *The Eternal Evidence.* 1930. Oil on canvas; five panels, top to bottom: **912** 8 $^5/_8$ × 4 $^3/_4$'' **913** 7 $^1/_8$ × 9'' **914** 10 $^3/_8$ × 7 $^1/_4$'' **915** 8 $^1/_2$ × 6 $^1/_8$'' **916** 8 $^1/_2$ × 4 $^1/_2$'' **917** Paul Delvaux. *Phases of the Moon.* 1939. Oil on canvas, 55 × 63''

Six: The 1940s

On September 1, 1939, the German army invaded Poland and began a worldwide conflict that lasted for six years. During World War Two more people—both military and civilian—were killed than in any other conflict in man's recorded history. The decade ended with the cold war and another armed conflict on the Korean Peninsula.

Germany's unprovoked attack on Poland brought a declaration of war on the part of Britain and France. It occurred only a little less than a year after Prime Minister Neville Chamberlain had returned to England from his meetings with Hitler in Munich, promising "peace in our time." But Winston Churchill's reply—"You have gained shame and you will get war"—proved correct.

Nazi Germany, having signed a nonaggression pact with Stalin's Soviet dictatorship, had prepared well. The Polish army collapsed after a few weeks of German blitzkrieg, and Soviet forces occupied the eastern half of the country by a prearranged accord with Germany. The following spring German forces invaded Denmark and Norway to secure Europe's northern flank and soon after overran the Netherlands, Belgium, and Luxembourg, to move rapidly into France, circumventing the sophisticated fortifications of the Maginot Line. By the end of May the German army reached the English Channel at Dunkirk. Almost mysteriously, most of the British army, about a quarter of a million men, was saved, while the large, well-trained, well-equipped French army soon collapsed. In June 1940 Germany occupied Paris and flew swastikas from its historic buildings.

With Italy and Japan as his allies and Spain as his friend, Hitler considered himself one of history's most successful conquerors. Only Russia and Britain had not succumbed. Under Churchill's determined and inspiring leadership the heavily besieged island of England, assaulted day and night by the German air force, became a fortress for defensive and offensive action. Churchill declared that "never ...was so much owed by so many to so few."

In the United States it became clear to many that the country was in great danger from the dynamic and undefeated Nazi war machine and an increasingly belligerent Japan, which had joined the German-Italian Axis in a tripartite pact in September of 1940. The United States became the "arsenal of democracy," and Franklin Roosevelt was elected to an unprecedented third term. The debate between isolationists and interventionists came to an immediate end when the Japanese air force struck Pearl Harbor in December of 1941.

With the United States entering the war, the conflict became truly global. The battle of the Pacific was in full force with Japan winning most of the battles until May 1942, when the military situation was reversed with the Battle of the Coral Sea and the repulse of the Japanese invading force at Midway Island. In October of that year the British launched a decisive counterattack in Africa that halted the highly successful desert campaign of General Erwin Rommel, and that winter the major forces of the German army were stopped at Stalingrad.

The Germans, who always kept at least two-thirds of their military strength on the Russian front, had begun the invasion of Russia in June of 1941. By fall they were within fifty miles of Moscow and at the outskirts of Leningrad, which was besieged for seventeen months, during which more than half a million inhabitants died. But after the defeat at Stalingrad the Wehrmacht was in constant retreat from the Soviet forces, while in the Pacific the United States was victorious in a series of actions from the Aleutian Islands to New Guinea. In July 1943 the Americans also landed troops in Sicily, followed by the invasion of Italy itself and a long, difficult struggle against the German forces. But finally, June 4, 1944, Rome was liberated, and two days later General Eisenhower landed a massive Allied force of men and matériel on the beaches of Normandy. German cities were now bombed day and night, and resistance against the Nazi rulers increased throughout Occupied Europe, while inside Germany millions—mostly Jews and Russian war prisoners—were tortured and killed in death camps.

In August 1944 Paris was liberated, and after the Battle of the Bulge, in Belgium, which proved to be the last gasp of German resistance, the Western Allies marched rapidly into Germany, while the Red Army swept in from the east. After a brief but devastating battle of Berlin, Hitler shot himself in his bunker as the Russians took over the city. Germany surrendered unconditionally May 7, 1945.

Since 1940 a group of American and European scientists who had taken refuge in the United States had been working on the production of an atomic bomb, and in December 1942 the first controlled nuclear chain reaction was accomplished at the University of Chicago. In August 1945 the United States under its new president, Harry S. Truman, decided to use this weapon and drop an atomic bomb on Hiroshima in Japan. More than half the city was obliterated with a single bomb, and at least 80,000 of its 340,000 inhabitants were killed. Three days

later the city of Nagasaki was similarly demolished. The Japanese announced their surrender August 14, 1945, and World War Two was officially concluded.

By the end of the war the Soviet Union had annexed a considerable slice of Eastern Europe and dominated the rest. The United States was the dominant force in Western Europe. The Continent was divided into spheres of influence, and Winston Churchill announced that an "iron curtain" had descended across Europe. Western Europe began to recover with considerable speed, due partly to American financial aid under the Marshall Plan. In 1947 the United States announced its far-reaching Truman Doctrine, promising the nation's support of "free peoples," a policy that eventually led to U.S. military involvements throughout the world, the most costly of which were the Korean War, which began in 1950, and the incursion into Vietnam in the 1960s. But the 1940s also saw the founding of the United Nations, which despite numerous shortcomings provided at least an international forum for discussion and communication.

Scientists during World War Two changed the patterns of human life in ways they themselves could never have predicted. Instead of being the purview of individual researchers, science entered the service of the state during this war, and with public funds practically unlimited, progress was achieved with stunning rapidity. The development of radar and telecommunications, the atomic bomb and the more general use of nuclear energy, and the advances in rocketry were among the most significant technical innovations, while astronomers discovered millions of other galaxies in addition to our own Milky Way, and biologists discovered antibiotic drugs. These advances and inventions—especially the atom bomb, able to destroy human civilization totally—suddenly placed the scientist in a position of public responsibility he had not known before.

The value of critical reason came into very great doubt in all aspects of human pursuit. Many of the horrors of the war had, in fact, been committed in the name of reason, and it is not surprising that the antirationalist, antipositivist philosophy of Existentialism became highly important for the postwar generation. The Existentialist carries the romantic search for the self, for sincerity or emotional authenticity, into a world of total uncertainty. He sees man as a participant in an absurd universe, confronting the meaninglessness of existence, yet subject to his own responsibility in dealing with himself and his fellow man.

Theologians such as Karl Barth and Paul Tillich conceived of Christianity as individual experience rather than revealed dogma—a largely subjective knowledge, sustained by moral commitment. Psychologists, as exemplified by Erich Fromm, while relating the individual and his anxieties more intimately to societal issues, also became increasingly aware of the problems of human alienation.

During this decade we find Samuel Beckett and Eugène Ionesco turning to the antinovel or the antidrama in which antiheroes become protagonists. In many postwar novels—Norman Mailer's *The Naked and the Dead* serves as the prime example—the author deals with estranged individuals in an increasingly anonymous world, while power has gone insane at all levels. Painters responded to the extreme situation by pressing painting "to the limit of no longer being painting" (Jean Dubuffet) or saw the canvas as "an arena in which to act" (Harold Rosenberg). Art gesture was valued more highly than the formal product, and the formulation of a personal myth took precedence over the artist's relationship to the outside world.

The immediate postwar period saw the emergence of the cinema as a major art form, as films became the personal creation of individual *auteurs*-directors, such as Orson Welles, Roberto Rossellini, and Vittorio de Sica. This tendency may be due partly to the major innovation, television, which replaced the movies as the chief purveyor of popular entertainment. Television, in addition, brought people throughout the world into close communication by its ability to broadcast events instantly, as they occurred, while simultaneously creating greater isolation, with people remaining in their living rooms instead of going to theaters or sports arenas.

The arts in many respects were dominated by the aging giants of the prewar world. Frank Lloyd Wright, Le Corbusier, Walter Gropius, and Mies van der Rohe continued to command the field of architecture, as Pablo Picasso, Henri Matisse, and Piet Mondrian did for painting; Arnold Schoenberg and Igor Stravinsky dominated music, T. S. Eliot and Thomas Mann governed the world of literature, and Bertolt Brecht was the dominant influence on the theater. At the same time the United States began to play a much larger role not only in scientific research and technology, but also in scholarship in the humanities and the social sciences, and in the creative pursuit of the arts.

Political Events	The Humanities and Sciences	Architecture, Painting, Sculpture
1940 Germany invades Norway and Denmark, the Netherlands, Luxembourg, and Belgium France concludes an armistice with Germany Battle of Britain Franklin D. Roosevelt reelected U.S. president Leon Trotsky assassinated in Mexico	Ernest Hemingway, *For Whom the Bell Tolls* Arthur Koestler, *Darkness at Noon* Charlie Chaplin, *The Great Dictator* Walt Disney, *Fantasia* First successful flight of a single-rotor helicopter Plutonium produced	New York: Piet Mondrian arrives First issue of the Surrealist magazine *View* Mexico City: "International Surrealist Exhibition" Lascaux, France: Discovery of prehistoric cave paintings
1941 Lend-Lease Act Germany invades the U.S.S.R. Siege of Leningrad begins Soviet counteroffensive saves Moscow Japan attacks the U.S. at Pearl Harbor and the Philippines; U.S. declares war on Japan, Germany, and Italy	F. Scott Fitzgerald, *The Last Tycoon* Erich Fromm, *Escape from Freedom* Bertolt Brecht, *Mother Courage and Her Children* Dmitri Shostakovich, *Symphony No. 7* Herbert Marcuse, *Reason and Revolution*	Paris: Founding of the Peintres de la Tradition Française Washington: National Gallery opens San Francisco: Arshile Gorky retrospective exhibition at the San Francisco Museum of Art
1942 Japan occupies Malaya, Burma, and the Netherlands East Indies U.S. defeats Japan in the battles of the Coral Sea and Midway British victory at El Alamein signals the defeat of the Axis in Africa Anglo-American forces land in French North Africa	Albert Camus, *The Stranger* Thornton Wilder, *The Skin of Our Teeth* Aaron Copland, *Rodeo* First self-sustaining nuclear chain reaction achieved Maurice Merleau-Ponty, *The Structure of Behavior* Susanne Langer, *Philosophy in a New Key* Ingrid Bergman and Humphrey Bogart, *Casablanca*	New York: First issue of the Surrealist magazine *VVV* New York: Peggy Guggenheim opens her Art of This Century gallery New York: André Breton and Marcel Duchamp organize "First Papers of Surrealism" exhibition
1943 Casablanca Conference U.S. victory at Guadalcanal Siege of Leningrad ends Soviet victory at Stalingrad Allied forces invade Italy Benito Mussolini overthrown; Italy surrenders Tehran Conference	Jean-Paul Sartre, *Being and Nothingness; The Flies* Hermann Hesse, *Magister Ludi (The Glass Bead Game)* Béla Bartók, *Concerto for Orchestra* Antoine de Saint-Exupéry, *The Little Prince*	New York: Jackson Pollock's first one-man exhibition, at Art of This Century gallery San Francisco: Clyfford Still's first one-man exhibition, at the San Francisco Museum of Art
1944 Rome and Paris liberated Allies land in Normandy Russians enter Romania, Poland, and Hungary Dumbarton Oaks Conference Franklin D. Roosevelt reelected U.S. president for a fourth term German V-1 and V-2 rockets deployed	Ernst Cassirer, *An Essay on Man* Gunnar Myrdal, *An American Dilemma* Première of Picasso's play, *Desire Caught by the Tail* Laurence Olivier, *Henry V* Tennessee Williams, *The Glass Menagerie* Jean-Paul Sartre, *No Exit* First electronic computer	New York: Hans Hofmann and Robert Motherwell exhibitions at Art of This Century gallery Chicago: Institute of Design founded by László Moholy-Nagy Paris: First Jean Dubuffet exhibition at the Galerie René Drouin

Political Events	The Humanities and Sciences	Architecture, Painting, Sculpture
1945 Yalta Conference Franklin D. Roosevelt dies; Harry S. Truman becomes U.S. president Germany surrenders United Nations Charter signed U.S. detonates atomic bombs Japan surrenders Vietnam Republic proclaimed	Evelyn Waugh, *Brideshead Revisited* George Orwell, *Animal Farm* Maurice Merleau-Ponty, *Phenomenology of Perception* Benjamin Britten, *Peter Grimes* Pablo Neruda, *The Heights of Macchu Picchu*	Paris: Henri Matisse retrospective at the Salon d'Automne Paris: Jean Fautrier and Wols exhibit at the Galerie René Drouin New York: Mark Rothko exhibition at Art of This Century
1946 First U.N. General Assembly 21-nation peace conference in Paris Beginning of the French war in Vietnam (–1954) Nuremberg war-crimes trials end with death sentences Philippines granted independence from the U.S.	Erich Auerbach, *Mimesis* Jean Cocteau, *Beauty and the Beast* William Wyler, *The Best Years of Our Lives* Roberto Rossellini, *Open City* Serge Eisenstein, *Ivan the Terrible* Hans Richter, *Dreams That Money Can Buy*	Paris: First Salon of the Réalités Nouvelles Buenos Aires: Lucio Fontana publishes his "White Manifesto" Robert M. Coates in *The New Yorker* applies the term "abstract expressionism" to New York painters
1947 India and Pakistan become independent Truman Doctrine Marshall Plan for European recovery proposed U.S. Congress passes the Taft-Hartley Act curbing union rights	Albert Camus, *The Plague* André Malraux, *Psychology of Art* Tennessee Williams, *A Streetcar Named Desire* Vittorio de Sica, *The Bicycle Thief* Discovery of streptomycin	London: Founding of the Institute of Contemporary Arts Chicago: Exhibition of "Abstract and Surrealist American Art" at The Art Institute New York: Exhibition of "The Ideographic Picture" at Betty Parsons Gallery
1948 Mahatma Gandhi assassinated in India Communists seize power in Czechoslovakia in a coup State of Israel proclaimed Rupture between the U.S.S.R. and its onetime satellite Yugoslavia U.S. and British airlift counters Soviet blockade of Berlin Harry S. Truman elected U.S. president	Ezra Pound, *The Pisan Cantos* Thomas Merton, *The Seven Storey Mountain* Truman Capote, *Other Voices, Other Rooms* Norman Mailer, *The Naked and the Dead* W. H. Auden, *The Age of Anxiety* Pierre Boulez, *Piano Sonata No. 2* Transistor invented	Venice Biennale: first prize awarded to Georges Braque Italy: Movimento Arte Concreta established New York: The Club (of Abstract Expressionist artists) starts New York: Willem de Kooning's first one-man show, at the Egan Gallery
1949 North Atlantic Treaty Organization (NATO) comes into being Separate governments established in East and West Germany Nationalist Chinese defeated; Communist People's Republic of China proclaimed Russia explodes an A bomb	George Orwell, *Nineteen Eighty-four* Theodor W. Adorno, *Philosophy of Modern Music* Margaret Mead, *Male and Female* Simone de Beauvoir, *The Second Sex* Arthur Miller, *Death of a Salesman*	Amsterdam: First Cobra exhibition Milan: First spatial environment, a completely black room, created by Lucio Fontana at the Galleria del Naviglio

The Architecture of War

918

919

920

Before and during the war, vast amounts of energy, money, and innovative technology were devoted to military architecture, a development that has, in general, been overlooked by academic architectural historians. During the twenties and thirties, the French General Staff built a fixed and impenetrable defensive wall on the German border. The Maginot Line was a continuous grid of completely equipped fortifications. The bombproof shelters, or casemates, were built of reinforced concrete in fluid, almost sculptural forms that were entirely functional and were as intimately wedded to their sites as native rock outcroppings. The Germans, in turn, constructed their West Wall (the Siegfried Line), which also included strong military fortresses as well as wall upon wall of "dragons' teeth," an interlocking grid of truncated concrete pyramids that were to constitute insurmountable obstacles to enemy tanks. In Britain, novel sea fortifications provided radar cover for the Thames Estuary as well as bases for antiaircraft batteries. These were concrete forts that were prefabricated on land and floated into location at sea. Others, resembling bulky boxes, were supported on stilts sunk into the ocean floor and connected by bridgeways—strange structures of innovative functional design.

After the Germans had occupied Western Europe, they built the Atlantic Wall (c. 1940–43) and erected high, fortified observation posts along the French coast. These mono-

921

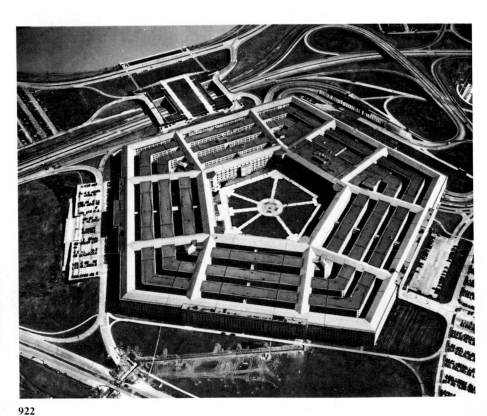

922

lithic pillboxes, with their narrow horizontal slits for gun emplacements, which seemed to have been carved from the living rock of the coast, had the superb finish of German craftsmanship. These structures strongly suggest the influence of military fortifications on the civil architecture called Brutalism. In the absence of overt warfare, such neomedievalism seems an appropriate response to the paranoia that attended the new atomic "balance of terror."

During the early 1940s the world's largest office building, the Pentagon, was erected across the Potomac River from Washington, D.C., in an area commonly known as "Hell's Bottom." According to esoteric lore, when a pentagon or pentogram is drawn on the ground with its chief point toward the south, it can be used for black magic and destructive purposes, and, indeed, the War Department's structure faces south.

918 Casemate, Maginot Line, France. 1927–36 **919** Siegfried Line (West Wall), Germany. 1936–39 **920** Floating Naval Fort, Great Britain. c. 1941–43
921 Atlantic Wall, Observation Tower, French coast. 1940–43 **922** George Edwin Bergstrom and David J. Witmer. Pentagon Building, U.S. War Department, Arlington, Va. 1941–43

Public Buildings

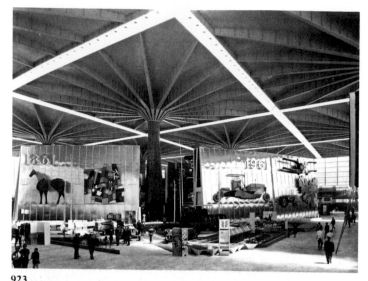

923

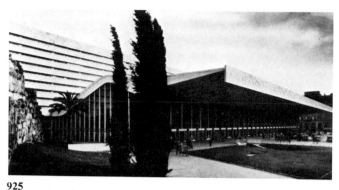

925

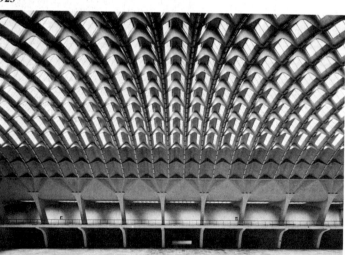

924

926

The war, of course, greatly restricted building for civilian use during the first half of the decade. The latter half was marked by phenomenal building activity as reconstruction got under way in the ruined cities of Europe. Pier Luigi Nervi, whose genius at combining technology and aesthetics was seen in the Municipal Stadium in Florence (plate 837), constructed several airplane hangars of prefabricated components during the war. At the end of the decade, he designed a breathtaking exhibition hall in Turin, an enormous structure of precast concrete elements. The great vault, with its transparent corrugations subtly lighting and silhouetting the parabolic roof struts,

seems a lighter, airier version of Max Berg's Centenary Hall at Breslau (plates 493–495). The structure, everywhere visible and fanning out from molded diagonal piers like tendons, has the supple, organic clarity of Gothic cathedrals. The end of the forties also saw the completion of work on the impressive Termini Station in Rome, which had been discontinued during the war. The design was altered in the postwar years, and a large, handsome concourse with a finely curved asymmetrical roof was added, as well as a flat facade with strip windows and a boldly cantilevered overhang, on a square facing the ancient ruins of the Baths of Diocletian. The architects

succeeded in achieving a harmonious interaction between the large modern building and its ancient neighbor.

Without doubt, the most massive building complex of the immediate postwar period was the Moscow State University, a group of thirty-eight buildings arranged symmetrically in military order around a thirty-two-story skyscraper topped by a tall spire. This ponderous tower of learning is almost eight hundred feet tall and dominates the university's main axis. The structure is entered by a vast, arid marble portico and is lavishly appointed with the usual bronze and marble statues and fountains proclaiming socialist virtues. It has almost as little stylistic

927

928

929

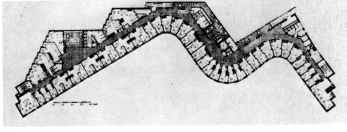

930

relationship to modern architectural problems as it does to historical styles. This mode, repeated in many succeeding buildings throughout Moscow as well as elsewhere in Eastern Europe during this period, is usually known simply as Stalinist architecture, bearing the heavy and reactionary imprint of its namesake.

In America, both the Massachusetts Institute of Technology and Harvard commissioned famed modern architects to build new dormitories for returning war veterans. At Harvard, Walter Gropius had served as chairman of the architecture department since 1938, after he fled Europe. Together with a group of younger men in The Architects Collaborative,

he helped to design the Harvard Graduate Center. In comparison to the ornate and symmetrical pile on Moscow's Lenin Hills, its modest, straightforward simplicity is striking. The flat, three-story dormitories, emphasizing their horizontality, do not, however, match the innovativeness of Gropius's earlier buildings for the Bauhaus school.

When the Finnish master Alvar Aalto was commissioned at about the same time to build a dormitory for MIT, he created a dignified structure with an undulating serpentine curve, giving most of its inhabitants a view of the Charles River. His use of red brick, certainly a surprising material for a contemporary structure, may

have been suggested by the famous brick serpentine walls designed by Thomas Jefferson at the University of Virginia. But like Gropius's work at Harvard, Aalto's building did not attain the high quality of his earlier or later work in his native land.

923–924 Pier Luigi Nervi. Exhibition Hall, Turin. 1948–49 925 Eugenio Montuori with Leo Calini, Massimo Castellazzi, Vasco Fadigati, Achille Pintonello, and Annibale Vitellozzi. Termini Station, Rome. 1947–50 926 L. V. Rudnev, S. E. Chernyshev, P. V. Abrosimov, F. A. Khryakov. Moscow State University. 1945–53 927–928 Walter Gropius and The Architects Collaborative. Harvard Graduate Center, Cambridge, Mass. 1949–50 928 Side view 929–930 Alvar Aalto. Student dormitory, Massachusetts Institute of Technology, Cambridge, Mass. 1947–48 930 Ground plan

931

933

932

934

The 1940s saw the building of two high-rise structures of signal importance and influence by two of the masters of modern architecture.

After the war Le Corbusier, who had previously received very few commissions commensurate with his abilities, was commissioned to design the kind of self-contained apartment block for a large number of people he had proposed much earlier. The appropriately named Unité d'Habitation in Marseilles is a monumental slab of seventeen stories, four hundred fifty feet long, housing sixteen hundred people. The building is supported on the ground floor by Le Corbusier's characteristic *pilotis*, tapered stilts that provide an open

walkway beneath the raised structure. Individual families are provided with a maximum of privacy in two-story apartments with balconies. The building is equipped with essential community services, such as restaurants and a "shopping street" partway up the building. Le Corbusier now rejected the prewar aesthetic of pristine form and straight-edged finish. Instead, he designed a building of rough-surfaced walls that is organic, brutal, and massive—like military fortifications. On its top he designed a communal roof garden with entertainment facilities and views of the Alps and the Mediterranean. The playgrounds, chimneys, exhaust funnels, and elevator shafts

were designed as functional but abstract poured concrete sculpture, an idea that Antoni Gaudí had used on the roof of his Casa Milá apartments four decades previously (plates 155–156).

During the same years in Chicago, Ludwig Mies van der Rohe's paired apartment towers were rising at 860–880 Lake Shore Drive, overlooking Lake Michigan. While the earlier work of these two architects was rather similar in form and concept, their styles diverged significantly in the postwar years. Whereas Le Corbusier's apartment block was made of massive, unfinished concrete, Mies relied on the steel cage, minimal, rational, and impeccably

935

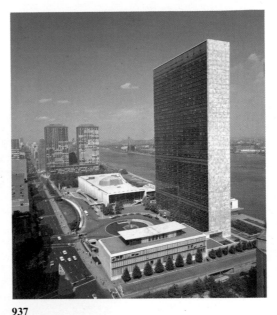

937

GROUND LEVEL

936

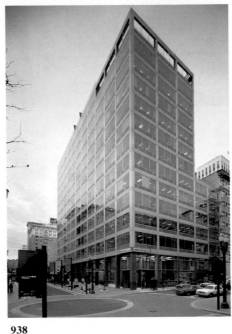

938

detailed with black-enameled I-beams. Le Corbusier's building stresses horizontality while Mies's towers are emphatically vertical. And finally, whereas Le Corbusier designed his apartment as a total environment for living, Mies designed spaces which are neutral in their function and rely for character on the personality of their occupants.

By 1950 Frank Lloyd Wright had completed a research tower as an addition to the Johnson Wax complex in Racine, Wisconsin (see page 307). Taking inspiration from nature, as always, he designed the tower like a tree, with floors cantilevered from a hollow concrete core. Translucent bands of glass tubing serve as windows and give a highly romantic appearance when illuminated at night—the kind of aesthetic so close to Wright's heart.

The most ambitious high-rise structure erected during the decade is the thirty-nine-story Secretariat building for the United Nations headquarters in New York. Designed by an international team of architects under the general direction of Wallace K. Harrison, it is a thin slab with walls of shimmering, reflecting glass on the long sides modeled after early designs by Le Corbusier, who was a consultant.

Far more modest was Pietro Belluschi's Equitable Life Assurance Building in Portland, Oregon, com-pleted in 1947. Here, the glass wall is flush with the steel frame, eliminating all aspects of architectural profile and creating a pristine, crystalline structure of almost levitating lightness.

931–932 Le Corbusier. Unité d'Habitation, Marseilles. 1946–52 932 Exterior stairway 933–934 Ludwig Mies van der Rohe. 860–880 Lake Shore Drive Apartments, Chicago. 1948–51 934 Detail 935–936 Frank Lloyd Wright. Laboratory and Research Tower. Johnson Wax Company, Racine, Wis. 1947–50 936 Vertical elevation 937 Wallace K. Harrison, Max Abramovitz, et al. United Nations headquarters, New York. 1947–50 938 Pietro Belluschi. Equitable Life Assurance Building, Portland, Ore. 1944–47

Private Houses

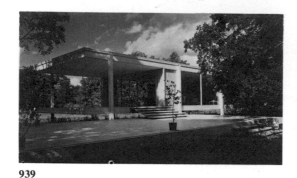

939

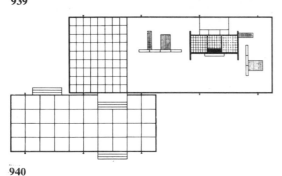

940

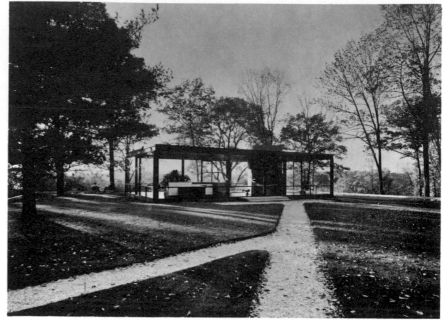

941

942

943

After the end of the war a number of distinguished private houses were built in the United States. Foremost among them was Mies van der Rohe's Farnsworth House in Plano, Illinois. Immaculately, though minimally, detailed, the house represents the apogee of the International Style. The interior has no dividing walls, providing maximum freedom and minimum privacy for the occupant, who inhabits an open space sandwiched between the two cantilevered slabs of floor and roof.

Raised on steel stilts over the flood plain of the Fox River, Farnsworth House appears to be hovering above the ground, while the Glass House, which Philip Johnson designed for himself in New Canaan, Connecticut, rests firmly on the earth. Johnson, then a disciple of Mies van der Rohe, adheres to his master's immaculate form in the house, but due to its symmetry, it lacks the dynamic tension of Mies's structures. The open interior of the transparent cube and the ephemeral walls of glass create an image of idyllic and harmonious existence in nature, which, it must be admitted, was possible only on Johnson's extensive private estate.

Richard Neutra also experimented with the glass box in his magnificent design for the Edgar Kaufmann House in Palm Springs, California.

Stressing horizontality, its walls little more than thin planes and its supports attenuated steel columns, it gives an impression of weightlessness and geometric abstraction that contrasts with the somber desert mountains it faces.

Frank Lloyd Wright's house and school for his fellowship of apprentices near Phoenix, Arizona—Taliesin West—displays a very different relationship toward the desert. Its walls are of indigenous rocks and concrete slanted like the ramparts of Maya temples. The brilliant desert light is filtered into the building through canvas tarpaulins stretched between redwood beams. Surrounded by

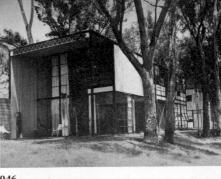

946

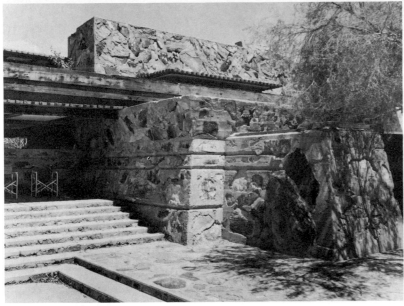

944

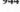

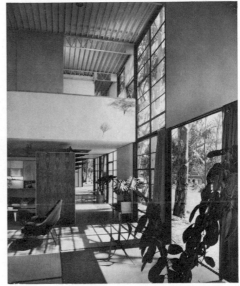

947

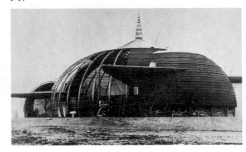

945 948

pools and desert vegetation, it expresses Wright's romantic sensibility as well as his subtle mastery of space.

Charles Eames, architect, filmmaker, and designer of modern furniture, was interested in using prefabrication when he built a house of his own in 1949. It was sponsored by the Los Angeles magazine *Arts and Architecture* in a "case-study" program in which many of the leading Los Angeles modern architects participated. The Eames House is a highly functional steel-frame building, made of structural modules. It is reminiscent in proportion and design of Japanese houses without

in any way overtly imitating their appearance.

Bruce Goff, a man entirely outside the so-called mainstream of modern architecture, though influenced by Wright's concept of organic building, designed a house in Aurora, Illinois, which is near Mies's Farnsworth House but is its complete antithesis. While the latter is an expression of Euclidean lucidity, Goff's Ford House explores the qualities of surprise and mystery. Its roof is made of domes of Quonset-hut sheeting covered with copper and wooden shingles, while the walls are built of coal. The roof of the central living space is supported by a branching

central column, creating a multi-leveled circular space to facilitate communication within it.

939–940 Ludwig Mies van der Rohe. Farnsworth House, Plano, Ill. 1945–50 **941–942** Philip Johnson. Glass House, New Canaan, Conn. 1949 **942** Floor plan **943** Richard Neutra. Kaufmann Desert House, Palm Springs, Calif. 1946–47 **944–945** Frank Lloyd Wright. Taliesin West, Maricopa Mesa, Ariz. 1938–59 **945** Detail of entrance **946–947** Charles Eames. Case Study House, Santa Monica, Calif. 1947–49 **948** Bruce Goff. Ford House, Aurora, Ill. 1949

World War Two and Its Aftermath

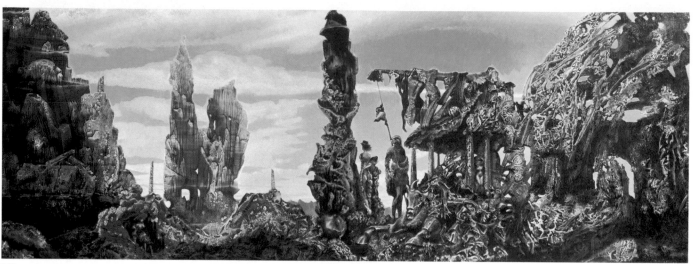

949

950

951

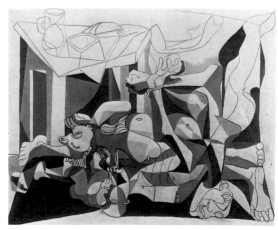

952

Themes of the war and its aftermath concerned many artists during the decade. None responded more evocatively than the great visionary painter Max Ernst. Decalcomania was the technical basis for the rich surfaces of *Europe after the Rain*. An apocalyptic landscape appears mysteriously in a burned jungle. Here, as in *Napoleon in the Wilderness* (plate 893), a tall biomorphic totem looms in the center of the canvas.

The daily reality of war was reflected in Henry Moore's watercolors and drawings of the London Tube, used as a shelter during the nightly bombings of London. Drawings such as *Tube Shelter Perspective* were not dreamscapes but docu-

mentaries of those who huddled in the cavernous subways—depictions of fear, protection, strength. Made by a great sculptor, they display a striking sense of volume and mass.

A much more desolate and macabre mood is evoked in Carl Hofer's *The Black Rooms*. Hofer, who had remained during the Hitler years in Germany, where he was labeled a "degenerate artist" and prohibited from exhibiting, referred to the Third Reich as a "cesspool of bestiality." In this melancholy picture, a naked man is beating the drums to a ritualistic dance of death. It was painted immediately after his studio and much of his work were destroyed by Allied air raids on Berlin.

Picasso, who spent the war years in France, treated carefully by the Germans occupying the country, continued to express the anguish he had masterfully captured in *Guernica* (plate 877). *The Charnel House*, like the earlier work, has a power that comes not from the accumulation of details, but from the strength of feelings compressed within a few figures: in the blank-faced baby rolling in the foreground, in the hand thrust up stiffly, in the disarrayed nostrils and vertical eye of the man in the foreground. The jumble and depersonalization of death in war fill this canvas, which, like *Guernica*, was painted entirely in blacks, grays, and whites.

953

955

954

956

Ben Shahn's *Liberation*, for all its desolation, is a picture of victory. Though the houses are gutted, and rubble fills the ground, the scarecrow children partake of universal childhood—at least to the extent of flying through the air on swings.

The young artist Philip Guston painted children fighting a mock war with an arsenal of garbage cans, sticks, and stones. In *Martial Memory*, which Guston considered his first mature work, play becomes a mysterious ritual. Guston's painting is carefully structured according to Renaissance compositional devices (Uccello comes to mind) combined with an understanding of Cubist space.

After the war Jack Levine painted his sardonic *Welcome Home*. Whereas Guston looked then to Renaissance painters, Levine turned to the Baroque, to Rembrandt and El Greco for inspiration. His figures are compressed into a tight pictorial space and viewed from unexpected and disquieting angles. "Dehumanization seems the keystone of every field of modern endeavor," Levine observed, and painted this scene of uncompromising cynicism, typical of his total work.

Jacob Lawrence, a black artist, painted *War Series, No. 6, The Letter*, a succinct statement of the impact of the war. His precise outline, flat, posterlike planes, strong color, and geometric shapes reveal the tremendous weight of human grief. The poignant picture is dominated by the image of the widowed woman bent in sorrow over the table with its large white letter of death.

949 Max Ernst. *Europe after the Rain*. 1940-42. Oil on canvas, 21 $\frac{1}{2}$ × 58 $\frac{1}{2}$″ **950** Henry Moore. *Tube Shelter Perspective*. 1941. Wash and crayon, 18 $\frac{1}{2}$ × 17″ **951** Carl Hofer. *The Black Rooms*. 1943. Oil on canvas, 58 $\frac{5}{8}$ × 43 $\frac{1}{4}$″ **952** Pablo Picasso. *The Charnel House*. 1944-45. Oil and charcoal on canvas, 78 $\frac{5}{8}$ × 98 $\frac{1}{2}$″ **953** Ben Shahn. *Liberation*. 1945. Tempera on board, 29 $\frac{3}{4}$ × 39 $\frac{3}{4}$″ **954** Philip Guston. *Martial Memory*. 1941. Oil on canvas, 40 $\frac{1}{8}$ × 32 $\frac{1}{4}$″ **955** Jack Levine. *Welcome Home*. 1947. Oil on canvas, 40 × 60″ **956** Jacob Lawrence. *War Series, No. 6, The Letter*. 1947. Egg tempera on gesso panel, 20 × 16″

357

958

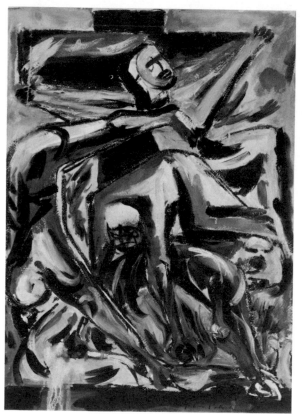

957

959

Understandably, the war and its aftermath produced an impressive series of paintings of the Crucifixion, a subject barely touched before by twentieth-century artists—although both Picasso and Chagall had treated it in the previous decade.

The young Jackson Pollock did an early Crucifixion, a gouache drawing. This quick sketch shows the anguished Christ, a fallen figure overlapping his body, a fierce hideous beast by his side. When Pollock drew this picture, he had reentered psychoanalysis with a Jungian doctor who asked him to draw "as a bridge to communication." Pollock at that time freed himself from the influence

of his teacher Thomas Hart Benton, and worked in a manner more related, as he said, to Beckmann, Orozco, and Picasso.

A few years later the older American painter Milton Avery did a strangely visionary *Crucifixion*, painted on commission from his gallery. Avery refers to Gauguin's famous *Yellow Christ* of 1889 in painting a yellow Christ with a sorrowful woman in prayer at his foot. The flattened form, hieratic frontal symmetry, and bold position of the simple crucifix transmit a sense of meditation, the theme of the painting.

In postwar Paris, Bernard Buffet

achieved extraordinary popularity because his paintings, such as his large *Pietà*, expressed desolation and wretchedness corresponding to the prevalent mood of dejection. This painting depicts the time after the Crucifixion. Sharply silhouetted angular adults and children witness the Virgin's sorrow. Buffet did this remarkable work when he was only eighteen, but he did not fulfill the early promise of his talent.

In 1946 the English painter Graham Sutherland was commissioned to paint a Crucifixion for the Church of St. Matthew, in Northampton. He found inspiration in "thorn bushes and the structure of thorns as they

960

961

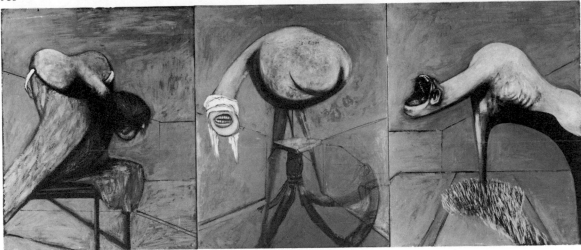

962

pierce the air." These became metaphors for the cruelty he wanted to depict in this rather orthodox canvas, informed by Grünewald's sixteenth-century Isenheim Altarpiece, as well as by Picasso's work.

Late in life Henri Matisse designed the whole interior of the Dominican Chapel of the Rosary in Vence. On one white wall of glazed ceramic tiles, painted in black outlines are *The Stations of the Cross*. The entire story of the Passion is compressed into a single composition. Linear and delicate, the numbered stations are pure, almost ascetic in their treatment; gone are Matisse's luxuriant color and dense form.

Francis Bacon's *Three Studies for Figures at the Base of the Crucifix*, painted two years earlier, is completely nontraditional. Bacon emerged after the war as a most original painter, whose works emanate, as he said, from his nervous system and often verge on the hallucinatory. This triptych presents aggregate forms: phallic, obscene, humanoid, protean images, referring to agonies suffered on earth. Howling at the foot of the Cross, these defeated creatures represent denial of the grace implicit in the Crucifixion.

957 Jackson Pollock. *Untitled (Crucifixion).* 1939–40. Gouache, 21 ½ × 15 ½"
958 Milton Avery. *Crucifixion (Yellow Christ).* 1946. Oil on canvas, 44 × 34"
959 Bernard Buffet. *Pietà.* 1946. Oil on canvas, 67 × 94" **960** Graham Sutherland. *Crucifixion.* 1946. Oil on cardboard, 96 × 90" **961** Henri Matisse. *The Stations of the Cross.* 1948–51. Painted and glazed ceramic tiles, 10' × 17'6" **962** Francis Bacon. *Three Studies for Figures at the Base of the Crucifix.* c. 1944. Oil on board, triptych, each panel 37 × 29"

The Human Figure in Its Environment

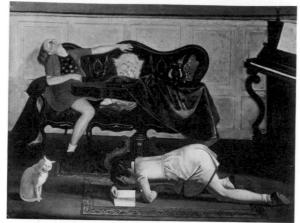

963

964

965

After his discharge from the French army, Balthus (see page 332) settled in Switzerland. There he painted the large canvas *The Living Room*, depicting two preadolescent girls apparently idling away the time. But time and space are frozen as the viewer becomes the voyeur of an erotic reverie. In this very carefully designed composition Balthus repeats the buttocks of the reading girl in the curve of the sofa, which, in turn, is echoed by the French curve of the piano leg. The oval table seems to impinge on the pelvic area of the second girl, half-seated, half-lying, in a trance of pleasure. In the corner sits an enigmatic white cat. The artist's obsession with eroticism has pro-

duced a painting of great intensity.

Max Beckmann's *Four Men around a Table* shares with his earlier work the effect of symbolic extradimensionality. Undoubtedly in this case, the charged atmosphere arises from Beckmann's situation as a German "degenerate artist," in exile in a Holland occupied by the German army. Beckmann is seated at the lower right, and crowded around the table are three artist friends, each holding an article of food precious in wartime. Their expressions may indicate their fear of a Gestapo raid.

Picasso turned to a subject of universal significance in *First Steps*. The child's face is faceted into many faces; the mother's is seen simultane-

ously from the front and from below, but these disjunctions are totally acceptable. The subject is fortified by Picasso's use of distortion, and a new coherence is achieved. We see the pressure of determination in the whole body of the child and the apprehension in the protective mother, in a painting that combines anxiety and humor.

Morris Hirshfield, who most of his life worked as a clothing and slipper manufacturer, turned to painting in his late sixties and became one of the few naïve painters to achieve deserved prominence. In 1940 he painted his enigmatic and exquisite *Girl in a Mirror*, completely unaware of Picasso's *Girl before a*

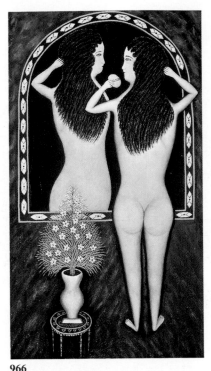

966

968

967

969

970

Mirror (plate 910), with its similar oval-framed double image.

The girl in Andrew Wyeth's *Christina's World* is a young polio victim crawling toward her old farmhouse on the horizon. The deep perspective and odd angles, as well as the tragic story, have an impact enhanced by Wyeth's painstaking tempera technique, which pays attention to every blade of grass.

Ben Shahn also uses tempera because it lends itself to meticulous precision. His figure on the shores of the sea is, like Christina, lonely in a vast and dwarfing world. Shahn's means are sparer than Wyeth's, but his tale is of death rather than Wyeth's tragedy in life.

In 1942 two major American painters made two significant and totally different works on man in his urban environment. Edward Hopper's *Nighthawks* depicts emptiness and solitude. The four people are encased in a glass cage illuminated by intense electric light, in strong contrast to the dark green night surrounding the cave. They are exposed in their loneliness and isolated passivity.

The opposite attitude prevails in Mark Tobey's *E Pluribus Unum*, showing Seattle's Pike Place Market. Figures appear and disappear in a flattened space that is much too shallow to hold them all. Yet distinct individuals are clearly recognizable

within the general melee, in a painting that insists on the uniqueness and energy of the individuals as it underscores the common bond of humanity.

963 Balthus. *The Living Room.* 1942. Oil on canvas, 44 × 57″ **964** Max Beckmann. *Four Men around a Table.* 1943. Oil on canvas, 58 $^3/_8$ × 45 $^1/_2$″ **965** Pablo Picasso. *First Steps.* 1943. Oil on canvas, 51 $^1/_8$ × 38 $^1/_4$″ **966** Morris Hirshfield. *Girl in a Mirror.* 1940. Oil on canvas, 40 $^1/_8$ × 22 $^1/_4$″ **967** Andrew Wyeth. *Christina's World.* 1948. Tempera on gesso panel, 32 $^1/_4$ × 47 $^3/_4$″ **968** Ben Shahn. *Pacific Landscape.* 1945. Tempera on paper, 25 $^1/_4$ × 39″ **969** Edward Hopper. *Nighthawks.* 1942. Oil on canvas, 30 × 60″ **970** Mark Tobey. *E Pluribus Unum.* 1942. Tempera on paper mounted on panel, 19 $^3/_4$ × 27 $^1/_4$″

The Figure Abstracted

971

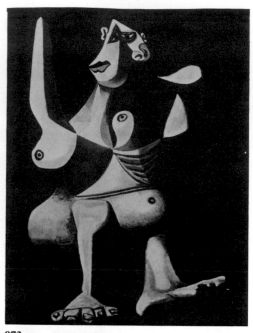

973

972

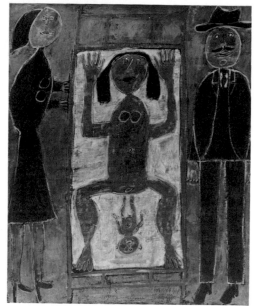

974

Death and Fire, painted shortly before Paul Klee died, is one of his most poignant images. The red color impregnating the burlap represents fire. In the center is a distorted, fearsome, flat white face. The stick figure of the ferryman, Charon, with oar or staff, approaches a sphere held by the central figure, a circle which may be interpreted as a symbol of unity and completion. Klee said that death held no terror for him, "or does one know which is more important, life now or the life that is to come?"

Victor Brauner was certainly aware of Klee's ability to give pictorial form to magic content. Brauner believed in the occult and participated in séances in his native Romania. He worked with images of beasts (plate 754) and hybrids, and painted *Stable, Unstable*, of which he wrote: "The sleepwalker, in her ritual at the hour of sunrise, transforms her hair into a fantastic animal that in its front paws holds the arrow that will kill forever the image of reality. With its back paws it grasps its head, threefold sign of the power it commands . . . image of the unstable-stable." In contrast to Brauner's figure, Picasso's *Nude Dressing Her Hair* is almost clinically observed, as she swivels her torso to pile up her hair.

Like Paul Klee, Jean Dubuffet sought inspiration from the art of children. He also looked at the expression of ordinary people, their graffiti, and studied the often complex compulsive art of the mentally ill. Early on, this extraordinary artist separated himself from the abstractionists of his generation: "I don't find the function of assembling colors in pleasing arrangements very noble." He was more concerned with communicating ordinary human experience by means of art, "a more direct vehicle than verbal language, much closer to the cry or to the dance." An early work, *Childbirth*, is indeed close to children's art. The double image of the woman recalls the successive imagery of early chronicles and votive pictures. It reminds one of those naïve thank offerings found in pilgrimage church-

975

976

977

es, with a comparable aspect of ritual.

Adolph Gottlieb also uses a sophisticatedly reduced vocabulary in depicting his *Man Looking at Woman.* He draws, too, on magic symbols from many cultures—hearts, arrows, circles, squares, disembodied eyes—to create a fascinating rebus on a universal theme.

Of the American artists of his generation, Robert Motherwell was perhaps in closest contact with the Surrealists and their theories of poetic consciousness. Soon after a trip to Mexico in 1941, with Sebastian Matta, Kurt Seligmann, and Wolfgang Paalen, Motherwell painted his remarkable *Pancho Villa, Dead and Alive,* the artist's semiabstract han-

dling of the Mexican folk hero in double image: hanging and spattered with blood next to a vibrant life image, dead and alive, reality and legend. Here is a depiction of the immortality of folklore and myth.

Rectangles are an essential element in Motherwell's composition, as they are in Willem de Kooning's *Queen of Hearts,* an intense painting in which parts fit together pictorially, though not anatomically. In fact, it appears that the virtually independent fragments of the body are integrated arbitrarily by the artist's free draftsmanship and application of clashing greens, pinks, and oranges. Yet for all its seemingly free and spontaneous expression, the painting

is carefully organized, and the Queen resides amid her kingdom of vertical rectangles. Although De Kooning's work moved in very different directions, he had been much impressed by Mondrian's work while still a student in Rotterdam.

971 Paul Klee. *Death and Fire.* 1940. Tempera on burlap, 18 ¹/₈ × 17 ³/₈″ **972** Victor Brauner. *Stable, Unstable.* 1942. Oil on canvas, 28 ³/₈ × 21 ¹/₄″ **973** Pablo Picasso. *Nude Dressing Her Hair.* 1940. Oil on canvas, 51 × 38 ¹/₄″ **974** Jean Dubuffet. *Childbirth.* 1944. Oil on canvas, 39 ³/₈ × 31 ⁷/₈″ **975** Adolph Gottlieb. *Man Looking at Woman.* 1949. Oil on canvas **976** Robert Motherwell. *Pancho Villa, Dead and Alive.* 1943. Gouache and oil with collage on cardboard, 28 × 35 ⁷/₈″ **977** Willem de Kooning. *Queen of Hearts.* 1943–46. Oil and charcoal on board, 46 × 27 ¹/₂″

978

980

979

981

Of Arshile Gorky his friend De Kooning said: "He understood everything . . . he had the curse of taste." Gorky felt compelled to replicate the great modern art of Europe —the work of Cézanne, Picasso, Kandinsky, Miró—before finding his own originality. A masterpiece like *The Liver Is the Cock's Comb* is informed by the floating color forms that he saw in Kandinsky's abstractions. This beautiful, intuitive picture is filled with cryptic images evoking erotic energy. There is an outburst of biomorphic vitality in the great "plumes" of color, as Gorky called his sumptuously hued forms. André Breton, who enthusiastically admitted Gorky to the Surrealist circle,

called him the "eyes's spring" and esteemed his contact with nature and his ability to transcribe his sensations.

Matta was the Surrealist painter with whom Gorky had the greatest rapport, and he was a man of signal importance to the new painting that emerged in New York during the war years. A brilliantly precocious artist, born in Chile, Matta spent the years immediately before the war in Paris, painting "inscapes" of eerie spaces. In 1939 he came to New York, and when he painted *The Earth Is a Man* and *Listen to Living*, he had just been to Mexico with Robert Motherwell; he found not an image for a myth, but images re-

flecting the inner experiences of that journey. Gorky's paintings based on involuntary memory, and Matta's based on psychic morphologies, both done in the early 1940s, were significant links between the Surrealists and the so-called Abstract Expressionist painters.

At the same time, and also in New York, Wifredo Lam began exhibiting his paintings. Lam was born in Cuba, of mixed Chinese, African, Indian, and European parentage, and he used ethnic sources in his work. Picasso, an early discoverer of primitive art, showed great interest in Lam's totemic landscapes. *The Jungle* is a primal forest in which constant metamorphosis occurs among animal,

983

982

984

human, and plant forms. In this large painting Lam achieves pictorial unity primarily by means of vertical rhythms, but he portrays a world of chthonic forces, filled with the nightmare of mysterious primitive rites.

Freely invented, skeletal biomorphic forms are also the dominant iconography in the work of Yves Tanguy, who settled in America in 1939. He solidified his organic structures of bones and rocks in the 1940s. A major work, *Indefinite Divisibility*, focuses on two objects: a tall spiny sculpture that casts a deep shadow into the infinity of a blue horizon, and a strange horizontal device shaped like a table. The objects, defined very clearly, are solidly grounded, and the color is more intense than in his earlier work (see plate 613). His is a world that could conceivably exist, even though no one has ever seen it.

Magritte employs the elements of the familiar world in *The Third Dimension*, but he enlarges and reduces their sizes to provide them with an extra dimension. The tiny birds (or the immense leaf) are painted so realistically that the viewer accepts his fiction.

Max Ernst also hews close to reality in *Vox Angelica*, but despite the aura of scientific rationality imparted by the calipers and protractors and neatly framed compartments, Ernst is also listening to the angelic voice of the title. With his use of Surrealistic devices—frottage, decalcomania, and superrealism itself—Ernst, like Gorky, Matta, Lam, and the others, challenges and provokes the viewer to discover magic and probe the unknown.

978 Arshile Gorky. *The Liver Is the Cock's Comb*. 1944. Oil on canvas, 72 × 98″
979 Sebastian Matta. *The Earth Is a Man*. 1942. Oil on canvas, 72 $\frac{1}{4}$ × 96 $\frac{1}{2}$″
980 Sebastian Matta. *Listen to Living (Ecoutez Vivre)*. 1941. Oil on canvas, 29 $\frac{1}{2}$ × 37 $\frac{3}{8}$″ **981** Wifredo Lam. *The Jungle*. 1943. Gouache on paper mounted on canvas, 94 $\frac{1}{4}$ × 90 $\frac{1}{2}$″ **982** Yves Tanguy. *Indefinite Divisibility*. 1942. Oil on canvas, 40 × 35″ **983** René Magritte. *The Third Dimension*. 1942. Oil on canvas, 29 $\frac{1}{8}$ × 21 $\frac{1}{2}$″ **984** Max Ernst. *Vox Angelica*. 1943. Oil on canvas, 60 $\frac{1}{8}$ × 80 $\frac{1}{8}$″

Still Life

985

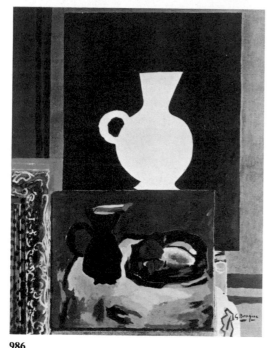

986

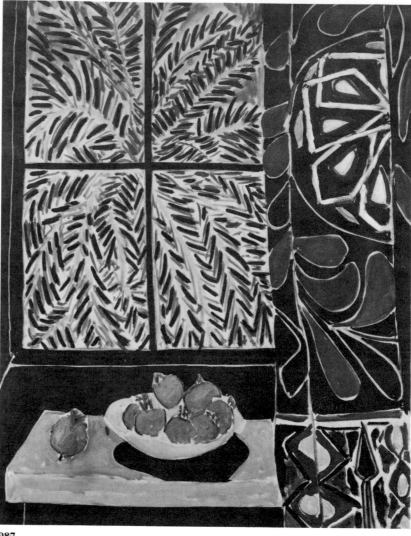

987

Always in contact with life, Picasso painted a still life, *Skull and Jug*, during the German occupation of Paris, when many of his friends were being tortured and killed in an effort to destroy European culture. This *memento mori* shows vestiges of Cubism in the distortion of shapes. He mobilized remarkable energy, using incisive lines and bright colors to define the plastic power of the two objects, each demanding its own background. But it is more than just a formal composition; one of the two objects denotes death.

Georges Braque, even when painting images similar to *Skull and Jug*, continued to achieve sensuous, beautiful textures and splendidly subtle

harmonies of color. In 1949 the artist, who often worked in series, began an ambitious project, that of painting his studio. The paintings became more complex, involved, and ornate during the seven years he spent on this final great project of his career. The earliest, *The Studio (I)*, depicts two paintings, one on top of the other, both variations on the simple theme of a pitcher. It is an elegantly balanced work in subdued color with a sense of euphony and sufficiency.

Matisse's *Interior with Egyptian Curtain* is a joyous outburst of color. The brilliant juicy yellow, green, and blue branches of a great palm tree make an explosion of color. The aggressive patterns and colors of the

Egyptian curtain are in visual contest with the tree—and as alive. Pink table and orange pomegranates mediate the composition. Matisse was almost eighty when he completed this painting; it was one of his last works in oil.

During the war Ben Nicholson lived in the artists' colony of St. Ives, Cornwall. His work, growing out of Cubist still lifes by Picasso and Mondrian's pure pictorial compositions, became less rigidly geometric in the 1940s. In his sparse *Still Life* color is introduced, and there is greater freedom. This painting seems transparent, almost weightless. Both his paintings and his reliefs have a lyrical and ephemeral quality.

988

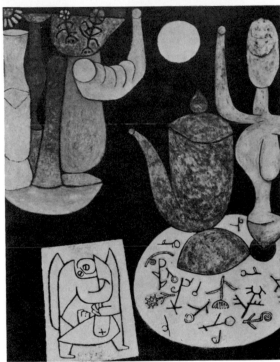

989

990

Both the Braque and Nicholson still lifes contain a picture of a still life within the picture; in Klee's *Still Life* the picture is not a still life but Jacob wrestling with the angel. Angels were a frequent subject of Klee's during 1939 and 1940, the final years of his life. The last picture he painted contains many motifs of his life, but his special offering here is this small work that links man and the eternal life of heaven.

After Alberto Giacometti returned to Paris from Switzerland at the end of the war, he began his great series of sculptures in which the human figure achieves ultimate reduction. More than previously, he now devoted most of his attention to paint-

ing. In *Three Plaster Heads in the Atelier* he created a still life from his own work as a sculptor by placing the plaster heads on a table. These heads dominate a space left undefined. As in most of Giacometti's other paintings, color was relinquished so that the artist could focus his attention on the relationship of objects to the space envelope surrounding them. Yet there are many subtleties in the gray-beige palette. White lines flicker throughout the surface, making the work almost a drawing on canvas. There seems to be little weight or substance; space and objects are evoked rather than defined. Giacometti is aware of a reality in which forms are not quite

tangible, and space and light are in flux.

985 Pablo Picasso. *Skull and Jug*. 1943. Oil on canvas, 21 $1/4$ × 25 $5/8$"
986 Georges Braque. *The Studio (1)*. 1949. Oil on canvas, 36 $1/4$ × 28 $3/4$" 987 Henri Matisse. *Interior with Egyptian Curtain*. 1948. Oil on canvas, 51 × 35" 988 Ben Nicholson. *Still Life*. 1945. Oil on canvas (laid down on cardboard), 23 × 21 $1/2$"
989 Paul Klee. *Still Life*. 1940. Oil on panel, 39 $5/8$ × 31 $1/2$" 990 Alberto Giacometti. *Three Plaster Heads in the Atelier*. 1947. Oil on canvas, 28 $3/4$ × 23 $3/8$"

367

992

991

993

A number of American artists working in New York, disillusioned with all varieties of realism, approached ancient myths as revealed in archetypal Greek, Roman, Egyptian, American Indian, Oceanic, and African art. Myth might support the realities of a world after Auschwitz and Hiroshima; it also served to discipline the automatic painting deriving from the unconscious and from contact with the Surrealists who had come to the United States during the war. Freudian and especially Jungian thought had an important impact on this group of New York artists generally known as Abstract Expressionists.

In *The Guardians of the Secret* Jackson Pollock still adhered to a Cubist grid. But the essential quality of this painting is its turbulent, evocative autobiographical content. The lighter-colored horizontal rectangle flanked by the totemic guardians is the "secret," which resembles the totally free painting that the artist soon turned to. The dog underneath the table can be identified as either Cerberus, guarding the entrance to the underworld, or Anubis, the jackal-headed god of mummification in Egyptian art, who protected the tombs in the necropolis.

Barnett Newman saw parallels between contemporary tragedy and that of the Greeks, as well as between contemporary terrors and those he recognized in the expressions of primitive cultures. Inspired by the art of the Northwest Coast Indians, he wrote that for the Indian abstract shapes could be "a carrier of the awesome feelings he felt before the terror of the unknowable." His own *Pagan Void* explores the mysterious origins of the universe.

In 1942 Mark Rothko began using automatic techniques to achieve amorphous shapes and calligraphic inventions. By 1946, when he painted *Vessels of Magic*, he had gone beyond simple automatism and was then reading Aeschylus and Nietzsche and searching for a visual expression in which "the known as well as the unknowable merge into a single tragic idea."

994

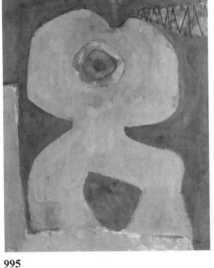

995

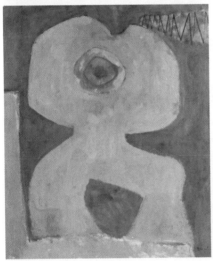

996

In collaboration with Rothko, Adolph Gottlieb wrote that "to us art is an adventure into an unknown world . . . fancy-free and violently opposed to common sense. . . . There is no such thing as good painting about nothing. We assert that the subject is crucial." Influenced by American Indian petroglyphs, Gottlieb painted a series of pictographs in the 1940s (see plate 975). *Alkahest of Paracelsus* is a rather successful attempt to find a visual equivalent for an alchemical substance: "Alkahest [which] is an imaginary universal solvent, capable of dissolving all bodies."

Through a semiautomatic technique adapted from the Surrealists, William Baziotes created his amorphous *Cyclops*, inspired by the rhinoceros in the Bronx Zoo. But this pink monster resembles the torso of a woman, a female Cyclops with one large breast and a tiny waist.

Arshile Gorky created his own myth of melancholy and anguish in *Agony*. It was painted in 1947 after a year of personal catastrophes: the burning of his studio and work, an unsuccessful operation for cancer, and the onset of sexual impotence. In a shallow closed room, humanoid beings seem to undergo some painful ritual. Gorky, the great transitional figure between Surrealism and Abstract Expressionism, committed suicide the following year.

991 Jackson Pollock. *The Guardians of the Secret*. 1943. Oil on canvas, 48 $^3/_8$ × 75 $^1/_4$″ **992** Barnett Newman. *Pagan Void*. 1946. Oil on canvas, 33 × 38″ **993** Mark Rothko. *Vessels of Magic*. 1946. Watercolor on paper, 38 $^3/_4$ × 25 $^3/_4$″ **994** Adolph Gottlieb. *Alkahest of Paracelsus*. 1945. Oil on canvas, 60 $^1/_4$ × 44″ **995** William Baziotes. *Cyclops*. 1947. Oil on canvas, 48 × 40″ **996** Arshile Gorky. *Agony*. 1947. Oil on canvas, 40 × 50 $^1/_2$″

Paris: Informal Art

997

998

999

In 1945 in Paris a group of painters began to exhibit heavily textured painting that came to be labeled Informal (really nonformal) Art (*Art Informel*) or Other Art (*Art Autre*). Such painting bore no debt to Cubism or Surrealism; simultaneously developing in different, radical ways in America, it initiated a new epoch in modern painting.

Leading French writers and intellectuals—Jean Paulhan and Francis Ponge among them—greatly esteemed the work of Jean Fautrier, but it was in André Malraux's preface to a Fautrier catalogue that one of the most cogent statements about the art of our time appeared: "Modern art was undoubtedly born on the day

when the idea of art and that of beauty were found to be disjoined." If we find beauty in the *Hostage* series, it is in the tenderness of the line, which seems to be totally incongruous with the brutal image. The image itself is created by a thick paste applied to prepared paper that in turn has been glued to the canvas. The effect is almost that of bas-relief. The small hieratic paintings were inspired by faces of hostages picked at random and executed during the German Occupation. Fautrier had exhibited his paintings since the 1920s, but in spite of this and of the fact that he helped create a new Informal Art which was in harmony with his poignant images, he has not

been granted the recognition due him —especially in the United States.

In contrast to the relatively thin surface Jean Dubuffet created in *Childbirth* (see plate 974), he now began to use "high impastos," with a heavy mixture of glue, asphalt, tar, and white lead compounded with plaster, varnishes, sand, coal dust, and anything else at hand. Into this paste he scratched graffitilike images. The color is largely limited to that of the materials. "Portraits," such as that of Jules Supervielle and the *Woman in High Heels*, reveal the artist's powerful presence and his sense of irony and amazement. Traditional beauty is denied in favor of fascination. As James Joyce's *Ulysses*

1000

1002

1003

1001

1004

reveals the writer's materials—his words—so Dubuffet brings the artist's materials to the viewer's consciousness.

Wols (Wolfgang Schulze) was persecuted by the Nazis, then interned by the French. He found affirmation in the work of Paul Klee, but his response was in a tragic vein— the constant prescience of doom. His pictures are often improvisations with dreamlike, semiorganic forms disclosed in colors and eerie light. His friend Jean-Paul Sartre concluded his essay on Wols saying: "The rigorous integration of the forms and the marvelous sweetness of their colors have the function of consolidating our damnation."

Hans Hartung also left his native Germany because of Nazi pressures. He served in the French Foreign Legion and after the war became a French citizen. As early as 1923, while still living in Germany, Hartung had made abstract improvisations, and his postwar paintings of intense spontaneous energy became an important aspect of the French Informal Art movement.

Nicolas de Staël turned to abstract painting during the war and soon achieved an opulent texture created by a heavy brush or wooden sticks. The substantial tactile quality of the paint had great sensuous appeal for De Staël. An admirer and friend of Braque, he approached color and

paint as if they were living organisms and managed to discipline them to create paintings that are part of the French tradition.

997 Jean Fautrier. *Tête d'Otage (Head of a Hostage), No. 1.* 1943. Oil on canvas, 13 ³/₄ × 10 ⁵/₈″ 998 Jean Fautrier. *Tête d'Otage (Head of a Hostage).* 1945. Oil on canvas, 16 ¹/₈ × 12 ⁵/₈″ 999 Jean Dubuffet. *Jules Supervielle, Large Banner Portrait (Grand Portrait Mythe Supervielle).* 1945. Oil on canvas, 15 ¹/₂ × 38 ¹/₂″ 1000 Jean Dubuffet. *Woman in High Heels.* 1946. Oil on canvas, 25 ¹/₂ × 21 ¹/₂″ 1001 Wols. *Composition* c. 1946. Watercolor and pen on white paper, 62 ⁵/₈ × 48 ¹/₂″ 1002 Wols. *Oiseau (Bird).* 1949. Oil on canvas, 36 ¹/₄ × 25 ⁵/₈″ 1003 Hans Hartung. *T-1945-27.* 1945. Oil on canvas, 10 ³/₄ × 7 ¹/₂″ 1004 Nicolas de Staël. *Composition.* 1946. Oil on canvas, 39 ¹/₄ × 25 ¹/₂″

Geometric Abstraction

1006

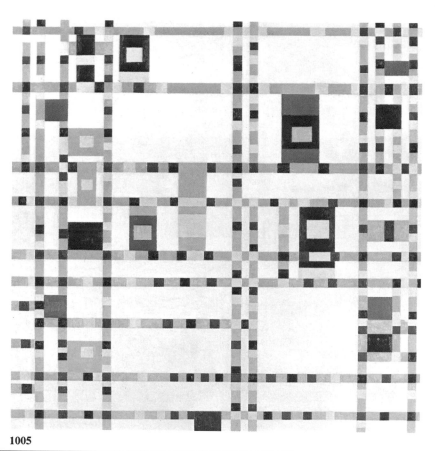

1005

1007

Piet Mondrian left Paris for London in 1938, and arrived in New York in 1940. He loved the dynamic quality of Manhattan, and in response to his new surroundings, at sixty years of age, the Dutch master broke loose somewhat from the Calvinist formal austerity of his earlier work. Under the impact of the syncopated rhythms of jazz music in Harlem dance halls, his late paintings—like those of his youth—once more relate to his visual and aural experiences. In *Broadway Boogie-Woogie*, his last completed painting, Mondrian discarded his rigid black grids in favor of primary colors—yellow lines with red and blue squares illuminating the intersections. Blocks of color

seem to float freely within the busy gridwork. The result is a flickering surface of dynamic rhythm that develops in time as well as space.

Josef Albers, who had been both a student and a professor at the Bauhaus, came to the United States in 1933. He brought much of the Bauhaus theory of design into his highly significant teaching, first at Black Mountain College in North Carolina and then at the Department of Design at Yale. Albers became the principal teacher of an art of geometric abstraction in this country and set up a theoretical and visual basis for the Hard Edge painting, Op Art, and Color Field painting of the 1960s. In his own painting he deals

with the relativity of color relationships, with the optical mutations of form, with the interaction of color and light in space; he explores optical and psychological meanings of illusion.

Since his student days at the Bauhaus, Max Bill has retained a concern with scientific and mathematical theory, realizing that the pure sciences, much like art, deal with the "mystery of space." His painting *Unlimited and Limited* is a metaphorical equivalent of scientific thought. The boundary line in the painting separates its colors, but they also flow into each other, the line opening the very areas it encloses. Bill deals with the conti-

1008

1009

1010

nuity of apparent contradictions. The painting is precise and clearly organized. But it is also open, free, and organic, its color areas at once clear and vaporous. Max Bill likes to deal with a topological figure called the Möbius strip, a mathematical paradox of a sheet which has only a single surface and edge but takes the form of a continuous loop. As he does not "abstract" from nature but develops work autonomously, Bill calls his own art "concrete."

The American painter Ad Reinhardt worked in a cool, almost ascetic style, and was affected little by his colleagues' search for personal mythology. He sought what he called an art that is ordered, timeless, life-less, and symmetrical. Finally reacting against his late Cubist painting— or in the case of this untitled work, late Cubist collage—Reinhardt began seeing himself as the heir of the pure and austere painting of Malevich (plate 376). He had the greatest esteem for Malevich's complete elimination of the subject and for the Russian's approach to pure painting. Oriental art and thought also never ceased to occupy Reinhardt's mind, and he admired the discipline of Zen and the wall-gazing meditation taught by Zen monks. In *Abstract Painting* he elicits a response from the optical nerve through the interplay of high-keyed hues of green, red, blue, and purple rectangles.

1005 Piet Mondrian. *Broadway Boogie-Woogie*. 1942–43. Oil on canvas, 50 × 50″ **1006** Josef Albers. *Indicating Solids*. 1949. Oil on masonite, 26 × 45 ³/₄″ **1007** Josef Albers. *Bent Black*. 1940. Oil on masonite, 26 × 19 ¹/₄″ **1008** Max Bill. *Unlimited and Limited*. 1947. Oil on canvas, 43 ³/₄ × 40 ¹/₂″ **1009** Ad Reinhardt. *Untitled*. 1940. Painted paper and gouache collage, 5 ³/₄ × 7 ³/₄″ **1010** Ad Reinhardt. *Abstract Painting*. 1948. Oil on canvas, 76 × 144″

Free Abstraction

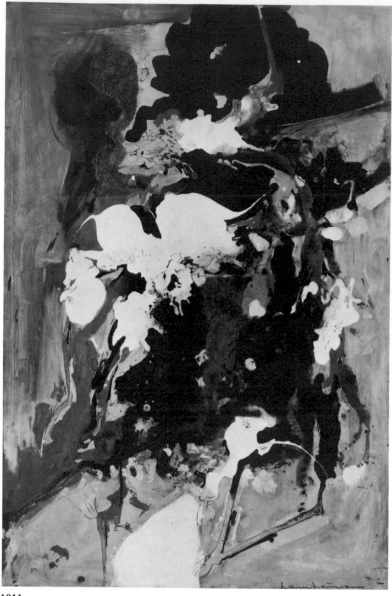

1011

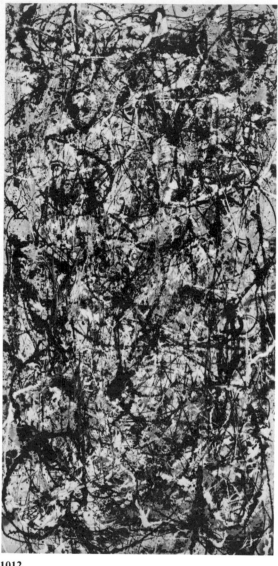

1012

Hans Hofmann, who belonged to Picasso's generation, was in close contact with the Paris avant-garde before World War One, and he established an important art school in Munich between the wars. He came to New York in 1932, and a year later opened the experimental and highly influential Hans Hofmann School of Fine Art. Hofmann, an untiring experimenter in new forms and techniques, made his first "drip" paintings by 1940. *Effervescence* consists of pools of pigment poured and dripped on the canvas with very little premeditation. By welcoming the effect of chance, Hofmann helped introduce the aesthetic of the controlled accident into his work as well

as his teaching. This new painting broke up the Cubist grid and replaced it with free and intuitive methods depending largely on the gestural energy of the artist. Hofmann's color sense, probably dating back to his early familiarity with the Fauves, was also an important contribution to the new American painting.

A few years after painting works such as *The Guardians of the Secret* (plate 991), Jackson Pollock transferred these techniques to a vast scale and with very different effect. In *Cathedral* color is minimal. The procedure was automatic, although a certain degree of involuntary control occurred. The artist dripped various fluid mediums

(enamel, aluminum paint) on canvas laid unstretched on the floor. The work—almost six feet high—functions somewhere between an easel painting and a mural. It carries the rhythmic movement of the artist's body to a much greater extent than Hofmann's far smaller work, and color and line have become the same.

Pollock was born in Wyoming; Clyfford Still came from North Dakota and spent most of his youth in the Pacific Northwest. Still was working in isolation in Richmond, Virginia, in 1945, when he painted foreboding pictures such as *Untitled* (also known as *PH-233*). He made highly individualistic works, turbulent and dynamic, appearing rugged

374

1014

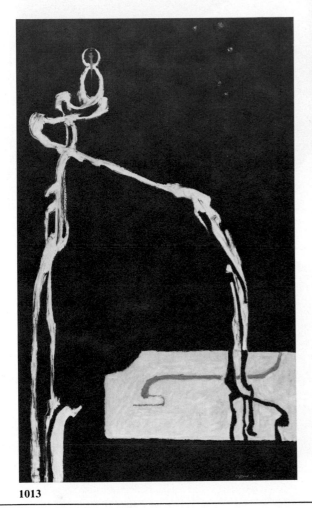

1013

1015

and unfinished. His friend Mark Rothko remarked on the "tragic-religious drama" in Still's work, and said: "Every shape becomes an organic entity, inviting the multiplicity of associations inherent in all living things."

Working in Seattle, Mark Tobey expanded his "white writing" to create broad surfaces of energy by the early 1940s. By the end of the decade, in *Universal Field*, his cryptic calligraphy moves ceaselessly across the picture. Color is largely avoided so that we can meditate on the linear web, which has the complexity of organic life, of ancient communication. Tobey's small tempera paintings rejected the concept of a formal composition at the same time as Pollock's large dripped and poured canvases.

Hans Hartung also looked at nature's continuous movement; his fluid signs were an expression parallel to nature. Like the American painters—who, according to the critic Harold Rosenberg, regarded the picture as "an arena in which to act—rather than as a space in which to reproduce . . . an object"—Hartung relied also on the directness of his gesture. Yet the work of the European artist seems more elegant and less problematical.

1011 Hans Hofmann. *Effervescence.* 1944. Oil, india ink, casein, and enamel on wood panel, 54 $^1/_8$ × 35 $^1/_2$″ **1012** Jackson Pollock. *Cathedral.* 1947. Duco and aluminum on canvas, 71 $^1/_2$ × 35 $^1/_{16}$″ **1013** Clyfford Still. *Untitled (PH-233).* 1945. Oil on canvas, 71 × 42 $^1/_8$″ **1014** Mark Tobey. *Universal Field.* 1949. Pastel and tempera on cardboard, 28 × 44″ **1015** Hans Hartung. *T-1948-19.* 1948. Oil on canvas, 38 $^1/_4$ × 40 $^5/_8$″

Spherical Form

1016

During the 1940s two traditions continued to function for the expression of basic sculptural forms: the organic, and the geometric. Barbara Hepworth is generally classed among the artists working in organic biomorphic form because she carved in wood and adhered faithfully to the tenet of truth to material. But in actuality a work such as *Pelagos* shows an almost perfect synthesis of the two traditions. She stated herself that she wanted "to infuse the formal perfection of geometry with the vital grace of nature." Here she used the dynamic configuration of a spiral, and not only emphasized the fine grain of the wood, but also painted the inside of the object. This white area gives a great sense of concavity and depth. She pierced the object so that the interior and exterior space could flow together, and she wrote that the "pierced holes had been thought out in relation to the scale of human beings." The string adds further to the sense of depth, leading the eye into the center of this work.

Naum Gabo's activities in England, including serving as an editor of the volume on art and architecture entitled *Circle*, brought the severe geometric tradition of the Constructivists into collaboration with the organic sense of British sculpture. Seeking to express his desire to visualize "kinetic rhythms as the basic forms of perception of real time," Gabo made *Spiral Theme*, which actualizes objectified motion. A series of translucent plastic planes defines dynamic movement by a delicate network of nylon lines incised into the curved surfaces. Gabo's commitment to the ideal that art could influence the state of mind of society, instead of adding to its materialism, is emphasized by the seemingly ephemeral and transparent nature of his materials.

As a student at the Bauhaus, Max Bill learned of and was greatly influenced by the work of Gabo. Bill's sculpture *Endless Ribbon from a Ring I* was designed about ten years after his *Construction* (plate 780) and deals with similar sculptural problems. It

1017

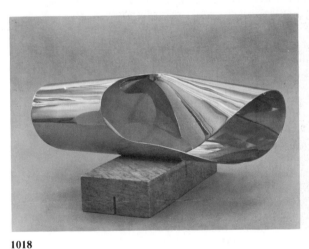

1018

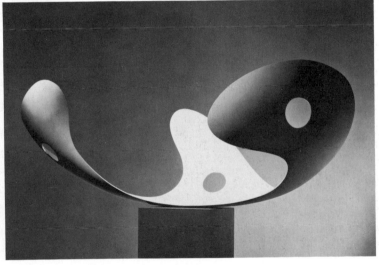

1019

dates from a time when Bill made his most systematic attempt to find a synthesis between mathematical procedures and artistic creation, which he explained in an important essay entitled "The Mathematical Approach to Contemporary Art" (1949). *Endless Ribbon I* consists of a continuous surface and is a variation on the theme of the Möbius strip (see page 373). Here Bill investigates the complexity of two-dimensional planes as they twist in endless convolutions to describe the nature of a sphere.

While Bill had been influenced by Gabo's search for a scientific methodology in the study of nature, the American artist José de Rivera found

a good starting point in the scientific theories of the Belgian Georges Vantongerloo (plate 781). De Rivera's works express geometric forms through the combination of varying planes. *Yellow Black* was cut from flat sheets of metal, then hammered and beaten into shape, and the surface filed and rubbed with abrasives. Paint in a primary yellow was then applied. *Yellow Black* is architectonic in structure and human in scale, analyzing the way space, materials, and light could denote a particular geometric form. However, here, too, geometry is tempered by the artist's intuitive act.

1016 Barbara Hepworth. *Pelagos*. 1946. Wood with colored strings, height 14 $^1/_2$″
1017 Naum Gabo. *Spiral Theme*. 1941. Construction in plastic, height 5 $^1/_2$″
1018 Max Bill. *Endless Ribbon from a Ring I*. 1947–49 (executed 1960). Gilded copper on crystalline base, height 14 $^1/_2$″
1019 José de Rivera. *Yellow Black*. 1946–47. Painted aluminum, length 22″

Objects of Fantasy

1021

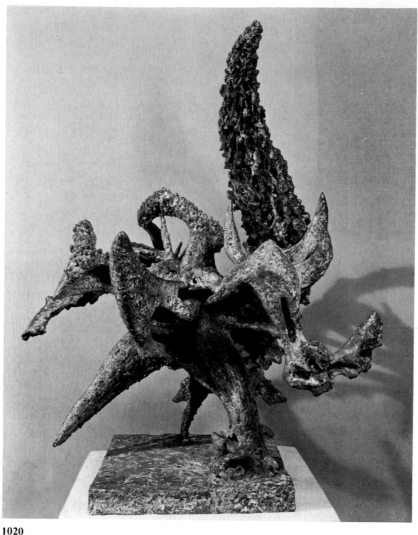

1020

1022

Theodore Roszak had also worked in the Constructivist tradition in the 1930s, but found himself completely disillusioned with mechanization in the face of the war and its aftermath. He turned toward a new and—to him—more meaningful sculpture dealing with organic form and human experience. During the war, Roszak had worked in an aircraft factory. When he returned to his studio, he welded gnarled and pitted surfaces into highly complex and often agonized forms. *Specter of Kitty Hawk* recalls prehistoric flying reptiles. The thorns and prongs, despite their prickly appearance, are beautifully textured as a result of the rich brazing of bronze and brass into steel.

Isamu Noguchi, in contrast, as-sembled simple marble slabs and interlocked them. He liked their beautiful grain; he appreciated the limitation imposed by this inflexible material, and also the fact that marble is both fragile and stable at the same time. Against the chaotic state of the world, Noguchi postu-lates a sense of ordered equilibrium in his work. Having been through Brancusi's "distillery of basic forms," Noguchi handles his forms in a similarly pure fashion. He recalls the marble standing male figures from Archaic Greece in titling a major work of 1945 *Kouros*; but he has imposed his own sense of struc-ture and animation of space.

David Hare, as well as Noguchi, was included in the last full-scale Surrealist show, held in Paris in 1947. Hare was in touch with the French artists in wartime New York and shared their concerns. His *Magician's Game* is a hybrid, emblematic form in which reality is changed by the artist's fantasy. It relies considerably on the principle of free association, what he called "the spaces of the mind." It is a bronze cast of a three-legged chair, the back of which resembles a woman's torso, with a comb hanging over the seat.

The high fantasy of Joseph Cor-nell's mind is evident in the yoking together of disparate objects, con-cepts, and civilizations in *Medici Slot Machine*. Again using varied materi-als, he contrives a dream environment in which the portrait of a Renais-

1023

1025

1024

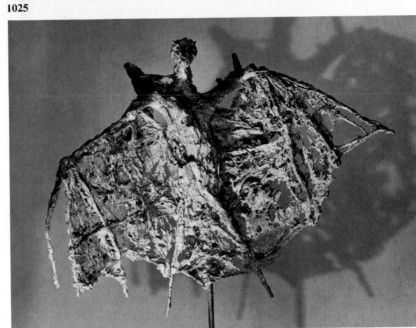

1026

sance prince, flanked by sections of a map showing the remains of ancient Rome, is set in a box with objects from our own time. It is a theater of illusions negating linear concepts of time.

Alberto Giacometti's *Nose*, a gigantic realization of the Pinocchio fantasy (itself one of an age-old line of physical fantasies), is a stripped-down, deceptively simple work. Because Giacometti suspends the head, there is a heightened feeling of terror and instability, compounded by the ambiguous cage that cannot really contain the nose.

In the 1940s Ibram Lassaw continued to develop a sculptural form based on an understanding of the apparently contradictory traditions of Constructivist and Surrealist aesthetics. Lassaw was a student of the German mystics, such as Meister Eckhardt, and was also familiar with Suzuki and Zen philosophy; to him the work of the sculptor is not unlike that of the alchemist. His *Star Cradle* deals with the relationship of solids and voids, with free biomorphic patterns flowing through a rigid rectilinear structure.

Germaine Richier created mysterious hybrid figures to convey her sense of drama and fear. She made disturbing sculptures with corroded surfaces. This sculptor, who achieved great fame in Europe, created a Boschian race of hydras, spiders, griffins, and bats, of praying mantises and six-headed horses. Human and animal qualities are merged into some kind of pantheism in which the humanoid animal is the measure of all things. In Richier's world to be ugly is to appeal; it is a world of transmutation and metamorphosis and organic interaction.

1020 Theodore Roszak. *Specter of Kitty Hawk*. 1946–47. Welded and hammered steel, brazed with bronze and brass, height 40 1/4″ **1021** Isamu Noguchi. *Kouros*. 1944–45. Pink Georgia marble, slate base, height 117″ **1022** David Hare. *Magician's Game*. 1944 (cast 1946). Bronze, height 40 1/4″ **1023** Joseph Cornell. *Medici Slot Machine*. 1942. Mixed mediums, box construction, height 15 1/2″ **1024** Alberto Giacometti. *The Nose*. 1947. Bronze, wire, rope, iron, height of cage 32″ **1025** Ibram Lassaw. *Star Cradle*. 1949. Lucite and stainless steel, height 12″ **1026** Germaine Richier. *The Bat Man*. 1946. Bronze, height 34 5/8″

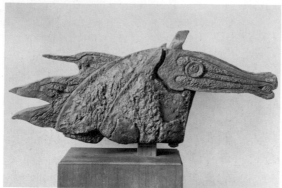

1027

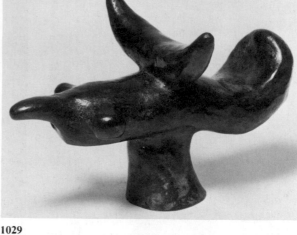

1029

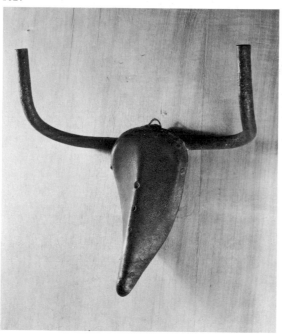

1028

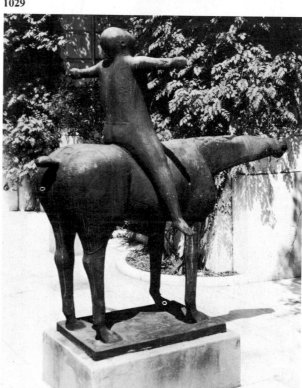

1030

Georges Braque did a good deal of sculpture during World War Two, but his pieces, cast in bronze, remain basically two-dimensional, the work of a painter. His *Head of a Horse*, inspired by a classical horse from the Parthenon pediment, belongs to the long tradition of Western art. His horse's head conveys the illusion of a wild gallop solely by means of small variations: the slightly elongated muzzle and the indications of an outspread mane.

During the 1940s Picasso continued to experiment. Always concerned with the ambiguity between reality and appearance, he simply took a bicycle saddle and its handlebars, slightly rearranged the two elements, and cast them into a *Bull's Head*—sleight of hand, but also a work that astonishes and stimulates with the shock of recognition.

Miró was preoccupied with images of birds throughout most of his career, but toward the end of the war he cast a large number in bronze. This *Bird*, with all its protuberances, is most certainly a female. Its squat arched legs are echoed by a crescent on top of which may be a beak or a pair of horns. From the front it looks arrogant, with its belly and tongue sticking out, but from the side or back this highly evocative animal looks much more placid. This is a bird that will never fly. It follows the laws of a fantasy both free and dis-

ciplined after years of thought and work.

In Italy, Marino Marini continued the tradition of equestrian sculpture. The T'ang dynasty ceramic horse was not unknown to him, and he created figures of horse and rider relating animal to man. But these figures are not the triumphant equestrian statues of antiquity or the *cavalieri* of the Renaissance. The forms became simplified in a Marini work such as *The Angel of the Citadel*, which guards the late Peggy Guggenheim's *palazzo* on the Grand Canal in Venice. The man with arms stretched out and head turned receptively toward the sky is no longer a heroic figure.

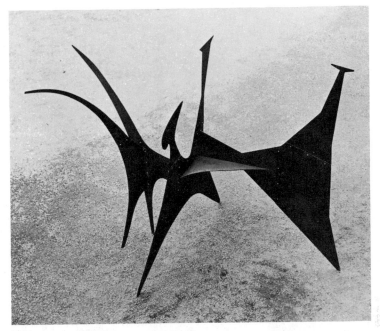

1032

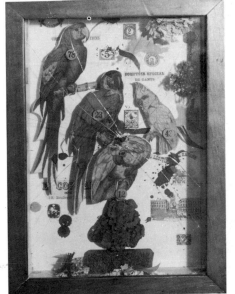

1031

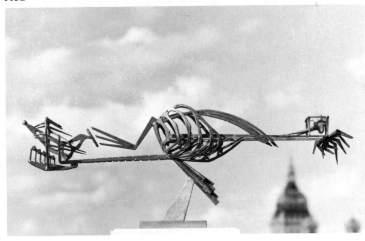

1033

Plumed paper birds, equipped with target numbers, occupy Joseph Cornell's *Habitat Group for a Shooting Gallery*. The glass protecting them has been shattered, supposedly by the shot of a rifle. It is hardly a sculpture in any traditional sense—any more than it is a painting. This colorful aviary of the imagination is visual poetry of an elusive nostalgia.

Alexander Calder, who frequently used fish or birds as the subjects of his mobiles—because they lent themselves to segmented or sequential depiction—created a *Black Beast* in this steel stabile. (When he made sculptures that did *not* move, Jean Arp called them "stabiles" to contrast them to Calder's moving ob-

jects.) The four legs rest firmly on the ground, but there is also a fifth leg, and two additional heads—or is this a tail and some spiky appendages? Calder compels us to view his beast from several angles, thereby achieving mobility even in stationary sculpture.

David Smith's *Royal Bird* is based on prehistoric ornithoids, but it is a totemic object for our time. It is a royal bird in that it refers to the emblems of eagles used by many countries as their insigne. Made after the end of World War Two, this predatory animal clearly has political implications, which were also expressed verbally by the sculptor. This five-foot-long open sculpture is ex-

perienced as a linear silhouette rather than as mass or volume. With its jagged, straight, and sweeping forms it transforms the steel into a rhythmic structure of expressive power.

1027 Georges Braque. *Head of a Horse*. 1943 (cast 1946). Bronze, height 17 $^3/_4$″ 1028 Pablo Picasso. *Bull's Head*. 1943. Bronzed bicycle seat and handlebars, height 16 $^1/_2$″ 1029 Joan Miró. *Bird*. 1944. Bronze, height 12 $^1/_2$″ 1030 Marino Marini. *The Angel of the Citadel*. 1949. Bronze, height 67″ 1031 Joseph Cornell. *Habitat Group for a Shooting Gallery*. 1943. Mixed mediums, box construction, height 15 $^1/_2$″ 1032 Alexander Calder. *Black Beast*. 1940. Stabile, sheet steel, height 81″ 1033 David Smith. *Royal Bird*. 1947–48. Welded stainless steel, height 21 $^3/_4$″

Drawing in Space

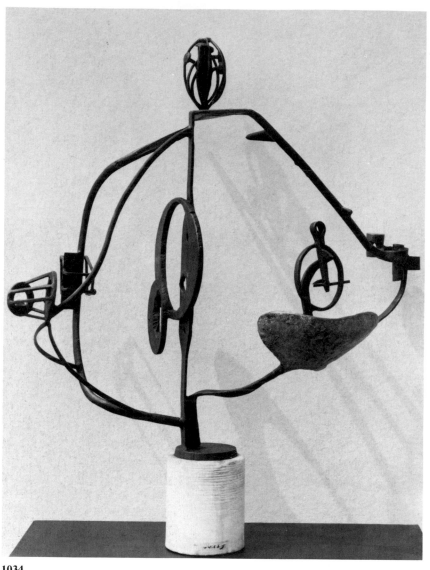

1034

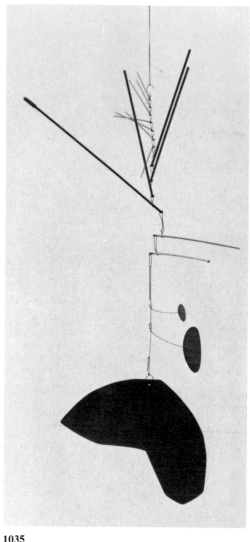

1035

The welding technique originated by Julio González (see page 295) made it possible for innovative sculptors to use three-dimensional lines and structures to define volumes—to draw in space. David Smith availed himself of the new possibilities of discarding the whole concept of solid mass in favor of an open, transparent form, as in *Blackburn*. Alexander Calder's constructed mobiles become very linear at this time, as exemplified in his skeletal *Thirteen Spines*. Here thirteen linear rods of steel are attached to each other at their fulcrum in a carefully calculated structure of balances and counterbalances. These lines in space describe their own movement in contrapuntal relation to all the other vectors, creating ever-changing spatial patterns.

Henry Moore, like Barbara Hepworth (see plate 1016), uses taut wire for a purpose different from Calder's. The copper wire in *The Bride* is stretched over its lead support not unlike the strings in a musical instrument. The wires define the shape of space occupied by the segmented solid form of cast lead. As in Hepworth's contemporaneous sculptures with strings, these wires guide the viewer's eye, increasing his awareness of the sculpture and the space in which it exists. The straight, geometric tautness of the string makes us more sensitive to the abstract, though anthropomorphic, quality of the bride, veiled by her curtain of strings.

Reg Butler was trained as an architect and worked as a blacksmith during the war. An architectural sense of structure and the knowledge of forging metals are the bases of the sculptural work he did after the war. In his early work Butler welded iron bars into open linear structures of great elegance and grace. When Butler makes his metal "drawings in space," however, he imbues these forms with a human presence, as in the spidery but very female *Woman*. "Somewhere in the back of my mind," the sculptor wrote to the author, "there has always been a conviction that to achieve an appropriate paraphrase of the human

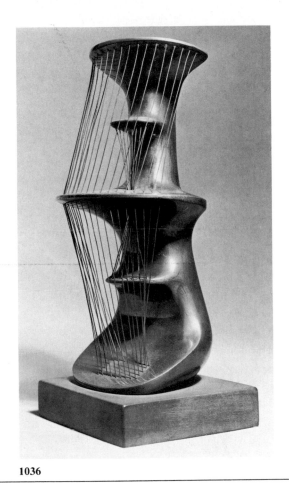

1036

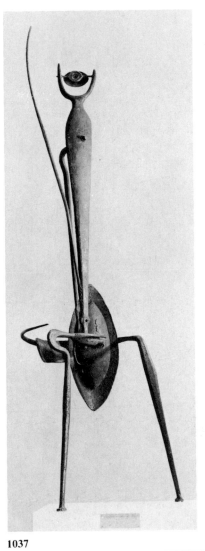

1037

1038

1039

image may well be the most considerable achievement of which man will ever be capable."

Although called *Brass Insect*, Robert Adams's sculpture, made in London at the same time, is totally abstract. This drawing in brass, which at first looks like a very simple exercise, consists of a single delicate line that is both curved and straight as it deliberately moves through space.

The American Richard Lippold was trained as an industrial designer and began to make constructions of metal wire around 1942. An early masterpiece, *Variation Number 7: Full Moon,* is a carefully calculated work, made of brass rods and tightly

stretched nickel-chromium and stainless-steel wires. It is a completely symmetrical construction, with a complex interlace of implied cubes, expanding from a central core with its wires in a state of total tension. It can be seen as a poetic metaphor of the crystalline structure of cosmic order. It is delicate, fragile, and mysterious; it seems to be drawn with reflected light.

1034 David Smith. *Blackburn, Song of an Irish Blacksmith*. 1949–50. Copper and iron, height 46 ¹/₂″ 1035 Alexander Calder. *Thirteen Spines*. 1940. Mobile, sheet steel, rods, wire, and aluminum, height 86 ⁵/₈″ 1036 Henry Moore. *The Bride*. 1939–40. Cast lead and copper wire, height 9 ³/₈″ 1037 Reg Butler. *Woman*. 1949. Forged iron, height 87″ 1038 Robert Adams. *Brass Insect*. 1949. Brass, length 16″ 1039 Richard Lippold. *Variation Number 7: Full Moon*. 1949–50. Brass rods, nickel-chromium, and stainless-steel wires, height 120″

The Human Figure

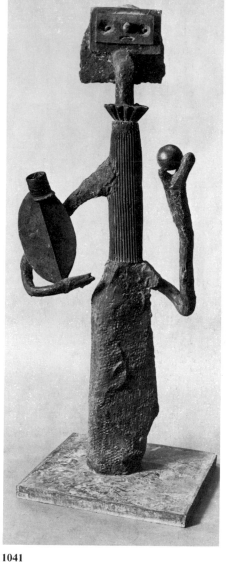

1040

1041

1042

1043

Jacques Lipchitz, who had worked with rather transparent Cubist structures in the mid-1920s, now adapted a new figurative style in the powerful *Mother and Child II*, completed after his emigration from France to the United States. This is a symmetrical tectonic structure which consists of breathing organic forms. It is as monumental as his earlier *Figure* (plate 718), but it is also very personal. Open to many interpretations, it can be read as a mother carrying her child or as a charging bull, and it has the appearance of the crucifix. It combines all these images and associations simultaneously in a solid, totemic image.

Picasso could work on a caprice

such as *Woman with Apple* and the severe *Man with a Lamb* at virtually the same time in his studio in Occupied Paris during the war. There are no distortions in this heroic shepherd based on an archetypal theme whose iconography goes back to Archaic Greek and Early Christian sculpture: a patriarch holding a sheep in his arm. It evokes the legends of Abraham and Isaac, the Greek *Moschophoros (Man Bearing a Newborn Calf)*, the Christian Good Shepherd. At this time Picasso was concerned with the establishment of direct communication with the viewer and adopted traditional subject matter to create a public monument. The seven-foot sculpture looks mag-

nificent in the busy little market square in Vallauris in the south of France, where one of its three casts was installed by the master.

The human figure was always essential to the art of Henry Moore, who explained that "if it were only a matter of making a pleasurable relationship between forms, sculpture would lose, for me, its fundamental importance." The *Family Group* was originally designed for the grounds of a school that was meant to be the center of the social life of the surrounding villages. It is based on the *Shelter Drawings* of draped figures that Moore had done during the war (see plate 950). Instead of the single female *Reclining Figure* or the

1044

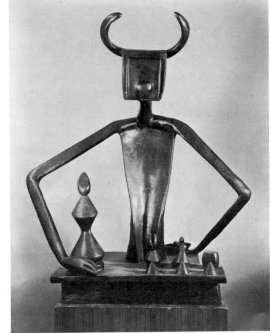

1045

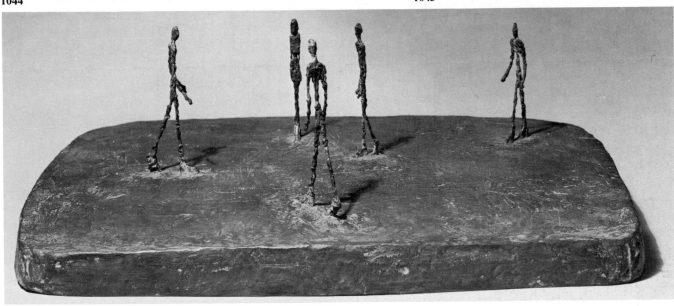

1046

mother and child, Moore for the first time adds the father, resulting in a different, vital interrelationship. In *Family Group*, Moore's first major work to be cast in bronze, he turned toward a monumental, simplified form, evoking the dignity of primitive and medieval sculpture and dealing, essentially, with the continuity of life.

Max Ernst's *The King Playing with the Queen* is a narrative work. The inanimate chess pieces have themselves become the active chess players. An overpowering monster-monarch, bull's horns crowning his head, is playing with a schematic queen on a chessboard, which is also a table. His large arms reach out

simultaneously protecting and controlling his queen.

Ernst had first turned to sculpture in 1934, under Giacometti's inspiration. Giacometti now felt the need to find a new and direct relationship to the human figure. Although it shares a sense of alienation with *The Palace at 4 a.m.* (plate 760), *City Square* is a very different kind of sculpture. Now the human figure is compressed to its ultimate reduction—five anonymous, depersonalized figures who are little more than armatures. These amorphous bodies, walking by each other, maintain their inviolate and absolute distance and integrity in the face of the threatening void. Yet their presence is intense, precisely because of

their physical relationship to the space surrounding them and to the viewer confronted with their existence.

1040 Jacques Lipchitz. *Mother and Child II*. 1941–45. Bronze, height 50″
1041 Pablo Picasso. *Woman with Apple*. 1943. Bronze, height 70 ⅞″ 1042 Pablo Picasso. *Man with a Lamb*. 1944. Bronze, height 86″ 1043 Henry Moore. *Family Group*. 1948–49 (cast 1950). Bronze, height 59 ¼″ 1044 Henry Moore. *Reclining Figure*. 1945–46. Elm, length 45″
1045 Max Ernst. *The King Playing with the Queen*. 1944 (cast 1954). Bronze, height 38 ½″ 1046 Alberto Giacometti. *City Square*. 1948. Bronze, height 8 ½″

Seven: The 1950s

The period 1950–59 was one of transition and paradox. The two superpowers that emerged from the war faced each other with distrust, and the cold war became a grim reality. Throughout the decade the two great powers managed to coexist and contain each other's tendencies to expand their spheres of influence. However, in Korea, Vietnam, and Cuba conflicts continued to be resolved by military force.

The nation of Korea—arbitrarily divided into two sections along the 38th parallel—exemplified the competitive fervor of the two rival world systems. Following the failure of the efforts of the U.S. and the U.S.S.R. to form a unified Korean government in 1946, and the disruption of the U.N.-sponsored elections in 1948, North Korean troops crossed the 38th parallel in June 1950. United Nations forces, consisting mostly of American military contingents led by General Douglas MacArthur, halted the initial push from the North. By late 1951 peace talks began, but a truce agreement was not signed until 1953, after Dwight D. Eisenhower, who had campaigned on the promise to end the war, was elected president.

Vietnam presented a somewhat similar situation, and one that escalated into enormous proportions in the following decade. A state of war had existed between the Democratic Republic of Vietnam under the leadership of Ho Chi Minh, and his Viet Minh Party, and the Republic of France, which had exercised colonial control over Indochina for almost a century. Ho, supported by Chinese and Soviet aid, sought to unify Vietnam under Communist rule. In 1954 the Geneva Conference partitioned Vietnam at the 17th parallel, attesting to the strength of Ho's army—and of the cause of independence. As French power diminished, in the South the U.S. presence increased in the form of military "advisers" attached to the government of Ngo Dinh Diem. Suspecting that the Communists would win in free elections, American agents helped the South Vietnamese government to postpone them indefinitely. A renewal of hostilities by Communist guerrillas in 1957 led to eventual full-scale U.S. military involvement.

In 1959 Fidel Castro, a young Cuban lawyer who had launched the 26th of July Movement in 1956, deposed the dictator Fulgencio Batista. Castro set up a socialist state and brought about agrarian reforms and the nationalization of industries. As Cuban relations with the United States deteriorated, Castro availed himself of Soviet economic and military aid, which resulted in a trade embargo by Washington, a complete diplomatic break, the abortive Bay of Pigs invasion of 1961, and eventually the Cuban missile crisis of 1962, bringing the world to the brink of nuclear disaster.

In the Middle East, strife continued as the new state of Israel was unable to conciliate Arab hostility. Open war broke out in 1956 when France, Britain, and Israel attempted to take over the Suez Canal, which Egypt's premier, Gamal Abdel Nasser, had nationalized.

Just as American foreign policy was largely rooted in fear and suspicion of the Soviet Union, so within the United States the "Communist menace" was seen as a constant threat. Foreign aid for social and economic development was far outweighed by military and defense expenditures. This, together with the great cost of the Korean conflict, renewed the wartime stimulus enjoyed by American industry. But whereas the threat of Communism induced great economic growth, the political and popular reaction shamed an entire nation. The first national incident concerning alleged Communist infiltration was the Alger Hiss case, which brought Congressman Richard M. Nixon into national prominence.

Joseph McCarthy, as chairman of the Senate permanent investigations subcommittee, led an insidious antileft crusade which succeeded for a considerable time, helped by an atmosphere of public fear and hysteria. McCarthy promised to expose Communists in colleges and universities, in the entertainment industry, in the State Department, and even in the armed forces; individuals were forced to answer questions under oath or risk charges of contempt of Congress. Some persons resisted McCarthy's onslaught; those who actively cooperated fueled the scandal by providing names, thereby ruining the careers and lives of former friends and associates. Eventually McCarthy was censured in a bipartisan Senate resolution for conduct unbecoming a senator. He had managed, however, to silence public debate for a long time to come.

In 1954, the year in which McCarthy was censured, the United States Supreme Court declared that the doctrine of separate but equal facilities was unconstitutional, thereby opening the way toward an end to the long segregation of blacks and whites and to more equal civil rights.

The postwar environment was also a time of reconstruction and reconciliation. The United States supported Western Europe militarily through the

North Atlantic Treaty Organization and economically through the Marshall Plan. Europe's economic recovery was much more rapid—and more permanent—than it had been after World War One. France, the Federal Republic of Germany, Italy, and the Benelux countries (Belgium, the Netherlands, and Luxembourg) set up the European Economic Community, known as the Common Market, which facilitated relatively unrestricted movement of labor, capital, and services among these nations.

Among the decade's scientific and technological advances, the most phenomenal was the exploration of outer space, initiated in 1957 when Sputnik I, the first man-made satellite, was launched by the Soviet Union. During this decade pharmaceutical firms began to market birth-control pills, which had an enormous effect not only on population growth but also on moral standards and human conduct. With the introduction of the computer with stored programs, information processing, or cybernetics, became a significant technology. The "knowledge industry" in the United States alone was estimated to constitute 29 percent of the gross national product by the end of the decade.

"Culture" too was consumed en masse with the proliferation of the paperback book, the long-playing record, and the tape recorder, and the abundance and wide dissemination of visual images, including the extensive color reproduction of works of art.

"Modernism" in all areas became accepted. The avant-garde was quickly co-opted, even canonized. Artists, instead of attempting to shock the bourgeoisie, were now eager to attract its patronage. With the remarkable economic recovery of the 1950s the new building in Europe and the United States turned to the International Style, which had been largely rejected as too radical in the prewar years.

The conventions of the past were put in doubt on all sides. Psychologists, such as Norman O. Brown, Erik Erikson, and R. D. Laing, and social philosophers, such as Herbert Marcuse, no longer propounded the need for people to adjust to society, but offered instead critiques of the standards a dehumanizing, technological society imposed on the individual. The presence of the disinherited and discontent is evident in the works of Samuel Beckett, Eugène Ionesco, and Alain Robbe-Grillet, as well as in the wild, unorthodox style of the Beat Generation. Its chroniclers include Jack Kerouac and Allen Ginsberg. All these writers in their own way reflected on the great distancing that occurred between the individual and an indifferent society in the post–World War Two world.

Film perhaps more than any other medium expressed the character of individual unrest, alienation, and irony. No longer beholden to the commercial hegemony of Hollywood, European and American filmmakers sought a new independence in their art. Moving away from elaborate studio production, filmmakers created their own concepts in which the visual image of the frame took precedence over the written script. Increasingly the film became not only an instrument of mass-audience entertainment, but also an artistic medium of serious import and merit.

The 1950s saw the introduction of electronic music machines, or synthesizers, which could produce tones of any desired frequency and create synthetic instrumental sound. Now almost any kind of sound could be regarded as music. This afforded both composer and performer much greater, indeed almost unlimited, freedom and responsibility. But in many cases it also eliminated the need for the performer to be present for the performance, placing the audience in a new, insecure relationship to the aural experience.

The leading movement in painting—Tachisme, or Informal Art, in Europe and Abstract Expressionism in America—similarly placed a greater burden of response on the audience. The manner and method by which the artist approached his subject—and indeed the canvas itself—became important, as did the resulting encounter between painter and painting. Ambiguity and subjectivity are terms in which much of the painting of the 1950s is to be understood. The artist sought the freedom he could not find in society in the private dialogue with his work.

In America the state itself, which heretofore had been hesitant to sponsor or support avant-garde art, gave full acceptance to this new intrasubjective art. Ironically this most personal and private expression of often anguished individuals was annexed by the American power structure as visible evidence of artistic freedom in the United States, in great contrast to the aesthetic restrictions in the Soviet Union and its banal Socialist Realism. By 1958 a large exhibition called "The New American Painting," organized by the International Council of The Museum of Modern Art, toured eight European countries presenting what was soon called "the triumph of American painting."

	Political Events	The Humanities and Sciences	Architecture, Painting, Sculpture
1950	Outbreak of the Korean War	Pope Pius XII proclaims the dogma of the bodily assumption of the Virgin Mary Eugène Ionesco, *The Bald Soprano* David Riesman et al., *The Lonely Crowd*	New York: The Irascible Eighteen (avant-garde artists) protest the conservative policy of the Metropolitan Museum New York: First Barnett Newman exhibition at the Betty Parsons Gallery Venice Biennale: Arshile Gorky, Jackson Pollock, and Willem de Kooning shown in the U.S. Pavilion Venice and Milan: Peggy Guggenheim organizes Pollock one-man exhibition Michel Tapié coins the term "Art Informel"
1951		London: Festival of Britain Igor Stravinsky, *The Rake's Progress* J. D. Salinger, *The Catcher in the Rye*	New York: Exhibition of "Abstract Painting and Sculpture in America" at The Museum of Modern Art New York: Ninth Street Show organized by sixty-one avant-garde artists Robert Motherwell (editor), *The Dada Painters and Poets* Liège: Second and last Cobra exhibition; work from nine countries represented Chicago: Jean Dubuffet lectures on "Anticultural Positions" at The Arts Club
1952	Elizabeth II succeeds to the British throne Establishment of the European Coal and Steel Community	Explosion of the first hydrogen bomb Samuel Beckett, *Waiting for Godot* John Cage, *4′3″* Paul Tillich, *The Courage to Be*	Paris: Michel Tapié publishes *Un Art Autre* Harold Rosenberg coins the term "Action Painting" Tokyo: Gutai (Concrete) group founded
1953	Dwight D. Eisenhower becomes U.S. president Death of Josef Stalin; Nikita Khrushchev becomes first secretary of the Communist Party of the U.S.S.R. End of the Korean War Workers riot in East Berlin Execution of Julius and Ethel Rosenberg	Karlheinz Stockhausen, *Kontrapunkte No. 1* Arthur Miller, *The Crucible* Saul Bellow, *The Adventures of Augie March* Mount Everest climbed for the first time by Edmund Hillary and Tenzing Norkay	New York: First Robert Rauschenberg exhibition at the Stable Gallery São Paulo: First São Paulo Bienal

Political Events	The Humanities and Sciences	Architecture, Painting, Sculpture
1954 Fall of Dienbienphu; French withdraw from Indochina Beginning of the Algerian War U.S. Senate votes condemnation of Senator Joseph McCarthy U.S. Supreme Court declares school segregation unconstitutional	Thomas Mann, *Confessions of Felix Krull* Federico Fellini, *La Strada*	New York: Exhibition of "Younger American Painters" at The Guggenheim Museum London: Exhibition of "Collage and Object" at the Institute of Contemporary Arts; the term "Pop Art" comes into use
1955	Herbert Marcuse, *Eros and Civilization* Vladimir Nabokov, *Lolita* Alain Robbe-Grillet, *The Voyeur* First mass immunization against polio by use of the Salk vaccine	Kassel: Documenta 1 exhibition; an important survey of twentieth-century art Paris: First survey of kinetic art at the Galerie Denise René
1956 Suez Canal nationalized by Egypt; England, France, and Israel invade Egypt Hungarian rebellion against Soviet domination quickly crushed	Jean Genêt, *The Balcony* Allen Ginsberg, *Howl* Ingmar Bergman, *The Seventh Seal*	
1957 Treaty of Rome establishes the European Common Market	Sputnik I launched by the U.S.S.R.; beginning of the exploration of outer space Samuel Beckett, *Endgame* Jack Kerouac, *On the Road* Leonard Bernstein: *West Side Story*	Oakland, California: Exhibition of "Contemporary Bay Area Figurative Painting"
1958 Charles de Gaulle becomes French president; establishment of the Fifth Republic	Claude Lévi-Strauss, *Structural Anthropology* Andrzej Wajda, *Ashes and Diamonds*	Brussels: World's Fair Düsseldorf: *Zero 1* and *Zero 2* are published Venice Biennale: important representation of Wols, Lucio Fontana, and Mark Rothko New York: First Jasper Johns exhibition, at the Leo Castelli Gallery Happenings begin
1959 Revolution in Cuba succeeds; Fidel Castro comes to power Hawaii becomes the fiftieth U.S. state	Norman O. Brown, *Life against Death* Stuart Hampshire, *Thought and Action* Günther Grass, *The Tin Drum* Michelangelo Antonioni, *L'Avventura* François Truffaut, *The 400 Blows* Jean-Luc Godard, *Breathless* Alain Resnais, *Hiroshima Mon Amour*	Los Angeles: Jules Langsner coins the term "hard-edge painting" for the work of four Los Angeles artists Kassel: Documenta 2; one-man shows of Jackson Pollock, Nicolas de Staël, and Wols Paris: 1st Biennale of Young Artists New York: Exhibition of "New Images of Man" at The Museum of Modern Art presents New Figuration

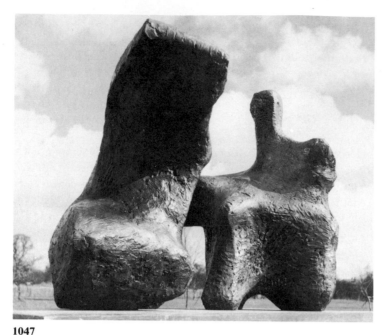

1047

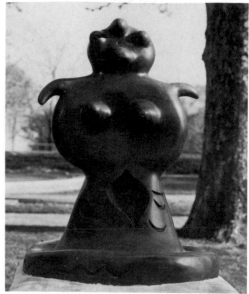

1049

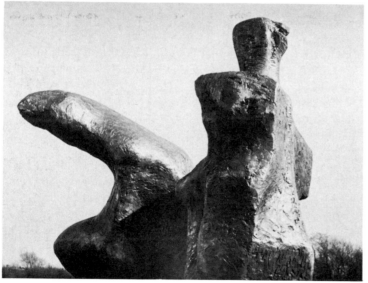

1048

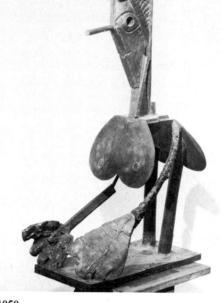

1050

Despite their basically abstract composition and segmented format, Henry Moore's heavy organic figures evoke female associations. According to the artist, "rounded forms convey an idea of fruitfulness, maturity, probably because the earth, women's breasts, and most fruits are rounded." Moore's grandiose images, with their fecund and ample protuberances, reveal a pantheistic notion of creation. Seemingly weathered by the vicissitudes of time, they exist harmoniously in the natural landscape.

Joan Miró's hybrid concretions also allude to the animal, mineral, and vegetable kingdoms. In *Woman (Personnage)* the static monumental figure, with its expansive torso, sprouting breasts, and branchlike arms, may be likened to a tree in bloom. Unlike Moore's more ponderous interpretations of the generative principle, Miró's *Personnage* is a statement of humor and whimsy.

Composed of a variety of found objects later cast into bronze, Picasso's *Bather Playing* also represents a jocular interpretation of the female anatomy. Enormous broomlike arms and spindly legs emerge from both a breast and a shoulder, wholly obviating the need for a torso. The grotesque proportions, dislocation and suppression of bodily parts, and awkwardness of posture reveal Picasso's total disinterest in the conventional standards and canons of beauty.

In sharp contradistinction, Giacometti's silent female specter, this solitary and inviolable *Woman of Venice*, stands immobile in space and time. Unlike his male figures, who stride forward, the women in his art remain static and impassive—perhaps a comment on the artist's view of the female principle. Like their masculine counterparts, however, they bespeak ethereality and insubstantiality rather than mass. Attenuated, their mottled surfaces in a constant state of flux, they are engulfed by the void instead of occupying it. These figures express psychological rather than physical isolation,

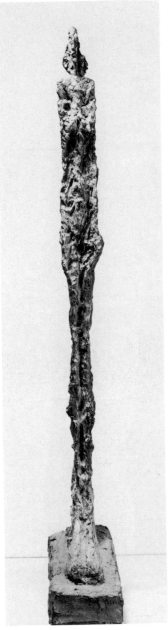

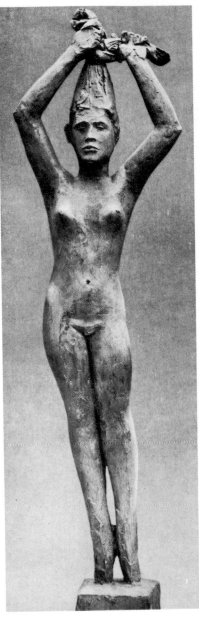

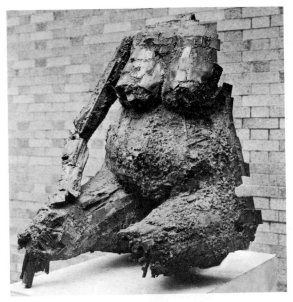

1053

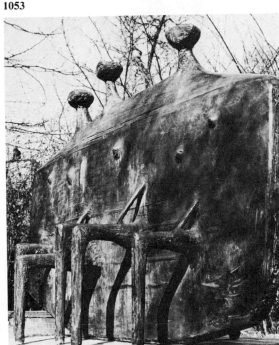

1051

1052

1054

an essentially asexual phenomenon.

Like Renaissance artists, the northern Italian sculptor Giacomo Manzù was apprenticed to master craftsmen in his early teens, and he worked from a sense of tradition all his life. Yet his work is imbued with a feeling of modernity, largely due to its simplicity of statement. His dancer, standing on her toe, is frontal and austere.

Although César's blatant emphasis on reproductive functions, seen in the pendulous breasts and ample abdomen, seems to evoke the fertility goddesses of the prehistoric era, his eroded surfaces, sinewy limbs, and jagged edges belie any such associations. In fact, his human figures are

composed of pieces of scrap iron and machinery as well as a network of irregular iron plates, tubes, pipes, and nails which he fuses together, linking these anthropomorphic fragments to modern technology rather than to biological processes. Negating the smooth sensuality of skin, moreover, the artist stresses decay and erosion; the body becomes a shattered and violated shell of a once organic whole.

Inspired by the great crowds and clusters of humanity in London, Kenneth Armitage joins his fellow urban dwellers into a new synthetic whole. The specific femininity of *Triarchy*, whose resemblance to Cycladic figurines evokes associa-

tions of fertility, can be seen in the budding breasts and supple creased skin, a function of the artist's sensual use of direct modeling in the original clay. The result is a creative synthesis of the primitive and the contemporary, in both its anonymity and constructive simplicity.

1047–1048 Henry Moore. *Two-Piece Reclining Figure No. 1*. 1959. Bronze, length 76″ **1049** Joan Miró. *Woman (Personnage)*. 1953. Black marble, height 38 $\frac{1}{4}$″ **1050** Pablo Picasso. *Bather Playing*. 1958. Bronze, after found objects, height 44 $\frac{1}{2}$″ **1051** Alberto Giacometti. *Woman of Venice, VI*. 1956. Bronze, height 52 $\frac{5}{8}$″ **1052** Giacomo Manzù. *Female Dancer*. 1957. Bronze, height 25 $\frac{5}{8}$″ **1053** César (Baldaccini). *Torso*. 1954. Welded iron, height 30 $\frac{3}{8}$″ **1054** Kenneth Armitage. *Triarchy*. 1958–59. Bronze, length 108″

The Male Figure

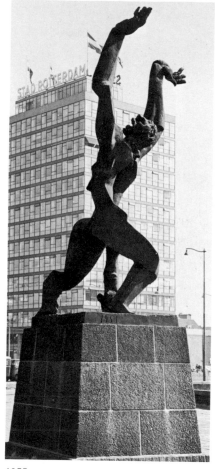

1055

1056

1057

For his monument to the destruction of Rotterdam, a passionate condemnation of the Nazi bombing of 1940, Ossip Zadkine created a single agonized human figure to symbolize the suffering and terror of the thousands killed in the attack. The last great Cubist sculpture, this twisted figure staggers backward, arms raised in supplication, head flung back, face distorted with pain and disbelief. Zadkine has adapted the Cubist vocabulary to create a profoundly moving and universal visual metaphor.

Like a primitive idol, Fritz Wotruba's *Figure with Raised Arms*, embodying strength, permanence, and dignity, is a tribute to these eternal

qualities of mankind. The figure's torso has been reduced to a few essential cylinders, and these dense vertical elements create a slow, powerful rhythm. Yet this silent, faceless figure remains human, as revealed by the oddly graceful gestures of his raised arms and single bent leg. Appositely, these pitted stone forms evoke the texture and monumentality of the earth, man's habitat.

In contrast to the timelessness of Wotruba's figure, Eduardo Paolozzi's *Japanese War God* belongs irrevocably to the twentieth century. Composed of numerous fragments from a mechanized civilization—clockworks, locks, wheels, parts of

radios and automobiles, already corroded and useless for their original function—this contemporary hero is a pathetic victim of the passage of time. Paolozzi created this fetish as an ironic warning of the potential victimization of man in a mechanical society. While his image celebrates these modern materials, it reviles the use of technology to bring about death and destruction.

Inspired by his perception of the preeminent dynamism of earthly forms, Jean Ipousteguy metamorphoses the male figure into interlocking polymorphous units. In his *David and Goliath*, forms—alternately round and angular, smooth and rough—are subtly varied to convey

1058

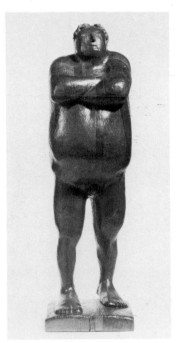

1059

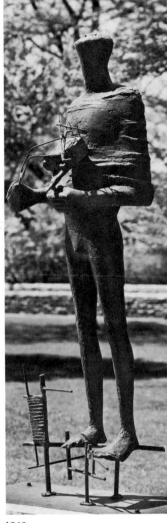

1060

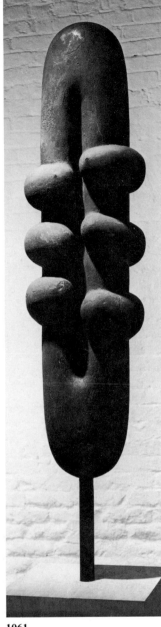

1061

the contrasting characteristics of the triumphant boy and the dead giant. The vertical thrust of David's legless torso, emphasized by his lifted chest and flung-back head, surges with energy, a soaring image of victory. The prone Goliath, a huge inert mass of bronze forms collapsed upon each other, is scarcely human. In his death the giant merges again with the earth.

Leonard Baskin, American draftsman, printmaker, and carver, confronts the spectator straight on with his wooden *Laureate Standing*. Baskin's figure carries his macabre irony: here is the artist, the poet who has attained society's acclaim—the laureate—crowned with the laurel wreath, bulky, fat bellied, heavy jowled, and stupid.

Reg Butler's *Manipulator* is no longer an abstract insectile figure like his *Woman* of the previous decade (plate 1037). Constrained in a straitjacket and enmeshed in a trap, this troubled figure tilts his head toward the sky while working a small mechanical device.

Drawing inspiration from both East and West, Isamu Noguchi creates austere, elegant, timeless forms. Although abstract, Noguchi's *Self* is quintessentially anthropomorphic. Its smooth elongated oval, gently animated by six bulbous appendages, is a fusion of organic and human shapes which can be perceived either as a reference to the human body or as some organic form just emerged from the earth. Suspended in space, defying gravity, *Self* embodies the tranquillity of self-contemplation, the most personal and transcendental aspect of the self.

1055 Ossip Zadkine. *The Destroyed City*. 1951–53. Bronze, height 21′4″ **1056** Fritz Wotruba. *Figure with Raised Arms*. 1956–57. Bronze, height 75 ¼″ **1057** Eduardo Paolozzi. *Japanese War God*. 1958. Bronze, height 64 ½″ **1058** Jean Ipousteguy. *David and Goliath*. 1959. Bronze: David, height 47 ⅞″; Goliath, height 30 ⅜″ **1059** Leonard Baskin. *Laureate Standing*. 1957. Carved cherry wood, height 36 ½″ **1060** Reg Butler. *Manipulator*. 1956. Lead, height 66″ **1061** Isamu Noguchi. *The Self*. 1957. Cast iron, height 34 ¼″

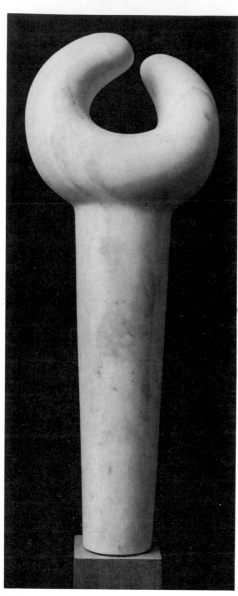

1062

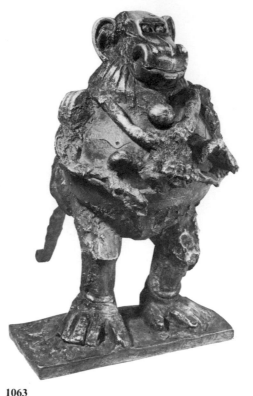

1063

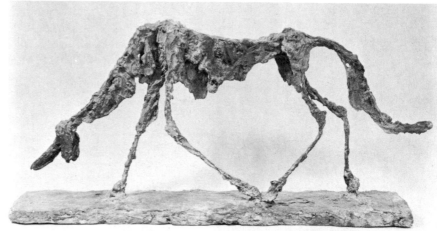
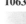

1064

Isamu Noguchi succeeded in bringing forth a synthesis of Eastern and Western art in works like his abstract *Birds* from the 1950s. *Bird C—or Mu* was designed during his return to Japan after a long absence and inspired by his "experience of the tranquillity of Zen." In fact, "mu" is a Zen term meaning nothingness. The pure abstract calmness of the piece—carved in Pentelic marble as a result of a journey to Greece—recalls the work of Brancusi, with whom Noguchi had worked when he was young.

The visual pun created by the use of two toy cars to form the mother baboon's head in Picasso's *Baboon with Young* shows vividly the artist's instinctive imagination and marvelous wit. A jug forms her body with its handles as shoulders; a metal rod with a bent end becomes her tail. Unlike the cars, which strongly assert their dual identity, the original character of these other elements is disguised by Picasso's free modeling. The whole is unified by the alternately lumpy and smooth texture of the bronze.

In contrast, Alberto Giacometti's *Dog* is a generalized vision symbolizing all such lonely scavengers of the twentieth century. With its low-slung head and emaciated torso *Dog* is the precise counterpart to Giacometti's humans worn thin by the space around them. Like the humans, *Dog* is isolated, a mute presence. Giacometti's uneven masses of bronze roughly define the animal's anatomy, his rough modeling evoking ragged or wet fur. Yet this ductile animal is not stripped of its strength. Under its rough surface, inner forces, though depleted, tenuously withstand the pressures of the world.

In the 1940s Marino Marini's riders are still erect on their mounts. In *The Miracle* a new dynamic relationship between man and beast is established. The struggle climaxes as the powerful horse collapses to its knees while the rider, arms flung wide, arches backward in an attempt to retain his position. The abstract beauty of the triangular horse and

1065

1067

1066

1068

soaring arabesque of the rider gives monumentality to the theme. Marini captured the miracle of one moment in this struggle: the man nearly unseated, the beast nearly subdued, yet equilibrium maintained.

In *Iron Throat* Theodore Roszak draws his formal elements from contemporary industrial vocabulary to reveal his perception of this canine-human's agonized state of being. A complex assemblage of metal webs and planes forming muscles, bones, and nerves evokes the mechanical while depicting the animal. An image of sound in clangorous flight, *Iron Throat* dynamically portrays both man's animal origins and his excruciating spiritual condition.

In the stabile (page 381) entitled *Black Widow* Alexander Calder enlarged the insect to architectural scale—a human can walk under it—and yet imbued his subject with an extraordinary strength and elegance. The curved triangular form of the spider's body is complemented by the open space created by the slender arched legs, which vividly evoke insect life. The sculpture as a whole is a witty depiction of the female spider's menace and grace.

In his "combine" *Monogram* Robert Rauschenberg, like Picasso, challenged the traditional materials of sculpture. But while Picasso unified his found objects by casting them together in bronze, Rauschenberg

presents a real stuffed angora goat in *Monogram*, puts an old tire around its middle, and places them together on a painting with strongly Abstract Expressionist brushstrokes. Here at the end of the decade, the artist has moved the canvas from the wall to the floor and made a stage out of it.

1062 Isamu Noguchi. *Bird C—or Mu.* 1952–58. Greek marble, height 20″
1063 Pablo Picasso. *Baboon and Young.* 1951. Bronze, after wood, height 21″
1064 Alberto Giacometti. *Dog.* 1951 (cast 1957). Bronze, height 18″ **1065** Marino Marini. *The Miracle.* 1959–60. Bronze, length 96 $\frac{1}{2}$″ **1066** Theodore Roszak. *Iron Throat.* 1959. Steel, height 42″
1067 Alexander Calder. *Black Widow.* 1959. Stabile, painted sheet steel, length 171″
1068 Robert Rauschenberg. *Monogram.* 1959. Construction: mixed mediums, length 72″

The Assembled Idol

1071

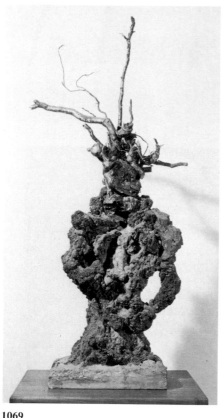

1069

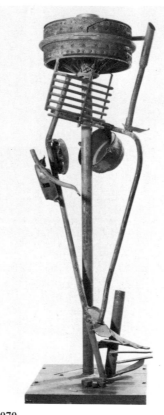

1070

1072

The object, whether found in nature, in a trash can, or perhaps in a sales catalogue, has been eligible to be considered "art" ever since the Cubists made their first collages, before World War One. Found and "assisted" by the artist, the ready-made object itself became the sculpture when Marcel Duchamp fastened a bicycle wheel to a stool in 1913 (plate 471), and the definition of art was altered fundamentally. In 1954 Jean Dubuffet created his "little statues of precarious life," made mostly of assemblages of fragments of natural elements. In *The Magician* the artist set a heavy root on a piece of slag and thereby transformed these

materials into a fabulous earth spirit.

Richard Stankiewicz created a witty personage out of a variety of rusty junk components and called it *Kabuki Dancer*. The sordid detritus of New York civilization was transformed into a serious and elegant sculptural statement. As in the Beat poetry of the time, the trivial aspects of our lives are incorporated into the work of art. Similarly John Chamberlain used smashed automobile fenders to construct his junk sculpture *Wildroot*, an assemblage that reminds us of car graveyards and stands as a shattered icon to our motorized civilization.

H. C. Westermann carefully fashioned a large box of laminated wood and added all kinds of cartoon fea-

tures and vernacular ingredients, such as the man's castellated head, which resembles the famous water tower in Chicago, where the artist lived at the time. When the *Memorial to the Idea of Man If He Was an Idea* is opened, the viewer is surprised by a headless baseball player and a hanging trapeze artist in a sea of Pepsi-Cola bottlecaps.

Bruce Conner's disquieting necrophiliac *Child* was created to express his outrage against the brutality of the death penalty. A shrunken and mutilated mannequin modeled in wax is tied cruelly with torn nylon stockings to a real high chair. The anguished, distorted, and desecrated head screams in torture. This is a

1073

1074

1075

DAYS TO
BE MOVED

1076

work of unrelieved pain—meant perhaps as a talisman or votive object against unmitigated horror.

Peter Voulkos, operating huge kilns in California, liberated ceramics from its tradition of utility. Working in a gestural vein closely related to that of the Abstract Expressionist painters, and pushing the ceramic technique to its limits, Voulkos made large bulbous polychrome clay sculptures such as *Little Big Horn* in the late 1950s—works that opened potent, unexpected possibilities to a traditional medium and technique.

Joseph Beuys, a wide-ranging artist, educator, mystic, public persona, politician, and performer, has worked in many mediums in Ger-

many and has had a great impact on the art and nonart of the postwar period. In *Door*, an early work, he turned something humble and commonplace into an aesthetic object. *Door* is nothing but an old charred wooden door on which the artist has hung a rabbit's tail and a bird's skull. Like a fetish, the ancient burned door seems somehow to be endowed with magical potency.

George Brecht derived his primary inspiration from John Cage's music and had helped found Fluxus, an association of European and American artists concerned with the interstices between the mediums of painting, sculpture, music, dance, poetry, and theater. In his *Blair*, objects from

ordinary life, playing cards and a daily calendar, can be rearranged by the spectator, who becomes a participant in the simple art event.

1069 Jean Dubuffet. *The Magician*. 1954. Slag and roots, height 43 ¹/₂″
1070 Richard Stankiewicz. *Kabuki Dancer*. 1956. Cast iron and steel, height 84″
1071 John Chamberlain. *Wildroot*. 1959. Metal construction, height 60″ **1072** H. C. Westermann. *Memorial to the Idea of Man If He Was an Idea*. 1958. Wood and metal, height 55″ **1073** Bruce Conner. *Child*. 1959–60. Assemblage: wax figure with nylon, cloth, metal, and twine in a high chair, height 34 ⁵/₈″ **1074** Peter Voulkos. *Little Big Horn*. 1959. Glazed ceramic, height 62″ **1075** Joseph Beuys. *Door*. 1954–56. Burned wood door, bird's scalp, and rabbit's fur, height 82 ³/₄″
1076 George Brecht. *Blair*. 1959. Rearrangeable assemblage, height 60″

Sculpture on a Monumental Scale

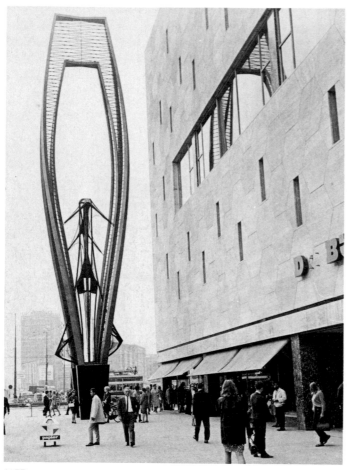

1077

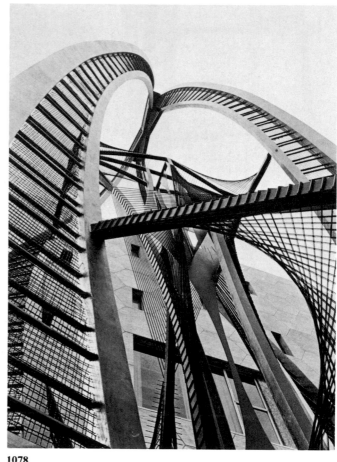

1078

Most of the grand, monumental schemes of the Constructivists—Tatlin's tower (plate 521), Gabo's *Project for a Radio Station* (plate 474)—remained in the realm of visionary aspiration. It was only after World War Two that Gabo received a commission for a truly monumental sculpture. The city of Rotterdam, destroyed by Nazi aerial bombing, was being rebuilt. Ossip Zadkine had erected his commemorative monument, and Marcel Breuer designed the new Bijenkorf department store, for which Gabo devised his eighty-five-foot *Rotterdam Construction*, so large that only a shipbuilder was able to execute it. It was here that Gabo could finally attain full expression of the Constructivist idea. Manifesting the desire for social reform through construction and development, Gabo created a sculpture which reflects the positive energy of a structured, working city. The *Construction* is composed of four subtly curved main shafts which twist independently, rising and stretching to join at their apex. The powerful steel inner structure appears graceful and organic within the tight framework. The sculpture allows a natural upward movement, and the dynamic verticality is softened by linear rhythms and pierced with unlimited volume. Juxtaposed to Breuer's massive rectangular department store, Gabo's sculpture is a human expression to complement the cool, austere, functionalist solution that modern architecture very often prescribes. Later Gabo spoke of his dependence on nature: "I was making a tree, nothing else. Instinct told me to twist the branches."

Mathias Goeritz, born and trained in Germany, went to Mexico after the war to work there as sculptor, architect, painter, poet, and writer. In 1957, in collaboration with the architects Luis Barragán and Mario Pani, he designed the *Square of the Five Towers* for a new residential section called Satellite City. The monument is seven miles north of Mexico City and acts as a sentinel to one of its entrances. Given a

1080

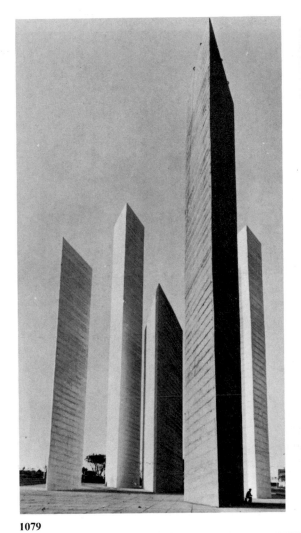

1079

1081

site set in flat plains, the trio of designers needed a sculpture that defied horizontality. Without destroying the purity inherent in this unadulterated landscape, they positioned five vertical towers of simple triangular shapes ranging from 135 to 165 feet tall, on a slightly sloping plateau. The towers are mounted on a trilevel pedestal over a reflecting pool that mirrors their grandiose scale. The slope of the ground distorts and defies their monumental stability; they seem to move in response to the observer. Three of the towers are white, one is orange, and one is yellow; they make a striking contrast to the vast blue skies of Mexico City's high valley, which ex-

tends in all directions. These stark geometric towers, forming a large environment in which sculpture and architecture have become blended, had a significant influence on art and architecture throughout the Western world.

Architecture and sculpture are totally fused in Eero Saarinen's *Jefferson Memorial Arch*, which stands between the city of St. Louis and the Mississippi River. Using the clean lines of industrial stainless steel, Saarinen engineered an arch which soars 630 feet, spreading an equal distance from leg to leg. Within the pure, tapered shape of the arch, elevators carry passengers to an observation area atop the continuous curve. In

the sunlight the stainless-steel shell is iridescent, and the arch appears like a flash of moving light whose form and depth seem elusive despite their stability. In the purity of its geometric form the catenary arch, with its cross section of an equilateral triangle, predicted much of the "primary structure" of the 1960s and did so on a monumental scale.

1077–1078 Naum Gabo. *Rotterdam Construction*. 1957. Monument for the Bijenkorf, gilded bronze and stainless steel spring, height 85′ **1079–1080** Mathias Goeritz, Luis Barragán, and Mario Pani. *The Square of the Five Towers*. 1957–58. Painted concrete, height 135–165′ **1081** Eero Saarinen. *Jefferson Memorial Arch*. 1948–67. Stainless steel, height 630′

Wall Pieces and Reliefs

1082

1083

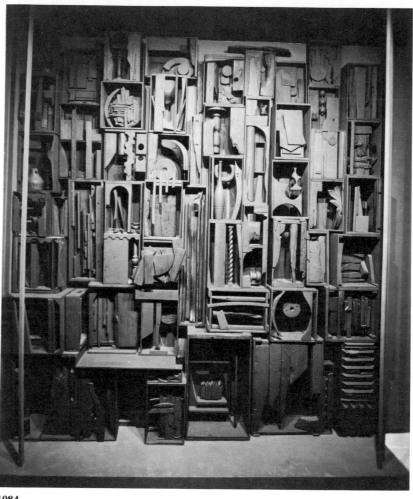

1084

Henry Moore's *Time-Life Screen* illustrates the harmonious integration of sculpture into architecture. The screen's four panels form a continuation of the building's surface, although the frequent piercing of the screen, its self-conscious play between solids and voids, reveals the space behind it as well as in front, reasserting its three-dimensionality. These abstracted interlocking forms suggest the monumentality and time-lessness of granite cliffs.

Giacomo Manzù's *Door of Death*, the first commission for St. Peter's since Bernini's Piazza (begun 1656), embodies the grandeur and dignity necessary for its majestic architectural setting. The location of these doors, on the threshold of the greatest church in Christendom—the portal separating sacred and profane—invested the project with profound symbolic significance. Manzù arranged his subjects in the traditional hierarchy: on top, the large panels depicting the deaths of the Virgin and Christ; below, the eight smaller panels showing the deaths of Christian martyrs and anonymous men. The use of the human figure as the main expressive vehicle reveals Manzù's own humanism.

Louise Nevelson's relief wall, called *Sky Cathedral*, is a metaphor, a series of poetic variations drawn from the spontaneous intuition and fantasy of the artist. Stimulated by the aesthetic properties of discarded and found materials, she put them into crates and boxes, which she stacked on top of each other, creating a sculpted wall. The boxes are round and angular, finished and jagged, and vary in depth, causing differing shadows and highlights. Unified by its shell of black mat paint, the wall is a theatrical environment, existing in space but relating to time.

A forest of tiny, elegant T-sections, a delicate pattern of light and shade, Zoltan Kemeny's metal relief *Shadow of the Miracle* fuses characteristics of painting and sculpture. The loosely clustered prefabricated T-sections fall into two groups, the larger group

1085

1087

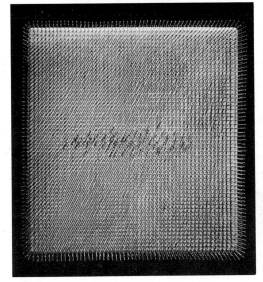

1086

1088

on top implying downward movement, the lower group remaining stationary. Like nature, this relief exudes a sense of mystery while also revealing a human dimension: the magic of invented forms.

Günther Uecker's reliefs utilize contemporary materials and achieve an almost painterly sense of depth and color. Uecker's technique is startlingly simple: he drives nails into wood and paints them white. In *White Object* the individual nails are assertively long and sharp, yet the undulating field they create has a delicate beauty, the monochrome lending it purity. The role of the spectator is essential here: his changing position alters the drama of light

and nails. While there is no overt trace of the artist's hand in *White Object*, his intellect and sensibility are evidenced in the metamorphosis of ordinary nails into a unique aesthetic rich in poetic suggestion.

In his series of sponge reliefs Yves Klein took natural sponges and sprayed them with epoxy, which converted the soft organic substance into a hard material. He then fastened the rigid sponges to a wooden support and painted the relief with his IKB (page 420) pigment.

Lee Bontecou's disquieting relief *Untitled* breaks down the distinction between painting and sculpture. While made of canvas and hanging on the wall, her haunting composi-

tion is strongly three-dimensional, creating dramatic sculptural contrasts of light and shadow. The construction of apertures surrounded by prickly work evidences a highly personal, mysterious, and even threatening aesthetic.

1082 Henry Moore. *Time-Life Screen.* 1952–53. Portland stone, height 120″
1083 Giacomo Manzù. *The Door of Death.* Commissioned 1952, dedicated 1964. Bronze, height 88″ **1084** Louise Nevelson. *Sky Cathedral.* 1958. Wood construction painted black, 135 ½ × 120 ¼ × 18″
1085 Zoltan Kemeny. *Shadow of the Miracle.* 1957. Copper T-sections mounted on wood, height 33 ⅝″ **1086** Günther Uecker. *White Object.* 1959. Canvas and nails on wood, height 21 ⅞″ **1087** Yves Klein. *Re 19.* 1959. Sponge relief, height 78 ¾″ **1088** Lee Bontecou. *Untitled.* 1959–60. Welded steel and canvas, height 46″ *401*

Open Construction

1089

1090

1091

Using welded steel in a manner reminiscent of earlier work by Picasso (plates 715–716) and Julio González (plates 770–771), David Smith expanded upon traditional notions of sculpture by situating his largely frontal compositions within the confines of a two-dimensional field, thereby moving closer to painting. Undecipherable ideographs dominate *The Letter*, illustrating the artist's desire to forge a new verbal as well as visual vocabulary. After he had read the works of James Joyce, the distinction between writing and drawing no longer existed for him. His calligraphic messages in space thus redefine sculpture as a pictorial as well as a literary endeavor.

Also using welding, a craft he learned from an ironsmith in Spain, Eduardo Chillida consciously carried on the traditional metalcraft of his Basque forefathers. He was concerned primarily with the space created by the projecting spearlike rods; this, he felt, was not abstract but as tangible as the masses that defined it. Comparing it to the silence and ethereal quality of music, he maintained that "there could be no volume in sculpture without the emptiness of space."

In Germany, Norbert Kricke likewise took full advantage of the potentialities of space rather than mass in *Space Sculpture*. Sleek steel members, emanating from modern technology, project dynamically in all directions, suggesting a surrounding field fraught with motion and energy. Their thinness and irregular contours also reinforce the predominance of void over solid. The dramatic diagonals, moreover, so uncorporeal in character, reveal that matter extends infinitely; its meager volumes are in a constant state of flux.

Frederick Kiesler's architectonic sculptural environments were meant, according to the artist, "to be lived with and within," and to create a feeling of relaxation. When making his *Galaxies*—probably the first examples of walk-in environmental sculpture—Kiesler did not recognize any distinction between sculpture

1093

1092

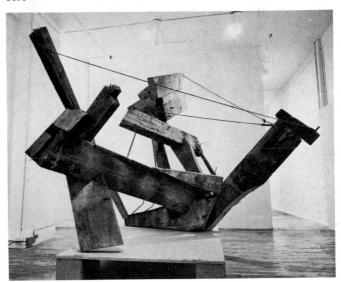

1094

and architecture, conceiving them as part of a single cluster, one endless process of creative endeavor, which included painting as well. These prickly, bonelike forms were viewed as "chunks of matter," similar to galactic structures. The "empty field of tension" supports the members like "planets in a void."

Welded bronze and silver bars imbue Ibram Lassaw's delicate open latticework with a quality of jewel-like magic, a feature absent from most sculpture in this decade. Although Lassaw was influenced by Mondrian's equilibrated paintings, his geometric labyrinth is much more intricate and introspective; but both artists wished to convey a feel-ing of spirituality in their work. During the genesis of this piece, the artist was concerned with *Kwannon* (Kuan Yin), a Buddhist goddess of compassion and pity. Developing the work organically, allowing chance to play a distinctive role, Lassaw inevitably incorporated aspects of Kwannon.

Often referring to himself as worker, welder, or crane operator, Mark di Suvero uses rough, unfinished surfaces, exposed nails, and rope, which evoke the constructive aspect of his craft. The form and the sheer size of his pieces also link him to the work of the Abstract Expressionists, especially the monumental black scaffolds of Franz Kline. In *Che Farò senza Euridice,* Cubistic planks are positioned to exploit the geometry of the surrounding space. The tightly stretched ropes which connect the massive members in precarious interaction reinforce Di Suvero's interest in balance and tension, concerns modern sculptors share with structural engineers.

1089 David Smith. *The Letter*. 1950. Welded steel, height 37 $^5/_8$″ (including base) **1090** Eduardo Chillida. *In Praise of Air*. 1956. Iron, height 52″ **1091** Norbert Kricke. *Space Sculpture*. 1958–59. Stainless steel, height 112 $^1/_4$″ **1092** Frederick Kiesler. *Galaxy*. 1951. Wood, height 144″ **1093** Ibram Lassaw. *Kwannon*. 1952. Welded bronze with silver, height 72″ **1094** Mark di Suvero. *Che Farò senza Euridice*. 1959. Wood construction with iron, length 104″

Kinetic Sculpture

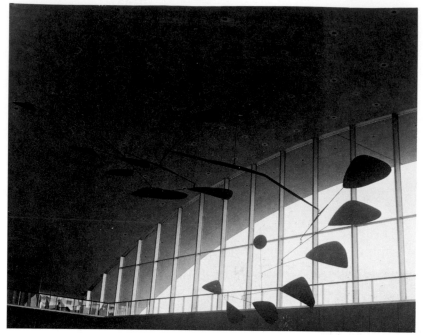

1095

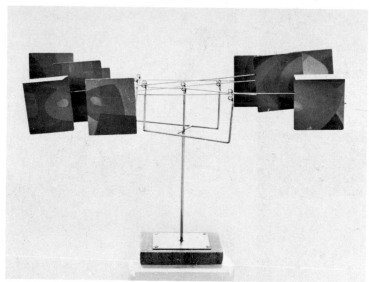

1096

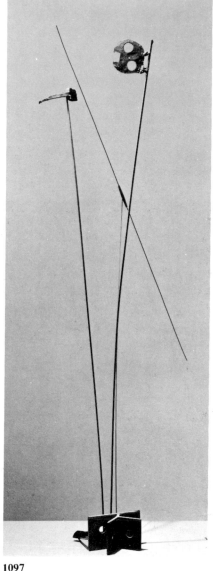

1097

In 1957 Alexander Calder was commissioned to construct a giant mobile for the International Arrivals Building at Idlewild (now Kennedy) Airport in New York. The mobile, more than forty feet in length, is composed of large leaflike blades painted red and blue. It articulates and animates the otherwise neutral architectural space. Calder, who in the early 1930s had changed the range of sculpture by constructing forms which would swing freely in the breeze, experienced great joy in his creations, a sense of delight in play which is immediately communicated to the viewer.

George Rickey's sculptures are similarly activated by air currents. In place of organic shapes, however, Rickey has fashioned clear geometric forms for his kinetic sculptures. An early work like *Diptych—The Seasons* is a machine in which twelve painted sheets of steel are driven by the wind in a circumscribed planar path, engaged in formal play.

The Greek sculptor Takis explores the vibrating movement of taut rods of iron and steel. In his *Signal Rocket* these wands are permitted to oscillate when set in motion by currents of air. The silent forces and the invisible energy within the metal are brought to life.

Hungarian-born Nicolas Schöffer belongs to the older Constructivist tradition. Believing in the fusion of art, science, and technology, he has worked with palpable materials such as steel and aluminum, and with the intangibles of light and shadow, and became seriously interested in information theory, incorporating cybernetic elements in his kinetic sculptures. His large *Cybernetic Tower* at Liège is made of Plexiglas and mirror plates of polished aluminum to create reflections of light and color. The tower contains an electronic brain that responds to sound and light. The structure, more than one hundred fifty feet high, has become an integral part of the life of the city, which it literally reflects. Schöffer has, in fact, projected a utopian Cybernetic City of the future

1098

1099

1100

based on his integrated aesthetic of the space-time continuum.

In kinetic sculpture, movement itself becomes an ingredient of the work, in much the way that a painter will use color. Art enters into the realm of time, and the artist becomes his own choreographer. Often, as in Jesús Rafael Soto's kinetic relief constructions, the spectator is needed to complete the work. When Soto arrived in Paris from his native Venezuela in 1950, he was impressed both by Calder's random movement and Vasarely's optical illusions. As the spectator viewing a Soto work moves his position, he experiences the sensation of dynamic optical movement and immaterial rhythm.

The Swiss artist Jean Tinguely—also living in Paris—has devised machines that are in no way intended to create a utopian future and a more perfect society. Ever since the late 1950s Tinguely has made absurd antimachines which are sardonic metaphors of the world of the assembly line, the conveyor belt, the automatic contraption. Knowing that our very civilization depends on machines, Tinguely questions them with a sense of playfulness and bestows upon them a rattling human soul. In 1959 he concocted a number of painting machines such as *Meta-Matic No. 9,* whose ballpoint pens, fixed in rapidly moving arms, made colored drawings to the accompaniment of

agitated clamor. With the machine moving almost at random, the resulting little pictures were, appropriately, Abstract Expressionist in style.

1095 Alexander Calder. *Mobile.* 1957–59. Sheet metal, width 42′ **1096** George Rickey. *Diptych—The Seasons.* 1956. Painted steel, width 22″ **1097** Takis (Takis Vassilakis). *Signal Rocket.* 1955. Painted steel and iron, height 48″ **1098** Nicolas Schöffer. *Cybernetic Tower.* 1959. Duraluminum, 180′ **1099** Jesús Rafael Soto. *Vibration 59.* 1959. Mixed mediums, height 49 1/4″ **1100** Jean Tinguely. *Meta-Matic No. 9.* 1959. Motorized kinetic sculpture, height 35 1/2″

Action in Space

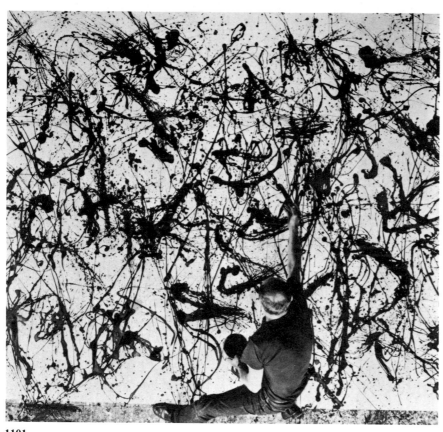

1101

1102

"I *am* nature," Pollock responded after Hans Hofmann accused him of not working from nature. Rudolph Burckhardt's photographs of Pollock painting make this nature concrete. We see Pollock's complete physical being immersed in his work. Recognizing the radical implication of equating the process with what was produced in making art, the critic Harold Rosenberg wrote in *Art News* in September 1952: "A painting that is an act is inseparable from the biography of the artist. . . . The act-painting is of the same metaphysical substance as the artist's existence. The new painting has broken down every distinction between art and life." Pollock later re-

ferred to this article as "Rosenberg's piece on me." He seemed to acknowledge that he was entering into the bare surface of the canvas to encounter something, through the act, as yet unknown to himself. The externalization of an artist's intuition into action began gradually to move away from art as object.

In Paris, Georges Mathieu also began to think in similar terms. April 25, 1954, he invited friends into his studio to witness the creation of a work entitled *The Battle of Bouvines*. The painting recorded a thirteenth-century French battle in which one of Mathieu's ancestors fought. He dressed in black silk pants and jacket, donned a white

helmet, and strapped greaves around his shins. In precisely the time it took to fight the battle, Mathieu reenacted this historical event physically and in paint. "Speed, intuition, excitement: that is my method of creation," he proclaimed. Unlike Pollock, whose private action focused on making the image, Mathieu's action involved the reciprocal relationship between the act of making and the audience's reception.

In 1952 a group of Japanese artists formed an association which they called the Gutai (Concrete Group). The Gutai performed actions which liberated them from the confines of pure painted surfaces or sculptured contours. Their events had the char-

1105

1103

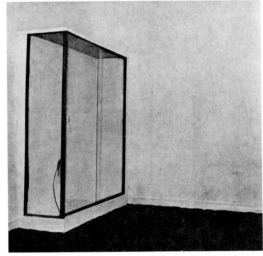

1104

1106

acter of semiimprovisational, open-ended series, much like the Happenings that occurred several years later in New York. Kazuo Shiraga expands physically the range of an artist's materials, using himself as well as paint. The work can be seen symbolically as a comment on the relationship of materials to the making of art and to the actuality of being an artist. The Gutai often engaged in actions to comment upon the rigidness of Japanese social and cultural institutions.

At the gallery of Iris Clert in Paris in April 1958, Yves Klein presented *The Void*. Several days before the opening Klein had carefully emptied the gallery of all objects, then cleaned the space and painted it white. The facade of the gallery and the sidewalk were painted blue, and Klein explained that the empty space "was sensitized" and that the void was actually filled with his blue presence and impregnated by his spirit.

The inclusion of real space and real time which action could add to art—these were the elements Allan Kaprow and his friends began to use: "specific substances of sight, sound, movement, people, odors, touch." As his *18 Happenings in 6 Parts* was performed in the Reuben Gallery in 1959, three rooms were created among which an audience was moved at the sound of a bell; collaged activities—combining live painting, music, poetry, slide projection, and audience participation—were experienced simultaneously, like the multilayered events of real life, through the thin, vaguely transparent walls of each of the rooms. With Kaprow proposing that mime and life become art, the transition from static works with discrete boundaries to temporal/spatial events and expressions of the artist's momentary sensibility had taken place by 1959.

1101 Rudolph Burckhardt. Jackson Pollock painting. 1950–51 **1102** Georges Mathieu painting *The Battle of Bouvines*. 1955 **1103** Kazuo Shiraga. *Making a Work with His Own Body*. 1955 **1104** Yves Klein. *The Void*. 1958 **1105–1106** Allan Kaprow. *18 Happenings in 6 Parts*. 1959. Environment for Happening

1107

1108

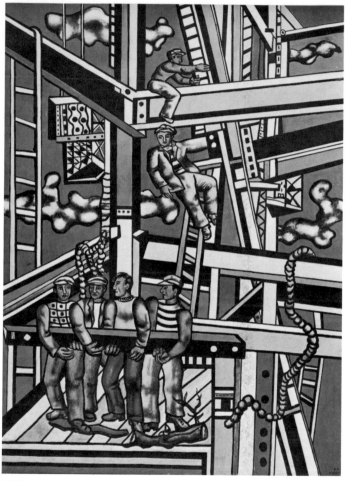

1109

In the last years of his life Matisse, then bedridden, took to drawing with scissors and sheets of paper which had been painted with pure color before being cut. Matisse cut into the color, carved out his images, thereby, as he said, "draw[ing] directly in the color. . . . This guarantees a precise union of the two processes; they become one." This was the synthesis, "the ultimate method" to which his entire career had been directed. In completing a work such as *The Snail,* he would pin the color rectangles on the wall, rearranging them until he found the configuration he sought, in this case an organic spiral based on the convolution of a shell. There is an extraordinary con-

sistency throughout Matisse's work: the implied movement in the five intensely colored squares, their dispersal around the central green shapes, is very similar in its rhythm to the movement of his dancers, painted forty-four years earlier (plate 229). But now the figures are no longer needed.

After the war Picasso, like other leaders of the School of Paris who had pioneered a new formal revolution in the history of painting, found himself with the status of an established master. In 1948 the Louvre acquired three of his works. In the winter of 1954 he painted a series of fifteen interpretations of Eugène Delacroix's *Women of Algiers*

of 1834. In the present work Picasso employs vibrant color and rich dynamic patterns, perhaps in homage to Delacroix's own chromatic experiments. Yet the inclusion of nude odalisque figures and the stress on linear, planar values demonstrate his indebtedness to Jean-Auguste-Dominique Ingres as well. Classicism versus Romanticism, linear versus painterly values, issues also hotly debated in the mid-nineteenth century, were reconciled by Picasso.

Fernand Léger had spent the war years in the United States. After his return to Paris, he painted *The Great Constructors*. A ladder has a central place in the painting; it is set in a steel scaffolding of I-beams, together

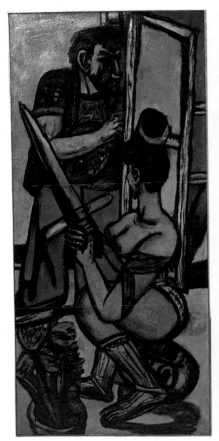

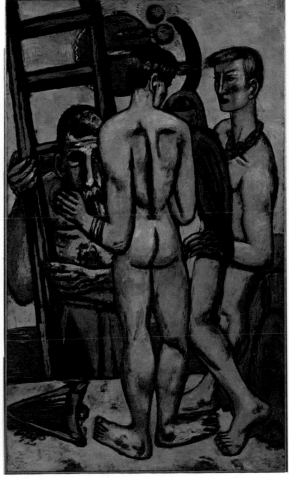

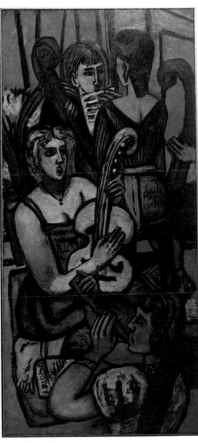

1110 1111 1112

with chains, ropes, and hoists. The human figures contrast with the metallic structure. It is the workers, the builders, who create this geometrical work, and there is no doubt that Léger, a politically engaged artist and member of the Communist Party, had a message to relate concerning the physical, tangible reconstruction of postwar Europe. Léger had originally been apprenticed to an architect, and he loved industry, technology, the modern world. As a painter, he was clearly a classicist, the heir of the French tradition of Poussin and David, an artist primarily concerned with the composition of form in space.

Max Beckmann spent the last years of his life in New York, and it was there that he painted *The Argonauts,* a great epic work and the last of his nine triptychs. In the left panel the vigorous figure of a painter almost attacks his canvas, while a voluptuous model—possibly alluding to Medea—is seated on a mask and holds a wooden sword. The right panel with its four calm female musicians functions as a Greek chorus, mediating between the action in the central panel and the artist's audience. In the center an archetypal Old Man of the Sea rises from the depths, confronting the handsome young heroes: Jason, on whose wrist is perched a fabulous bird, and Orpheus, who has dropped his lyre on the desert soil. The old man or god climbs a ladder—not Léger's functional steel ladder, but a ladder of life—and he bears his momentous message, which points the way to a different plane of consciousness. The painting, dealing with life's mystery, was completed the day before the artist's death and stands as Beckmann's final testament.

1107 Henri Matisse. *The Snail.* 1953. Gouache on cut and pasted paper, 112 ³/₄ × 113″ **1108** Pablo Picasso. *Women of Algiers.* 1955. Oil on canvas, 44 ⁷/₈ × 57 ¹/₂″ **1109** Fernand Léger. *The Great Constructors.* 1950. Oil on canvas, 118 ³/₄ × 85 ¹/₂″ **1110–1112** Max Beckmann. *The Argonauts.* 1950. Oil on canvas, triptych: center panel, 80 ¹/₄ × 48″; side panels, each 74 ³/₈ × 33″

1113

1115

1114

1116

For some of the artists who came to maturity during the war the human situation, rather than formal structure, is the wellspring and object of their art. Even Picasso's often cruel reinventions of human anatomy seemed but formal exercises in view of the realities of Buchenwald and Hiroshima.

Jean Dubuffet painted a series of women ironically entitled *Corps de Dames (Women's Bodies)*. They are a brutal frontal attack on the Western tradition of beauty and grace. *Triumph and Glory* is like a coarsely textured map of the female body. This woman, cut off at the legs, raising her thin arms around a small profiled head, her large buttocks arched, is a savage evocation of a never-eradicated archetype, going back to paleolithic fertility effigies.

After his great achievement in abstract painting (plate 1133) De Kooning returned to the theme of women. This series of six masterly compositions owe a debt to the shallow space and pictorial structure of early Cubist painting. But De Kooning's shamelessly erotic *Women* were painted with torrents of dripping pigment, creating a vibrant fabric of color. He painted them close up, in immediate encounter, giving us a feeling of uncanny intimacy. The savage smile of these Amazons— who are indeed endowed with a sense of humor, gruesome as it may be—was derived from mouths of advertising beauties that the artist had cut out of magazines.

Giacometti's figure in *The Artist's Mother* is distant from us, both actually and psychologically. The repeated framing device, the inverted perspective, the discontinuous line, and the subdued color are all devices which help separate the figure in her uncertain environment. But this isolation is also a protection, as the ghostlike figure remains inviolable.

In *The Rebel* Albert Camus exclaimed that "only the cry of anguish can bring us to life," and when Francis Bacon painted his *Study after Velásquez's Portrait of Pope Innocent X*, he made a shrieking accusation.

1117

1118

1119

The pope in all his regalia is seated on his throne. He is closed in by bars. The smeared image is one of violent and intense despair.

To Karel Appel a painting is "a chunk of life, it is a scream, it is a night, it is like a child, it is a tiger behind bars." Appel, together with other Northern European artists, established the Cobra (*C*openhagen, *B*russels, *A*msterdam) group in 1948, a European parallel to the Abstract Expressionists in New York. *The Condemned* is Appel's outraged protest against the miscarriage of justice in the case of Julius and Ethel Rosenberg, who were executed for allegedly stealing atomic secrets. It is instructive to compare Appel's vehement handling of the subject with the more deliberate paintings of Ben Shahn's Sacco and Vanzetti series (plate 868).

Leon Golub's *Damaged Man* is a tortured yet still human head on a body which has been flattened out into a skin. The surface is encrusted with eruptions as if the life sap had come to the surface of this mutant, whose carcass is all that remains. Yet *The Damaged Man* retains the significance of individual destiny, continuing to exist in spite of mutilation.

In Spain, Antonio Saura restricts himself to painting almost exclusively in black and white. In the face of fascist repression he painted passionate and accusatory works. His not very graceful *Three Graces* was painted with violent spontaneity. "Love and the desire to destroy are not incompatible," he wrote. "To love, to protest, to destroy: this is painting."

1113 Jean Dubuffet. *Triumph and Glory (Corps de Dame)*. 1950. Oil on canvas, 51 × 38 $^1/_2$″ **1114** Willem de Kooning. *Woman I*. 1950–52. Oil on canvas, 75 $^7/_8$ × 58″ **1115** Alberto Giacometti. *The Artist's Mother*. 1951. Oil on canvas, 36 $^1/_4$ × 23 $^3/_4$″ **1116** Francis Bacon. *Study after Velásquez's Portrait of Pope Innocent X*. 1953. Oil on canvas, 60 × 46 $^3/_8$″ **1117** Karel Appel. *The Condemned*. 1953. Oil on canvas, 56 $^1/_8$ × 43 $^3/_8$″ **1118** Leon Golub. *The Damaged Man*. 1955. Oil on canvas, 48 × 36″ **1119** Antonio Saura. *The Three Graces*. 1959. Oil on canvas, 76 $^3/_4$ × 114 $^1/_4$″

The Figure in Its Environment

1121

1120

In 1951 Jackson Pollock began painting or drawing in black enamel paint and turned once more to anthropomorphic imagery, as in *Portrait and a Dream*. In this diptych he combined two seemingly disparate images. The left panel, with its convoluted, vehement web of vaguely figurative, yet incomprehensible skeins of black, probably signifies the dream. On the right panel is the face of a man, presumably a self-portrait. This painting may be seen as a comment on the relationship between man and his unconscious, the artist and the environment of his psyche.

The Danish painter Asger Jorn, recovering from tuberculosis, created a painting which has a similar im-

pulsive quality, although it is based not on personal fantasy but on old iconographic motifs. Jorn painted *The Wheel of Life* when he was given a studio in the sanatorium's mortuary, where "the corpses came in at one end and I came in at the other, so we competed for who would win." It is a circular composition, painted in thick brushstrokes with carefully controlled color relationships. It deals with cycles of life, birth, and death, regeneration, love, childbirth. It suggests the circle of the zodiac and was certainly meant to be a personal record of Jorn's feelings about his recovery.

Edward Hopper conveys both the physical and the psychological

isolation of the contemporary urban dweller in his crisp, veristic image of a woman sitting on her bed in a bleak room. Muted tones are employed in the profoundly empty but ordered ambience, where this lone figure gazes on a cityscape devoid of all vestiges of humanity. Hopper spoke of the "hopeless boredom" of the American town and the "sad desolation" of the suburban landscape, qualities evident in his work.

The work of Richard Lindner is related to the painting of Fernand Léger and Oskar Schlemmer and at the same time shows certain resemblances to what was soon called Pop Art. But *The Meeting* is a very private exposition, combining mem-

1122

1124

1123

1125

ory and actuality. The young boy dressed in a sailor suit may perhaps be seen as a metaphor for the artist's own youthful innocence, while the corseted amazon in the center, a figure who appears frequently in Lindner's erotic fantasies, can be interpreted as symbol of both sexual initiation and domination. In the right-hand portion are people who inhabited Lindner's world in the 1950s, the artists Saul Steinberg and Hedda Sterne. At the left is the legendary King Ludwig II, that madly extravagant patron of the arts in Bavaria, where Lindner grew up.

Just What Is It That Makes Today's Homes So Different, So Appealing?, by the English artist Rich-

ard Hamilton, is generally considered to be the first Pop painting. This collage is a cool commentary on life in a technological society dominated by mass media. Things as diverse as a huge Tootsie Roll, a tape recorder, and a comic book framed as a painting allude to the pervasiveness of advertising in modern living. It is a life of consumerism and materialism. In fact, the people, the muscleman and the nude stripper, have lost all individuality and have become as plastic and depersonalized as the things that surround them.

Richard Diebenkorn's vital and spontaneous brush texture relates not only to his Abstract Expressionist period but also to the sensuous color

and sense of composition of Matisse. The asymmetrical structure of verticals and horizontals within the squarish format is essential. The faces are barely indicated, but the personages, awkward and isolated in the empty space, recall the lonely people in Hopper's paintings.

1120 Jackson Pollock. *Portrait and a Dream.* 1953. Enamel on canvas, 58 $^1/_8$ × 134 $^1/_4$" **1121** Asger Jorn. *The Wheel of Life.* 1953. Oil on hardboard, 51 $^1/_2$ × 41 $^3/_8$" **1122** Edward Hopper. *Morning Sun.* 1954. Oil on canvas, 28 $^1/_8$ × 40 $^1/_8$" **1123** Richard Lindner. *The Meeting.* 1953. Oil on canvas, 60 × 72" **1124** Richard Hamilton. *Just What Is It That Makes Today's Homes So Different, So Appealing?* 1956. Collage, 10 $^1/_4$ × 9 $^3/_4$" **1125** Richard Diebenkorn. *Man and Woman in Large Room.* 1957. Oil on canvas, 71 × 62 $^1/_2$"

Landscape and Cityscape

1126

1128

1127

1129

Although derived from landscape, subject matter in Diebenkorn's earlier *Berkeley, No. 32* is not nearly so accessible. Even during his Abstract Expressionist emotion-charged period, Diebenkorn's image is architectonic, its layered asymmetrical sections of sensuous color animated by diagonal ribbons of pigment. A tension exists between the spatial illusion, appropriate for landscape painting, and the painting's flatness.

In France, Nicolas de Staël's desire to capture reality led him toward calmer works with motifs such as *La Seine*, a radically simplified cityscape. This luminous vision of horizontal movement and vertical expanse, of strong, dark color and light, gentle hues, celebrates both the earthly phenomenon and De Staël's own creative act. In 1955, at forty-one, De Staël took his life.

Only a few months after his *Corps de Dames* series, Jean Dubuffet focused on the earth and painted his delightful *Geologist*. A little man with a perky hat, armed with a magnifying glass, walks over the barren crust of the earth, or perhaps on top of a cross section of geological strata. The soil is seen head-on and, simultaneously, from the top. A narrow band of sky allows for some possibility of orientation. The childlike orb of the sun is even smaller than the man, who represents mankind in its relationship to the fertile, heavy mother earth. But instead of being a part of it, he is man the scholar, the observer.

Friedrich Hundertwasser's art was largely shaped by his Viennese origins, by the work of Klimt (plate 218) and Schiele (plate 305). But unlike Schiele, Hundertwasser is primarily a colorist. *The Big Way* is an abstract landscape in the shape of a spiral, executed in glittering spectral colors. The spiral for Hundertwasser is "the fortress that I've constructed for myself in unknown territory." It is his most consistent motif.

There was nothing mystical or cryptic about New York's Stuart Davis. *Rapt at Rappaport's* (the

1131

1130

1132

famous kosher restaurant) is loud and clear, noisy and urban. Words are part of the pictorial composition. They help animate the surface of the two-dimensional painting. Davis also must have liked the alliteration, as he took great pleasure in the syncopated rhythm of jazz, which is evident in his paintings. Letters and shapes, very crisp and clean, are both floating and anchored. Although Davis's work was clearly designed and thought out with deliberation and great intelligence, he was always ready for change, saying: "The old idea of the statically complete picture is eliminated by the new concept of the painting as record of fresh day-by-day creative decisions."

Larry Rivers uses the painterly idiom of the Abstract Expressionists such as De Kooning (below) in *Second Avenue with "THE."* This is a view from his studio window. The letters are a fragment of a sign, and a female figure appears among the diffuse images of the urban environment—all merged in a sensuously painted canvas.

Before his depiction of *Women* (plate 1114), De Kooning had explored abstraction, and in *Door to the River* he returned to a relatively abstract mode. But frequently his gesture, the wide, vigorous sweep of the brush suggested the possibility of the landscape in these paintings. In this, the finest of them, a door is

defined by three or four capacious strokes. The element of depth is intimated by the brushed structure, but the master's use of color brings us back to a two-dimensional plane. Colors become much lighter as the element of light itself becomes a dominant feature.

1126 Richard Diebenkorn. *Berkeley, No. 32.* 1955. Oil on canvas, 59 × 57″ **1127** Nicolas de Staël. *La Seine.* 1954. Oil on canvas, 35 × 51 ³/₈″ **1128** Jean Dubuffet. *The Geologist.* 1950. Oil on canvas, 38 × 51″ **1129** Friedrich Hundertwasser. *The Big Way.* 1955. Mixed mediums on canvas, 63 ³/₄ × 63″ **1130** Stuart Davis. *Rapt at Rappaport's.* 1952. Oil on canvas, 52 ³/₈ × 40 ³/₈″ **1131** Larry Rivers. *Second Avenue with "THE."* 1958. Oil on canvas, 72 ³/₄ × 82 ³/₄″ **1132** Willem de Kooning. *Door to the River.* 1960. Oil on canvas, 80 × 70″

Abstraction: The Breakthrough—1950

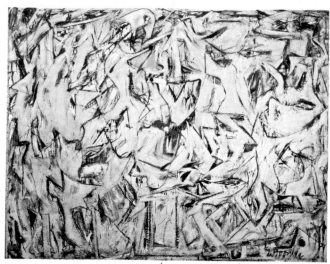

1133

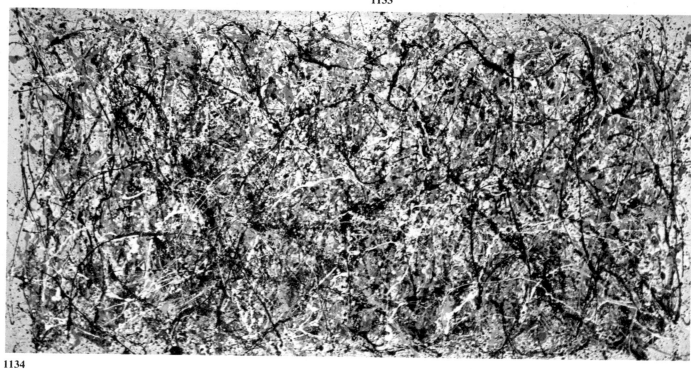

1134

De Kooning painted *Door to the River* at the very end of the decade that began with the more abstract *Excavation*, which itself constitutes a resolution of many years of experimentation. He explored his own painterly gesture, which resulted in agitated Expressionist brushstrokes—the picture is as large as the reach of the painter. The biomorphic figuration is the result of free association as well as the spontaneous act. Both angular and organic forms twist across the canvas from edge to edge. *Excavation* relates to Cubism, but whereas Cubist painters built a pictorial order out of the general chaos of perception, De Kooning in 1950 actually constructs a chaotic

work relating to the disruptive character of contemporary life.

Soon after this major work was exhibited, the critic Harold Rosenberg wrote about "The American Action Painters," referring primarily to De Kooning and Jackson Pollock. Pollock's "classical" drip paintings were perhaps even more significant in creating a new concept of art and in shifting the major attention of the art world from Paris to New York. For *One (Number 31, 1950)* Pollock used his entire body, pouring paint onto the canvas with exuberant energy. The element of chance is basic, but the final, edited composition of the densely painted web is a knowing response to chance. It is a

matter, he noted himself, of "organic intensity—energy and motion made visible—memories arrested in space, human needs and motives—acceptance." Pollock, although primarily a draftsman and using a totally different technique, created an identity of color and line at the same time as Matisse achieved this unity in paper cutouts (plate 1107). The overall shimmering surface of the interlace recalls the work of Monet and the other Impressionists, and the semiautomatic technique derives from the Surrealists. Yet the final result of an effulgent work such as *One* is a unique experience of surging energy.

Mark Rothko moved from paintings charged with symbol and per-

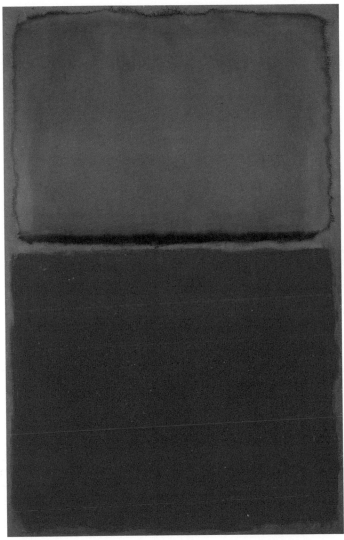

1135

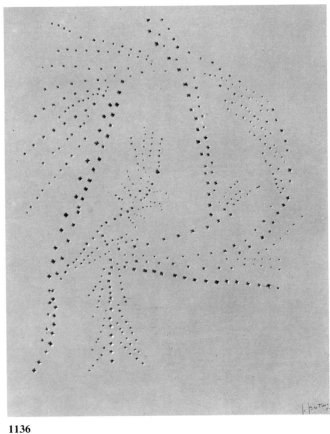

1136

sonal myth toward an absolute statement, a totally individual style. Unlike Pollock and De Kooning, he renounced gesture and brushwork or any marks of agitated action. In his search for "the simple expression of complex thought" he found affirmation in the clarity and balanced asymmetry of Mondrian and the sensuous use of the saturated color planes of Matisse. Rothko painted large pictures, "because I want them to be very intimate and human," he said. His paintings of rectangles of colors like *Green, Red, on Orange* are quiet surfaces which prompt us to contemplation. As we absorb the concealed light within the picture, as we enter into its soft

atmosphere, we are able to share the artist's enigmatic vision.

In Italy, Lucio Fontana, a former sculptor (plate 752), extended the realm of painting in a different way. In 1949 he had built an all-black environment, a room with a single light into which the spectator went to experience the mysterious space, and in 1950 he painted *Spatial Concepts*, monochrome canvases whose surfaces he pierced. With this gesture of perforation (which occurred in Milan at the same time as Pollock in New York first poured pigment onto the canvas), Fontana questioned the function of the canvas as a vehicle for painting—and extended the limits and confines of the

easel picture. Significantly, Fontana, instead of projecting space by illusion as in perspective painting, introduced space into the picture as a fact, as part of reality. A volume of absence could then function almost sculpturally on the face of the picture, casting shadows which gave clues to the changing light of space.

1133 Willem de Kooning. *Excavation.* 1950. Oil and enamel on canvas, 80 $\frac{1}{8}$ × 100 $\frac{1}{8}$" 1134 Jackson Pollock. *One (Number 31, 1950)*. 1950. Oil and enamel paint on canvas, 8'10" × 17'5 $\frac{5}{8}$" 1135 Mark Rothko. *Green, Red, on Orange*. 1950. Oil on canvas, 93 × 59" 1136 Lucio Fontana. *Spatial Concept.* 1950. Oil on canvas

Abstraction: Predominantly Black

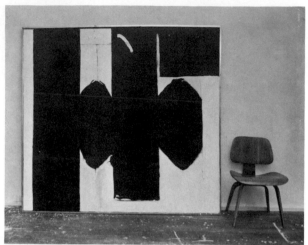

1138

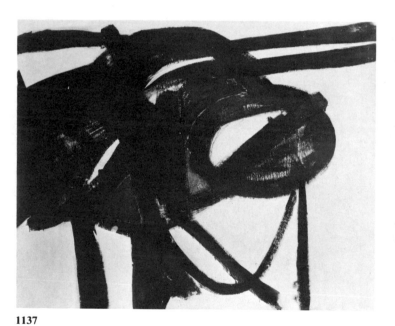

1137

1139

Named after a locomotive in the Pennsylvania mining town where Franz Kline was born, *Chief* epitomizes both the dynamic of the giant machine and the rough vigor of the industrial locale. Kline's inextricable link to his gritty New York urban milieu must also have inspired his surging black scaffolds of lines, executed with common commercial enamel paint and huge brushes. The reduction to the chromatic scale of black and white was probably motivated in part by a desire to limit the artistic act to sheer energy and motion. But the white areas are assertive zones that contain the activity of the black strokes.

While illustrating a poem by Harold Rosenberg in 1948, Robert Motherwell developed the basic format of the *Elegies to the Spanish Republic*, a series of paintings now numbering well over a hundred. He conceives of the group—basically composed of adjacent rectilinear and ovoid shapes—as "general metaphors of the contrast between life and death." By limiting his palette largely to black on white ground and relying on the colors' evocative and symbolic associations, Motherwell hoped to convey the tragedy of the Spanish Civil War.

Clyfford Still's mural-sized canvas *Untitled* evokes the personal struggle of man engaged in discovering his own identity. Dense black impasto paint with visible marks of brush and palette knife creates a vivid surface. The dominant black is intersected by jagged, flamelike striations of red, orange, and yellow. The scale and space of Still's works have been compared with the expansiveness of the American landscape, and his jagged forms have been likened to mountain crags or lightning. The artist himself, however, rejected any association with a natural landscape, and claimed that his work related solely to his own life and his struggle for authenticity. It was meant to "exalt the spirit of man."

While Clyfford Still in America set out to break all ties with both traditional and modern styles, the

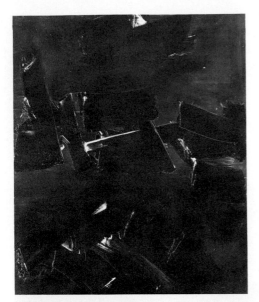

1140

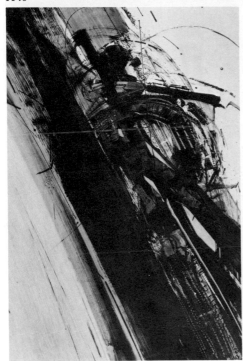

1141

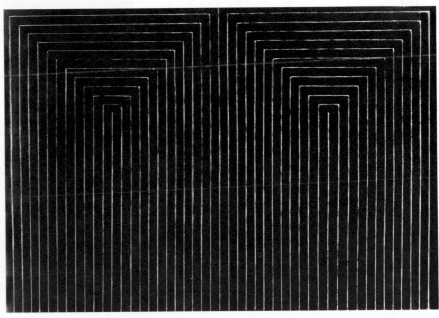

1142

French artist Pierre Soulages painted dark abstractions which reflect the refinement of European art culture in general and a reliance on his Cubist predecessors in particular. His preference for traditional modes is also seen in his admiration of Romanesque cathedrals, whose architectonic character may have influenced his carefully structured compositions. His use of rich, velvety oil, rendered in subtle gradations of black, gives a sense of gravity to Soulages's nocturnal canvases of the 1950s.

Danish-born K. R. H. Sonderborg executes his black tempera paintings with almost automatic gestural movement. Sonderborg, unlike Kline, uses no preparatory sketches. *Flying*

Thought indeed suggests flight, noise, electricity; the diagonal composition helps convey the impression of swiftness and energy. In his spontaneous improvisations of man shooting through space, Sonderborg carries out much of the promise of Italian Futurist painting.

In contrast, Frank Stella's symmetrical *The Marriage of Reason and Squalor* is calm and austere. Wide bands of black paint point up the "pin stripes" of unpainted canvas and extend to the very edge of the lateral boundary defining the perimeter of the painting as an object. Stella's work marked a definite break with the painterly, subjective approach and the spontaneous method

of many of his colleagues. He worked carefully from prior designs to create a unified and orderly picture. Attempting to deny any remnant of illusory space, he spoke for many contemporaries in explaining that "my painting is based on the fact that only what can be seen there *is* there."

1137 Franz Kline. *Chief*. 1950. Oil on canvas, 58 $^3/_8$ × 73 $^1/_2$″ **1138** Robert Motherwell. *Elegy to the Spanish Republic No. 55*. 1955–60. Oil on canvas, 70 $^1/_8$ × 76 $^1/_8$″ **1139** Clyfford Still. *Untitled*. 1957. Oil on canvas, 112 × 154″ **1140** Pierre Soulages. *9 Decembre 59*. 1959. Oil on canvas, 79 $^3/_8$ × 63 $^3/_4$″ **1141** K. R. H. Sonderborg. *Flying Thought*. 1958. Tempera on board, 42 $^7/_8$ × 27 $^1/_2$″ **1142** Frank Stella. *The Marriage of Reason and Squalor*. 1959. Oil on canvas, 90 $^3/_4$ × 132 $^3/_4$″

Abstraction: Monochrome

1143

1144

1145

Sam Francis's white paintings of 1950 rely on metaphor since the artist believed the process of executing them to be a catharsis. Experiencing the gray Paris skies, Francis expunged color from his pictures and painted almost totally white paintings with a barely visible brushstroke. He would work from the edge toward the center; "centering," the Eastern concept related to energy flow, is an important element in his work.

A year later Robert Rauschenberg experimented with pure white painting in a work entitled, like Francis's, *White Painting*, but consisting of seven regular panels, resulting in a system of redundance. But Rauschenberg was particularly interested in the shadows cast by viewers onto his plain white panels.

In his search for ever greater purity Ad Reinhardt now composed a painting with twenty-five squares in the same color. It does not remind us of light, nor does it reflect its surroundings. It does not relate to anything outside its own rigidly geometric dimensions. It is silent and static, and stands for itself.

The search for the "ineffable" also led the French painter Yves Klein toward the monochrome. In fact, Klein, who invented IKB (International Klein Blue) was called *"le monochrome."* For him color was autonomous and painting was simply a prop for color. He would have liked to impregnate the whole world with blue, the color of the sky, of space itself. "Through color," he said, "I experience a feeling of complete identification with space. I am truly free." *IKB 48* was exhibited with many other IKB pictures, all totally identical panels, with the same color, same dimensions, etc.

From 1948 to 1954 Ellsworth Kelly also worked in Paris. His work was close to that of Mondrian and other painters of pure geometric abstraction. However, Kelly was absorbed by the problems of the pictorial edge, as in his *Broadway*. It consists of a large red square set at a slight angle on a white sur-

1146

1148

1147

1149

rounding rectangle. Although this work is reminiscent of Malevich's *Suprematist Composition: Red Square and Black Square* of 1915 (plate 385), Kelly is more concerned with the effect of color as color.

Otto Piene, who, together with Heinz Mack, founded the Zero group in 1958, was close to Yves Klein, and like him, Piene rejected the subjective and often pessimistic attitude of Informal Art and Abstract Expressionism. Zero meant "a zone of silence . . . for a new beginning." *Light Yellow Light* is an example of Piene's attempt to free color from form, and his hope to capture "the purity of light." He wrote, "Light is the life-substance both of men and

painting. . . . The energy of light emanating from the field of painting is converted mysteriously into the spectator's vital energy."

In Italy, Piero Manzoni was close to the new trends, to the Zero group, and to Fontana and Klein. Considering the canvas "an area of liberty," Manzoni eliminated coloristic and figural inferences to yield an achrome, a material object that exists without space, color, or space illusion, without the superimposition of the artist's touch.

By 1960 monochrome painting had become so prevalent that the museum of Leverkusen in Germany was able to assemble a large international exhibition of monochrome works.

1143 Sam Francis. *White Painting.* 1950. Oil on canvas, 80 × 64″ **1144** Robert Rauschenberg. *White Painting.* 1951. House paint on canvas, 72 × 126″ **1145** Ad Reinhardt. *Abstract Painting, Red.* 1953. Oil on canvas, 40 × 40″ **1146** Yves Klein. *IKB 48.* 1956. Oil on composition board, 58 ³/₄ × 49 ¹/₄″ **1147** Ellsworth Kelly. *Broadway.* 1958. Oil on canvas, 78 × 69 ⁵/₈″ **1148** Otto Piene. *Light Yellow Light.* 1958. Oil on canvas, 27 ⁵/₈ × 67″ **1149** Piero Manzoni. *Achrome.* 1957. Kaolin and glue on canvas

Abstraction: The Circle

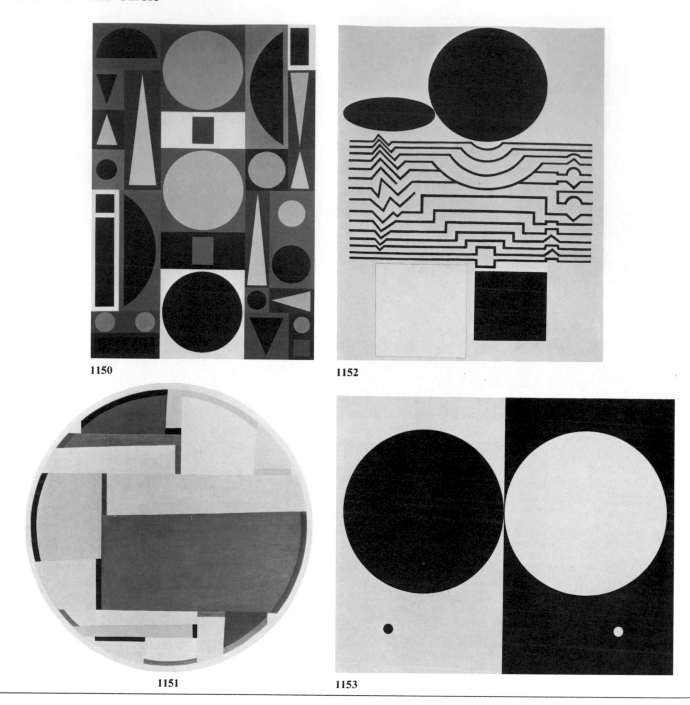

1150

1152

1151

1153

Some of the abstract painters of the 1950s explored new possibilities with geometric forms such as the circle, the figure without beginning or end. In *Vie No. 1* Auguste Herbin displays his alphabet of signs, which are systematically arranged and compartmented in fields of color and executed with geometric exactitude. The Swiss painter Fritz Glarner, a disciple of Mondrian's who arrived in the U.S. in 1936, chose the circular format in his *Relational Painting, Tondo 40* to pursue the principles of pure relationships of primary colors.

Victor Vasarely carries on the abstract and rational geometric tradition. He confined himself during the 1950s largely to black and white paintings of optical illusions. These, he said, are meant to "aggress the retina." Indeed, a painting such as *Mindanao* elicits immediate physiological responses in the eye. The network of parallel lines with irregular undulations gives the canvas the appearance of a warped surface. Above and slightly off center hovers a dark circle which gives stability to the vibrating picture.

At a time when most New York painters worked in the free-wheeling Abstract Expressionist mode, Alexander Liberman, photographer and sculptor as well as painter, did immaculate geometric paintings. *Diptych—One Way* was one of the first in a series of "circle paintings."

Two large circles implicitly divide the painting into vertical halves of a diptych; two dots complete a complementary horizontal division. Each half mirrors the other in dichromatic opposition. The circles are precisely planned and placed according to the laws of chance—which is a contradiction in itself. Liberman has often used the *I Ching (Book of Changes)* to plot his compositions.

To Adolph Gottlieb painting had to be "an adventure into the unknown world." Yet, after the mid-1950s, when he began his long series of emblematic bursts such as *Blast I,* formal considerations were uppermost in his mind. These paintings express his continuing fascination

1154

1155

1156

with the dynamics of universal op-
posites. Using two shapes, a circle
and a mass consisting of harsh, inter-
secting brushstrokes, Gottlieb cen-
ters these forms on the canvas. In
Blast I the red circle is the active
agent, which is contrasted to the
jagged black shape lying below it.

Symbolic content has no place in
the work of the "color painter" Ken-
neth Noland. In *Beginning* all con-
ventional considerations of pictorial
space or perspective are elim-
inated as the cyclic bands control
and confine all movement on the flat
ground. The circle is painted with
thin pigment on an almost square
unsized canvas. Working with the
formal constraints of circles, chev-

rons, and stripes, Noland consistently
creates compositions which utilize
his expert knowledge of color optics
and principles of design.

In Jasper Johns's *Target with Four
Faces*, painted three years earlier, we
are again confronted by the emblem of
the target and its concentric circles.
The target, done in the wax technique
of encaustic on newsprint laid on
canvas, presents an uneven surface.
Above the square target are four
boxes which contain four tinted
plaster casts of human heads. They
are blindfolded by the frame of the
enclosure, with its hinged top which
can be lowered to cover them com-
pletely. The concentric target is an
object visually precise and psycho-

logically dangerous. Its uncompro-
mising center is a point of aim. As
we aim our eyes to observe this work,
we become aware that the artist has
not only questioned what we see but
also who we are.

1150 Auguste Herbin. *Vie No. 1*. 1950.
Oil on canvas, 57 × 38″ **1151** Fritz
Glarner. *Relational Painting, Tondo 40*.
1956. Oil on masonite, diameter 42″
1152 Victor Vasarely. *Mindanao*. 1952–55.
Oil on canvas, 64 × 51 1/8″
1153 Alexander Liberman. *Diptych—One
Way*. 1950. Enamel on masonite, 60 × 74 1/4″
1154 Adolph Gottlieb. *Blast, I*. 1957. Oil
on canvas, 90 × 45 1/8″ **1155** Kenneth
Noland. *Beginning*. 1958. Acrylic on
canvas, 90 × 96″ **1156** Jasper Johns.
Target with Four Faces. 1954–56. Encaustic
on newspaper on canvas, 26 × 26″,
surmounted by four tinted plaster faces
in wooden box with hinged front; box
open, 33 5/8 × 3″

1158

1157

1159

The figure of the rectangle or square painted on the rectangle of the canvas and bordered by its frame presented a problem very different from that of a circle placed in its angular support. Beginning in 1950, Josef Albers (plates 1006–1007) created his series *Homage to the Square*, which numbered many hundreds by the time of his death, in 1976. In them he superimposes four squares of different hues, shifting the three internal squares down from center to lend a slight gravity to the floating forms. Through juxtaposition Albers changes the quality of his selected hues, creating illusions of depth and/or enlargement. Spotlessly executed, the advancing and receding squares

achieve a perfection of form while coming close to one of his goals: the depersonalization of painting.

Like Albers, Hans Hofmann was primarily a colorist, but his work remains personal and subjective, even when, in the mid-1950s, he started to introduce rectangular forms into his paintings. The rectangle in *Equinox* gives architectonic strength to his autobiographic gesture. He creates a tension between the floating geometric forms and the violent gestural areas. As a result, the work is a dramatic experience, its unity established by the dynamic push-pull of these opposing forces.

An expanding wall of glowing blue pigment, anchored and symmetrical-

ly divided by a single white vertical "zip," Barnett Newman's large-scale *Onement VI* simultaneously confronts and envelops the viewer. The irregular zip, painted between two strips of masking tape under which a little pigment has bled, slightly roughing the line, suggests instantaneous electric motion—like a flash of lightning. The whole embodies a sublime harmony and an order both material and metaphysical. Curious retinal afterimages challenge the viewer psychologically, intellectually, and emotionally.

Whereas Newman's pure abstract paintings—like those of Reinhardt and Rothko or Mondrian and Malevich before them—are charged with

1160

1161 1162

the pressure of an ascetic passion, Ellsworth Kelly's *Colors for a Large Wall* is concerned chiefly with formalist values. It is a uniform sequence of clearly demarcated colored squares butted against each other like a brilliant tile floor elevated to the wall to be contemplated as a painting. The hard-edge panels have immaculate surfaces with no trace of the artist's hand. Kelly's fine sense of scale and proportion enables him to maintain an equilibrium between the parts and the whole.

In England, Victor Pasmore created a series of three-dimensional paintings of great precision and architectural order. *Relief Painting* is a rational yet dynamic work in the Constructivist tradition. Pasmore chose two basic motifs, an ideal rectangle and a straight line, arranging them in a system, symmetrical yet varied, in which thin diffuse elements are countered with two solid blocks of wood. Light falling on the relief casts shadows which are an integral part of the horizontal-vertical system. Composed entirely of shapes not found in nature, this work asserts its source in the human intellect.

John McLaughlin, who worked in southern California in relative isolation from the art world, composed his canvases of rectangles, painted flat, and arranged by trial and error until he was satisfied with their stable balance. Colors serve merely to define the forms. His concern is not to imitate nature, but to postulate his own relationship to it and, as he said, to develop a composition "which might enable the spectator to contemplate nature beyond the limitation of an image of symbolism."

1157 Josef Albers. *Homage to the Square: Apparition.* 1959. Oil on board, 47 1/$_2$ × 47 1/$_2$″ **1158** Hans Hofmann. *Equinox.* 1958. Oil on canvas, 72 1/$_8$ × 60 1/$_4$″ **1159** Barnett Newman. *Onement VI.* 1953. Oil on canvas, 102 × 120″ **1160** Ellsworth Kelly. *Colors for a Large Wall.* 1951. Oil on canvas, mounted on 64 wood panels; overall, 94 1/$_4$ × 94 1/$_2$″ **1161** Victor Pasmore. *Relief Painting in Black, White and Maroon.* 1954. Oil on wood, 27 × 29″ **1162** John McLaughlin. *Untitled.* 1951. Oil on masonite, 31 3/$_4$ × 37 3/$_4$″

Abstraction: Random Order

1163

1164

1165

The brushstrokes in Mark Tobey's *Edge of August* are even smaller than they were in his tablet painting, *Universal Field* (plate 1014). The calligraphic signs move with never-ceasing pulsations across the panel. We can sense the organic, rhythmic movement of nature in this, one of Tobey's masterpieces. He himself explained that his picture was "trying to express the thing that lies between two conditions of nature, summer and fall. It's trying to capture that transition and make it tangible. Make it sing."

After a successful career as a figure painter (plate 954), Philip Guston turned toward abstraction at the end of the 1940s. In *Native's Return* he too worked with brushstrokes of great high-pitched energy. Guston centered his weighty image in an evanescent atmosphere. His seductive, vibrating surface and bright colors created an almost romantic atmosphere. Yet incarnate in this lushness are quiet, searching images. Palpable if unfathomable forms emerge out of the pigment, recording the artist's hesitations and doubts as he intuitively metamorphosed pigment and canvas into a life-enhancing painting.

Somewhat related in lyric sensitivity is the work of Israel's revered leading abstractionist, Joseph Zaritsky, who, like Guston, has been called an Abstract Impressionist. *Flowers*, a gestural abstraction, is the vehicle by which the artist asserts the emotive and intellectual aspects of the art of painting. It is a sensitive structure of both naturalistic and abstract forms; narrow bold strokes alternate with wide relaxed washes, both evidencing Zaritsky's skillful evocation of the emotional qualities of color. Flickering throughout the canvas, the delicate blooms are the painter's tribute to the tradition of still life and to the beauty of nature.

In contrast, Emilio Vedova's Abstract Expressionist painting is an ebullient, at times violent assertion of the potential dynamics of pictorial means. Like other Italian artists of his generation, Vedova searched for a

1167

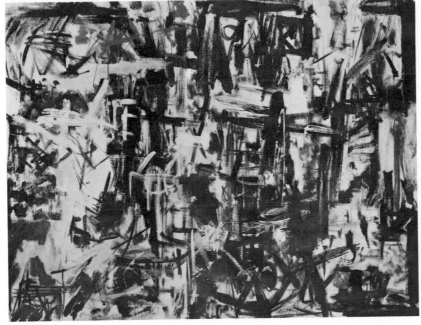

1166

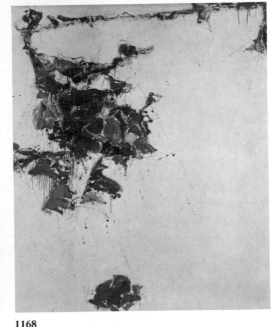

1168

new language of art, evolving a purely plastic, nonrepresentational image of human tensions. *Documenta No. 2* slashes into its basic Cubist structure with a dynamic energy which recalls the painting and theories of the Futurists. The painting is built up of harsh contrasts of aggressive black brushstrokes across a white surface, with flashes of color emerging in various parts of the canvas. Vedova has continued to work in the passionate, expressive vein, exploring primarily a world of light and dark.

Jean-Paul Riopelle, a Canadian-born Paris painter, also uses dynamic strokes of brush and palette knife, but his heavily textured paintings

are a deluge of color. In *Robe of Stars* the mosaic-like facets of pigment are vigorously stacked on top of each other to build a dense, tactile surface all over the canvas. The powerful rhythm of these multidirectional strokes and daubs of colors, recording the artist's impulses during the act of creation, are actually based on a carefully thought-out compositional concept.

In his large picture *The Whiteness of the Whale* Sam Francis shifts the central mass of rich colors to the upper left, freeing the lower areas of white to expand and soar. The pulsing cluster of color cells and surging white space achieve a dynamic equilibrium perfected by the

smaller cell of blue which has spun off into the void. Moving through this seemingly random veil of color, an enigmatic structure emerges, a white memory of gigantic grace and effortless strength, evoking indeed the surging power and physical vastness of Herman Melville's splendid creature.

1163 Mark Tobey. *Edge of August*. 1953. Casein on composition board, 48 × 28″ 1164 Philip Guston. *Native's Return*. 1957. Oil on canvas, 65 × 76″ 1165 Joseph Zaritsky. *Flowers*. 1951. Oil on canvas, 72 $^1/_2$ × 78 $^3/_4$″ 1166 Emilio Vedova. *Documenta No. 2*. 1952. Oil on canvas, 56 × 74″ 1167 Jean-Paul Riopelle. *Robe of Stars*. 1952. Oil on canvas, 78 $^3/_4$ × 58 $^1/_8$″ 1168 Sam Francis. *The Whiteness of the Whale*. 1957. Oil on canvas, 104 $^1/_2$ × 85 $^1/_2$″

Abstraction: The Canvas Stained and Attacked

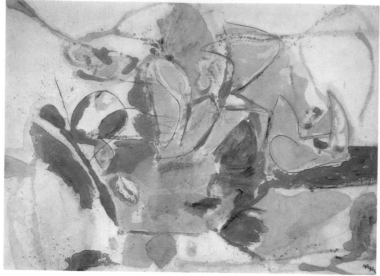

1169

1170

1171

While retaining the large scale and overall composition of the slightly older "first-generation" Abstract Expressionists, Helen Frankenthaler developed a new "soak-stain" technique in 1952. The consistency of the paint was greatly diluted, the thinned paint then spilled directly onto the unprimed canvas and allowed to soak into the weave, expunging all suggestions of spatial illusion and reinforcing the two-dimensionality of the surface. *Mountains and Sea*, which was painted after the artist had visited Nova Scotia, is the first of these experiments in spilling and staining. While the work is not a literal rendition of the landscape, its aquatic colors, ethere-

ality of paint, and large unpainted areas serve as analogues to the forces or essence of nature.

Although Morris Louis was affected by the methods employed by Frankenthaler, his staining is more systematic in its exploration of the flow of paint from one portion of the canvas to the other. Stroke and gesture are virtually obliterated as the subtly channeled pigment completes the creative act—perhaps what the artist meant when he referred to Frankenthaler as "a bridge between Pollock and what was possible." But there is no agitation in Louis's paintings. In *Beth Gimel* a veil of monochrome color interacts with variegated colors, pro-

ducing both nuances of translucent light and dramatic visual contrasts at the edges of the configuration. While continuing the exploitation of light begun by the Impressionists, Louis seems primarily concerned with the properties of paint: its viscosity, its physical relation to gravity, and its evocative possibilities.

Antoni Tàpies's thickly layered canvases deal with the specific heaviness and weight of paint and plaster, and have consequently been characterized as "matter painting." Tàpies is concerned with the earth, with erosion and decay. His tactile paintings are heavy and somber; their surfaces have the mysterious, secretive appearance of old walls.

1172

1173

1174

As we saw in his photograph (plate 1102), Georges Mathieu was one of the first artists in Europe to realize the potential of spontaneity, gesture, flow, and improvisation. For him the materials employed and the theatrical aspects of painting take precedence. Working like a dancer in front of his canvas, he assailed it in a playful and festive mood. Despite the spontaneous energy of the calligraphic and linear arabesques in *The Capetians Everywhere*, a Cubist grid seems to be maintained. Whereas Pollock sought to obliterate the distinction between figure and ground, Mathieu's loops and squiggles maintain a separation.

A fascinating attack on the traditionally sacred canvas was made by Yves Klein early in 1960 in his *Anthropometries*: nude women administered his International Klein Blue to their bodies and then Klein directed these "living brushes" to apply their bodies to the white canvas. At the Galerie Internationale d'Art Contemporaine this action was performed in public in March 1960. The artist, in formal attire, directed the movements of the women while an orchestra played his *Monotone Symphony*. The resulting body print *is* the painting, as in *Shroud Anthropometry 20, "Vampire,"* in which red and black pigment was added to the ultramarine. In these works, done two years before he died, Yves Klein found a very personal way to move beyond abstraction.

Lucio Fontana, having pierced the canvas with small perforations (plate 1136), turned in 1951 toward *Spatial Concepts* in which linear slashes or signs of gestural energy are cut elegantly into the canvas like marks left by a fencer's foil.

1169 Helen Frankenthaler. *Mountains and Sea*. 1952. Oil on canvas, 86 $^7/_8$ × 117″ **1170** Morris Louis. *Beth Gimel*. 1958. Acrylic on canvas, 133 × 93″ **1171** Antoni Tàpies. *Painting LXX: Grey Ochre*. 1958. Oil on canvas, 102 $^3/_8$ × 76 $^3/_4$″ **1172** Georges Mathieu. *The Capetians Everywhere*. 1954. Oil on canvas, 9′8 $^1/_8$″ × 19′8 $^1/_4$″. **1173** Yves Klein. *Shroud Anthropometry 20, "Vampire."* 1960. Pigment on canvas, 43 × 30″ **1174** Lucio Fontana. *Spatial Concept (Attese)*. 1951. Oil on canvas, 39 $^3/_8$ × 33 $^1/_8$″

1175

1176

1177

1178

In Dubuffet's *Geologist* (plate 1128) the little man was still on top of the earth. Seven years later, in *Mirandoliana*, the figures are totally submerged. Dubuffet painted specific colors and textures on large sheets of canvas, cut them into irregular pieces, and pasted them onto new canvas. For this technique he coined the term "assemblage" to distinguish his own work from collage. In *Mirandoliana* the colors are those of the earth, and the human protagonists are composed of the same materials as their surroundings, displaying a pantheistic view of the universe or, as he called it, a "universal soup with the savor of life itself."

Instead of Dubuffet's largely addi-

tive process, Raymond Hains used *décollage*, the actual removing or unsticking of materials. The artist's visual imagery consisted of torn posters. These were selected sometimes for their communicative verbal content or, as in *Palissade de Trois Planches (Group of Three Boards)*, for their unexpected aesthetic appeal. A new urban poetry is thus created by Hains and François Dufrêne, who similarly utilized tattered remnants of advertising. The final result, the torn posters, resembles the abstract painting of the time: a similar aesthetic or style prevails, whether the artist applies paint or tears away at paper.

Motherwell's collages illustrate the artist's sensuous and tactile contact

with the materials. In *The Tearingness of Collaging,* the act of ripping the paper components becomes the subject of the work. It is the physical interaction with the paper that is most significant for the artist, situating the work, he says, on the plane of feelings. His poetic interests are also in evidence, as words or letters are introduced as an integral component of the collage. His calligraphic signature in the center of the work also reveals a desire to incorporate a part of the self into the work of art.

Beginning with a rough sketch, Conrad Marca-Relli cut out fragments of the unpainted canvas, mixed them with paint and glue,

1179

1180

1181

and placed them on another pictorial field. Collage components were then shifted and changed, linking his work to the semiautomatic, process-oriented endeavors of the Action Painters. Accident is exploited further in the overall black dots (originally a result of the finger marks in the glue), which increase the already energized motion of the whole. The remnants of figures in *Trial* are engaged in what the artist referred to as the "architecture of an event."

In Miró's "picture-objects" the boundaries of painting are expanded to include knotted and braided rope, linking the work to the craft of weaving and imbuing it with primitivistic overtones. In *Painting* these

fetishistic cords are appropriately surrounded by whimsical pictographic figures whose ambiguously situated body parts carry erotic associations. The dangling strands, moreover, appear to have also served as an integral part of the painting process. The uniform staining of the canvas reinforces Miró's willingness to partake of a variety of methods and materials.

Alberto Burri's tattered scraps of burlap and rags evoke the horror of his experience as an army doctor during World War Two. In *Composition* the precarious stitching unravels to reveal woundlike gaps which ooze red liquid. These discarded remnants recall the blood-soaked

bandages with which Burri came into daily contact, providing a method by which the artist could work out the traumas associated with the tragedy of wartime.

1175 Jean Dubuffet. *Mirandoliana*. 1957. Oil on canvas (assemblage), 36 $^1/_4$ × 53″ **1176** Raymond Hains. *Palissade de Trois Planches (Group of Three Boards)*. 1959. Wood and paper, 39 $^3/_8$ × 25 $^1/_4$″ **1177** François Dufrêne. *Quartier du Plafond de la 1e Biennale des Jeunes de Paris (Section of the Ceiling of the First Paris Biennale)*. 1959. Torn-off posters mounted on linen, 76 $^3/_4$ × 38 $^1/_4$″ **1178** Robert Motherwell. *The Tearingness of Collaging*. 1957. Collage with oil, 29 $^5/_8$ × 21 $^3/_8$″ **1179** Conrad Marca-Relli. *Trial*. 1956. Oil and canvas collage, 81 × 132″ **1180** Joan Miró. *Painting*. 1950. Oil, cords, and casein on canvas, 39 × 29 $^7/_8$″ **1181** Alberto Burri. *Composition*. 1953. Oil, gold, and glue on canvas and burlap, 34 × 39 $^3/_8$″

Objects

1182

1183

The Surrealist René Magritte, continuing to pursue his enigmatic visions, challenges our preconceived notions concerning the placement and context of objects by divorcing them from their traditional associations in order to situate them in totally unrelated ambiences. A monumental green apple which invites credibility due to its almost photographic accuracy finds itself mysteriously in a tense, claustrophobic space. Not only does the fruit seem displaced, but its size belies its function as something edible. Or is it the room which has shrunk to minuscule proportions? The relationship of the image to its name is also called into question as the title of the work, *The Listening Chamber,* bears no apparent relationship to the image rendered. It is clear that the world of consensual reality has given way to that of the imagination and the dream.

Composed of bold, Abstract Expressionist-inspired strokes creating a color relationship between the white pillow and a lovely quilt, Robert Rauschenberg's *Bed* reflects a desire to incorporate a part of the self into the work of art, thus bridging the gap between aesthetic production and life. Upon discovering that he had neither canvas nor the means to purchase it, Rauschenberg decided to use his quilt and pillow instead. These objects of sleep are thus wrenched from their traditional recumbent position and nocturnal associations into the arena of art. Like Duchamp, in his readymades of some four decades earlier, Rauschenberg has bestowed artistic credibility on his favored personal possessions, essentially because this is what he has selected to be art.

Few objects are so firmly imprinted in our psyches as the American flag. In *Three Flags* Jasper Johns transmutes a triple Stars and Stripes into both a literal as well as a physical painting. The object's prevalence is alluded to by its threefold presenta-

1185

1184

tion, which prefigures the Pop artist's serial presentation of the banal trappings of contemporary culture. The inherent two-dimensionality of the image, which belies illusionism, is mitigated by the use of encaustic technique, which imbues the image with both texture and depth. The tension between the hand-painted, sensuous surface of the painting and its familiar, pervasive image of the national symbol of "the greatest power on earth" arouses continual consternation.

The German artist Konrad Klapheck is, like Johns, a link in the chain from Dada to Pop. Recalling the Dadaists' iconic presentation of mechanical objects, Klapheck also stresses the anthropomorphic properties of these inanimate pristine products of mechanized society. The isolated machine appears like a powerful iconic object. The artist himself explained that *Typewriter* is male "because all the most important decisions of our lives have been taken over by it." It has become a substitute for the father, the politician, the artist. Klapheck's *Typewriter* stands as a cryptic representation of the civilization that has created it.

1182 René Magritte. *The Listening Chamber*. 1953. Oil on canvas, 31 $\frac{1}{2}$ × 39 $\frac{3}{8}$" **1183** Robert Rauschenberg. *Bed*. 1955. Combine painting, 74 × 31" **1184** Jasper Johns. *Three Flags*. 1958. Encaustic on canvas, 30 $\frac{7}{8}$ × 45 $\frac{1}{2}$" **1185** Konrad Klapheck. *Typewriter*. 1955. Oil on canvas, 23 $\frac{5}{8}$ × 29 $\frac{1}{8}$"

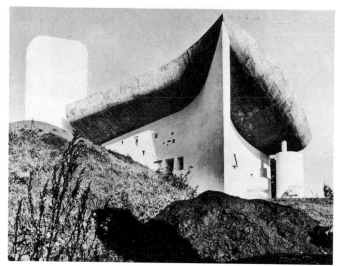

1186

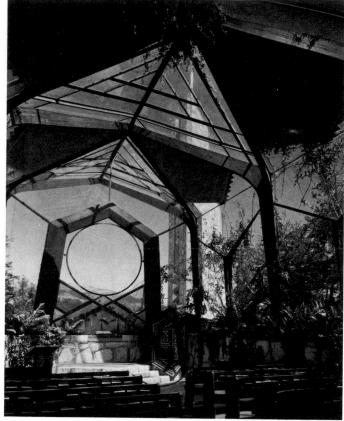

1188

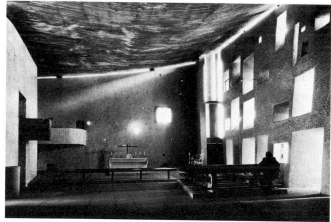

1187

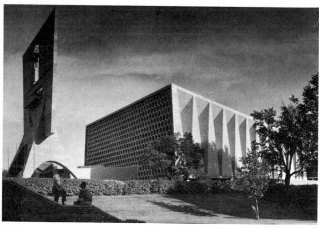

1189

In the emotional chaos following World War Two and the reality of the atomic bomb, organized religion entered a period of intense moral debate and spiritual reexamination. Architects created striking new images embodying new religious values, resulting in some of the most vividly emotional works of the decade.

The most celebrated and most distinguished and individual religious building of the decade, Le Corbusier's Notre-Dame-du-Haut, is perched high on a hill above Ronchamp in the verdant rolling hillsides of eastern France. The landscape itself has become an integrated part of this pilgrimage church.

Designed as a shrine for the miraculous image of the Virgin, the chapel was to be, in Le Corbusier's words, "a place of silence, prayer, of peace and spiritual joy." In antithesis to the austere rationalism of his earlier work, Le Corbusier created at Ronchamp an emotional sculptural presence with symbolic meaning. The thick, powerful, curvilinear walls, sprayed with rough white concrete, curve outward and upward, climaxing in a massive soaring concrete roof, which appears like a billowing sail on its hilltop. Le Corbusier, who also worked as a painter for most of his career, designed colored glass that was placed in "light funnels" to relieve the other-

wise heavy interior and flood it with colored light.

In contrast to the mass and solidity of Ronchamp, Lloyd Wright's Wayfarers' Chapel, on a cliff above the Pacific Ocean in Palos Verdes, California, is a thing of fragility and ethereal beauty. In accord with the naturalistic tenets of Swedenborgian religious philosophy, the structure is a simple framework of redwood beams filled in with glass and tile. An inexorable invasion of vines and shrubbery has romantically wedded the chapel to its spectacular site.

The Bauhaus-trained Marcel Breuer received several ecclesiastical commissions during the decade. His undisputed masterwork in this field

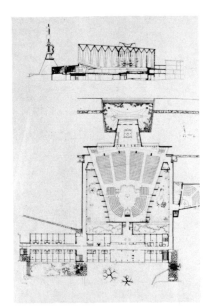

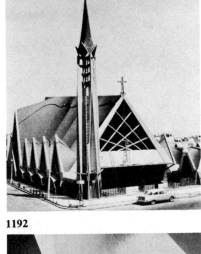

1192

1190

1193

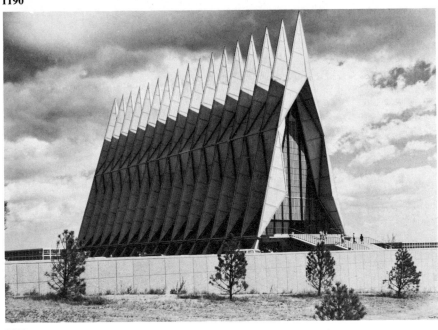

1191

1194

is St. John's Abbey Church in Collegeville, Minnesota. Like Le Corbusier and others, Breuer was fascinated with the dramatic possibilities inherent in cast concrete technology. At St. John's, Breuer's creative facility with this material is given full play, both in the trapezoidal "bell banner" entry and in the honeycombed facade of the church.

One of the decade's most widely publicized—and most widely criticized—projects was the sprawling new United States Air Force Academy in Colorado Springs, designed by the leading architectural firm of Skidmore, Owings and Merrill. The spiky profile of the shimmering glass and aluminum chapel, done in mech-

anized Gothic, was meant to echo the Rocky Mountain background and breaks sharply with the otherwise unrelieved monotony of the low-lying campus.

The first commission for which the Spanish-born architect and engineer Félix Candela served in both capacities was the Church of the Miraculous Virgin, in Mexico City. Candela's hyperbolic paraboloid forms were clearly inspired by Eduardo Torroja's work in thin shell construction (plate 838). Though rigorously and precisely calculated, the concrete vaults of Candela's church interior have an Expressionist flamboyance that harks back to the work of Gaudí fifty years earlier.

1186–1187 Le Corbusier. Notre-Dame-du-Haut, Ronchamp. 1950–54 **1188** Lloyd Wright. Wayfarers' Chapel, Palos Verdes, Calif. 1951 **1189–1190** Marcel Breuer and Hamilton Smith. St. John's Abbey and University, Abbey Church, Collegeville, Minn. 1953–61 **1191** Skidmore, Owings and Merrill. U.S. Air Force Academy Chapel, Colorado Springs. 1956–62 **1192–1194** Félix Candela. Church of the Miraculous Virgin, Mexico City. 1954–55

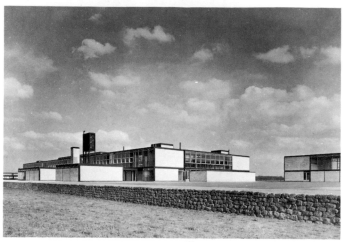

1195

1196

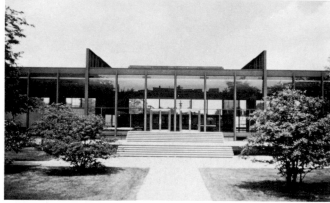

1197

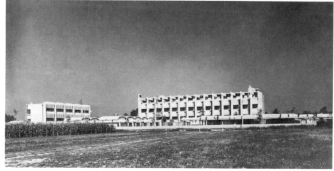

1198

The 1950s witnessed a far-reaching rejuvenation of the tenets of the modern movement in architecture, of structural honesty and truth to materials. Younger architects turned to the *beton brut* (rough concrete) of Le Corbusier in Marseilles and to the precision and suavity of Ludwig Mies van der Rohe's steel-framed buildings in Chicago—and from them forged a new style which came to be known as Brutalism.

Peter and Alison Smithson's Hunstanton Secondary School, though designed in the late 1940s, was not completed until 1954, partly because of a shortage of steel. The English journal *Architectural Review* called it the "most truly modern building in

Britain." Critics were both shocked and impressed by the manner in which the industrial materials and functional conduits were exposed. The building has a formal clarity and geometrical purity that harks back to the work of Palladio.

Mies van der Rohe had settled in the U.S. in 1938, and a year later was commissioned to design an entire new campus for the Illinois Institute of Technology (then the Armour Institute). His earliest plan was rigid and hierarchical, with Beaux-Arts axiality. The plan loosened somewhat in execution, but the overall effect is still one of formality, clarity, and control. Crown Hall is the last of Mies's buildings for the campus,

and probably the best. Like the other IIT buildings, it is constructed on a severe, black-painted steel frame, with buff-brick infill, the whole governed by a four-foot module. It is further distinguished by its breathtaking open main floor, a vast volume of free-flowing space and light measuring two hundred by one hundred twenty feet.

One of the most uncompromisingly Brutalist buildings of the decade is Vittoriano Viganò's Istituto Marchiondi in Milan, a residential school for psychologically disturbed boys. The concrete, like the structure itself, is treated "honestly"; it is plain and unfinished, with the residual pattern of the wood formwork

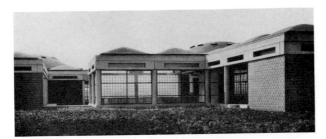

1199

1201

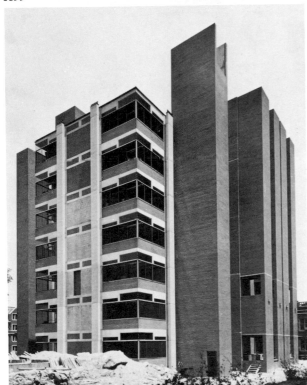

1200

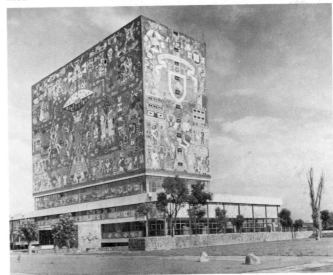

1202

clearly visible. It is a stern, even aggressive building; one wonders about its effects on its inhabitants.

Another large-scale educational complex, Aldo van Eyck's Orphanage School in Amsterdam is only slightly less severe. It is a vast, low warren of neatly ordered units, encompassing facilities for living, learning, and playing. The materials are much the same as those in the Istituto Marchiondi—but the manner in which they are deployed is less flamboyant and exhibitionistic.

Probably the single most influential American building of the late 1950s is Louis Kahn's Richards Medical Research Building at the University of Pennsylvania in Phila-delphia. Composed basically of a glazed concrete-framed block surrounded by a cluster of brick-faced towers, it seems a perfect resolution of the problem of articulating the building's various functions. The towers house stairwells and utilities, while the center contains research laboratories. The concept of formally distinguishing "served" and "servant" spaces is now reinterpreted into a wholly modern presence.

The university library in Mexico City is the centerpiece of what was virtually a new university city. The library, designed by Juan O'Gorman, Gustavo Saavedra, and Juan Martínez de Velasco, was originally conceived as a Central American stepped pyramid. In its final form, the library stack tower, though reduced to a simple block, still retains an ancient American feeling in the wildly exuberant and brilliantly colored mosaic pattern, designed by O'Gorman himself.

1195–1196 Peter and Alison Smithson. Hunstanton Secondary School, Hunstanton, England. 1953–54 1197 Ludwig Mies van der Rohe. Crown Hall, Illinois Institute of Technology, Chicago. 1952–56 1198 Vittoriano Viganò. Istituto Marchiondi, Milan. 1957–58 1199 Aldo van Eyck. Orphanage School, Amsterdam. 1958–60 1200–1201 Louis Kahn. Richards Medical Research Building, University of Pennsylvania, Philadelphia. 1957–61 1202 Juan O'Gorman, Gustavo Saavedra, and Juan Martínez de Velasco. Central Library, University City, Mexico City. 1951–53

Exhibition Buildings, Theaters, and Museums

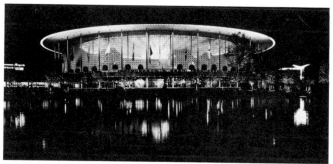

1203

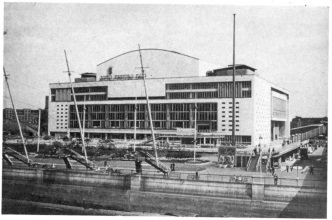

1204

1205

1206

A growing dissatisfaction with the strict austerity of the Miesian style led some architects in the 1950s to a decorative interpretation of the basic International Style vocabulary. A prolific practitioner of this rather flaccid Neoclassicism was Edward Durell Stone, who received dozens of government and corporate commissions. His approach, typified in his U.S. Pavilion for the 1958 Brussels World's Fair, was to prettify modernist form by cloaking the volume of a building in a pierced metal screen and surrounding it with spindly gold columns, all of which serve to inflate the building with a kind of vulgar self-importance and monumentality.

The centerpiece of the 1951 Festival of Britain, which was planned as an exuberant display of the country's postwar cultural recovery, was the Royal Festival Hall, designed by Robert H. Matthew of the Architects' Department of the London County Council. Harshly criticized for its weak, picturesque modernism, the concert hall nevertheless proved to be an acoustical success.

Though construction on the spectacular Sydney Opera House began in 1956, the project, plagued by myriad difficulties, proceeded at a medieval pace, and was not completed until more than fifteen years later. Following in most respects the initial designs of Danish archi-

tect Jørn Utzon, the Opera House, dramatically sited on a promontory in Sydney Harbor, is daringly composed of a series of concrete paraboloid shells. Few modern structures since the Eiffel Tower have captured popular imagination to the extent of the Sydney Opera House, which has become the symbol of its city, indeed of the Australian continent.

Louis Kahn was nearly fifty when he received his first major commission—the Art Gallery for Yale University in New Haven, completed in 1954. In a crowded, rather chaotic urban setting Kahn's building is a grace note of order, purity, and calm. The simple vigor of the forms is

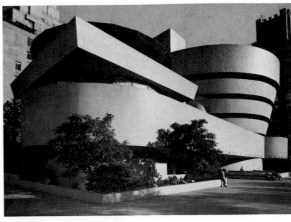

1208

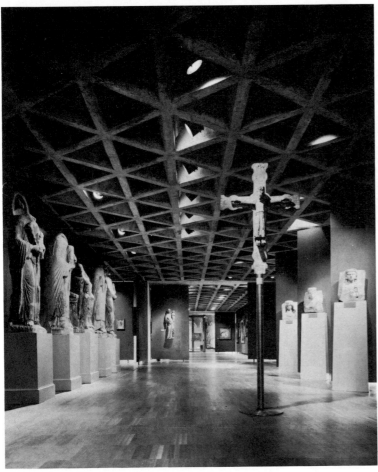

1207

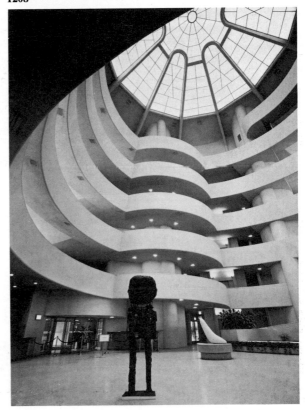

1209

complemented by a straightforward treatment of materials, such as in the impressive tetrahedral concrete space frame of the gallery ceilings.

In more than a simple chronological sense, Frank Lloyd Wright's Guggenheim Museum, projected as early as 1943 but not completed until shortly after his death in 1959, is the capstone of his brilliant career and the culmination of his architectural philosophy. Facing Central Park on New York's Fifth Avenue, the Guggenheim (the only Wright design ever executed in the nation's largest city) has also proved to be a very controversial building. Critics have assailed its hermetic form as arrogantly antiurban (and, indeed, Wright's aversion to cities in general was well known). There were, in addition, more basic conflicts with the city: construction details had to be modified repeatedly to conform with strict local codes. Like the Sydney Opera House, the Guggenheim's idiosyncratic appearance has given rise to many derisive metaphors—a UFO, a parking garage, a skateboarder's dream. Museum curators complain that the curving, inclined ramp of the galleries and the outward-canted walls make conventional displaying and viewing of pictures difficult. Yet for all its real and imagined problems, the Guggenheim remains an undisputed masterpiece of architectural art. The dynamism of the interior is palpable, as one perceives the seamless unity and snapping vigor of the curves, the subtle brilliance of the light, and the continuous, constantly varying views of works of art and fellow spectators. "My Pantheon," Wright called the Guggenheim. The association is apt, for one's experience of this shrine to abstract modern art is charged with a sense of mystery, wonder, and excitement.

1203 Edward Durell Stone. U.S. Pavilion, World's Fair, Brussels. 1958 **1204** Robert H. Matthew. Royal Festival Hall, London. 1951 **1205–1206** Jørn Utzon. Opera House, Sydney. 1956–72 **1207** Louis Kahn. Art Gallery, Yale University, New Haven. 1952–54 **1208–1209** Frank Lloyd Wright. The Solomon R. Guggenheim Museum, New York. 1943–59

Office and Administration Buildings

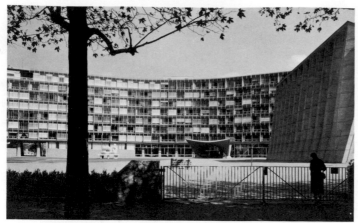

1210

1212

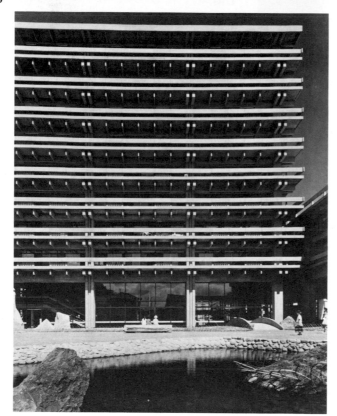

1211

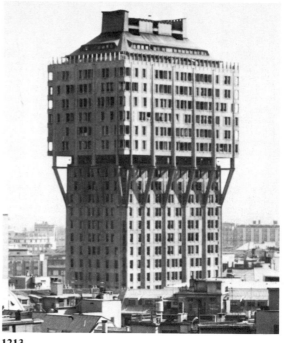

1213

As with the U.N. Headquarters in New York City, a panel of internationally renowned architects, among them Le Corbusier and Gropius, consulted on the UNESCO Headquarters in Paris, though design and engineering credit belongs to Marcel Breuer, Pier Luigi Nervi, and Bernard Zehrfuss. The Y-shaped UNESCO building, on slanting stilts and rather fussily over-detailed with *brises-soleils* (sun breaks), depends heavily on the work of Le Corbusier in the 1930s and 1940s. The separate Conference Hall is perhaps more successful, a stark and dramatic essay in the technology of poured concrete.

The so-called second Corbusian style of the 1930s onward is also the clear inspiration for Kenzo Tange's Administration Building for the Kagawa Prefecture in Takamatsu, Japan. Tange was in the vanguard of the extraordinary renascence of Japanese architecture after the devastation of the war. His prefecture is a respectful yet self-possessed handling of the Corbusian idiom.

War-torn Italy also witnessed an uncommon vigor in its architectural scene during the 1950s, and the group of architects known as Studio Architetti BBPR (Gianluigi Banfi, Lodovico Belgioioso, Enrico Peressuti, Ernesto Rogers) was in great part responsible for this. Their Torre Velasca, a massive steel and con-

crete office tower in Milan, is one of the first true skyscrapers on the Continent. It was initially criticized for its unwieldy scale and its "retrogressive" allusions to Italian medieval towers. Today, however, there is renewed sympathy for historicism in architectural imagery.

At the beginning of the decade Alvar Aalto produced one of his finest buildings—a civic center for the small town of Säynätsalo, Finland. The decisive angularity of the building's outlines is muted by the warm reddish-brown of the bricks and the craftsmanlike handling of details, an Aalto hallmark. In the irregular, seemingly casual plan of the ensemble, Aalto provided ex-

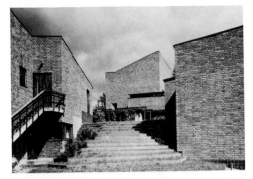

1214

1215

1216

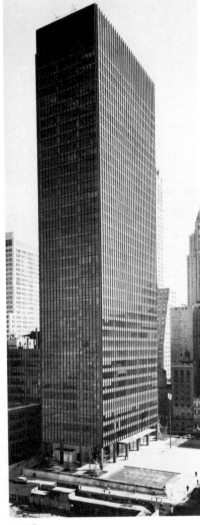

1217

terior spaces of engaging variety.

Eero Saarinen's Technical Center for General Motors is colossal in scale yet exhibits a precise, machined elegance. This gleaming complex of low-lying steel and glass buildings, martially arranged around a vast, perfectly rectangular lake, is, indeed, the perfect reflection of the confidence and awesome power of this corporate leviathan.

In the wave of business expansion that followed the war, a stretch of Park Avenue in midtown Manhattan became the testing ground for what was to prove the archetypal symbol of twentieth-century corporate capitalism—the glass and steel skyscraper with plaza. Here, within a few years of each other, were erected two of the earliest buildings of this type—Lever House (1951–53) and, diagonally across the street, the Seagram Building (1957–58). The Seagram tower is the more successful of the two, due in no small part to a luxurious budget. But its reputation as a flawless paradigm is primarily due to the fastidiousness and sophistication which Mies van der Rohe brought to its design. He chose to pull the building well back from the bustling street, relinquishing more than half the site for an ample, austere plaza. The space sets off the mass, giving it greater visibility and a commanding presence. The tower of steel and glass rises in a swift, uninterrupted ascent. This pronounced verticality is achieved by the extrusion between the windows of custom-designed I-beams, fabricated, remarkably, in bronze. The mellow, mutable colors of the bronze combine with the gray-amber of the glass to produce a deeply resonant richness.

1210 Marcel Breuer, Pier Luigi Nervi, and Bernard Zehrfuss. UNESCO Building, Paris. 1953–58 **1211–1212** Kenzo Tange. Administration Building, Kagawa Prefecture, Takamatsu, Japan. 1955–58 **1213** Studio Architetti BBPR. Torre Velasca, Milan. 1954–58 **1214–1215** Alvar Aalto. Town Hall, Säynätsalo, Finland. 1950–53 **1216** Eero Saarinen. General Motors Technical Center, Warren, Mich. 1945–57 **1217** Ludwig Mies van der Rohe and Philip Johnson. Seagram Building, New York. 1957–58

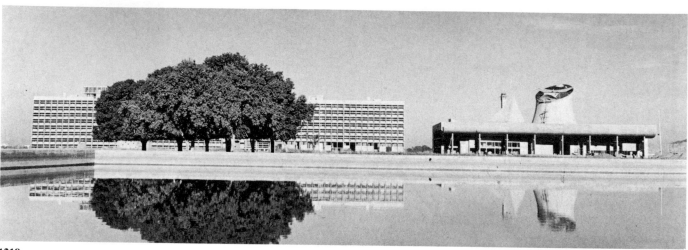

1218

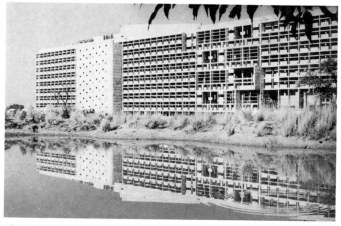

1219

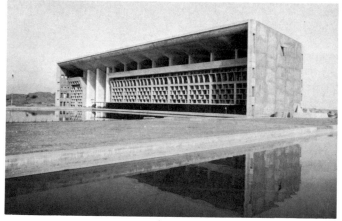

1220

In the postwar decades intense attention was focused on problems of urbanism, a preoccupation occasioned not only by the necessity to rebuild war-shattered cities, but also by an enormous increase in population numbers and mobility. It is significant that the keenest enthusiasm in city-planning circles was generated not by the actions of major world powers but by the construction of new capital cities in two economically struggling countries.

To build the provincial capital of Chandigarh on a vast, sun-baked plain stretching out from the foothills of the Himalayas, in the Indian state of Punjab, the government appointed a team of architects with Le Corbusier at its head and including his cousin, Pierre Jeanneret, and the British architects Maxwell Fry and Jane Drew. Le Corbusier was responsible for some reordering of the existing master plan and the design of the buildings at the city's core. The entire complex was to house 150,000 inhabitants and to permit growth for 500,000. A cross-axial arrangement of major boulevards, with commercial and cultural buildings clustering at the center, governs the classically proportioned plan. Terminating the long axis toward the mountains is the government complex, composed of plazas, monuments, the Secretariat, the High Court, and the Assembly buildings.

The visual impact of this monumental grouping is stunning: vigorous concrete buildings played off against the distant mountains and the close-in, man-made landscape of excavated earth mounds and reflecting pools.

The long, rough concrete block of the Secretariat acts as a visual stop at the northernmost edge of the complex. The High Court Building, on an axis with the Assembly, is a powerful rectangular box, screened at its open side by a *brise-soleil* and a massive polychromed portico.

For Chandigarh, Le Corbusier provided what surely are some of the most cogent expressions in architecture of national power and achievement. Nevertheless, his structures

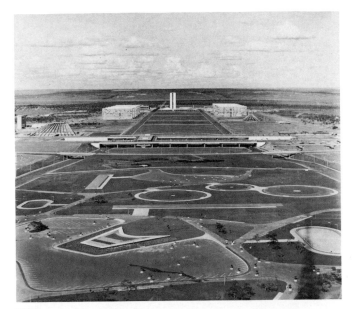

1221

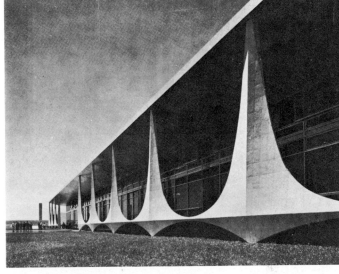

1223

1222

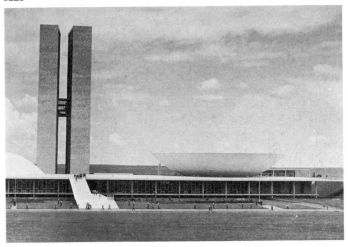

1224

have been severely, and correctly, criticized for their functional shortcomings and their lack of regard for Indian customs and formal precedent—criticisms that apply equally well to the city plan as a whole.

At the same time, an ambitious approximation of the Corbusian urban ideal for the Ville Radieuse (page 237) suddenly appeared in the desolate heartland of Brazil. Brazilians had dreamed of an inland capital as early as the eighteenth century. With a swiftness that astounded the world, that dream became reality under the impetus of President Juscelino Kubitschek, who appointed Oscar Niemeyer chief designer.

The plan of Brasília is also cross axial. A superhighway, sweeping across the flat, arid landscape, composes one axis, and is lined with large apartment and commercial buildings. It is bifurcated by a straight, broad axis, along which are ranged the principal government and cultural buildings. The termination of this vast avenue is the monumental core of Brasília—the Plaza of the Three Powers and the Presidential Palace.

Niemeyer's design for the Presidential Palace is essentially a rectangular glass box with a generously shading concrete slab roof carried on a series of diamond-shaped supports. The sharp-edged, attenuated elegance of these supports, common to Niemeyer's work in general, es-

pecially characterizes his many designs for Brasília.

The Plaza of the Three Powers is the political and architectural solar plexus of Brasília. At one point of the triangular plaza is the Supreme Court Building, at another the Executive Building, and at the apex is the striking Congress Building, containing the concrete dome of the Senate chambers and its complement, the inverted half-sphere of the Assembly. A tall double tower behind the podium houses legislative offices.

1218–1220 Le Corbusier et al. Chandigarh, India. 1953–60 **1219** Secretariat **1220** High Court **1221–1224** Oscar Niemeyer. Brasília. 1957–60 **1222** Regulatory plan by Lúcio Costa **1223** Presidential Palace **1224** Congress Building

1225

1227

1226

1228

In the aftermath of World War Two, no other basic human need was more urgently felt than the need for shelter. The number of experiments in new housing types begun in the 1950s is staggering; they range from elegant suburban settlements to minimal urban apartments, from the smallest scale to the largest, and from the intelligent effort to the abysmal failure.

No failure is more notorious than the Pruitt-Igoe public housing development in St. Louis, Missouri. Designed by Minoru Yamasaki (plate 1418), Pruitt-Igoe was one of hundreds of appalling high-rise apartment complexes funded by public moneys for impoverished inner-city minorities. Intended to assuage the urban crisis, such shoddily built and minimally maintained buildings only exacerbated the problem. Crime and vandalism thrived in these instant ghettos. In the case of Pruitt-Igoe, city officials were forced to concede defeat, and parts of the project were dynamited in 1970.

Middle-class flight from decaying cities, a social phenomenon of long standing in the United States, reached epidemic proportions during the decade. Though there were countless similar suburban developments throughout the country, the archetype was undoubtedly Levittown, Long Island, which was launched soon after the war's end. The con-

cept proved so successful that the Levitts quickly extended their developments to other areas of the country on a vastly expanded scale, as in Pennsylvania. The name Levittown, in fact, has become almost a generic term for the sprawling tracts of nearly identical single-family detached houses that sprang up in every major U.S. metropolitan area.

In Europe, abandonment of older cities by the middle class did not take place on the same scale as it did in the United States. In addition, the European suburban housing did not, on the whole, assume the American form of the large tract of detached houses. Rather, architects and developers focused their atten-

1229

1230

1231

tion on more unified and original housing concepts.

Halen Siedlung, outside Berne, Switzerland, remains one of the most significant attempts of the 1950s to forge new housing types. Designed by the Atelier 5 architects, Halen Siedlung is a compact, meticulously planned whole. The basic unit is a tall, narrow apartment, disposed on several levels, according to the lay of the land. On each level, living quarters are extended outdoors—to a sunporch, a balcony, an inviting grass-covered rooftop. Automobiles are hidden under the terraces, and public space is given over to a village square, a pedestrian street, and recreational areas.

The fertile design and planning imagination of Le Corbusier is, inevitably, behind every major European housing scheme of the 1950s. This is true of Atelier 5's work in Switzerland, as well as of much of the highly publicized Roehampton housing estate in London. The Alton West section of Roehampton was a serious attempt to realize the ideals of Le Corbusier's Ville Radieuse. Large slabs of small apartments, built of rough concrete (both poured and precast) and raised from the ground on thick columns, are arranged throughout a gently rolling, heavily planted landscape.

1225 Minoru Yamasaki. Pruitt–Igoe Housing, St. Louis. 1952–55 **1226–1227** William and Alfred Levitt (builders). Tract housing **1226** Levittown, N.Y. c. 1950 **1227** Levittown, Pa. 1952–54 **1228–1229** Atelier 5 (Erwin Fritz, Samuel Gerber, Rolf Hesterberg, Hans Hostettler, Niklaus Morgenthaler, Alfredo Pini, Fritz Thormann). Halen Siedlung. 1959–61 **1230–1231** London County Council Architects' Department (Housing Division). Alton West Housing, Roehampton (London). 1952–59

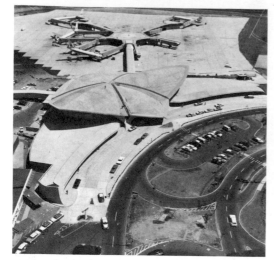

1232

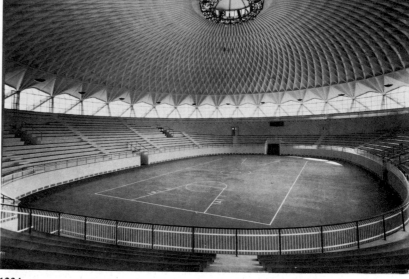

1234

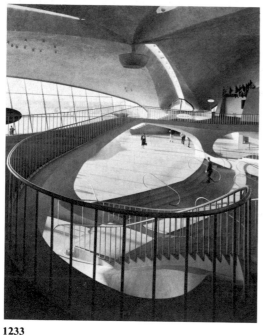

1233

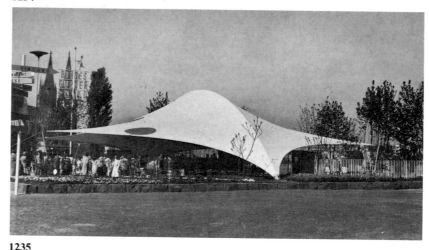

1235

Since the Industrial Revolution, the lines separating architecture and engineering have progressively weakened. In critical literature, structures are no longer dismissed as "merely" engineering but rather are evaluated for the contribution they make to the art of building. The process of melding the two professions of architect and engineer seemed to quicken during the postwar decade.

More perhaps than any other structural material, the ancient medium of concrete became a potent component of the architect's design imagination. In the hands of the brilliant Eero Saarinen, a terminal for Trans World Airlines at New York (now Kennedy) International

Airport became a spectacular tour de force in concrete. Swooping, pulsing curves animate this unabashedly Expressionistic building, expectantly poised for flight.

In the 1950s, the Italian engineer Pier Luigi Nervi continued the daring experiments in reinforced concrete spans he had begun in the period between the wars (plate 837). Of the two sports halls he designed for the 1960 Olympiad in Rome, the smaller *palazzetto* is the more perfect jewel. The underside of the hemispherical concrete roof, a taut web of precast units, seems to scintillate with a muscular, nervous energy.

Combining receptivity to the potentials of new materials with an

agile theoretical imagination, the innovative German architect-engineer Frei Otto has produced a breathtaking series of totally new architectural forms, such as his entrance arch to the Federal Garden Exhibition in Cologne of 1957, one of his earliest works. Designed, like most of Frei Otto's work, as a temporary structure to be erected and dismounted with relative ease, the Cologne arch was a coated fabric spun from glass filaments, stretched over a single thin steel arch, and stabilized at only four points.

The epitome of the polymorph—architect-engineer-inventor-philosopher-genius—is Buckminster Fuller. His great contribution to modern ar-

1236

1238

1237

1239

chitecture and technology, the geodesic dome, was successfully tested in Baton Rouge, Louisiana. The largest such dome yet built (three hundred eighty-four feet in diameter), housing a repair facility for the Union Tank Car Company, is a welded honeycomb of bright yellow hexagons supported by a blue extruded pipe skeleton.

Air-supported and inflatable structures, dreamed of for decades, were designed and built in the 1950s. Victor Lundy and Walter Bird's portable theater for the U.S. Atomic Energy Commission was a particularly successful and sophisticated example of this revolutionary technology. The strange biomorphic

structure contained an exhibition of the potential peacetime uses of atomic energy.

As cities continued to sprawl, their inhabitants relied all the more heavily on automobiles. During the 1950s, highway engineers, especially in America, made spectacular contributions to the built environment, with seemingly endless ribbons of broad, high-speed freeways slashing through urban and suburban landscapes, overlaid at their junctures in incredibly complex "spaghetti bowl" interchanges, such as this one in Fort Worth, Texas. The 1950s were not yet fully aware of all the negative results, including pollution, noise, and traffic jams, engendered by the

great superhighways. Modern architecture, with its claim of rationality, was seen as the harbinger of social salvation. The collaboration of the engineer's craft with the architect's art was welcomed as a promise to shape a better environment.

1232–1233 Eero Saarinen and Associates (William Gardner, principal). Trans World Airlines Terminal, Kennedy Airport, New York. 1958–62 **1234** Pier Luigi Nervi and Annibale Vitellozzi. Palazzetto dello Sport, Rome. 1956–57 **1235–1236** Frei Otto. Entrance Arch, Federal Garden Exhibition, Cologne. 1957 **1237** R. Buckminster Fuller. Union Tank Car Company Dome, Baton Rouge, La. 1958–59 **1238** Victor Lundy and Walter Bird. U. S. Atomic Energy Commission Portable Theater. 1960 **1239** Texas Highway Department. Freeway interchange, Fort Worth. 1958

Eight: The 1960s

The economic growth of Western Europe during the 1960s seemed almost miraculous. The Common Market relaxed trade restrictions and tariffs among its members, and the economy flourished. Almost all of Africa gained independence. Nevertheless, the new countries depended largely on foreign imports not only for capital investment but also for the necessities of life.

In the Mideast a third war between Israel and its Arab neighbors broke out in 1967 and was won by the Israeli army and air force in a matter of six days, creating a new dilemma in a turbulent region. In Iran a dictator, Shah Mohammed Reza Pahlevi, used terror to modernize and westernize the country.

In Latin America, Fidel Castro's apparently successful pursuit of revolution gave impetus to economic reform and theoretical debate on the left, while military dictatorships triumphed in Brazil, Argentina, Bolivia, and Peru. The powerful "neighbor to the north" officially sponsored the Alliance for Progress, while its CIA seemed to be aiding the right-wing juntas.

In the Soviet Union the leaders were alarmed primarily by the danger—real or imagined—they saw from China and its huge population. There Chairman Mao Tse-tung, adulated as a demigod, expressed great disdain for the "reactionary" policies of the Soviet leaders. In 1965 he announced the Great Proletarian Cultural Revolution against all established power, including the Communist bureaucracy and the country's intellectuals. The Red Guards, dominated by the young, declared war on the old culture of China, and the population was terrorized in the name of permanent and continuous revolution.

The 1960s was certainly a decade of American hegemony, and it was then that many of the problems of this tumultuous century reached a crisis.

The decade began with the election of John F. Kennedy to the presidency. The watchword of the nation was "the New Frontier." There was a sense of dedication after the lethargy of the 1950s, and ten thousand people volunteered for the Peace Corps in its first three months of existence. Intellectuals and artists seemed welcome at the White House. But 1961 also saw the disastrous invasion of Cuba at the Bay of Pigs, where CIA-trained Cuban exiles were easily defeated by Castro's army. A year later the Russians shipped medium-range nuclear missiles to Cuba, and the world seemed on the verge of nuclear war. Then in November 1963 John F. Kennedy was assassinated.

His successor, Lyndon B. Johnson, spoke bravely of "the Great Society" and promised to wage a "war on poverty." But instead he sent American troops abroad. U.S. soldiers were sent to the Dominican Republic to keep a left-wing government from gaining power. Three years later, when the Communist Party of Czechoslovakia, under the courageous leadership of Alexander Dubček, opted for political reform and democratic freedom, the Soviet army was sent to invade its ally and neighbor.

It was the decade in which the war in Indochina evolved into a major war. In 1964 Johnson alleged that North Vietnamese torpedo craft had attacked two American destroyers in the Gulf of Tonkin, and Congress immediately passed a resolution authorizing the president to take all manner of offensive action against the enemy. It was only six years and millions of tons of bombs later that it was proved that there had been no attack as charged, and the Gulf of Tonkin Resolution was repealed.

The war escalated, and in 1968 Johnson, aware of the rising opposition to the war, decided not to stand for reelection. Hubert Humphrey, his vice-president and a loyal supporter of the war, was nominated to carry the Democratic Party standard. But the Republican candidate, Richard Milhous Nixon, was elected by a small popular margin.

The 1960s was the decade of black emergence in America. It occurred by means of black nonviolence and black militancy, by legislation and court decisions. At the beginning of the decade Negroes were generally confined to segregated ghettos and schools. There were poll taxes and trumped-up literacy tests in the South, and racial discrimination in public facilities was the custom of the land. Then in 1960 black students in North Carolina staged the first lunch-counter sit-ins. This was followed by the Freedom Rides and voter-registration drives and peaceful assaults against segregation under the leadership of Martin Luther King. In August of 1963 more than two hundred thousand people marched on Washington to demonstrate for their civil rights and to hear the Reverend King speak of his dream of brotherhood and peace. Although Congress passed civil rights legislation beginning in 1964, several leaders in the cause, such as Medgar Evers, had been assassinated, as was the militant Malcolm X. Martin Luther King, the great spokesman of nonviolent action, was shot in April 1968. There were riots and protest fires in more than a hundred U.S. cities. The militant Black Panthers began to protect the rights of blacks in the inner cities, and black leaders began to speak of their African heritage and of Black Power.

Feminism also experienced a rebirth in the United

States. The National Organization for Women was founded in 1966, and, guided by dedicated leaders such as Betty Friedan and Gloria Steinem, women began to assert their rights.

A rebellious youth also made itself heard. In 1960 Berkeley students went to the San Francisco City Hall to protest against the actions of the House Un-American Activities Committee and were beaten and jailed by the police. The Free Speech Movement in Berkeley followed. Soon everywhere young people held peace demonstrations and burned their draft cards in public. In 1968 they went en masse to Chicago to protest the Democrats' nomination of Hubert Humphrey for president. They were beaten by Mayor Daley's police in full view of the national television audience.

The youth culture of the 1960s was also the world of the motorcycle gangs and surfboarding. It was the time of the "hippies" and "flower children" with an epicenter at the corner of Haight and Ashbury streets in San Francisco. Young people rejected the Protestant work ethic and the acquisitive society. They observed that the land, air, and water were being polluted. They took drugs and "grooved" on each other's "good vibes." Some became part of a subculture in which a standard response of the young to boredom and insecurity was to "drop acid." Many went to the Fillmore in San Francisco and the Electric Circus in New York to listen to the loud, hard beat of rock music. They came to watch the dazzling kaleidoscopic shows of colored lights, to experience a psychedelic world. The total synesthetic sensory experience that artists had striven for ever since Richard Wagner spoke of the *Gesamtkunstwerk* had here become a reality. It all came to an end at the conclusion of the decade with the joyous experience of the "super love-in," the great youth "happening" for three hundred thousand at Woodstock, which was followed by bloody violence, the "bad trip" at Altamont.

In 1961 Alan Shepard was the first American to fly in space. Soon astronauts orbited the earth and linked up with other spacecraft. In July 1969 Neil A. Armstrong and Edwin E. Aldrin landed on the barren surface of the moon. These new heroes, farther away than men had ever conceived of being able to travel, were kicking up moondust while millions on the earth watched them on their home television screens. The wildest fantasies of science fiction had come true as we saw them leaving the plaque reading "WE CAME IN PEACE FOR ALL MANKIND" on the moon.

This was also the decade in which the computer promised to facilitate virtually all forms of human endeavor from the research of astronomers to the selection of mates for dating. This was the time in which "information retrieval" threatened to replace the reading of books. Newspapers continued to shut down during the 1960s: the printed word was in danger of being replaced by the printed circuit.

The 1960s was the decade in which the arts became truly popular. More people had more time for art, and they had more money. Distinctions between art and entertainment (some called it "the gap between art and life") were largely eradicated. By middecade a group of four Liverpool singers was captivating the world. Not only did the Beatles provide popular entertainment for the masses, but their unique rock tunes and electronic technique had to be taken seriously, and they themselves had to be recognized as accomplished musicians.

The literature of the 1960s shares with the best films of the period, such as *Bonnie and Clyde* and *Easy Rider*, the unraveling of moral platitudes used as cover-ups of corruption. They all seem to deal with the tension arising from feelings of helplessness and frustration. Many point to the violence of the time.

In the visual arts silver-haired Andy Warhol—promoter of the Brillo box, the Campbell's soup can, and the instant photographic silk-screened portrait, producer of voyeuristic movies and superstars—became a celebrity and culture hero. Art was *talked about* in the 1960s. It became an industry. Full-fledged art movements—Pop, Op, Hard Edge, Color Field, Minimal—seemed to follow one another with breathless rapidity, and there were patrons for all of them. Strangely, during this era of radical political movements, the visual arts remained largely insulated and indifferent. The Pop Artists seemed to celebrate the middle-class values of consumerism. For the Color Field painters and the Minimalists passion and emotional expression were as taboo as political statements. While this concept presents an interesting dialectic position, their handsome, immaculate work seemed well suited for the corporate boardrooms in the skyscrapers lining Park or Sixth avenues or similar boulevards from Düsseldorf to São Paulo.

These structures themselves, these tall slender slabs with skins of glass and bones of steel or concrete, were not the great solution for the urban environment envisaged by the pioneers of modern architecture. Modern technology, the "machine look," was not commodious or delightful. Many of the assumptions and precepts of the modern movement had indeed begun to be questioned.

	Political Events	**The Humanities and Sciences**	**Architecture, Painting, Sculpture**
1960	Soviets shoot down Francis Gary Powers in U.S. spy plane Cuba begins confiscation of U.S.–owned property Belgium grants freedom to the Congo (now Zaire)	Willard F. Libbey wins Nobel prize in chemistry for work on dating by use of carbon 14 First working model of lasers Harold Pinter, *The Caretaker* Eugène Ionesco, *Rhinoceros* Robert Duncan, *The Opening of the Field* Federico Fellini, *La Dolce Vita* François Truffaut, *Shoot the Piano Player*	New York: Jean Tinguely's *Homage to New York* presented at The Museum of Modern Art Brazil: Brasília is opened as capital Milan: French critic Pierre Restany issues the first manifesto of New Realism
1961	John F. Kennedy becomes U.S. president Unsuccessful invasion of Cuba at the Bay of Pigs Beginning of Freedom Rides in the U.S. South Berlin Wall erected Dag Hammarskjöld awarded the Nobel Peace Prize	Russians orbit the first man in space Joseph Heller, *Catch-22* Yevgeny Yevtushenko, *Babi Yar* Dmitri Shostakovich, Twelfth Symphony Akira Kurosawa, *Yojimbo* Alain Resnais, *Last Year at Marienbad*	Düsseldorf: Manifesto by George Maciunas begins Fluxus New York: Exhibition of "The Art of Assemblage" at The Museum of Modern Art New York: Exhibition of "Abstract Expressionists and Imagists" at the Guggenheim Museum
1962	Cuban missile crisis Algeria achieves independence from France Opening of Vatican Council II presided over by Pope John XXIII U.S. Supreme Court bans mandatory prayer in public schools Adolf Eichmann executed in Israel	U.S. astronaut John Glenn orbits the earth three times James Baldwin, *Another Country* Aleksandr Solzhenitsyn, *One Day in the Life of Ivan Denisovich* Ken Kesey, *One Flew over the Cuckoo's Nest* Edward Albee, *Who's Afraid of Virginia Woolf?* Rachel Carson, *Silent Spring* François Truffaut, *Jules and Jim*	New York: Exhibition of "New Realists" at the Sidney Janis Gallery presents Pop Art *Time, Life, Newsweek* covers feature Pop Art New York: Pop Art symposium at The Museum of Modern Art Spoleto: David Smith exhibits his *Voltri* series at the Festival of Two Worlds
1963	Pope John XXIII dies, Paul VI succeeds Nuclear-test–ban treaty signed Mammoth civil-rights rally in Washington, D.C. Severe race riots in Birmingham, Alabama Fall of Ngo Dinh Diem government in South Vietnam Assassination of U.S. president John F. Kennedy; Lyndon B. Johnson succeeds	Betty Friedan, *The Feminine Mystique* Jessica Mitford, *The American Way of Death* James Baldwin, *The Fire Next Time* Kurt Vonnegut, *Cat's Cradle* Rolf Hochhuth, *The Deputy* Beatles' first record success: *I Want to Hold Your Hand* Hannah Arendt, *Eichmann in Jerusalem*	New York: Exhibition of "Toward a New Abstraction" at the Jewish Museum Wuppertal: First exhibition of video art, by Nam June Paik
1964	Leonid Brezhnev replaces Nikita Khrushchev as U.S.S.R. leader People's Republic of China explodes an atomic bomb Free Speech movement starts in Berkeley, California U.S. Congress passes Civil Rights Bill Martin Luther King awarded the Nobel Peace Prize	Saul Bellow, *Herzog* Herbert Marcuse, *One-Dimensional Man* Marshall McLuhan, *Understanding Media: The Extensions of Man* Peter Weiss, *Marat/Sade* Hiroshi Teshigahara, *Woman in the Dunes* Stanley Kubrick, *Dr. Strangelove*	Venice Biennale: Robert Rauschenberg is awarded first prize Saint-Paul-de-Vence: Opening of the Fondation Maeght museum Los Angeles: Exhibition of "Post-Painterly Abstraction" at the Los Angeles County Museum of Art

	Political Events	The Humanities and Sciences	Architecture, Painting, Sculpture
1965	Indian-Pakistani war Large-scale U.S. bombing of North Vietnam Voter registration demonstrations in Alabama Assassination of Malcolm X Medicare becomes U.S. law, offering health care to the aged Beginning of the Cultural Revolution in China	Norman Mailer, *An American Dream* Bob Dylan, *Like a Rolling Stone, Electric Album, Highway 61* Wole Soyinka, *The Interpreters* U.S.S.R. astronaut is the first man to walk in space Ján Kádar, *The Shop on Main Street*	Washington, D.C.: Establishment of the National Foundation for the Arts and Humanities New York: Exhibition of "The Responsive Eye" at The Museum of Modern Art New York: Exhibition of "Shape and Structure" at the Tibor de Nagy Gallery
1966	Black Panthers organized in Oakland, California Indira Gandhi becomes Indian prime minister Founding of the National Organization for Women (NOW) in U.S.	Mao Tse-tung, *Quotations of Chairman Mao* Konrad Lorenz, *On Aggression* Alain Resnais, *La Guerre Est Finie* *Jefferson Airplane Takes Off* becomes a recording success	New York: Exhibition of "Primary Structures" at the Jewish Museum New York: Exhibition of "Systemic Painting" at the Guggenheim Museum Berkeley, California: Exhibition of "Directions in Kinetic Sculpture" at the University Art Museum U.S. government receives Hirshhorn Collection
1967	Che Guevara killed by Bolivian troops Six-Day War between Israel and Arab countries Military coup in Greece Antiwar demonstrations in U.S. Race riots in U.S. cities	First heart transplant operation by Dr. Christiaan Barnard Gabriel García Márquez, *One Hundred Years of Solitude* Arthur Penn, *Bonnie and Clyde* Beatles, *Sgt. Pepper's Lonely Hearts Club Band*	Montreal: Expo '67 includes Moshe Safdie's Habitat
1968	Tet offensive by North Vietnamese; Mylai massacre Prague Spring ends with Russian invasion of Czechoslovakia Assassination of Martin Luther King Assassination of Robert F. Kennedy Student rebellions in Europe and U.S.	Noam Chomsky, *Language and Mind* Norman Mailer, *The Armies of the Night* Aleksandr Solzhenitsyn, *The Cancer Ward* Eldridge Cleaver, *Soul on Ice* Beatles, *Yellow Submarine* Stanley Kubrick, *2001: A Space Odyssey*	Kassel: Documenta 4; Pop Art predominates
1969	Richard M. Nixon becomes U.S. president Riots in Northern Ireland Willy Brandt elected chancellor of Germany Native Americans seize Alcatraz Island Golda Meir becomes Israeli prime minister	U.S. spacecraft *Apollo II* lands successfully on the moon Philip Roth, *Portnoy's Complaint* Dennis Hopper, *Easy Rider* Woodstock and Altamont music festivals Costa-Gavras, *Z*	New York: First completely conceptual exhibition at the Seth Siegelaub gallery New York: Establishment of the Art Workers' Coalition London: Publication of *Art-Language* Berne: Exhibition of "When Attitudes Become Form" at the Kunsthalle

Contemplation

1240

1241

Mark Rothko's painting *Number 207* (*Red over Dark Blue on Dark Grey*) was done at the time of his important retrospective at New York's Museum of Modern Art, where the unique quality of each of the fifty-four paintings shown became apparent. His canvases had grown wider and more expansive since 1950 (plate 1135). The image remains frontal and symmetrical, the colors dark and somber, yet the large vibrating red rectangle with its fuzzy outlines looms brightly, as it seems not only to hover above the dark blue rectangle but actually to float in from the canvas itself, entering our space. The painting's opaque quality has absorbed light. A picture such as this is a still and self-sufficient object of contemplation. Rothko soon afterward painted a series of dark, almost monochrome paintings for the ecumenical Rothko Chapel in Houston.

Renunciation and reduction, which were evident in Yves Klein's blue monochromes (plate 1146) and in Ad Reinhardt's earlier work (plate 1145), were carried to the ultimate in Reinhardt's work of the sixties. Between 1953 and the time of his death in 1967 he painted a long series of black paintings with cruciform images which are not easy to perceive. Beginning in 1960, these paintings were all square in format. To see them takes a great deal of time, effort, quiet meditation, and indeed, a deep search and commitment.

From 1958 until 1966 Barnett Newman worked on a series of paintings of the Stations of the Cross. These are not narrative illustrations of Christ's Passion. The artist explained that they were meant "to stand witness to the story of each man's agony; the agony that is single, constant, unrelenting, willed —world without end." Barnett Newman, a Jew, universalized the story of the Gospel in his fourteen stark statements in black and white, painted on raw canvas. The *Twelfth Station* (The Death of Christ) consists mostly of a wide black area, interrupted by a white "zip." Then a second sharp white zip of raw canvas

1242

1243

1244

comes through on the right. It seems like a flash of light. Finally, a thin, smudged black outline vibrates into a field of white.

Clyfford Still continued to paint his agitated dramatic pictures. Unlike the surfaces in the paintings of Rothko, Reinhardt, and Newman, Still's surfaces are tactile; they are heavy and roughly textured. He moved from a dark, earthlike palette (plate 1139) to light canvases with large expanses of white. The field in *PH-261* has an open, atmospheric quality. Slightly off center, the raw flamelike red patch pulsates between the black and white blotches. Although totally abstract, the painting evokes the memory of organic shapes

and leads to a meditation on the patterns of nature.

Hans Hofmann's rectangles seem to take on a spiritual quality as they hang suspended over the lightly brushed surface in *Memoria in Aeternum*. This painting, done when Hofmann was in his eighties, embodies his reflection on the deaths of five younger friends, the American painters Arthur B. Carles, Arshile Gorky, Bradley Walker Tomlin, Jackson Pollock, and Franz Kline. Hofmann placed one bright yellow and one red rectangle on a brown surface. The rectangles appear to recede and advance against the darker ground, a tension which Hofmann described as "push-pull." This implied motion,

combining two- and three-dimensional rhythms, contained "the secret of Michelangelo's monumentality and Rembrandt's universality"; it is also the underlying dynamic force of nature itself. The artist, Hans Hofmann felt, is the individual who has the gift to transform the spiritual in nature into the reality of the painting.

1240 Mark Rothko. *Number 207 (Red over Dark Blue on Dark Grey)*. 1961. Oil on canvas, 92 $^3/_4$ × 81 $^1/_8$″ **1241** Ad Reinhardt. *Abstract Painting*. 1960–61. Oil on canvas, 60 × 60″ **1242** Barnett Newman. *Stations of the Cross: Twelfth Station*. 1965. Acrylic polymer on canvas, 78 × 60″ **1243** Clyfford Still. *Untitled (PH-261)*. 1962. Oil on canvas, 113 × 152″ **1244** Hans Hofmann. *Memoria in Aeternum*. 1962. Oil on canvas, 84 × 72 $^1/_8$″

Art about Art

1245

1246

Compared to the level of gravity in the art of the five American painters discussed in the last section, the often jocular comments by artists on the art of the past may appear trivial. Art has always carried on a dialogue with art, but in recent years this has increasingly become the actual subject matter of many artists. As reproductions of masterpieces became little more than popular consumer products, Marcel Duchamp—always delightfully irreverent, but also the twentieth-century artist who shows the greatest affinity with the Florentine master—took a cheap reproduction of Leonardo da Vinci's *Mona Lisa* and added a mustache and a little beard, as well as the letters *L.H.O.O.Q.*

Duchamp was very fond of puns, both visual and verbal. These letters when read out loud sounded like: "Elle a chaud au cul" ("She has a hot arse"). Forty-six years later he made fun of his own earlier piece, distributing a reproduction of the *Mona Lisa* on a playing card to guests at the opening of one of his rare exhibitions. The letters are still under the smiling lady, but now she is no longer equipped with her mustache and beard; therefore, it is *L.H.O.O.Q./Shaved.*

In *The Greatest Homosexual* Larry Rivers selects another celebrated image, Jacques-Louis David's *Napoleon in His Study* (1812), a picture of a self-conscious emperor striking a rather ludicrous pose. Rivers re-

places David's centered likeness with not one, but numerous portraits of the narcissistic ruler. At the same time he burlesques the Action Painters' stress on process by showing us several unfinished successive likenesses without erasure. Pop elements enter with the inclusion of transparent plastic sections and David's name in raised stenciled letters.

The process of painting is the subject matter in Roy Lichtenstein's *Big Painting No. 6*. This painting refers to the popular conception of Abstract Expressionist works: their large size, broad brushstrokes, drips. But Lichtenstein's painting is all neat and clean. Since the simplification refers to printed color reproductions, Lich-

1247

1248

tenstein paints in the benday dots of the mechanical process. The affective content of an Action Painting is replaced by a painted image that, paradoxically, resembles an industrial product.

Edouard Manet's original painting of 1863 is hardly recognizable in Alain Jacquet's paraphrase because of the persistence here of the large-grain benday dots. Jacquet also substitutes contemporary portraits of his friends (the man on the right is the critic Pierre Restany) for Manet's characters in his *Déjeuner sur l'Herbe (Luncheon on the Grass)*. Manet's picture, highly controversial in its time for its suggestive subject matter but even more for its

formal characteristics of simplified modeling and resulting flatness, was adapted from Marcantonio Raimondi's engraving after Raphael's *Judgment of Paris*. And Raphael himself had probably studied models from classical antiquity for his motifs.

Clearly, art continues to propagate and rephrase art. References and meaning change with the context, and current art about art seems to comment primarily on the easy availability of the art of the past as a consumer product. Finally, these pictures were done at a time when a number of younger painters, collectors, museum curators, and critics wanted to demystify "the work of

art" and saw little room for the artist as hero and unique image maker.

1245 Marcel Duchamp. *L.H.O.O.Q./ Shaved*. 1965. Playing card pasted on folded note paper, 8 $^1/_4$ × 5 $^1/_2$"
1246 Larry Rivers. *The Greatest Homosexual*. 1964. Oil and collage on canvas, 80 $^1/_8$ × 61" **1247** Roy Lichtenstein. *Big Painting No. 6*. 1965. Oil and Magna on canvas, 91 $^3/_4$ × 129 $^1/_8$" **1248** Alain Jacquet. *Déjeuner sur l'Herbe (Luncheon on the Grass)*. 1964. Oil on canvas, two panels, each 69 $^3/_4$ × 40 $^5/_8$"

Chromatic Abstraction

1249

1250

1251

Color became both form and subject for several painters in the 1960s. Called by different names—Color Field painting or Post-Painterly Abstraction—their works display high-keyed color, open, often airy design, and general lucidity of composition. Sam Francis, whose sense of expanse (plate 1143) anticipated this trend, painted organic shapes that float rhythmically through the white surface in *Why Then Opened I.* Color and forms are organic, sensuous, and joyous. Exploring the canvas's edge, Francis surrounds the central seed with clusters of interacting forms in constant flux, linked by splatters and drips.

"My paintings," Joan Mitchell wrote, "are about a feeling that comes from the outside, from landscape." Living in a house in Vétheuil, near Paris, where Monet once lived and worked, Mitchell painted pictures, such as *Dégel (Thaw)*, that are remembered sensations about natural forces, rendered with intense energy.

Morris Louis, too, opened his design in the early 1960s in a series of works called "unfurleds," such as *Alpha-Pi.* The irregular diagonal bands stained into the fabric of the unprimed canvas seem to conduct energy at different rates, depending on the length and color of the stripe. The enclosed white of the support changes its status from passive backdrop to active agent. Looking at the white center of the long horizontal painting and allowing the eye to travel to the colorful edges, the spectator becomes newly aware of peripheral vision and perceptual field.

Helen Frankenthaler poured pigment onto a large unsized canvas in *Magic Carpet.* The paint was then rubbed into the surface to encourage textural variation. In place of her fragile image of the 1950s (plate 1169), Frankenthaler's work in acrylic is characterized by density of color, though the image here seems to continue beyond the edge. The painting still alludes to conformation of a landscape: the fluid blue advancing over the slightly rough

1253

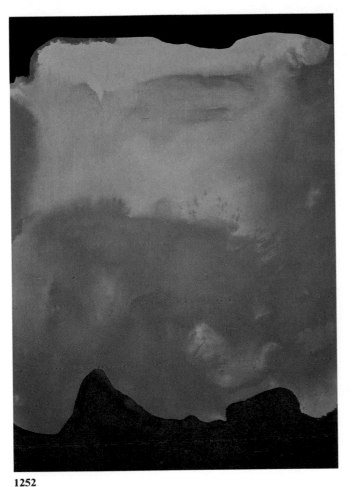

1252

1254

yellow recalls ocean and sand or mountains outlined against the sky.

In contrast to Frankenthaler's interest in color's potential evocativeness, Jules Olitski concentrated primarily on optical interaction of hues. Influenced by her stain technique and, like her, promoted by the influential critic Clement Greenberg, Olitski composed large sprayed paintings. In *Comprehensive Dream* the hues assert the surface flatness of the canvas, but the colors also seem disembodied and the painting has an evanescent, airy quality, like that of perfume sprayed into the air. During the 1960s and early 1970s Olitski was probably written about more frequently in American art magazines than any other artist. He was, in fact, called "best painter" by critics who believed in a simple "mainstream" of cultural evolution in painting, which, they thought, led from Monet to Cubism to Pollock and then to Frankenthaler and Morris Louis, culminating in Olitski. They suggested a development (called "modernist painting") toward increasing emphasis on autonomous color and flatness in painting.

Painting as chroma is also evident in the luminous pictures of Wojciech Fangor, a Polish émigré to New York, whose work is characterized by the inseparability of pigment and surface. In *M48-1968* Fangor applied a thinned blue oil pigment to the canvas which interlocks with the pinkish white. Fangor is concerned with the dynamic interaction of color and illusory space, created by our perception of the color relationships. Although totally abstract, his canvas evokes images from nature such as photochromes of stellar formations.

1249 Sam Francis. *Why Then Opened I.* 1962–63. Acrylic on canvas, 84 × 72″
1250 Joan Mitchell. *Dégel (Thaw).* 1961–62. Oil on canvas, 87 × 78 ³/₄″
1251 Morris Louis. *Alpha-Pi.* 1960. Acrylic on canvas, 102 ¹/₂ × 177″
1252 Helen Frankenthaler. *Magic Carpet.* 1964. Acrylic on canvas, 96 × 68″
1253 Jules Olitski. *Comprehensive Dream.* 1965. Acrylic on canvas, 113 × 93″
1254 Wojciech Fangor. *M48–1968.* Acrylic on canvas, 80 ¹/₄ × 92″

Fragmented Experience

1255

1256

1257

Robert Rauschenberg accepts modern urban life in all its blatancy, and the fragmentary and perplexing aspects of mass culture are reflected in his "combine paintings," as well as in his slightly later silk-screen paintings. In *Tracer* we see a reproduction of Rubens's *Venus before the Mirror*, helicopters, floating cubes, the American eagle, caged birds, a Manhattan street scene. The viewer is energized by the excitement of discovery within this "uncensored continuum."

Jean Dubuffet deals with a ceaseless continuum in his *Hourloupe* series. He abandons his earlier earth colors and limits his palette to reds, blues, whites, and black. In *Virtual* *Virtue* his painted world has no beginning or end, only faces that appear and vanish into a maze seen simultaneously from many viewpoints. The viewer tries to enter this world of doodlings but cannot.

Romare Bearden proposes a human unity by examining elements common to many cultures. From his series on *The Prevalence of Ritual,* the collage *Baptism* concerns one of the Christian sacraments, but also the black American folklore connected to it. Masked to eradicate individual and racial differences, here are monumental ritualized figures whose disparate limbs, taken from newspapers and magazines, are organized by expressive potential, not by an-

atomically correct size or proportion.

Richard Lindner painted *The Street* ten years after *The Meeting* (plate 1123). Life in contemporary New York has replaced the nostalgia of the earlier picture. A provocative masked woman wears a leather dress, a black man is pointing his rifle at the target in a Times Square shooting gallery, a two-dimensional comic-strip character seems pasted on at the right, and Mack the Knife flourishes his cane and walks right out of the picture. Unconnected images move through space, while a purple dog keeps barking.

R. B. Kitaj, an American expatriate living in London, uses images taken from comic strips, graffiti,

1258

1260

1259

1261

snapshots, film, news photographs, art history books, and whatever else seems appropriate. The two figures in *Erie Shore*, the Red Cross nurse and the man in red vest and striped pants, confront each other in a boat where we also see an enigmatic bound torso of a woman, while a yellow seal occupies the lower left of right panel. Connections are not spelled out. Kitaj's pictures, with their shallow space and bright colors, which seem so random and discontinuous, correspond to the multiplicity of experiences in life.

Saul Steinberg, a Romanian expatriate in New York, uses all manner of past styles for his paintings, which are on the verge of being

cartoons, and for his cartoons, which are elegant drawings. In both his subject is the human comedy. In *New York Cops* we see the uniformed policeman, the hero, on horseback, galloping toward brightly painted taxicabs. The great skyscrapers with balconies are falling apart, while the heavy Chrysler Building seems to have sunk into the ground, with only its splendid peak still visible. Rainbow-colored beacons flare into the black skies of the absurd midsummer nightmare.

The Belgian artist Pierre Alechinsky, like Appel and Jorn an original member of Cobra, also painted a fragmented picture of New York, using apparently unconnected vi-

gnettes to simulate that magical state where fantasy and reality interweave. It is a painted version of a child's imagination spurred by the famous statue of Alice in Wonderland in New York's Central Park.

1255 Robert Rauschenberg. *Tracer*. 1964. Oil on canvas with silk screen, 84 × 60″ **1256** Jean Dubuffet. *Virtual Virtue*. 1963. Oil on canvas, 37 ³/₄ × 50 ⁷/₈″ **1257** Romare Bearden. *The Prevalence of Ritual: Baptism*. 1964. Collage on board, 9 × 12″ **1258** Richard Lindner. *The Street*. 1963. Oil on canvas, 72 × 72″ **1259** R. B. Kitaj. *Erie Shore*. 1966. Oil on canvas, 72 × 60″ **1260** Saul Steinberg. *New York Cops*. 1964. Charcoal, crayon, ink, and watercolor on paper, 22 × 28 ³/₄″ **1261** Pierre Alechinsky. *Central Park*. 1965. Acrylic on canvas, 63 ³/₄ × 76″

1262

1263

1264

Several younger artists are concerned above all with visual perception. Their work is informed by the gestalt psychologists' interpretation of phenomena as structural wholes, and they have undoubtedly been influenced by Josef Albers and Victor Vasarely (plates 1006 and 1152).

In the work of Richard Anuszkiewicz, who had studied with Albers at Yale, the interaction of colors creates a vibrating figure-ground relationship. Like Albers's paintings, *Splendor of Red* is foursquare and it is symmetrical and carefully planned, without a visible brushstroke. But the younger painter's work is Op Art; it attacks the eye, producing an immediate physiolog-ical sensation. The painting's center is occupied by a red diamond of full intensity. Radiating from it are bands of red and light blue lines, joined toward the corners by yellow lines. As a result of these yellow lines, a second diamond shape seems to appear, while a shimmering blue halo occurs around the center figure.

Larry Poons in *Northeast Grave* seems interested in evoking afterimages. First allowing the red ground to soak into the linen canvas, he then applied the pattern of small colored dots, following a definite plotted grid. The carefully manipulated color surface stimulates the optic nerve and activates our vision.

In Bridget Riley's *Current* optical illusion is carried to a point where the two-dimensional plane seems to be warped. Using a little color, she achieves a pulsating "current" effect. The spectator again experiences an immediate and intense optical response to the virtual, implied movement on the picture plane.

Victor Vasarely is the originator and supreme practitioner of perceptual dynamics. After having worked largely with black and white (plate 1152), he turned toward color composition in the early 1960s. He experimented with the effect of advancing and receding colors and the contradictory space on the picture plane, "giving the illusion of movement and duration." *Vega Per* is a square paint-

1266

1265

1267

ing, made up of circles in red-green complementaries and blues of different values. By careful manipulation of color and form he makes the central portion appear to burst forward into the viewer's space with an almost explosive force. Vasarely's experiments in activating the viewer's vision have made him one of the most popular artists in our time. He sees the broader aesthetic and sociopolitical ramifications of the kinetic idea for a communal plastic art and visualizes new solar cities which are to be "geometrical, sunny, and full of colors." He has set up a large communal workshop in the south of France to help bring this concept into reality.

Ellsworth Kelly continued to present a disciplined world, while exploring various color relationships. In his *Green, Blue, Red* two hard-edged, flattened ovals, one green and one blue, appear to be located on top of the red ground. The colors are all of the same value. Their intensity and their interaction create tension, and halos are formed on the edge of the two figurations. An immediate adjustment of the eye is demanded.

After his period of "black paintings," Frank Stella, a most versatile and very influential painter, assigned a primary role to color in the 1960s. In 1967 he began his "protractor" series—shaped canvases of geometrical complexity and architectonic

structure. *Agbatana III* is built up of segmented arches in fluorescent rainbow colors of full intensity. The bright, throbbing colors have an almost hypnotic effect on the viewer.

1262 Richard Anuszkiewicz. *Splendor of Red*. 1965. Acrylic on canvas, 72 × 72″
1263 Larry Poons. *Northeast Grave*. 1964. Liquitex on canvas, 90 × 80″
1264 Bridget Riley. *Current*. 1964. Synthetic polymer paint on composition board, 58 $\frac{3}{8}$ × 58 $\frac{7}{8}$″ **1265** Victor Vasarely. *Vega Per*. 1969. Oil on canvas, 63 × 63″
1266 Ellsworth Kelly. *Green, Blue, Red*. 1964. Oil on canvas, 73 × 100″
1267 Frank Stella. *Agbatana III*. 1968. Fluorescent acrylic on canvas, 120 × 180″

461

Numbers and Letters

1268

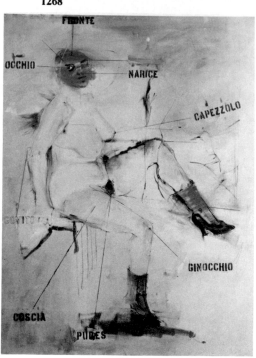

1269

1270

1271

Jasper Johns transforms the numerals 0 through 9 into painted objects of weight and substance in *Sculpmetal Numbers*. His rendering is faithful to their stencil-like shapes and mathematical sequence. However, the numbers alternately emerge from and merge with the pigment with which they are made, while the non-hierarchical succession of numerals records multiple presences.

In *Parts of the Body: Italian Vocabulary Lesson* Larry Rivers labeled his voluptuous nude with crudely stenciled references, transforming her into an anatomical diagram. Although incomplete, she is painted fluently, her rich, warm tonality and very pose evoking the tradition of the Western nude. However, the two-dimensionality and commercialism of the stenciled lettering mock this tradition.

Robert Indiana's *The Demuth American Dream No. 5* is a homage to the painter Charles Demuth and his famous painting *I Saw the Figure 5 in Gold*. Indiana quintuples the heraldic 5 into a Greek cross, adding several commands. While the image quotes the revered older American painter, the design and the use of stencil are quotations from the world of commercial art.

Cy Twombly calls on both writing and mathematics in *Crimes of Passion*. Scattered across the pictorial field, his scrawls combine decisive gesture and indeterminate action. Despite the evocation of linguistic signs, they carry no linguistic meaning. While Twombly's work pivots upon this process of evocation and logical denial, the end result is affirmative.

Joseph Kosuth's *Art as Idea as Idea* illustrates its title, the replacement of the aesthetic art object with the artist's verbalized idea. His image, a photostat of a dictionary definition, is visually logical and controlled. The fact that he did not construct the work is consistent with his notion that the artist is not a craftsman but a conceptual source. The choice of the particular dictionary entry asserts his view that new

1272

1274

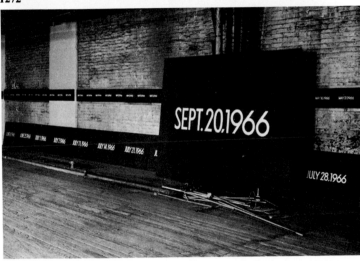

1273

1275

art is dependent upon language. Ironically, he makes this language itself into art by mounting it and giving it a title.

In *The Today Series of Date Paintings* On Kawara uses the alphabet and number system, in the form of neatly printed dates, to signify both the actual dates themselves and the artist's past actions. His dates are slightly irregular and nonhierarchical, each panel an equal component in the series, with the meaning of the work carried by the whole. Kawara's art does not refer to the realm of ideas but acts as a verification of the continuous existence of the artist.

Ed Ruscha's *Flash, L.A. Times* embodies the concept of work as image, his boldface-type bright yellow "FLASH" burning across a field of electric green. Ruscha selects the most ordinary details of everyday life to memorialize some aspect of Southern California culture.

Shusaku Arakawa's art plays with the meaning of signs. In *8 Reassembling* he explores the linguistic-mathematical pattern A + B equals C. Questions such as "To what extent is = a function of + ?" reveal the metaphysical as well as the mathematical implications of his pattern. He further complicates the apparent meaning of the work by his use of words in contradiction to their logical meaning (e.g., the word "pink" for a green equals sign).

1268 Jasper Johns. *Sculpmetal Numbers.* 1963. Sculpmetal on canvas, 58 × 44″ **1269** Larry Rivers. *Parts of the Body: Italian Vocabulary Lesson.* 1963. Oil on canvas, 69 × 52″ **1270** Robert Indiana. *The Demuth American Dream No. 5.* 1963. Oil on canvas, 5 panels, each 48 × 48″ **1271** Cy Twombly. *Crimes of Passion.* 1960. Oil, crayon (chalk), and pencil on canvas, 74 ³/₄ × 78 ³/₄″ **1272** Joseph Kosuth. *Art as Idea as Idea.* 1966. Mounted photostat, 48 × 48″ **1273** On Kawara. *The Today Series of Date Paintings.* 1966 **1274** Ed Ruscha. *Flash, L.A. Times.* 1963. Oil on canvas, 67 × 72″ **1275** Shusaku Arakawa. *8 Reassembling.* 1968–69. Oil, pencil, and magic marker on canvas, 84 ¹/₂ × 60 ¹/₂″

Painting with Objects

1276

1277

Increasingly in the 1960s, and even more in the 1970s, artists ignored or blurred distinctions among mediums. Although elements from vulgar "real" life had long been incorporated into painting, their use now was expanded beyond formal concerns or playful illusions. Asserting the continuum of art and recognizing a lifestyle saturated with commodities, artists explored the object's role, ranging from explication to ritualism. Robert Rauschenberg included common objects in his "combine paintings" partly to illustrate his idea that the environment, which art continues, is a tableau of scattered objects and meanings that collide haphazardly. In *Third Time*

Painting, a reversed number and sideways sign for time (clock) are applied to a painted surface that obliquely implies a human presence through ghostly shirt and brushmarks. Through reused objects arranged in a calculated but elusive order Rauschenberg elucidates the object's growing dominance over man.

Jasper Johns employs familiar tools of the painter—brushes, palette knife, and paint can, as well as colors—in his *Field Painting* to interrupt the process of perception and thus demonstrate the deceptiveness of illusion. Although the shapes of the painted letters which spell the primary colors correspond to the projected letters, the denotations of the

words do not—"red" is described pictorially by blue, orange, etc. Johns requires the viewer's active involvement to manipulate the artist's clues in order to discover his full intent and thus finish the creative act.

Johns's confrontation of painted and three-dimensional versions is paralleled on a much simpler level by Tom Wesselmann's literal but humorous probes of people's voyeuristic fascination with sexuality. In *The Great American Nude #54* he maneuvers objects onto a fastidious stage where three-dimensional confections and flowers on the table before a painted tree are equated with the painted diagrammatic female eroti-

1278

1280

1279

1281

cally splayed beneath her window. Flattened and reduced to erogenous zones, woman recedes into her paradoxical surface space and simultaneously into a desirable object of consumption.

Jim Dine selects banal objects and qualifies them through autobiographical reference to make his environments like reliquaries. Integral to one's ritual of living, the bathrobe of *Red Robe with Hatchet (Self-Portrait)* hangs like a recently emptied mold behind the hatchet, a sacred but indispensable instrument of the artist's beloved outdoor life. Generally self-exploratory, Dine's work differs from much of the somewhat cool commentary of the 1960s.

Alfonso Ossorio makes his "congregations" of objects to venerate the ideal of unification in a ceremonial atmosphere. The door-mirror-wall *Inxit*, whose title consolidates "in" and "exit," joins molded plastic primitive masks and contemporary lettering to bridge time and cultures. Mesmerizing colors and intricate shapes from the American artist's exotic Philippine-Chinese-Spanish background form an icon upon which to meditate about man's residual lives.

Larry Rivers worked in collaboration with Niki de Saint-Phalle to paint the portrait of his friend—and her husband—Jean Tinguely on a storm window. As the window is

moved into different positions, varying views of Tinguely's face make their appearance. Here it is the variable subject perhaps more than the viewer who activates the response.

1276 Robert Rauschenberg. *Third Time Painting*. 1961. Combine painting, 84 × 60″ **1277** Jasper Johns. *Field Painting*. 1963–64. Oil on canvas on wood with objects, 72 × 36 ³/₄″ **1278** Tom Wesselmann. *The Great American Nude #54*. 1964. Phone, radiator, table, chair, painting, 84 ¹/₂ × 102 ¹/₃″ **1279** Jim Dine. *Red Robe with Hatchet (Self-Portrait)*. 1964. Oil on canvas with metal and wood, 60 × 60″ **1280** Alfonso Ossorio. *Inxit (Door Closed)*. 1968. Plastic and various materials on wood, 102 × 96″ **1281** Larry Rivers. *Tinguely (Storm Window Portrait)*. 1965. Oil, collage on board with storm window, 29 × 25″

Eatables and Drinkables

1282

1283

1284

Faced with a superabundance of consumer goods, artists in the 1960s turned their attention to food—in supermarkets and restaurants and on dining-room tables, as well as in advertising—as nourishment of their art. The patronage of modern art had changed critically in this decade: new patrons entered the art market, and many of them did not want to be perturbed by complex works of art that made great demands on them.

Seizing the edible consumer product, Andy Warhol in 1962 painted *100 Cans* with their Campbell's soup labels, stacked up precisely as we find them in the supermarket. To the question of "Why soup cans?" Warhol replied that he "used to drink it . . .

same lunch every day for twenty years . . . the same thing over and over again . . . I liked the idea." The painting is about both the repetition of the object and the totally impersonal mechanistic look of modern printing techniques.

Like Andy Warhol, James Rosenquist began his career as a commercial graphic designer. Rosenquist's *I Love You with My Ford* is a conjunction of fragmented images: the front fender of an old Ford, a face in profile, and a large portion of orange Franco-American spaghetti which the viewer might associate with human entrails. Is it about a car accident or is it about how the consumer travels and eats?

For Robert Indiana the process of

eating is transformed into a huge emblematic sign. The letters *E A T* were displayed in huge scale on the New York State building at the New York World's Fair of 1964. Indiana also used the same emblem as well as the words "love" and "die" in a number of his canvases. He is concerned both with the literal meaning of these verbs as well as with banal road signs, and billboards.

Claes Oldenburg, creator of Happenings, inventor of Soft Sculpture, is also a designer of Colossal Monuments. Traffic used to flow down Park Avenue and then surge around the island of Grand Central Station (plate 477)—until the Pan Am Building closed it all in. But

1285

1286

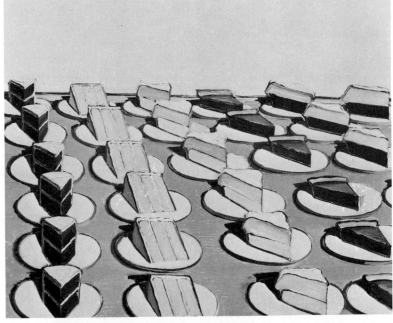

1287

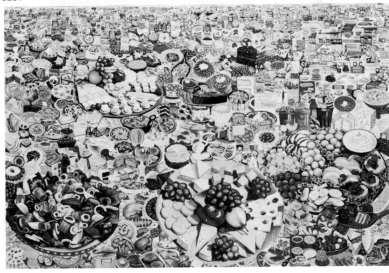

1288

now Oldenburg finds a monumental solution: he suggests using a partly melted ice cream pop to cover the ill-sited highrise. Now cars can pass where someone took a big bite out of the Good Humor bar.

In his *Val Veeta* California's Mel Ramos has a nude blonde stretched out brazenly on a package of Velveeta cheese. Both cheese spread and nude again deal with preexisting images. Here the pin-up girl is united with the pasteurized processed cheese. The woman is reduced to a sex symbol, the cheese to a food symbol; both are commercial signs and they are as real as our communications system.

Wayne Thiebaud is a more tradi-tional still-life painter, an artist greatly aware of the painted surface. While the image of *Pies and Cakes* is derived from advertising layouts, the technique is personal and painter-ly. In fact, the buttery brushstroke seems to describe the very substance, the texture, of the pies and cakes. Thiebaud is interested in serial as-pects of the pie, that same, standard piece of pie everywhere in America. This he sees as a metaphor of both the similarity between people in this country and the abundance of food in America.

Seeing all the paintings of edibles and potables, the Icelandic artist Erro painted his *Foodscape* in 1964. He has overcrowded his canvas with allover food in this rich satire on the overall painting of the Abstract Expressionists, on American pleni-tude, and on the mode of painting which has been described by Euro-pean critics as "Capitalist Realism."

1282 Andy Warhol. *100 Cans*. 1962. Oil on canvas, 72 × 52" 1283 James Rosenquist. *I Love You with My Ford*. 1961. Oil on canvas, 84 $\frac{1}{4}$ × 95 $\frac{5}{8}$" 1284 Robert Indiana. *Eat*. 1964. Photograph of 20-foot sign, New York State Pavilion, World's Fair, New York. 1285 Claes Oldenburg. *Colossal Monument to Park Avenue: Good Humor Bar*. 1965. Crayon and watercolor, 23 $\frac{3}{4}$ × 18" 1286 Mel Ramos. *Val Veeta*. 1965. Oil on canvas, 70 × 60" 1287 Wayne Thiebaud. *Pies and Cakes*. 1963. Oil on canvas, 30 × 40" 1288 Erro. *Foodscape*. 1964. Oil on canvas, 78 × 118"

Women

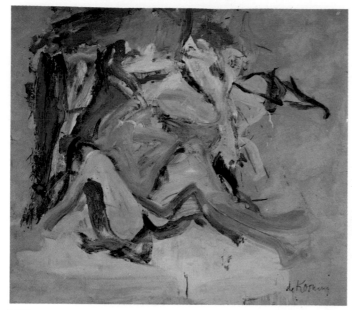

1289

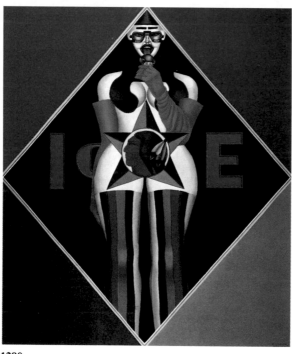

1290

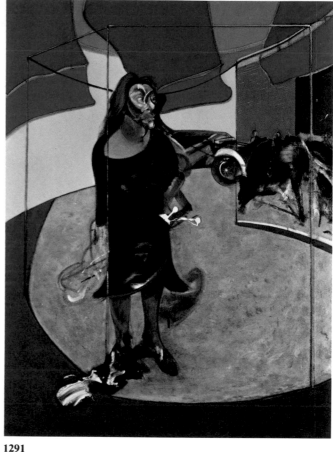

1291

Since Willem de Kooning's move to the Long Island countryside, in 1963, the colors of his paintings have become almost delicate. He is still, or again, occupied with the image of women, but these women are no longer aggressively frightening. They have become frankly sensuous and hilariously human. But it is, above all, the effect of flowing light that has changed his palette, evoking a much lighter, almost joyous mood. Richard Lindner's obsessive corseted woman has become more blatant in *Ice* than she was in his earlier work. Although the forms are treated with hard-edged precision, the meaning is enigmatic. Why is the insignia of an Indian head placed in the geometric center of the temptress's groin? Does Lindner's painting of this robot-woman comment on the equivalence of love and ice? The letters seem separated too widely to spell "ICE" and may indeed also be meant to read "LOVE."

Francis Bacon's portraits are cinematic, fugitive, shifting. He works from photographs to be alone with his memory and to avoid interference from the sitter. *Portrait of Isabel Rawsthorne* evokes the assault to our sensibility by the various media, and at the same time catapults the viewer violently into the actuality of life. Bacon frames his friend in a pose that might suggest a prostitute. Yet the urgency of the paint application, the artist's own trembling, invests the image with a great sense of human frailty.

Some of Bacon's blurred imagery is reflected in the early work of David Hockney, who also gained a great deal from Dubuffet and from his friend Kitaj. Hockney now has developed a cool, almost deadpan art. In 1966, on one of his frequent trips to California, he painted the portrait of an art collector, which he called *Beverly Hills Housewife*. The lady in pink is seen behind sheets of glass in her environment, which includes a zebra-covered Le Corbusier chair, a moosehead, and a William Turnbull sculpture. Through his great talent and craftsmanship, Hock-

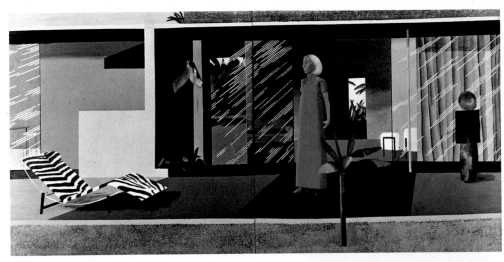

1292

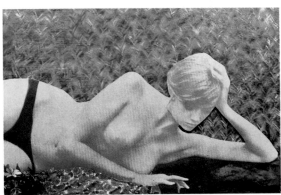

1293

1294

1295

ney lends a sense of poetry to the depiction of a specific woman, place, and time.

Martial Raysse, a member of the group of French avant-garde artists whom Pierre Restany called Nouveaux Réalistes (New Realists), has "modernized the iconography of the odalisque." The bathing beauty in his *Simple and Quiet Painting* is seen in a photograph; the background is airbrushed; the tablecloth and plants are plastic. Once again the plastic world has appropriated the timeless image of the reclining nude.

The versatile German painter Gerhard Richter managed to retain his model's sensuousness in his parody of Marcel Duchamp's famous *Nude Descending a Staircase* (plate 276). Richter in *Emma—Nude on a Staircase* actually photographed his nude and concentrated on the camera's inability to put all elements in focus simultaneously by blurring his whole painting and thus further softening Emma's already curvaceous figure.

Michelangelo Pistoletto also works from photographs and transfers the enlargements to highly polished, mirrorlike surfaces of stainless steel. The sheet of steel holding the silhouette of the *Female Nude on the Telephone* is filled with the reflections of the room; the reflected viewer too is an integral part of the picture as the whole environment is embraced. The formal, static image and the temporal continuum are one. Art is, literally, brought into life.

1289 Willem de Kooning. *Woman on the Dune*. 1967. Oil on paper mounted on canvas, 48 $^1/_4$ × 54 $^1/_2$″ **1290** Richard Lindner. *Ice*. 1966. Oil on canvas, 70 × 60″ **1291** Francis Bacon. *Portrait of Isabel Rawsthorne Standing in a Street in Soho*. 1967. Oil on canvas, 77 $^3/_4$ × 58 $^1/_8$″ **1292** David Hockney. *Beverly Hills Housewife*. 1966. Acrylic on canvas, 72 × 144″ **1293** Martial Raysse. *Simple and Quiet Painting*. 1965. Photo on cardboard, oil on canvas, plastic, artificial flowers, 51 $^1/_4$ × 76 $^3/_4$″ **1294** Gerhard Richter. *Emma—Nude on a Staircase*. 1966. Oil on canvas, 79 $^3/_4$ × 51 $^1/_4$″ **1295** Michelangelo Pistoletto. *Female Nude on the Telephone*. 1964. Collage of photograph on polished stainless steel, 47 $^1/_4$ × 84 $^5/_8$″

1297

1296

```
17K=No1   5169-21   24K=No8   10169-26   28K=No12
          4269-21             9269-26    12169-28
1169-17   3369-21   8169-24   8369-26    11269-28
          2469-21   7269-24   7469-26    10369-28
18K=No2   1569-21   6369-24   6569-26    9469-28
                    5469-24   5669-26    8569-28
2169-18   22K=No6   4569-24   4769-26    7669-28
1269-18             3669-24   3869-26    6769-28
          6169-22   2769-24   2969-26    5869-28
19K=No3   5269-22   1869-24   11069-26   4969-28
          4369-22                        31069-28
3169-19   3469-22   25K=No9   27K-No11   21169-28
2269-19   2569-22             11169-27   11269-28
1369-19   1669-22   9169-25   10269-27
                    8269-25   9369-27    29K=No13
20K-No4   23K-No7   7369-25   8469-27
                    6469-25   7569-27    13169-29
4169-20   7169-23   5569-25   6669-27    12269-29
3269-20   6269-23   4669-25   5769-27    11369-29
2369-20   5369-23   3769-25   4869-27    10469-29
1469-20   4469-23   2869-25   3969-27    9569-29
          3569-23   1969-25   21069-27   8669-29
21K-No5   2669-23             11169-27   7769-29
          1769-23   26K=No10             6869-29
```

1298

"Systemic" thinking characterized a large body of work done in the middle 1960s. Logical, mathematical, repetitive structures were chosen as a primary means of expressing abstract concepts or of exploring variation through modification of an essential unit. These systems—grids, numbers, letters, simple geometric forms, the repetition of single visual signifiers—were used to confront or explore issues as widely divergent as the relationship of art world structures (e. g., museums and galleries) to the meaning of art in society and visual problems of perception.

In Agnes Martin's *The Tree* the persistent use of grids becomes a recurrent system for a holistic form. Although her titles often suggest natural referents, Martin is primarily concerned with the concepts of lightness, merging, and formlessness. "When I cover the square with rectangles," she said, "it lightens the weight of the square, destroys its power." Martin was influenced by the repetitive forms and meditational qualities of Reinhardt, Rothko, and Newman, as well as by Chinese landscape painting and poetry, and the paintings of Paul Klee. Her clear structural surfaces reflect an integrative mentality seeking clarity.

In 1968 Robert Ryman made a series of paintings on handmade Classico paper, such as *Classico III*. He applied white polymer paint in an even film to twelve squares of paper carefully placed adjacent to one another to form a larger square of grid structure with shadowed lines. Upon this structure a white painted field slightly off center echoed the basic form. He sought complex visual order with the simple means of geometric form. Ryman's concern with the white rectangle is paradigmatic of 1960s imagery and the testing of perceptual acuity.

Hanne Darboven's obsessive number systems depend upon a basic form and a date which generates permutating sequences: day, month, year, and then a century evolve into a *Drawing*. Digits added, multiplied, and interwoven become finally too

1299

1300

1301

large and are then returned to smaller units. These numbers form a graphic vocabulary in which words spelling out numbers or numbers themselves lose any symbolic meaning and become visual and sensually subjective reflections of her own mentality, a means of steady, limited evolution of time. and her own experiences in it.

Sol LeWitt's *Wall Markings* moved the graphic process from the paper to the wall. The series began as a complete pattern structure of thought about the idea of drawing. He isolated the basic properties of this drawing activity into four absolute directions of line with all variations through systematic permutations. He explained that "the

work is the manifestation of ideas. It is an idea and not an object." The wall, then, could function in exactly the same way as paper or canvas and would retain its absolute two-dimensionality, consistent with drawing practice.

Daniel Buren made propositions to reveal the relationship between the "contained" of art, in which art objects/actions are presented, and their functions. By reducing his work to a uniform neutral and immutable internal structure (commercially printed vertical stripes), and placing them into any given environment he could vary the external structure without changing the initial proposition. In this way, he felt, he might

come closer to what he considered the essential issues of art—color, support, surface—and might deal with ideology, economics, and politics and with the place and audience for which objects are made. In 1968 Buren, wanting to work outside the confines of museums, went to the Paris streets, where he made his first street performance, creating a new artistic milieu.

1296 Agnes Martin. *The Tree.* 1964. Oil and pencil on canvas, 72 × 72″ **1297** Robert Ryman. *Classico III.* 1968. Polymer on paper, 93 × 89″ **1298** Hanne Darboven. *Drawing.* 1969 **1299** Sol LeWitt. *Wall Markings.* 1969. Plan, pen and ink, 16 × 16″ **1300–1301** Daniel Buren. *Untitled Paris.* Photo/ Souvenir. 1968 (destroyed)

Political Images

1303

1302

1304

It is surprising how relatively little effect the political ferment of the decade had on art. Although most artists in the U.S. and Europe were strongly opposed to the war in Southeast Asia, very few expressed their dissent in their work. By no means a shocking and cruel accusation like Conner's *Child* (plate 1073), Andy Warhol's *Orange Disaster* was a theme suggested by a museum curator and an image taken from a press photograph. It tells us more about the mass media than it does about capital punishment. By excluding all sentimental associations, *Orange Disaster* also dismisses interpretation, emotion, and commitment.

Claes Oldenburg's proposals for monuments are both mockeries and political statements. He proposed to replace the Washington Monument with his gigantic *Scissors Obelisk*. Like wit in general, his satirical proposal is also in dead earnest. The artist tells us that "A strange intolerance of division, separation, in the U.S.A. is expressed by the cruelty of the scissors in obtaining union: as the scissors close—unifying—they separate the material they close about."

One of the most politically engaged painters in the U.S. during the 1960s was Leon Golub, who had painted agonized and damaged but implacable figures in the 1950s. His "Gigantomachies" deal with human

struggle on a colossal scale. We see two figures engaged in battle in the poses of ancient Greek pedimental sculpture in *Napalm I*. The fallen figure with burning flesh and the nude warrior are engaged in their necessary tragic encounter. They are locked into their fate.

Oyvind Fahlstrom was a Swedish artist who was born in São Paulo, lived in Paris, and spent the last fifteen years of his short life in New York. He used comic strip characters and images from photographs and various mass media, as well as the written word, in his work. In a "variable painting" like *The Cold War* the figures and images are attached on hinges and magnets and can be

1305

1306

1307

moved to form any number of configurations. Many of Fahlstrom's paintings are filled with the paradox of dealing with brutal facts in a playful manner. Fahlstrom explained: "Living in LBJ's and Nixon's America during the Vietnam war . . . it became impossible not to deal with it in my work . . . with what was going on around me: Guernica, multiplied a million times."

Juan Genoves, who refers to himself as a "pictorial journalist," like Goya before him has been concerned with political events in Spain in his time. Genoves has painted powerful crowd scenes, influenced by Sergei Eisenstein's film *The Battleship Potemkin*. *Stop* is a painting of a fleeing crowd in the distance with the gigantic shadowy silhouette of a man with a pistol in the foreground. It is a somber and terrifying painting: the anonymous crowd seen through the telescope of a gunsight runs in fright of the all-powerful dark killer.

One of the most disturbing and eloquent images of the decade is Wolf Vostell's *Miss Amerika*. Vostell had worked with *dé-collage* (plates 1407–1408) as early as 1954 and was producing street and theater pieces and Happenings in Europe by 1962. *Miss Amerika* is based on an Associated Press photograph showing the shooting of a young Vietnamese civilian. Vostell combines this with other photos of executions in the lower register, while above the scenes of killing is the sexy beauty queen—a juxtaposition which makes direct reference to the nightly offerings on the TV tube, but "Miss Amerika" too is spattered with blood.

1302 Andy Warhol. *Orange Disaster #5.* 1962–63. Silk screen and Liquitex on canvas, 106 × 82″ **1303** Claes Oldenburg. *Proposed Colossal Monument to Replace the Washington Obelisk, Washington, D.C.: Scissors in Motion.* 1967. Crayon and watercolor, 30 × 19 3/4″ **1304** Leon Golub. *Napalm I.* 1969. Oil on canvas, 44 7/8 × 36 1/4″ **1305** Oyvind Fahlstrom. *The Cold War.* 1963–65. Variable diptych, tempera on steel and plastic, 94 1/2 × 138 1/8″ **1306** Juan Genoves. *Stop.* 1968. Acrylic on canvas, 39 3/8 × 43 3/8″ **1307** Wolf Vostell. *Miss Amerika.* 1968. Mixed mediums, 78 3/4 × 47 1/4″

Posters

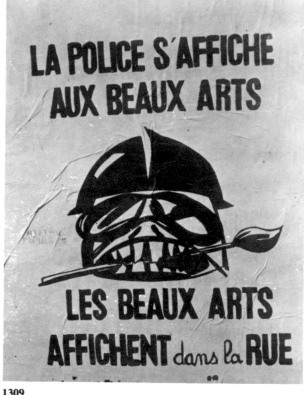

1309

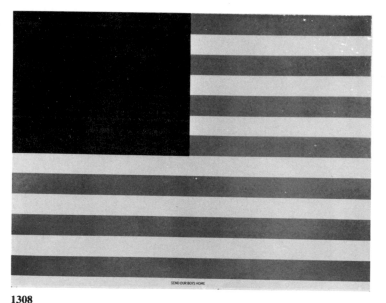

1308

1310

The ferment and the involvement which were an integral part of life in the 1960s manifested themselves in the revival of the poster as an art expression. With it artists found a fresh and immediate new audience with whom they could communicate on issues and causes of importance. The poster, reflecting political and social issues, became a truly public art, far removed from the advertising motivation of past decades. It was printed in thousands and usually sold at low prices. It was displayed in new places: campus buildings, casual art galleries, homes and offices, storefronts, the streets. Along with other graphic innovations, the imagery, typography, style, and subject matter of the poster

in the 1960s reflect the eclecticism of this decade.

The American flag has been used as a symbol throughout America's history. In the 1950s it was used by Jasper Johns for its readymade two-dimensional form (plate 1184), while for other artists it became the symbol and target of their opposition to the war in Southeast Asia. Christos Gianakos made a terse, powerful graphic statement in *Send Our Boys Home*, its image and message making an impact on many levels. He employed graphic economy: the black field with alternating red and white stripes of the flag and a simple line of text create an urgent and demanding message.

The French student rebellion of May 1968 spread to the labor unions, had political repercussions, and brought about some long overdue changes in higher education. During the demonstrations students turned out hundreds of posters, some of which had powerful imagery. Apparently hastily drawn and quickly produced, the silk-screen poster *The Police Occupy the Beaux Arts, The Beaux Arts Take to the Streets* was made by an unknown designer who was probably a student at the École des Beaux-Arts. It demonstrates the turbulent energy in the lives and politics of committed individuals and groups of the 1960s.

The Czech poster protesting the

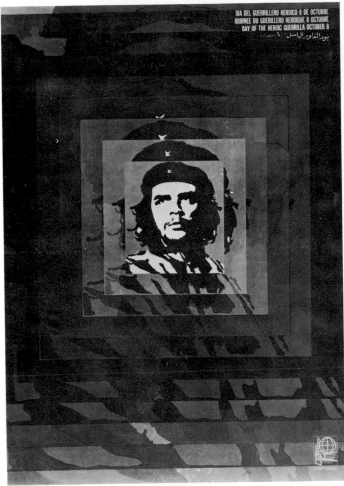

1311

1312

Soviet invasion of Czechoslovakia in the summer of 1968 was prompted by similar turmoil. The design grows out of a tradition of satire that goes back to the eighteenth century and of which Jules Feiffer's cartoons are a contemporary example. This cursorily drawn two-frame picture tells a story a great deal less light-hearted than its endearing graphic qualities would make it appear. The childlike simplicity of the drawing carries a message of surprising poignancy.

In revolutionary Cuba posters were and are an important means for the education of the masses and for the promulgation of political attitudes. Giant posters are displayed in Havana, dominating the Central Square of the Revolution. In the poster of the revolutionary leader Che Guevara a photographic image of the dead leader is projected on the map of South America. The center square, progressing outward like spreading ripples of water, gives a graphic indication of the international consequences of the revolution, which, it was hoped, would reach out to the whole continent.

While many of the finest posters of the 1960s were prompted by political upheavals, the decade was also the time of psychedelic experiences. A notable example of the "hippie poster" is Robert Wesley Wilson's *The Association*. Posters such as this were brought into being at a given time for a specific community. In this work, influenced by Art Nouveau design, the transmission of information is deliberately made difficult; it is illegible, except to the initiated—and this special appeal was very much the purpose of the artist.

1308 Christos Gianakos. *Send Our Boys Home*. 1966. Offset lithograph, 12 $^1/_4$ × 17″ **1309** Artist unknown. *The Police Occupy the Beaux Arts, The Beaux Arts Take to the Streets*. 1968. Silk screen, 36 × 24″ **1310** Artist unknown. *1945/1968*. 1968 **1311** OSPAAAL (Organization for Solidarity with the People of Asia, Africa, and Latin America). *Day of the Heroic Guerrilla— October 8*. 1968 **1312** Robert Wesley Wilson. *The Association*. 1966. Offset lithograph, 19 $^5/_8$ × 13 $^3/_4$″

475

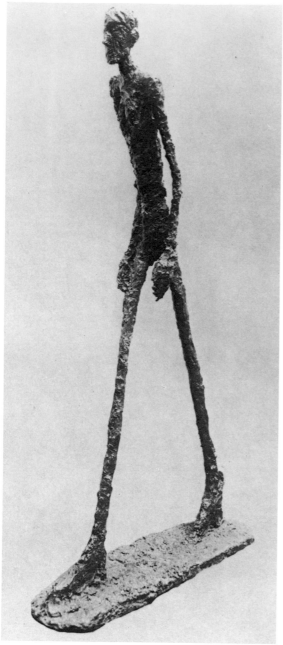

1313

1314

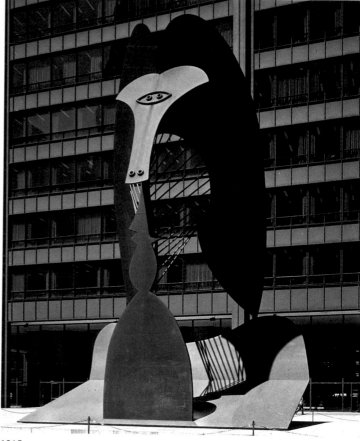

1315

Alberto Giacometti's *Walking Man I* no longer strides with power, confidence, and self-assurance, as did Rodin's (plate 167). His feet seem welded to the ground, making it impossible for him to advance. And the figure always keeps its distance.

Walking Man, originally planned for Chase Manhattan Plaza in New York, was installed with three standing women in the formal courtyard of the Fondation Maeght museum in France (plates 1431–1432).

Next to the building itself Joan Miró installed his triumphal *Arch*. With its bulges and protuberances *Arch* belongs in its surroundings and seems to mingle with the trees and hills.

In his final sculptures, instead of placing the pieces in space, Picasso began to work with sheets of metal that enveloped space itself. At eighty-four he made the maquette for a monument to go into the new Chicago Civic Center. Although the sculpture relates to earlier female heads by Picasso, it also evokes the image of a horse's head, and it recalls the Renaissance tradition of a monumental horse in the city square. In form it is the final realization of the open sculpture he had hoped to build some forty years earlier.

The great bronze *Nuclear Energy* was the culmination of Henry Moore's concern with the relationship of external and internal forms;

the interior surfaces are reminiscent of great rock formations, and the dome shape seems to protect the forms within and below it. The work was commissioned by the University of Chicago to commemorate the spot where the first controlled nuclear reaction had occurred. Moore said that he "meant the sculpture to suggest that it was man's cerebral activity that brought about the nuclear fission discovery. It can also suggest the mushroom cloud, the destructive element of the bomb."

During the 1960s Alexander Calder's stabiles assumed a gigantic scale. *Man*, commissioned for Expo '67 in Montreal, reaches a height of ninety-four feet. The shapes are pointed and

476

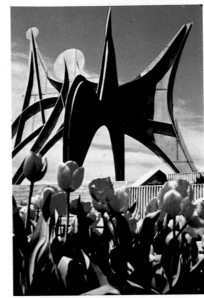

1317

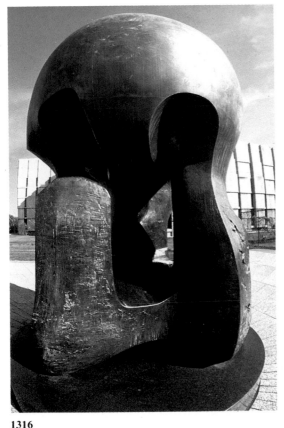

1316

1318

1319

rounded, geometric and organic at the same time; they represent Woman as well as Man, combining rational and intuitive elements.

Noguchi's *Stone of Spiritual Understanding* appears brutal and primitive when compared to his elegant earlier work. The rough organic clay (cast in bronze) is in telling contrast to the cleanly cut wooden beam that pierces it. It makes us understand Noguchi's dictum that "It is the sculptor who orders and animates space, gives it meaning."

Everyone thought that Marcel Duchamp had long retired from making art after he had assembled his life's work in the *Box in a Valise* (plate 762). When asked about his ac-

tivities, he would reply: "I breathe." Yet between 1946 and 1966, known only to his wife, he produced an astonishing tableau, *Etant Donnés*. It consists of an old wooden Spanish door which is barred and will never open. The door has two viewing holes, and as the visitor-voyeur peeps through them, he is presented with a naked girl with open legs, stretched out on branches of a tree and holding a gas lamp. Behind her is an idyllic landscape with a waterfall which is set in motion by a hidden motor. Duchamp had been fascinated by gas and water ever since the *Large Glass* (plate 323). As it is in the *Large Glass*, the process of looking through (glass = holes in door) is

significant here. The bride appears only when she is gazed at, because, as Duchamp pointed out: "It is the spectator who makes the pictures."

1313 Alberto Giacometti. *The Walking Man I.* 1960. Bronze, height 71 ³/₄″ **1314** Joan Miró. *Arch.* 1963. Cement, height 196 ⁷/₈″ **1315** Pablo Picasso. *Chicago Civic Center Sculpture.* 1966. Welded steel, height 65′9″ **1316** Henry Moore. *Nuclear Energy (Memorial to the First Self-Sustaining Controlled Nuclear Chain Reaction).* 1967. Bronze, height 198″ **1317** Alexander Calder. *Man.* 1967. Stainless steel plate, height 94′ **1318** Isamu Noguchi. *Stone of Spiritual Understanding.* 1962. Bronze and wood, height 52 ¹/₄″ **1319** Marcel Duchamp. *Etant Donnés (Given: 1. The Waterfall, 2. The Illuminating Gas).* 1946–66. Mixed mediums, height 95 ¹/₂″

Boxes

1320

1322

1321

1323

Tony Smith's prototypical boxes ushered in a decade in the United States in which the most representative image/object could be described as having equal sides, right angles, straight edges, flat surfaces. Artists were concerned with primary shapes: pyramids, cubes, and other geometrical volumes. Critic Barbara Rose called this "Minimal Art." Smith extended the concepts he learned in Chicago's New Bauhaus and as an assistant to Frank Lloyd Wright by working with modular systems and basic architectonic shapes. But the rational quality of his sculpture was countered by the irrational "presence" that resulted from the simplicity of his abstract forms.

The first artist to grasp the full significance of these primary structures was Donald Judd. Believing that the best art provides immediately comprehensible visual sensations, he chose serial units of geometric form as his sculptural vehicle. His first objects were painted wood, followed by metal objects. His drawings underscore the fact that his work is fabricated industrially. Nevertheless, his series of eight cubes creates its own environment at the same time as it reflects and alters its context.

Robert Morris began about 1963 to experiment with the same gestalt principles of perception that interested Judd: essentially, that awareness of whole structure precedes discovery of

parts. However, after having tested them, Morris reversed it in a series of glass mirrored boxes. These boxes dissolved the total gestalt, deflecting the unitary structure into the environment by reflecting objects, persons, and atmospheric conditions. It was difficult to understand the discrete forms and the size of the boxes and the distances between real things as distinct from mirror surfaces.

The intellectual imagery of mathematics was most thoroughly explored by Sol LeWitt. His modular forms appear to be the product of theoretical thought, yet he proclaimed, "Conceptual Artists are mystics rather than rationalists." This para-

1324

1326

1325

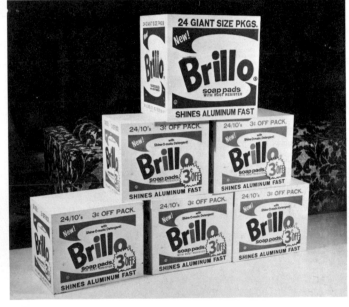

1327

dox becomes clear when the abstract nature of drawing a cube is compared to the constructed cube: two different realities, one phenomenological, the other conceptual, both resulting from the single idea of "cube."

Ostensibly, Piero Manzoni's *Magic Base* fits the definition of minimal shapes. Manzoni's base was not meant as a thing in itself; he proclaimed the pedestal to have talismanic powers by which ordinary people who stood on its surface would be endowed with that rare, supernatural value "art." Manzoni himself was the first to stand on this box and be photographed as a "living work of art."

Franz Erhard Walther has created another kind of participatory box in the shape of a giant book of sixty-eight pages, each large enough for a man to lie in. The only information available from his *Process Book* is the prostrate person inside it, and, Walther writes: "The measurements of the shapes, forms, structures on/in/at each page are related to the human body: finger, span, hand, arm, foot, head. . . ."

Andy Warhol borrowed the dehumanized, banal, mass-produced object and exhibited it in the art context of a gallery. In *Brillo* the replication process of silk screen was used to convey the "massification" of consumerism and product imagery, channeling it back into the eco-nomic system from which it originated. *Brillo* parodies the high-art seriousness of serial imagery and geometric form, even though Warhol was one of the first to exploit series as form.

1320 Tony Smith. *Die*. 1962. Steel, height 72″ 1321–1322 Donald Judd. *Untitled*. 1968. Eight boxes 1321 Stainless steel, 12″ apart, height 48″ each 1322 Drawing. Ink on paper 1323 Robert Morris. *Untitled*. 1965. Four boxes, glass mirrors on wood, height 21″ each (destroyed) 1324 Sol LeWitt. *Open Modular Cube*. 1966. Painted aluminum, height 60″ 1325 Piero Manzoni. *Magic Base*. 1961. White wood, 11 ³/₄″ 1326 Franz Erhard Walther. *Process Book*. 1963–69. Heavy canvas, wood, length 78 ³/₄″ 1327 Andy Warhol. *Brillo*. 1964. Acrylic silk screen on wood, height 17″ each box

Geometric Form

1328

1329

1330

In his welded *Cubi* series David Smith composed monumental statements with strong and simple elements. Smith's use of metal evolved from his early work in machine shops, and for him steel carried the connotations of the twentieth century with its "power, structure, movement, progress, suspension, destruction, brutality." In *Cubi XIX* Smith's daring arrangements of cylinders, blocks, disks, and cubes—to him "found" shapes—emphasized the coherence and logic of the geometric forms with their untold possibilities of juxtaposition. And with its hieratic verticality, *Cubi XIX* evokes a powerful surge of the human spirit.

In his massive *Large Sphere*

Arnaldo Pomodoro uses the sphere as his starting point but alters its pure geometric character dramatically. The polished surface is penetrated by holes and textured by complex patterns with the precision and complexity of machinery. Ultimately, a fundamental characteristic of the form—its sameness at every point along its circumference—is negated; each aspect of this sphere is unique. Pomodoro's powerful synthesis of objective geometry and subjective patterning is dramatized by his skillful manipulation of the metal.

Mark di Suvero's graceful sculptural composition *Are Years What (For Marianne Moore)* is an exercise in delicate equilibrium on a grand

scale. Its energy springs from the crossing of the main bars, then moves upward, following the vertical thrust of its striking tall element. Unlike the Minimalists' boxes, it was not entirely preconceived; its form evolved on the site during the building process with the artist directing the crane. The obvious potential for movement of the precarious arrangement heightens the tensions among individual elements, at once threatening stability and suggesting the possibility that the dynamic red structure may expand and claim more space.

Barnett Newman's sculpture also utilizes geometric form but metamorphoses it. In *Broken Obelisk* he radically alters our perception of

1332

1331

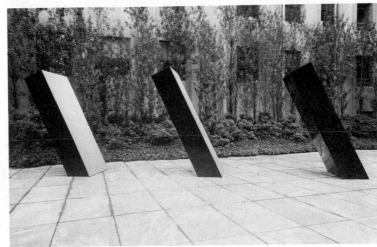

1333

this ancient form by inverting it and focusing on the tense junction with the pyramidal base (another age-old form). The two tips of the geometric forms meet in perfect balance. While the tremendous energy embodied in the forms reverberates outward from this junction, a second locus of intensity emerges: the obelisk's top, the point at which this geometric purity is shattered.

Anthony Caro worked for many years with his countryman Henry Moore, but he is much more indebted to David Smith. In Caro's *Midday*, composed of bolted and welded metal girders, he explored the relationship between planes through his placement of smaller geometric shapes against *Midday*'s strong diagonal axis, which is the backbone of the sculpture. The work, sitting directly on the ground and painted an aggressive orange, has a light, playful, gestural effect.

Ronald Bladen's *Untitled* illustrates the Canadian sculptor's exploration of the potentialities of massive geometric forms in space. Three monolithic rhomboids form a slow, expansive rhythm of alternating solids and voids. The sharp incline, stressed by Bladen's use of color—black on three sides, burnished aluminum on the upper vertical side—logically suggests that the forms should fall, yet they resist gravity, exuding an enigmatic force of their own. While not referentially anthropomorphic in shape, these rhomboids call forth a human presence. Reminiscent of Stonehenge, they evoke a sense of ancient human intelligence and organizing action.

1328 David Smith. *Cubi XIX*. 1964. Stainless steel, height 112″ 1329 Arnaldo Pomodoro. *Large Sphere*. 1966–67. Bronze, diameter 141 ³/₄″ 1330 Mark di Suvero. *Are Years What (For Marianne Moore)*. 1967. Steel, height 40′ 1331 Barnett Newman. *Broken Obelisk*. 1963–67. Cor-ten steel, height 26′ 1332 Anthony Caro. *Midday*. 1960. Painted steel, height 94″ 1333 Ronald Bladen. *Untitled*. 1966–67. Painted and burnished aluminum in three parts, 112″ apart, height 120″

Reliefs

1335

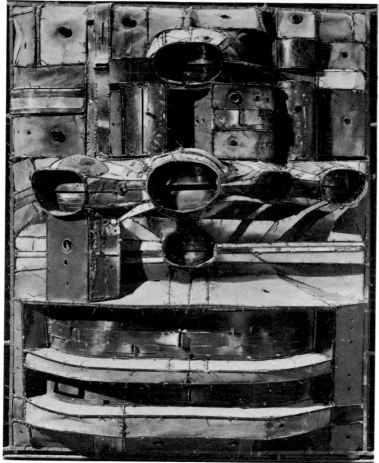

1334

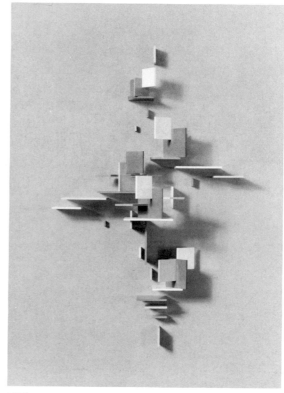

1336

Lee Bontecou's disquieting *Composition* of dark apertures relates to her earlier relief (plate 1088). Its rough metal craters, strips, and concentric rings welded to each other or tied with sharp little wires are awesome presences. Its specific emotional significance, she has said, must come from the viewer, who may glimpse in the work "some of the fear, hope, ugliness, beauty, and mystery that exist in us all."

Similarly fearsome are the Kafka-like reliefs that the German artist Bernard Schultze calls "Migofs." Starting from a representational depiction of human features on canvas, Schultze's *Migof-Ursula-Genealogy* expands into the third dimension.

Fantastic eruptions of butterfly wings and tongue forms are garishly painted, emphasizing the multiple surfaces that can be explored visually and tangibly. This chthonic labyrinth of stiff, gnarled shapes hovers magically in front of the picture plane—an organic, startling fusion of sculpture, color, and space.

Charles Biederman presents a totally distinct world of clarity and order. Working in the small town of Red Wing, Minnesota, he has been creating reliefs which carry on the European Cubist-Constructivist–de Stijl traditions and which have had a much greater impact on European than on American art. His *#27 Red Wing* demonstrates the basic tenets

of his artistic theory: that art, while nonmimetic, should correspond to nature's method of construction, and he rejects the traditional distinction between painting and sculpture. Instead, there is the interaction of colored geometric elements with two variables: light and the constantly changing perspective of the viewer. Through their interaction the rectangular plane with its strictly ordered horizontal and vertical elements is animated into a dialogue of light and shade, of movement and depth, parallel to the appearance and structure of natural forces.

Influenced by Lucio Fontana, Enrico Castellani in his relief *White Surface 2* replaced the master's holes

1337

1338

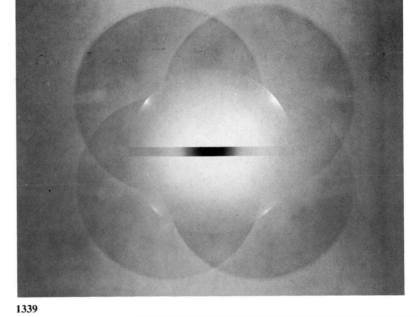

1339

and slashes with projections on the canvas created by the presence of nails below its surface. The result is a fascinating, somewhat irregular pattern, depending on the play of light on the white membrane.

Although the Argentinian Julio Le Parc and the other members of the Paris-based Groupe de Recherche d'Art Visuel (Group for Research in the Visual Arts) were profoundly stimulated by Vasarely's paintings with their dynamic surface pattern and optical illusions, they were determined to move beyond the limitations of two-dimensional composition. Le Parc's *Continuel-Mobile, Continuel-Lumière* is a kinetic programmed work that incorporates the

element of change through the use of actual movement and actual light. In recognition of his advances in visual theory, Le Parc was awarded the painting prize at the 1966 Venice Biennale—the last time this competitive prize was given to an artist.

Robert Irwin's *Untitled* typifies his experimentation both with the reduction and clarification of means and with the exploration of colored forms in space. The invisibly suspended convex acrylic disk, carefully lighted from four directions, casts four overlapping, symmetrically arranged halos which at once frame and echo the luminous disk itself. The disk is bisected and anchored by a horizontal band which forms a

central foil for the subtle interplay of the floating disk and the soft shadows. Irwin plays with the idea of transparency; as his pattern disappears into light and space, his concern with reduction of form evolves into the questioning of perception itself.

1334 Lee Bontecou. *Composition.* 1962. Welded steel with canvas, height 44″ **1335** Bernard Schultze. *Migof-Ursula-Genealogy.* 1963 **1336** Charles Biederman. *#27 Red Wing.* 1968–69. Painted aluminum, height 41 $^1/_8$″ **1337** Enrico Castellani. *White Surface 2.* 1962. Oil on shaped canvas, 74 × 55 $^1/_2$″ **1338** Julio Le Parc. *Continuel-Mobile, Continuel-Lumière.* 1963. Motorized lights, height 63″ **1339** Robert Irwin. *Untitled.* 1968. Sprayed Plexiglas disk, diameter 53″

Chairs

1340

1342

1341

1343

Chairs became a prime subject for sculpture in the 1960s. Giacomo Manzù, who had made bronzes of young girls in chairs during the 1940s and 1950s, now substituted fruits and vegetables for nudes. The abundance of the produce creates an almost Surreal contrast to the simple chair.

In California, Harold Paris was among the first sculptors to do bronze casting himself, and, experimenting with the technique, he cast an actual kitchen chair in *Big Momma*. The chair is broken; a disembodied breastlike form protrudes downward. The horrifying humanoid image of this chair may well have been called forth by Paris's having been assigned during World War Two to report on German death camps for an army newspaper.

Joan Miró also had the chair cast directly. A red undefined thing sits on the chair and above the back is a large disk painted blue with a red protrusion where one might expect eyes—if this is a face. But we do not know what it is—all we can see is a playful object of absolute delight.

A feeling of hostility is communicated in the menacing objects designed by Lucas Samaras. In his typical *Untitled* an unbalanced chair covered with brightly colored yarn leans forward toward an equally unsteady chair which bristles with pins.

In a culture that is consumed with "packaging," Christo, who was born

in Bulgaria and came to New York by way of six years in Paris, became famous for wrapping objects as large as buildings and as common as chairs. In *Packed Armchair* he changed the identity of the chair into a curious and mysterious package.

In his poignant tableau *The Wait* Edward Kienholz set the image of a crippled, aged woman into a thronelike chair. Her memories hang around her neck in glass jars. Her head is replaced by the recollection of herself as a girl, and a photograph of her husband when young hangs above the chair. A live bird is in the cage, but otherwise there is only death to wait for.

Soundings by Robert Rauschen-

1344

1346

1345

1347

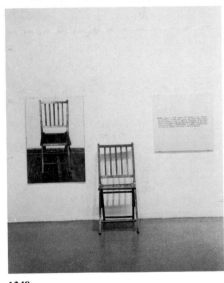

1348

berg is a mixed-media work, made in cooperation with a group of scientists and artists called EAT (Experiments in Art and Technology). When visitors enter the room, they see only their own images reflected. But every sound or noise activates lights and creates multiple images of chairs on Plexiglas panels. Like Duchamp, Rauschenberg makes the spectator responsible for the art.

For George Brecht's *Chair Event* the artist simply presents an ordinary white kitchen chair on which he has placed a cane and an orange. That is all. It recalls the Count de Lautréamont's evocative remark about "the chance encounter, on a dissecting table, of a sewing machine and an umbrella," often quoted by the Surrealists.

The idea, rather than the formed object, gained importance during the 1960s. Heretofore art had been defined largely as physical formulation. Picasso said: "What one does is what counts, not what one had the intention of doing." In contradistinction, Joseph Kosuth wrote in 1969: "All art . . . is conceptual in nature because art only exists conceptually." His *One and Three Chairs* consists of a real folding chair, a photograph of it, and a dictionary definition of a chair. It deals with communication and linguistic problems rather than with a visual or formal object.

1340 Giacomo Manzù. *Chair with Fruits.* 1960. Bronze, height 36″ **1341** Harold Paris. *Big Momma.* 1960–61. Manganese bronze, height 42 $^3/_4$″ **1342** Joan Miró. *Seated Woman and Child.* 1967. Painted bronze, height 52 $^3/_8$″ **1343** Lucas Samaras. *Untitled.* 1965. Wood, pins, and wool, height 35 $^1/_2$″ **1344** Christo. *Packed Armchair.* 1964–65. Armchair, plastic, cloth, polyethylene, and rope, height 38″ **1345** Edward Kienholz. *The Wait.* 1964–65. Tableau: epoxy, glass, wood, and found objects, length 148″ **1346** Robert Rauschenberg. *Soundings.* 1968. Silk screen on Plexiglas with electronic equipment, length 36′ **1347** George Brecht. *Chair Event.* c. 1960. Painted chair, painted cane, and fresh orange, height 33″ **1348** Joseph Kosuth. *One and Three Chairs.* 1965. Wooden folding chair (height 32 $^3/_8$″), photograph of chair (36 × 24 $^1/_8$″), and photographic enlargement of dictionary definition of chair (24 $^1/_8$ × 24 $^1/_2$″)

Conversion of Objects

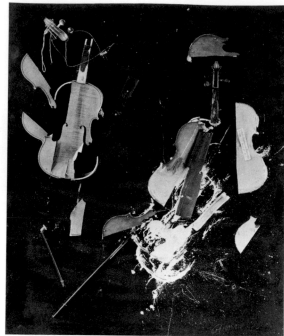

1350

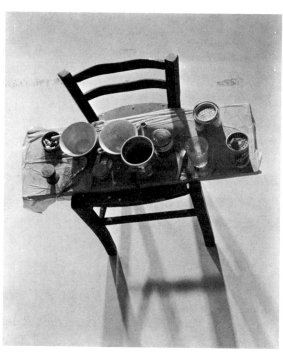

1349

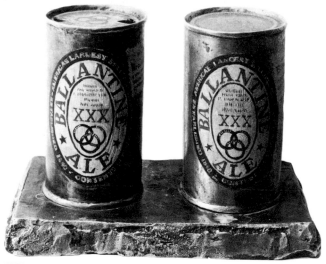

1351

Daniel Spoerri's tableau *Kichka's Breakfast* is concocted of leftovers, literally—the dirty dishes and empty cans remaining from a meal of rather low culinary interest. Mounted on its original table, placed on a wooden chair, and hung on the wall like a picture, *Kichka's Breakfast* documents the remains of an everyday activity. Spoerri's treatment of litter does not physically convert these objects but freezes their momentary appearance into permanence. These objects—cups, Nescafé jar, silverware, cigarette butts—are life stilled.

Arman, like Spoerri, was a member of the Nouveau Réaliste group in Paris. In *Colère du Violon* he seized two violins, familiar romantic forms

carrying age-old cultural implications, and violently fragmented and juxtaposed them, freezing the assemblage in a wall of Plexiglas. Arman's purpose is not destruction but metamorphosis. The clearly identifiable forms of the violins are retained, but the objects, stripped of their original function, now act as aesthetic and intellectual stimuli; they are fossilized remnants of twentieth-century action, evoking tradition while standing irrevocably for the new.

Jasper Johns remade everyday objects—Ballantine ale cans—and transposed them into "art" through subtle and deft touches. Cast in bronze, then mounted on a pedestal, the cans become sculpture. Although

apparently identical, the cans are in fact different. The one on the left is smaller and empty, with a raised imprint on the lid. The can on the right is unexpectedly solid and heavy. While this work originated from a remark which credited the dealer Leo Castelli with the ability to sell anything, even beer cans, it is characteristic of Johns's sense of humor and of the Pop Art ethic in its celebration of images of consumer society as "art."

Claes Oldenburg is the master of metamorphosis—mental and physical conversion. Duchamp had exhibited an actual urinal (plate 459), but Oldenburg softens the toilet in his devastating comment on the

1352

1353

1354

American bathroom culture. What can we do if the toilet has become soft and sagging? Like Charlie Chaplin's great satirical movies, Oldenburg's absurd sculpture is a lampoon on our civilization. The very idea of making sculpture soft is also a frontal attack on the historical notion of sculpture as permanent, but Oldenburg said: "I am for an art that is political-erotical-mystical, that does something other than sit on its ass in a museum."

Robert Arneson's ceramic *Typewriter* also metamorphoses a common inanimate object into a highly personal and uncannily suggestive reference to twentieth-century culture. While the typewriter is easily identifiable, the thick, loosely applied ceramic glazes slightly obscure its careful details and emphasize its hand-made character. The garishly painted finger-keyboard carries the central thrust of Arneson's black humor: while this keyboard is clearly a most witty alteration of a common object, its suggestion of severed fingers is boldly grotesque. Arneson's *Typewriter* mocks not only the man-made object itself but the very notion of sculpture as morally and aesthetically uplifting. Like Oldenburg, Arneson celebrates the absurdities of life *and* art.

The Italian artist Mario Merz, known as a builder of igloos, has turned his attention to these prehistoric domical dwellings and their nomadic implications. He built *Objet cache-toi* of yellow clay, placing neon tubes on its side. The neon light stands in illogical contrast to the igloo, situating the nomadic structure in the modern world.

1349 Daniel Spoerri. *Kichka's Breakfast.* 1960. Wooden chair with board across seat, coffee pot, tumbler, china, egg cups, eggshells, cigarette butts, spoons, tin cans, etc., length 27 1/4″ **1350** Arman. *Colère du Violon.* 1962. Smashed violin with paint, 48 × 39″ **1351** Jasper Johns. *Painted Bronze.* 1960. Painted bronze, height 5 1/2″ **1352** Claes Oldenburg. *Soft Toilet.* 1966. Vinyl, kapok, cloth, and Plexiglas, height 55″ **1353** Robert Arneson. *Typewriter.* 1965. Ceramic, height 6 1/8″ **1354** Mario Merz. *Objet cache-toi.* 1968. Yellow clay and neon, height 43″

Moving Objects

1355

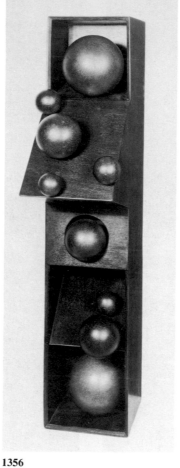

1356

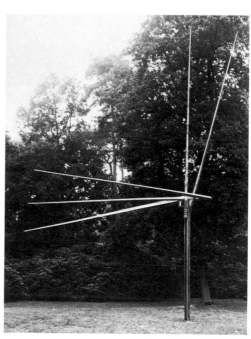

1357

In the late fall of 1960 the Swiss sculptor Jean Tinguely approached this writer with the request that he be allowed to construct a large machine in the garden of New York's Museum of Modern Art, a machine that would destroy itself as a public spectacle. As machines are all around us, Tinguely feels that we might as well play games with them, enjoy them, and set them free. Let them do what *they* want to do.

His suicidal *Homage to New York* was a great Neo-Dada performance. The self-destroying contraption was constructed of a vast quantity of junk—scores of discarded bicycle wheels, saws, an upright piano, a meteorological balloon, etc. The final object, built by the artist, was a handsome piece of junk sculpture, painted white. Then, clinking, clanking and burning, the great machine began to dismember and destroy itself before two hundred guests, only to be prevented from achieving suicide by a crew of firemen —an unexpected finale, not inappropriate to Tinguely's intention.

The Belgian artist Pol Bury works with slow-moving objects. *Nine Balls on Five Planes* has concealed mechanical parts which cause a very slight, almost imperceptible movement. When we gaze at the balls for some time, we see them roll down the inclined plane; they seem to be ready to fall off, only to be mysteriously brought to a halt by the hidden "prime mover." But Bury's world is always precarious, because, as Eugène Ionesco has written, "for Bury there is a constant anguish originating from the basic intuition that everything might collapse under us at any moment: we are sure of nothing."

George Rickey's "lines" are constructed of tapering straight-edged blades, made of stainless steel. They are highly polished, precisely engineered and balanced. Yet, like clouds or waves or leaves, they move randomly with the currents of air. They reflect the light of the sun or moon, they slice the sky. Rickey's blades are engaged in palpable

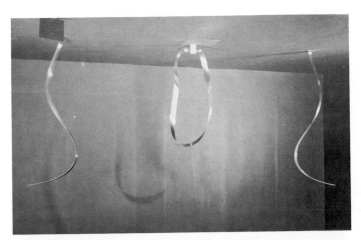

1358

1360

1359

1361

movement, realized in time. Time is as integral an element in Rickey's sculpture as is shape or space.

Len Lye, a pioneer of the abstract film, turned to "tangible motion sculpture" in the late 1950s. With extraordinary creative energy and an explorative mind, Lye was able to harness science and technology in the service of art. His *Flip and Two Twisters* combined the seemingly contradictory qualities of grace and violence. The flip is a band of stainless steel programmed to gather itself into a quivering loop, only to straighten itself out with reverberations, while the twisters on each side spin wildly, only to release themselves with thunderous clangor.

Otto Piene, who was primarily concerned with light in his monochrome paintings (plate 1148), choreographed mechanical ballets whose projected light patterns would pervade the room, increasing the sensation of space for the viewer. Space would appear to open up for the participant, whose movements and agitations were controlled largely by the artist's program.

In New Haven, Connecticut, a group calling itself Pulsa used environment sensors, sound, signal controllers, heat, and strobe lights, all programmed to respond to movement and sound in the environment, similar to Nicolas Schöffer's tower (plate 1098). The person moving through the computer-programmed space here became actually the kinetic object, and viewer participation in the work of art a reality.

1355 Jean Tinguely. *Homage to New York*. 1960. Photograph of event **1356** Pol Bury. *Nine Balls on Five Planes*. 1964. Wood and synthetics, motorized, height 39 ³/₈″ **1357** George Rickey. *Two Verticals, Three Horizontal Lines*. 1966. Stainless steel, height 25′ **1358–1359** Len Lye. *Flip and Two Twisters, "Trilogy."* 1965. Stainless steel, motorized and programmed to flip; flip 88 × 54″ in motion; twisters, height 108″ **1360** Otto Piene. *Light Ballet*. 1965. Eight light sculptures with programmed neon, argon, or incandescent bulbs, height 82 ²/₃″ **1361** Pulsa Group. Yale Golf Course Work. 1969

Process and Materials

1363

1362

1364

Carl Andre's first works, stacked and dismountable vertical pieces, were influenced by his admiration for the pedestals of Brancusi's sculptures. By 1966 Andre became committed to horizontal, ground-hugging forms, wanting his work to be "more like roads than buildings." *Lever* includes two important concerns of Andre's. First, the use of prefabricated materials was meant to shift the viewer's focus from concern with aesthetic character or economic value toward understanding the conceptual basis of the work. Second, the form could easily be understood by mere verbal description, which, of course, diminished the importance of the execution. The fact that almost anybody could assemble the bricks was seen as a democratization of art.

Among the artists working with this methodological approach it was Richard Serra who was most acclaimed by critics. At all times it was the physicality of the materials that mattered most to Serra. *9 Rubber Belts and Neon* has a harnesslike assemblage effect. Although it looks improvisational, the units are not random but are repeatable systems in which the use of the neon tube in the last belt acts as a linear counterpoint. The multiunit pieces then can be seen as substantial and insubstantial, luminous and opaque, structured and unstructured.

Robert Morris turned to "scatter pieces" after working with primary forms. In *Untitled* there appears to be total disorder, but it is the relationship, the "continuity of details," that is important. The pieces may be seen as an overall field, relating to Pollock's unified tangle of drips and spatters. They may also be experienced as a series of units, an indeterminate number of specifically related substances, colors, spaces, and sizes.

Eva Hesse's *Expanded Expansion* is a form which required layering, drying, and assembling. The layered cheesecloth was coated with rubber, dried, then peeled off, creating rough irregular edges and uneven surfaces. Then the ten-foot Fiberglas poles were laid down on the cheesecloth

490

1365

1367

1366

1368

and coated with rubber and resin. This piece combined features prevalent in American art at the end of the sixties, modular systems and serialization, but Hesse was acutely aware of the absurdity of repetition. She brought back feeling and emotion. She wanted to penetrate to a vision of "total risk, freedom, discipline," as she wrote at the end of her very brief life, to "what is yet not known, thought, seen, touched. . . ."

Finding ways to fuse painting and sculpture engrossed Sam Gilliam, a Washington painter who earlier had worked in a vein similar to that of Kenneth Noland (plate 1155). In his *Carrousel Form II* Gilliam splashed paint at random onto the canvas;

then he removed the supports and suspended it freely from the ceiling. It is not seen as what it is—canvas, a piece of cloth, hanging down; somehow it evokes images of mountains and valleys.

Jannis Kounellis, a Greek artist who moved to Italy in the 1950s, was influenced by Lucio Fontana and Alberto Burri, whose art revealed their interest in process. After doing stripe painting in public, Kounellis produced pieces like *Cotton Sculpture*. It is made of steel and cotton, soft and hard, and it too affords a contrast between the structured and the unstructured. The dialectic of structure and nature is fundamental to the work of Kounellis, who later

brought horses into a gallery primarily to disclose the contrast between the rigid social structure of an art gallery and the natural behavior of animals.

1362 Carl Andre. *Lever*. 1966. Fire bricks, length 30′ **1363** Richard Serra. *9 Rubber Belts and Neon*. 1968. Length 18′ **1364** Robert Morris. *Untitled*. 1968–69. Felt, rubber, zinc, aluminum, nickel, stainless steel, and Cor-ten steel, size indeterminate **1365** Eva Hesse. *Expanded Expansion*. 1969. Rubberized cheesecloth, Fiberglas, three sections of 3, 5, and 8 poles each: length 120, 180, 240″ respectively **1366** Sam Gilliam. *Carrousel Form II*. 1969. Acrylic on canvas, length 75′ **1367** Jannis Kounellis. *Cotoniera (Cotton Sculpture)*. 1967. Steel and cotton **1368** Jannis Kounellis. *Horses*. Installation, 1969, Galleria L'Attico, Rome

Aspects of Air and Water

1369

1370

1371

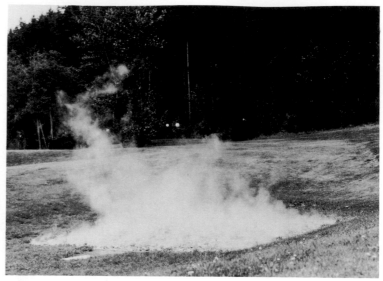

1372

1373

In *Condensation Cube* Hans Haacke allows the cycle of evaporation, condensation, and gravitation to evolve, its pace and pattern dependent upon the variables of climate in the area of display. The process occurs slowly, but can be deciphered from the condensation patterns on the container. Thus, time becomes an essential component of the artistic process. Haacke's exploration of this weather system examines the way the world functions at its most fundamental level, calling the viewer to witness this slow, subtle process.

Allan Kaprow's multilocational Happening *Fluids* consisted of constructing several large, rectangular structures of ice blocks throughout Pasadena over a period of three days. It existed in four phases: (1) a poster advertising the event and soliciting volunteers, (2) an in-depth planning session, (3) construction, (4) the melting process. It combined man-shaped forms and human actions with natural materials and processes. In labeling these activities art, Kaprow questioned the concept of art as an enduring product of a single consciousness executed by a single hand.

Robert Morris's *Untitled* also uses a natural phenomenon as artistic material, substituting the artist's treatment of this material—steam—for a lasting formal arrangement. Not only was the artist's behavior an essential part of the work, but the work itself involved natural and transitory processes of condensation and evaporation, their exact pattern dependent on the local temperature, humidity, pressure, and wind velocity.

Constructed in 1968 for Documenta, the international art exhibition in Kassel, West Germany, Christo's giant *5,600 Cubic Meter Package* was easily the world's tallest inflated sculpture. The synthetic fabric skin was bound in a frame of ropes anchored to the ground by steel wires. Christo's method of packaging, revelation through concealment, was thus applied to the immaterial—air—his sausagelike fabric giving form to the formless. The work's priapic aspect, denied by the artist,

1374

1376

1375

1377

was somewhat emphasized by the contrasting flatness of the landscape in which it was set.

A year later Klaus Rinke ladled Rhine water from twelve points along the river into barrels which he then exhibited with the intention of bringing a flowing, natural element into the formal structure of an institution. The temporal aspects of his own activity may be compared to the continual flow of the river. This unmeasured duration also contrasts markedly with the linear structure of clocked time of the gallery where the water was placed.

Douglas Huebler's *Location Piece #1* involved photographs taken from a plane window over each of the states between New York and Los Angeles. The photographs are indistinguishable from each other. Since, like most of Huebler's other works, *Location Piece* is beyond direct perceptual experience, it thus depends heavily upon documentation, which the artist considers an intrinsic part of the work. Huebler has no interest in creating a new art object, but desires to reinform us about familiar things.

The conceptual artist Robert Barry created a perpetually ongoing and invisible work in his *Inert Gas Series*, for which he released two cubic feet of helium in the Mojave Desert to expand infinitely. While the work continues to exist, its documentation is restricted to the artist's written statement and a photograph of the original site; again aesthetics is replaced by records. His work is a clear illustration both of the de-objectification of art and of the celebration of the natural world.

1369 Hans Haacke. *Condensation Cube.* 1963–65. Acrylic plastic, water, climatological conditions of environment, height 11 3/4″ 1370–1371 Allan Kaprow. *Fluids.* 1967 1372 Robert Morris. *Untitled.* 1967–73. Four steam outlets placed at corners of 25′ square 1373–1374 Christo. *5,600 Cubic Meter Package.* 1968. Height 280′ 1375 Klaus Rinke. *Rhine Action.* 1969 1376 Douglas Huebler. *Location Piece #1.* 1969 1377 Robert Barry. *Inert Gas Series.* 1969. Helium

Land Projects

1378

1379

1380

Toward the end of the 1960s artists began making works by digging, cutting, or directly marking the natural landscape. They took their form from the topographic configurations of the particular site. A crucial impetus was the desire to transcend the limitations imposed by the space available in a studio or gallery and the transitoriness of gallery installations. Another fact in the creation of land projects, or "earthworks," was the desire to avoid making commercial commodities for exhibition and sale. However, due to the relative inaccessibility of the land projects, knowledge of them necessarily depends on secondhand sources. Artists are then dependent upon the art system for dissemination of information through exhibitions of photographs or diagrams and through articles, films, and videotapes.

Early use of phenomena of nature consisted in bringing the elements directly into the gallery space. Walter de Maria's first *Earth Room* filled a Munich gallery with 1,766 cubic feet of pure, fluffy dirt. The dark loam exuded a moist fragrance into the air and provided a sensual and aesthetic contrast to the pristine white architecture. At the same time, the monumental expanse, about 2 feet deep, became an act of aggressive displacement of normal gallery function.

For Dutch artist Jan Dibbets, sites in nature are the locus for explorations in perception. In *Construction in a Forest* one row of trees is distinguished from the others because its trunks have been painted white to a height of 6 feet. The individuality of each tree is unimportant; their sequential use is similar to the seriality of contemporaneous Minimal sculpture.

The gentle manipulations of outdoor environments by the English artist Richard Long are part of a conceptual attitude in which the work serves more as a record of the artist's experience in nature than as an aesthetic product. In *Circles on the Beach* strips of paper have been

1381 **1382**

laid down lightly on the shoreline. Great economy of means has been used. In contrast to artists who have dug deeply into the earth, Long's work has been described as a "portrait of the artist touching the earth."

Dennis Oppenheim also incorporates time and experience into his transitory land projects. In *Annual Rings* he marked the land with a geometric configuration. The irregular circles were hacked with great effort in the ice of the St. John River at the Maine-Canada border. He conjoined the time elements of the two concentric layers of organic growth rings (symbolized in the ice and water layers of the river) with

the dissolution of evidence of that time and growth in the melting of the snow in the spring. As with other such impermanent projects, evidence of the event is maintained through photographed and written documentation.

Michael Heizer's dramatic altering of the surface of the earth at the abutment of canyon and mesa is a sculptural work on the grandest scale. Two 29-foot-wide notches intersect the canyon edge at different angles, yet face each other with 49-foot-deep interior spaces on a single angle. Its massive geometry relates the work to large-scale steel sculpture, yet its enormous size and the requisite displacement of

240,000 tons of earth render this act comparable to the immensity and grandeur of nature. It is a work which can be seen in its entirety—like the panorama of the landscape itself—only from the air. Yet its scale and massiveness are best experienced by standing within the cuts.

1378 Walter de Maria. *The Munich Earth Room.* 1968. 50 cubic meters (1,766 cubic feet) of earth **1379** Jan Dibbets. *Construction in a Forest.* 1969. Ithaca, N.Y. **1380** Richard Long. *Circles on the Beach.* 1967. Paper strip. Krefeld, Germany **1381** Dennis Oppenheim. *Annual Rings.* 1968. Frozen river (St. John River), Fort Kent, Me., 150 × 200′ **1382** Michael Heizer. *Double Negative.* 1969. Virgin River Mesa, Nev., length 1,100′

Environments: Figurative

1383

1385

1384

The fact that George Segal casts his figures from life assures their individuality and realistic quality despite the stark and austere whiteness of the plaster. He places his "white mummies" within readymade props —here a dull, bare wood-and-Formica restaurant booth. Like Degas some seventy years earlier (plate 114), Segal is a master of the simple eloquent gesture; the figure's alienation from this commonplace environment is exposed through her inward-turning pose, her bowed head, her empty coffee cup.

In his figurative group sculptures, or tableaux, Edward Kienholz comments critically on the life of his time, depicting the agony of the human condition as in *The Wait* (plate 1345) or reproducing life as it appears in its customary environment. *The Beanery* is a Hollywood bar into which fourteen figures are crowded. The boredom of these people and the meaninglessness of their activities are indicated by the clock-heads, for they are clearly "killing time." Kienholz's insight into the darker self-centered side of their nature is radically exposed by the wealth of supporting detail: the blaring TV set, the pet poodle, the unread newspaper headline, "CHILDREN KILL CHILDREN IN VIETNAM RIOTS."

Paul Thek built an awesome ziggurat-shaped tomb to house his life-size *Death of a Hippie*. Thek offers this disreputable-looking corpse with a matter-of-fact acceptance of the "ugly-beautiful" character of death. With this nonelevating, antiart-historical subject matter Thek's aim is not simply to shock but to revitalize the viewer into perceiving and acknowledging the mundane, the distasteful, and the true.

Duane Hanson's *Race Riot* embraced superrealism as the vehicle by which to censure the violence and racism of middle-class America. The work was composed of seven figures cast from live models and meticulously reworked. The resulting scene vividly re-created contemporary reality with revealing details: the

496

1386

1387

1388

1389

1390

smug facial expression of the over-weight policeman, arm raised in the act of beating a fallen black youth; the blood-covered weapon held by another youth who is staring at the back of one of the white assailants.

Red Grooms's *City of Chicago* de-fies specific artistic categorization. Individually, his cutouts resemble three-dimensional paintings; collec-tively, they evoke theatrical stage sets. Grooms first created char-acteristic elements of the Windy City (skyscrapers, Mrs. O'Leary's cow), then personified it (Mayor Daley, ecdysiast Sally Rand). The humorous, caricaturelike nature of Grooms's work further divorces it from most traditional sculpture,

while endowing it with a home-made flavor and affection. These figures form an essential component of Grooms's subject—the American urban mix.

Surprisingly, rather similar work was done in the People's Republic of China at the same time. The realistic tableau *Rent Collection Courtyard: Sculptures of Oppression and Revolt* personifies the suffering of thousands under the feudal system in the figure of a single aged man weighed down by the age-old burden of providing food for the rent. The figure's role is defined in the written explanation accompanying the work, but his bent figure and anxious expression are explicit. The anonymity of the artist

is apposite here: no trace of the artist's hand interferes with the ex-pressiveness of the figure itself.

1383 George Segal. *Woman in a Restaurant Booth.* 1961. Plaster, wood, metal, vinyl, and Formica, length 65″
1384–1385 Edward Kienholz. *The Beanery.* 1965. Mixed mediums, length 22′
1386–1387 Paul Thek. *Death of a Hippie.* 1967. Pink painted hardwood, height 102″
1386 *The Tomb* **1387** *The Coffin* **1388** Duane Hanson. *Race Riot.* 1969–71 (destroyed). Mixed mediums, life size **1389** Red Grooms. *City of Chicago.* 1968. Two tons consisting of 5 main pieces, plywood and beaverboard painted with acrylic
1390 Anonymous. Chinese. *Rent Collection Courtyard: Sculptures of Oppression and Revolt.* Late 1960s. Clay. Detail: "The crushing load of rent symbolizes the man-eating feudal system of oppression."

Environments: Abstract

1391

1393

1392

1394

Isamu Noguchi is a sculptor of astounding versatility—carver and modeler, designer for the stage, creator of gardens and urban spaces. He is at home in his New York studio, in the marble quarries of Carrara, in the holy city of Kyoto. He proposed that a sunken garden be an integral part of the overall design for the Chase Manhattan Plaza, an environment for meditation based on Japanese rock gardens and on his thoughts about sculpture as horizontal space. His garden consists of large boulders, which he placed on the floor in concentric circles to allude to the wind blowing on the sea. Water covers the floor, adding to the suggestion of islands in the ocean. Amid the loud pressure of New York's Wall Street this silent Zen garden can set the mind free.

Sculpture as interior environment has been a concern of modern artists for a long time. There were the Futurist interiors by Balla, the *Merzbau* by Schwitters, and the Surrealist space in Giacometti's *Palace at 4 a.m.* In 1961 Herbert Ferber exhibited a room at the Whitney Museum in New York in which his biomorphic forms activated the space and gave it a dynamic effect.

Harold Paris turned from his eroded bronzes (plate 1341) to the creation of eloquently silent ambiences. *Room I* was composed of fifty different elements; some were soft, others hard, and the consistency was always unexpected to the viewer's touch. Many of the objects were erotic in shape, but clinically stark and often frightening in their black and white funerary coldness.

In 1966 Lucas Samaras built *Room #2*, a relatively small space whose four interior sides, floor, and ceiling were totally covered with mirrors. The psychological effect of seeing ourselves in infinite receding images is astonishing: we no longer know where we are located; we seem to be levitating. In this endless room Samaras recalls the death rite of the Greeks, "the scary custom of covering all the mirrors of the house as long as the corpse was in it."

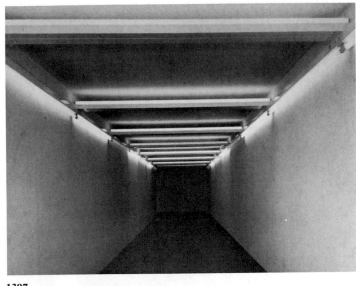

1397

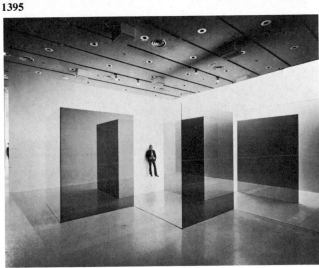

1395

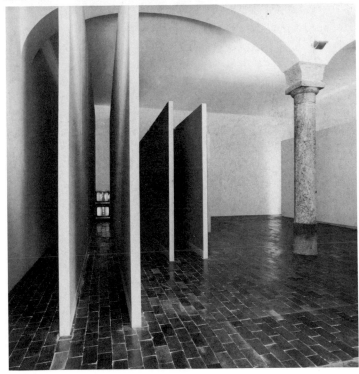

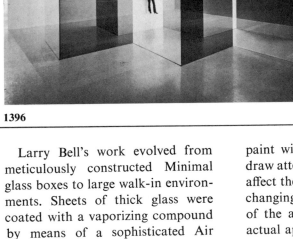

1396

1398

Larry Bell's work evolved from meticulously constructed Minimal glass boxes to large walk-in environments. Sheets of thick glass were coated with a vaporizing compound by means of a sophisticated Air Force "high vacuum optical coating machine" in order to yield both transparent and reflecting surfaces, which merge imperceptibly into each other. The effect is one of mystery: we see our reflection one moment, then it vanishes from sight. The immaculate finish was typical of Los Angeles art in the late 1960s.

Dan Flavin employs industrial fluorescent tubes and places them with great skill at crucial junctures in his spaces. He is actually able to paint with colored light. The lights draw attention to themselves but also affect the environment around them, changing both the virtual appearance of the architectural spaces and the actual appearance of the spectator.

Bruce Nauman made his *Corridor* pieces to give the participants a heightened sense of physical awareness. However, he does not allow the participant to do what he wishes, but "only what I want him to do." The *Corridor* is extremely narrow, and only one person can enter it at a time. In some of the *Corridors* TV cameras are installed so that the participant, trying to negotiate the narrow passageway, can observe the video image of his own behavior. As in Samaras's *Mirrored Rooms*, the viewer has become the subject of the work, and the apparently abstract environment has become figurative, peopled by our own images.

1391 Isamu Noguchi. Chase Manhattan Plaza Garden, New York. 1961–64 **1392** Herbert Ferber. *Sculpture as Environment.* 1961 **1393** Harold Paris. *Room I.* 1965. Mixed mediums, height 144″ **1394** Harold Paris. *Kaddish for the Little Children.* 1966–74. Rubber, brick, sand, plastic, and wood, 12 × 17 × 30′ **1395** Lucas Samaras. *Room #2.* 1966. Wood and mirrors, 8 × 10 × 8′ **1396** Larry Bell. *Untitled.* 1968. Gray and clear glass, 10 panels, height 72″ each **1397** Dan Flavin. *Untitled (To S. M.).* 1969. Red, yellow, pink, and blue fluorescent lights, length 64′ **1398** Bruce Nauman. *Corridor.* 1968–70. Live taped video corridor, width 36″

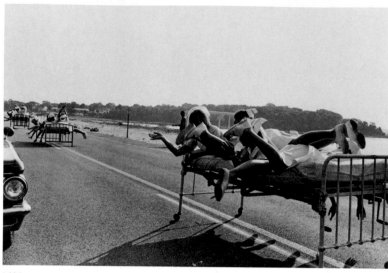

1399

1401

1400

1402

In *The Void* (plate 1104) Yves Klein attempted to prove that the aesthetic experience does not necessarily depend on an actual object. As patrons wanted to purchase his work, however, he permitted them to bring pure gold bullion at an appointed time to a specified place in Paris on the banks of the Seine. In the presence of witnesses from the official art world, Klein would transfer a receipt, which he called *The Immaterial Pictorial Sensitivity Zone,* to the client in exchange for the gold. Like alchemists who had hoped to convert base metals into gold in order ultimately to reach toward the immaterial, Klein then completed the ritual of the immaterial aesthetic by throwing the gold into the river, while the buyer was to burn his receipt.

Joseph Beuys's *Eurasia, 34th Section of the Siberian Symphony* was performed in a number of art galleries as part of the international Fluxus movement. It contained the shamanistic elements and themes that have occupied Beuys throughout his career and that form the corpus of his philosophy. The theme was "the division of the cross," symbolizing the different political ideologies of East and West since the times of Rome and Byzantium. A metal plate represented the vast frozen land mass crossed by migratory animals and people. It was meant to unify diversity and resolve polarities. On the blackboard—symbol of the chief-man in possession of wisdom—he drew a cross and wiped it off, writing below it "Eurasia."

Toward the end of the 1960s Allan Kaprow grew dissatisfied with the theatricality of his earlier Happenings. Reducing their extravaganza aspect, Kaprow began to call his works "activities." For these activities participants were chosen because of their commitment to the realization of projects and their awareness of the deeper implications of the work. *Gas,* an activity realized in several locations on Long Island, could be apprehended only in parts

1403

1405

1404

1406

and through individuals' imaginations; later, each participant compared photographs and experiences.

A group of Viennese artists explored the psychological roots of physical expression. Hermann Nitsch began his *Orgy-Mystery Theater* late in the 1950s and performed his first public action in 1963. Blood, jasmine tea, visceral organs, rose petals, wine, sugar, and the skinned carcass of a lamb were the materials Nitsch used. In an effort to create an "abreactive" ritual, he poured, splashed, smeared, and wallowed in these elements, beating the lamb wildly. Basing his actions on Antonin Artaud's Theater of Cruelty, as well as Greek drama and the Christian Passion, Nitsch

hoped to create a theater in which reenactment of mythical and ritual sacrificial practices could bring about a spiritual healing through catharsis. Nitsch was arrested and charged with indecency, immorality, breach of the peace, and illegal distribution of anonymous printed matter.

Czech artist Milan Knížák's demonstrations in the streets of Prague were fundamentally sociopolitical. They included picking up rubbish and creating assemblages from it, and destroying paintings and sculptures in order to show that they were not aesthetic objects but bearers of repressive culture.

The American Vito Acconci explored behavioral, linguistic, phe-

nomenological, and psychological problems of the body in space. In *Following Piece* he picked out an unknown person on a public street and followed closely until he/she went into a private place. He acted the role of performer, moving with and against another person.

1399 Yves Klein. *Yves Klein Exchanges 20 Grams of Gold Leaf for the Immaterial Pictorial Sensitivity Zone.* 1961. Action **1400** Joseph Beuys. *Eurasia* from the *Siberian Symphony.* 1966 **1401–1402** Allan Kaprow. "Montauk Bluffs" segment of *GAS,* 1966. Photos: © Peter Moore **1403** Hermann Nitsch. *Orgy-Mystery Theater: Action Painting.* 1960–63 **1404–1405** Milan Knížák. *An Individual Demonstration.* 1964. Prague **1406** Vito Acconci. *Following Piece.* 1969. New York

1407

1408

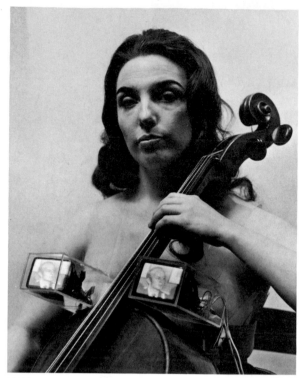

1409

1410

1411

Wolf Vostell worked in many mediums and was the first artist to use television as sculpture. His TV *dé-collage* in New York featured TV sets out of focus and alignment, others bashed in or riddled with bullets. As a participant in Fluxus and Happening activities, Vostell created instant *dé-collage* events by manipulating the controls of a television set to fracture images. He uses TV for purposeful sociopolitical commentary on the impact of the electronic medium on human experience.

The Korean-born artist Nam June Paik is the acknowledged pioneer of television video as an artistic medium. In *Bra for Living Sculpture* he collaborated with Charlotte Moorman, designing *TV Bra* and *Train Bra* for her. *TV Bra* is a pair of small television sets fastened as cups to a plastic strapping apparatus. The television imagery changes in modulation to the sound of Moorman playing her cello. "Video art is not just a TV screen and tape, it is a whole life . . . the TV screen on her body is literally the embodiment of live video art . . . she becomes video," Paik explains.

Bruce Nauman used the medium to document the physical activity of skipping, hopping, and running in the privacy of his own studio, as in *Video Pieces (a-n)*.

Ira Schneider and Frank Gillette's *Wipe Cycle* examined pure feedback and the interrelationship of spectator and medium. Nine monitors programmed into four different cycles returned the viewer's own image mixed with previously recorded tapes and normal television programming. This complex temporal orientation, shifting between past and present with a metaphoric future (the wipe cycle, which erased the image), combined with the layering of visual information, was called by Schneider an "information collage."

Keith Sonnier's early tapes were deliberately crude. He presented close-up images, and as a result, his tapes, like Nauman's, were more intimate than the sophisticated systems of Schneider and Gillette. *Dis-*

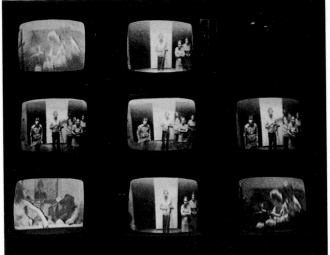

1412

1414

1413

1415

Play focuses on the interplay between a moving hand and a strobe light, which creates patterns of color and movement on the screen. Rather than the dissemination of rational information, Sonnier's primary concern was the visual image, the integration of color and space.

Dan Graham's *Two Correlated Rotations* utilized two super-8 film cameras and projectors to examine the interchangeability of the subject/object position. Each performer, holding the camera viewfinder to his eye, followed the other in counterclockwise movement until the cameraman in the inner circle reached the limits of his inward turn. At this point the activity stopped. In the gallery the viewer saw the two separate "I"'s on two screens set at right angles to one another. The placement of the two screens reestablished the subject/object dichotomy.

Les Levine's *Iris* was a closed-circuit system with six TV monitors and three cameras. The cameras had lenses of different focal lengths in order to provide close-up, wide-range, and long-range views so that a person in front could see three differing views of himself/herself. *Iris* also had a thermostatic device that would respond to a person's body temperature, switching the cameras from one monitor to another. New experience of self and environment is provided electronically.

1407 Wolf Vostell with TV *dé-collage*. Smolin Gallery, New York, Yam Festival, 1963. Photo: © Peter Moore 1408 Wolf Vostell. TV *dé-collage*. Segal's Farm, New Brunswick, N. J., Yam Festival, 1963. Photo: © Peter Moore 1409 Nam June Paik. *Charlotte Moorman TV Bra for Living Sculpture*. 1969. TV sets and cello. Photo: © Peter Moore 1410–1411 Bruce Nauman. *Video Pieces (a-n)*. 1968. $^{1}/_{2}''$ video tape with sound, approximately 2,370' (1 hour) 1412 Ira Schneider and Frank Gillette. *Wipe Cycle*. 1969. Video tape 1413 Keith Sonnier. *Dis-Play*. 1969. $^{1}/_{2}''$ video tape (Sony V–32), approximately 2,370' (1 hour) 1414 Dan Graham. *Two Correlated Rotations*. 1969. Two super-8 film cameras and projectors 1415 Les Levine. *Iris*. 1968. Three TV cameras, TV monitors

Office Buildings

1416

1417

1418

"The tall office building . . . must be tall," Louis Sullivan wrote in 1896; a simple dictum, but one with great meaning at a time when other skyscraper pioneers seemed embarrassed about the daring heights of their creations. In the 1960s architects were no longer masking the extraordinary heights of their buildings; rather, they seemed to revel in a new spirit of one-upmanship. Local and regional height records were broken with dizzying speed, and the world's record was tossed back and forth between Chicago and New York, ending (for the time being) in Chicago, with the topping off of the Sears Tower in 1973.

The first salvo in the race was fired by Skidmore, Owings and Merrill with their 1,105-foot-tall John Hancock Center on Chicago's North Side. The tapered form and bold crisscross exterior bracing were primarily stabilizing devices (though the building, like all skyscrapers, still sways considerably). The same devices, and the building's dull black color, give it an aggressive, virile power. The Hancock also attracted attention because of its combination of uses—offices, apartments, shops, and entertainment. Hancock denizens can ride an elevator from home to work.

In contrast to the Hancock's bold masculinity, Minoru Yamasaki's twin towers for the World Trade Center in New York City appear almost mincing, in spite of their somewhat greater height. Lighter in color, with threadlike strips of windows, and more delicately detailed overall, the shimmering World Trade Center towers are gentler monsters, which have, in fact, been compared to oversize computers.

One of the more curious buildings of the sixties was the General Post Office Tower in London. The fact that this extraterrestrial edifice was commissioned by a government and designed by the staff architects of the Ministry of Public Buildings and Works makes it even more curious. Staid London, so long dominated by the dome of Christopher Wren's

1419

1420

1421

1422

St. Paul's Cathedral, was horrified, but the *outré* appearance of the Post Office Tower was perhaps merely another reflection of the "kickier" side of London in the 1960s.

An enlightened corporate client, gifted architects, and a practically unlimited budget combined to produce *the* prestige office building of the decade—Kevin Roche and John Dinkeloo's Ford Foundation headquarters in New York City. In the midst of the clamorous city, the Ford Foundation building is an oasis of repose and taste. A glass-enclosed, heavily planted atrium rises through the center of the eleven-story structure, with all offices opening onto this paradisical space. While the casual visitor usually finds the building enchanting, its users reportedly have found its fish-bowl openness disconcerting.

At the end of his life Eero Saarinen produced a brilliant building, the John Deere Company Headquarters in Moline, Illinois. Saarinen had already proved his ability to deliver a high-prestige public image for a wealthy corporate client—the General Motors Technical Center (plate 1216). Yet the distance traveled from that polished, mechanistic complex to the Deere building, his last work, is remarkable. Only eight stories tall, the building stretches 330 feet through a beautifully landscaped glade, graced by meandering streams and lakes. The main structural material is Cor-ten steel, which rusts to a warm reddish-brown. The building is a celebration of structure and of man's orderly, respectful presence in nature—the very essence of humanistic architecture.

1416–1417 Skidmore, Owings and Merrill. John Hancock Center, Chicago. 1969 1418 Minoru Yamasaki. World Trade Center, New York. 1964–72 1419 Ministry of Public Buildings and Works. General Post Office Tower, London. 1961–65 1420–1421 Kevin Roche, John Dinkeloo and Associates. Ford Foundation Building, New York. 1967 1422 Eero Saarinen. John Deere Company Headquarters, Moline, Ill. 1961–64

1423

1425

1424

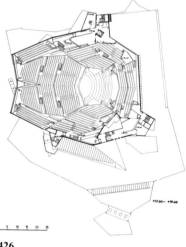

1426

The plan for the Lincoln Center for the Performing Arts in New York City was to provide a nexus for some of the city's most prestigious cultural institutions—the Metropolitan Opera, the New York Philharmonic—and to revitalize Manhattan's West Side. Though designed by several architects, the buildings share a common vocabulary—an attenuated, rather insipid Neoclassicism. If architectural critics were disappointed, concertgoers were appalled by the poor acoustics and obstructed views. The sole exception was Eero Saarinen and Associates' Vivian Beaumont Theater—a strong, unpretentious design.

New public concert halls inevit-

ably generate controversy. Such was the case also with the Sydney Opera House (plate 1205) and the Philharmonic Hall in Berlin, designed by Hans Scharoun. For the interior of the main hall, Scharoun shattered the seating arrangement into a variety of angular shapes, a concept which focuses the concertgoer's maximum attention on the orchestra. Though this spatial organization was dramatically original, it recalls the Expressionist architecture of the 1920s in which Scharoun himself had played a key role.

Frederick Kiesler was a visionary architect as well as an innovative sculptor, and his influence on design theory was significant. In collabora-

tion with Armand Bartos, he designed the Shrine of the Book in Jerusalem. While most of the building is underground, its dome stands as a powerful emblem, superbly sited in the hills of Jerusalem.

Philip Johnson was more responsible than any other architect for defining the contours of American cultural institutions in the 1960s. In addition to commissions at Lincoln Center (the New York State Theater) and the 1964 World's Fair, Johnson designed art museums in Fort Worth, Texas; Lincoln, Nebraska; Corpus Christi, Texas; and Utica, New York. His building for the Munson-Williams-Proctor Institute is a handsome marble block.

1427

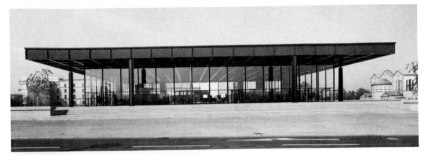

1430

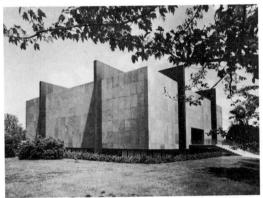

1428

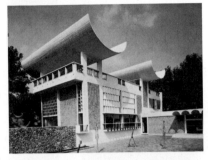

1431

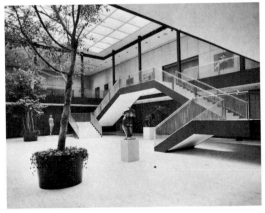

1429

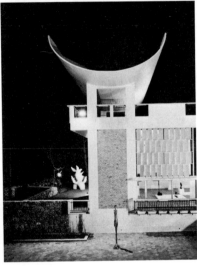

1432

The extruded steel framing frees the skylit interior for changing exhibits.

For most of his life Ludwig Mies van der Rohe unswervingly pursued an ideal architecture that would be, as he put it, "beinahe nichts" ("almost nothing")—an architecture that would derive its power from the simplest resolution of structure and enclosure. None of his buildings expresses this more eloquently than one of his last works, the Nationalgalerie in Berlin—a volume of free space enclosed by a minimal, revealing cage of black steel and glass.

In 1959 Aimé Maeght, the Paris art dealer and publisher, commissioned José Lluís Sert to design a museum for his large personal collection of modern art. Sert had first displayed his talent for integrating the architectural and visual arts at the 1937 world's fair in Paris in his Spanish Pavilion. The Fondation Maeght occupies a breathtaking site atop a hill in Provence. Maeght and Sert decided that the Fondation should resemble a small village, built of local stone and blazingly white stucco. Some works were commissioned for specific spaces; details were worked out *in situ*, with architect, artist, client, and even construction workers involved. Their care was richly rewarded: a museum that is an experience of enduring delight.

1423–1424 Max Abramovitz, Wallace K. Harrison, Philip Johnson, and Eero Saarinen. Lincoln Center Plaza, New York. 1959–69. **1424** (left) Metropolitan Opera House, (right) Vivian Beaumont Theater **1425–1426** Hans Scharoun. Philharmonic Hall, Berlin. 1960–63 **1427** Frederick Kiesler and Armand P. Bartos. Shrine of the Book, Jerusalem. 1957–65 **1428–1429** Philip Johnson. Munson-Williams-Proctor Institute, Utica, N.Y. 1957–60 **1430** Ludwig Mies van der Rohe. Nationalgalerie, Berlin. 1962–68 **1431–1432** José Lluís Sert. Fondation Maeght, Saint-Paul-de-Vence, France. 1959–64

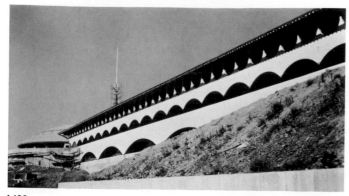

1433

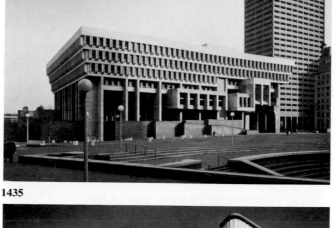

1435

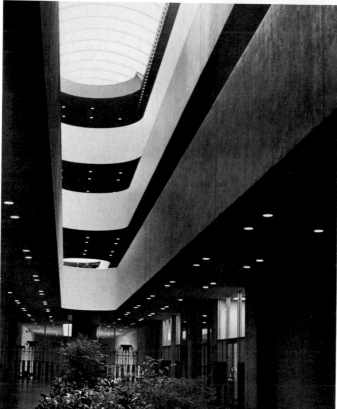

1434

1436

Toward the end of his long life, Frank Lloyd Wright received a commission for a civic center for Marin County, California. Though construction was not begun until after his death, most of the basic design and details are Wright's alone. The centerpiece is a low-profiled administration building, set against a backdrop of softly curved hills, with San Francisco Bay nearby. Two long wings, angling out from a domical hub, stretch across the hillside like aqueducts. Like many of Wright's other late buildings, the Marin County Civic Center has been criticized for its rather gaudy detailing —a shiny gold spire, gold aluminum grilles, and the powder-blue roof.

Nevertheless, the Civic Center remains a grand final statement of Wright's organic ideal.

Though the *concours*, or competition, for major public buildings, a firmly entrenched Beaux-Arts principle, enjoyed great popularity in America around the turn of the century, the practice diminished following World War One. Thus, it was not surprising, after such a long hiatus, that the announcement in 1961 of an open competition for a new city hall in Boston generated much excitement. Two hundred fifty-six designs were submitted, the winning entry being that by the virtually untried firm of Kallmann, McKinnell, and Knowles. The Bos-

ton City Hall was intended as a keynote in a large urban-renewal scheme. The building offered no new design concepts (American public buildings rarely have); the architects relied heavily on Le Corbusier's recent designs for the monastery at La Tourette and his government buildings at Chandigahr. The derivative nature of its Brutalist concrete forms, however, does not diminish the building's success as an image of stability and civic resolve.

The winning design for the Toronto City Hall, by Viljo Revell and John D. Parkin Associates, pairs two tall, curving slabs, cupped around a curiously shaped council chamber. The Toronto buildings

1438

1437

1439

were meant to provide a new focus for a sprawling and diffuse community, and to act as a symbol of Toronto's modernity. Such sentiments were common to many cities in the late 1950s, and their architectural expression was fairly consistent. The ingredients of the Toronto solution—tall office slabs; flamboyantly styled, symbolic legislative building; plaza and fountain—are identical, for example, to those employed at Brasília a few years earlier. But the Toronto buildings, unlike those of Brasília, had to be wedged into an older urban fabric, and the complex's turning of its back walls to its surroundings has been criticized.

In the 1960s Louis Kahn attained a truly international stature, receiving commissions from Israel, India, and Pakistan. In 1962 he was asked to design a "government citadel" for Dacca in East Pakistan (now Bangladesh). The massive project was viewed as more than mere construction; by common consent of architect and client it was seen as an architectural education for a fairly backward, struggling country and as a way of boosting local construction resources. The site presented no special problems, and the basic material, brick, was plentiful locally. Still, the Dacca project proceeded only fitfully, and ground to a complete halt during the Indian-Pakistani wars of the late 1960s.

Though work was resumed under the new Bangladesh government, Dacca remains unfinished. Kahn himself, though speaking in general terms, described the tragic poetry of this complex: "When its use is spent, and it becomes a ruin, the wonder of its beginnings appears again."

1433–1434 Frank Lloyd Wright. Marin County Civic Center, San Rafael, Calif. 1959–61 **1435** Gerhard Kallmann, N. M. McKinnell, and E. F. Knowles. City Hall, Boston. 1961–69 **1436** Viljo Revell and John B. Parkin. City Hall, Toronto. 1958–65 **1437–1439** Louis Kahn. National Assembly Building, Dacca, Bangladesh. Started 1963; unfinished **1438** Model **1439** Ground plan

University Buildings and Research Institutes

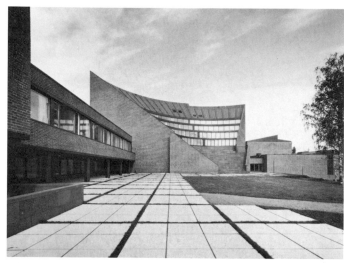

1440

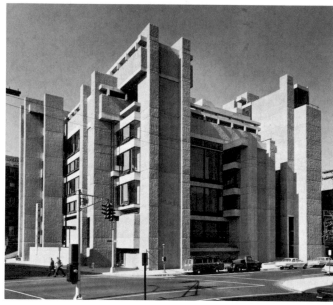

1442

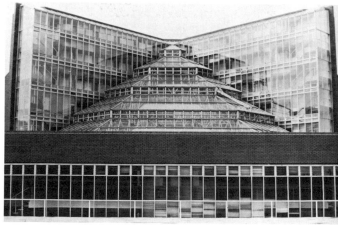

1441

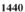

1443

The phenomenal growth of colleges and universities in the 1960s began in the immediate wake of World War Two, but it was not until the products of the postwar baby boom came of age that a dramatic rise in campus populations and construction budgets occurred on a global scale. Alvar Aalto had prepared a plan for a new campus of the Polytechnic Institute in Otaniemi, Finland, as early as 1949. The keystone of the plan was a magnificent auditorium and office building. The auditorium, with its sweeping gesture, crisp outline, and meticulous detailing, marks another high point in Aalto's career.

In England the pressure for uni-

versity growth affected even tradi-

tion-bound Cambridge University where a new History Faculty was built. Offices are contained in an *L*-shaped block, totally glazed on its interior side. The auditorium, wedged into the *L*, sports a flamboyant glass roof. The building has been criticized for the problems of internal temperature control, which inevitably accompany such extensive glazing.

In the decades following the war, the campus of Yale University, in Connecticut, became a showcase for the several major American architects—Louis Kahn, Paul Rudolph, Eero Saarinen, Philip Johnson, and Gordon Bunshaft. Rudolph's Art and Architecture Building, for

obvious reasons, was symbolically the most important. Inspired by Kahn and Le Corbusier, Rudolph delivered a building which functions better scenically than practically. The concrete was poured into corrugated forms; when set, the ridges on the piers were chiseled back by hand, exposing the nubbly aggregate. This finicky and expensive process is an indication of Rudolph's excessive concern with picturesque effects.

From its Zen-like sculpture court designed by Isamu Noguchi, to its plush, carpeted interior, the Beinecke Rare Book Library at Yale, designed by Gordon Bunshaft of Skidmore, Owings and Merrill, has the atmosphere of a *sanctum sanctorum*. It is

1444

1446

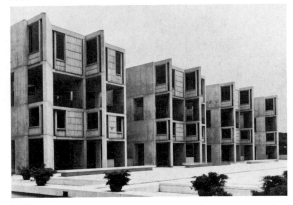

1447

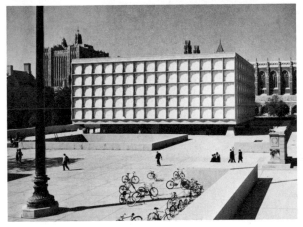

1445

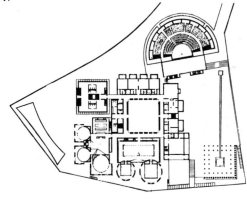

1448

composed of an exterior grid of translucent marble panels slipped over an interior cage of glass and steel, which contains book stacks and exhibition spaces. While some have rhapsodized over the rich nocturnal effect created by the muted gold light emanating from the marble panels, others have waggishly compared the experience to watching a field of blank television screens.

Few architects were able to exercise as much control over an entire campus as was Arthur C. Erickson, in association with Geoffrey Massey, at Simon Fraser University in British Columbia. The university, occupying a spectacular site near Vancouver, is integrated with the terrain by ter-

racing and heavy planting. Instead of the traditional spread-out "sylvan" campus, the plan blends departments, disciplines, and other university functions into a tightly knit unit with interior courts and esplanades.

Louis Kahn's Salk Institute for Biological Studies, in La Jolla, California, is one of the finest examples of twentieth-century institutional architecture. Two research wings, with offices angled out to face the ocean, are separated by an open formal court through which runs a perfectly straight stream of water. Kahn's intent seems to have been to impose a grand order and profound silence on the chaotically beautiful

landscape, the jagged cliffs high above the Pacific Ocean—an inherently classical conceit which directly links this citadel of science with the great monuments of Greece and Rome.

1440 Alvar Aalto. Polytechnic Institute, Otaniemi, Finland. 1955–64
1441–1442 James Stirling and James Gowan. History Faculty, Cambridge University, England. 1966–68 **1443–1444** Paul Rudolph. Art and Architecture Building, Yale University, New Haven. 1959–63 **1445** Skidmore, Owings and Merrill (Gordon Bunshaft). Beinecke Rare Book Library, Yale University, New Haven. 1963
1446 Arthur C. Erickson and Geoffrey Massey. Simon Fraser University, Burnaby Mountain, Vancouver, B.C. 1963–65
1447–1448 Louis Kahn. Jonas B. Salk Institute for Biological Studies, La Jolla, Calif. 1959–65

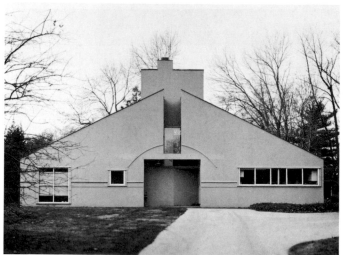

1449

1451

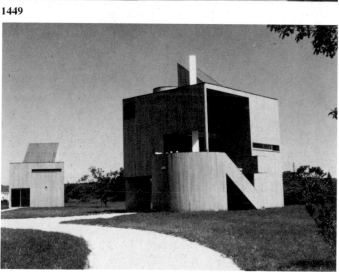

1450

1452

In the 1960s the single-family house became the principal focus of a new inventiveness and willfulness in modern architecture. Not since the heyday of the Prairie School had innovation in this sphere received so much attention from the architectural avant-garde. Robert Venturi, the *enfant terrible* of the profession in the 1960s, gave the new freedom both a theoretical base, through writings such as *Complexity and Contradiction in Architecture* and *Learning from Las Vegas*, and some of its most memorable images. The architect's own house, designed with his partner John Rauch, appears at first a simple thing, but on closer (and internal) examination emerges as a sophisti-

cated exercise in historical and popular allusion and spatial complexity. Venturi's buildings seem at times anti-elegant, self-consciously and wittily coarse.

In quite another vein the work of Charles Gwathmey and Robert Siegel, such as Gwathmey's own house and studio on Long Island, maintains a coolness and suavity very much like that of the Internationalists of the 1920s. The distance is maintained by the extensive use of smoothly planed, naturally weathered wood, by the suppression of mechanistic details, and by the abruptness and variety of interior spaces.

No domestic architect of the de-

cade came closer to the resolution of a true *type* than did the firm of MLTW with Sea Ranch, a weekend-home development on California's North Coast. The basic components of the typical Sea Ranch home—an accretive appearance, irregular outlines, rough, weathered wood exteriors, bold supergraphics, and dramatic spaces inside—soon became distilled into an eminently exportable and profitable commodity. The "Sea Ranch style" was, by the end of the decade, to be found in almost every corner of the United States.

The "modern" movement of Mies and Le Corbusier continued to triumph in the rapidly proliferating field of the high-rise apartment

1453

1455

1454

1456

building. Mies, of course, had been at the forefront of this urban phenomenon, with his Lake Shore Drive Apartments in Chicago. In the 1960s, in the same city, Schipporeit-Heinrich Associates' Lake Point Tower, soaring nearly six hundred fifty feet at the edge of Lake Michigan, was a stunning realization of a visionary design by Mies in 1922 (plate 589) for an undulating, curtain-wall skyscraper. Sheathed in smoky gray glass and framed in concrete, the tower contains some nine hundred luxurious apartments, each commanding a view of the lake.

Many young architects were dissatisfied with the detached house and the apartment skyscraper. Count-less proposals for a new form of domestic architecture poured out of architectural schools. At least one such senior thesis was constructed—Moshe Safdie's Habitat, built for Expo '67 in Montreal. So enthusiastic was its reception that Habitat outdrew all other exhibits. The basic concept—stacking prefabricated concrete boxes in a picturesque jumble to form a dense, cohesive whole—was a simple one in theory, and one with appealing historical and sentimental traditions, such as the Mediterranean village or the pueblos of ancient America. But inevitably, the realization of such a radical concept was not achieved without serious difficulties, the compromising of some of its promise of prefabrication, and enormous cost overruns. Far from serving as a catalytic prototype, the Habitat ideal remains today an elusive dream.

1449 Robert Venturi and John Rauch. Venturi House, Chestnut Hill, Philadelphia. 1962–64 **1450–1452** Charles Gwathmey and Robert Siegel. Gwathmey House and Studio, Amagansett, N.Y. 1965–67 **1453** MLTW (Charles Moore, Donlyn Lyndon, William Turnbull, and Richard Whitaker; Lawrence Halprin, landscape architect). Sea Ranch Condominiums, Gualala, Sonoma County, Calif. 1964–66 **1454** Schipporeit-Heinrich Associates (Associated Architects: Graham, Anderson, Probst, and White). Lake Point Tower, Chicago. 1968 **1455–1456** Moshe Safdie (August Komendant, structural engineer). Habitat, Expo '67, Montreal. 1966–67

Megastructures and Conceptual Architecture

1457

1458

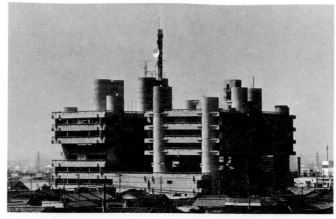

1460

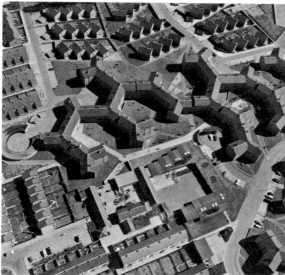

1459

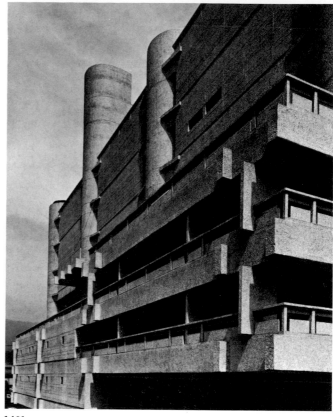

1461

A dominant theme in architectural circles in the 1960s was the idea of a "megastructure," a complex urban structure, or group of structures, that would be infinitely extensible, multipurpose, and highly adaptable to individual tastes and changing needs. Two of the most significant megastructures of the decade emerged from Great Britain.

One was chiefly the work of Peter Cook. Calling on the imagery of fantasy, science fiction, comic books, the Moderne, Futurism, and space technology, his scrupulously detailed drawings for a "Plug-in City" (as well as the zany prose which accompanied them) fairly exploded with a frenzied comic vitality. Yet

beneath this resonated the serious demand for an increased architectural sensitivity to human needs and social and technological change.

Britain's most completely realized megastructure is a town center on a harsh, windswept ridge in Cumbernauld, Scotland. One of Britain's "new towns" of the postwar era, it is relatively small, but within it are met most of the demands of the megastructuralists. Most of the governmental, social, and commercial facilities of the town, as well as some housing, are densely concentrated here; part of the structure straddles a busy highway, making a gesture toward an architectural solution to the traffic problem; and finally, the

building was left "unfinished," that is, it appears to be waiting for future additions.

Kenzo Tange, Japan's leading architect in the 1960s, gave a definitive seal of authority to the image of megastructure with his epic "floating city" projects for Boston Harbor and Tokyo Bay. These imaginative, holistic designs galvanized and solidified an entire movement. The spirit of the Japanese "Metabolists" can be best judged from Tange's Yamanashi Communications Center. The horizontal levels seem to be snapped onto a series of sixteen towers and thus attain the favored image of limitlessness. The forms have a kind of brute, clashing force,

1462

1463

1464

1465

1466

which, combined with the relative enormity of the building in terms of a conventional Japanese town, provides a memorable impact.

Paolo Soleri's "Arcologies" are visionary schemes for packaging the entire range of city activities in colossal, self-contained structures, to be built in remote areas of the globe. Soleri became a veritable cult figure, attracting many ecologically minded followers to his experimental prototype, Arcosanti, in the Arizona desert. There they paid for the privilege of working on the project, an apprenticeship arrangement comparable to the Taliesin Fellowship of Frank Lloyd Wright, with whom Soleri had worked.

The Vehicle Assembly Building for Advanced Saturn Rockets does not actually qualify as a megastructure, as it houses essentially a single function. It does, however, meet one requirement—great size—better than any existing megastructure, because it is volumetrically the largest building ever constructed.

In some ways the grandfather of the urban visionaries of the 1960s, Buckminster Fuller continued to rail at the myopia of contemporary architects and planners, proposing utopian solutions for city problems for which the word "radical" hardly suffices. Fuller's reach has always exceeded his—and society's—grasp. This is clearly indicated by his com-

prehensive project for a two-mile-wide geodesic dome to cover part of Manhattan, with full control of the environment.

1457–1458 Peter Cook and the Archigram team. Plug-in City. 1964 **1459** Hugh Wilson, Dudley Leaker, and Geoffrey Copcutt. Town Center, Cumbernauld New Town, Scotland. 1961–67 **1460–1461** Kenzo Tange and the URTEC team. Yamanashi Communications Center, Kofu, Japan. 1967 **1462–1463** Paolo Soleri. Arcology "Babel II C," Design for a Mushroom City. 1965–69 **1464–1465** Max Urbahn. Vehicle Assembly Building, Advanced Saturn C-5 Launch Complex 39, Merritt Island, Cape Canaveral, Fla. 1962–66 **1466** Buckminster Fuller. Project for hemispherical dome for New York City. 1961

Nine: The 1970s

When the beautiful tall sailing vessels from many nations sailed into New York Harbor in 1976 to help celebrate America's two hundredth birthday, they came to a country that had experienced its first military defeat and whose people were deeply divided. The early seventies had seen the illegal invasion of Cambodia, the heaviest aerial bombardment in history against Vietnamese cities, the deliberate murder of Vietnamese civilians, the killing of American students who protested these outrages, and the revelation of wholesale deception of the public with the publication of the Pentagon Papers.

The loss of the war indicated a decline of a world hegemony the United States had enjoyed since mid-century. The American dollar, once the world's standard currency, went through a series of devaluations. For the first time, the West, dependent on oil for industrial power, was impeded by economic pressures exerted by heretofore politically insignificant oil-rich states. Western need for oil transformed the balance of international power.

President Richard M. Nixon ended two decades of antagonism with the People's Republic of China by visiting Peking in 1972. First Portugal, then Spain, ended decades of dictatorship and repression. This decade was also marked by bloody conflicts in Rhodesia (now Zimbabwe) and Northern Ireland and between Israel and its Arab neighbors.

Terror erupted in many parts of the world, taking its toll of Israeli athletes at the Munich Olympics in 1972; a year later right-wing forces murdered President Salvador Allende of Chile and assumed control of that country. The United States stood accused of aiding the coup, and of backing repressive regimes in Iran and the Philippines, as well. The Soviet Union continued to deny civil rights to its citizens. In Germany industrialists were killed by members of secret revolutionary organizations. Italian Red Brigades kidnaped and killed former Premier Aldo Moro.

While the U.S. was trying to extricate itself from war in Cambodia and Vietnam, it faced corruption at home. The president and many of his lieutenants were implicated in a burglary at Democratic headquarters during the 1972 election and in subsequent cover-ups of these acts. It became clear that the president, believing himself to be above the law, had abused his power. A congressional committee voted to impeach him, and in the bicentennial decade Richard M. Nixon became the first president of the United States ever to resign. Two years later America elected Jimmy Carter, an honest, "born-again" Christian, to the presidency. Many longed for a sense of identity and belonging at a time when most of the old foundations such as the belief in family, country, progress, science and technology, and the reasoning power of the mind itself were placed in doubt. A new kind of Evangelical Christianity became a powerful alternate cultural force in America, claiming more than fifty million adherents at the end of the decade.

A growing skepticism about science and medicine turned millions toward forms of faith healing. Some went to the ultimate extreme of madness in 1978 when the Reverend Jim Jones and 909 members of his People's Temple killed themselves and poisoned their children in the jungles of Guyana.

Less outrageous were the chanting Hindu Hare Krishna devotees with shaved heads and saffron garments, small but conspicuous evidence of a hunger for some sort of spiritual strength. Many engaged in serious study of Eastern religions and some embraced Zen Buddhism. A movement known as Transcendental Meditation, based on Indian religious beliefs, gained millions of adherents.

A Muslim revival swept the Middle East, leading its adherents to topple a regime in Iran backed by America and to engage in civil war in Afghanistan against a government installed by Russia.

The most magnetic individual in the West during the 1970s was Karol Wojtyla, raised from his post as the conservative cardinal of Krakow to become the first non-Italian pontiff in more than four hundred sixty years. He was able to capture the minds and loyalty of millions throughout the world. A Roman Catholic nun, Mother Teresa, who had dedicated her life to helping the poor in Calcutta, was awarded the Nobel peace prize.

The most significant writer of the decade, Aleksandr Solzhenitsyn, was a fervently religious man whose faith in Russian Orthodox precepts of morality underlies much of his work. He vigorously criticized the West's self-indulgence and lack of tough moral standards, while Werner Erhard, founder of est, assured his seminarians that "You are perfect exactly the way you are."

This pronouncement was, of course, the obverse side of the search for spirituality. A new hedonism marked the 1970s as the "me decade." The pursuit of pleasure and awareness of the body became the dominant concerns of the affluent who sat in hot tubs, resting from playing tennis or jogging. Immediate gratification often seemed preferable to work and

thrift in a society whose economic well-being depended on consumerism. "Have a nice day" was the ubiquitous "Farewell" of the decade.

Perhaps people were aware that the "nice days" could be running out. Never had people realized more poignantly that the earth's resources were limited. No new sources of energy seemed in reach as substitutes for petroleum. The malfunction of the Three Mile Island nuclear power plant in Pennsylvania indicated that such power was an extremely hazardous energy alternative. People had been promised a "better life through chemistry" but now found increased pollution. Technological progress certainly had improved the standard of living in developed countries, and held great promise for poor nations. But it was also clear that the computer could govern human lives, that efficiency entailed sacrifice, that bigger was often worse, that technology had the potential to abuse the earth and threaten the natural order and all within it.

In the U.S., blacks continued to press—often unsuccessfully—for parity in the job market and real integration in schools and cities. Homosexuals formed the Gay Liberation Movement, and many Americans finally accepted the premise that in a democratic society the purpose of law is neither to discriminate nor to intrude into private life.

Feminists not only questioned, but assailed, long-held conventions about the place of women and men in society. Using law, clear logic, and human emotion, and often working in a newfound solidarity, they urged the equality of women in jobs, in schools, in the home, in human relationships, advocating liberation of women from their long house arrests as "homemakers." Women affirmed the right to control their own bodies; in 1973 the Supreme Court of the United States ruled abortion legal, which added to the freedom at least of those able to afford the medical expense. By the end of the decade 50 percent of all American women were gainfully employed, yet few held positions of power; they still lacked equal pay for equal work, and ratification of the Equal Rights Amendment, which states simply that "Equality of rights under the law shall not be denied or abridged by the United States or any state on account of sex," was, incredibly, still in doubt.

The feminist movement made a decided impact on the art of the 1970s. One of the main issues of art of the 1970s was whether there is a specific type of women's art. Whereas much of the art of the 1960s was characterized by formalism and cool indifference, and much painting was principally self-referring, art of the seventies was likely to deal with autobiography, politics, society, and the environment—and much of it was done by women.

Performance art, action art, body art—all autobiographical events—became important. There was a new wave of mural painting in the inner cities of America, much of it by ethnic minorities. Art also moved out onto the land. Among the major works of the 1970s were those on a gigantic scale, such as Robert Smithson's *Spiral Jetty* in Utah and Christo's *Running Fence*, meandering for almost twenty-five miles in California.

The old barriers between painting and sculpture on which the formalists had insisted were almost eradicated; even the distinction between the temporal and plastic arts was cast into doubt. Art became "de-defined," as Harold Rosenberg stated. Numerous artists stopped making "objects" to be sold in galleries or displayed in the home.

The 1970s was a decade of pluralism and of revivals. In architecture many of the precepts of the "modern movement" were seen to be flawed, and many architects of the new generation turned toward nostalgia, as distinct from tradition—toward metaphor and mannerism, which they called "postmodern architecture." Photography itself finally—and belatedly—achieved a status on a par with painting and sculpture and became the most collected art form of the decade.

Reacting to the great uncertainty of the 1970s, people invested not only in gold but also in art, causing auction prices to skyrocket. Big art shows, or "blockbusters," traveled to museums from coast to coast and packed in unprecedented masses of eager viewers. They came to admire the relics from the boy pharaoh's tomb in Egypt, the treasures of ancient China, the manuscripts and artifacts of Celtic Ireland, the art that had been buried at Pompeii, the golden crafts of the ancient Scythians, and the curios collected in the *Kunstkammer* by the kings of Saxony. Art was popular as a sentimental journey into the past which seemed to supply millions with a sense of history and glory totally at variance with the unpalatable present. Yet artists, working in multifarious mediums that varied from self-searching performances to imprints on the environment, presented paradigms for an unpredictable future.

	Political Events	**The Humanities and Sciences**	**Architecture, Painting, Sculpture**
1970	United States invades Cambodia Antiwar demonstrations close many U.S. colleges; Ohio National Guard kills four students at Kent State University Salvador Allende becomes Chilean president	People's Republic of China launches its first satellite Aleksandr Solzhenitsyn awarded the Nobel prize for literature Hannah Arendt, *On Violence* Kate Millett, *Sexual Politics* Robert Altman, *M*A*S*H*	New York: Exhibition of "Information" at The Museum of Modern Art New York: Exhibition of "Software" at the Jewish Museum Great Salt Lake, Utah: Robert Smithson, *Spiral Jetty* Scottsdale, Arizona: Paolo Soleri begins Arcosanti
1971	200,000 people march peacefully on Washington to demand end of the Vietnam War Lt. William L. Calley sentenced for murder of Vietnamese civilians at Mylai East Pakistan declares its independence as Bangladesh People's Republic of China admitted to the United Nations	*The New York Times* publishes the Pentagon Papers Astronomers confirm the "black hole" theory Stanley Kunitz, *The Testing Tree* Germaine Greer, *The Female Eunuch* Jerzy Kosinski, *Being There* Peter Bogdanovich, *The Last Picture Show*	Los Angeles: Exhibition of "Art and Technology" at the Los Angeles County Museum of Art
1972	Watergate burglary in Washington, D.C. President Nixon visits the People's Republic of China U.S. Supreme Court holds death penalty unconstitutional Richard M. Nixon reelected U.S. president	Noam Chomsky, *Problems of Knowledge and Freedom* Isaac Bashevis Singer, *Enemies, A Love Story* Bernardo Bertolucci, *Last Tango in Paris* Frances FitzGerald, *Fire in the Lake* Francis Ford Coppola, *The Godfather* (film)	Kassel: Documenta 5; important international survey of new art directed by Harald Szeemann Basel: Exhibition of "Konzept"-Kunst at the Öffentliche Kunstsammlung New York: Exhibition of "Sharp-Focus Realism" at the Sidney Janis Gallery
1973	U.S. and North Vietnam sign a peace treaty Right-wing military junta kills Chilean President Salvador Allende and assumes power War between Israel and Arab countries (Yom Kippur War) Arab oil embargo jolts U.S., Western Europe, and Japan U.S. Supreme Court rules abortion legal	First orbiting space laboratory (Skylab) launched by U.S. Doris Lessing, *The Summer before the Dark* Peter Shaffer, *Equus* Erica Jong, *Fear of Flying* Thomas Pynchon, *Gravity's Rainbow*	Jasper Johns's *Double White Map* sold for $240,000, highest price yet paid for a work by a living American artist
1974	U.S. House Judiciary Committee votes to impeach President Nixon; Nixon resigns; Gerald Ford succeeds India becomes the sixth country to explode a nuclear device Army coup in Portugal ends civilian dictatorship	Nadezhda Mandelstam, *Hope Abandoned* Aleksandr Solzhenitsyn, *The Gulag Archipelago*	New York: "Open Circuits," international conference on video art, held at The Museum of Modern Art

	Political Events	The Humanities and Sciences	Architecture, Painting, Sculpture
1975	International Women's Year, World Conference in Mexico City Generalissimo Francisco Franco dies; Juan Carlos I becomes king of Spain Fall of Phnom Penh to Khmer Rouge troops ends the Cambodian war	American and Soviet astronauts rendezvous in space: Apollo/Soyuz docking Saul Bellow, *Humboldt's Gift* V. S. Naipaul, *Guerrillas* Michelangelo Antonioni, *The Passenger* Robert Altman, *Nashville*	Chicago: Exhibition of "Body Works" at the Institute of Contemporary Art
1976	U.S. celebrates its Bicentennial Israeli commando raid at Entebbe, Uganda, frees 103 aboard a hijacked plane Civil war rages in Lebanon Chairman Mao Tse-tung and Premier Chou En-lai of the People's Republic of China die	U.S. *Vikings 1* and *2* land on Mars, relay photos, and find no life on the planet First synthetic gene constructed Michael MacClure, *Gorf* John Cage, *Renga, Apartment House 1976*	Sonoma and Marin counties, California: Christo's *Running Fence* Los Angeles: Exhibition of "Women Artists: 1550–1950" begins its national tour at the Los Angeles County Museum of Art
1977	Jimmy Carter becomes U.S. president President Anwar el-Sadat of Egypt flies to Israel on a peace mission U.S. signs treaty to relinquish the Panama Canal to Panama First National Women's Conference in Houston, Texas	Günter Grass, *The Flounder* Robert Lowell, *Day by Day* Trans-Alaska pipeline opens George Lucas, *Star Wars*; most successful movie in film history Woody Allen, *Annie Hall*	Paris: Opening of the Centre National d'Art et de Culture Georges Pompidou (Beaubourg) Kassel: Documenta 6 exhibition U.S.: National tour of "The Treasures of Tutankhamen" begins; called "biggest blockbuster ever"
1978	Red Brigade terrorists in Italy kidnap and kill former Prime Minister Aldo Moro Rev. Jim Jones and more than 900 of his followers commit mass suicide in Guyana Civil war in Nicaragua Karol Cardinal Wojtyla elected pontiff; takes name John Paul II	First "test-tube baby" born in Britain Isaac Bashevis Singer awarded the Nobel prize for literature Michael Cimino, *The Deer Hunter*	Washington, D.C.: Opening of the East Building, dedicated to modern art, at the National Gallery of Art Paris: Exhibition of "Paris-Berlin 1900–1933" at the Centre Pompidou New York: Publication of *catalogue raisonné* on Jackson Pollock
1979	Peace treaty signed between Egypt and Israel Margaret Thatcher becomes British prime minister Revolution in Iran: the Shah flees and the Ayatollah Khomeini establishes an Islamic government; American hostages held in Tehran Soviet invasion of Afghanistan Seven-year guerrilla war ends in Rhodesia (now Zimbabwe)	Grave nuclear accident at Three Mile Island, Pennsylvania, causes protests by antinuclear movement *Pioneer 11* photographs Saturn's moons, rings, and satellites William Styron, *Sophie's Choice* Francis Ford Coppola, *Apocalypse Now*	Paris: Exhibition of "Paris-Moscow 1900–1930" at the Centre Pompidou New York: Exhibition of "Transformations in Modern Architecture" at The Museum of Modern Art

1467

1469

1468

A new eclecticism as well as the continuation of modern precepts was evident in buildings. John Portman in his Hyatt Regency Hotel in San Francisco is bad taste at its best. Similar to the hotels that line Miami Beach and the Las Vegas Strip, this building attempts to create an ambience with something for everyone, uneasily unified by the vast, seventeen-story atrium lobby, a signature of Portman's enormously successful series of luxury hotels all over the country. While the space, made possible by modern architectural technology, *is* impressive, it lacks the functional intent of Wright's Larkin Building (plates 136–138), from which it ultimately derives. It is impressive for its intentional shock value, for its "cablecar" elevators that "climb half way to the stars," providing visual excitement for a satiated clientele of corporate and convention visitors.

A sensitively designed series of outdoor "rooms" with carefully defined functions make up the projected Roosevelt Memorial in Washington, D.C. It would contrast markedly with the other presidential monuments around the Tidal Basin. The work of landscape architect Lawrence Halprin and several sculptors, this memorial accepts the impossibility of designing a single building to enshrine the complex personality of FDR, who meant many different things to many people. Instead, gardens, the play of water, huge blocks of unfinished stone, and sculptured reliefs —all on a generous scale—create an environment that forces the visitor to find his own meaning.

The Piazza d'Italia in New Orleans, designed as part of a large urban redevelopment scheme, commemorates the contribution of Italian immigrants to the city. It is also one of the decade's most blatant examples of eclecticism, with a wide range of classical elements taken out of context and reintegrated through Pop Art devices, including neon lighting, to create both a stage set for urban life and a comment on the bizarre, scaleless environment of the

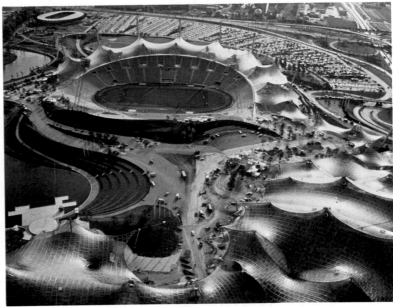

1471

1470

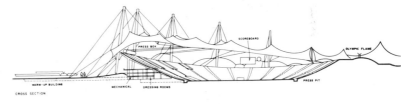

1472

modern city. Whether this project adds to the confusion or helps provide a note of urban amenity is still hotly debated in New Orleans and in architectural circles.

The Rainbow Center Mall and Winter Garden, in Niagara Falls, New York, is the centerpiece of a series of interesting new buildings designed to revitalize the fading image of this once-popular resort city. Cesar Pelli of Victor Gruen Associates has updated the popular nineteenth-century winter garden (or greenhouse), the most famous example of which is the seminal Crystal Palace of 1851. Here steel has replaced cast iron, with a dramatically modern cascading asymmetry instead of the usual classical symmetry of earlier versions. This soaring building brings a garden into the urban core, offering one more tool to combat the flight to the suburbs that has had such disastrous effect on American cities.

The earlier experiments of Frei Otto, the brilliant German engineer (plates 1235–1236), bore fruit in the 1972 Munich Olympiad in a series of interconnected facilities, roofed by a single polymorphous structure that is almost geographic in scale. Like most of Otto's other work, this is a compilation of sinuously curving forms that rely not on a traditional post-and-beam, or compression, structure but on a taut, tensile system: a gossamer web of steel cables is covered with shimmering plastic panels, like a huge transparent circus tent, its nearest relative in earlier architecture.

1467 John Portman. Hyatt Regency Hotel, San Francisco. 1968–73 **1468** Lawrence Halprin. Design for Franklin D. Roosevelt Memorial, Washington, D.C. 1976. **1469** Charles Moore and William Hersey. Piazza d'Italia, New Orleans. 1974–78 **1470** Cesar Pelli and Associates. Rainbow Center Mall and Winter Garden, Niagara Falls, N.Y. 1976–78 **1471–1472** Frei Otto. Olympic Sports Complex, Munich. 1972 **1472** Cross section of stadium

High-Rise Buildings

1473

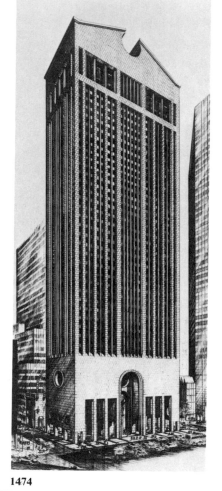

1474

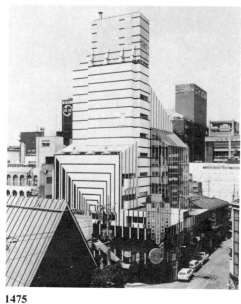

1475

As the most developed architectural symbol of twentieth-century capitalism, the skyscraper is theoretically dedicated to maximizing profit on investment. The Sears Tower, designed by the Chicago office of Skidmore, Owings and Merrill, is the ultimate embodiment of this. The tallest building in the world, the Sears Tower is conceived as a cluster of independent modular "tubes" tied together for mutual bracing. The setbacks in the design are dictated entirely by function: a decreasing number of elevators is needed to service a decreasing office population near the top. Even the dark moodiness of the building is based on function. The curtain wall is of black anodized aluminum because it shows weathering and soot buildup less than other colors and materials, and its bronze-tinted glass reduces the heat in summer.

Philip Johnson in his American Telephone and Telegraph Building, in New York, rejects the Sears formula in favor of historicism, especially in the curiously pedimented main facade. Johnson, an architectural historian and critic before he became an architect, had collaborated enthusiastically with Mies van der Rohe in the International Style (plate 1217). It was not expected that he would resort to what has been called "Chippendale Modern."

The skyscraper, an American invention, has been adopted virtually everywhere. Two recent examples from Japan suggest that the classic American formula is being revamped. Minoru Takeyama's Ni-Ban-Kahn is a miniskyscraper by Sears standards, and even its function—it contains fourteen bars and no offices—is surprising. Dressed in a wild collection of bull's-eye targets and other attention-grabbing supergraphics, the building is designed to stand out in a honky-tonk area.

No less unorthodox is Kisho Kurokawa's Nakagin Capsule Building. A hotel-system for itinerant businessmen and bachelors, it consists almost wholly of prefabricated capsules trucked to the site and lifted into place in the manner of Habitat (plates

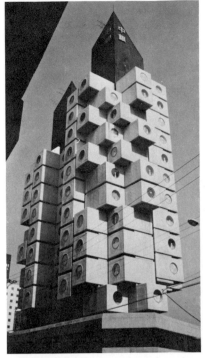

1476

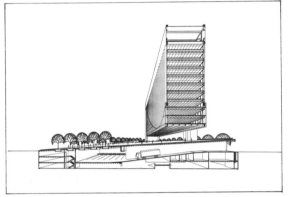

1478

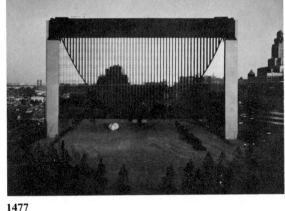

1477

1479

1455–1456), without the amenities—gardens, courts, etc.—of the latter. The resultant stack of modular cubes may look to the Western eye like a pile of washing machines; apparently the intended metaphor was a Japanese birdcage.

Gunnar Birkerts's Federal Reserve Bank, in Minneapolis, challenges the structural concept of previous skyscrapers. With a catenary support system suspended between two towers at ends of the building, this radical structure is closer to a suspension bridge than to the post-and-beam skyscraper. It frees the entire central part of the site from any support columns that would have penetrated into the high-security

vault space below the plaza level, leaving the offices to float dramatically. The vast open plaza becomes a gift to the city.

Gifts to the city are also provided in Hugh Stubbins's Citicorp Building. The gleaming tower terminates in a bold slanted roof originally intended for solar energy panels. The silhouette of its roof distinguishes the building from all the surrounding flat-topped skyscrapers. Raised on huge columns equivalent to a six-story structure, Citicorp provides a munificent plaza at its base. In the huge atrium, where concerts are held and brown baggers are welcome, there are also restaurants, shops, and other services. Even the old Lutheran

church of St. Peter's, which had occupied a part of the site, reappeared, phoenixlike, as a feature of the new complex—with a chapel designed by Louise Nevelson. This is a skyscraper with a conscience.

1473 Skidmore, Owings and Merrill. Sears Tower, Chicago. 1974 1474 Philip Johnson and John Burgee. Design for the American Telephone and Telegraph Building, New York. 1977 1475 Minoru Takeyama. Ni-Ban-Kahn, Tokyo. 1968–70 1476 Kisho Kurokawa. Nakagin Capsule Building, Tokyo. 1970–72 1477–1478 Gunnar Birkerts and Associates. Federal Reserve Bank, Minneapolis. 1967–74 1478 Elevation 1479 Hugh Stubbins. Citicorp Building, New York. 1970–77

1480

1481

1482

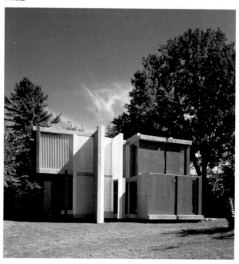

1483

The single-family house also exhibits divergent tendencies in this decade, as seen in the contrast between the works of Richard Meier and Masahiro Chatani. Chatani's House on a Cliff represents a fusion of traditional Japanese forms, seen in the sensitive siting, with the International Style reflected in the use of materials, the machinelike regularity of design elements, and the articulated modular structure. Though adapted to local custom and needs, the house is very much in the mainstream of houses as they evolved in past decades in the West.

Meier's Douglas House represents the postmodernist mode in its much freer use of the modern tradition.

Meier views the early modern, obviously incorporated here—e.g., Le Corbusier's Villa Savoye (plates 553–554)—as *historical* material to be interpreted and played with in an eclectic manner. He also uses an unusually complex spatial development, giving the interior openness, three-dimensionality, and transparency that opens the formal boundaries of the house in every direction.

Peter Eisenman's House VI goes much farther afield in its testing of formal and programmatic concepts that lie outside the accepted canon of modern architecture: this is an architecture of pure geometry, of pure relationships, in which function is a word without meaning. It rep-

resents an "art for art's sake" approach that is the antithesis of modern functionalist ideals, and for this reason is probably closer to certain notions of contemporary sculpture—Minimalism, for example—than to the principles of social responsibility usually expected of the architect. Not since such De Stijl efforts as the Schroeder House (plate 557) have architects been so dominated by theoretical concerns, but now those concerns are as much semantic as real, as Eisenman's abstruse writings about his own work confirm.

J. P. Hölzinger's house and studio in Bad Nauheim, Germany, is equally experimental, but perhaps more successful as a living environment

1484

1486

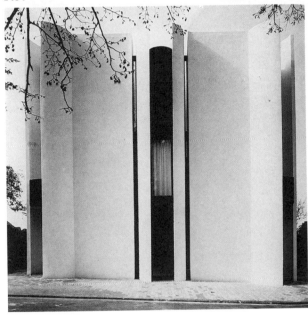

1485

1487

because it is concerned not with pure geometric speculation but with the kind of problem solving that generated modern architecture in the first place. A Baroque sense of illusion is here achieved with the so-called high-tech materials of the latter part of the twentieth century.

The fortresslike appearance of Maurizio Betta's house and studio at Lake Garda is ameliorated by its open receptiveness to the sun. This is Brutalism domesticated.

Bruce Goff's Harder House, in Mountain Lake, Minnesota, represents the continued interest in an architecture all but impossible to label. Part vernacular, but with enormous design sophistication, and part Japanese in feeling, it also belongs to Wright's organic tradition and yet is remarkably free of the mannerisms associated with his followers. Goff experiments freely with the latest material offerings from the cornucopia of twentieth-century technology. The house combines bright orange indoor-outdoor carpeting stretched like a tight skin for the roofing with rugged, Richardsonian boulders dragged from nearby fields. A refreshing kind of underground antihero in modern architecture, Goff can be seen as an American pragmatist. He scorns the arcane theories of Eisenman, countering with the idea that anyone who cannot devise a half-dozen different schemes to fill the program of a project is not worthy of the title of architect. Comparison of the Harder House with the Ford House (plate 948) suggests the protean nature of this disarmingly folksy architect.

1480 Masahiro Chatani. House on a Cliff, Japan. 1971–72 1481–1482 Richard Meier. Douglas House, Harbor Springs, Mich. 1971–73 1483–1484 Peter Eisenman. House VI, Frank House, Cornwall, Conn. 1976 1485 J. P. Hölzinger. House/Studio, Bad Nauheim, Germany. 1977 1486 Maurizio Betta. House/Studio, Lake Garda, Italy. 1978 1487 Bruce Goff. Harder House, Mountain Lake, Minn. 1970

Recycling

1488

1490

1489

1491

The most interesting architectural phenomenon of the decade was the enthusiasm for refurbishing older buildings. Obviously, this was not an entirely new phenomenon. What is new is the wholesale interest in re-using the past, in recycling, in adaptive rehabilitation. A few trial efforts, such as Ghirardelli Square in San Francisco, proved their financial viability in the 1960s, but it was in the 1970s, with strong government support through tax incentives and rapid depreciation, as well as growing interest in ecology issues, that recycling became a major factor on the urban scene.

One of the most comprehensive ventures was the restoration and transformation of Boston's eighteenth-century Faneuil Hall and the Quincy Market, designed in 1824. This section had fallen on hard times, but beginning with the construction of a new City Hall immediately adjacent (plate 1435), it has returned to life with the intelligent reuse of these fine old buildings under the design leadership of Benjamin Thompson. He has provided a marvelous setting for dining, shopping, professional offices, and simply walking.

A similar triumph is underway in London in the recycling of Thomas Telford's 1825–28 St. Katherine Docks. These structures have long since been inadequate for modern shipping and warehousing. The com-

plex now includes fashionable shops, townhouses, restaurants, and a superb marina. The "I" Warehouse restoration consisted largely of removing later additions and layers of grime to reveal the straightforward original design that had inspired a good deal of modern functionalism.

Butler Square, in Minneapolis, exemplifies major changes in its complex of offices, commercial space, and public amenities carved out of a massive pile designed in 1906 as a hardware warehouse. The exciting interior timber structure of the building was highlighted by cutting light courts through the interior and adding large skylights.

The Piranesian spaces of the

1492

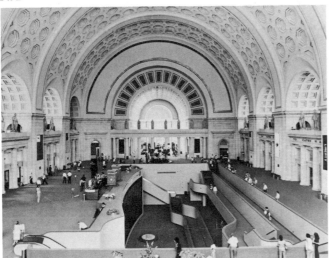

1493

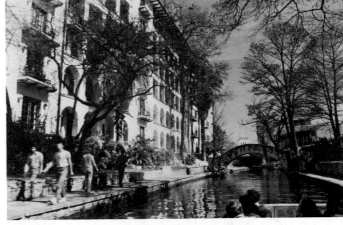

1494

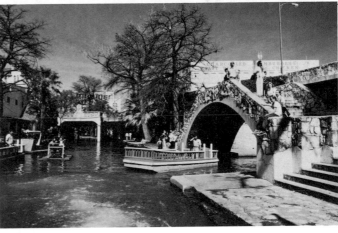

1495

Queensborough Bridge Markets in Manhattan remain essentially as built around 1900 as a farmer's market under the Fifty-ninth Street approach to the bridge—though since about 1930 they have been used as a garage for city vehicles. As proposed by Hardy Holzman Pfeiffer Associates, the great markets are to be modernized and reconverted to their original use, thus returning a note of humanity and community to the city.

Of course, not all efforts at rehabilitation and adaptive reuse have been successful. The project to restore and reuse Washington's Union Station, designed by Daniel Burnham and completed in 1908, proved a disaster. Congress had authorized

the conversion of the huge Roman waiting room into a National Visitor Center—an information service and audiovisual introduction to the national capital. Lacking completion of an Amtrak depot and a four-thousand-car parking structure, the center never came into being.

San Antonio, Texas, offers an object lesson for numerous other cities combating urban decay. Rather than bringing in the bulldozers, San Antonio's leaders rehabilitated existing structures, while simultaneously cleaning up the San Antonio River, which meanders through the business district. Small boats ply through downtown amid lush landscaping; there is a walkway parallel to the

river with access to numerous restaurants, hotels, and specialty shops.

1488 Faneuil Hall and Quincy Market, Boston. Photograph c. 1900 **1489** Benjamin Thompson and Associates. Quincy Market, Boston. 1972–76 **1490** Renton, Howard, Wood, Levin Partnership. "I" Warehouse, St. Katherine Docks, London. 1974 **1491** Miller, Hanson, Westerbeck, and Bell. Butler Square, Minneapolis. 1974 **1492** Hardy Holzman Pfeiffer Associates. Design for Queensborough Bridge Markets, New York. 1977 **1493** Aram H. Mardirosian. Union Station/National Visitor Center, Washington, D.C. 1973–76 **1494–1495** Callins & Wagner. Paseo del Rio, San Antonio. 1964–75

Museums

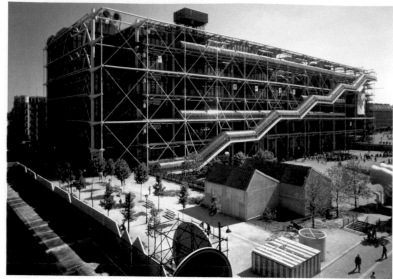

1496

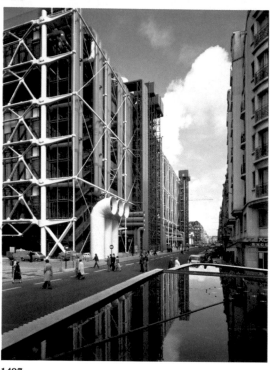

1497

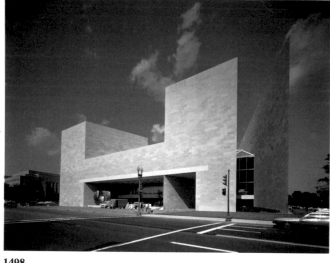

1498

The Centre National d'Art et de Culture Georges Pompidou is an exoskeletal structure of pipes and trusses looking like a child's tinker-toy fantasy realized on an elephantine scale. In addition to serving as a conventional museum, the building houses libraries of books, music, and film, facilities for video and multimedia presentation, as well as a design center. It is one of the few realized buildings of the English Archigram group of the 1960s (plates 1457–1458), and seems to embody some slightly Rube Goldberg–like notions in its references to ships, machines, and high technology. It remains hotly debated because of its high energy consumption and be-

cause of its somewhat temporary appearance. Its five-story escalator ride through transparent plastic tubes offers magnificent views of Paris. Its huge plaza, which includes a reconstruction of Brancusi's studio, provides a forum for everything from artists showing their wares to a Brueghelian carnival of jugglers, fire-eaters, pretzel sellers, and chamber quartets—all mixed with tourists and Parisians.

The jazzy look of high tech was clearly deemed inappropriate for I. M. Pei's East Building addition to the National Gallery, in Washington, the official citadel of fine art in America. The addition actually consists of two separate buildings joined by a glass-

roofed court spanned by an A-space frame (the only element in this impeccably tasteful design that approaches the Beaubourg's love affair with technology). Money was no object in Pei's $94.4 million building, largely financed by Paul Mellon, whose father had donated the main wing back in the late 1930s (plate 844). The elitist design has been hailed by architects and is also a great popular success. It is also a measure of the general acceptance that modern architecture has won: it is inconceivable that fifteen or twenty years earlier the Commission of Fine Arts would have permitted this building to infiltrate into the Neo-classical preserve of the Federal

1499

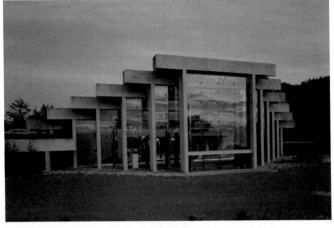

1501

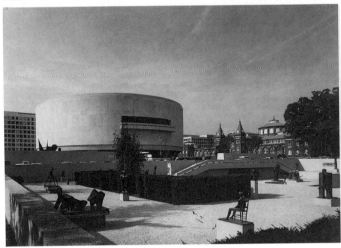

1500

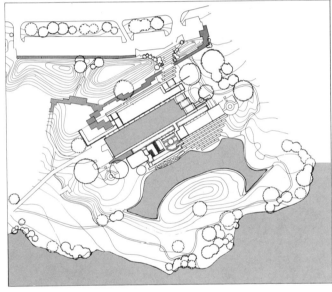

1502

Triangle. It is uncompromisingly modern: its forms, its use of materials, even the functional bifurcation of the building derive from premises of the modern movement.

A few years earlier on the other side of Washington's Mall rose the Hirshhorn Museum and Sculpture Garden. Designed by Gordon Bunshaft, who was responsible for Yale University's Beinecke Library (plate 1445), the Hirshhorn houses the modern art collection donated to the Smithsonian Institution by Joseph H. Hirshhorn. It is a large doughnut-shaped building devoid of significant detailing, and its smooth, unmodulated walls of concrete seem impoverished compared with Pei's struc-

ture diagonally opposite. The building's cold personality is relieved by the expansive sculpture garden and its magnificent contents.

The Museum of Anthropology of the University of British Columbia, designed by Arthur C. Erickson, is a powerfully sculpted building of poured concrete that echoes, but does not compete with, a marvelous collection of Northwest Coast Indian artifacts. Although the museum is less dramatically sited than Erickson's Simon Fraser University (plate 1446), the total design is a subtle metaphor for the arrangement of an Indian village in its orientation to the sea and the forest. The stepped outline of the building is dictated by

its innovative open storage system for its collections. The range of gallery heights allows installation of objects that vary from huge totem poles forty-five feet high to small carvings in horn, wood, and stone, as well as basketry and pottery.

1496–1497 Renzo Piano and Richard Rogers. Centre National d'Art et de Culture Georges Pompidou, Paris. 1971–78 **1498–1499** I. M. Pei and Partners. National Gallery of Art, East Building, Washington, D.C. 1971–78 **1500** Skidmore, Owings and Merrill (Gordon Bunshaft). Hirshhorn Museum and Sculpture Garden, Smithsonian Institution, Washington, D.C. 1974 **1501–1502** Arthur C. Erickson. Museum of Anthropology, University of British Columbia, Vancouver. 1976 **1502** Ground plan

Maps

1503

1506

1504

1505

1507

Many artists in recent years have been making maps—some to orient themselves in an uncertain world, some to explore the new territories of the world and the mind, others to forge political tools.

Jasper Johns painted his *Map of the World* after Buckminster Fuller's Dymaxion air-ocean world map of 1940. Like Fuller, Johns translated geographical information from its usual spherical disposition to a flat surface without breaking the contours of the continents or distorting their actual relations. But Johns's map is above all a painted image, a sensuous, vivid painting.

Derived from satellite photographs, Nancy Graves's *Pacific Ocean Floor, 150 Miles Out* uses a Pointillist technique to suggest subtle barometric patterns on the ocean floor. The allover patterning creates the impression of arrested natural movement, while the controlled technique also suggests scientific objectivity.

William T. Wiley does not base his maps on geographic evidence. They are charts to terrains of fantasy. A lively charcoal line trails across the surface, devising a multitude of images. The yellow square in dead center affirms the flatness of the picture plane. The eccentric punning and zany activity of this narrative picture have inspired numerous young artists to whom Wiley was an alternative to "mainstream art."

Newton and Helen Harrison call their maps, which they began in 1970, "Survival Pieces." They are didactic and have a political purpose. *Meditation*, consisting of hand-tinted maps, was part of a comprehensive campaign which also included handwritten texts, readings of poetic litanies, posters, and use of news media and graffiti to alert the public to the dangerous conditions of the ecosystem. The work is concerned with the survival of nature and of art.

Suzanne Lacy, artist, teacher, and feminist, in collaboration with other artists, created a map of the Los Angeles area and displayed it in the City Mall. Every day Lacy stamped the word "RAPE" in red

1510

1508

1509

1511

to designate the places where a sexual assault had been reported to the police the previous day. *Three Weeks in May* also included public discussion, readings, self-defense demonstrations, and street theater, as well as performances by Lacy.

The maps of Charles Ross and Agnes Denes are more closely related to science than to politics. Ross's map of the stars flattens the universe into the two dimensions of a mural painting. It is based on Hans Vehrenberg's *Falkau Atlas,* which shows stars to the thirteenth magnitude. Ross's viewpoint is that of an observer at the center of the earth. The straight line shows the path of the sun during the year. The maps are

projections of time and light but are also abstract paintings that seek to give aesthetic order to the celestial infinity of the space-time continuum.

Agnes Denes's *The Doughnut,* like her other meticulously rendered map projections, is based on mathematical and philosophic probes. Denes is able to combine systematic and intuitive knowledge and come forth with a new sculptured reality. Searching for the logic of matter, "the continents are allowed to drift, gravity has been tampered with, earth mass altered, polar tensions released. The north pole is forced to meet the south. . . ." Art, as Paul Klee knew, is "the likeness of creation."

1503 Jasper Johns. *Map of the World.* 1969–71. Encaustic, pastel, and collage on canvas (22 panels), 16'5" × 32'9" **1504** Nancy Graves. *Pacific Ocean Floor, 150 Miles Out.* 1971. Acrylic on canvas, 90 × 72" **1505** William T. Wiley. *The World at Large.* 1975. Charcoal and acrylic on canvas, 90 × 98" **1506–1507** Newton and Helen Harrison. *Meditation on the Condition of the Sacramento River, the Delta, and the Bays of San Francisco.* 1977. Collage, photography, oil, graphite, ink, and chalk mounted on plaster walls (6 of 8 maps), 8 × 60' **1507** Detail: *Agricultural Map, Meditation V: On Valving Topsoil* **1508** Suzanne Lacy. *Three Weeks in May* (detail). 1977. Map, 6 × 25' **1509–1510** Charles Ross. *Point Source/Star Space, Sun Center/Degree Cut.* 1975. Acrylic, paper, and ink on canvas, 8'10" × 24'9" **1510** Detail **1511** Agnes Denes. *Isometric Systems in Isotropic Space: Map Projections—The Doughnut (Tangent Torus).* 1974–76. Ink, charcoal on graph paper, and Mylar, 24 × 30"

1512

1514

1513

1515

Alex Colville paints his carefully selected subjects with a keen and precise realism. He observes a street in Berlin: a woman is walking a fox terrier on the banks of *The River Spree,* while a barge floats silently. As in a photograph from a poorly held camera, the woman's head, neck, and shoulder are cut off. The peculiar frame, as well as Colville's ability to freeze time and space, endows his pictures with a sense of mystery. Dating back to the 1950s, his sharply focused paintings without evidence of brushmarks anticipated much of Photorealism.

Richard Estes and Robert Bechtle are among the sharp-focus realists who have concerned themselves with the urban landscape. Working from photographs, they are able to paint the city without street life and traffic; stillness prevails. Estes is fascinated with reflection. In *Ansonia* the right third of the painting is a mirror image of the left-hand section, showing Broadway at Seventy-first Street in Manhattan. The reflected double image caused by the camera's eye—the photograph itself—is the real subject matter of the painting. Suddenly we become aware of the almost total absence of people; their presence would only disturb the stillness of this isolated moment.

Bechtle paints similar cool, objective renderings of city streets in California. A closer look at *Date Palms,* however, shows that the bushy and organic palm trees are contrasted to the ugly plastic-looking buildings, and the three parked cars seem to impersonate the people who are omitted from the sun-drenched street.

Wayne Thiebaud departed from depicting pies and cakes (plate 1287) in the late 1970s to paint the cityscape of San Francisco, a place of precarious heights, dislocated physically and psychologically. In *Down from Twin Peaks* the street shoots up almost vertically as in a primitive painting, but it also provides the cinematic excitement of a car chase.

In *Ruckus Manhattan* Red Grooms and his associates continued their Chicago diorama (plate 1389). The

1516

1519

1517

1518

1520

buildings look real enough to be identified, but they bend and swing in this grotesque tableau; Grooms (one of the initial Happening artists) uses Expressionist distortions. His Manhattan is inhabited by welfare clients, lunch eaters, meter maids, gangsters, protesters, sunbathers—and people just sitting around in this unsavory but very human environment.

Anne and Patrick Poirier work on the theme of the fictional city of Aussee. After staying at the ancient temple site of Angkor Wat in Cambodia and watching excavations at Ostia, they became fascinated with structuring an archaeology of their own. Reality, dream, mythology, curiosity, archaeological study, and nostalgia all enter into their dark and ancient buildings.

Charles Simonds's *Dwellings* are also fantasy remnants of ancient civilizations once inhabited by the tribe of the "Little People." Simonds sited many of these miniature dwellings made of clay bricks and twigs in the fissures and on ledges of the walls of buildings. They created a startling, disorienting effect on the passersby who came upon these diminutive cities, which made the stones of the actual buildings appear gigantic. The dwellings are reminiscent of Pueblo Indian architecture, but unlike the ancient cliff dwellings that survive at Mesa Verde, Simonds's ephemeral ruins were often reduced to rubble in a few days. New York gives much evidence of the life and death cycle of civilization, and Charles Simonds has given tangible form to the transience of culture.

1512 Alex Colville. *The River Spree*. 1971. Acrylic polymer emulsion on board, 23 $\frac{5}{8}$ × 41″ **1513** Richard Estes. *Ansonia*. 1977. Oil on canvas, 48 × 60″ **1514** Robert Bechtle. *Date Palms*. 1971. Oil on canvas, 60 × 84″ **1515** Wayne Thiebaud. *Down from Twin Peaks*. 1977. Oil on canvas, 22 × 16″ **1516–1517** Red Grooms. *Ruckus Manhattan* (details). 1975. Mixed mediums **1516** *Chambers Street* **1517** *Ferry Slip* **1518–1519** Anne and Patrick Poirier. *Reconstruction of the City of Aussee*. 1976. Wood and charcoal, 8 $\frac{1}{4}$″ **1519** Detail **1520** Charles Simonds. *Dwelling*. 1975. Bricks ($\frac{1}{2}$″) and clay

The Human Figure: Photographic Perception

1521

1522

1523

1524

Although Philip Pearlstein does not work from photographs, he views his subject in a manner similar to that of a wide-angle lens and deals with optical problems in sharp focus. He poses his models in an academic way, but his striking use of the diagonal, acute foreshortening, explicit sexuality, and harsh lighting are very much his own, as is his particular way of cropping the composition.

Alfred Leslie, who had achieved considerable success as a second-generation Abstract Expressionist, turned to photographic realism in the late 1960s. In *Angelica Fenner* the light is on the young woman and on the music stand; the background is dark and foreboding. She has just

paused and is looking at the score. Very much like a photographer, the painter has chosen and lighted the instant, providing a sudden, unexpected glimpse into life.

Perhaps the most amazing photographic likeness is Jean-Olivier Hucleux's portrait of the German collectors of contemporary art Irena and Peter Ludwig. The couple stands in a traditional photographic pose. Hucleux's procedure was to project a color slide onto the canvas and reproduce all the details, all the color nuances of hue and tone, and light and shadow, in order to arrive at the hand-made painting which exactly resembles the mechanical photograph. Whereas the original intention

of photography was to accomplish the mimesis at which realistic painting aimed, painting has now succeeded in imitating the camera.

For Chuck Close it is the photograph of Linda, rather than the head of the woman itself, that is his subject. He transfers the photographic image onto the canvas by means of a grid and then, using an airbrush and scratching into the gesso underpaint, creates a monumental frontal image. He paints the human face with all its texture, hair follicles and all. Every part of the face is given equal attention. Although interested primarily in the photograph and its information, Close, by the very intensity of his involvement, ends by

1525

1527

1526

1528

creating heroic heads that recall the giant late Roman marble heads of the Constantinian period.

Duane Hanson and John de Andrea carry realism to the point of deception. Hanson's earlier work, such as *Race Riot* (plate 1388), was a statement of political criticism. His figures of the 1970s, such as *Woman with Suitcases*, are even more lifelike, and viewers are startled when they discover that they are made of Fiberglas and polyester. In Hanson's and De Andrea's work artistic form, structure, and style are replaced by illusion and disguise. In most of his pieces Hanson has chosen lonely, often desperate, people, casualties of life, stereotypes in isolation in their typical surroundings. In contrast, De Andrea's naked young men and women are handsome, slender American types, erotic but no more alive than their Fiberglas-polyester bodies.

Ruth Francken's *Mirrorical Returns* (an expression borrowed from Marcel Duchamp) are pencil drawings, based on photographs with cutout fragments added. Drawn with the utmost realism, her mix of mediums results in the integration of photograph and drawing: the technological product and that created by the hand of the artist exist on the same level. *Mirrorical Returns* are also confrontations in which one profile of the sitter (who is usually a well-known cultural figure) scruti-

nizes the other profile. Observing his mirror image here, the painter Richard Lindner appears to question his own identity.

1521 Philip Pearlstein. *Reclining Nude on Green Couch*. 1971. Oil on canvas, 60 × 48″ **1522** Alfred Leslie. *Angelica Fenner*. 1978. Oil on canvas, 108 × 84″ **1523–1524** Jean-Olivier Hucleux. *Portrait of Irena and Peter Ludwig*. 1975–76. Oil on panel, 59 $\frac{7}{8}$ × 48 $\frac{3}{8}$″ **1524** Unfinished portrait in studio **1525** Chuck Close. *Linda*. 1975–76. Acrylic on linen, 108 × 84″ **1526** Duane Hanson. *Woman with Suitcases*. 1973. Polyester resin and Fiberglas, life size **1527** John de Andrea. *Reclining Figure*. 1970. Polyester resin polychromed in oil, life size **1528** Ruth Francken. *Mirrorical Return—Richard Lindner* (section 1 of triptych). 1977–78. Drawing on cardboard with cutout and photo fragments, 25 $\frac{5}{8}$ × 19 $\frac{5}{8}$″

The Human Figure: Painterly Perception

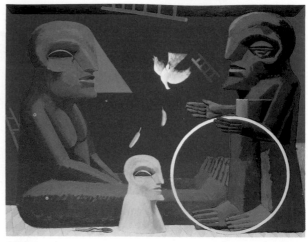

1531

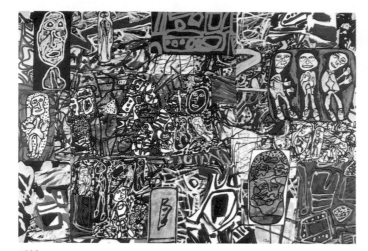

1529

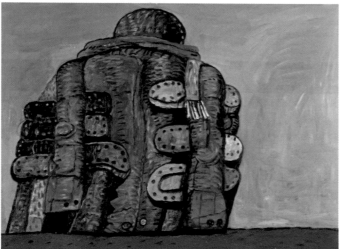

1530

1532

In his mid-seventies the infinitely inventive Jean Dubuffet embarked on a great summary of his work, the *Theaters of Memory* series. As in his earlier assemblages (plate 1175), he cut passages from previously prepared paintings and glued them to the new support. Images from his whole protean career appear in a layered panorama in *Recycling Machine*. Some are clearly delineated, while others are hazy, but all are afloat in the stream of fluid memory.

Whereas Dubuffet rejected the European tradition, Guston felt himself always part of the continuous dialogue of art. Above all, he admired and understood the work of Piero della Francesca and wrote about the great Renaissance painter's "rhythm of the plane," his "cosmic geometry," and the "slowness of his spaces." A related monumental solidity and mystery of form is achieved in Guston's *Back View*. In this somber painting, a man, seen from the back, upturned shoes on his pack, walks into nowhere. The brushstroke is vigorous and the colors are beautiful, creating an eloquent contrast to the haunting futility in this work.

In *Family Picture* a boulderlike father confronts the seated giant earth mother, while the bust of a child appears between them. Horst Antes paints austere humanoid figures engaged in measured, magic interaction. Like Beckmann's enigmatic paintings, they are filled with a disquieting sense of mystery.

Irving Petlin deals with a more Surreal mystery, a Redon-like transcendental world encapsulated in a drop of water. No known scale helps us measure this eerie landscape of the mind in which figures—silent, allusive—gravitate to the edge.

The English painter Frank Auerbach also does not fit the avant-garde conventions of his time. He has endowed the Northern Expressionist tradition with new vigor. His thick, relieflike impasto is the result of a sustained struggle with matter; the richly textured portraits are memorable paintings of a passionate brush gesture.

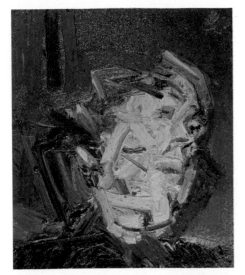

1533

1535

1534

1536

A vehement brush was also used by Arnulf Rainer, the highly innovative Austrian action painter, when he painted over a photograph of his face and torso. The purpose of this work was to articulate the tensions of muscles and nerves, of which he first became aware during experiments with hallucinogenic drugs. The result is a highly self-revealing portrait like *Butterfly on My Nose*.

The Israeli artist Avigdor Arikha, born in Romania and living in Paris, had been working in an abstract style when he decided to work from nature to achieve greater immediacy and lucidity. A man of erudition and deep art-historical knowledge, he was able to arrive at an absolutely correct and astonishing composition in a painting like *Self-Portrait Standing behind Canvas* and to complete the picture in a single sitting. Disparaging photography, he re-creates a tradition in painting in which volume, depth, and feeling are communicated through the artist's intense scrutiny of his subject.

May Stevens made a modern history painting in her large *Mysteries and Politics*, juxtaposing portraits of contemporary feminist artists and art historians with the large out-of-scale image of Rosa Luxemburg, the German revolutionary leader. Personal art and public concerns, the past and present, are combined to form a new political allegory.

1529 Jean Dubuffet. *Recycling Machine*. 1978. Acrylic and paper collage on canvas, 79 × 114″ 1530 Philip Guston. *Back View*. 1977. Oil on canvas, 69 × 94″ 1531 Horst Antes. *Family Picture*. 1979. Oil on canvas, 39 $^1/_2$ × 50″ 1532 Irving Petlin. *Rubbings from the Calcium Garden . . . Sarah Born*. 1974. Oil on canvas, 120 × 96″ 1533 Frank Auerbach. *Head of J.Y.M.* 1974. Oil on canvas, 28 × 24″ 1534 Arnulf Rainer. *Butterfly on My Nose*. 1970–73. Oil on photosensitive canvas, 65 $^3/_8$ × 45 $^5/_8$″ 1535 Avigdor Arikha. *Self-Portrait Standing behind Canvas*. 1978. Oil on canvas, 45 $^3/_4$ × 29 $^5/_8$″ 1536 May Stevens. *Mysteries and Politics*. 1978. Acrylic on canvas, 72 × 144″

Installations

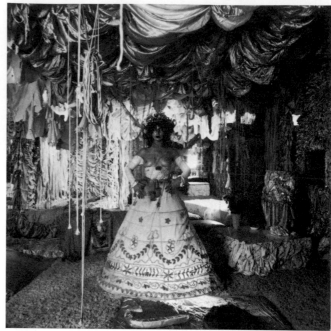

1538

1537

1539

Tram Stop by the German Joseph Beuys was a largely autobiographical installation at the Venice Biennale of 1976. Simple materials and construction belied a complex iconography keyed to symbols from Beuys's career. In the center stood an iron column topped with a head of a man (sculpted by Beuys). Near it ran a tramline. A hole was sunk into the water of the lagoon below and connected with the installation by tube, linking land above and water below. Three of the elements were thus bound into the work: air (the vertically rising monument), earth (the horizontally running tramline), and water. Also part of *Tram Stop* was a pile of dirt and bones excavated during the installation. These were to evoke history, Germany/Italy, and human memory.

Whereas most installations have a very short life span, Colette has worked for ten years on her *Living Environment* "transformation." Using silks and satins, mirrors, concealed lighting, and cascading ropes, Colette has converted a nondescript space in New York's Wall Street area into her own mystery theater in which she appears as a "living doll."

At Chicago's Institute of Contemporary Art, Robert Irwin focused on the way in which light can interact with space. He created such subtle visual experiences that it took a great deal of time before the ex-
 tremely dematerialized reality became apparent. "Art," he says, "is placing your attention on the periphery of knowing."

Music Room by Takis at Documenta 6 in Kassel was a kinetic sculpture consisting of steel, wire, and electromagnetic components. In a room the visitor heard thunderous sounds from a large metal sheet and the response from an electronic chorus of smaller stringed instruments. All the sounds were produced at random by magnetic forces, mysterious natural powers.

Lynn Hershman created a series of tableaux in the windows of a New York City department store. In one a mannequin's hand crashed

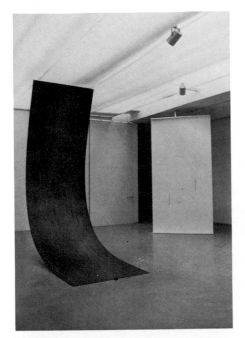

1540

1541

1543

through the glass in order to escape her confinement. A mirror near the break reflected buildings and traffic, as well as the viewer's face. In other windows, Hershman showed the liberated "Bonnie's" journey through Manhattan.

Vito Acconci installed a platform suspended by rope ladders at Wright State University in Dayton, Ohio. Dealing with physical and psychological states, Acconci's installation evoked notions of stability and instability by a series of questions and statements piped into the space from a sound tape: "What do you know? Can I get out? Is it falling in on top of you? Are you in it alone?" Climbing the ladders and sitting in

the middle of the suspended platform, visitors experienced a precarious balance in this metaphor for structures in general.

Dennis Oppenheim's visionary model referring to a locomotive roundhouse was a proposal for an Earthworks Symposium in Seattle, Washington. Water would gain partial entry along a two-hundred-fifty-foot trough leading to the circle within, one hundred feet in diameter. A quasi-functional covered tunnel led away from the inner circle on train tracks, ostensibly to carry the ghost ships of the subtitle, which also suggests possible events which might result from the engagement of elements.

1537 Joseph Beuys. *Tram Stop.* 1976
1538 Colette. *Justine of Colette Is Dead Co., Ltd. Posing as the Doll in Living Environment (1970–80).* Transformation
1539 Robert Irwin. *Untitled.* 1975
1540 Takis. *Music Room.* 1977 **1541** Lynn Hershman. *The Future Is Always Present, Bonwit Teller* (detail). 1976 **1542** Vito Acconci. *The Middle of the World.* 1976
1543 Dennis Oppenheim. *Waiting Room for the Midnight Special (A Thought Collision Factory for Ghost Ships).* 1979

Wood and Fiber Sculpture

1544

1546

1545

1547

Radar, consisting of sharply cut pieces of maple placed on a smooth platform which is set on a revolving table, continues Louise Bourgeois's long interest in the juxtaposition of organic and geometric forms. It is a maquette for a larger outdoor piece to signal the use of solar energy.

After the more mechanical, almost Minimal, pieces of the 1960s, Louise Nevelson returned to her assemblages (plate 1084). In *Mrs. N.'s Palace* the artist, who once referred to herself as "an architect of shadows," has made a mysterious cavelike room. As the visitor walks on the black mirror floor of this sanctuary, the concealed dim light slowly discloses its allusive surfaces.

Mary Miss's constructions facilitate perception of environmental space and transient time. The five heavy plank walls of her *Untitled* of 1973 were arranged at regular intervals across a flat area of Hudson River landfill, in New York. Each wall had a circular opening in its center, but in each progressive plank the aperture was at a lower level. While the horizontal planks were parallel to the horizon plane, the gradual sinking of the circle evoked the image of a setting sun.

Alice Aycock also operates in a world between sculpture and architecture. Or perhaps all these works can be seen as nonfunctioning architecture. Aycock's Documenta project

encouraged and frustrated exploration. Combining elements that differ radically in scale, this Potemkin village or movie set is a precarious labyrinth. The top edge of the series of partitions descends in steps toward the ground so that the cut windows eventually appear as a doorway in the lowest panels. This work causes bewilderment and perplexity.

While it may be surprising that it was, above all, women who built large wooden constructions in the 1970s, both women and men worked in fabric and fiber. Dominic di Mare uses a mixture of traditional materials which he illuminates with modern understanding and fierce attention to details. *Ancient Tide/1962*

1548

1550

1549

1551

is a tepeelike structure in which image and content, material and form are fused. Although it is small, this configuration is monumental in concept.

Magdalena Abakanowicz, working in Poland, has made a cycle of enigmatic images called *Alterations—Thinkers on the Human Condition.* She uses organic materials to underscore the human being's place in the world of nature and to emphasize organic reality, with its rhythms and rules, which, she feels, are contrary to the artificial and mechanical aspects of modern society.

Barbara Shawcroft's *Legs* was commissioned for a subway station of the San Francisco Bay Area Rapid

Transit system. *Legs* is a gigantic sculpture fifty feet high and weighing seven thousand pounds. "In bigness," Shawcroft writes, "we are remembered." *Legs* seems like a revered old ritual object amid modern technology.

The Belgian artist Panamarenko combines wood, synthetic fibers, and much else to construct utopian flying machines, such as *Umbilly I.* This fantastic apparatus can flap its wings and create a special aerodynamic lift, imitating certain high-speed wasps. An inventor who works with precise data and calculations, this modern Icarus writes that "when flying is analyzed, it is discovered that one flies farther in spirit than in reality."

1544 Louise Bourgeois. *Radar.* 1978. Maple, height 16 $\frac{1}{4}$″ **1545** Louise Nevelson. *Mrs. N.'s Palace.* 1964–77. Wood painted black and black mirror, height 140″ **1546** Mary Miss. *Untitled.* 1973. Five wooden walls, 50′ apart, height 66″ each **1547** Alice Aycock. *The Beginnings of a Complex.* 1977. Wood and concrete, height 29′6″ **1548** Dominic di Mare. *Ancient Tide/1962.* 1978. Hawthorne wood, spun Gampi paper, silk thread, linen thread, ink, colored pencil, carved bone, and feathers, height 11″ **1549** Magdalena Abakanowicz. *Alterations—Thinkers on the Human Condition.* Installation, 1976, Art Gallery of New South Wales, Sydney **1550** Barbara Shawcroft. *Legs.* 1978. NOMEX (nonflammable nylon), height 50′ **1551** Panamarenko. *Umbilly I.* 1976. Balsa wood, styrofoam, Mylar film, Fiberglas tubes, and steel mechanism

Line and Space

1552

1553

1554

Over a period of almost thirty years Al Held's work has experienced many changes before arriving at the black and white paintings of linear illusions. *South Southwest* is an exploration of space by means of cubes and circles seen in various projections and from multiple vantage points. By means of a network of black acrylic lines, he achieves a dynamic geometric fusion of interior and exterior space.

Dorothea Rockburne's *Velar— Combination Series* has a striking simplicity and immediacy, yet its minimal means contain rather complex relationships. The translucent vellum fold and pencil traces create crosses, triangles, bisections, and other basic geometric forms, and the previous stages of the vellum are incorporated as well in the present folded work. The austere, impersonal formal aesthetic of this work is apposite for Rockburne's expression of art as a record embodying a system of thought.

In *Morr Sucking P.I.S.E.* Alan Shields combines canvas belting, thread stitching, and beads to make a two-sided painting, hung freely in space. Shields, rejecting many of the cool and formalist dogmas of his generation, constructs refreshing, playful, colorful pictures, with linear grids or patterns that mix geometry with irregularity.

Norbert Kricke's major concern has always been to give form to the concept of the space-time continuum, which the sculptor reveals by means of line, "line as the form of movement." In the 1970s he simplified his statements, and instead of bursts of trajectories (plate 1091), he reduced his sculpture to a single line, as in this piece, whose title pays homage to Sigfried Giedion, the author of the influential treatise *Space, Time, and Architecture*. The linear tube makes rectangular turns along the ground and then rises sharply at a ninety-degree angle to a considerable height, pointing to infinity. It is painted white to emphasize the contrast between the organic world and that of man's rational, deliberate creation.

1555

1556

1557

For Patrick Ireland, too, line takes on a sense of materiality. His *Rope Drawing #19, 25 Lines* depended on the natural aesthetic properties of pieces of rope and on the viewer, whose changing perceptions brought the piece to life. The temporary work was composed of twenty-five vertical ropes or "lines" of varying heights set in rows at an angle to the room's rectangle. There was no single fixed point of view; the visitor wandered through the ropes, his vistas altering with each step. The installation was in an old building, whose uneven floors, mildewed walls, and crumbling ceiling created a dramatic contrast to Ireland's exactly placed lines and the austere white-walled gallery.

Klaus Rinke's *Expansion* is a series consisting of fifty photographs and graphite drawings concerned with physical action as a demonstration of temporal/spatial change, visual perception, transformation of conditions, and the various means by which we come to understand these conditions. Photographs show Rinke's sequential moves from a fixed point in space to a distant point and back. While moving from position to position, he swung a graphite pencil which recorded the expansion of his advance and retreat. The resulting series of concave and convex markings increase and decrease in size from point to point. The duration and the distance are ex-

pressed through line and photograph (from toe point to distant full figure); communication with the mental and physical experience is accomplished by means of graphic design.

1552 Al Held. *South Southwest*. 1973. Acrylic on canvas, 98 × 144" 1553 Dorothea Rockburne. *Velar—Combination Series*. 1978. Vellum and colored pencil, 45 × 33" 1554 Alan Shields. *Morr Sucking P.I.S.E.* 1971. Canvas belting, thread stitching, and beads, 96 × 192" 1555 Norbert Kricke. *Space-Time-Sculpture Large Giedion*. 1977. Stainless steel, height 38' 1556 Patrick Ireland. *Rope Drawing #19, 25 Lines*. 1976. Rope and nylon 1557 Klaus Rinke. *Expansion*. 1973. Photographs and graphite drawing (50 parts), 8'3" × 49'6"

Color and Structure on Canvas

1558

1559

1560

1561

Alfred Jensen is a very private and difficult artist who exerts a powerful underground influence on other artists. He sees himself as a mystic and relies on recurrent images of his childhood in Guatemala. His paintings are related to cabalistic signs and alchemical diagrams, to his study of Egyptian and Maya calendars, tantric diagrams, the *I Ching,* to his interest in space travel and Goethe's theory of color. *The Doric Order* refers to the Pythagorean laws which helped determine the design of the Parthenon. Despite their concern with abstract ideas, Jensen's paintings are very physical—substantial and thickly painted.

544 Always defying expectations, Jas-

per Johns turned in the early 1970s to painting which appears totally abstract. *Céline* consists of four interacting oblong panels; the lower ones are based on his flagstone motifs, while the upper panels are crosshatched. The painting is seductive in its sheer visual beauty, but Johns has never been satisfied with aesthetic form itself. He has a message encoded in this painting, titled after the misanthropic French novelist.

When pure abstract painting seemed to be an endangered species so far as younger painters were concerned, Brice Marden appeared and painted monochromes in static, muted, persistent colors. He painted five canvases inspired by the mystery

of the Annunciation as described by a fifteenth-century Florentine monk, which are primarily about color and order. *Conturbatio* consists of four panels, two of which are half as wide as the other two. Each panel is an individual unit and simultaneously part of a rhythmic whole which moves alternately from dark to light.

After a decade of figurative painting (plate 1125) Richard Diebenkorn returned to abstraction. His *Ocean Park* series is based on his experience of light and color, and on his deeply felt relationships to the art of the past, above all to Matisse, for his understanding of color and pictorial structure. Diebenkorn, who uses oil

1562

1563

1564

because it yields greater luminosity than acrylic, bases *Ocean Park No. 66* on the structural system of a vertical grid. Spacious and flat at the same time, it is expansive and airy and full of light.

Robert Motherwell's *Open* series was triggered by his seeing a small picture against a large canvas with a monochrome surface in his studio. In *Blueness of Blue* the color itself is definitely a "Motherwell blue," undoubtedly related to the artist's love for sea and sky. "I love painting," he wrote, "the way one loves the body of a woman . . . [painting] is only to enhance and make more rich an essentially warm, simple, radiant act, for which everyone has a need."

A similar shade of blue is used by Hans-Peter Reuter in a room he created for the Documenta 6 exhibition in Kassel. It consisted partly of actual blue tile and partly of a paint imitating the tile. The curved room, which extends to the first three steps, is dematerialized by the reflecting gloss of the tile and is extended by the trompe l'oeil of the painting.

In his works of the late 1970s Frank Stella explored new possibilities in abstraction. He now challenged the boundary between painting and sculpture. In his painterly relief *Sāt Bhāi*, he juxtaposed overlapping shapes, variations deriving from a draftsman's French curve, demonstrating a dynamic sense of

balance. This complex composition is brought to life by the brash carnival lacquer encrusted with sand. Stella has engaged in a mannered Abstract Expressionist revival, creating opulent curves with glittering surfaces.

1558 Alfred Jensen. *The Doric Order*. 1972. Oil on canvas, 78 × 117″ **1559** Jasper Johns. *Céline*. 1978. Oil on canvas, 85 ⁵/₈ × 48 ³/₄″ **1560** Brice Marden. *Conturbatio*. 1978. Oil and wax on canvas, 84 × 96″ **1561** Richard Diebenkorn. *Ocean Park No. 66*. 1973. Oil on canvas, 93 × 81″ **1562** Robert Motherwell. *Blueness of Blue*. 1974. Acrylic on canvas, 72 × 84″ **1563** Hans-Peter Reuter. *Documenta Space Object*. 1977. Majolica tile on plaster and oil on canvas, height 163 ³/₈″ **1564** Frank Stella. *Sāt Bhāi*. 1978. Mixed mediums on metal relief, height 109 ¹/₂″

1565

1566

Traditionally, books are printed instruments of information. Even illuminated books or books with original artists' illustrations still convey their identities as books in the traditional sense. But with barriers between different means and mediums breaking down since the late 1960s artists, such as Franz Erhard Walther (plate 1326), have used the book not as a showcase for their work but as an independent medium.

George Brecht conceives of his work as a continuous but everchanging whole, which is a "research into the continuity of un-like things, of objects and events, of scores and objects. . . ." *The Book of the Tumbler on Fire*, Volume IV, Chapter

4, is part of this record of accumulated symbols which mark significant points in Brecht's life since he began the book, in 1964. When the austere black suede box is opened, it reveals a glimmering array of precious and fetishistic objects. The interior is divided into compartments. In the center in a chemist's dish are clear crystals which Brecht grew over a period of years. The other compartments are filled with amber balls, ivory, pieces of crystal, and other natural objects such as seedpods. Over each compartment a piece of crystal was placed to act as a semitransparent cover and to magnify the objects. Each one of these crystal tops is etched with Chinese characters

forming webs of exotic messages. The entire box is a kind of alchemist's drawer containing the secrets of its creator.

Dieter Roth's *Collection of Flat Waste* focused on the two-dimensional qualities of the debris which he collected during a predetermined period. Notices, tickets, etc., are dated according to the day when each passed through Roth's hands. The careful dating and labeling projects an authentication of these objects beyond their individual significance. Roth's flat waste is precisely a "collection," in which the meaning is his awareness of and our attention to these banal bits of information.

A set of twenty-five black-and-

1567

1568

1569

white photographs of vacant lots, with captions locating each in a specific part of Los Angeles, vacuously introduces the viewer/reader to *Real Estate Opportunities,* a book photographed and compiled by Ed Ruscha. These unappealing urban landscapes are ironically, or perhaps sadistically, called "opportunities." Ruscha's book clearly comments upon the Southern California mecca of short bank loans, instant history, transparent glamour, movie-star dreams, and here-today-gone-tomorrow reality.

Stanley Brouwn's *1 Step–100000 Steps* retains the traditional form of a book, with neat black print on white pages, yet metamorphoses the book's content, the nature of the "message." The message, embodied in rows of numbers and letters, at first appears unintelligible, but it is in fact exactly what it appears to be, a recording of one hundred thousand steps taken in various countries. These steps become the smallest reducible units from a vast and complex experience of perception. The counting of steps gives a quantitative value to a qualitative process. The book is a conceptual record of a phenomenological event; language and symbol replace environmental context. In many ways Brouwn's restatement of his walks in these symbols is the most effective way to present his experience in print.

1565 George Brecht. *The Book of the Tumbler on Fire*, Volume IV, Chapter 4. 1977–78. Black suede, clear crystal, gold leaf, and mixed mediums **1566–1567** Dieter Roth. *Collection of Flat Waste*. 1975–76. Printed matter, in transparent sleeves (approx. 30–75 per day), stored in 366 file boxes, height 12 $5/8$" each **1568** Edward Ruscha. *Calgrove Blvd. & Wiley Canyon Rd., Newhall,* from *Real Estate Opportunities*. 1970. 25 photographs **1569** Stanley Brouwn. *1 Step–100000 Steps*. 1972. Height 10 $5/8$". Edition of 275

Sculpture on a Gigantic Scale

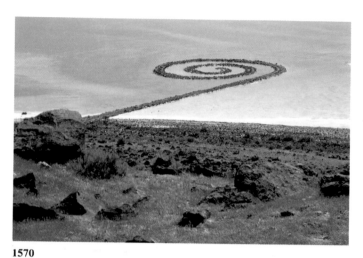

1570

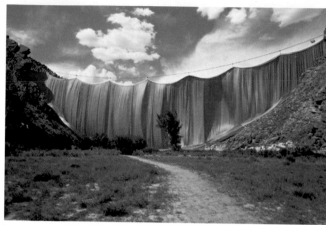

1572

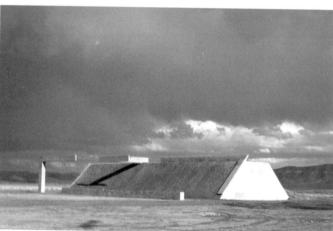

1571

1573

Robert Smithson chose Rozel Point on the Great Salt Lake of Utah as the site of his *Spiral Jetty* because the water is wine red—rich in metaphors of fire, blood, primordial seas. The spiral configuration was suggested by the intense light radiating from the water's surface, as if from an "immobile cyclone." The curvilinear shape also enacted his frequently mentioned concern with entropy: the idea in physics of the continually decreasing organization of a system. The spiral, while rotating outward, simultaneously collapses inward; he incorporated as part of the work expectations of its changes over time—its eventual degeneration and entropic breakdown.

Michael Heizer's work began as a literal manipulation of earth (plate 1382). Significantly, the materials of *The City—Complex One* include structural reinforcements of concrete and steel, as well as earth, which will make the shape permanent. While the general form of the mound comes from that of an Egyptian mastaba, the framing elements at the ends were derived from the ball court at Chichén-Itzá, a Maya city.

Christo, the veteran of large-scale fabric sculpture (plates 1344 and 1373–1374), decided to hang a huge translucent orange curtain across the canyon at Rifle Gap, Colorado. This gigantic project dramatically juxtaposed a visionary man-made work to

the grandeur of the Rocky Mountains for twenty-eight hours before it was ripped down by a windstorm.

Several years later he laid his *Running Fence* across almost twenty-five miles of hills north of San Francisco. The white curtain, which hung for two weeks in September 1976, may be the most widely known public sculpture in a rural environment partly because of the controversies the artist engendered in getting all the authorizations needed. *Running Fence* rose from the Pacific Ocean, traversed the hills of Marin and Sonoma counties, and ended at a great highway. The white nylon appeared black in the shadows, brown and blue reflecting earth and sky,

1574

1575

1576

and took on a purple tint at dawn and dusk. Christo celebrated the landscape much as painters had done in the past and made thousands aware of the very beautiful countryside.

For Walter de Maria the connection between earth, sculpture, and viewer is mysterious. At Documenta 6 he sank a brass rod into the ground to make his *Vertical Earth Kilometer*. On the surface the point of penetration was covered by a two-yard slab of sandstone. In this largely invisible work De Maria returned to the earth metals man had alloyed and formed. The slab, which is all that can be seen, acts as a navel for this *axis mundi* in this monument for the mind.

At the same exhibition Robert Morris made a widely dispersed arrangement of loose basalt stones in various configurations. The rough-hewn stones were striking against the soft green of the smooth lawn and the gently curving trees. Their very conjunction gave a sense, similar to that at Stonehenge, of both drama and elemental simplicity.

During the same year Carl Andre placed thirty-six glacial boulders in the snow in the center of Hartford, Connecticut. This work has caused a good deal of controversy; many people have questioned its aesthetic value, while others have become newly aware of the rock as well as the area occupied by the piece.

1570 Robert Smithson. *Spiral Jetty*. 1969–70. Black rock, salt crystal, and earth, diameter 160′ **1571** Michael Heizer. *The City—Complex One*. 1972–76. Earth mound with concrete framing, height 23′6″ **1572** Christo. *Valley Curtain*. 1971–72. Grand Hogback, Rifle, Colo. Span 1250′; height 185–365′; 200,000 sq. ft. of nylon polyamide; 110,000 lbs. of steel cables. Project Director: Jan van der Marck. Photo: Shunk-Kender **1573** Christo. *Running Fence*. 1976. Sonoma and Marin counties, Calif. Nylon fabric, steel poles and cables, height 18′, length 24 $^1/_2$ miles. Project Director: Peter Selz **1574** Walter de Maria. *The Vertical Earth Kilometer*. 1977. Sandstone plate and brass rod **1575** Robert Morris. *Untitled*. 1977. Basalt granite **1576** Carl Andre. *Stone Field Sculpture*. 1977. 36 boulders, length 290′

Performance

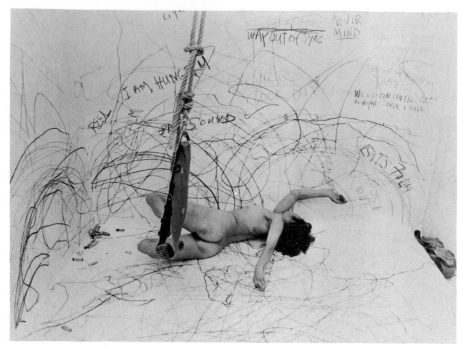

1577

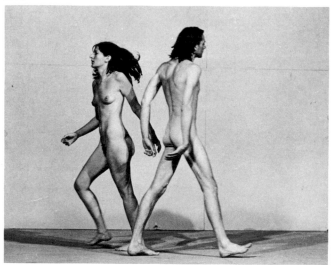

1578

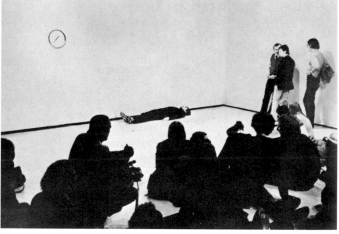

1579

Performance became a major art medium in the 1970s. Its many antecedents lie in the work of the Futurists, Dadaists, Constructivists, and Surrealists, as well as in the Happenings in the 1960s. Performance art makes use of many mediums, and performance artists often use their own bodies and psyches as primary material.

Carolee Schneemann has used her nude body since the early 1960s to express women's sexuality. In *Up To and Including Her Limits* she conceived herself as a random drawing machine, a body pencil, creating "automatic" markings on the walls and floor of a small enclosure. She is acutely aware of our cultural restrictions on morality, and her traces are her metaphor of woman's physical and psychological limits.

Marina Abramovic, a Yugoslav artist, began to work with the Dutch artist Ulay in 1976, creating what they call "art vital." Committed to the concepts of permanent movement, direct contact, passing limits, and taking risks, they express these themes in the works of synchronized mobile energy. In *Relation in Space* the two nude artists ran at high speed into opposite walls, turning back, running, colliding with each other, exhausted, fifty minutes later. Their performance suggests multiple meanings ranging from the phenomenological to Existential qualities of their physical presence and action to considerations of male/female relations, similarities, and differences.

In Chris Burden's performances the audience is inevitably made aware of its voyeurism and frequently is required to take responsibility by participating in the outcome of his actions. A five-by-eight-foot sheet of glass, a clock, and the artist's motionless wait determined the formal elements of Burden's *Doomed*. Forty-five hours and ten minutes after its beginning, the artist's wait ended when a person placed a glass of water inside the space between wall and glass. Burden immediately got up, smashed the face of the ticking clock with a hammer, and recorded the

1581

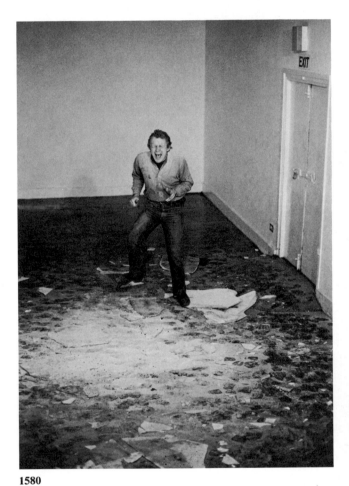

1580

1582

amount of time of his silent vigil.

Stuart Brisley's *Identity A/B* took place on two floors of a London gallery, where he developed two separate personalities. Each floor represented the domain of one personality, and he changed psychological identities each time he went upstairs or down. One character was a dominant, extroverted, active, and bureaucratic type. The other was submissive, introverted, passive, and independent, a creative personality. For one hundred eighty hours the gallery was opened to the public day and night so that a visitor could encounter one of the two personalities inhabiting one of the two floors. Brisley considers these characters

representative of wider sociocultural alienation manifested in human relations and institutions.

Laurie Anderson's performances utilize complex combinations of mediums and high technology (transducers and harmonizers) to communicate a structure primarily based on music and sound. In *Several Songs Backwards* she stood casting her shadow against a screen and playing her violin, on which was mounted a playback head from a tape recorder across which she ran prerecorded pieces of tape attached to her bow. Singing, telling anecdotes, and often humorously narrating her own experiences, Anderson mixed sound, linguistic phrases, and

still and moving pictures projected upon a screen behind her into a whole which simulated real-time existence. Anderson, like most performance artists, creates for the viewer-listener an experience that drifts between art and real life.

1577 Carolee Schneemann. *Up To and Including Her Limits* **1578** Abramovic/Ulay. *Relation in Space*. 1976 **1579** Chris Burden. *Doomed*. 1975 **1580–1581** Stuart Brisley. *Identity A/B*. 1978 **1580** *A* **1581** *B* **1582** Laurie Anderson. *Several Songs Backwards*. 1978

Murals

1583

1584

1585

The 1970s signaled a significant resurgence of mural painting. Many artists rejected making collectible art objects for a consumer society. Even more important for mural painting was the artists' desire to go into the streets and establish communication with mass audiences and obtain support and response from broad communities.

In the U.S. established artists enlarged their work to huge mural blowups. City Walls, Inc., in New York, sponsored designs by well-known artists to spruce up the walls of ghettos and other dreary sites. Attractive and colorful as the works are, they do not solve the problems of urban renewal. But Tania's mural in Lower Manhattan is certainly a colorful delight for the thousands who see the illusion of gigantic three-dimensional polyhedrons on a flat wall.

In Los Angeles megamurals were painted by groups such as the Los Angeles Fine Arts Squad in a style of superrealist illusionism. *Isle of California*, painted after the earthquake of 1971, depicts the collapse of freeways into the ocean.

Community-based murals done by and for the people of urban neighborhoods often communicate political and educational messages. These began to spring up quite spontaneously in the late 1960s in black, Chicano, Latino, and other ethnic neighborhoods. In Chicago the *Wall of Respect* of 1967 was seen by Bill Walker, the founder of the Chicago Mural Group, as "a people's weapon against oppression and barbarism." The wall also became a center for the South Side community. Walker together with the black muralist Mitchell Caton and the Thai painter Isrowuthakul made the mural *Day Dreaming Nightmare*. It is a large-scale statement against the drug culture, with some of the direct power of David Alfaro Siqueiros. The ghostlike black head with its white hat and the giant hypodermic needle are images not easily forgotten.

In a much lighter vein is *Latinoamérica* in San Francisco's Mission

1586

1587

1588

District, painted by the all-women's group Mujeres Muralistas. This richly colored mural is a visual statement to celebrate the land and to proclaim the solidarity of the different Latin-American groups who live in the area. It gives new pride to the community, which can identify with the mural and gain a sense of belonging, of dignity and joy.

Latinoamérica owes a significant debt to the great modern mural tradition of Mexico. But unlike the time when government sponsorship existed for the revolutionary murals of "los tres grandes" (Orozco, Rivera, and Siqueiros), José Hernández Delgadillo, the most noteworthy of the new Mexican muralists, now ob-

serves that "It is very risky to make political art now. You endanger your livelihood and freedom." The painting at the College of Science and Humanities in the Atzcapotzalco district of Mexico City is a bold, flat design and has a direct billboardlike effect. The mural, referring to the brutality at Tlaltelolco, where more than three hundred students were shot by the police and army shortly before the Olympic Games of 1968, is a stylized work in which Indian heads with rifles and flamelike forms burst forth from the abstract central core.

The trend to commission artists to bring new visual appeal to the city spread to Europe, and a Berlin jury

assigned Eduardo Paolozzi (plate 1057) to paint a mural on a large nondescript wall on the Kurfürstenstrasse, in the very center of West Berlin. In his rhythmic designs of black and white painting, Paolozzi's stylized machine components have the look of a heraldic image.

1583 Tania. *Untitled.* 1970. Mercer and Third streets, New York **1584** The Los Angeles Fine Arts Squad. *Isle of California.* 1971. West Los Angeles **1585** Mitchell Caton, Bill Walker, and Isrowuthakul. *Day Dreaming Nightmare.* 1975. Chicago **1586** Mujeres Muralistas. *Latinoamérica* (detail). 1974. San Francisco **1587** José Hernández Delgadillo. *Untitled.* 1973. College of Science and Humanities, Atzcapotzalco District, Mexico City **1588** Eduardo Paolozzi. *Untitled.* 1976. City Center Wall, Berlin

Video

1589

1591

1590

1592

Video is the electronic recording of a continuous flow of images on a magnetic tape which can be played back immediately, or later, on the screen of a TV monitor. Like performance art, it has attracted many innovative artists in the 1970s.

Peter Campus's *Interface* created a sensual encounter with phenomenological problems of perception. A large sheet of glass, a video monitor, and a video projector recorded three aspects of appearance. When a spectator entered this field, three images appeared: one reflected on the transparent glass, another electronically projected on the wall, and the third was seen as mass in the monitor. All three views united levels of ap-

pearance into a continuous whole. The live video feedback allowed for these realities to be perceived simultaneously.

Richard Kriesche produces electronically a multiplicity of perceptions that appear to be identical but in fact are not. Two identical rooms, two identical situations, twins each reading the German cultural philosopher Walter Benjamin, appear to be exact duplications. Kriesche reveals the ability of electronic equipment to alter "reality," to multiply and fool us. He suggests that the future of art lies not in the production of objects but in ferreting out issues of being and appearance.

In *Vertical Roll* Joan Jonas used

the technology of video to synchronize spatial, auditory, and visual illusion. She began with her face horizontally on the screen, clacking what sounded like spoons together as the rolling action of the image began. She jumped, clapped, and made movements which created a harmony to the rolling action on the screen.

In *The Austrian Tapes* Douglas Davis appeared seated in the room where a camera panned in on him, until only the image of his hands filled the screen. His taped voice then requested the viewer to approach the screen and to put his/her hands against Davis's hands. Reaching across the distance of space, time,

1593

1595

1594

1596

and technology, Davis attempted to create a live exchange with the viewer using his body as a "pencil extending his nervous system."

In *Don't Think I'm an Amazon* the German feminist artist Ulrike Rosenbach shot fifteen arrows at a Renaissance picture of the Madonna, metaphorically killing or wounding this traditional image. Attacking the clichés of feminine submissiveness, she wished to expose the sexual and political suppression of women. Yet, as she stepped in front of the wounded Madonna, she appeared to have been shot herself. Rosenbach thus became the warrior Amazon as well as the victim.

Linda Montano's *Mitchell's Death*

was a ritualistic lamentation on the death of her former husband. Montano was dressed in black, her whitened face pierced by acupuncture needles, as she chanted the story of Mitchell Payne's death in a high monotone in a darkened room. The visual image and the sound of her voice, together with soft music, had the power of a great tragic performance.

Vito Acconci's *Red Tapes* are in many ways a compendium of his autobiographical performances of the 1970s. In a series of vignettes, he mixes visual objects, verbal poetics, political innuendo, and spatial situations which define psychological and behavioral motifs in complex

visual rhythms. In one sequence, he portrays two roles in a lovers' debate. Walking up and down, between two cantilevered platforms, he keenly expresses the empty argumentation and competition which often occur in emotional relationships.

1589 Peter Campus. *Interface*. 1972. Closed-circuit video installation with glass 19'8", video camera, and video projector **1590** Richard Kriesche. *Reality vs. Reality*. 1977. Video installation with 2 cameras, 2 monitors, twins, and text **1591** Joan Jonas. *Vertical Roll*. 1972. b/w, sound, 20 minutes **1592** Douglas Davis. *The Austrian Tapes*. 1974. Color, sound, 3 videotapes, 5 minutes each **1593–1594** Ulrike Rosenbach. *Don't Think I'm an Amazon*. 1975. b/w, sound, 15 minutes **1595** Linda Montano. *Mitchell's Death*. 1979. b/w, sound **1596** Vito Acconci. *The Red Tapes*. 1976. b/w, sound, 3 parts, 2 1/2 hours

1597

1598

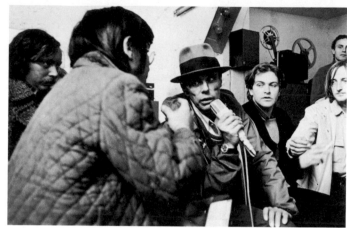

1599

1600

Although Christo's *Running Fence* project did conclude with a very tangible work of art, the art process, the seventeen public hearings, the heated controversies, the Environmental Impact Report, the involvement of many people in the process, was a significant aspect of the work.

The Artist Placement Group, founded by John Latham and Barbara Steveni, in England, pays artists retainers and places them in communities where they act as catalysts on social, economic, and political systems. Latham proposes that artists use their particular insights to provide political alternatives. He and his co-workers in APG propose a "comprehensive concept of structure in events that disposes of the division since Plato into the two unrelated areas 'mind' and 'body.' "

The Free International University of Creative and Interdisciplinary Research is based on Joseph Beuys's belief in "Social Sculpture," a romantic concept that holds that all people have the potential to be artists and that it is possible to transform all of life into a positive creative experience. At the 1977 Documenta, the FIU set up workshops on nuclear energy, media, human rights, urban decay, migrant workers, Ireland, violence, and unemployment.

The Collectif d'Art Sociologique, formed in France in 1974 by Hervé Fischer, Fred Forest, and Jean-Paul Thenot, works both collaboratively and independently, also focusing upon a sociological praxis of intervention in the social milieu. As sociologist-artists attempting to activate people in their own social context, they, like the FIU, reject the "artist-genius" role and the production of objects, and consider alternatives to the art market. Hervé Fischer's project for the Jordaan district in Amsterdam exemplifies many of their aims. During one week in 1978 the inhabitants had the opportunity to write and edit a whole page in their main daily newspaper, *Het Parool,* an activity for which Fischer had obtained the agreement of the newspaper's editor. The project attempted to reverse the

1602

214 E 3 St.
Block 385 Lot 11
5 story walk-up old law tenement

Owned by Harpmel Realty Inc., 608 E 11 St., NYC
Contracts signed by Harry J. Shapolsky, President('63)
 Martin Shapolsky, President('64)
Principal Harry J. Shapolsky(according to Real Estate
Directory of Manhattan)

Acquired 8-21-1963 from John the Baptist Foundation,
c/o The Bank of New York, 48 Wall St., NYC,
for $237 600.- (also 7 other bldgs.)

$150 000.- mortgage at 6% interest, 8-19-1963, due
8-19-1968, held by The Ministers and Missionaries
Benefit Board of the American Baptist Convention,
475 Riverside Drive, NYC (also on 7 other bldgs.)

Assessed land value $25 000.- , total $75 000.- (includ-
ing 212 and 216 E 3 St.) (1971)

1601

1603

"one-way communication" of the mass media by organizing a situation in which the people could realize their collective and individual political potential.

Artists such as the Harrisons (plates 1506–1507), Les Levine, and Hans Haacke make rather direct political statements. Upon being invited to exhibit at the Guggenheim Museum, Haacke created *Shapolsky et al. Manhattan Real Estate Holdings, a Real-Time Social System.* Investigating the holdings of two New York City real estate groups, Haacke traced the webs of ownership by cross indexing the individuals and businesses of each and documenting them with texts, photographs, lo-

cations on a map, and assessed values. The museum's administration charged that Haacke's work violated its political "neutrality" as a public educational institution, canceled the exhibition, and fired the curator of the show. Haacke has no program or theory but systematically reveals sociopolitical, economic, and cultural structures.

In *The Troubles: An Artist's Document of Ulster* Les Levine created a powerful interpretation of the violence in Northern Ireland. Aware of the power of the mass media to cause activities as well as reporting on them, he exposes the situation by means of documentary photographs, films, and sound tracks. A native of

Ireland, Levine views the conditions there as a microcosm of the problems of violence facing our world.

1597 Christo addressing the Sonoma County Board of Supervisors, March 18, 1975. Peter Selz is seated front row, left, looking down at papers **1598** Artist Placement Group (right) and German government officials (left) in Bonn, 1976 **1599** Joseph Beuys at Documenta 6, Kassel, 1977 **1600** Hervé Fischer. Collectif d'Art Sociologique in Amsterdam, 1977–78. Photo modified with ballpoint pen by the artist: lettering and body outline **1601** Hans Haacke. *Shapolsky et al. Manhattan Real Estate Holdings, a Real-Time Social System, as of May 1, 1971.* 142 photos, 2 maps, 6 charts. Edition of 2 **1602–1603** Les Levine. From *The Troubles: An Artist's Document of Ulster.* 1973

Selected Bibliography

This bibliography was designed as a classified, cross-referenced listing of the major monographs and documents of modern art and its milieus, and as a guide to further study.

The first sections, covering bibliographies, dictionaries, and the like, list the principal sources for independent research. Subject bibliographies will be found in the relevant sections. An asterisk indicates that the monograph or catalogue cited includes useful, often definitive, bibliographical data.

Individual artists are represented by their writings and statements, in monographs or anthologies. For secondary sources on individual artists and periodical literature, the reader should consult the relevant bibliographies, indexes, and dictionaries.

Eugenie Candau, Librarian
Louise Sloss Ackerman Fine Arts
Library
San Francisco Museum of
Modern Art

Abbreviations

P. Works available in paperback; publication data are given for original editions only
E.C. Exhibition catalogue
MoMA The Museum of Modern Art
SRGM The Solomon R. Guggenheim Museum
WMAA Whitney Museum of American Art

BIBLIOGRAPHIES AND INDEXES

ARTbibliographies Modern. Santa Barbara, Calif., and Oxford: Clio Press, 1973–.

Art Index. January 1929–, vol. 1–. New York: Wilson, 1930–.

CHAMBERLIN, MARY W. *Guide to Art Reference Books.* Chicago: American Library Association, 1959.

COLUMBIA UNIVERSITY. AVERY ARCHITECTURAL LIBRARY. *Avery Index to Architectural Periodicals.* 2d ed., rev. Boston: Hall, 1973. 15 vols.

EHRESMANN, DONALD L. *Fine Arts: A Bibliographic Guide to Basic Reference Works, Histories, and Handbooks.* Littleton, Colo.: Libraries Unlimited, 1975.

LOMA: Literature on Modern Art. London: Lund Humphries, 1969–71.

THE MUSEUM OF MODERN ART, NEW YORK. *Catalog of the Library of The Museum of Modern Art.* Boston: Hall, 1976. 14 vols.

PARRY, PAMELA JEFFCOTT, comp. *Contemporary Art and Artists: An Index to Reproductions.* Westport, Conn.: Greenwood Press, 1978.

RILA: Répertoire Internationale de la Littérature de l'Art/International Repertory of the Literature of Art. Williamstown, Mass.: College Art Association, 1975–.

SHARP, DENNIS, comp. *Sources of Modern Architecture: A Bibliography.* London: Lund Humphries for the Architectural Association; New York: Wittenborn, 1967. P.

UNIVERSITY OF CALIFORNIA, SANTA BARBARA. *Catalogs of the Art Exhibition Catalog Collection of the Arts Library.* Teaneck, N.J.: Somerset House in cooperation with the University of California at Santa Barbara, 1977.

DICTIONARIES AND ENCYCLOPEDIAS

BÉNÉZIT, EMMANUEL. *Dictionnaire Critique et Documentaire des Peintres, Sculpteurs, Dessinateurs et Graveurs.* 3d ed. Paris: Grund, 1976. 10 vols.

BERCKELAERS, FERNAND LOUIS [MICHEL SEUPHOR]. *Dictionary of Abstract Painting, with a History of Abstract Painting.* Translated by Lionel Izod, John Montagu, and Francis Scarfe. Paris: Hazan; New York: Paris Book Center and Tudor, 1957.

The Britannica Encyclopedia of American Art. Chicago: Britannica Educational Corp., 1973.

Contemporary Artists. Edited by Colin Naylor and Genesis P-Orridge. London and New York: St. James and St. Martin's, 1977.

CUMMINGS, PAUL. *Dictionary of Contemporary American Artists.* 3d ed. New York and London: St. Martin's and St. James, 1977.

Dictionary of Modern Painting. Edited by Carlton Lake and Robert Maillard. 3d rev. ed. New York: Tudor, 1964.

Encyclopedia of Modern Architecture. Edited by Wolfgang Pehnt. London: Thames and Hudson, 1963; New York: Abrams, 1964.

Encyclopedia of World Art. New York: McGraw-Hill, 1959–68. 15 vols.

MAYER, RALPH. *A Dictionary of Art Terms and Techniques.* New York: Crowell, 1969. P.

New Dictionary of Modern Sculpture. Edited by Robert Maillard. 2d ed. New York: Tudor, 1971.

Phaidon Dictionary of Twentieth-Century Art. London and New York: Phaidon, 1973, 1978. P.

SCHMIED, WIELAND. *Malerei nach 1945, in Deutschland, Osterreich und der Schweiz.* Berlin-Vienna: Propyläen, 1974.

THIEME, ULRICH, and BECKER, FELIX. *Allgemeines Lexikon der Bildenden Künstler von der Antike bis zur Gegenwart.* Leipzig: Englemann, Seemann, 1907–50. 37 vols.

VOLLMER, HANS. *Allgemeines Lexikon der Bildenden Künstler der XX. Jahrhunderts.* Leipzig: Seemann, 1953–62. 6 vols.

WALKER, JOHN A. *Glossary of Art, Architecture and Design Since 1945.* 2d rev. ed. London: Clive Bingley; Hamden, Conn.: Linnet Books, 1977.

Who's Who in Architecture: From 1400 to the Present. Edited by J. M. Richards. New York: Holt, Rinehart and Winston, 1977.

GENERAL

* ARNASON, H. H. *History of Modern Art: Painting, Sculpture, Architecture.* Rev. ed. Englewood Cliffs, N.J.: Prentice-Hall; New York: Abrams, 1977.

* BENEVOLO, LEONARDO. *History of Modern Architecture.* Cambridge, Mass.: MIT Press, 1977. 2 vols. P.

BLAKE, PETER. *Form Follows Fiasco: Why Modern Architecture Hasn't Worked.* Boston: Little, Brown, 1974. P.

* BURNHAM, JACK. *The Structure of Art.* New York: Braziller, 1971. P.

* CHIPP, HERSCHEL, with PETER SELZ and JOSHUA C. TAYLOR. *Theories of Modern Art: A Source Book by Artists and Critics.* Berkeley: University of California Press, 1968. P.

* CONE, MICHÈLE. *The Roots and Routes of Art in the 20th Century.* New York: Horizon Press, 1975.

DREXLER, ARTHUR. *Twentieth Century*

Engineering. New York: MoMA, 1964. E.C.

GREENBERG, CLEMENT. *Art and Culture, Critical Essays.* Boston: Beacon Press, 1961. P.

* HAFTMANN, WERNER. *Painting in the Twentieth Century.* London: Lund Humphries; New York: Praeger, 1960. 2 vols. P.

* HAMILTON, GEORGE HEARD. *19th and 20th Century Art: Painting, Sculpture, Architecture.* New York: Abrams, 1970.

* HAMMACHER, A. M. *The Evolution of Modern Sculpture: Tradition and Innovation.* New York: Abrams, 1969.

KOZLOFF, MAX. *Renderings: Critical Essays on a Century of Modern Art.* New York: Simon and Schuster, 1968. P.

KRAUSS, ROSALIND E. *Passages in Modern Sculpture.* New York: Viking, 1977.

ROSENBLUM, ROBERT. *Modern Painting and the Northern Romantic Tradition: Friedrich to Rothko.* New York: Harper and Row, 1975. P.

SCHAPIRO, MEYER. *Modern Art, 19th and 20th Centuries: Selected Papers.* New York: Braziller, 1978.

SHARP, DENNIS, ed. *The Rationalists: Theory and Design in the Modern Movement.* New York: Architectural Book Publishing Corp., 1979.

———. *A Visual History of Twentieth-Century Architecture.* Greenwich, Conn.: New York Graphic Society, 1972.

STEINBERG, LEO. *Other Criteria, Confrontations with Twentieth-Century Art.* New York: Oxford University Press, 1972. P.

* TRIER, EDUARD. *Form and Space: Sculpture of the 20th Century.* London: Thames and Hudson; New York: Praeger, 1961.

BEFORE 1945

BANHAM, REYNER. *Theory and Design in the First Machine Age.* New York: Praeger, 1960.

CASSOU, JEAN; LANGUI, EMILE; and PEVSNER, NIKOLAUS. *Gateway to the Twentieth Century: Art and Culture in a Changing World.* New York: McGraw-Hill, 1962.

ELSEN, ALBERT E. *Modern European Sculpture, 1918–1945: Unknown Beings and Other Realities.* New York: Braziller with the Albright-Knox Art Gallery, 1979. E.C.

———. *Origins of Modern Sculpture: Pioneers and Premises.* New York: Braziller, 1974. P.

EVERS, HANS GERHARD. *The Art of the Modern Age.* Translated by J. R. Foster. New York: Crown, 1970.

GIEDION, SIGFRIED. *Space, Time and Architecture: The Growth of a New Tradition.* Cambridge, Mass.: Harvard University Press, 1941.

* GIEDION-WELCKER, CAROLA. *Contemporary Sculpture: An Evolution in Volume and Space.* 3d ed. New York: Wittenborn, 1960.

* HAMILTON, GEORGE H. *Painting and Sculpture in Europe, 1880 to 1940.* Rev. ed. Baltimore: Penguin Books, 1972. P.

HESS, WALTER. *Dokumente zum Verständnis der Modernen Malerei.* Hamburg: Rowohlt, 1956.

HILDEBRANDT, HANS. *Die Kunst des 19. und 20. Jahrhunderts.* Berlin: Athenaion, 1924.

* HITCHCOCK, HENRY-RUSSELL. *Architecture: Nineteenth and Twentieth Centuries.* 4th ed. Baltimore: Penguin Books, 1977. P.

———. *Modern Architecture: Romanticism and Reintegration.* New York: Payson and Clarke, 1929.

LICHT, FRED. *Sculpture, 19th and 20th Centuries.* Greenwich, Conn.: New York Graphic Society, 1967.

MEIER-GRAEFE, JULIUS. *Entwicklungsgeschichte der Modernen Kunst.* 3d ed. Munich: Piper, 1966. 2 vols.

PEVSNER, NIKOLAUS. *Pioneers of Modern Design.* Harmondsworth: Penguin Books, 1960. P.

RAYNAL, MAURICE, et al. *History of Modern Painting.* Geneva: Skira, 1949–50. 3 vols.

* RITCHIE, ANDREW CARNDUFF. *Sculpture of the Twentieth Century.* New York: MoMA, 1952. E.C.

ROWELL, MARGIT. *The Planar Dimension: Europe, 1912–1932.* New York: SRGM, 1979. E.C. P.

SEYMOUR, CHARLES. *Tradition and Experiment in Modern Sculpture.* Washington, D.C.: American University Press, 1949.

* *Tendenzen der Zwanziger Jahre.* Berlin: Dietrich Reimer Verlag, 1977. E.C.

TUCKER, WILLIAM. *Early Modern Sculpture: Rodin, Degas, Matisse, Brancusi, Picasso, González.* New York: Oxford University Press, 1974.

VALENTINER, W. R. *Origins of Modern Sculpture.* New York: Wittenborn, 1946.

WHITTICK, ARNOLD. *European Architecture in the Twentieth Century.* London: Lockwood, 1950–53. 2 vols.

ZERVOS, CHRISTIAN. *Histoire de l'Art Contemporain.* Paris: Cahiers d'Art, 1938.

SINCE 1945

From this point the reader will become increasingly dependent on exhibition catalogues and periodical literature.

International Exhibition Catalogues

Bienal de São Paulo. São Paulo: Museu de Arte Moderna, 1951–.

Biennale Internazionale d'Arte Venezia. Venice: Biennale, 1895–.

Documenta. Kassel, Ger.: Documenta, 1958–.

Guggenheim International Awards. New York: SRGM, 1956–.

Pittsburgh International Exhibition of Contemporary Painting and Sculpture. Pittsburgh: Carnegie Institute, 1929–.

Surveys

Art Since Mid-Century: The New Internationalism. Greenwich, Conn.: New York Graphic Society, 1971. 2 vols.

DREXLER, ARTHUR. *Transformations in Modern Architecture.* New York: MoMA, 1979. E.C.

GOTTLIEB, CARLA. *Beyond Modern Art.* New York: Dutton, 1976. P.

JENCKS, CHARLES A. *The Language of Post-Modern Architecture.* New York: Rizzoli, 1977. P.

* JOEDICKE, JÜRGEN. *Architecture Since 1945: Sources and Directions.* New York: Praeger, 1969.

* KULTERMANN, UDO. *The New Sculpture: Environments and Assemblages.* Translated by Stanley Baron. New York: Praeger; London: Thames and Hudson, 1968.

LIPPARD, LUCY. *Changing: Essays in Art Criticism.* New York: Dutton, 1971. P.

* LUCIE-SMITH, EDWARD. *Art Now: from Abstract Expressionism to Superrealism.* New York: Morrow, 1977.

New Art Around the World: Painting and Sculpture. New York: Abrams, 1966.

ROSENBERG, HAROLD. *The Anxious Object: Art Today and Its Audience.* New York: Horizon, 1964. P.

———. *Artworks and Packages.* New York: Horizon, 1969. P.

———. *The De-definition of Art: Action Art to Pop to Earthworks.* New York: Horizon, 1972.

———. *The Tradition of the New.* New York: Horizon, 1959.

* SELZ, PETER. *New Images of Man.* New York: MoMA, 1959. E.C.

TOMKINS, CALVIN. *The Bride and the Bachelors: The Heretical Courtship in Modern Art.* New York: Viking, 1965. P.

Über Kunst/On Art: Artists' Writings on the Changed Notion of Art after 1965. Edited by Gerd de Vries. Cologne: DuMont Schauberg, 1974.

POST-IMPRESSIONISM

HERBERT, ROBERT L. *Neo-Impressionism.* New York: SRGM, 1968. E.C.

LÖVGREN, SVEN. *The Genesis of Modernism: Seurat, Gauguin, van Gogh, and French Symbolism in the 1880's.* 2d rev. ed. Bloomington: Indiana University Press, 1971.

* REWALD, JOHN. *Post-impressionism from Van Gogh to Gauguin.* 3d rev. ed. New York: MoMA, 1978.

SIGNAC, PAUL. *D'Eugène Delacroix au Néo-Impressionnisme.* Paris: Floury, 1899.

* VENTURI, LIONELLO. *Les Archives de l'Impressionnisme*. Paris, New York: Durand-Ruel, 1939. 2 vols.

SYMBOLISM AND THE NABIS

CHASSÉ, CHARLES. *Le Mouvement Symboliste dans l'Art du XIX Siècle*. Paris: Floury, 1947.

———. *The Nabis and Their Period*. Translated by Michael Bullock. London: Lund Humphries; New York: Praeger, 1969.

* DELEVOY, ROBERT. *Symbolists and Symbolism*. Translated by Barbara Bray, Elizabeth Wrightson, and Bernard C. Swift. New York: Rizzoli, 1978.

DENIS, MAURICE. *Théories 1890–1910: Du Symbolisme et de Gauguin vers un Nouvel Ordre Classique*. 4th ed. Paris: Rouart et Watelin, 1920.

* GOLDWATER, ROBERT. *Symbolism*. New York: Harper and Row, 1979. P.

HUMBERT, AGNES. *Les Nabis et leur Epoque, 1888–1900*. Geneva: Cailler, 1954.

JULLIAN, PHILIPPE. *Dreamers of Decadence: Symbolist Painters of the 1890's*. Translated by Robert Baldick. New York: Praeger, 1971. P.

REDON, ODILON. *A Soi-Même: Journal 1867–1915*. Paris: Floury, 1922.

ROOKMAAKER, H. R. *Synthetist Art Theories: Genesis and Nature of the Ideas on Art of Gauguin and His Circle*. Amsterdam: Swets and Zeitlinger, 1959.

SYMONS, ARTHUR. *The Symbolist Movement in Literature*. New York: Dutton, 1958.

ART NOUVEAU

* BORSI, FRANCO. *Bruxelles 1900*. Brussels: Marc Vokaer, 1974; New York: Rizzoli, 1977.

* BRUNHAMMER, YVONNE, et al. *Art Nouveau, Belgium/France*. Houston: Institute for the Arts, Rice University, 1976. E. C.

* KEMPTON, RICHARD. *Art Nouveau, an Annotated Bibliography*. Los Angeles: Hennessey and Ingalls, 1977.

* MADSEN, STEPHAN TSCHUDI. *Art Nouveau*. Translated by R. I. Christopherson. New York: McGraw-Hill, 1967. P.

———. *Sources of Art Nouveau*. New York: Wittenborn, 1956. P.

MUCHA, ALPHONSE. *Lectures on Art*. London: Academy Editions; New York: St. Martin's, 1975.

PEVSNER, NIKOLAUS, and RICHARDS, J. M., eds. *The Anti-Rationalists*. New York: Harper and Row, 1973.

* SCHMUTZLER, ROBERT. *Art Nouveau*. Translated by Edouard Roditi. New York: Abrams, 1962.

* SELING, HELMUT. *Jugendstil: Der Weg ins 20. Jahrhundert*. Heidelberg: Keyser, 1959.

* SELZ, PETER, and CONSTANTINE, MILDRED. *Art Nouveau: Art and Design at the Turn of the Century*. New York: MoMA, 1959. E.C.

FAUVISM

CRESPELLE, JEAN-PAUL. *The Fauves*. Translated by Anita Brookner. Greenwich, Conn.: New York Graphic Society, 1962.

DIEHL, GASTON. *The Fauves*. New York: Abrams, 1975.

* DUTHUIT, GEORGES. *The Fauvist Painters*. New York: Wittenborn, Schultz, 1950.

ELDERFIELD, JOHN. *The "Wild Beasts": Fauvism and Its Affinities*. New York: MoMA, 1976. E.C. P.

LEYMARIE, JEAN. *Fauvism, Biographical and Critical Study*. Translated by James Emmons. Geneva: Skira, 1959.

* OPPLER, ELLEN CHARLOTTE. *Fauvism Reexamined*. Ann Arbor, Mich.: University Microfilms, 1976.

CUBISM

* APOLLINAIRE, GUILLAUME. *The Cubist Painters: Aesthetic Meditations 1913*. Translated by Lionel Abel. New York: Wittenborn, Schultz, 1949.

* BARR, ALFRED H. *Cubism and Abstract Art*. New York: MoMA, 1936. P.

COOPER, DOUGLAS. *The Cubist Epoch*. London: Phaidon, 1970.

* EDDY, ARTHUR JEROME. *Cubists and Post-Impressionists*. Chicago: McClurg, 1914.

* FRY, EDWARD. *Cubism*. New York: McGraw-Hill; London: Thames and Hudson, 1966. P.

GLEIZES, ALBERT, and METZINGER, JEAN. *Du Cubisme*. Paris: Figuière, 1912.

* GOLDING, JOHN. *Cubism: A History and an Analysis, 1907–1914*. New York: Wittenborn, 1959.

GRAY, CHRISTOPHER. *Cubist Aesthetic Theories*. Baltimore: Johns Hopkins Press, 1953.

HABASQUE, GUY. *Cubism, Biographical and Critical Study*. Paris and New York: Skira, 1959.

KAHNWEILER, DANIEL-HENRY. *The Rise of Cubism*. Translated by Henry Aronson. New York: Wittenborn, Schultz, 1949.

KOZLOFF, MAX. *Cubism/Futurism*. New York: Charterhouse, 1973.

LAWDER, STANDISH D. *The Cubist Cinema*. New York: New York University Press, 1975. P.

LÉGER, FERNAND. *Functions of Painting*. Edited by Edward Fry. Translated by Alexandra Anderson. New York: Viking, 1973.

* ROSENBLUM, ROBERT. *Cubism and Twentieth-Century Art*. New York: Abrams, 1961.

FUTURISM

* ANDREOLI-DeVILLERS, JEAN PIERRE. *Futurism and the Arts, a Bibliography, 1959–1973*. Toronto: University of Toronto Press, 1975.

* APOLLONIO, UMBRO, ed. *Futurist Manifestos*. Translated by Robert Brain, R. W. Flint, C. Higgitt, and Caroline Tisdall. London: Thames and Hudson; New York: Viking, 1973.

BRAGAGLIA, ANTON GIULIO. *Fotodinamismo Futurista*. Turin: Einaudi, 1970.

CARRIERI, RAFFAELE. *Futurism*. Milan: Milione, 1963.

CRISPOLTI, ENRICO. *Il Secondo Futurismo, Torino, 1923–1938*. Turin: Pozzo, 1961.

* DRUDI GAMBILLO, MARIA, and FIORI, TERESA, eds. *Archivi del Futurismo*. Rome: De Luca, 1958–62. 2 vols.

KIRBY, MICHAEL. *Futurist Performance*. New York: Dutton, 1971. P.

MARTIN, MARIANNE W. *Futurist Art and Theory, 1909–1915*. London: Oxford University Press, 1968.

* TAYLOR, JOSHUA C. *Futurism*. New York: MoMA, 1961. E.C.

EXPRESSIONISM

The "Blaue Reiter" Almanac, edited by Wassily Kandinsky and Franz Marc. Edited by Klaus Lankheit. Translated by Henning Falkenstein, Manug Terzian, and Gertrude Hinderlie. New York: Viking; London: Thames and Hudson, 1974. P.

* BUCHHEIM, LOTHAR-GÜNTHER. *Die Künstlergemeinschaft Brücke: Gemälde, Zeichnungen, Graphik, Plastik, Dokumente*. Feldafing: Buchheim Verlag, 1956.

EISNER, LOTTE. *The Haunted Screen: Expressionism in the German Cinema and the Influence of Max Reinhardt*. Translated by Roger Greaves. Berkeley: University of California Press, 1969. P.

MYERS, BERNARD S. *The German Expressionists: A Generation in Revolt*. New York: Praeger, 1957. P.

PFISTER, OSKAR. *Expressionism in Art: Its Psychological and Biological Basis*. London: Kegan Paul, Trench, Trubner, 1922.

* REED, ORREL P., JR. *German Expressionist Art: The Robert Gore Rifkind Collection*. Los Angeles: Wight Art Gallery, University of California, 1977. E.C.

RICHARD, LIONEL. *Phaidon Encyclopedia of Expressionism*. New York: Phaidon, 1978. P.

ROETHEL, HANS KONRAD. *The Blue Rider*. Translated by Hans Konrad Roethel and Jean Benjamin. New York: Praeger, 1971.

SAMUEL, RICHARD, and THOMAS, R. HINTON. *Expressionism in German Life, Literature and the Theatre 1910–1924*. Cambridge: Heffer, 1939.

* SELZ, PETER. *German and Austrian Expressionism: Art in a Turbulent Era*. Chicago: Museum of Contemporary

Art, 1978. E.C.
* ———. *German Expressionist Painting*. Berkeley: University of California Press, 1957. P.
* SHARP, DENNIS. *Modern Architecture and Expressionism*. London: Longmans, Green, 1966.
* SPALEK, JOHN M., et al. *German Expressionism in the Fine Arts: A Bibliography*. Los Angeles: Hennessey and Ingalls, 1977.

CONSTRUCTIVISM, DE STIJL, AND THE BAUHAUS

* BANN, STEPHEN, ed. *The Tradition of Constructivism*. New York: Viking, 1974.
BAYER, HERBERT; GROPIUS, WALTER; and GROPIUS, ISE. *Bauhaus, 1919–1928*. New York: MoMA, 1938. P.
BERCKELAERS, FERNAND LOUIS [MICHEL SEUPHOR]. *Abstract Painting: Fifty Years of Accomplishment from Kandinsky to the Present*. New York: Abrams, 1962. P.
BIEDERMAN, CHARLES. *Art as the Evolution of Visual Knowledge*. Red Wing, Minn.: The Author, 1948.
Circle: International Survey of Constructive Art. Edited by J. L. Martin, Ben Nicholson, and Naum Gabo. London: Faber and Faber, 1937.
DELAUNAY, ROBERT, and DELAUNAY, SONIA. *The New Art of Color: The Writings of Robert and Sonia Delaunay*. Edited by Arthur A. Cohen. Translated by Arthur A. Cohen and David Shapiro. New York: Viking, 1978.
GROPIUS, WALTER, ed. *The Theater of the Bauhaus*. Middletown, Conn.: Wesleyan University Press, 1961. P.
ITTEN, JOHANNES. *Design and Form: The Basic Course at the Bauhaus*. Translated by John Maass. New York: Reinhold, 1964.
* JAFFÉ, HANS L. C., ed. *De Stijl*. London: Thames and Hudson, 1970; New York: Abrams, 1971.
——— . *De Stijl, 1917–1931: The Dutch Contribution to Modern Art*. Amsterdam: Meulenhoff, 1956.
KLEE, PAUL. *Pedagogical Sketch Book*. Translated by Sibyl Moholy-Nagy. New York: Praeger, 1953. P.
LANG, LOTHAR. *Das Bauhaus 1919–1933, Idee und Wirklichkeit*. Berlin: Zentralinstitut für Formgestaltung, 1965.
MALEVICH, K. S. *Essays on Art 1915–1933*. Edited by Troels Andersen. Translated by Xenia Glowacki-Prus and Arnold McMillin. Copenhagen: Borgens, 1968; New York: Wittenborn, 1971. 2 vols.
MOHOLY-NAGY, LÁSZLÓ. *The New Vision*. Translated by Daphne M. Hoffman. 4th rev. ed. New York: Wittenborn, 1947. P.
MONDRIAN, PIET. *Plastic Art and Pure Plastic Art*. New York: Wittenborn, 1945.
NEUMANN, ECKHARD, ed. *Bauhaus and Bauhaus People*. New York: Van Nostrand, 1970.
* RICKEY, GEORGE. *Constructivism: Origins and Evolution*. New York: Braziller, 1967.
ROTERS, EBERHARD. *Painters of the Bauhaus*. Translated by Anna Rose Cooper. New York: Praeger, 1969.
* WINGLER, HANS M. *The Bauhaus: Weimar, Dessau, Berlin, Chicago*. Cambridge, Mass.: MIT Press, 1969. P.

DADA AND SURREALISM

ADES, DAWN. *Dada and Surrealism Reviewed*. London: Arts Council of Great Britain, 1978. E.C.
ARP, JEAN. *Arp on Arp: Poems, Essays, Memories*. Edited by Marcel Jean. Translated by Joachim Neugroschel. New York: Viking, 1972.
BALAKIAN, ANNA. *Surrealism, the Road to the Absolute*. Rev. ed. New York: Dutton, 1970.
BRETON, ANDRÉ. *Manifestoes of Surrealism*. Translated by Richard Seaver and Helen R. Lane. Ann Arbor: University of Michigan Press, 1969. P.
——— . *What Is Surrealism? Selected Writings*. Edited by Franklin Rosemont. New York: Monad, 1978. P.
DUCHAMP, MARCEL. *Salt Seller: The Writings of Marcel Duchamp*. Edited by Michel Sanouillet and Elmer Peterson. New York: Oxford University Press, 1973.
* GERSHMAN, HERBERT S. *A Bibliography of the Surrealist Revolution in France*. Ann Arbor: University of Michigan Press, 1969.
HUELSENBECK, RICHARD, ed. *Dada Almanach: im Auftrag des Zentralamts der deutschen Dada-Bewegung*. New York: Something Else Press, 1966.
JEAN, MARCEL, and MEZEI, ARPAD. *The History of Surrealist Painting*. Translated by Simon Watson Taylor. London: Weidenfeld and Nicolson; New York: Grove Press, 1960.
LIPPARD, LUCY R., ed. *Dadas on Art*. Englewood Cliffs, N.J.: Prentice-Hall, 1971.
——— , ed. *Surrealists on Art*. Englewood Cliffs, N.J.: Prentice-Hall, 1970.
* MOTHERWELL, ROBERT, ed. *The Dada Painters and Poets: An Anthology*. New York: Wittenborn, Schultz, 1951.
* NADEAU, MAURICE. *Histoire du Surréalisme*. Paris: Editions du Seuil, 1945–48. 2 vols.
——— . *History of Surrealism*. Translated by Richard Howard. New York: Macmillan, 1965. P.
READ, HERBERT, ed. *Surrealism*. London: Faber and Faber; New York: Harcourt, Brace, 1936. P.
RICHTER, HANS. *Dada: Art and Anti-Art*. New York: McGraw-Hill, 1965. P.
* RUBIN, WILLIAM S. *Dada and Surrealist Art*. New York: Abrams, 1969.
VERKAUF, WILLY, ed. *Dada: Monograph of a Movement*. New York: Wittenborn, 1957.
WALDBERG, PATRICK. *Surrealism*. New York: McGraw-Hill, 1965. P.

ABSTRACT EXPRESSIONISM

ASHTON, DORE. *The New York School: A Cultural Reckoning*. New York: Viking, 1973. P.
——— . *The Unknown Shore, a View of Contemporary Art*. Boston: Little, Brown, 1962.
* GELDZAHLER, HENRY. *New York Painting and Sculpture: 1940–1970*. New York: Metropolitan Museum, 1969. E.C. P.
HOFMANN, HANS. *Search for the Real and Other Essays*. Cambridge, Mass.: MIT Press, 1948.
The New American Painting: As Shown in Eight European Countries 1958–1959. New York: MoMA, 1959. E.C.
The New Decade: 35 American Painters and Sculptors. New York: WMAA, 1955. E.C.
* *Poets of the Cities: New York and San Francisco 1950–1965*. New York: Dallas Museum of Fine Arts, 1974. E.C. P.
REINHARDT, AD. *Art-as-Art: The Selected Writings of Ad Reinhardt*. Edited by Barbara Rose. New York: Viking, 1975.
* SANDLER, IRVING. *The New York School, the Painters and Sculptors of the Fifties*. New York: Harper and Row, 1978. P.
* ——— . *The Triumph of American Painting: A History of Abstract Expressionism*. New York: Praeger, 1970. P.
SEITZ, WILLIAM C. "Abstract-Expressionist Painting in America." Ph. D. dissertation, Princeton University, 1955.
* TUCHMAN, MAURICE, ed. *New York School, the First Generation*. Greenwich, Conn.: New York Graphic Society, 1970. P.

ART INFORMEL

BAZAINE, JEAN. *Notes sur la Peinture*. Rev. ed. Paris: Du Seuil, 1960.
* *Cobra 1948/51*. Rotterdam: Museum Boymans-van Beuningen, 1966. E.C. P.
COURTHION, PIERRE. *Peintres d'Aujourd'hui*. Geneva: Cailler, 1952.
GIANI, GIAMPIERO. *Spazialismo, Origini e Sviluppi di una Tendenza Artistica*. Milan: Conchiglia, 1956.
MATHIEU, GEORGES. *From the Abstract to the Possible*. New York: Wittenborn, 1960.
* PONENTE, NELLO. *Modern Painting: Contemporary Trends*. Lausanne: Skira, 1960.
* RITCHIE, ANDREW CARNDUFF, ed. *The New Decade: 22 European Painters and Sculptors*. New York: MoMA, 1955. E.C.

TAPIÉ, MICHEL. *Un Art Autre où il s'agit de nouveaux dévidages du réel.* Paris: Giraud, 1952.

———. *Morphologie Autre.* Turin: Pozzo, 1960.

Younger European Painters: A Selection. New York: SRGM, 1953. E.C.

HAPPENINGS AND FLUXUS

* *Fluxus International & Co.* Nice: Galerie d'Art Contemporain des Musées de Nice, 1979. E.C.

HANSEN, AL. *A Primer of Happenings and Time/Space Art.* New York: Something Else Press, 1965.

* *Happening & Fluxus.* Cologne: Kolnischer Kunstverein, 1970. E.C.

KAPROW, ALLAN. *Assemblage, Environments and Happenings.* New York: Abrams, 1966.

KIRBY, MICHAEL. *Happenings: An Illustrated Anthology.* New York: Dutton, 1966.

KOSTELANETZ, RICHARD. *The Theatre of Mixed Means: An Introduction to Happenings, Kinetic Environments and Other Mixed Means Performances.* New York: Dial, 1968.

KULTERMANN, UDO. *Art and Life.* New York: Praeger, 1971.

OLDENBURG, CLAES. *Raw Notes.* Halifax: Nova Scotia College of Art and Design, 1973.

* RUHÉ, HARRY. *Fluxus: The Most Radical and Experimental Art Movement of the 60's.* Amsterdam: "A," 1979.

POP ART AND PHOTOREALISM

* ALLOWAY, LAWRENCE. *American Pop Art.* New York: WMAA, 1974. E.C.

AMAYA, MARIO. *Pop Art and After.* New York: Viking, 1965.

BATTCOCK, GREGORY, ed. *Super Realism: A Critical Anthology.* New York: Dutton, 1975. P.

KULTERMANN, UDO. *The New Painting.* Rev. ed. Boulder, Colo.: Westview, 1977.

———. *New Realism.* Greenwich, Conn.: New York Graphic Society, 1972.

LIPPARD, LUCY R., ed. *Pop Art.* New York: Praeger, 1966.

RESTANY, PIERRE. *Le Nouveau Réalisme.* Paris: Union Générale d'Editions, 1978.

———. *Les Nouveaux Réalistes.* Paris: Planète, 1968.

RUSSELL, JOHN, and GABLIK, SUZI. *Pop Art Redefined.* New York: Praeger, 1969.

* SAGER, PETER. *Neue Formen des Realismus: Kunst zwischen Illusion und Wirklichkeit.* Cologne: DuMont Schauberg, 1973.

WARHOL, ANDY. *The Philosophy of Andy Warhol (From A to B and Back Again).* New York: Harcourt Brace Jovanovich, 1975. P.

OP ART, MINIMAL ART, AND COLOR FIELD PAINTING

ALLOWAY, LAWRENCE. *Systemic Painting.* New York: SRGM, 1966. E.C.

BARRETT, CYRIL. *Op Art.* New York: Viking, 1970.

BATTCOCK, GREGORY, ed. *Minimal Art: A Critical Anthology.* New York: Dutton, 1968. P.

* CARMEAN, E. A., JR. *The Great Decade of American Abstraction: Modernist Art 1960–1970.* Houston: Museum of Fine Arts, 1974. E.C.

CARRAHER, RONALD G., and THURSTON, JACQUELINE B. *Optical Illusions and the Visual Arts.* New York: Reinhold, 1966.

COPLANS, JOHN. *Serial Imagery.* Pasadena, Calif.: Pasadena Art Museum, 1968. E.C.

* GOOSSEN, E. C. *The Art of the Real: USA 1948–1968.* New York: MoMA, 1968. E.C.

JUDD, DONALD. *Complete Writings 1959–1975.* Halifax: Nova Scotia College of Art and Design, 1975.

Primary Structures: Younger American and British Sculptors. New York: The Jewish Museum, 1966. E.C.

SEITZ, WILLIAM C. *The Responsive Eye.* New York: MoMA, 1965. E.C.

KINETIC ART AND ART AND TECHNOLOGY

BANN, STEPHEN; GADNEY, REG; POPPER, FRANK; and STEADMAN, PHILIP. *Four Essays on Kinetic Art.* St. Albans: Motion Books, 1966.

BATTCOCK, GREGORY, ed. *New Artists' Video: A Critical Anthology.* New York: Dutton, 1978. P.

* BENTHALL, JONATHAN. *Science and Technology in Art Today.* New York: Praeger, 1972.

BRETT, GUY. *Kinetic Art: The Language of Movement.* London: Studio Vista; New York: Reinhold, 1968.

BURNHAM, JACK. *Beyond Modern Sculpture: The Effects of Science and Technology on the Sculpture of This Century.* New York: Braziller, 1968. P.

DAVIS, DOUGLAS. *Art and the Future: A History/Prophecy of the Collaboration between Science, Technology and Art.* New York: Praeger, 1973. P.

* HULTÉN, K. G. PONTUS. *The Machine as Seen at the End of the Mechanical Age.* New York: MoMA, 1968. E.C.

KEPES, GYORGY. *New Landscape in Art and Science.* Chicago: Theobald, 1956.

* KRANZ, STEWART. *Science and Technology in the Arts.* New York: Van Nostrand, 1974.

PIENE, OTTO, and MACK, HEINZ, eds. *Zero.* Translated by Howard Beckman. Cambridge, Mass.: MIT Press, 1973.

POPPER, FRANK. *Origins and Development of Kinetic Art.* Greenwich, Conn.: New York Graphic Society, 1968.

REICHARDT, JASIA, ed. *Cybernetic Serendipity: The Computer and the Arts.* London: Studio International, 1968; New York: Praeger, 1969. E.C.

SCHNEIDER, IRA, and KOROT, BERYL, eds. *Video Art.* New York: Harcourt Brace Jovanovich, 1976. P.

SELZ, PETER. *Directions in Kinetic Sculpture.* Berkeley: University of California Art Museum, 1966. E.C.

TUCHMAN, MAURICE. *A Report on the Art and Technology Program of the Los Angeles County Museum of Art, 1967–71.* Los Angeles: Los Angeles County Museum, 1971. P.

CONCEPTUAL ART, PROCESS ART, AND EARTH ART

BATTCOCK, GREGORY, ed. *Idea Art: A Critical Anthology.* New York: Dutton, 1973. P.

Carl Andre, Robert Barry, Douglas Huebler, Joseph Kosuth, Sol LeWitt, Robert Morris, Lawrence Weiner. New York: Seth Siegelaub and John Wendler, 1968.

CELANT, GERMANO, ed. *Art Povera.* New York: Praeger, 1969.

* LIPPARD, LUCY R., ed. *Six Years: The Dematerialization of the Art Object from 1966 to 1972.* New York: Praeger, 1973. P.

Live in Your Head: When Attitudes Become Form. Berne: Kunsthalle, 1969. E.C.

* McSHINE, KYNASTON L., ed. *Information.* New York: MoMA, 1970. E.C.

MEYER, URSULA. *Conceptual Art.* New York: Dutton, 1972. P.

MILLET, CATHERINE. *Textes sur l'Art Conceptuel.* Paris: Templon, 1972.

PINCUS-WITTEN, ROBERT. *Postminimalism.* New York: Out of London Press, 1977. P.

* *Probing the Earth: Contemporary Land Projects.* Washington, D.C.: Smithsonian Institution, 1977. E.C.

SMITHSON, ROBERT. *The Writings of Robert Smithson: Essays with Illustrations.* Edited by Nancy Holt. New York: New York University Press, 1979.

YOUNG, LAMONTE, and MacLOW, JACKSON, eds. *An Anthology.* Munich: Heiner Friedrich, 1967.

BODY ART, ACTION ART, AND PERFORMANCE

AUE, WALTER, ed. *P.C.A.: Projecte, Concepte, Actionen.* Cologne: DuMont Schauberg, 1971.

Bodyworks. Chicago: Museum of Contemporary Art, 1975. E.C.

* GOLDBERG, ROSELEE. *Performance: Live Art 1909 to the Present.* New York: Abrams, 1979. P.

HENRI, ADRIAN. *Total Art: Environments, Happenings, and Performance.* New York: Praeger, 1974. P.

NITSCH, HERMANN. *Orgien Mysterien Theater/Orgies Mysteries Theatre.* Darmstadt: März, 1969.

PLUCHART, FRANÇOIS. *L'Art Corporel.* Paris: Rodolphe Stadler, 1975.

* POPPER, FRANK. *Art—Action and Participation.* New York: New York University Press, 1975.

VERGINE, LEA. *Il Corpo come Linguaggio (La "Body-Art" e Storie Simili).* Milan: Prearo, 1974.

WEIBEL, PETER, and EXPORT, VALIE. *Wien: Bildkompendium.* Frankfurt: Kohlkunstverlag, 1970.

ART AND POLITICS AND GOVERNMENT

ALQUIÉ, FERDINAND. *The Philosophy of Surrealism.* Translated by Bernard Waldrop. Ann Arbor: University of Michigan Press, 1965.

BERGER, JOHN. *Art and Revolution: Ernst Neizvestny and the Role of the Artist in the U.S.S.R.* New York: Pantheon, 1969.

BLUM, PAUL VON. *The Art of Social Conscience.* Introduction by Peter Selz. New York: Universe, 1976. P.

EGBERT, DONALD DREW. *Socialism and American Art in the Light of European Utopianism, Marxism and Anarchism.* Princeton: Princeton University Press, 1967. P.

FITZPATRICK, SHEILA. *The Commissariat of Enlightenment: Soviet Organisation of Education and the Arts under Lunacharsky, October 1917–1921.* Cambridge, Eng.: Cambridge University Press, 1970.

GROSZ, GEORGE. *A Little Yes and a Big No: The Autobiography of George Grosz.* Translated by Lola Sachs Dorin. New York: Dial, 1946.

Kunst und Politik. 2d ed. Karlsruhe: Badischer Kunstverein, 1970. E.C.

LANE, BARBARA MILLER. *Architecture and Politics in Germany 1918–1945.* Cambridge, Mass.: Harvard University Press, 1968.

LONDON, KURT. *The Seven Soviet Arts.* New Haven: Yale University, 1937.

MILLON, HENRY A., and NOCHLIN, LINDA, eds. *Art and Architecture in the Service of Politics.* Cambridge, Mass.: MIT Press, 1978.

* MINIHAN, JANET. *The Nationalization of Culture: The Development of State Subsidies to the Arts in Great Britain.* New York: New York University Press, 1977.

* O'CONNOR, FRANCIS V., ed. *Art for the Millions: Essays from the 1930's by Artists and Administrators of the WPA Federal Art Project.* Greenwich, Conn.: New York Graphic Society, 1973. P.

READ, HERBERT. *The Politics of the Unpolitical.* London: Routledge, 1946.

ROH, FRANZ. *"Entartete" Kunst: Kunstbarbarei im dritten Reich.* Hanover: Fackelträger, 1962.

* SOLOMON, MAYNARD, ed. *Marxism and Art.* New York: Knopf, 1973. P.

TAYLOR, ROBERT R. *The World in Stone: The Role of Architecture in National Socialist Ideology.* Berkeley: University of California Press, 1974.

* WILLETT, JOHN. *Art and Politics in the Weimar Period: The New Sobriety 1917–1933.* New York: Pantheon, 1978. P.

SPECIAL TOPICS

* COCKCROFT, EVA; WEBER, JOHN; and COCKCROFT, JIM. *Toward a People's Art: The Contemporary Mural Movement.* New York: Dutton, 1977. P.

CONSTANTINE, MILDRED, ed. *Word and Image: Posters from the Collection of The Museum of Modern Art.* Text by Alan M. Fern. New York: MoMA, 1968.

———, and LARSEN, JACK LENOR. *Beyond Craft: The Art Fabric.* New York: Van Nostrand, 1972.

GOLDWATER, ROBERT. *Primitivism in Modern Art.* New York: Harper, 1967.

* RISCHBIETER, HENNING, ed. *Art and the Stage in the 20th Century: Painters and Sculptors Work for the Theater.* Greenwich, Conn.: New York Graphic Society, 1969.

* SEITZ, WILLIAM C. *The Art of Assemblage.* New York: MoMA, 1961. E.C.

WESCHER, HERTA. *Collage.* 2d ed. Translated by Robert E. Wolf. New York: Abrams, 1971.

NATIONAL STUDIES

Austria

COMINI, ALESSANDRA. *The Fantastic Art of Vienna.* New York: Knopf, 1978.

* FEUCHTMÜLLER, RUPPERT, and MRAZEK, WILHELM. *Kunst von Österreich 1860–1918.* Vienna and Hanover: Forum, 1964.

HOFMANN, WERNER. *Modern Painting in Austria.* Vienna: Wolfrum, 1965.

JOHNSTON, WILLIAM M. *The Austrian Mind: Intellectual and Social History.* Berkeley: University of California Press, 1976.

SOTRIFFER, KRISTIAN. *Modern Austrian Art: A Concise History.* New York: Praeger, 1965.

WAISSENBERGER, ROBERT. *Vienna Secession.* New York: Rizzoli, 1977.

Belgium, The Netherlands

Belgian Art 1880–1914. Brooklyn, N.Y.: The Brooklyn Museum and the Ministries of Communities of the Government of Belgium, 1980. E.C.

BERCKELAERS, FERNAND LOUIS [MICHEL SEUPHOR]. *Abstract Painting in Flanders.* Brussels: Arcade, 1963.

BLIJSTRA, R. *Netherlands Architecture Since 1900.* Amsterdam: Kampen & Zoon, 1966.

Contemporary Painting in Belgium. Washington, D.C.: Corcoran Gallery of Art, 1964. E.C.

Eastern Europe

Avantgarde Osteuropa, 1910–1930. Berlin: Kunstverein, 1967. E.C.

* *Constructivism in Poland 1923–1936: BLOK, Praesens, a.r.* Lodz: Museum Sztuki; Essen: Museum Folkwang, 1973. E.C.

Hungarian Art: The Twentieth Century Avant-Garde. Bloomington: Indiana University Art Museum, 1972. E.C.

MEISSNER, GÜNTER. *Leipziger Künstler der Gegenwart.* Leipzig: Seemann, 1977.

SELZ, PETER. *15 Polish Painters.* New York: MoMA, 1961. E.C.

* *Die 20er Jahre in Osteuropa/The 1920s in Eastern Europe.* Cologne: Galerie Gmurzynska, 1975.

France

* DORIVAL, BERNARD. *Les Etapes de la Peinture Française Contemporaine.* Paris: Gallimard, 1943–46. 3 vols.

Four Americans in Paris: The Collections of Gertrude Stein and Her Family. New York: MoMA, 1970. E.C.

GAUSS, CHARLES EDWARD. *The Aesthetic Theories of French Artists, 1855 to the Present.* Baltimore: Johns Hopkins Press, 1949.

LEMAÎTRE, GEORGES. *From Cubism to Surrealism in French Literature.* Cambridge, Mass.: Harvard University Press, 1941.

MARCHIORI, GIUSEPPE. *Modern French Sculpture.* Translated by John Ross. New York: Abrams, 1963.

NACENTA, RAYMOND. *School of Paris: The Painters and the Artistic Climate of Paris since 1910.* Greenwich, Conn.: New York Graphic Society, 1960.

RAYNAL, MAURICE. *Modern French Painters.* Montreal: Louis Carrier, 1928.

* SHATTUCK, ROGER. *The Banquet Years.* New York: Vintage, 1968. P.

* WILENSKI, R. H. *Modern French Painters.* 3d ed. London: Faber, 1954.

Germany

CAMPBELL, JOAN. *The German Werkbund: The Politics of Reform in the Applied Arts.* Princeton: Princeton University Press, 1977.

Die Dreissiger Jahre: Schauplatz Deutschland. Munich: Haus der Kunst, 1977. E.C.

* *Neue Sachlichkeit and German Realism of the Twenties.* London: Arts Council of Great Britain, 1978. E.C.

Neue Sachlichkeit und Realismus: Kunst zwischen den Kriegen. Vienna: Museum des 20. Jahrhunderts, 1977. E.C.

* *Paris-Berlin: Rapports et Contrastes France-Allemagne 1900–1933.* Paris:

Centre National d'Art et de Culture Georges Pompidou, 1978. E.C.

RÖTHEL, HANS KONRAD. *Modern German Painting.* New York: Reynal, 1957.

ROH, FRANZ, with additions by Julianne Roh. *German Art in the Twentieth Century.* Greenwich, Conn.: New York Graphic Society, 1968.

Die Zwanziger Jahre: Manifeste und Dokumente. Edited by Uwe M. Schneede. Cologne: DuMont Schauberg, 1979.

Italy

ARGAN, GIULIO CARLO. *L'Arte Moderna, 1770–1970.* Florence: Sansoni, 1970.

BALLO, GUIDO. *Modern Italian Painting, from Futurism to the Present Day.* New York: Praeger, 1958.

CARRÀ, CARLO. *Pittura Metafisica.* Florence: Vallecchi, 1919.

* CARRÀ, MASSIMO, ed. *Metaphysical Art.* New York: Praeger, 1971.

CARRIERI, RAFFAELE. *Avant-Garde Painting and Sculpture (1890–1955) in Italy.* Milan: Domus, 1955.

* *Du Futurisme au Spatialisme: Peinture Italienne de la Première Moitié du XXe Siècle.* Geneva: Musée Rath, 1977. E.C.

KOSTOF, SPIRO. *The Third Rome 1870–1950: Traffic and Glory.* Berkeley: University of California Art Museum, 1973. E.C.

* LAVAGNINO, EMILIO. *L'Arte Moderna dai Neoclassici ai Contemporanei.* Rev. ed. Turin: Unione Tipografico, 1961. 2 vols.

* SOBY, JAMES THRALL, and BARR, ALFRED H., JR. *Twentieth-Century Italian Art.* New York: MoMA, 1949. E.C.

Latin America

* CATLIN, STANTON LOOMIS, and GRIEDER, TERENCE. *Art of Latin America since Independence.* New Haven: Yale University Art Gallery; Austin: University of Texas Art Museum, 1966. E.C.

CHARLOT, JEAN. *The Mexican Mural Renaissance: 1920–25.* New Haven: Yale University Press, 1963.

DAMAZ, PAUL F. *Art in Latin American Architecture.* New York: Van Nostrand Reinhold, 1963.

HITCHCOCK, HENRY-RUSSELL. *Latin American Architecture since 1945.* New York: MoMA, 1955. E.C.

* MESSER, THOMAS M. *The Emergent Decade: Latin American Painters and Paintings in the 1960s.* New York: SRGM; Ithaca: Cornell University Press, 1966. E.C.

SCHMECKEBIER, LAURENCE E. *Modern Mexican Art.* Minneapolis: University of Minnesota Press, 1939.

Spain

MORENO GALVÁN, JOSÉ MARÍA. *Spanish Painting: The Latest Avant-Garde.* Boston: New York Graphic Society, 1977.

* O'HARA, FRANK. *New Spanish Painting and Sculpture.* New York: MoMA, 1960. E.C.

Spanische Kunst Heute. Munich: Haus der Kunst, 1974. E.C.

United Kingdom

CORK, RICHARD. *Vorticism and Abstract Art in the First Machine Age.* London: Lund Humphries, 1975; Berkeley: University of California Press, 1976. 2 vols.

English Art Today 1960–76. New York: Rizzoli, 1976. 2 vols. E.C.

Henry Moore to Gilbert and George: Modern British Art from The Tate Gallery. London: Tate Gallery, 1973. E.C.

ROTHENSTEIN, JOHN K. M. *British Art Since 1900: An Anthology.* London: Phaidon, 1962.

———. *Modern English Painters.* Rev. ed. New York: St. Martin's, 1976. 3 vols.

* *Thirties: British Art and Design before the War.* London: Arts Council of Great Britain, 1979. E.C.

United States

AGEE, WILLIAM C. *The 1930's: Painting and Sculpture in America.* New York: WMAA, 1968. E.C.

ALLOWAY, LAWRENCE. *Topics in American Art Since 1945.* New York: Norton, 1975. P.

ANDERSEN, WAYNE. *American Sculpture in Process: 1930/1970.* Boston: New York Graphic Society, 1975.

ASHTON, DORE. *Modern American Sculpture.* New York: Abrams, 1968.

BATTCOCK, GREGORY, ed. *The New Art: A Critical Anthology.* New York: Dutton, 1966. P.

BAUR, JOHN I. H. *Revolution and Tradition in Modern American Art.* Cambridge: Harvard University Press, 1951. P.

BROWN, MILTON W. *American Painting from the Armory Show to the Depression.* Princeton: Princeton University Press, 1955.

* ———; HUNTER, SAM; JACOBUS, JOHN; ROSENBLUM, NAOMI; and SOKOL, DAVID M. *American Art: Painting, Sculpture, Architecture, Decorative Arts, Photography.* New York: Abrams, 1979.

CALAS, NICHOLAS, and CALAS, ELENA. *Icons and Images of the Sixties.* New York: Dutton, 1971. P.

* DIJKSTRA, BRAM. *The Hieroglyphics of a New Speech: Cubism, Stieglitz, and the Early Poetry of William Carlos Williams.* Princeton: Princeton University Press, 1969.

* EKDAHL, JANIS. *American Sculpture: A Guide to Information Sources.* Detroit: Gale, 1977.

HITCHCOCK, HENRY-RUSSELL, and DREXLER, ARTHUR. *Built in U.S.A.: Post-War Architecture.* New York: MoMA, 1952. E.C.

* KEAVENEY, SYDNEY STARR. *American Painting: A Guide to Information Sources.* Detroit: Gale, 1974.

LEVIN, GAIL. *Synchromism and American Color Abstraction 1910–1925.* New York: WMAA, 1978. E.C.

MUMFORD, LEWIS, ed. *Roots of Contemporary American Architecture.* New York: Reinhold, 1952.

* *Paris-New York.* Paris: Centre National d'Art et de Culture Georges Pompidou, 1977. E.C.

ROSE, BARBARA. *American Art Since 1900: A Critical History.* Rev. ed. New York: Praeger, 1975. P.

———. *Readings in American Art, 1900–1975.* Rev. ed. New York: Praeger, 1975. P.

SELZ, PETER. *2 Jahrzehnte amerikanische Malerei 1920–1940.* Düsseldorf: Stadtische Kunsthalle, 1979. E.C.

TOMKINS, CALVIN. *The Scene: Reports on Post-Modern Art.* New York: Viking, 1976.

* TUCHMAN, MAURICE, ed. *American Sculpture of the Sixties.* Los Angeles: Los Angeles County Museum of Art, 1967. E.C.

U.S.S.R.

* BOWLT, JOHN E., ed. *Russian Art of the Avant-Garde: Theory and Criticism, 1902–1934.* New York: Viking, 1976.

CHEN, JACK. *Soviet Art and Artists.* London: Pilot, 1944.

GIBIAN, GEORGE, and TJALSMA, H. W., eds. *Russian Modernism: Culture and the Avant-Garde, 1900–1930.* Ithaca: Cornell University Press, 1976.

GRAY, CAMILLA. *The Great Experiment: Russian Art, 1863–1922.* New York: Abrams, 1962.

GUERMAN, MIKHAIL. *Art of the October Revolution.* New York: Abrams, 1979.

LISSITZKY, EL. *Russia: An Architecture for World Revolution.* Cambridge, Mass.: MIT Press, 1970.

* *Paris-Moscou 1900–1930.* Paris: Centre National d'Art et de Culture Georges Pompidou, 1979. E.C.

SHIDKOVSKY, O., et al. *Building in the U.S.S.R., 1917–1932.* London: Studio Vista; New York: Praeger, 1971.

WILLIAMS, ROBERT C. *Artists in Revolution: Portraits of the Russian Avant-Garde, 1905–1925.* Bloomington: Indiana University Press, 1977.

Index

Collections/Locations and Photograph Sources

The author and publisher wish to thank the museums, galleries, libraries, and private collectors listed here for permitting the reproduction of works of art in their possession and for supplying the necessary photographs. Photographs from other sources are gratefully acknowledged below; those not listed have been provided by the publisher.

Abbreviations

P	Photo source or photographer
AIC	The Art Institute of Chicago
AK	Albright-Knox Art Gallery, Buffalo
Beaubourg	Musée National d'Art Moderne, Paris. Centre National d'Art et de Culture Georges Pompidou
HMSG	Hirshhorn Museum and Sculpture Garden, Smithsonian Institution, Washington, D.C.
KB	Kunstmuseum, Berne
KMB	Kunstmuseum, Basel
LP	Louvre, Paris
MFA	Museum of Fine Arts, Boston
MMA	The Metropolitan Museum of Art, New York
MoMA	The Museum of Modern Art, New York
NGA	National Gallery of Art, Washington, D.C.
NW	Kunstsammlung Nordrhein-Westfalen, Düsseldorf
PC	The Phillips Collection, Washington, D.C.
PMA	Philadelphia Museum of Art
RKM	Rijksmuseum Kröller-Müller, Otterlo
Service	Service Photographique du Réunion des Musées Nationaux, Paris
SRGM	The Solomon R. Guggenheim Museum, New York
TGL	The Tate Gallery, London
WMAA	Whitney Museum of American Art, New York
YU	Yale University Art Gallery, New Haven

CHAPTER ONE

1–2 P: Chicago Architectural Photographing Co. 3–4 P: MoMA 5 P: © A.C.L., Brussels 6 P: Kunstgewerbemuseum, Zurich 7 P: Jörg P. Anders, Berlin 8 P: Bildarchiv Foto Marburg, Marburg/Lahn 9 P: Dr. Franz Stoedtner, Düsseldorf 10 P: The Preservation Society of Newport County, R.I. 11–12 P: Wayne Andrews, Grosse Pointe, Mich. 13 P: Jane Bechell, London 14 P: MoMA 15 P: Dôtreville, Brussels 18 P: L'Art Ancien, S.A., Zurich 19 P: Dr. Franz Stoedtner, Düsseldorf 20 P: André Martin, Paris 22 P: Bildarchiv der Österreichischen Nationalbibliothek, Vienna 23 P: Atelier Kurt Gerlach, Vienna 25 P: Forbes Library, Northampton, Mass. 26 P: AIC 28 P: Chicago Historical Society 29 P: Bibliothèque Nationale, Paris 30 Musée d'Orsay, Palais de Tokyo. P: Archives Photographiques, Paris 31 National Gallery of Scotland, Edinburgh. P: Tom Scott, Edinburgh 32 LP. P: Service 33 AIC. Robert A. Waller Fund 34 MMA. Bequest of Stephen C. Clark 35 Musée Toulouse-Lautrec et d'Art Moderne, Albi 36 Private collection, New York. P: Charles Uht, New York 37 Private collection, New York 38 Nationalmuseum, Stockholm 39 Munch-Museet, Oslo 40 Collection Mr. and Mrs. Leigh B. Block, Chicago 41 LP 42 TGL 43 Scottish National Gallery of Modern Art, Edinburgh 44 AIC. Helen Birch Bartlett Memorial 45 Kaiser Wilhelm Museum, Krefeld, Ger. 46 SRGM. Thannhauser Collection 47 RKM 48 Walker Art Gallery, Liverpool 49 PMA. Given by Mrs. Thomas Eakins and Miss Mary A. Williams 50 KMB. Gottfried Keller Foundation 51–52 TGL 53 MFA. Tompkins Collection, Arthur Gordon Tompkins Residuary Fund 54 Pushkin Museum, Moscow 55 KB 56–57 Nasjonalgalleriet, Oslo. P: O. Vaering, Oslo 58 Cleveland Museum of Art. Purchase from the J. H. Wade Fund 59 AK. A. Conger Goodyear Collection 60 KB 61 MoMA. Gift of Mrs. Simon Guggenheim 62 Museo de Arte de Ponce, Puerto Rico. The Luis A. Ferré Foundation 63 Chrysler Museum at Norfolk, Va., Gift of Walter P. Chrysler, Jr. 64 Nasjonalgalleriet, Oslo, courtesy Munch-Museet, Oslo 65 Musées Royaux des Beaux-Arts de Belgique, Brussels. P: © A.C.L., Brussels 66 Manchester Art Galleries, England 67 Bayerische Staatsgemäldesammlungen, Munich 68 British Museum, London 69 YU. Gift of Archer M. Huntington, B.A. 1897 70 P: Sotheby's Belgravia, London 71 Boston Public Library 72 Bowdoin College Museum of Art, Brunswick, Me. Gift of the Misses Walker 73 Musée Gustave Moreau, Paris. P: Bulloz, Paris 74 RKM 75 Boston Public Library 76 MMA. Bequest of Samuel A. Lewisohn, 1951 77 RKM 78 Munch-Museet, Oslo 79 Museum Koninklijk voor Schone Kunsten, Antwerp 80 Museum der Bildenden Künste, Leipzig 81 Collection Arthur G. Altschul, New York 82 RKM 83 MFA. Gift of Edwin Atkins Grozier 84 MoMA. Gift of Abby Aldrich Rockefeller 85 Tretyakov Gallery, Moscow. P: Editions Cercle d'Art, Paris 86 MFA. Juliana Cheney Edwards Collection. Bequest of Robert J. Edwards in memory of his mother 87 The Art Museum, Princeton University, Princeton, N.J. Gift of Professor Francis A. Comstock 88 Museum of Art, Carnegie Institute, Pittsburgh. Acquired through the generosity of the Sarah M. Scaife Family 89 Rijksmuseum Vincent van Gogh, Amsterdam 90 Courtauld Institute Galleries, London, courtesy of Home House Trustees 91 Segantini Museum, St. Moritz 92 Musées Royaux des Beaux-Arts de Belgique, Brussels. P: © A.C.L., Brussels 93 AIC. Helen Birch Bartlett Memorial Collection 94 PC 95 RKM 96 MoMA. Gift of Nelson A. Rockefeller 97 North Carolina Museum of Art, Raleigh 98 Smith College Museum of Art, Northampton, Mass. 99 Munch-Museet, Oslo 100 Stavros S. Niarchos Collection, London 101 Museum der Bildenden Künste, Leipzig 102 Museum Bellerive, Sammlung des Kunstgewerbemuseums, Zurich 103 Stadtmuseum, Munich 104 Det Danske Kunstindustrimuseum, Copenhagen 105 Osterreichisches Museum für Angewandte Kunst, Vienna 106 Place de la Nation, Paris. P: Giraudon, Paris 107 Boulevard Raspail and Boulevard Montparnasse, Paris 108–109 Lenbachplatz, Munich. P: Dr. Franz Stoedtner, Düsseldorf 110 Rock Creek Cemetery, Washington, D.C. 111 Central Park, New York 112 Private collection, New York. P: John D. Schiff, New York 113 MFA. Arthur Tracy Cabot Fund 114 MMA. Bequest of Mrs. H. O. Havemeyer, 1929. The H. O. Havemeyer Collection 115 Galleria Internazionale d'Arte Moderna di Ca' Pesaro, Venice 116 HMSG 117 MMA. Gift of Charles Follen McKim, 1897 118 LP. P: Archives Photographiques, Paris 119 HMSG 120 Nationalgalerie, Berlin 121 MoMA. Gift of Mr. and Mrs. Samuel Josefowitz 122 MoMA. Acquired through the Lillie P. Bliss Bequest 123 National Cowboy Hall of Fame and Western Heritage Center, Oklahoma City

CHAPTER TWO

124–125 P: Chicago Architectural Photographing Co. 128 P: Bildarchiv der Österreichischen Nationalbibliothek, Vienna 129 P: Hans Sibbelee, Middenweg 130 P: Foto van Ojen, The Hague 132 P: Dr. Franz Stoedtner, Düsseldorf 133 P: Caisse Nationale des Monuments Historiques et des Sites, Paris 134 P: Dr. Franz Stoedtner, Düsseldorf 135 The Museum of Finnish Architecture, Helsinki 136 P: Buffalo and Erie County Historical Society 137 P: MoMA 139 P: Bildarchiv Foto Marburg, Marburg/Lahn 140 P: Hedrich-Blessing, Chicago 141 P: Marie Blumer-Maillart, Zurich 142 P: Ronald Partridge, Berkeley, Calif. 143 P: Wayne Andrews, Grosse Pointe, Mich. 144–145 P: T. & R. Annan & Sons, Ltd., Glasgow 146 P: MAS, Barcelona 149 P: Wayne Andrews, Grosse Pointe, Mich. 150 P: Caisse Nationale des Monuments Historiques et des Sites, Paris 151 P: Lucien Hervé, Paris 152, 155 P: MAS, Barcelona 157 P: Bildarchiv der Österreichischen Nationalbibliothek, Vienna 158 P: Wayne Andrews, Grosse Pointe, Mich. 159 P: Hedrich-Blessing, Chicago 161 P: Chicago Architectural Photographing Co. 163 P: Bildarchiv der Österreichischen Nationalbibliothek, Vienna 164 P: Dr. Franz Stoedtner, Düsseldorf 165 P: Studio Minders, Ghent 166 P: Bildarchiv Foto Marburg, Marburg/Lahn 167–168 HMSG 169 AIC. A. A. Munger Collection 170 Musée Constantin Meunier, Brussels 171 P: Leonard von Matt, Buochs, Switz. Courtesy M. Knoedler & Co., Inc., New York. 172–173 MoMA. Gift of Stephen C. Clark 174–175 HMSG 176 P: Mme. Duthuit, Paris 177 Muzeul de Artă, R.S.R., Bucharest 178 Stedelijk Museum, Amsterdam 179 Editions Graphiques Gallery, London 180 Private collection, Houston 181 MoMA. Gift of Anthony Russo 182 Musée des Arts Décoratifs, Paris 183 Rodin Museum, Philadelphia. P: Philadelphia Museum of Art 184 MoMA. Gift of Mrs. Maurice L. Stone in memory of her husband 185 Museum der Bildenden Künste, Leipzig 186 HMSG 187 MoMA. Purchase 188–189 HMSG 190 MFA. J. H. and E. A. Payne Fund 191 HMSG 192 Collection Richard S. Davis, New York 193 Private collection 194 Scottish

National Gallery of Modern Art, Edinburgh. Bequeathed by Sir D. Y. Cameron, 1905 **195** Musée Rodin, Paris **196** Vigeland Museet, Oslo **197** MoMA. Gift of the artist **198** Montparnasse Cemetery, Paris. P: Etienne B. Weill, Paris **199** LP. P: Service **200** Collection Mme. Vlaminck, Paris **201** LP. P: Service **202** Pushkin Museum, Moscow. P: Editions Cercle d'Art, Paris **203** Nationalgalerie, Berlin. P: Walter Steinkopf, Berlin **204** Rasmus Meyers Collection, Bergen, Norway **205** Ludwig Roselius Museum, Bremen **206** Bayerische Staatsgemäldesammlungen, Munich **207** Nationalgalerie, Berlin. P: Jörg P. Anders, Berlin **208** MMA. Gift of pupils of William M. Chase, 1905 **209** KMB **210** Beaubourg. P: Service **211** PMA. A. E. Gallatin Collection **212** Statens Museum for Kunst, Copenhagen. J. Rum Collection **213** Kunsthalle, Hamburg **214** MMA. Bequest of Gertrude Stein, 1946 **215** Private collection, San Francisco. P: M. Lee Fatherree, San Francisco **216** Von der Heydt Museum, Wuppertal. P: Studio van Santvoort, Wuppertal **217** MoMA. Gift of Mr. and Mrs. Peter A. Rübel **218** Osterreichische Galerie, Vienna **219** Corcoran Gallery of Art, Washington, D.C. **220** AIC. Friends of American Art Collection **221** PMA **222** AIC. Mr. and Mrs. Martin A. Ryerson Collection **223** Scottish National Gallery of Modern Art, Edinburgh. P: T. & R. Annan & Sons, Glasgow **224** The Hermitage, Leningrad **225–226** KMB **227** PMA. The Wilstach Collection **228** MoMA. Acquired through the Lillie P. Bliss Bequest **229** The Hermitage, Leningrad **230** PMA. Louise and Walter Arensberg Collection **231** RKM **232** Kunsthistorisches Museum, Vienna **233** The Brooklyn Museum, New York **234** MMA. Gift of George A. Hearn, 1909 **235** MMA. Purchase. Mr. and Mrs. William Coxe Wright Gift, 1957 **236** The Baltimore Museum of Art. Cone Collection **237** KMB **238** NW **239** Bayerische Staatsgemäldesammlungen, Munich **240** Staatsgalerie, Stuttgart **241** Collection Mme. Martinais-Manguin, Paris. P: Galerie de Paris, France **242** Kunsthaus, Zurich **243** Private collection **244** Musée d'Art Moderne de la Ville de Paris **245** NGA. Chester Dale Collection **246** LP. P: Service **247** Private collection, Switz. P: Leonardo Bezzola, Bätterkinden **248** Cleveland Museum of Art. Gift of the Hanna Fund **249** Osterreichische Galerie, Vienna. P: Fotostudio Otto, Vienna **250** MoMA. Gift of Mr. and Mrs. Charles Zadok **251** MoMA. Purchase **252** Estate of the artist **253** Collection Dr. Giuseppe Cosmelli, Rome. P: Giacomelli, Venice **254** WMAA **255** Wadsworth Atheneum, Hartford. The Ella Gallup Sumner and Mary Catlin Sumner Collection **256** LP. P: Service **257** Private collection, Pa. P: Philadelphia Museum of Art **258** Private collection, Switz. P: Leonardo Bezzola, Bätterkinden **259** Private collection, Paris **260** Addison Gallery of American Art, Phillips Academy, Andover, Mass. **261** Beaubourg. P: Service **262** KB. Hermann and Margit Rupf Foundation **263** Gemeentemuseum, The Hague. S. B. Slijper Collection **264** MoMA. Fractional gift of Mrs. Bertram Smith

CHAPTER THREE

265 Collection Morton D. May, St. Louis. P: The St. Louis Art Museum **266** AIC. Gift of Arthur Jerome Eddy Memorial **267** Bayerische Staatsgemäldesammlungen, Munich. Staatsgalerie Moderner Kunst. P: Blauel, Munich **268** MMA. The Alfred Stieglitz Collection, 1949 **269** MMA. Rogers Fund, 1962 **270** MoMA. Gift of Mr. and Mrs. Morton D. May **271** MoMA. A. Conger Goodyear Fund **272** Location unknown. P: Estate of George Grosz, Princeton, N.J. **273** Staatsgalerie, Stuttgart **274** Collection Richard S. Zeisler, New York **275** WMAA **276** PMA. The Louise and Walter Arensberg Collection **277** Gemeentemuseum, The Hague **278** Bayerische Staatsgemäldesammlungen, Munich. Staats-

galerie Moderner Kunst **279** Collection Morton D. May, St. Louis. P: Savage Studio, St. Louis **280** Collection Christian A. Nebehay, Vienna. P: Serge Sabarsky Gallery, New York **281** NW. P: Walter Klein, Gerresheim **282** MoMA. Gift of Mr. and Mrs. John Hay Whitney **283** Bequest of A. Conger Goodyear to George F. Goodyear, life interest, and the Albright-Knox Art Gallery, Buffalo, 1964 **284** MoMA. Purchase **285** The National Gallery of Canada, Ottawa **286** Museum Boymans-van Beuningen, Rotterdam **287** KMB. P: Hinz, Basel **288** Private collection, Ger. **289** MoMA. Purchase **290** AIC. Gift of Mrs. Gilbert W. Chapman **291** AIC. Gift of Mr. Leigh B. Block **292** MoMA. Gift of T. Catesby Jones **293** Museum of Art, Rhode Island School of Design, Providence, R.I. Auction and Museum Works of Art Funds **294** NGA. Chester Dale Collection **295** MMA. The Alfred Stieglitz Collection, 1949 **296** Collection Marguerite Arp-Hagenbach, Clamart **297** Collection Luigi Sprovieri, Rome **298** Musée d'Art et d'Histoire, Geneva. P: Borel-Boissonnas, Geneva **299** Folkwang Museum, Essen **300** Private collection **301** Estate of the artist **302** MoMA. Purchase **303** MoMA. Mrs. Simon Guggenheim Fund **304** Collection Andreas Jawlensky, Locarno. P: O. Stutz, Tegna/Ti, Italy **305** Private collection, São Paulo **306** Graphische Sammlung Albertina, Vienna **307** Collection Morton G. Neumann, Chicago. P: Oliver Baker, New York **308** YU. Gift of Collection Société Anonyme **309** Musée d'Art Moderne de la Ville de Paris **310** Beaubourg. P: Service **311** Private collection. Courtesy Leonard Hutton Galleries, New York **312** TGL **313** MMA. Bequest of Stephen C. Clark, 1960 **314** Wallraf-Richartz Museum, Cologne **315** MoMA. Acquired through the Lillie P. Bliss Bequest **316** MMA. The Alfred Stieglitz Collection, 1949 **317** KMB. P: Hinz, Basel **318** Art Gallery of Ontario, Toronto. Gift of Sam and Ayala Zacks, 1970 **319** Collection Andreas Jawlensky, Locarno **320** The Hermitage, Leningrad **321** MoMA. Acquired through the Lillie P. Bliss Bequest **322** Folkwang Museum, Essen. P: Liselotte Witzel, Essen **323** PMA. The Louise and Walter Arensberg Collection **324** P: PMA **325** MoMA. Purchase **326** PMA. The Louise and Walter Arensberg Collection **327** Private collection **328** MoMA **329** Folkwang Museum, Essen **330** PMA. The A. E. Gallatin Collection **331** MoMA. Mrs. Simon Guggenheim Fund **332** NGA. Gift of Ethelyn McKinney in memory of her brother, Glenn Ford McKinney **333** PC **334** YU. Gift of Collection Société Anonyme **335** The Brooklyn Museum, New York. Gift of Otto J. and Eloise A. Spaeth Foundation and J. B. Woodward Fund **336** KMB. Deposited by the Emanuel Hoffmann Foundation. P: Hinz, Basel **337** SRGM **338** MoMA. The Alfred Stieglitz Collection, 1949 **339** Union Memorial Hospital, Baltimore **340** WMAA. Gift of Mr. and Mrs. Benjamin Halpert **341** YU. Gift of the Société Anonyme **342** SRGM **343** Collection Mme. Denise Staechelin, Basel. P: Hinz, Basel **344** Private collection **345** Estate of the artist **346** Collection Milton and Edith Lowenthal, New York. P: Geoffrey Clements, New York **347** Stiftung Seebüll Ada und Emil Nolde, Neukirchen. P: Blauel, Munich **348** MoMA. Acquired through the Lillie P. Bliss Bequest **349** PMA. The Louise and Walter Arensberg Collection **350** MoMA. Gift of G. David Thompson **351** KMB. P: Hinz, Basel **352** Oesterreichische Galerie, Vienna **353** Private collection, Hamburg **354** MoMA. Acquired through the Lillie P. Bliss Bequest **355** Collection Dr. Gianni Mattioli, Milan **356** Stiftung Seebüll Ada und Emil Nolde, Neukirchen. P: Blauel, Munich **357** St. Louis Art Museum. Bequest of Curt Valentin **358** Collection Henry P. McIlhenny, Philadelphia. P: MoMA. **359** TGL **360** MoMA. Mrs. Simon Guggenheim Fund **361** Collection Morton D. May, St. Louis **362** WMAA **363** YU. Gift of Collection Société Anonyme **364** PMA. The Louise and Walter Arensberg Col-

lection **365** Minneapolis Institute of Arts **366** Cleveland Museum of Art. Leonard C. Hanna, Jr. Collection **367** Pushkin Museum, Moscow **368** NW **369** MoMA. Acquired through the Lillie P. Bliss Bequest **370** Private collection **371** NGA. Chester Dale Collection **372** SRGM **373** Stedelijk Museum, Amsterdam **374** PMA. The Louise and Walter Arensberg Collection **375** RKM **376** MoMA **377** Private collection, Paris **378** Collection Frau Doris Diekmann, Stuttgart **379** Collection Mr. and Mrs. Jack L. Wolgin, Philadelphia **380** Los Angeles County Museum of Art. Gift of Morton D. May **381** AIC. The Alfred Stieglitz Collection **382** Amon Carter Museum of Western Art, Fort Worth **383** KMB. P: Hinz, Basel **384** TGL **385** MoMA **386** MoMA. Philip Johnson Fund **387** Destroyed **388** Estate of the artist, Paris **389** MoMA. Purchase **390** AIC. Anonymous gift **391** SRGM **392** Beaubourg **393** Collection Riccardo and Magda Jucker, Milan. P: Sponga, Milan **394** HMSG **395** AK. Gift of Seymour H. Knox **396** YU. Gift of Collection Société Anonyme **397** Estate of the artist. P: MoMA **398** Private collection, New York **399** Lydia and Harry L. Winston Collection (Dr. and Mrs. Barnett Malbin), New York **400** Collection Dr. Gianni Mattioli, Milan **401** Private collection, Paris **402** Leonard Hutton Galleries, New York **403** YU. Gift of the artist to Collection Société Anonyme **404** Moderna Museet, Stockholm **405** Private collection, Basel **406** Private collection, Paris **407** Stedelijk Museum, Amsterdam **408** Collection Herman Berninger, Zurich **409** Tretyakov Gallery, Moscow **410** Klee Foundation, KB **411** Staatsgalerie, Stuttgart **412** PC. P: Henry Beville, Annapolis **413** Stedelijk Museum, Amsterdam **414** SRGM **415** Gemeentemuseum, The Hague **416** National Gallery, Prague **417** MMA. Bequest of Mrs. H. O. Havemeyer, 1929, The H. O. Havemeyer Collection **418** Musée Rodin, Paris **419** Nationalgalerie, Berlin **420** TGL **421** National Collection of Fine Arts, Smithsonian Institution, Washington, D.C. Bequest of the artist **422** Robert Isaacson Gallery, New York **423** Private collection, Los Angeles. P: Condit Studio, Portland, Ore. **424** YU. Gift of Collection Société Anonyme **425** Private collection, New York. P: Adolph Studly, Pennsburg, Pa. **426** HMSG **427** MoMA. Abby Aldrich Rockefeller Fund **428** MoMA. Gift of Mrs. John D. Rockefeller, Jr. **429** HMSG **430** Destroyed **431–432** MoMA. Acquired through the Lillie P. Bliss Bequest **433** Dismantled. P: TGL **434** Perls Galleries, New York **435** MoMA. Mrs. Simon Guggenheim Fund **436** MoMA. Gift of William S. Paley (by exchange) **437** Lydia and Harry L. Winston Collection (Dr. and Mrs. Barnett Malbin), New York **438** Beaubourg **439** HMSG **440** PMA. Given by Mrs. Rodolphe M. de Schauensee **441** NGA. Chester Dale Collection **442–446** HMSG **447** Lachaise Foundation, courtesy Robert Schoelkopf Gallery, New York **448** MoMA **449** Estate of the artist. Reproduction rights SPADEM, Paris **450** SRGM **451** Tretyakov Gallery, Moscow **452** MoMA. Purchase **453** NGA. Andrew W. Mellon Fund, 1977 **454** Collection Sir Roland Penrose, London. P: John Webb, London **455** MoMA. Aristide Maillol Fund **456** MoMA. Gift of Mrs. Bertram Smith **457** TGL **458** Collection M. et Mme. Claude Laurens, Paris **459** Sidney Janis Gallery, New York **460** MoMA. Gift of Philip Johnson **461** HMSG **462** AIC. The Ada Turnbull Hertle Fund **463** Des Moines Art Center. Gift of John and Elizabeth Bates Cowles, 1960 **464** Private collection **465** TGL **466** Private collection **467** Collection Mme. Alexander Archipenko, Hollywood **468** Lydia and Harry L. Winston Collection (Dr. and Mrs. Barnett Malbin), New York **469** HMSG **470** MoMA. Blanchette Rockefeller Fund **471** MoMA. The Sidney and Harriet Janis Collection **472** Location unknown **473** YU. Gift of Collection Société Anonyme **474** Private collection, U.S.S.R. **477** P: Ed Nowak,

New York 479 P: Dr. Franz Stoedtner, Düsseldorf 480 P: Colin C. McRae, Berkeley 482 P: Dr. Franz Stoedtner, Düsseldorf 486 P: Lucien Hervé, Paris 487 P: Jahrbuch der Deutsches Werkbundes, 1915 488 P: Walter Gropius, Cambridge, Mass. 489 P: Moulin Studios, San Francisco 490 P: California Historical Society, San Francisco 491 P: Mies van der Rohe Archive, MoMA 492 P: Akademie der Künste, Berlin 493 P: Verlag Gerd Hatje, Stuttgart-Bad Cannstatt 496 P: RKM 497 P: Jahrbuch der Deutsches Werkbundes, 1915 498 P: Wayne Andrews, Grosse Pointe, Mich. 499 P: Hans Schiller, Mill Valley, Calif. 500 P: German Information Center, New York 501 P: A. Renger-Patsch, Wameldorf near Soest, Westfalen, Ger. 502 P: Dr. Franz Stoedtner, Düsseldorf 503–504 P: Till Behrens, Frankfurt 505 P: Dr. Franz Stoedtner, Düsseldorf 506 P: F. R. Yerbury, London 507 P: Dartmouth College, Hanover, N. H. 508 P: Wayne Andrews, Grosse Pointe, Mich. 509 P: Amigos de Gaudí, Barcelona 511 P: Elizabeth Menzies, Princeton 512 P: Chicago Board of Education 513 P: Dartmouth College, Hanover, N. H. 514 P: Heydebrand-Osthoff, Dornach, Switz. 515 P: Museum of the City of New York 516 P: Swedish Information Service, New York 517 P: MAS, Barcelona 518 P: Amigos de Gaudí, Barcelona 519 P: Chicago Architectural Photographing Co. 520 P: Chicago Historical Society

CHAPTER FOUR

522 P: Sovfoto, New York 523 P: Bauhaus-Archiv, Berlin 525 P: the artist 526–534 P: Chicago Tribune 536 P: the author 538–539 P: Publicity and Special Events Department, Bullocks Wilshire, Los Angeles 540 P: Wellington Associates, Inc., New York 542–543 P: Chicago Architectural Photographing Co. 545 P: Tass from Sovfoto, New York 547 P: Lucien Hervé, Paris 548 P: Kiesler Archive, New York 549 P: Lucien Hervé, Paris 550, 552 P: MoMA 553 P: Lucien Hervé, Paris 555 P: Dr. Franz Stoedtner, Düsseldorf 556 P: Wayne Andrews, Grosse Pointe, Mich. 557 P: Florian J. Lem, Hollandische Rading, The Netherlands 558 P: MoMA 560 P: Wayne Andrews, Grosse Pointe, Mich. 562 P: Stadtarchiv, Frankfurt-am-Main 563 P: Akademie der Künste, Berlin 564 P: MoMA 565 P: Stadtarchiv, Stuttgart 567 P: Bauhaus Archiv, Berlin 568 P: Stadtarchiv, Stuttgart 569 P: Helga Schmidt-Glassner, Stuttgart 570 P: Stadtarchiv, Stuttgart 571 P: Fototechn. Dienst Gemeente Werken, Rotterdam 572 P: MoMA 573 P: Musées de la Ville de Strasbourg 575 P: Dr. Franz Stoedtner, Düsseldorf 577 P: Bauhaus-Archiv, Berlin 578 P: MoMA 579–580 P: Bauhaus-Archiv, Berlin 581 P: Emil Gmelin, Dornach 585 P: MoMA 586 P: the author 588 P: MoMA. Frank Lloyd Wright Collection 589 P: MoMA 590 P: Fondation Le Corbusier, Paris 592 Beaubourg. P: Service 593 MoMA 594 Moderna Museet, Stockholm 596 Beaubourg 597 NW 598 SRGM. Gift of Katherine S. Dreier Estate from Marcel Duchamp, New York 599 MoMA. Purchase 600 Collection Mme. Simone Collinet, Paris 602 MoMA. Gift of William Rubin 603 MoMA. Acquired through an anonymous fund, the Mr. and Mrs. Joseph Slifka and Armand G. Erpf Funds, and by gift of the artist 604 MoMA. Given anonymously 605 Collection Mme. Jean Krebs, Brussels 606 Private collection, Paris 607 Galerie Isy Brachot, Brussels 608 Private collection 609 Kunsthalle, Hamburg 610 Galerie Nierendorf, Berlin 611 Private collection, Switz. 612 KMB 613 Collection Mr. and Mrs. William Mazer, New York 614 MoMA. Sidney and Harriet Janis Collection 615 Collection Richard S. Zeisler, New York 616 SRGM 617 MoMA. Mrs. Simon Guggenheim Fund 618 Private collection 619 MMA. Rogers Fund, 1951. Acquired from MoMA,

Lillie P. Bliss Collection 620 NGA. Chester Dale Collection, 1962 621 Beaubourg. P: Service 622 Kunsthalle, Hamburg 623 TGL 624 Leeds City Art Gallery. P: Courtauld Institute of Art, London 625 Chapingo, Mexico 626–627 Ministry of Education, Mexico City 628 National Preparatory School, Mexico City 629 NGA. Rosenwald Collection 630 Staatliche Galerie Moritzburg, Halle 631 Nationalgalerie, Berlin 632 Collection Morton D. May, St. Louis 633 Busch-Reisinger Museum, Harvard University, Cambridge, Mass. 634 Städtische Kunsthalle, Mannheim 635 Niedersächsisches Landesmuseum, Hanover 636 AIC 637 WMAA. Gift of Julien Levy for Maro and Natasha Gorky in memory of their father 638 MoMA. Purchase 639 MoMA. Gift of Abby Aldrich Rockefeller 640 MMA. The Alfred Stieglitz Collection, 1949 642 The Dance Museum, Stockholm 643 MoMA. Gift of Lily Auchincloss 644 Institut für Theaterwissenschaft, Cologne 645 Niedersächsisches Landesmuseum, Hanover 646 Wadsworth Atheneum, Hartford. The Ella Gallup Sumner and Mary Catlin Sumner Collection 647–648 Bakhrushin Theater Museum, Moscow 649 MoMA. Mrs. Simon Guggenheim Fund 650 The Baltimore Museum of Art. Mabel Garrison Siemonn Collection 651 Niedersächsisches Landesmuseum, Hanover 652 Collection Mary Hemingway, New York. P: AIC 653 The Corcoran Gallery of Art, Washington, D.C. Museum Purchase. William A. Clark Fund 654 PC. P: Henry Beville, Annapolis 655 AIC. Purchase fund 656 WMAA 657 Wallraf-Richartz Museum, Cologne 658 Private collection, Los Angeles. P: Serisawa, Los Angeles 659 Galerie Isy Brachot, Brussels 660 Formerly William N. Copley, New York 661–662 WMAA 663 AK. Room of Contemporary Art Fund, 1941 664 Printroom, University of Leiden, The Netherlands 665 MoMA. Acquired through the Lillie P. Bliss Bequest 666 Fisk University, Nashville. The Alfred Stieglitz Collection 667 Kunsthaus, Zurich 668–669 MoMA. Mrs. Simon Guggenheim Fund 670 KMB 671 Private collection 672 MoMA. Mrs. Simon Guggenheim Fund 673 MoMA. A. Conger Goodyear Fund 674 Dallas Museum of Fine Arts. Foundation for the Arts Collection. Gift of Gerald Murphy 675 Private collection, New York 676 Private collection. P: Geoffrey Clements, New York 677 MoMA. Van Gogh Purchase Fund 678 NW 679 Salvador Dali Museum, Cleveland 680 Collection Mrs. Hans Popper, San Francisco 681 Santa Barbara Museum of Art. Gift of Wright Ludington 682 PMA. The Louise and Walter Arensberg Collection 683 MoMA. Purchase 684 AK. The Room of Contemporary Art Fund 685 Estate of the artist. Reproduction rights SPADEM, Paris. P: MoMA 686 The Elephant Trust, London. P: TGL 687 PMA. The A. E. Gallatin Collection 688 AIC. The Alfred Stieglitz Collection 689 MoMA. Purchase 690 NW 691 Tretyakov Gallery, Moscow 692 The Columbus Gallery of Fine Arts, Ohio. Gift of Ferdinand Howald 693 Fogg Art Museum, Harvard University, Cambridge, Mass. Purchase. Louise E. Bettens Fund 694 The Newark Museum, N. J. 695 Museum voor Hedendaagse Kunst, Ghent 696 MoMA. Gift of Philip Johnson in memory of Sibyl Moholy-Nagy 697 MoMA. Gift of Philip Johnson 698 PMA. The Louise and Walter Arensberg Collection 699 HMSG 700 San Francisco Museum of Modern Art. Gift of Mrs. Sibyl Moholy-Nagy 701 KMB 702 Collection Mr. and Mrs. Morton G. Neumann, Chicago 703 PMA. The Louise and Walter Arensberg Collection 704 Norton Simon Museum of Art, Pasadena. Gift of Mrs. Robert A. Rowan, 1969 705 MoMA. A. Conger Goodyear Fund 706 PMA. The Louise and Walter Arensberg Collection 707 MoMA. Gift of LeRoy W. Berdeau 708 City Art Gallery, Manchester, Eng. 709 MoMA. Purchase 710 SRGM 711–712 Hanover. Destroyed 1943 713 SRGM 714 MoMA. Gift of Mrs. Sibyl Moholy-Nagy

715–716 MoMA. Gift of the artist 717 SRGM 718 MoMA. Van Gogh Purchase Fund 719 Kunsthaus, Zurich. Alberto Giacometti Foundation 720 WMAA 721 Leeds City Art Galleries, Eng. 722 MoMA. Katherine S. Dreier Bequest 723 Destroyed. P: Etienne Weill, Paris 724 MoMA. Gift of Edward M. M. Warburg 725 Succession Jean Arp, Clamart 726 HMSG 727 Private collection, Paris. P: Archives Photographiques, Paris 728 HMSG 729 MoMA. Abby Aldrich Rockefeller Fund 730 Collection Buckminster Fuller, Philadelphia. P: Patricia Ruben, Philadelphia 731 Beaubourg. P: Service 732 TGL 733 Location unknown. P: MoMA 734 YU. Gift of Collection Société Anonyme 735 MoMA. James Thrall Soby Fund 736–737 Busch-Reisinger Museum, Harvard University, Cambridge, Mass.

CHAPTER FIVE

739 P: Tass from Sovfoto, New York 740 MoMA. Abby Aldrich Rockefeller Fund 742 Rockefeller Center, New York 743–744 HMSG 745 Collection the artist, New York. P: Jerry L. Thompson, New York 746 Private collection, Paris. P: Leni Iselin, Paris 747 MoMA. Purchase 748 Beaubourg. P: Galerie A. F. Petit, Paris 749 Beaubourg. P: Galerie Claude Bernard, Paris 750 WMAA 751 Collection the Zorach children 752 Galleria d'Arte del Naviglio, Milan 753 Kunsthaus, Zurich. Alberto Giacometti Foundation. P: Walter Dräyer, Zurich 754 Collection Alexander Iolas, Athens 755 Destroyed 1949. P: Mrs Kurt Seligmann 756 Collection the artist 757 Collection Mr. and Mrs. Morton G. Neumann, Chicago 758 MoMA. Gift of Mr. and Mrs. Pierre Matisse 759 Wadsworth Atheneum, Hartford. The Henry and Walter Kenay Fund 760 MoMA. Purchase 761 P: Images et Textes, Denise Bellon, Paris 762 MoMA. James Thrall Soby Fund 763–764 Los Angeles 765 HMSG 766 Beaubourg 767 Collection Astolfo Ottolenghi, Acqui Terme. P: Editalia, Rome 768 NGA. Ailsa Mellon Bruce Fund, 1974 769 Private collection. P: Adolph Studly, Pennsburg, Pa. 770 Moderna Museet, Stockholm 771 Stedelijk Museum, Amsterdam 772 Detroit Institute of Arts. Gift of Dexter M. Ferry, Jr. Trustee Corporation 773–774 MoMA. Sir Michael Sadler Fund 775 PMA. Gift of Curt Valentin 776 MoMA. Purchase 777 RKM 778 Wakefield Art Gallery and Museums, West Yorkshire, Eng. 779 Estate of the artist. Reproduction rights SPADEM, Paris 780 HMSG 781 KMB. Emanuel Hoffmann Foundation 782 HMSG 783 SRGM. Collection Mary Reynolds, gift of her brother 784 Collection the artist 785 WMAA. Gift of Monique Storrs Booz 787 P: Tass from Sovfoto, New York 788 P: Chicago Historical Society 789 P: California Historical Society, San Francisco 790 P: Museum of the City of New York 793 P: Marie Blumer-Maillart, Zurich 794 P: The Port Authority of New York and New Jersey 795 P: San Francisco Convention and Visitors Bureau 796 P: Redwood Empire Association, San Francisco 797 P: E. M. van Ojen, The Hague 798 P: Hedrich-Blessing, Chicago 799 P: the author 800–801 P: S. C. Johnson Wax Company, Racine 802 P: Marie Blumer-Maillart, Zurich 804 P: Paul Mayen 805 P: Wayne Andrews, Grosse Pointe, Mich. 806–807 P: The Architects Collaborative, Inc., Cambridge, Mass. 810 P: The Museum of Finnish Architecture, Helsinki 814 P: Empire State Building Company, New York 815 P: Visitors Bureau, Rockefeller Center, New York 818 P: New York Daily News 820 P: The Museum of Finnish Architecture, Helsinki 823 P: Ghizzoni di Scotti, Como 824 P: the author 827 P: Publicity Department, Radio City Music Hall, New York 828–829 P: the author 830–831 P: Country Life Magazine, London 832 P: Library of Congress, Washington, D.C. 833 P: Alinari, Florence 834 P: Spiro Kostof

835–836 P: Library of Congress, Washington, D.C. 837 P: Alinari, Florence 838 P: MAS, Barcelona 839 P: MoMA 840–841 P: Archives Photographiques, Paris 842 P: Harvey Croze, Cranbrook Educational Commission 844 P: NGA 845 P: the author 846–847 Location unknown. P: the author 848 The John Deere Art Collection, Moline, Ill. 849 MMA. George A. Hearn Fund, 1934 850 MMA. George A. Hearn Fund, 1946 851 University of Minnesota, Minneapolis 852 Musée du Petit Palais, Paris. P: Service 853 PMA. The Louise and Walter Arensberg Collection 854 MoMA. Given anonymously 855 Collection the artist. P: Malcolm Varon, New York 856 Max Zurier Collection, Beverly Hills. P: WMAA 857 PC 858 KB 859 The New Britain Museum of American Art, Conn. Harriet Russell Stanley Fund 860 AIC. Collection Friends of American Art 861 Museum Boymans-van Beuningen, Rotterdam 862 AIC. Gift of the artist 863 Baker Library, Dartmouth College, Hanover, N.H. 864 Detroit Institute of Arts 865 MoMA. Mrs. Simon Guggenheim Fund 866 MMA. Purchase, 1963. Hugo Kastor Fund 867 MoMA. Gift of A. Conger Goodyear 868 WMAA 869–870 Location unknown. P: the author 871 Tretyakov Gallery, Moscow. P: the author 872 Location unknown. P: the author 873 PMA 874 MoMA. Fractional gift of James Thrall Soby 875 MoMA. Gift of Edward M. M. Warburg 876 Location unknown. P: the author 877 On extended loan to The Museum of Modern Art, New York, from the artist's estate 878 PC 879 MoMA. The James Thrall Soby Bequest 880–881 WMAA 882 Worcester Art Museum, Mass. 883 MMA. Arthur H. Hearn Fund, 1932 884 Private collection 885 MMA. Arthur H. Hearn Fund, 1942 886 MoMA. Given anonymously 887 Frary Dining Hall, Pomona College, Claremont, Calif. 888 Vollard Suite, Pl. 85 889 KB 890 NW. P: Walter Klein, Gerresheim 891 Collection Morton D. May, St. Louis 892 Museum of Art, Carnegie Institute, Pittsburgh 893 MoMA. Acquired by exchange 894 Location unknown. P: the author 895 TGL 896 Collection Mr. and Mrs. Milton Lowenthal, New York. P: MoMA 897 Museum of Art, Rhode Island School of Design, Providence, R.I. Albert Pilavin Fund 898 Private collection, Paris. P: Yves Hervochon, Paris 899 Stedelijk Museum, Amsterdam 900 MoMA. Gift of Miss Ettie Stettheimer 901 SRGM 902 PC. Katherine S. Dreier Bequest 903 RKM 904 SRGM 905 Collection Mrs. Burgoyne Diller, New Jersey. P: Geoffrey Clements, New York 906 Museum Sztuki, Lodz 907 Bayerische Staatsgemäldesammlungen, Munich. P: the author 908 MMA. Arthur H. Hearn Fund, 1949 909 Galerie Louise Leiris, Paris 910 MoMA. Gift of Mrs. Simon Guggenheim 911 The Baltimore Museum of Art. Cone Collection 912–916 Collection Edwin Janss, Thousand Oaks, Calif. 917 MoMA. Purchase

CHAPTER SIX

918–921 P: the author 922 P: Library of Congress, Washington, D.C. 923 P: Federico Arborio Mella, Milan 924 P: Moncalvo, Milan 926 P: the author 931 P: G.E. Kidder-Smith, New York 935 P: John Jacobus, Hanover, N.H. 937 P: United Nations 941 P: the architect 943 P: Julius Shulman, Los Angeles 949 Wadsworth Atheneum, Hartford. The Ella Gallup Sumner and Mary Catlin Sumner Collection 950 TGL 951 Nationalgalerie, Berlin 952 MoMA. Mrs. Sam A. Lewisohn Bequest and Purchase 953 MoMA. Bequest of James Thrall Soby 954 The St. Louis Art Museum. Eliza McMillan Fund 955 The Brooklyn Museum, New York. John B. Woodward Memorial Fund 956 WMAA. Gift of Mr. and Mrs. Roy R. Neuberger 957 Private collection 958 Estate of the artist 959 Beaubourg 960 Church of St. Matthew, Northampton, Eng. 961 The Chapel of the Rosary of the Dominican Nuns, Vence, Fr. 962 TGL. P: John Webb, London 963 Collection Mr. and Mrs. John Hay Whitney, New York 964 Washington University, St. Louis 965 YU. Gift of Stephen C. Clark 966–967 MoMA. Purchase 968 MoMA. Gift of Philip L. Goodwin 969 AIC. Friends of American Art Collection 970 Seattle Art Museum. Gift of Mrs. Thomas D. Stimson 971 Klee Foundation, KB 972 Beaubourg 973 Estate of the artist. Reproduction rights SPADEM 974 Private collection 975 Location unknown 976 MoMA. Purchase 977 HMSG 978 AK. Gift of Seymour H. Knox, 1956 979 Collection Mr. and Mrs. Joseph R. Shapiro, Oak Park, Ill. 980 MoMA. Inter-American Fund 981 MoMA. Inter-American Fund 982 AK. Room of Contemporary Art Fund, 1945 983 Collection Mme. Jean Krebs, Brussels 984 Private collection 985 Galerie Louise Leiris, Paris 986 Collection Jean-Pierre Guerlain, Paris 987 PC 988 The Art Gallery of Western Australia, Perth 989 Collection Felix Klee, Berne 990 Kunsthaus, Zurich. Alberto Giacometti Foundation 991 San Francisco Museum of Modern Art 992 Collection Mrs. Annalee Newman, New York 993 The Brooklyn Museum, New York 994 MFA 995 AIC 996 MoMA. A. Conger Goodyear Fund 997 Collection Panza, Varese 998 Location unknown 999 AIC. Gift of Mr. and Mrs. Maurice E. Culberg 1000–1003 Private collections 1004 AIC. Gift of Mr. and Mrs. William Wood-Prince 1005 MoMA. Given anonymously 1006 MMA 1007 HMSG 1008 Collection the artist, Zurich 1009 Allen Memorial Art Museum, Oberlin College, Ohio. Ruth C. Roush Fund for Contemporary Art 1010 Private collection 1011 University Art Museum, University of California, Berkeley 1012 Dallas Museum of Fine Arts. Gift of Mr. and Mrs. Bernard J. Reis 1013 San Francisco Museum of Modern Art. Gift of Peggy Guggenheim 1014 WMAA 1015 Collection James Johnson Sweeney, New York 1016 TGL 1017 MoMA. Advisory Committee Fund 1018 HMSG 1019 Neuberger Museum, State University of New York, Purchase. Gift of Roy R. Neuberger 1020 MoMA. Purchase 1021 MMA. Fletcher Fund, 1953 1022 MoMA. Given anonymously 1023 Private collection, New York 1024 HMSG 1025 Collection the artist 1026 Wadsworth Atheneum, Hartford 1027 M. Knoedler and Co., Inc., New York 1028 Estate of the artist. Reproduction rights SPADEM, Paris 1029 Private collection 1030 Peggy Guggenheim Collection, Venice 1031 Des Moines Art Center. Coffin Fine Arts Trust Fund, 1975 1032 MoMA. Eliot Noyes Bequest 1033 Walker Art Center, Minneapolis. Gift of T. B. Walker Foundation 1034 Wilhelm Lehmbruck Museum, Duisburg, Ger. 1035 Museum Ludwig, Cologne 1036 MoMA. Acquired through the Lillie P. Bliss Bequest 1037 TGL 1038 Location unknown 1039–1040 MoMA. Mrs. Simon Guggenheim Fund 1041 Estate of the artist. Reproduction rights SPADEM, Paris 1042 Town Square, Vallauris, Fr. 1043 MoMA. A. Conger Goodyear Fund 1044 Cranbrook Academy of Art, Bloomfield Hills, Mich. 1045 MoMA. Gift of Mr. and Mrs. John de Menil 1046 MoMA. Purchase

CHAPTER SEVEN

1047–1048 Chelsea School of Art, London. P: the artist 1049 HMSG 1050 Formerly Galerie Louise Leiris, Paris. P: Leiris, Paris 1051 Fondation Marguerite and Aimé Maeght, St.-Paul-de-Vence, Fr. 1052 Collection Pezzotta, Bergamo 1053 MoMA. Blanchette Rockefeller Fund 1054 Marlborough Gallery, New York. P: New London Gallery, Ltd., London 1055 City of Rotterdam 1056 HMSG 1057 AK. Gift of Seymour H. Knox 1058 MoMA. Matthew T. Mellon Foundation Fund 1059 Elvehjem Museum of Art, University of Wisconsin, Madison. Gift of Dr. and Mrs. Abraham Melamed, 1976 1060 HMSG 1061 TGL 1062 MoMA. P: The Stable Gallery, New York 1063 MoMA. Mrs. Simon Guggenheim Fund 1064 MoMA. A. Conger Goodyear Fund 1065 Kunsthaus, Zurich 1066 Collection the artist 1067 MoMA. Mrs. Simon Guggenheim Fund 1068 Moderna Museet, Stockholm 1069 MoMA. Gift of Mr. and Mrs. N. Richard Miller and Mr. and Mrs. Alex L. Hillman and Samuel Girard Funds 1070 WMAA. Gift of the Friends of the Whitney Museum of American Art 1071 Collection Karl Stroher, Darmstadt. P: Rudolph Burckhardt, New York 1072 Collection Mr. and Mrs. Lewis Manilow, Chicago 1073 MoMA. Gift of Philip Johnson 1074 The Oakland Museum, Calif. Gift of the Art Guild of the Oakland Museum Association 1075 Museum Moderner Kunst, Vienna. Sammlung Hahn 1076 P: Eric Pollitzer, New York 1077–1078 Rotterdam. P: L. W. Schmidt, Rotterdam 1079–1080 Satellite City, Mexico. P: Marianne Goeritz 1081 St. Louis 1082 Time and Life Building, London. P: Brian Seed, Life. © Time, Inc. 1083 St. Peter's, Rome 1084 MoMA. Gift of Mr. and Mrs. Ben Mildwoff 1085 MoMA. Gift of G. David Thompson 1086 Kaiser Wilhelm Museum, Krefeld 1087 Museum Ludwig, Cologne 1088 The Harry N. Abrams Family Collection, New York. P: Leo Castelli Gallery, New York 1089 Munson-Williams-Proctor Institute, Utica, N. Y. 1090 Private collection, Zurich. P: Museum of Art, Carnegie Institute, Pittsburgh 1091 Municipality of Leverkusen, Ger. 1092 Private collection, New York 1093 MoMA. Katharine Cornell Fund 1094 Private collection. P: Rudolph Burckhardt, New York 1095 International Arrivals Building. John F. Kennedy International Airport, New York. P: The Port Authority of New York and New Jersey 1096 Collection Edith L. Rickey. P: the artist 1097 MoMA. Mrs. Charles V. Hickox Fund 1098 Collection the artist. P: Doisneau-Rapho, Paris 1099 Kaiser Wilhelm Museum, Krefeld 1100 The Museum of Fine Arts, Houston. Purchased from funds donated by Dominique and John de Menil 1101 P: Rudolph Burckhardt, New York 1102 P: © Art News 1103 P: Jiro Yoshihara 1104 P: the author 1105–1106 P: Scott Hyde, New York 1107 TGL. P: John Webb, London 1108 Private collection, New York 1109 Musée National Fernand Léger, Biot 1110–1112 Collection Mrs. Mathilde Q. Beckmann, New York 1113 SRGM 1114 MoMA. Purchase 1115 Collection Aimé Maeght, Paris 1116 Collection Carter Burden, New York 1117 Stedelijk van Abbemuseum, Eindhoven 1118 Private collection, Laguna Beach, Calif. P: the artist 1119 Private collection 1120 Dallas Museum of Fine Arts. Gift of Mr. and Mrs. Bernard J. Reis. P: Bill J. Strehorn, Dallas 1121 Municipal Library, Silkeborg, Den. Donated by the artist 1953 1122 Columbus Museum of Art, Ohio. Howald Fund Purchase 1123 MoMA. Given anonymously 1124 Private collection, Los Angeles 1125 HMSG 1126 Collection Dorothy and Richard Sherwood, Beverly Hills 1127 HMSG 1128 Private collection 1129 Oesterreichische Galerie, Vienna. © 1979 by Gruener Janura AG, Glarus, Switz. 1130 HMSG 1131 Private collection, Cincinnati 1132 WMAA 1133 AIC. Gift of Mr. Edgar Kaufmann, Jr. and Mr. and Mrs. Noah Goldowsky 1134 MoMA. Gift of Sidney Janis 1135 Collection Denise and Andrew Saul, New York. P: The Pace Gallery, New York 1136 Private collection 1137 MoMA. Gift of Mr. and Mrs. David M. Solinger 1138 Cleveland Museum of Art, Ohio 1139 WMAA. Gift of the Friends of the Whitney Museum, and purchase 1140–1141 NW 1142 MoMA. Larry Aldrich Foundation Fund 1143 The National Museum of Western Art, Tokyo 1144 Collection the artist 1145 Collection Gilbert Kinney, Washington, D.C. 1146 Moderna Museet, Stockholm 1147 TGL 1148 Westfälisches Landesmuseum für Kunst und Kulturgeschichte, Münster 1149 Private col-

lection 1150 AK. Gift of the Seymour H. Knox Foundation, Inc., 1966 1151 Walker Art Center, Minneapolis 1152 AK. Gift of Seymour H. Knox, 1958 1153 Collection the artist, New York 1154 MoMA. Philip Johnson Fund 1155 HMSG 1156 MoMA. Gift of Mr. and Mrs. Robert C. Scull 1157 SRGM 1158 University Art Museum, University of California, Berkeley. Gift of the artist 1159 Collection Mr. and Mrs. Frederick R. Weisman, Beverly Hills 1160 MoMA. Gift of the artist 1161 Location unknown. P: Marlborough Fine Art Ltd., London 1162 Private collection, Los Angeles. P: Nicholas Wilder Gallery, Los Angeles 1163 MoMA. Purchase 1164 PC 1165 Stedelijk Museum, Amsterdam 1166 Wadsworth Atheneum, Hartford 1167 Museum Ludwig, Cologne 1168 AK. Gift of Seymour H. Knox, 1959 1169 Collection the artist, New York. P: National Gallery of Art, Washington, D.C. 1170 Collection Robert A. Rowan, Pasadena 1171 TGL 1172 Beaubourg. P: Service 1173 Galerie Flinker, Paris 1174 Moderna Museet, Stockholm 1175 On permanent loan to the Israel Museum, Jerusalem, and the Tel-Aviv Museum from the Art Gallery of Toronto. Sam and Ayala Zacks Collection 1176–1177 Museum Moderner Kunst, Vienna. Sammlung Hahn 1178 The Max M. Zurier Collection, Beverly Hills. P: the artist 1179 The Minneapolis Institute of Arts. Julia B. Bigelow Fund, 1957 1180 Stedelijk van Abbemuseum, Eindhoven 1181 SRGM 1182 Collection David Geffen, New York 1183 Collection Mr. and Mrs. Leo Castelli, New York 1184 Collection Mr. and Mrs. Burton Tremaine, Meriden, Conn. 1185 Collection the artist, Düsseldorf 1186–1187 P: Lucien Hervé, Paris 1189–1190 St. John's Abbey and University, Abbey Church, Collegeville, Minn. 1191 P: Wayne Andrews, Grosse Pointe, Mich. 1195–1196 P: Architectural Association, London 1198 P: Publifoto, Milan 1199 P: the architect 1200 1202 P: Wayne Andrews, Grosse Pointe, Mich. 1204 P: Architectural Association, London 1205–1206 P: Australian Tourist Commission, New York 1208–1209 P: SRGM 1210 P: UNESCO 1211–1212 P: Toshio Taira, Osaka 1216 P: Wayne Andrews, Grosse Pointe, Mich. 1217 P: Courtesy the Seagram Corp. 1218–1220 P: the architect 1225 P: The Pulitzer Publishing Company, St. Louis 1228–1229 P: the architects 1230–1231 P: Architectural Association, London 1232–1233 P: Ezra Stoller © ESTO, Mamaroneck, N.Y. 1235–1236 P: Karl Arendt, Cologne 1237 P: Buckminster Fuller Archives, Philadelphia 1239 State Department of Highways and Public Transportation, Austin, Tex.

CHAPTER EIGHT

1240 University Art Museum, University of California, Berkeley 1241 MoMA. Purchase (by exchange) 1242 Collection Annalee Newman, New York. P: Malcolm Varon, New York 1243 San Francisco Museum of Modern Art. Gift of the artist 1244 MoMA. Gift of the artist 1245 MoMA. Gift of Philip Johnson 1246 HMSG 1247 NW 1248 Collection Pierre Restany, Paris 1249 Dallas Museum of Fine Arts. Gift of Mr. and Mrs. Algur H. Meadows and the Meadows Foundation, Incorporated 1250 Xavier Fourcade, Inc., New York 1251 MMA. Arthur H. Hearn Fund, 1967 1252 Collection Mr. and Mrs. Bernard Surgil, New York 1253 Collection Robert A. Rowan, Pasadena 1254 University Art Museum, University of California, Berkeley 1255 Collection Mr. and Mrs. Frank M. Titelman, Altoona, Pa. P: Leo Castelli Gallery, New York 1256 Private collection. P: SRGM 1257 HMSG 1258 Collection Mr. and Mrs. I. M. Pei, New York 1259 Nationalgalerie, Berlin. P: Bildarchiv Preussischer Kulturbesitz, Berlin 1260 Collection Mr. and Mrs. Morton Globus, New York 1261 Collection the artist,

Paris 1262 YU. Gift of Seymour H. Knox 1263 HMSG. P: Scott Hyde, New York 1264 MoMA. Philip Johnson Fund 1265 Collection the Honorable Clare Boothe Luce 1266 WMAA. Gift of the Friends of the Whitney Museum 1267 Allen Memorial Art Museum, Oberlin, Ohio. Ruth C. Roush Fund for Contemporary Art and National Foundation for the Arts and Humanities grant 1268 The Woodward Foundation, Washington, D.C. P: Leo Castelli Gallery, New York 1269 Marlborough Gallery, New York. P: Eric Pollitzer, New York 1270 Art Gallery of Ontario, Toronto. Gift of the Women's Committee Fund, 1964 1271 Museum Ludwig, Cologne 1272 Collection Dorothy and Roy Lichtenstein, New York 1273 P: the artist 1274 The Mead Corporation, Dayton, Ohio 1275 Collection the artist 1276 The Harry N. Abrams Family Collection, New York 1277 Collection the artist 1278 Neue Galerie, Aachen. P: Sidney Janis Gallery, New York 1279 Collection Sydney and Frances Lewis, Richmond, Va. 1280 Collection the artist 1281 Marlborough Gallery, New York 1282 AK. Gift of Seymour H. Knox, 1963 1283 Moderna-Museet, Stockholm 1284 P: Eric Pollitzer, New York 1285 Collection Carroll Janis, New York 1286 Bianchini Gallery, New York 1287 WMAA 1288 Moderna Museet, Stockholm 1289 Collection Marielle L. Mailhot, Montreal 1290 WMAA. Gift of the Friends of the Whitney Museum of American Art 1291 Nationalgalerie, Berlin. P: Bildarchiv Preussischer Kulturbesitz, Berlin 1292 Private collection. P: Petersburg Press Ltd., London 1293–1294 Museum Ludwig, Cologne 1295 Collection Morton G. Neumann, Chicago 1296 MoMA. Larry Aldrich Foundation Fund 1297 Stedelijk Museum, Amsterdam. P: Konrad Fischer Gallery, Düsseldorf 1299 John Weber Gallery, New York 1300–1301 P: the artist 1302 SRGM. Gift of the Harry N. Abrams Family Collection, New York 1303 Collection David Whitney, New York 1304 Galerie Darthea Speyer, Paris. P: the artist 1305 Private collection, Paris. P: Moderna Museet, Stockholm 1306 Location unknown. P: Marlborough Gallery, New York 1307 Museum Ludwig, Cologne 1308 MoMA. Gift of the designer 1309 Collection Herschel B. Chipp, San Francisco 1310 P: Herschel B. Chipp, San Francisco 1311 Collections of the Library of Congress, Washington, D.C. 1312 MoMA. Purchase 1313 Private collection, New York 1314 Fondation Marguerite and Aimé Maeght, St.-Paul-de-Vence, France 1315 Civic Center, Chicago. P: Balthazar Korab, Troy, Mich. 1316 The University of Chicago, Ill. P: Michael E. Shields, Chicago 1317 Montreal. P: Ugo Mulas 1318 MoMA. Gift of the artist 1319 Philadelphia Museum of Art 1320 Private collection. P: Fischbach Gallery, New York 1321–1322 Private collection. P: Leo Castelli Gallery, New York 1323 Installation, 1965, Green Gallery, New York. P: Rudolph Burckhardt, courtesy Leo Castelli Gallery, New York 1324 Art Gallery of Ontario, Toronto. Purchase, 1969 1325 Collection Aage Damgaard, Haring, The Netherlands 1326 Nationalgalerie, Berlin 1327 Collection Mr. and Mrs. Peter Brant, Greenwich, Conn. P: John D. Schiff, New York 1328 TGL 1329 Mt. Sinai Hospital, New York. P: Gianfranco Gorgoni, New York 1330 Collection the artist. P: Richard Bellamy, New York 1331 Institute of Religion and Human Development, Houston. P: Balthazar Korab, Troy, Mich. 1332 Collection Timothy and Paul Caro 1333 MoMA. James Thrall Soby Fund 1334 Moderna Museet, Stockholm 1335 Museum Ludwig, Cologne 1336 The Minneapolis Institute of Arts. Gift in memory of Faye Cole Andrus by Mr. and Mrs. John E. Andrus III 1337 HMSG 1338 TGL 1339 San Francisco Museum of Modern Art. T. B. Walker Foundation Fund 1340 Collection Raccolta Amici de Manzù, Ardea 1341 Estate of the artist. P: Stephen Wirtz Gallery, San Francisco 1342 Fundació Joan Miró, Barcelona 1343 Walker

Art Center, Minneapolis 1344 Stedelijk van Abbemuseum, Eindhoven 1345 WMAA. Gift of the Howard and Jean Lipman Foundation, Inc. 1346 Museum Ludwig, Cologne 1347 Museum Moderner Kunst, Vienna. Sammlung Hahn. P: the artist 1348 MoMA. Larry Aldrich Foundation Fund 1349 MoMA. Philip Johnson Fund 1350 Musée Royaux des Beaux-Arts, Brussels. P: © A.C.L., Brussels 1351 Private collection. P: Leo Castelli Gallery, New York 1352 Private collection. P: Geoffrey Clements, New York 1353 University Art Museum, University of California, Berkeley. Gift of the artist 1355 MoMA 1356 AK. Gift of Seymour H. Knox, 1964 1357 RKM 1358–1359 University Art Museum, University of California, Berkeley. Gift of Howard Wise, New York 1360 Collection Patrick Lannan. P: the artist 1361 Pulsa Group, New Haven 1362 Jewish Museum, New York. P: John Weber 1363 Collection Panza, Milan 1364 Installation, 1969, Castelli Warehouse, New York. P: Leo Castelli Gallery, New York 1365 SRGM 1366 Jefferson Place Gallery, Washington, D.C. 1369 John Weber Gallery, New York. P: the artist 1370–1371 Pasadena, Calif. P: Julian Wasser, Life Picture Service, New York 1372 University of Washington, Bellingham 1373–1374 Installation, 1968, Documenta 4, Kassel, Ger. P: David Bourdon 1375 Bonn, opposite the Bundeshaus. P: the artist 1378 Installation, 1968, Heiner Friedrich GmbH., Munich. P: Dia Art Foundation, New York 1379 Stedelijk van Abbemuseum, Eindhoven 1381 St. John's River at Ft. Kent, Me. P: John Gibson Commissions, Inc., New York 1382 Mormon Mesa, Nev. P: Dwan Gallery, New York 1383 Museum Moderner Kunst, Vienna. P: Rheinisches Bildarchiv, Cologne 1384–1385 Stedelijk Museum, Amsterdam 1386–1387 On extended loan to the Kunstmuseum, Lucerne 1388 Destroyed. P: O.K. Harris Gallery, New York 1389 AIC. Anonymous gift 1390 Location unknown 1392 M. Knoedler & Co., Inc., New York. P: Rudolph Burckhardt 1393–1394 Estate of the artist, Oakland, Calif. P: the author 1395 AK. Gift of Seymour Knox, 1966 1396 Private collection. P: Eric Sutherland 1397 Leo Castelli Gallery, New York. P: the artist 1398 Collection Panza, Milan 1400 Galerie René Block, Berlin. P: Carla Gottlieb 1401–1402 Allan Kaprow in his "Montauk Bluffs" segment of the collaborative (Kaprow, Charles Frazier, Gordon Hyatt, and Mordecai Gerstein) three-day happening Gas, performed throughout the Hamptons on Long Island, August 1966. P: © Peter Moore. 1404–1405 Performed in Prague, 1964. P: Fotografovala, Prague 1406 Performance, New York, 1969. P: Sonnabend Gallery, New York 1407 Exhibition at Smolin Gallery, New York, Yam Festival, 1963. P: © Peter Moore 1408 Performance at Segal's Farm, New Brunswick, N. J., Yam Festival, 1963. P: © Peter Moore 1409 Bra, Collection Howard Wise, New York. P: © Peter Moore 1410–1411 Leo Castelli Gallery, New York 1413 PMA. P: Leo Castelli Gallery 1414 Sonnabend Gallery, New York 1415 PMA 1416–1417 P: Hedrich-Blessing, Chicago 1418 P: Joseph W. Molitor, Valhalla, N. Y. 1419 P: Architectural Association, London 1420–1422 P: Ezra Stoller © ESTO, Mamaroneck, N. Y. 1423–1424 P: Bob Serating, Morris Warman, © Lincoln Center for the Performing Arts, Inc. 1425–1426 P: Akademie der Künste, Berlin 1427 P: Kiesler Archives, New York 1431–1432 P: Galerie Maeght, New York 1433–1434 P: The Frank Lloyd Wright Foundation, Scottsdale, Ariz. 1436 P: Wayne Andrews, Gross Pointe, Mich. 1440 P: The Museum of Finnish Architecture, Helsinki 1443–1444 P: Ezra Stoller © ESTO, Mamaroneck, N. Y. 1445, 1447–1448 © P: Wayne Andrews, Grosse Pointe, Mich. 1449 P: Will Brown, Philadelphia 1450–1452 P: the architects 1453 P: Wayne Andrews, Grosse Pointe, Mich. 1460–1461 P: Kenzo Tange and URTEC, Tokyo 1464–1465 P: NASA, Wash-

ington, D.C. **1466** Buckminster Fuller Archives, Philadelphia

CHAPTER NINE

1467 P: Hyatt Regency Hotel, San Francisco **1468** P: Jeremiah O. Bragstad **1469–1470** P: Norman McGrath, New York **1471** P: German Information Center, New York **1472** Walter R. Thiem, Greenwich, Conn. **1473** P: Hedrich-Blessing, Chicago **1474** P: Gil Amiaga, courtesy the architects **1476** P: Sekai Bunka Photo, New York **1477** P: the architect **1478** P: Office of Public Information, Federal Reserve Bank of Minneapolis **1479** P: Citicorp, New York **1480** P: Taisuke Ogawa © *The Japan Architect* **1481–1482** P: Ezra Stoller © ESTO, Mamaroneck, N.Y. **1483–1484** P: The Institute for Architecture and Urban Studies, New York **1485** Photo Gruppe für Design **1486** P: Federico Arborio Mella, Milan **1487** P: the architect **1488** P: the architect **1489** P: Steve Rosenthal, Boston **1490** P: Ian A. Niamath, courtesy the architects and Spaced Gallery, New York **1491** P: Philip MacMillan James, St. Paul, Minn. **1492** P: the architects **1493** P: United States Department of the Interior, Washington, D.C. **1494–1495** P: © Peter Papademetriou, Houston, Tex. **1496** P: Etienne Bertrand Weill, Paris **1497** P: Dmitri Kessel, Paris **1498–1499** P: NGA **1501** P: University of British Columbia, Museum of Anthropology, Vancouver **1502** P: the architect **1503** Museum Ludwig, Cologne **1504** University Art Museum, University of California, Berkeley **1505** Collection Dorothy Wiley. P: Wanda Hansen, Sausalito, Calif. **1506** P: the artists **1507** P: Edmund Shea, Ronald Feldman Fine Arts, Inc. **1508** P: Robert Blalock **1509–1510** John Weber Gallery, New York **1511** Collection the artist. P: Eric Pollitzer, New York **1512** Sammlung Ludwig, Aachen. P: Fischer Fine Art Ltd., London **1513** WMAA. Gift of Frances and Sydney Lewis **1514** Neue Galerie, Sammlung Ludwig, Aachen **1515** Collection the artist **1516–1517** P: Marlborough Gallery, New York **1518** Collection the artists. P: Sonnabend Gallery, New York **1520** P: the artist **1521** Corcoran Gallery of Art, Washington, D.C. **1522** Allan Frumkin Gallery, New York **1523** Museum Moderner Kunst, Vienna. P: Foto Mayr, Vienna **1524** P: the artist **1525** Private collection. P: The Pace Gallery, New York **1526** Collection Mr. and Mrs. Morton G. Neumann, Chicago **1527** Private collection. P: Geoffrey Clements, New York **1528** P: the artist **1529** AK. George B. and Jenny R. Mathews Fund, 1979. P: The Pace Gallery, New York **1530** San Francisco Museum of Modern Art. Gift of the artist **1531** Lefebre Gallery, New York **1532** Odyssia Gallery, New York **1533** Collection T. R. Eyton. P: Marlborough Fine Art Ltd., London **1534** Collection the artist. P: Atelier Arnulf Rainer, Vienna **1535** Marlborough Fine Art Ltd., London **1536** P: Lerner-Heller Gallery, New York **1537** Installation, 1976, Biennale, Venice. P: Cameraphoto, Venice **1538** P: the artist **1539** P: The Pace Gallery, New York **1540** P: the artist **1541** P: Christine Harris **1542** P: Michael Inderrieden **1543** P: the author **1544** Xavier Fourcade, Inc., New York **1545** The Pace Gallery, New York. P: Tom Crane **1546** Installation, 1973, Battery Park, New York. P: the artist and Max Protetch Gallery, New York **1547** Installation, 1977, Documenta 6, Kassel, Ger. P: John Weber Gallery, New York **1548** Private collection. P: the artist **1549** P: Mildred Constantine, New York **1550** BART, Embarcadero Station, San Francisco. P: © Lancaster-Miller Publishers. Used by Permission **1551** Collection the artist **1552** WMAA. Purchase. **1553** Collection the artist. P: Nathan Rabin, New York **1554** Collection the artist. P: Paula Cooper Gallery, New York **1555** P: the artist **1556** P.S. 1, New York. P: the author **1557** Collection the artist **1558** Museum of Art, Carnegie Institute, Pittsburgh. P: The Pace Gallery, New York **1559** Leo Castelli Gallery, New York **1560** The Pace Gallery, New York **1561** AK. Gift of Seymour H. Knox, 1974 **1562** Collection the artist **1563** Installation, 1972, Documenta 5, Kassel, Ger. P: Galerie Denise René Hans Mayer, Düsseldorf **1564** Collection Graham Gund. P: Leo Castelli Gallery, New York **1565** P: the artist **1566–1567** Edition Hansjorg Mayer. P: the artist **1568** From Edward Ruscha, *Real Estate Opportunities*, 1970 **1569** P: Cor Van Weele, courtesy Art & Project, Amsterdam **1570–1571** P: © Gianfranco Gorgoni/Contact **1572** P: Shunk-Kender, courtesy Jeanne-Claude Christo **1573** P: © Gianfranco Gorgoni/Contact **1574** Installation, 1977, Documenta 6, Kassel, Ger. P: Dia Art Foundation, New York **1575** Installation, 1977, Documenta 6, Kassel, Ger. P: Leo Castelli Gallery, New York **1576** P: Paula Cooper Gallery, New York **1577** P: Henrik Gaard, New York **1578** P: Jaap de Graaf, courtesy Galerie Krinzinger, Innsbruck **1579** P: the artist **1580–1581** P: the artist **1582** P: Galerie Krinzinger, Innsbruck **1583** P: Doris C. Freedman, courtesy the Public Art Fund, Inc., New York **1584** P: Susan Einstein, Santa Monica, Calif. **1585** P: John Pitman Weber, Chicago **1586** P: Susan Einstein, Santa Monica, Calif. **1587** P: the author **1588** P: Ullstein Bilderdienst, Berlin **1589** Bykert Gallery, New York. P: Nathan Rabin, New York **1590** Installation, 1977, Documenta 6, Kassel, Ger. P: the artist **1591** P: Gwen Thomas, Castelli-Sonnabend Tapes and Films, Inc., New York **1592** Produced by ORF-TV in collaboration with Galleria P.O.O.L., Graz, Austria. P: the artist **1593** Vertrieb Oppenheim Studio, Cologne **1594** Documenta Archiv, Kassel, Ger. **1595** P: the author **1596** P: Gwen Thomas, Castelli-Sonnabend Tapes and Films, Inc., New York **1597** P: © Gianfranco Gorgoni/Contact **1598** P: Artist Placement Group, London **1599** P: Dieter Schwerdtle, Documenta Archiv, Kassel, Ger. **1600** P: the artist, modified by the artist **1601–1602** P: © Les Levine **1603** Collection the artist. P: John Weber Gallery, New York